RURAL ARTISTS' COLONIES

IN EUROPE

1870–1910

**ISSUES IN
ART HISTORY SERIES**

Tim Barringer, Nicola Bown
and Shearer West
SERIES EDITORS

Steven Adams and Anna Gruetzner Robins, eds.,
Gendering landscape art

James Aulich and John Lynch, eds.,
Critical Kitaj

David Peters Corbett and Lara Perry, eds.,
English art, 1860–1914

Rafael Cardoso Denis and Colin Trodd, eds.,
Art and the academy in the nineteenth century

Nina Lübbren,
Rural artists' colonies in Europe, 1870–1910

Elizabeth Prettejohn, ed.,
After the Pre-Raphaelites

Brandon Taylor,
Art for the nation

Rural artists' colonies in Europe

1870–1910

NINA LÜBBREN

Rutgers University Press
New Brunswick, New Jersey

First published in the United States 2001
by Rutgers University Press, New Brunswick, New Jersey

First published in Great Britain 2001
by Manchester University Press,
Oxford Road, Manchester M13 9NR, UK
http://www.manchesteruniversitypress.co.uk

Library of Congress Cataloging-in-Publication Data

Lübbren, Nina.
 Rural artists' colonies in Europe, 1870–1910/Nina Lübbren.
 p. cm.—(Rutgers University Press issues in art history)
 Includes bibliographical references and index.
 ISBN 0–8135–2976–X (alk. paper)—ISBN 0–8135–2977–8 (pbk. : alk. paper)
 1. Artist colonies—Europe. 2. Art, Modern—19th century—Europe. 3. Art,
 Modern—20th century—Europe. I Title. II. Issues in art history.

N6757 .L75 2001
709'.4'091734—dc21

00–051733

*British Cataloguing-in-Publication Data for this book is available from
the British Library.*

Printed in Great Britain

Für meine Eltern

Contents

Illustrations

Map

Colour plates

Figures

Acknowledgements

This book began as an idea in Berlin, survived a year in Berkeley, had its first incarnation as a Ph.D. dissertation in Leeds, and was written once I had become a lecturer in Cambridge. It is a great pleasure finally to thank all those people who helped along the way. My first debt is to my supervisor, Griselda Pollock, for her critical guidance, intellectual inspiration and unfailing support of this project. I also wish to thank John House and Adrian Rifkin who turned a doctoral *viva* into a celebratory occasion. Warm thanks are also due to John House for rereading the manuscript at a later stage and offering exceptionally constructive and generous comments.

This book would quite literally not exist without Michael Jacobs. His own volume on artists' colonies introduced me to the subject, his friendly response to my first forays into the topic encouraged me to pursue it further, and his generous loan of materials was invaluable. My research on Ottilie Reylaender and Worpswede was made possible through the commitment and generosity of Susanna Böhme-Netzel of the Worpsweder Kunststiftung Friedrich Netzel, and the late Friedrich Netzel. My aunt, Juliane Brunßen, kindly drove me to many hidden homes and provincial galleries near Bremen.

Others helped by supplying rare and unpublished material, guiding me around regional museums and villages, and otherwise assisting my research: Andreas Bantzer of the Malerstübchen Willingshausen; Ronald van Vleuten of Egmond; Piet Vellekoop and Anne Stempels in Katwijk; Karin Verboeket of the Singer Museum in Laren; Hans Kraan and Ernst van de Wetering of the wonderful Rijksbureau voor kunsthistorische documentatie in the Hague; Alf Elmberg of the Stiftelsen Grez-sur-Loing at Gothenburg, and Niels Chöler of Sveriges Television in Gothenburg. Hans-Günther (Pawel) Pawelcik of the Verlag Atelier im Bauernhaus in Fischerhude has been more than generous in sharing his expertise and materials.

I also thank all those who responded to parts of this book in the form of seminar or conference papers, in particular Ysanne Holt, David Peters Corbett, Claus Pese, Bettina von Andrian, Imke Bösch, Claudia Caesar, David Crouch, Jonathan Steinberg, Brendan Simms, Anita Bunyan, and Paul Smith. Richard Sanger and Deborah Lambie first alerted me to the distinction between utopia and nostalgia which ended up being unexpectedly central to the book's argument. Elisabeth

Fraser, John Urry, Robert L. Herbert, and the anonymous first reader of the Barber Institute's series read and commented on drafts, and I owe much to their insightful criticisms.

I thank Kate Clark and Catherine Garrett for their encouragement while this book was looking for a publisher. Margit Thøfner kindly and most scrupulously translated a sheaf of Danish and Swedish texts. Alison Whittle of Manchester University Press has been an understanding and supportive editor.

Much-needed financial support was provided by a Regents Internship at the University of California at Berkeley, by the British Academy, and by the Research Development Fund at Anglia Polytechnic University. Carola Muysers generously tided me over with a loan, and Jennifer Gordon helped to keep me in part-time employment when most wanted.

Collecting all the images for this book has been an adventure in itself, and I am grateful to all those institutions and individuals who kindly waived reproduction fees for their photographs. I only wish there were more of them. Every effort has been made to trace the copyright of all works reproduced but if, for any reason, a request has not been received, the copyright holder should please contact the publisher.

Finally, I most warmly thank my husband, Christopher Clark, who has been my most enthusiastic supporter and most constructive critic. Our two dear sons Josef and Alexander have interrupted work on the book in many delightful ways.

I dedicate this book to my parents, Christa and Rainer Lübbren, with much love.

Facing Principal rural artists' colonies in Europe, *c.* 1900

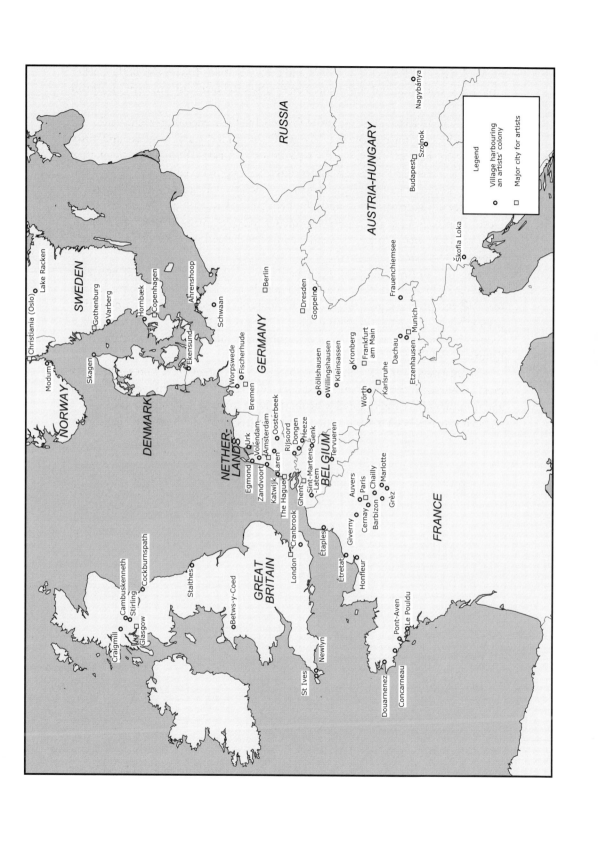

Legend

Village harbouring
an artists' colony

Major city for artists

RUSSIA

AUSTRIA-HUNGARY

Nagybánya

Szolnok

Budapest

Škofja Loka

SWEDEN

Christiania (Oslo)

Lake Racken

Gothenburg

Varberg

Hornbæk

Copenhagen

Ekensund

Ahrenshoop

Schwaan

Berlin

Dresden

Goppeln

Frauenchiemsee

NORWAY

Modum

Skagen

DENMARK

GERMANY

Worpswede

Fischerhude

Bremen

Rollshausen

Willingshausen

Kleinsassen

Kronberg

Frankfurt
am Main

Dachau

Etzenhausen

Munich

NETHER-
LANDS

Egmond

Urk

Volendam

Zandvoort

Amsterdam

Laren

Katwijk

Rijsoord

Dongen

Heeze

The Hague

Ghent

Sint-Martens-
Latem

Genk

Tervueren

Worth

Karlsruhe

BELGIUM

Oosterbeek

Auvers

Paris

Chailly

Cernay

Barbizon

Marlotte

Grèz

GREAT
BRITAIN

Cockburnspath

Stalthes

Betws-y-Coed

London

Cranbrook

Étaples

Giverny

Honfleur

Étretat

Cambuskenneth

Stirling

Glasgow

Craigmill

Newlyn

St Ives

Douarnenez

Pont-Aven

Le Pouldu

Concarneau

FRANCE

Introduction

This book is about a remarkable and internationally significant phenomenon of artistic practice in the late nineteenth and early twentieth century: the mass movement of painters from the traditional urban centres of art into the countryside, and the forming of artists' communities in rural locations throughout Europe. Between 1830 and 1910, over three thousand artists from all over the world left the established centres of art production to live and work in artists' communities scattered across the European countryside. By 1900, eleven European states harboured between them over eighty rural artists' colonies. These sites attracted a cultural traffic that was quantitatively and qualitatively without precedent in the history of Western art. A substantial proportion of all artists practising in Europe and North America spent at least one or more seasons living and working in one of these colonies. By the 1880s, settlement in an artists' village, on a temporary or permanent basis, had become a serious career option for artists, and a steady stream of painters migrated from city to country while an ever-growing quantity of rural paintings was sent back to urban exhibition venues. Artists' colonies were a fixture in contemporary critical discourse, and many artists' villages transformed themselves into popular tourist attractions.

This book provides the first systematic, comparative and critical analysis of European rural artists' colonies as a dominant mode of international art practice during their heyday between 1870 and 1910. It reconstructs the history of the movement, drawing on a wide range of textual and pictorial sources, but the empirical documentation of the phenomenon is combined throughout with a critical and theoretical reconceptualisation of late nineteenth-century European art as a whole. This rereading is a timely intervention in a field which has become comfortably entrenched in a number of well-worn lines of argument. As I will outline in greater detail below, most histories of the art of this period are preoccupied with the urban avant-garde and have little time for a movement that, on the surface, seems anti-urban and not very avant-garde. Yet rural artists' communities hatched some of the most exciting innovations of late nineteenth-century painting and interacted with the concerns of the canonical modernists in unexpected ways. This book neither privileges the familiar avant-garde sites and movements of nineteenth-century art nor does it seek to rediscover neglected artists for the sake of novelty alone. Rather, it maps out a cultural terrain inhabited by both conservative and so-called avant-garde

artists. Expanding upon recent theoretical work on the meanings of place, the book argues that rural artists' colonies set the scene for a qualitatively new encounter between artists and the rural environment, characterised by an intense engagement with the specifics of a particular location. Through their collusion in the elaboration of place-myths (see chapter 6), the colonies played a formative role in the profound cultural transformations associated with the emergence of modern tourism. The practices and images of rural artists articulated central concerns of urban middle-class audiences, in particular the yearning for a life that was authentic, pre-modern and immersed in nature. Paradoxically, it was precisely this nostalgia for the pre-modern that placed artists' colonies firmly within modernity.

Before I go on to outline some of the theoretical and methodological premises of this book, I offer a general overview of the when, where, who and how of rural artists' communities.

Rural artists' colonies: an overview

Rural artists' colonies, as they are defined in this book, were communities of artists, mainly painters, who worked and lived in a village for a certain period of time. The mixture of commitment to a rural place and commitment to a group life based on ties of friendship is characteristic of the type of community explored in this book.

The majority of rural artist' colonies were to be found in France, Germany and the Netherlands but there were also sizeable communities in Belgium, Britain, Denmark, Norway, Sweden, Hungary, Poland and Slovenia (see map). At least 3,000 artists worked in one or more art villages at one point in their careers.[1] Of these, at least 400 were women, that is, about 13 per cent of the total (though these figures are no doubt skewed by the poor research base available for women artists).[2] The smallest artists' colonies seem to have had the highest proportion of women artists while large, popular communities like Barbizon and Pont-Aven included only a tiny number.[3]

While some of the villages attracted mainly regional or national artists, others were international in character. Artists came from all over Europe, and indeed, from all over the world, to Barbizon, Pont-Aven, Katwijk, Newlyn and Dachau.[4] United States citizens formed a sizeable national entity within many colonies. Americans started the communities in Pont-Aven, Giverny, Rijsoord and Egmond, dominated those of Concarneau and Volendam, and were present in substantial numbers in Barbizon, Grèz, Laren, Katwijk and St Ives. In the mid-1880s, Grèz went through a predominantly Scandinavian phase, and Germans were the second-largest national group in Katwijk, next to the Dutch. On the other hand, foreigners were rare in Sint-Martens-Latem, Tervueren, Nagybánya, Kronberg, Worpswede and Willingshausen, and the catchment area of Staithes was confined to Yorkshire and Nottingham. Skagen was dominated by Danes, with a sprinkling of other Scandinavians. Overall, at least thirty-five nationalities

were represented in European artists' villages, with Americans, Germans and British forming the largest contingents.[5]

Rural artists' colonies existed for most of the nineteenth century. The first were formed in the 1820s (Barbizon, Chailly and Frauenchiemsee), and others followed in the decades after. Their heyday, however, was in the last thirty years of the nineteenth and the first ten of the twentieth century, when over two-thirds of all artists' colonies were established, peaking at thirty-two new formations in the 1880s.[6] Moreover, in this period, the artistic populations of already-established colonies were at their height, with some villages attracting over one hundred artists per season.[7] The reasons for this increased popularity of rural artists' colonies in the 1880s and 1890s remain difficult to pinpoint. The rise in numbers is clearly linked, although cannot be exhaustively explained by, the rise in the overall number of training and practising artists in this period.[8] More specifically, the growing cult around Jean-François Millet, boosted by the artist's death in January 1875 and reflected in the dramatic rise of prices for works by Millet and his rural colleagues, doubtless accounted in part for both the growing numbers of visitors to Barbizon and the spate of new artists' colonies founded elsewhere.[9] Barbizon became 'one of the most famous villages in the world',[10] and provided a model for others to emulate, even for those artists (such as Otto Modersohn in Worpswede) who had never been there. However, recent historical work suggests that artists' colonies were also part of much wider cultural developments during the 1880s and 1890s which encompassed, among other things, a growing mood of nostalgic longing for the countryside as compensation for accelerated industrialisation and urbanisation.[11]

The size of artists' colonies ranged from just thirteen known names in Rijsoord to over five hundred in Katwijk.[12] Barbizon, Dachau, Pont-Aven and Willingshausen all housed over two hundred artists throughout the nineteenth century while Volendam, Concarneau, Grèz, Laren and St Ives each attracted over one hundred. All of these figures are estimates as it is difficult to determine precisely how many artists were present in a village at any one time, and how exactly the demographic situation changed over the years. Hotel registers such as the ones kept in Katwijk, Volendam, Egmond, Barbizon, Giverny and Pont-Aven are helpful; still, many artists did not stay at a hotel, and extant registers also generally do not cover the entire period of artistic activity at a place.[13] The above statistics are also somewhat distorted with a bias towards those artists' colonies that have been the subject of exhaustive data collecting, notably Katwijk, Dachau, Willingshausen and, to a lesser degree, Pont-Aven.[14] The lifespan of individual communities must also be taken into account: for example, I have recorded 253 names in Barbizon from the 1820s to the 1900s while visitors' registers chronicle 517 artists in Katwijk, nearly all of whom arrived between 1880 and 1910 (that is, over a period of just thirty years compared with Barbizon's ninety). Future research may bring more clarity to this situation.

The number of permanent versus temporary residents varied from colony to colony. Some villages had a transient and fluctuating artistic population. Volendam

was for most a transit stop for the summer season, as were Honfleur, Giverny, Katwijk, Frauenchiemsee and Willingshausen. However, most artists' colonies (such as Barbizon, Concarneau, St Ives, Laren, Skagen, Ahrenshoop and Dachau) had a mixture of permanent and seasonal visitors while some (such as Worpswede, Newlyn, Sint-Martens-Latem and Egmond) were focused more exclusively on a relatively stable group of permanently settled artists. In all of the latter places, artists bought or built their own houses and studios. In Dachau, the architect Georg Ludwig designed an entire settlement of houses especially for artists.[15] Many artists settled in a village for many years or for life. For example, both Jean-François Millet and Charles Emile Jacque died in Barbizon after twenty-five years and forty-five years of residence respectively, as did Fritz Mackensen in 1953 after fifty-four years in Worpswede and Robert Wylie in 1877 after thirteen years in Pont-Aven. William Babcock settled in Barbizon for twenty years from around 1850, and Heinrich Vogeler lived in his own Worpswede residence for thirty-two years from 1895 to 1927. In many cases, artists settled in a village for a period of years and then moved on. Laura Knight, for example, lived in Staithes for around thirteen years and in Newlyn for about five. Other artists were regular 'colony-hoppers', visiting a new one every summer or moving from one to the next in nomadic fashion: Max Liebermann painted at Barbizon, Dachau, Etzenhausen and in a whole range of Dutch villages: Laren, Katwijk, Zandvoort, Zweeloo and Dongen; Evert Pieters was active in Barbizon and throughout the Netherlands in Egmond, Katwijk, Laren, Blaricum, Volendam and Oosterbeek; Frederick Waugh painted in Barbizon, Concarneau, Grèz, St Ives and Provincetown in the United States; Elizabeth Armstrong Forbes worked in Pont-Aven, Zandvoort, Newlyn and St Ives.

Whether or not individual artists settled in a village, what remains distinctive and important about artists' colonies is the possibility of settlement that always remained open for every visitor. Artists who settled inserted themselves into the collective enterprise of that colony. Their decision not only affected their own lives but contributed to the overall ethos of colonies, namely, that settling in a village was somehow superior to visiting a village as a transitory Sunday sketcher. This communal ethos of permanent residence left its mark on those many painters in colonies who did *not* settle, and contributed to the peculiarly loaded meanings of plein-air work in artists' colonies. Even recent arrivals in a colony ranged themselves around the symbolic core group. In places like Volendam and Willingshausen where there was no group of permanently resident painters, artists nevertheless fell into the 'artist-colonial' mode of professing familiarity with the location by dint of frequent returns, childhood connections, special relationships with locals and so forth. In the end, the permanent settlement of particular individuals was not as important for the ongoing success of an artists' colony as the continued presence of *some* artists; the individuals themselves were, to a certain degree, interchangeable. If a painter came to the village and found a group of other painters there (although their identities might differ from year to year), that was enough to establish the place as an artists' colony, with its own social and pictorial traditions.

A special case are local artists. In fact, almost none of the artists working in a rural location had been born or reared in that place. I have found only twenty-nine artist-colonists who were natives of their village, that is, fewer than one per cent of the total. An exception is the German artists' colony at Schwaan in Mecklenburg, begun around 1892 by a local man and counting at least five Schwaaners among its artists.[16]

All of the artists' colonies started in a seemingly haphazard and often serendipitous fashion. The American pioneers at Giverny, for example, claimed that they had happened upon the village quite by chance while on a train bound for another destination altogether:

> The train follows the River Seine practically the whole way. Just before reaching Vernon, [Willard] Metcalf rose up and said, 'Fellows, just look at that – isn't it lovely?' They all took a look and agreed with him. Then he said, 'If we don't see anything better than that by the time we get to Pont de l'Arche let's come back and stay there.' … They stayed the night at Pont de l'Arche and as they had seen nothing better or even anything so good in their unanimous opinion as Giverny, back to it they went in the morning.[17]

Stanhope Forbes, freshly returned from a trip to Brittany, tried out several locations in Cornwall before hitting upon Newlyn, later saying: 'I came to Newlyn for a fortnight and I have stayed sixteen years.'[18] Fritz Mackensen came to Worpswede because the niece of his landlady in Düsseldorf happened to be from there and invited him home for the summer vacation.[19] Paul Müller-Kaempff went hiking with a friend while on holiday in Wustrow on the Baltic Sea; upon cresting the last hill, both saw below them a delightful village they had never heard of: Ahrenshoop. A few days later, they found lodgings there, and Müller-Kaempff went on to buy himself a house, establish a painting school and live in Ahrenshoop until the 1920s.[20] One of the more romantic versions of the 'discovery' of Barbizon in 1824 recounts how three painters, starting out on a tramp through the forest in search of motifs, got lost as it was getting dark. Following the sound of a cowherd's horn and the tinkling of bells, they encountered a local who led them to nearby Barbizon, 'escorted by 40–50 cows with a bell each'.[21] Many stories told in retrospect about a colony's 'pioneers' were shaped by a similar mythology of adventure and discovery.

Most artists' colonies grew by word of mouth some time before they were written about or gained notice through exhibitions. Once that happened, though, publications (both text and reproductions) and exhibited paintings could induce yet more artists to visit a place. The photographer and art student Hermine Rohte, for example, was so impressed by Fritz Overbeck's *Moonrise in the Moor*, shown in Munich in 1896, that she travelled to Worpswede especially to receive instruction from Overbeck (whom she married shortly thereafter).[22] By the 1870s at the latest, the idea of working in rural communities and knowledge of their locations had become a fixture of the art world, and at least one group of painters made an unusual attempt to structure the selection process:

At a dinner of artists held one night in Paris the question came up regarding the best place for summer work. It was agreed that the guests present should start out in different directions and visit the coast towns of France, Belgium, Holland and England and that on their return they should compare notes. ... Ed Simmons had been to St Ives (Cornwall) and the photos which he had brought back and his enthusiastic description led me to decide against Honfleur in favour of St Ives.[23]

Haphazard beginnings thus gave way to specific coherent patterns of group interaction, relation to place and aesthetic practice. By the turn of the century, the tradition of artists' colonies was so firmly established that one could set out with the deliberate objective of 'founding an artists' colony', as demonstrated by the Grand Duke of Hesse who instituted the artists' colony at Darmstadt in 1899 more or less by decree and advertisements. However, the systematic planning of the venture 'from above', the appointment of fixed-term salaried positions, and the emphasis on architecture, decorative arts and industrial design separate Darmstadt from the kinds of communities discussed in this book.[24]

A few final notes on the objects circumscribed by the term 'artists' colony'. There is some debate about the exact definition of this term.[25] Among contemporaries, the designation 'artists' colony' increasingly cropped up in various languages in the 1870s; it enjoyed particular currency in Germany (Künstlerkolonie) while speakers of other languages tended to prefer a variety of paraphrases, such as artists' village, artists' haunt, artists' resort, sketching ground, and, most popularly, 'school'.[26] I have retained the word 'artists' colony' as the most familiar and widely-used shorthand term available for the rural communities under discussion in this book.

It may be worth saying a few words about the kinds of communities sometimes associated with the word 'artists' colony' which are *not* discussed in this book, notably craft, lifestyle, urban and avant-garde groups. Utopian ideals of collective handiwork and anonymity of production oriented toward mediaeval workshop practice did exist around the turn of the nineteenth century in experimental craft communities such as Eric Gill's artisanal groups in Ditchling (Sussex, England) and Capel-y-ffin (Wales), Charles Robert Ashbee's Guild of Handicraft in rural Chipping Campden (England), or the weaving, book-binding and glass-painting workshops of the Hungarian craft colony in Gödöllő.[27] However, these were quite distinct from the groups discussed here, which included craft initiatives only sporadically and always in addition to conventional easel painting.[28] This book is also not concerned with rural communities that experimented with alternative lifestyles, such as vegetarianism, free love, communal farming or various forms of naturism. These, too, existed in such locations as Monte Verità at Ascona in northern Italy or Blaricum in the Netherlands.[29] Rural artists' colonies remained entirely separate from and even antithetical to these other communities in almost all cases. As we shall see, artist-colonists overwhelmingly tended to adhere to middle-class values of respectability and professionalism, with only touches of bohemianism to lend them an aura of 'artistic' freedom. The phrase 'artists'

colony' is sometimes also applied to groups of artists in cities, especially with regard to distinct nationalities, such as the late nineteenth-century Scandinavian 'colony' in Paris or American 'colony' in Munich. In this book, however, I refer solely to groups in villages. I also do not include any artists' groups congregating in one particular patron's or friend's country estate, as was the case in Abramtsevo and Talaskino in Russia, Piagentina and Castiglioncello in Italy, or Broadway in the English Cotswolds.[30]

German writers and curators occasionally appropriate the label 'artists' colony' for avant-garde groups like the Expressionists of *Die Brücke* or *The Blue Rider* whose members variously painted in the countryside near Dresden, in Murnau, Dangast and elsewhere. These painters were indebted to contemporary artist-colonial practices in a variety of ways but, as will become clear, their confrontational stance, publication of manifestos and pursuit of alternative exhibition strategies place them outside the parameters of the kinds of communities examined in this book. It should be noted at this point that rural artist-colonists, with few exceptions, trained and exhibited within conventional institutional frameworks, such as the École des Beaux-Arts in Paris or the Royal Academy in London. Some of the artists did become associated with various Secessionist groups of the 1890s but these quickly became institutionalised in their turn and, at any rate, never mounted the kind of strident critique of established values familiar from twentieth-century avant-gardes.

Indeed, one could take 1906 – the year of the first Brücke exhibition at Seifert's lamp factory showroom in Dresden – as a symbolic cut-off date for the heyday of rural artists' colonies. This exhibition prefigures that whole set of oppositional, counter-establishment, frequently dogmatic, often highly politicised, self-consciously innovative and formally experimental group practices that was to dominate Western art worlds after 1918. End-dates are never cut and dried, of course, and artists' villages continued to attract artists well into the twentieth century (as elaborated in the Epilogue) but they lost their role as key sites of bourgeois modernity.

Artists' colonies in art history

In terms of magnitude and geographic dispersal, there is no doubt that we are dealing with a major phenomenon of nineteenth-century European art practice. However, despite the conspicuous presence in the print media that rural painters' colonies had for people observing and participating in the European art worlds of the nineteenth century, relatively little is known about them today. Most of the artists involved are now almost completely unknown outside a small group of specialists or local enthusiasts, and artists' colonies in general tend to be misunderstood as amusing but marginal footnotes to the central history of modern art.

Confronting a substantial new body of previously scattered material (artists, paintings, villages, texts) exerts its own pressure upon the familiar art-historical

archives and questions. It is the challenge faced by anybody who introduces 'redis-covered' or hitherto 'neglected' artists into art-historical debates. Linda Nochlin recognised this in the early 1970s when she argued that it was not enough simply to add the names of 'forgotten' women artists to the canon of male masters but that the interest in women artists raised issues that challenged the established way of understanding the conditions of artistic production *per se*.[31] This book arises out of the conviction that serious attention to a previously relatively unknown archive can lead to the formulation of new questions that are relevant to the entire period under discussion and, perhaps, to the discipline of art history as a whole.

The challenge for this book lay in finding an analytical framework for a body of material and a set of practices that had, almost without exception, been discussed in completely untheoretical terms. The literature on artists' colonies is fragmented, monographic and, for the most part, uncritical. Texts include guide books, exhibi-tion catalogues and pamphlets of provincial art museums and galleries, articles in local newspapers, auction house catalogues, coffee table books and popular paper-backs intended for a regional and touristic readership. Most of the relevant writers, publishing houses and exhibition curators have a partisan interest in promoting a particular artists' community as part of their native heritage. This type of partial literature and exhibition is closely tied to local tourist industries. Most of the books on Worpswede, for example, are the product of two local publishing houses and sold in card shops and galleries in the village itself but are difficult to obtain outside the region. Few authors recognise 'their' artists' colony as an integral part of a wider phenomenon, and if they do, they refer to other colonies only in passing. There are only a handful of books that treat more than one artists' colony, and only one of these, the volume by Michael Jacobs, is international in scope.[32]

Jacobs' pioneering account, *The Good and Simple Life*, discusses eleven artists' colonies in seven different countries, including the United States. The author makes extensive use of participants' own writings to assemble a series of informal portraits of the social life in each of the villages under consideration. *The Good and Simple Life* offers a sensitive evocation of the world inhabited by rural artist-colonists, but the book's approach is narrative and descriptive rather than analyt-ical. Still, my own enquiry is deeply indebted to Jacobs' eclectic and wide-ranging collection of sources as well as to his sustained attempt at a synthetic overview of the phenomenon, and his anecdotal approach to the material has prompted my analysis of the anecdote in chapter 1.

The only other attempts at systematically collating material on a number of dif-ferent artists' villages across one country come from Germany. Artists' colonies gen-erate particularly lively interest among German writers, curators and, it seems, the German public.[33] The small but growing number of comparative treatments of sev-eral communities remains indebted to Gerhard Wietek's *Deutsche Künstlerkolonien und Künstlerorte*, a compilation of eighteen chapters (themselves monographic and varying in quality) on twenty-three German 'artists' colonies and artists' places'.[34] In his introduction, Wietek briefly emphasises the importance of 'geographically

fixed locations' for artists' colonies rather than criteria of group affiliation or style, and my own findings support this contention. However, Wietek dismisses group formation as of secondary import, and his frustratingly vague notion of 'artists' places' allows him to include regions that contained no coherent group of artists at all, such as Rügen or Amrum. This has opened the door to some all-encompassing definitions of artists' colonies that ultimately prove meaningless.[35] By contrast, this book argues that the existence of a close-knit artistic community was an essential precondition and integral part of artists' colonies (as shown in chapter 1), and formations that follow a different pattern have been excluded.

Few of the findings of the above publications are reflected in the authoritative general accounts of nineteenth-century art. Only very rarely do the two stories – the story of artists' colonies and the story of nineteenth-century art – meet, most notably in the person of Paul Gauguin and his sojourn at Pont-Aven and Le Pouldu. The classic modernist treatment of artists' colonies is to be found in John Rewald's *Post-Impressionism: From Van Gogh to Gauguin*. In a book that is otherwise meticulously researched and footnoted, the scores of painters at Pont-Aven remain faceless extras in the unfolding story of Gauguin and company. They enter the scene only as the 'mediocre horde of conformists at the Pension Gloanec'.[36] This handling of artists' villages is characteristic of most art histories until the 1960s and beyond. Modernist art history, based on the chronology of stylistic progress embodied by a succession of heroic masters (Courbet, Manet, Monet, Gauguin) and 'isms' (Realism, Impressionism, Symbolism) continues to remain dominant in most art publications and curatorial strategies. It is a narrative of formal innovation and solitary artistic struggle for personal expression at odds with established values and norms. It is not a narrative that is likely to incorporate most of the works produced in rural artists' colonies, many of which were the kinds of images (mostly of rural subjects), painted in a naturalist idiom and organised around an anecdote, that modernist critics denigrated as retrograde. It is also not a narrative that can make sense of the group character of artistic practice in colonies, centred as it is on the individual practitioner. Finally, because modernist histories accord only subsidiary importance to extra-pictorial factors, they do not offer methodologies for the understanding of the rural context for artists in villages. Artists' colonies across Europe do not share a common style; formal analysis alone is therefore inadequate to grasp the principles underlying their formation.

From the 1960s, critiques of formalism and individualism from within the discipline gathered momentum, and the variety of approaches often grouped together under the heading of 'social', 'new' or 'critical' art history offered a way out of the modernist impasse by opening out the enquiry into areas of knowledge that are not strictly pictorial or biographical. Still, while social art historians have asked new questions of the nineteenth century and have shifted attention from formal innovation to issues of modern subject matter and negotiations of class identity (pre-eminently due to T. J. Clark's study of Manet and his followers), they have continued to shadow the familiar canonical 'modern masters' (Courbet,

Manet, Monet *et al.*).[37] Indeed, Stephen Eisenman, in his survey of nineteenth-century art, argues that a critical art history should restrict itself to the modernist canon as it alone represents a body of formally advanced work that contests the prevailing ideology of society.[38] Eisenman, although aligning himself with social histories of art, shares here the modernist assumption that there are the artists who 'matter' versus a crowd of (presumably) uncritical and uninteresting other artists. Of course, all researchers have to select from the chaotic richness of historical material but to narrow the focus to include only the comparatively small group of avant-garde artists distorts the way we see those artists, to say nothing of the way we see the nineteenth century. Art history as a discipline should be able to illuminate all the manifestations of art, regardless of 'quality' or 'critical' potential, not just the minority singled out by museum curators and modernist teleologians. As a side effect of a more inclusive investigation, hitherto unsuspected critical qualities or connections to the canonical avant-garde may well emerge in surprising new contexts, as the rest of this book will show.

The attempts to unsettle the modernist 'masters' from their canonical positions and to replace them with an alternative set of 'great artists' are often grouped together under the rubric of 'revisionist' art history. The set of works examined in revisionist works such as Norma Broude's and Gabriel Weisberg's international surveys overlap with the set of paintings discussed in this book, and in that respect revisionist texts have been invaluable sources of pictorial information.[39] However, Broude's anthology expands the stylistic category of 'Impressionism' to encompass a hugely diverse set of practices and the stylistic umbrella thus set up corresponds only intermittently with the variety of forms, techniques and group affinities to be found in artists' communities – communities that were, as we shall see in chapter 1, particularly resistant to being classed as any kind of movement. Weisberg rightly indicts modernist art history for focusing on France as the 'measure of all things' and identifies an international body of similar-looking paintings that don't fit into the modernist story.[40] Unfortunately, Weisberg also falls prey to the polarisation inherent in the revisionist project: that of promoting 'his' neglected artists by belittling the achievements of the opposite camp, the modernists. Suppressing one group of 'heroes' in favour of another does not further our understanding of the complexities and interrelationships within the network of nineteenth-century art worlds. This strategy also carries with it the danger of becoming entrapped by spurious evaluations of quality and of leaving the modernist canon and ideology more or less intact while creating ghettos for subsidiary artists.[41] In this sense, the above-mentioned regional publications with their one-sided partisanship and *campanilismo* succumb to the same revisionist fallacy.

The challenge for this book lay in trying to join the two histories that touch upon artists in villages – the modernist–critical and the revisionist–regional. I want to insist that art historians must find a way of talking about the artists who worked in communal rural contexts and their works that neither devalues them as retrogressive and unreflective nor forces them into a subversive alternative that

they themselves never wanted to be part of. In his incisive critique of revisionism, Neil McWilliam warned of the limitations of attempting either 'to co-opt or co-habit the canon', calling instead for 'a history less singlemindedly transfixed by the centrality of the image'.[42] By examining the practices and patterns of interaction within and among rural artists' colonies, I hope to circumvent this tiresome fixation upon the canon. However, while drawing on a range of other disciplines and fields of enquiry outside the traditional borders of art history, this book does remain unashamedly committed to the 'centrality of the image'. Indeed, many of my arguments turn on the assumption that it is not a turning away from the image that is the key to a greater understanding of the complexities and contexts of art in the nineteenth century, but rather a renewed attention to what images are capable of doing. While I do wish to unsettle the several established canons, be they modernist or revisionist, it is only to reinstate the central importance of the image, no matter of what stylistic persuasion.

The painters and their works and practices are at the centre of my enquiry, and I have employed many of the conventional tools of art history to examine them, notably close formal analyses of pictorial objects as well as giving attention to techniques of making and to the codes and strategies of representation. But I have also moved outside the traditional confines of art history to draw on the sociology of group interaction, on the history and ethnography of rural cultures, theories of tourism and human geography. Because rural artists' colonies do not fit seamlessly into any of the standard histories of nineteenth-century art, the questions I have asked of them have arisen out of an eclectic engagement with the theoretical practices and approaches of a variety of disciplines, including art history. As artists' colonies do not constitute a 'style' or 'movement', my questions focus on the common patterns of interaction that underpin the colonial project.

Geographies of nostalgia

Rural artists' colonies were a heterogeneous collection of sites that differed in national and international composition, gender balance, artistic affiliations, religious conviction and, not least, pictorial style. It would be misleading to collapse these differences into one homogeneous entity. Still, what is remarkable and distinctive about the formation of artists' colonies is the way that a variety of local and specific qualities could be marshalled to represent overarching national and international meanings, and vice versa. As will be shown in chapter 6, the generic rituals of open-air painting, immersion in nature and social interaction in the village context were deployed to construct a range of specific meanings, some feeding into regional and national identities. Everywhere across Europe remarkably *similar* tropes and modes of painting (but not necessarily styles) were activated to represent remarkably *similar* wider issues. For example, while recent writers on English national identity tend to claim that the identification of nationhood with the countryside is uniquely English,[43] a glance at the terms in which the paintings of artists'

colonies were received reveals that nationhood was associated with rural areas in almost every country in Europe. Within the differences among individual colonies, therefore, one can discern common red threads and shared practices. I wanted to avoid the fragmentation of the phenomenon into its constituent components. Strictly speaking, this volume does not provide a comparative history of European artists' villages; instead, it proposes a synthesis of the phenomenon.

This book, then, goes beyond a narrowly empirical enterprise. It makes use of an innovative interdisciplinary methodological approach. Of course, social historians of art, too, have made much use of other disciplines, especially history, sociology and ethnography; in this sense, my book is a contribution within the field of the social history of art. The use of theories of tourism is more unusual but I am here participating in an interest in the linking of tourism and the history of modern art that is just beginning, adumbrated by Fred Orton and Griselda Pollock's pioneering essay on the implication of touristic modes of travelling and viewing the countryside for the reading of the Pont-Aven paintings by Emile Bernard and Paul Gauguin, and recently extended by Griselda Pollock to Gauguin in Tahiti and by Robert Herbert to Monet in Normandy.[44] These accounts are indebted, as is mine, to Dean MacCannell's seminal identification of tourism as a paradigmatic mode of being modern, and in this sense, looking at rural art practices through the lens of tourism enables us to gain an insight into ways of being modern that are not identical with being modernist.[45] Theories of tourist ideologies and the tourist gaze provide one key for making sense of the activities and beliefs of artists who left their places of origin and training in provincial or national urban centres in order to travel to rural locations.

Another key is geography. The most valuable insights geography can offer are analyses of place and spatiality. One of my main concerns in this study is to put place back into art history. This arises not only out of the issues raised by the subject itself – members and critics of artists' colonies always stressed the primacy of location – but also out of a wish to claim the field of art geography for the study of modern art. To speak of a 'field of art geography' is perhaps to presuppose too much. There is, in fact, no such coherent body of theory or methodology. Art history as a discipline has traditionally not been exceptionally alert to issues of location and geography. The history of modern art, in particular, has been notorious for its emphasis on sequence, teleology and the quest for chronological origins. We may think of these as diachronic lines of enquiry which neglect the synchronic axis of simultaneity in space. However, the 1980s and 1990s witnessed some beginnings of a revived interest in questions of place, part of a more general 'turn to place' in the humanities and social sciences.[46] In the arena of nineteenth-century painting, the focus has shifted on to the traces left in actual works of art by the social, political, economic, sexual and scopic regimes of a particular topographical context. Studies by T. J. Clark, Griselda Pollock, Robert Herbert and others as well as the millennial exhibition *Modern Starts: People, Places, Things* at the Museum of Modern Art in New York have yielded some invaluable insights for anyone interested in how nineteenth-century

representations interact with places but they are, unfortunately, overwhelmingly focused on metropolitan places (in fact, limited mostly to Paris) or on canonical modernist masters (like Monet).[47]

Rural artists' colonies were an international phenomenon, extending even beyond Europe. (The artists' colonies in the United States, Australia and Japan lie outside the scope of this book.)[48] Artists working in the countrysides of Europe were part of the general movement of people and artefacts that characterised nineteenth-century processes of modernisation. More exhibition-goers than ever before viewed large numbers of paintings from many different countries, thanks to the relatively speedy transport service offered by trains and steamships. And, of course, growing numbers of people were on the move throughout the nineteenth century, either for purposes of finding employment or, increasingly, for leisure travel. This book examines what increasing mobility meant for artists caught up in these transformations, what weight was given to individual places within the spatial matrix and how permanency in one location mattered once it ceased to be self-evident. The consideration of the synchronic axes of place thus cuts across, qualifies and also enriches the usual diachronic axis of chronology and art history.

The book is organised into four parts which examine common patterns of interaction: artists' interactions with each other, with the natural environment, with the local population and, finally, with the place as a whole. Part I resurrects the forgotten social microcosm of rural artists' communities and reveals the central significance of shared plein-air activity, dinner-table conversation and ties of friendship. Artists' communal life is linked to the larger networks of sociability being consolidated in the nineteenth-century middle class. Part II focuses on the interaction between villagers and artists, a completely under-researched topic. This part examines first how painters, in their visual representations, suppressed signs of the social diversity of the local community and its modernisation and, instead, painted the locals as if they were all pre-industrial peasants or fisherfolk. These paintings of imagined peasants were targeted at urban middle-class audiences and conjured up agrarian idylls whose alleged authenticity was guaranteed by the eyewitness status of artists 'in the field'. Second, part II examines the crucial role played by a distinctive new class of entrepreneur and art patron, the village innkeepers, who provided the infrastructure necessary for artists' colonies' survival and for subsequent tourist exploitation. Part III turns to artists' interactions with the rural environment which took place primarily in the form of immersing oneself in the multi-sensual experience of nature. This part identifies two key types of nature painting, both elaborated in artists' communities in order to capture the experience of immersion: the *sous-bois* or forest interior, and the minimal landscape. Both types address fundamental issues of the relationship of interior subjectivity to exterior terrain, summed up in the concept of *Stimmung* or mood, and both types adumbrate pictorial abstraction.

The final part draws the different strands of the previous analyses together under the rubric of place to determine how artists were instrumental in shaping the stereotypical images of their specific locations while being implicated in a general

reconceptualisation of the landscapes and regions of the whole continent. The discussion weaves together detailed case studies of individual places with bird's-eye views of the entire map of Europe, arguing that it was artists' intense engagement with 'their' village as a particular as well as a typical place that constituted the ideological backbone of the whole artist-colonial project.

The relationship of artists and their audiences to rural places was imbued with nostalgia. Nostalgia is the counterpart of utopia.[49] While the utopian attitude expects a better life in the future, nostalgia locates it in the past. Both modes of relating to the world are also fundamentally modern attitudes. As various commentators have pointed out, nostalgia is not a trans-historical emotion but a disposition that became possible only at a certain historical juncture, namely modernity. It represents one response to 'modernity's cultural conflict'.[50] In the 1980s, nostalgia was either dissected in psychoanalytic-linguistic terms[51] or decried as a politically conservative stance.[52] Subsequent writers have drawn attention to the critical potential of nostalgia: disaffection with the present can constitute a way of coming to terms with and even a form of critique of present conditions.[53] I would like to add that nostalgia is not only an affect but also a set of attitudes that are enacted in institutionalised frameworks and social rituals, and as such it can mobilise and actively produce meaning and cultural significance.

Nostalgia cannot only be located in time (modernity looking back) but also in space. For late nineteenth-century consumers of art, culture and nature (that is, the educated middle classes), the longing for a pre-industrial life, imagined to be somehow more complete and abundant than the present, came to be predominantly linked to rural locations. Although nineteenth-century images of rural life, pictured as if untouched by any sign of modernity, can (and have been) interpreted as frank misrepresentations of contemporary reality, they are, to borrow Siegfried Kracauer's words from a different context, the 'daydreams of society, in which its actual reality comes to the fore and its otherwise repressed wishes take on form'.[54] This is why the paintings and practices of rural artist-colonists are central to an understanding of urban bourgeois culture on the brink of twentieth-century modernism. This book sets out to trace those elusive daydreams of nature.

PART I
AMONG ARTISTS

Creative sociability

Rural artists' communities were characterised by a particular form of sociability. Artists lived, worked, dined, sang and played together; they organised communal picnics and parties; they admired, befriended, irritated and, not infrequently, married each other. And, of course, they painted together, looked at each others' pictures and talked a great deal about art. It is crucial to note that artists' colonies were not simply haphazard collections of individuals who happened to share the same space but cohesive social entities with shared rituals and commitments. In artists' villages, sociability and artistic production were closely intertwined. In the words of one participant, the Irish painter Henry Jones Thaddeus: 'The life in the open air, together with the absorbing, delightful occupation of painting from nature, followed by the pleasant reunions in the evening, constituted an ideal existence to which I know no parallel.'[1]

This chapter focuses on those 'pleasant reunions', remembered with such enraptured fondness by Thaddeus and countless fellow colonists. It examines precisely what it was that constituted artistic group life in villages and why this particular mode of existence proved so phenomenally successful with artists. The chapter sets the scene for the remainder of the book by piecing together a mosaic of artists' experiences of daily life in a rural community, based on first-hand writings (diaries, letters, articles and memoirs). It will have little to say about paintings, as artists rarely painted their group activities in a village (a circumstance to be further explored in part II).

Being a painter was, and arguably never is, only about putting brush to canvas. It also involves social networks which reinforce and support the individual's sense of purpose as well as the activities and routines associated with cultural production. Artists' colonies served as mutual support groups and social enclaves in places that were unused to artists, and they facilitated communication and negotiation with rural communities. Two general points may be noted here. First, for the artists, pleasurable meaning was generated out of the twinning of open-air painting and sociability with peers; each aspect required and reinforced the other. Second, artists in colonies were trying out a form of practice that captured what, in their view, an artist should be. They were experimenting with and living out new artistic identities.

I argue that colonists developed a form of sociability that promised them a sense of belonging at the same time as appearing to guarantee artistic and personal

freedom. As we shall see, artists' colonies were held together primarily by loose bonds of friendship rather than by institutionalised formal structures or publicly stated manifestos. It is this primacy of voluntary, affective group membership that roots rural artists' communities within modern forms of bourgeois sociability.

Rural artists' colonies differed from the kinds of artists' groups usually associated with the European art worlds of the nineteenth century.[2] They were not an institutional body of professionals, like the Royal Academy in England or the Académie des Beaux-Arts in France. Nor were they registered associations, like the many artistic societies that were founded in the nineteenth century to counterbalance the monopolies of the official academic bodies, like the Danish *kunstforeninger* or the numerous German *Künstlervereine*. Artists' colonies were not established for the purpose of providing exhibition opportunities, like the French Impressionist group of 1874 or the German and Austrian Secessions of the 1890s. Nor, finally, did they constitute themselves as avant-garde factions with oppositional agendas, like Paul Gauguin and Emile Schuffenecker's *Groupe impressionniste et synthétiste* of 1889 or *Die Brücke*, founded in Dresden in 1905. Rural artists' communities were much looser affiliations than any of these better-known unions. Furthermore, artist-colonists consistently distanced themselves from being associated with anything approaching the form of a structured group. Such instances are numerous but two examples will suffice to illustrate the point.

The first concerns the Belgian artists' colony of Sint-Martens-Latem. One of its members, the poet Karel van de Woestijne, dismissed the label 'Latem school', retrospectively applied to the group by critics. Woestijne denied the existence of a common style or insight among those working at Sint-Martens-Latem while at the same time insisting on 'the artists' mutual sympathy and even shared emotional experience'. According to Woestijne, it was precisely this shared emotional experience that marked out those artists who 'regularly met in the evenings just before and just after the turn of the century' as a distinct group.[3] Note the emphasis on evening get-togethers and the highly subjective but none the less very potent concepts of mutual sympathy and shared emotions.

The second example of colonists rejecting the strictures of organised groups concerns Worpswede. Here, the first six artists who had founded the colony almost five years earlier created an officially registered association, the *Künstler-Vereinigung Worpswede*, in 1894, complete with statutes and secretary. It was established primarily in order to facilitate exhibition and the dissemination of prints, and it is telling that this association disbanded only four and a half years later, with the resignation of three of its members. Otto Modersohn justified his withdrawal in a circular revealingly headed 'Dear friends!' by pointing to the overarching importance of 'personal, individual freedom':

Durch einen Verein wird die persönliche, individuelle Freiheit beeinträchtigt. ... Je straffer organisiert z.B. ein Staat ist, desto weniger ist der einzelne Bürger. Noch ein

Vergleich aus der Natur scheint mir passend: Die Rinde eines Baumes kann zu fest werden, so daß der Baum abstirbt. Unsere Beziehungen müssen möglichst locker sein, wir dürfen keinerlei Druck und Zwang empfinden. Das zehrt künstlerische Kräfte auf.[4]

(A society impedes personal, individual freedom. ... The more strictly organised a state is, for example, the less value [is accorded to] the individual citizen. Another comparison from nature seems fitting to me: The bark of a tree can become too tight so that the tree dies. Our relationships must be as loose as possible, we must not experience any pressure or compulsion. That saps artistic powers.)

Freedom and friendship: for Otto Modersohn and innumerable others, these were the two main prerequisites for a creative life in an artists' community. They are, however, not central terms within usual art-historical enquiry. How, then, can art historians deal with such informal groupings based on mutual sympathy? Two scholars provide a helpful entrance point into my examination of artists' colonies. The first is Raymond Williams in his analysis of the Bloomsbury Group in 1920s London.[5] Williams contends that many small cultural groups (as opposed to large organised corporations) have a 'body of practice' or an ethos in common, rather than stated aims or principles.[6] This certainly applies to rural artists' colonies, and it is partly for this reason that paying attention to artists' personal memoirs and letters is so useful because it allows us insight into that diffuse and unstated 'body of practice'. The Bloomsbury Group denied its existence as a formal group while insisting on its group qualities, especially its foundation in friendships, and Williams interprets the importance attached to friendships as a sign of the bourgeois enlightenment values typical of such small groups: above all, the value attached to the free expression of the civilised individual.[7] As my second scholar, the sociologist Friedhelm Neidhardt observes, small groups are not governed by rules and sanctions regulating interaction nor are they dependent on ranked positions (such as boss, goalkeeper, and so forth). They tend instead to be regulated by subjective relationships, personal inclination, emotion and trust. Neidhardt concludes that the meaning of groups lies in the institutionalisation of personality.[8] To put it in a different way, members of informal groups based in friendships feel they are being valued for 'who they are' rather than for 'what they represent'.

Using the interpretative frameworks proposed by Williams and Neidhardt, we can view artists' colonies as social formations which enabled their members to fulfil and express their personal individualities. Indeed, if we take the view that identities are primarily constructed in interaction with and differentiation against others, we can advance the hypothesis that the 'small groups' that formed in rural artists' colonies were optimally designed to foster a sense of personal freedom and individuality.

In their memoirs, artists wrote about rural artists' groups as if they had been communities of untroubled harmonious relationships. Interaction amongst colleagues was not as conflict-free as these remembrances claim but there were a

number of mechanisms that, to some extent, minimised the risk of grave rifts. One factor was the formation of sub-groups. For the most part, rural artists' communities did not experience any break-ups into opposing factions. What happened instead was the formation of coexisting sub-groups within the larger ensemble. This was especially the case in villages which attracted an international, polyglot artistic community. The main divisions were drawn along linguistic lines. In Pont-Aven, the American and the French artists gravitated towards different local inns.[9] In Laren, Dutch artists stayed at Jan Hamdorff's hotel on the central square while Anglo-Saxons preferred the English-speaking pension of Mrs Kam.[10] Laura Knight reported that the Anglo-Saxons and the Dutch did not mix, each party regarding the other with slight contempt:

> The colony of Dutch painters in Laren kept entirely to themselves, thinking we foreigners had gone over there to copy them. We considered most of their work purely commercial, painted in either the Jacob [sic] Israels or the Maris brothers' manner, for the dealers to sell it like roasted chestnuts.[11]

This keeping to separate spheres is, paradoxically, a further instance of the powerful urge towards group formation in artists' colonies. Group cohesion arises as much out of demarcation and a sense of difference from those without as out of internal unity. In Laren, the division of the artistic population into 'Dutch' and 'foreigners' seems to have enabled both communities to live side by side, with artists in either group sharing a secure sense of group identity in the knowledge that they were not like those in the other group.[12] Sub-divisions also allowed artists to retain a sense of being intimately bound up with a small community at the same time that the absolute number of artists in a place was increasing.

Another factor fostering group cohesion was the ritualisation of daily life. Artistic life in villages was regulated by clearly set-out daily routines. A particularly striking example is the standard pattern of everyday practice described by the painter Anne C. Goater who spent the summer of 1885 in the artists' community at Pont-Aven: breakfast between six and nine; lunch at twelve; work resumed from two to five; a pre-supper walk; evening amusements in the form of games, dancing, singing, musical performances, plus billiards and quoits 'for the gentlemen'.[13] This pattern recurs in every artists' colony. At Laren, too, for example, the daily routine followed a pattern of early rising, daylight hours spent sketching from nature, punctuated by regular breaks ('coffee from five to ten, lunch at one, dinner at six'),[14] and rounded up with sociable gatherings in the evenings, including strolls, chats around the inn's dining table or in its back garden, games of billiards or cards, music, dancing, bowling and shooting, and even theatrical performances.

Given artists' insistence on informality, such routines may appear to be surprisingly, even excessively, regulated. However, they facilitated the smooth workings of personal interaction by allowing for the alternation of social gatherings in order to chat and eat (among the many) and intervals of departures into fields and woods in order to work (among the few or alone).

Narrated experience

Artists wrote a great deal about their collective doings in the countryside; indeed, they tended to write about little else. Everything that is missing from their paintings – from conversations around the dinner table and picnics in the woods to group sketching, boating, pranks and parties – appears abundantly in their writings. Primary texts written by one-time members of artists' colonies include personal writings not meant for publication, such as letters and diaries, as well as accounts addressed to a wide audience, such as journal articles and memoirs. At least one hundred colonists (mostly painters but including some writers, art critics and other visitors) left us their written impressions of life in an artists' village.[15]

Artist-colonists' writings contain relatively little in the way of analytical or theoretical discussion of the artists' project. They constitute a body of writing that delights in endless anecdotal detail, in the recounting of humorous tales, the repetition of commonplaces and the stringing together of chunks of description, storytelling, dialogue and reverie, seemingly with very little interference from an ordering hand. These texts focus almost without exception on the *group* character of colony life. They are, to paraphrase the title of one of the most comprehensive memoirs, 'chronicles of friendships'.[16]

The anecdote, once the mainstay of biographers like Giorgio Vasari and still used extensively in many contexts (popular biography, museum guides, coffee-table art books), has fallen into disrepute within academic art history. Art historians do read anecdotes, but they tend to dismiss them as too trivial for serious consideration in scholarly treatises, preferring the 'hard' evidence provided by critics' assessments, historical data or, at most, more 'literary' sources. Here, I wish to recuperate the anecdote as an analytical tool for historians and critics. This project involves the attempt to theorise what has so far largely been regarded as impervious to intellectual enquiry. Indeed, to theorise the anecdote is paradoxically to recognise that one of its key characteristics is precisely its resistance to theory. I draw on selected theories of narrative to re-evaluate the anecdote as a valid rhetorical form, peculiarly suited to the perceived informalities of daily life in the countryside.

Anecdotes form particular kinds of narrative. Stephen Greenblatt distinguishes anecdotes or what the French call *petites histoires* from 'the *grand récit* of totalising, integrated, progressive history'.[17] Since its inception as an academic discipline less than a century and a half ago, the *grand récit* of art history has been the modernist story of the progression of artistic styles. There has been little room for the contingencies of day-to-day life. To give shape to their everyday experiences in rural settings, artist-colonists made use of the *petites histoires* which occupy that tentative space between an ordered and teleological History of Art and the unordered moments of a day. In Greenblatt's words, anecdotes are

mediators between the undifferentiated succession of local moments and a larger strategy toward which they can only gesture. They are seized in passing from the

swirl of experiences and given some shape, a shape whose provisionality still marks
them as contingent – otherwise, we would give them the larger, grander name of his-
tory – but also makes them available for telling and retelling.[18]

Many of the anecdotes about rural artists' colonies were indeed told and retold.
This is akin to the kind of formulaic repetition of particular events and themes that
Ernst Kris and Otto Kurz have described with regard to the literary genre of
artists' biographies.[19] According to Kris and Kurz, anecdotes in an artists' biog-
raphy are employed as supplements to the official *vita*, with the purpose of showing
us the 'hero' in a human light. As such, they constitute a kind of 'secret biography'
of the artist.[20] This secret history is the stuff of the personal memoirs of artist-
colonists. The memoirs proclaim the trivial minutiae of day-to-day routines as
essential ingredients in the artist-colonial experience: what was eaten for breakfast,
what clothes people wore, who played a joke on whom, how some artists played
leap-frog, how ants ate one's picnic lunch, how a great hero-artist did a 'bottle
dance', and so forth.[21]

Greenblatt points out that *petites histoires* are often not simply told for their
own sake but are recorded as '*representative* anecdotes'.[22] The artistic sociability
referred to in artist-colonists' memoirs does take on representative character; it
comes to embody in a nutshell the experience of life in a rural artists' community.
This happens in two ways. First, one single vignette can in a few short sentences
conjure up memories of an entire summer or phase in an artist's life. Such para-
digmatic anecdotes include, for example, the informal after-dinner discussion
around the table or on the steps of a village inn. This motif recurs in almost every
text written on any one of the many European artists' village. Here is an example
from Pont-Aven:

> When night came, the men gathered in the dining room of the hotel, and after the
> evening meal was disposed of settled down to quiet talk and interchange of ideas. The
> walls of the room were covered with panels, painted by the artists who from time to
> time had sojourned there, many of them characteristic bits, fresh impressions that
> stood out in bold relief, challenging admiration and interest. The talk was enter-
> taining, of course, though mostly of the shop, for there is no class of men in the world
> who talk shop more than artists.[23]

Second, artists' writings habitually embed the recording of one-off events within
the description of recurring 'typical' routines; the preferred mode of telling is not
so much 'we did so-and-so' but rather 'we *would* do so-and-so'. Here is the
American painter Will Hicok Low on a day in the life of the Hôtel Siron in
Barbizon in the 1870s:

> The early morning saw us all astir, and a generous bowl of coffee and a bit of bread
> under the arbour at the back of the hotel having been disposed of, we separated to our
> work. Those who went far into the forest took a lunch with them, the others, working
> on the plain or in the peasants' houses in the village, met again at noon. But it was
> about sunset that one by one we entered the courtyard, shifted our loads of painting

materials from our shoulders to the ground, and placed our freshly painted studies against the wall of the house. Then would come an hour of mutual criticism of our work, as seated at little round tables, conveniently placed, we absorbed various *estrats* [drinks of alcohol not included in the weekly bill] in the guise of vermouth, or strolled from one canvas to the other. Many a helpful word came at these times, criticisms and suggestions as various as the nationalities represented; and the cheerful witticism was by no means debarred.[24]

This passage touches upon themes that crop up again and again in artists' descriptions and reminiscences of life in a rural artists' community: the combination of hard work in rustic surroundings and the congeniality of critical discussion and general easy sociability. Kris and Kurz call such recurring narrative topoi 'typical anecdotes'. They argue that it is pointless for the scholar to attempt to verify any truth content in these anecdotes; what matters is that the repeated iteration of certain themes and motifs suggests an underlying 'typische Vorstellung' (typical image) about what an artist is.[25] If we take this line of thinking further, we might argue that the telling of anecdotes constructs an experience (in retrospect) as much as it reports it, and that an analysis of anecdotes can lead us towards what artists perceived as 'essential' or 'typical' about the experience of life in a rural colony. As we have seen, a central ingredient of what artists sought in rural colonies was the experience of a creative life lived in personal freedom yet enriched by informal friendships among peers. Far from recording mere peripheral trivia, the anecdote would rather appear to be the ideal prose form for capturing that elusive experience in its quintessence.

In the light of these remarks, I will now move on to analyse some of these anecdotes in further detail. Let us begin with Barbizon and the aforementioned Will Hicok Low's memoirs. Low's initial encounter with rural life in France is instructive for the light it sheds on the attraction of artists' colonies as enclaves of bourgeois, urban sensibility in the countryside. In the summer of 1873, Low followed the trend of his co-pupils at the Paris studio of Carolus-Duran and went to the forest of Fontainebleau in order to spend the summer vacation sketching before nature. However, unlike most of his countrymen, Low did not initially go to Barbizon, the area's chief artistic attraction; wishing to avoid his compatriots, he set out for an alternative destination, the hamlet of Recloses, about 15 miles from Barbizon. Just as he had hoped, there were no Americans there, but solitude did not bring the longed-for rewards.

Here I had stopped in a miserable apology for an inn, with no other company than that of peasants, whose one relaxation from toil was poaching in the neighbouring forest. For about a week a desperately homesick boy struggled with these conditions until his resolution gave out. On a beautiful morning, consulting Denincourt's map, I made my way through the forest, and by noon was seated at the hospitable board of the Hotel Siron in Barbizon, shamelessly glad to be able to express myself freely in my native tongue, and from that time forth for many years Barbizon was to be the spot where I felt myself the most at home.[26]

Low's memoir evokes many of the most important reasons why artists preferred to work in a community rather than on their own in the countryside: linguistic difficulties (especially acute in the case of the many foreigners in the French countryside but also applicable to nationals when confronted with local dialects), the realisation of the wide social gap between oneself and the local population, and the delights of shared common interests. It was not only the direct contact with the landscape and the local rustics that was sought by artists who flocked to Barbizon; after all, that could be had in more unadulterated form at a place like Recloses. In fact, Recloses afforded a contact with the region and its inhabitants that was perhaps *too* direct, with the result that the forest presented a blank face to the hapless art student. The presence of fellow artists in the countryside was a necessity; it ensured that there was an audience and community of fellow-travellers to lend significance to one's activities.

It is significant that Low's seminal encounter with the artists' community of Barbizon took place at the 'hospitable board' of a local inn. Hans Peter Thurn has pointed to the frequency with which artists' groups have constituted themselves over the communal ritual of taking food or drink.[27] Probably more than half of all European rural artists' colonies harboured local hotels whose dining rooms became the focus for all social activity. These inns and their proprietors will be considered in further detail in chapter 3; here I want to concentrate on their role in drawing together the community of artists. The two main inns in Barbizon were the Hôtel Siron, popular in the 1870s and 1880s, and the even more famous Auberge Ganne, home to artists since the 1820s. No special dates were set for communal activities; interaction simply occurred when painters returned from their day's work painting in the forest to gather in the inn's dining room or to sit outside to have a smoke before or after dinner. The painters who gathered there in the 1850s even acquired for themselves the nickname 'peint' à Ganne'.[28] The informal appellation 'peint' à Ganne' is revealing in two ways. First, artists chose for themselves a group label that had nothing to do with stylistic criteria, or other criteria pertaining to their profession, thus marking them out as distinct from both the institutional and the critical categories of urban art society. Second, the choice of Ganne's hotel (or, outside the context of Barbizon, any other village inn) as prototypical nexus of communal bonds places convivial informality at the centre of artistic group identity (figures 1, 2, 24). The gastronomic centre of a village frequently became the symbolic centre of the rural artists' colony. Arthur Hoeber enthused about Pont-Aven (where he worked in the early 1880s): 'Out of doors, around the small tables after *déjeuner* and over our coffee, what pleasant stories and reminiscences, what sociability and good-fellowship!'[29]

The intermingling of art and life or, to put it differently, vocational commitment and leisure pursuits, was central to nearly all written descriptions of artists' colonies. What is striking is the general effect of cosy intimacy evoked in these memoirs, far removed from Bohemian excess. Low conjured up an idyllic domestic setting in his account of after-work sociability in Barbizon:

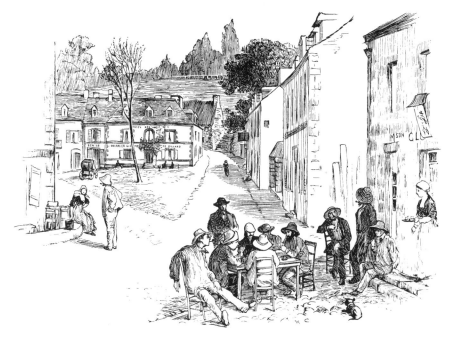

1 Randolph Caldecott, *Pont-Aven*, *c.* 1879, from Henry Blackburn, *Breton Folk: An Artistic Tour in Brittany*, 1880

2 Peder Severin Krøyer, *Artists' Luncheon in Cernay-la-Ville, June 1879*, 1879, 53 x 95 cm

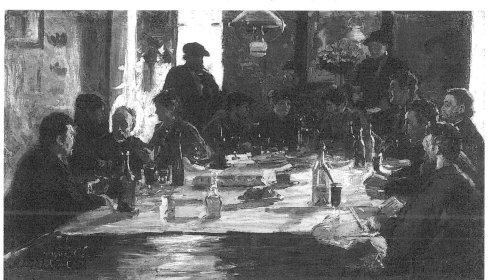

The lights would be lit in the inn on your arrival [after a day's work in the forest], the painters, growing fewer in number as the season advanced, would be gathered in the high room, panelled with sketches, where we dined; where the table, already set, awaited, and a fire crackled [*sic*] on the hearth in the corner. Here, by the light of a candle held close to your sketch, your work received the approbation or frank disapproval of your friends, each on his arrival running the gauntlet of criticism, and there ensued a discussion on art in general, accompanied by becoming personalities, until it was interrupted by the entrance of Siron, bearing high a huge and smoking souptureen, and crying, '*à table, Messieurs, à table*'.[30]

Robert Louis Stevenson summoned up a similarly intense atmosphere of familial evening *Gemütlichkeit* or cosiness in Barbizon. Some artists would sit sunning themselves outside Siron's inn, waiting for the omnibus from Melun, others would play billiards, others sit in the courtyard with a cigar and a vermouth.

The doves coo and flutter from the dovecot; Hortense [the maid] is drawing water from the well; and as all the rooms open into the court, you can see the white-capped cook over the furnace in the kitchen, and some idle painter, who has stored his canvases and washed his brushes, jangling a waltz on the crazy tongue-tied piano in the salle-à-manger. '*Edmond, encore un vermout,*' cries a man in velveteen, adding in a tone of apologetic after-thought, '*un double, s'il vous plaît.*' 'Where were you working?' asks one in pure white linen from top to toe. 'At the Carrefour de l'Epine,' returns another in corduroy (they are all gaitered, by the way). 'I couldn't do a thing to it. I ran out of white. Where were you?' 'I wasn't working, I was looking for motives.' Here is an outbreak of jubilation, and a lot of men clustering together about some new-comer with outreached hands; perhaps the 'correspondence' has come in and brought So-and-so from Paris, or perhaps it is only So-and-so who has walked over from Chailly to dinner. '*A table, Messieurs!*' cries M. Siron, bearing through the court the first tureen of soup.[31]

In these accounts, the painters seem embedded in a close family circle of warmth and secure routine. The tribulations of artistic work are discussed in a good-humoured vein. The evening questions (again, formulated in the manner of family members enquiring after each others' day) provide reassurance that what one is doing is the right thing: everyone is doing it and is confronted with similar problems.

I have chosen Barbizon as an entry point into these issues but tropes of domesticity recur in writings of group life in all artists' colonies. A particularly evocative account of life at the Hôtel des Voyageurs in Pont-Aven in 1885 is Anne Goater's previously cited essay. Goater enlists in a few paragraphs on 'the free Bohemian life of an artist in summer' all the familiar ingredients of a plein-air life among kindred artists.

Russia, Sweden, England, Austria, Germany, France, Australia, and the United States were represented at our table, all as one large family, and striving towards the same goal. After lunch, on pleasant, sunny days, would follow the mid-day chat, as seated outside on hotel stoop and doorway, we leisurely sipped coffee and cognac. ...

Criticism would be freely given and received; all were at liberty to say just what they pleased, and without any ill-feeling. They were pleasant hours, indeed, spent around that Breton doorway, and not wholly fruitless ones either.[32]

For Goater, the artists' colony offered an arcadian reconciliation of opposites. Life at Pont-Aven was domestic yet also Bohemian, secure yet free, hard-working but at the same time leisurely. The setting was quaint and 'out-of-the-way' but also cosmopolitan with its international artistic population. The suspension of some of the usual strictures of etiquette may have held a special appeal for a woman, perhaps glimpsed in the author's delight at being able to appear at breakfast 'in any toilet'. Most importantly, everything is undertaken in 'pleasant, congenial company'.[33] The evening amusements are also typical: billiards, for example, were not only available at Pont-Aven's Hôtel des Voyageurs but also at Barbizon's Hôtel Siron and Jan Hamdorff's hotel in Laren; musical get-togethers were part of life at Pont-Aven, Barbizon, Newlyn, Worpswede and elsewhere. The artists, as Goater describes them, were hard-working and absorbed in their vocation but not excessively so: after-hours, they were able to relax. The group was 'as one large family', with domestic evening amusements typical of bourgeois family life. Goater portrays an ideal (and idealised) framework of interaction within which members could retain their individualities intact while communicating easily and constructively.

These intensely described and intensely felt experiences of social plenitude and unobstructed conversation were, on one level, expressions of a nostalgia for an ideal sociality. This longing for perfect intimacy, trust and security within an intact environment represented a reaction to the transformations of communal life under the conditions of modernity. The historians Thomas Nipperdey and Maurice Agulhon have argued that the early nineteenth-century proliferation of societies in Germany and men's clubs in France respectively were symptomatic of an *embourgeoisement* or *Verbürgerlichung* of modern society. These new types of association were characterised by an ideology of the bourgeois individual, unhampered by the traditional ties of rank and birth and free to choose his personality.[34] However, by the second half of the nineteenth century and the heyday of artists' colonies, these earlier clubs and societies had come to seem restrictive to many. Artists in village colonies were attempting to recreate or, more accurately, to create something even more intimate and able to provide a refuge from the rivalries, anonymities and severities of the commodification of art in modern market economies. In the absence of former support systems such as guilds, workshops and patronage networks, artists' colonies represented a kind of compensation for what were perceived to be lost structures of human interaction and belonging.[35] This may also explain the quasi-domestic set-up in many artists' colonies, based on an imaginary idealisation of the bourgeois family as a powerful model for social intimacy. I will return to this point in the next chapter where I discuss how these idealisations were projected onto the local village community.

Charismatic personalities

Given the focus on personalities, the reader will not be surprised to learn that artists' writings contain little in the way of stylistic analysis or even critical evaluation of colleagues' work. Group unity was not remembered by artists as stylistic unity. Many fellow artists were mentioned but little was said of anyone's actual work. Comments on colleagues' art were often couched in terms of humorous anecdotes that fit in with the atmosphere evoked by the remainder of the narrative. For example, Jean-Georges Gassies recounts how the German painter Georg Saal worked on the same canvas all day, copying what he saw before him without any awareness of the light changing; the result was a strange patchwork painting in which the light had different colours and came from all directions. When Saal reputedly heard the other artists complaining about the difficulties of rendering beautiful effects, he replied that he couldn't understand their problems and that for him there was nothing simpler than to copy what was before one's eyes. Gassies tersely adds that Saal won a number of medals at the Salon.[36]

This is perhaps art criticism in a very rudimentary form but these brief remarks served mainly as a description of the idiosyncrasies of a comrade's personality. Personality is what was emphasised in these accounts, not artistic merit. Similarly, Will Hicok Low liked to include details of personal eccentricities or foibles, thus Wilbur Woodward from Cincinnati was remembered for playing the banjo and wearing shoulder-length hair, a sombrero and hip-high cavalry boots; Albert de Gesne was 'bearded like a pard' and wore a scarlet coat, 'a good fellow despite his startling appearance'; and the Swede Carl Hill was constantly heard proclaiming his artistic credo in an appalling accent: 'il faut faire de la beindure nouvelle'.[37] Birge Harrison described the 'infectious laugh' and 'goggle-eyes' of fellow-artist Theodore Robinson, and the brilliant story-telling talents and 'black and fiery' appearance of Robert Mowbray Stevenson.[38] Carl Larsson did accredit 'a good sense of colour' to his Grèz colleague Frank Chadwick but immediately appended information about his personality and his romantic attachment as well as an amusing anecdote involving the shooting of a gun.[39]

It is important to note that the existence of artistic differences was not necessarily suppressed by memoir writers in order to create a homogeneous stylistic community. On the contrary, the fact of stylistic diversity seems to have been used by many ex-colonists as proof of the tolerance and inclusiveness of the artists' communities. Differences were typically glossed in humorous form. Here is Anne Goater on artistic debate in Pont-Aven:

> What theories of life and painting would there be proclaimed, as some idealist would soar away into the clouds; and what rare sport it was to start some two artists of known differences of opinion upon their favorite hobbies![40]

The diversity of artistic opinion was far from dividing the community. If anything, the tolerant pluralism of the group cemented it closer together – or so it

would appear from most artist-colonists' accounts. One painter remembered the 'pleasant' relationship among artists in Kronberg where Anton Burger would discover an attractive landscape motif while out strolling and exclaim: 'Das ist ein Maurer, das muß ich ihm sagen, daß er's malt.'[41] (This is a Maurer, I have to tell him about it so that he can paint it.) The English painter Mortimer Menpes who stayed in Pont-Aven for three years in the 1880s wrote of the 'bevy of schools' he encountered there, amongst whom were 'the Stripists', 'the Dottists', a sect of the Dottists called 'the Spottists', further 'the Bitumen School' and 'the Primitives'. Lest we are misled into thinking that with the latter label Menpes was actually employing a sophisticated art-critical term, it is as well to note that his 'Primitives' were distinguished by carrying about 'a walking stick carved by a New Zealand Maori'.[42] This is stylistic classification on the level of farce. However, the serious kernel to be extracted from such an account is again the experience of unfettered personal development in the context of stimulating group life. The young Menpes was 'free to work at whatever he liked, yet with unlimited chances of widening, by daily argument, his knowledge of technical problems'.[43] We encounter the familiar refrain: individual creative freedom plus group security. The colourful eccentrics in the group lent credence to this freedom but it was a contained freedom.

The relative absence of professional judgement does not mean that artists were not acquainted with their peers' accomplishments. On the contrary, they were constantly in the vicinity of each others' work, and the kind of informal but for the most part unrecorded art criticism that went on was instrumental in shaping the practice and group identity of artists' colonies. One (non-artist) commentator was impressed by the comradely habits of mutual criticism prevailing in the artists' village of Sevray-sur-Vallais, in the forest of Fontainebleau:

> One wholesome feature was the daily discussion of work and methods. The still wet canvases were brought to the *salle à manger* and ranged in the best light; the day's labours were criticised, encouraged, joked over, more to the profit than the hurt of any one concerned.[44]

Low's memory of helpful comments and 'witticism' and Goater's delight at the absence of ill feeling (quoted above) accord with this impression. All accounts suggest an intercourse among peers without the professional pressures of urban art worlds.[45]

This account of friendly tolerance may come as a surprise to art historians familiar with John Rewald's account of Paul Gauguin's stays in Pont-Aven, sojourns that were purportedly marked by aggressive rivalry based on artistic differences. In the form of an unreferenced but subsequently much-quoted anecdote, Rewald tells how in 1886, the newly arrived 'Impressionist' painters, Gauguin among them, allegedly took their meals at a different table from the long-standing lodgers at the Pension Gloanec, and how Gauguin's canvases were later jeered when hung on the inn's walls.[46] Another oft-repeated tale, reported by the painter Maurice Denis at second hand, involves Gauguin signing a still-life he had done

with the name of Madeleine Bernard, Emile Bernard's sister, in order to camou-
flage the identity of its maker and so prevent the picture being removed from the
wall.[47] This is a rare instance of stylistic differences leading to personal differences;
so rare, that one wonders to what extent the hostilities were enhanced and embell-
ished into a story by later commentators with a modernist bias and an interest in
keeping Gauguin and his group separate from the more academic painters at Pont-
Aven.[48]

The exchange of criticism was important in a further respect. Through daily
contacts and discussion, artists exchanged ideas on what to paint and how to paint
it. Constant discussion and familiarity with each others' work meant that artists
followed their peers' advice about what motifs to paint, from where to paint them,
how to dispose them on their canvas, what colours to use, what models to hire, what
time of day and what season to choose. Theirs was an intensive *collective* engage-
ment with the location.

When looking back on the first years in Worpswede, Fritz Mackensen under-
scored personal stylistic independence while at the same time maintaining a sense
of group unity:

> Jeder von uns ging seinen eigenen Weg. Das Gemeinsame war die glühende
> Begeisterung an dem unendlichen Formen- und Farbenreichtum und dem
> Stimmungsgeheimnis unseres Landes.[49]

> (Each one of us went his own way. The common factor was our ardent enthusiasm for
> the infinite richness of forms and colours and the atmospheric secret of our land.)

Mackensen's common denominator is altogether more vague than any specifi-
cally stylistic factor or even artistic aim: it is 'ardent enthusiasm' for the local land-
scape. At first glance, 'ardent enthusiasm' may not seem like a very promising start
for art-historical analysis; it seems too emotive, subjective and unverifiable. Upon
closer scrutiny, however, it becomes apparent that Mackensen's characterisation
actually lies at the centre of the colonial project. Mackensen claimed that the
common factor uniting the Worpswede artists was their enthusiasm for the colours,
forms and atmosphere of *their land*: that is, Mackensen draws attention to the cen-
trality of place in the artists' group identity. The artists made their commitment to
and engagement with the location into a central group concern. The intricacies and
details of this collective attachment to place is absolutely crucial and will be dis-
cussed further in part IV.

Artists in colonies rarely painted their communal life, nor did they issue manifestos,
as we have seen. Nevertheless, they did perform their group status in a variety of
ways, all of which were designed to preserve the integrity of individual expression.
One way was the decoration of their semi-public meeting places. In artists' inns
across Europe, painters embellished the dining rooms with murals, cartoons and
other pictures, and this ornamentation was a kind of marker of territory. Another

way to demonstrate group cohesion was the participation in social activities, like the singing of specially-worded songs, staging of plays, and so forth.[50] Finally, a third effective strategy was the donning of eccentric dress.

Straw hats, berets, velvet coats and wooden clogs are conspicuous in at least four photographs and one drawing of motley crowds of artistic men posing in Pont-Aven (figures 1, 3).[51] Poses are self-consciously relaxed: propped-up elbows and heads in hand, hands in pockets, slight slouches. The self-dramatisation evident in the photos echo the texts members of the Pont-Aven colony produced about themselves, for example, the American Earl Shinn's description of artists at Gloanec's inn:

> But such a set of apparitions! Each man was a 'long-haired, long-bearded, solitary', like an Enoch Arden after six months' abstinence from barber shops. They were heavily browned upon the face, hands and back of the neck. There was something outlandish in their dress. Brown men with long hair have a lonely look even when they go in bands.[52]

This text was a piece of newspaper journalism, and Shinn was no doubt playing upon popular American stereotypes of artistic eccentricity among his readership. But these were stereotypes that the artists themselves shared and tried to live up to. The adoption of unconventional dress was one way of being Bohemian; what made the dress a specific hallmark of belonging to a rural artists' community was the incorporation of local peasants' garb. Robert Henri described one such outfit:

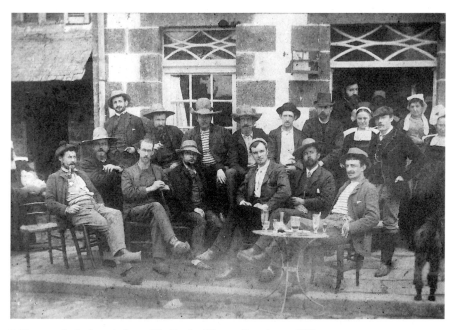

3 Photograph of painters in front of the Pension Gloanec, Pont-Aven, c. 1888

[The painter Paul Peel] wore a big straw hat over his rather good looking face with its red pointed beard. Instead of a vest he had a Bretagne gilet with the very pretty gold embroidery around the neck. On his feet were the characteristic Pont-Aven sabots – with the toes turned up into a point. This is the general make-up for artists in this part of the country – everywhere, I suppose – a general throwing together of costume which pleases the perhaps eccentric taste of the wearer.[53]

Artists actually adopted only certain chosen components of the local dress. No painter, for example, wore the baggy Breton breeches known as *bragoù-bras* or grew his hair long in imitation of local custom. The most popular item of regional apparel among Pont-Aven's artists was the wooden shoe. This item symbolised in a nutshell the supposed backwardness and general picturesqueness of the region. Artists often justified the purchase of clogs as purely practical in places where 'the ordinary shoe of civilisation was of no avail'.[54] The artist William Rothenstein remembered his visit to Pont-Aven in the mid-1880s: 'Attached to the inn was a typical village shop, where I purchased a pair of wooden sabots – not altogether an affectation, for sabots make useful wear for painting out-of-doors, especially in winter.'[55]

It is unlikely, however, that artists donned *sabots* solely because they were practical, despite their protestations to the contrary. In any case, the insistence on functional dress and the avoidance of anything fancy or 'dressy' was in itself a stance that served to underline the nature of life in an artists' colony: rustic painters, intent on their vocation, oblivious of the claims of fashion or fashionability. Still, the wooden clog resounded with connotations that go beyond dry feet, as attested by Paul Gauguin's much-quoted claim, written in Pont-Aven:

J'aime la Bretagne: j'y trouve le sauvage, le primitif. Quand mes sabots résonnent sur ce sol de granit, j'entends le ton sourd, mat et puissant que je cherche en peinture.[56]

(I love Brittany; I find there the savage, the primitive. When my wooden clogs resound on the granite ground, I hear the muffled, dull and powerful tone which I seek in painting.)

Sabots here stand for the alleged primitive character of Brittany as a whole. However, keeping in mind the many other artists in Pont-Aven wearing this footgear at the same time as Gauguin, one realises that *sabots* also stood for the rustic life of artists in villages. It is not known why Gauguin bought a pair of clogs but I would suggest that he did so not in imitation of the locals, but of other artists. Adopting a slightly eccentric mode of dress meant conforming to a popular mainstream image of the artist; it was also a lively way to demonstrate group cohesion, in Pont-Aven and elsewhere (figure 4).

We have seen that interacting with peers on the basis of informal bonds of friendship was valuable to artists in villages because this kind of sociability maintained the integrity of the individual members. Such a community had an ambiguous

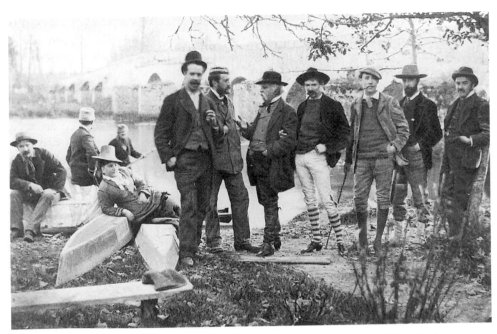

4 Photograph of artists at Grèz, in the garden of Chevillon's inn, 1877, from Will Hicok Low, *A Chronicle of Friendships, 1873–1900*, 1908; standing from left to right: the artists Anthony W. Henley (brother of the poet), Frederic Bentz, the Chevalier G. Palizzi, R. A. M. Stevenson, Frank O'Meara, Ernest Parton, William Simpson (brother of Sir Walter Simpson)

relationship toward the outstanding individual. The assumption was that everyone in the group was equal. However, it seems that in many artists' colonies some group members were more equal than others. A leader could at most be a *primus inter pares*, not someone accorded special privileges or expected to represent the group in an authoritative way to the outside world. Jean-François Millet in Barbizon, Claude Monet in Giverny and Robert Wylie in Pont-Aven were accepted voluntarily as 'charismatic leaders', by virtue of the commonly agreed supremacy of their character and art.[57] Even the latter criterion has to be qualified as most artists' accounts of these 'charismatic leaders' focused overwhelmingly on the artists' personalities, not on their style and only rarely on their working methods.

It may seem perverse to gloss over Millet's mythical status among Barbizon artists from the 1850s onwards and Monet's role of Impressionist guru for the American community in Giverny; however, much has already been written about these painters and, considering rural artists' colonies as a whole, these men were exceptions.[58] Much more typical is the case of the American painter Robert Wylie, who had been one of the founders of the artistic community in Pont-Aven in 1866. Wylie took on a kind of leadership role for some of his compatriots in the village,

although 'leadership' is actually much too forceful a word for the muted impact he had on his colleagues. Even more so than in the case of Millet at Barbizon, it was a case of Wylie's personality rather than his art impressing his (mostly younger) fellow artists, although the fact that he won a second-class medal at the 1872 Paris Salon for his *Fortune Teller of Brittany* no doubt increased his stature (figure 5).[59] Artists remembered him as a saint-like, modest yet authoritative person. Earl Shinn found in him 'the confidential spirit we all expect to meet some day'.[60] Benjamin Champney liked Wylie for being 'a true man and artist, unassuming, sympathetic': 'He harmonized us together.'[61] Julian Alden Weir who arrived in Pont-Aven in 1874, almost a decade after Shinn and Champney, named Wylie as 'one of the best American painters liv[ing] here', and thought him 'a quiet, gentlemanly man and a strict Presbyterian, a man of excellent principles, and a strict observer of Sunday'.[62] William Lamb Picknell who first came to Pont-Aven in 1876 told his sister on his deathbed: 'Do you know I rarely think of Christ without thinking of Wylie? There was a serenity and purity about him that was unique in my experience of men.'[63]

Robert Wylie ended up living in Pont-Aven for almost eleven years and died there in 1877. He never acquired the heroic status of Millet or Monet; indeed, Wylie has virtually dropped out of sight of art history's purview. However, Wylie embodies more than his famous colleagues the kind of relationships based on personal bonds that held artists' colonies together. By virtue of his long residence in

5 Robert Wylie, *A Fortune Teller of Brittany* (Pont-Aven), 1872, 86 x 121 cm

the village, he provided a focal point for his compatriots who mostly stayed only for the summer. His importance for the other artists in the village cannot be measured in terms of stylistic influence, nor was he the spokesman for any of the group's activities. He was, above all, respected as a friend and a 'good person', in the sense discussed by Neidhardt (see above, p. 19). In this sense, he was the complete opposite of the man who later took over his role, Paul Gauguin.

If we compare Gauguin's letters from Brittany to those of other painters at Pont-Aven, the absence of a comfortable sense of being part of a group is striking. Gauguin billed himself as a loner, and if there was talk of a group, he represented himself as its superior, even its leader.[64] There is relatively little in the way of anecdotal material. The case of Gauguin shows that not everyone in a rural artists' colony necessarily conformed to the norms of practice current there. The collective framework was loose and flexible enough to permit a broad range of individual practices. But it must be noted that Gauguin – his own utterances notwithstanding – was nevertheless part of the colonial phenomenon; he made use of the same infrastructure as everybody else and, as will be seen in parts II and IV, owed more than he admitted to his rural colleagues in his choice of motifs and mode of working and socialising. In Pont-Aven, and even more so after the move to Le Pouldu, a cluster of other artists gathered around Gauguin, forming the kind of sub-group often encountered in artists' colonies and discussed above. The strategy of moving from one village that harboured an established artists' group to another, less frequented one in the vicinity, was also common among artists in rural colonies.[65] Gauguin was in many ways a maverick whose allegiances to an urban avant-garde cut across and against the grain of much that went on in Pont-Aven. On the other hand, the artists' colony absorbed him with a remarkable degree of success. Most colonists went on as before; some, inspired by Gauguin, experimented with a more self-conscious formal idiom but they did so within the parameters set up by artist-colonial practice.

Robert Wylie and his position within the artists' colony in Pont-Aven reveals that there were several 'typical images', in the sense of Kris and Kurz, of what an artist was in the second half of the nineteenth century. The image of Gauguin is the one that has entered modernist art history – hostile to traditional values, intent on pursuing his art at the expense of personal relationships – but the image of Wylie provided a model of artistic *and* personal integrity for a greater number of artists. It is perhaps inaccurate, then, to imagine the prototypical nineteenth-century artist as the misunderstood genius in his garret. For many practitioners (arguably for the majority), being an 'artist' could entail the serious pursuit of artistic goals without compromising one's social respectability.

Whereas Gauguin's persona embraced the alienation from society that comes with the territory of avant-gardism, Wylie's case (and that of almost all other artist-colonists) illustrates a reconciliation of the burden of artistic autonomy with acceptance by society. The relatively small and cohesive group of an artists' colony provided the leaven for such a reconciliation. In her seminal essay on early twentieth-century avant-garde artists, Carol Duncan persuasively argues that these

artists' middle-class patrons were, on a symbolic level, buying into a daring, licen-
tious lifestyle at the same time as acquiring art objects: a sign of the chasm opening
up between avant-garde artists and their respectable audiences.[66] By contrast,
artists in rural colonies were trying out another model altogether: they were not
anti-bourgeois, on the contrary. Their personalities and modes of living featured
prominently in widely-read texts on art because they offered exemplary models of
ideal existence for their audiences. As we shall see in subsequent chapters, their art,
too, spoke to fundamental dreams and wishes of their bourgeois viewers.

PART II

ARTISTS AND VILLAGERS

So far, this book has examined the way artists interacted with each other within the enclaves of quasi-bohemian life that they formed in villages. In this part, I turn to the networks of interaction between the two communities, artist and local.

The native population was crucial in a number of ways. Not only did villagers provide the single most popular subject for paintings produced in the countryside (followed closely by landscape), but artistic life had also constantly to be negotiated with the local population. Artists were dependent on the services provided by local innkeepers, models and others while residents reshaped their own occupations and their village's infrastructure to accommodate artists and other tourists. To sum up, villagers figured centrally in artists' colonies both as subject matter for paintings and as agents in their own right. On both counts, the locals were an integral part of the artist-colonial project. Although there were some fundamental dissimilarities between the two communities, I will argue that what marked out successful artists' villages was the way both of these groups combined to form a cohesive new entity: a rural art world.

Artists travelling into the countryside thought they were going to a place that was recognisably non-urban, pre-modern and home to stable communities of countryfolk, living according to the ancient customs of their forefathers and attuned to the rhythms of 'nature'. This configuration of stereotypes and wishful projection made up the myth of agrarian romanticism. The term 'agrarian romanticism', coined by the political scientist Klaus Bergmann, describes an idyllicising urban discourse of the countryside.[1] Bourgeois nostalgia for the pre-modern informed virtually all artistic practice in rural artists' locations, irrespective of style, and it was central to the way the locals were represented as other than themselves. In her suggestive study of nineteenth-century German rural life, Ingeborg Weber-Kellermann investigates various forms that this outlook took: the popular genre of the peasant novel, peasant paintings, children's toys in the form of wooden villages and village animals as well as picture books, societies for the preservation of regional costumes, journals devoted to country life, and finally, urban tourism into the countryside. She argues that these products of agrarian romanticism emerged at a time when Germany was undergoing a radical transformation from an agrarian to an industrial state and that they represented a response by members of the urban bourgeoisie and the land-owning aristocracy to the historical and economic changes affecting both city and country. Most of these cultural representations revolved around the evocation of an idealised bygone age, and some openly exhorted peasants to stay where they were and to cultivate their traditional customs and costumes. Villagers found themselves curiously suspended between the dissolution of traditional agrarian society on the one hand, and the desperate attempts by agrarian romantics to preserve this old life at all costs on the other.[2]

The enormous increase in the popularity of peasant painting in the last quarter of the nineteenth century was part of the larger cultural phenomenon of agrarian romanticism. In his seminal article on rural images in French paintings of the period, Robert L. Herbert attributed this increase to the massive transformations

associated with the transition from agricultural to largely industrial economies. Herbert links the two phenomena – peasant art and migration of peasants to cities – by arguing that 'the peasant was among the most important subjects for the embodiment of artists' attitudes toward the urban–industrial revolution'.[3] Artists were painting a way of life that they feared was vanishing, and their paintings expressed their antipathies to the industrialisation and modernisation of their time. In other words, paintings of peasants were not about peasants but about (urbanised) artists' resistance to the effects of modernisation.[4]

They were also, and this is a crucial point, about the dreams and nostalgic imaginaries of art's bourgeois audiences. It should be noted that many aspects of the vision of rural life, analysed in more detail below, were common to paintings produced within as well as without the context of artists' colonies. However, what distinguishes artist-colonial images from those made elsewhere is their much-vaunted connection to artists' first-hand experience of the countryside. Chapter 2 examines how paintings of rural life produced in artists' colonies were particularly successful in activating urban bourgeois dreams because they grounded their representations of agrarian idylls in reality, authenticated by the eyewitness status of artist-colonists 'on location'. It is true that a number of non-colonial individuals, notably the enormously popular painter Jules Bastien-Lepage in the late 1870s and early 1880s, also emphasised their personal acquaintance with rural circumstances. Indeed, the value placed upon familiarity with the land and its people by artists, viewers and critics in the second half of the nineteenth century may have been partly a result of the growing popularity of artists' colonies.

The processes of rural modernisation are themselves brought more sharply into focus in chapter 3. Most villages in central and northern Europe were undergoing some form of transformation (involving, among other factors, the introduction of new methods of agriculture, migration into cities and abroad, shifting patterns of labour, and changing modes of dress). However, artists were also agents of a very specific kind of modernisation: tourism. Local entrepreneurship – in which innkeepers often played a prominent role – provided the infrastructure necessary both for artists' colonies' survival and for subsequent tourist exploitation.

A final note: not all rural artists' colonies were, strictly speaking, rural. A large number of colonies were formed in maritime communities where the principal activity was not agriculture and animal husbandry, but fishing. I have elsewhere examined some of the ways in which images of fisherfolk mobilised different meanings from images of peasants.[5] However, both functioned as markers for pre-industrial and supposedly traditional ways of life and both drew on nostalgic idealisations in the vein of agrarian romanticism; so for the present purposes, I will subsume fishing communities under the heading of 'rural', while bearing in mind that the two cannot be assimilated on all counts.

Painted peasants

The way artists perceived villagers was inevitably conditioned by stereotypical assumptions they had brought with them from urban, bourgeois contexts. Still, artist-colonists attached enormous importance to the circumstance that they were painting 'from life' and denied any indebtedness to expectations formed outside the village community. Artists used the circumstance that they lived in close proximity to villagers to invest their observations with the authority of authenticity. For example, when a critic reproached Stanhope Forbes for depicting ambidextrous blacksmiths in his painting *Forging the Anchor* (figure 6), Forbes protested that he had seen this skill with his own eyes in a Newlyn smithy.[1] What was at stake for critics and artists alike was a kind of visual truth value, grounded in the meticulous observation of a specific social and occupational habitus.

It is useful in this context to borrow the sociologist Erving Goffman's model of stage performances as an analogy for human interactions.[2] The way that artists represented their privileged insight into villagers' lives may be described in the form of a collective performance, addressed to the artists' urban audiences. This performance involved pictorial as well as textual representations. The purported eyewitness records in the form of visual images were supported by writings in journals and newspapers, informing the public of the artists' intimate knowledge of their peasant subjects. Rural artists fulfilled the function of being envoys in the field, relaying their 'authentically' witnessed and felt experiences back to urban audiences in the manner of ethnographers. However, unlike ethnographers, artists were expected to probe the 'heart' of the natives, not just their tools and customs.

This package of artistic self-presentation may also explain why artists so rarely painted themselves or each other or, indeed, any other metropolitan visitors, among the local folk. The inclusion of urban non-peasants would have undermined the impression that rural artists were peeking in upon an unchanging, pre-modern world. Images of peasants were offered to the public as glimpses snatched from real life, as if no intrusion from the outside had ever taken place. This mode of painting and marketing paintings may be termed 'documentary romanticism', and the following sections of this chapter will examine how this rhetorical and pictorial strategy worked and what functions it fulfilled for the late nineteenth-century urban bourgeoisie.

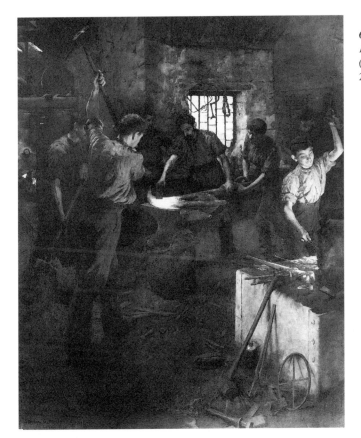

6 Stanhope Forbes, *Forging the Anchor* (Newlyn), 1892, 213 x 51 cm

Performing authenticity

Critics insisted that, in the case of artist-colonists, proximity yielded an unproblematic insight into the locals' nature and lives. For Paul Warncke, for example, there was no difference between Worpswede art and Worpswede peasant reality: these people 'are in reality and on Mackensen's pictures … a most characteristic part of the landscape'.[3] Claims to privileged insight into local life were in part founded upon the belief that artists enjoyed special empathy with the people of the village. Karl Krummacher discerned a kinship between the Worpswede villagers and Fritz Mackensen, manifested in their shared 'serious-mindedness'; and Benjamin Champney extolled fellow-painter Robert Wylie as being uniquely in the confidence of Pont-Aven locals.[4] If artists happened to have rural connections, no matter how tenuous, these were fully exploited by themselves and by writers. Much was made of the supposed affinity for land and locals of such painters as Heinrich Otto and Carl Bantzer in Willingshausen, Albijn Van den Abeele in Sint-Martens-Latem and, of course, Jean-François Millet in Barbizon.[5]

Artists were conscious that they were engaged in a form of 'reality research' in the field. Leopold von Kalckreuth wrote in a letter of July 1882 that he had been painting a lot in the rain, part of the immersion in the 'real' (as well as in the natural elements) involved in the construction of his picture *Funeral Procession in Dachau* (figure 7). The sense of 'really being out there' is reinforced here by the effects of muddy texture and wet reflections. The boys at right and the first few men in the crowd of mourners are endowed with portrait-like faces. Judging from another letter by Kalckreuth, it seems not to have been too easy to find models: 'I have to make great friends with the peasants so that they will pose for me.'[6]

'Reality research' could take on voyeuristic overtones. William Titcomb's *Piloting Her Home* (figure 8) was painted in St Ives under the following extraordinary circumstances. One day, Titcomb happened to observe four Methodist fisherpeople praying at the bedside of a dying woman, a certain Mrs Rouncefield. A year later, the old woman, now aged eighty-five, had miraculously recovered, and the painter persuaded the chief protagonists to re-enact the entire scene for him in a purpose-built and specially furnished cottage interior. 'I think my presence was almost forgotten, for I surveyed it [the scene] through a hole cut in the side of this old cottage.'[7]

Artists felt that they had entered the site of the locals' 'true' essence when they enjoyed the privilege of being able to paint such private scenes in peoples' domestic spaces. Hiding behind an artifical wall, Titcomb could enjoy the fantasy of witnessing authentic native life – which in this case was patently an elaborately staged

7 Leopold Graf von Kalckreuth, *Funeral Procession in Dachau*, 1883, 179 x 300 cm

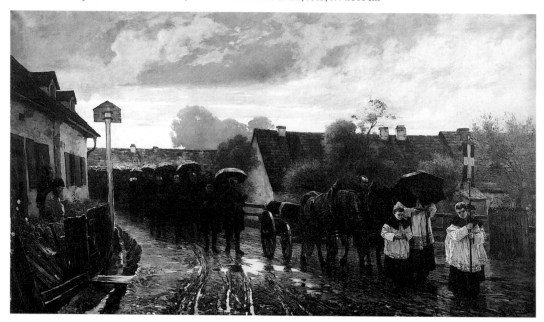

performance, orchestrated by and for the artist himself. The painting purports to capture a moment of intimate insight, yet the actual making of it was a laborious and time-consuming process: the canvas took over forty sittings to complete.[8] Still, the initial eyewitness experience of Titcomb's previous presence in the dying woman's bedroom that had originated the idea for the painting served to coat the enterprise with a veneer of veracity. 'I have seen this with my own eyes', is the authenticating message stamped upon this work.

Erving Goffman coined the term 'back region' to designate those areas where a group of people staging a performance relax and let 'their guard down', as is, for example, the case with waiters in a restaurant's kitchen. Dean MacCannell applied the concept to touristic experience, arguing that tourists in search of authenticity in places away from their home are especially drawn to what they take to be the back regions of local settings where, supposedly, the 'real' life of the natives reveals itself.[9] Titcomb's painting can be read as a pictorial enactment of a back region.

Back regions did not always need to be staged quite as obviously as in Titcomb's case. Indeed, that was one of the attractions of living in a village. In their quest for entrance to native back regions, artists could penetrate into actual private living spaces and appropriate the people they found there as their models. Stanhope Forbes admitted that the opportunity to spy on the private lives of local people was a key charm of Newlyn:

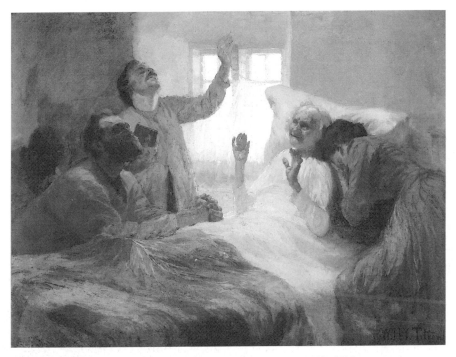

8 William Holt Yates Titcomb, *Piloting Her Home* (St Ives), date unknown, 113 x 151.1 cm

Painters have an easy way of walking into other people's houses, calmly causing their occupants no little inconvenience. It is this habit of theirs which perhaps causes them to congregate in places where their oddities are known and their motives understood.[10]

The American Henry Ward Ranger reported that in Laren 'it is also the custom to drop in at any peasant home and look about *sans cérémonie*'.[11] Laura Knight painted in a Laren cottage 'where the *Vrow* [sic] cooked the rice or potatoes for dinner while she posed for me, having to get up constantly to stir'.[12] The resulting representations laid claim to a privileged 'fly-on-the-wall' voyeur's insight, based on artist-colonists' 'reality research' in the back regions of their rural locations. Published texts with anecdotes like those told by Knight and Ranger anchored the truth claim of the pictorial texts. I will return to the intriguing relationship of text and imagery presently.

Rural harmonies

Let us look at one image more closely: Gari Melchers' *The Sermon*, painted in Egmond in 1886 (colour plate 1). We see a congregation of women and men in regional costume during a church service in Egmond's Protestant church. The focus is on the young woman in the centre foreground who has slumped forward in her chair, asleep. Our attention is drawn to her by the old woman seated two seats beyond the sleeper, the only figure to turn her head and face in our direction. The others all look out, beyond the left-hand margin of the canvas, presumably at the clergyman giving his sermon. The pictorial strategies employed include placing the main focus of attention outside of the painting, presenting a variety of listening attitudes and poses, including redundant details that are not immediately relevant to the main theme but contribute to an overall 'reality effect' (like the numbers on the chair backs or the discarded cloak hung on the back of a chair) and centring the scene around a story that is subsidiary to the main theme of sermon but essential in that it adds lighthearted 'human interest'.[13] All of these devices serve to draw the viewers into the scene by encouraging them to use their imaginations to fill in the 'gaps' in the story.[14] Indeed, the empty chair in the right foreground practically invites the viewer to join the congregation. However, the illusion of reality achieved in this painting had its limits. For example, in 1980, old Egmonders commented that the women looked underdressed in their lace caps, in church they should have been wearing bonnets.[15] Such 'mistakes' were not infrequent, as we shall see. However, they did not really matter for Melchers and other rural artists. These artists were not in the countryside in order to study and document the locals, they were there to paint them. Ethnographic details were mobilised only if they served the purposes of the picture. The indignant Egmonders who saw *The Sermon* were not its original audience. The picture was intended for a bourgeois metropolitan audience which was, of course, oblivious to its minor infidelities. Indeed, one critic praised it as 'the last word of realism in painting'.[16]

The social and physical realities of wearing costume found no echo in artist-colonists' paintings where costume functioned as a generic sign of 'peasantness' (or 'fisherfolkness') rather than as an indicator of specific regional identity, not to mention the minutiae of social information communicated by costume. Costume was a complex signifying system within its local context. The different elements of costume, especially of feminine costume, could identify the wearer's marital and economic status, the degree of bereavement, and the wealth and virginity of a bride; they also marked out the seasons and days of the month.[17] Painters treated this complicated system with a great deal of artistic licence. For example, the protagonists in the German Carl Jacoby's triptych *An Old Story* sport the typical Volendam costume but the interior shown in the central panel is not typical of Volendam fishermen's cottages and the landscape glimpsed through the doorway contains dunes which are certainly not found on the Zuiderzee (figure 9).[18] The English painter George Clausen who made Volendam known to the Anglo-Saxon world with his painting *High Mass at a Fishing Village on the Zuyderzee* depicted Volendamers (who were Catholic) unconcernedly kneeling in front of the portal of the Protestant church at nearby Monnickendam (figure 10).[19] The American Walter MacEwen in his *The Ghost Story* (*c.* 1888, Cleveland Museum of Art) painted young Volendam women wearing a type of headdress that had gone out of fashion twenty-odd years previously and was at that time only worn by old women.[20] In Willingshausen, Bantzer painted old Frau Siebert from nearby Merzhausen in the black costume of another region, the Hinterland, because 'the little [local] Schwalm cap did not suit the serious expression of this handsome head'.[21]

These examples make plain that artists were happy to sacrifice ethnographic exactitude for picturesque effect. In Jacoby's, Clausen's, Melchers' and MacEwen's paintings, a general sense of 'Dutchness' was to be conveyed, and if this could be more vividly achieved by including 'typical' Dutch dunes or a picturesque 'Dutch' church of whatever denomination, then so be it.[22]

Not only did artists confuse the details of costume, they also often painted costume where none was worn. The late nineteenth century witnessed the beginning of a gradual decline of village costume and a slow adaptation of city fashions in most parts of northern and central Europe. In many regions, mass-produced accessories were incorporated into the costume itself.[23] Most urban commentators decried these developments, to the point of calling for legislation to prohibit the sale of cheap glass beads.[24] Carl Bantzer discovered that a 'fine specimen' of an old-fashioned peasant in a village near Willingshausen who 'had to be painted', actually only wore costume on Sundays; during the week he worked in a factory and wore city clothes. Bantzer was reportedly very disappointed because of his 'sensitivity toward things that were not quite genuine' ('echt').[25] The 'genuine' or the authentic had, in this case, little to do with historical reality. For Bantzer and many others, the sign of tradition was categorically 'genuine'; if villagers strayed outside of the parameters set by urban myth-making and into modernity, they ceased to be quite 'real'. Certainly, they ceased to exist as subjects for painting.

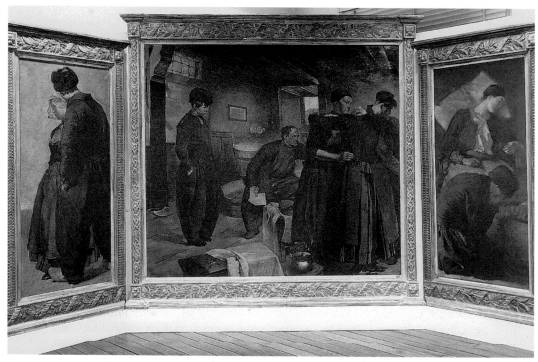

9 Carl Jacoby, *An Old Story* (Volendam), 1901–2, 221.5 x 436.5 cm

10 George Clausen, *High Mass at a Fishing Village on the Zuyderzee* (Volendam), 1876, 47 x 84 cm

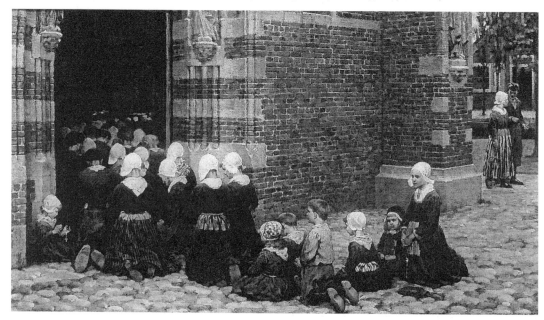

The carefully stage-managed compositions of *The Sermon*, *Piloting Her Home* and countless others should alert us to the highly mediated way in which artists produced 'reality' in their representations. The point is that it is misleading to interpret images made in rural artists' colonies as faithful reflections or falsifiable documents of village life. It is important to emphasise this point because many writers on artists' villages persist in unproblematically equating the images with reality.[26] This is to confuse art with ethnography and ignores these paintings' distinctive function of being *art* and the types of rhetoric employed in them which were aimed at urban middle-class audiences. It was these urban viewers who needed to be convinced (not the local population), and the strategies apparent in a painting such as Melchers' *Sermon* were geared towards drawing them in and encouraging them to believe in the created fictional world on the canvas.

Ethnographic details were included if they served to bolster the image's reality effect but scientific exactitude was never an end in itself. It was always subordinated to considerations of form, composition and pictorial narrative. To co-opt the Marxist philosopher Louis Althusser's term, viewers were interpellated by the rhetorical codes employed in these images. According to Althusser, interpellation or 'hailing' is the operation by which individuals are recruited as subjects into ideology.[27] I propose to transpose the general mechanism of ideological hailing onto the specific rhetorical address of late nineteenth-century visual representations of peasants in order to untangle some of the strands of meaning woven into these seemingly straightforward pictures. In sum, I shall argue that images of rural life produced in artists' villages interpellated their audience as urban, bourgeois subjects by both playing on stereotypes familiar to that audience and producing 'new' realities by virtue of the supposed authority of authentic eyewitness behind their conditions of production.

Two devices were central to this operation: the anecdote and the heroic type. The anecdote was the most widespread and involved the dramatisation of the rural actors within the framework of an engaging story taken from 'everyday' life (colour plate 1, figures 7, 8, 9, 10, 11). Melchers', Kalckreuth's and Titcomb's paintings give us an indication, even a prescriptive one, of how we are to feel and respond towards the depicted scene. Beholders were here not left to their own devices as they are before the blunt realism of, for example, Wilhelm Leibl's *Three Women in Church* (1882, Kunsthalle Hamburg – which, incidentally, was not painted in a rural colony). Charles Rosen and Henri Zerner observe that the anecdotal is the 'projection in time of the single moment seized by the picture, leading away from the immediate visual sensation into both past and future'.[28] Clues are placed in the painted scene to enable the viewer to reconstruct how it came about, and to predict what will happen next: 'In this way, the painting becomes a point of departure for the spectator's fantasy, absorbing him in an imaginary world'[29] – in other words, interpellating him or her.

The anecdotal mode also allowed a supposedly typical verity to be shown in a nutshell, as we saw in a different context in chapter 1. Melchers' painting (colour plate 1) not only tells an engaging story but also produces and reinforces a larger

11 Hans von Bartels,
Fisherfolks' Courtship
(Volendam), *c.* 1893

ideological stereotype of countryfolk being pious but also hard-working (hence overcome by sleep in church), perhaps also of village parsons boring their congregation (causing the young woman to snooze off), and also of peasants being simple but kind (the older woman's empathetic look), and above all, unthreateningly humorous and always good for a joke at their own expense.

The second principal means by which the audience was interpellated by images of rural life was the production of heroic stereotypes. The prototypical 'peasant' of artists' writings and paintings was marked by a hard-working, pious and pre-modern life, and was almost exclusively clothed in regional costume. Carl Bantzer described the Willingshausen peasants thus:

> Der Eindruck, den ich vom Schwälmer Bauern … bekam, war der des stolzen, selbstbewußten und freien Mannes, eines Menschenschlags, der allgemein überaus arbeitsam ist, aber nach sauren Wochen auch frohe Feste kennt, Feste der Lebensfreude und Feste der Arbeit. An Sonntagen zeigte der rege Kirchgang das

treue Festhalten an der Kirche. ... Auffallend war auch die Genügsamkeit und Zufriedenheit armer Leute.[30]

(The impression I gained from the peasant of the Schwalm region [around Willingshausen] was that of a proud, self-assured and free man. These peasant-types are generally extremely hard working but also know, after weeks of sour labour, how to enjoy merry feasts, celebrations of joy and celebrations of labour. On Sundays, the lively church attendance showed a faithful adherence to the church. ... Remarkable, too, was the undemanding contentedness of poor people.)

Bantzer's paintings reinforce this image of the hard-working and proud yet contented and devout peasant. *Harvest Worker from Hesse* synthesises many of the key elements of this ideal specimen (figure 12). The rough, sun-tanned hands and face of the figure suggest years of manual labour. The man's frontal stance and upright posture, legs planted firmly on the earth he works, convey an unbroken pride and dignity, while the hands hanging loosely by his side and his bow-legged limbs suggest the awkwardness appropriate to an unsophisticated countryman when facing the painter's eye. Locals did wear white clothes at harvest time to counteract the summer heat but the spotlessly clean garment of the *Harvest Worker* is not only an indicator of anthropological veracity but also functions as a metaphor for moral purity and, finally, as an instrument of aesthetic orchestration. No doubt, the white outfit initially appealed to Bantzer for its pictorial potential: the manner in which it pulls together the other, subsidiary colours in the composition and the way it allowed the painter to display his skill at handling dazzling whites and pale-blue shadows.[31]

Images of dignified village figures, neatly costumed in regional garb and behaving in an orderly fashion in the context of church-going, celebrating, grieving, flirting, dining, resting or going about their daily business, were the norm in the production of rural painters (colour plate 1, figures 9, 10, 11, 18, 50). All of these paintings displayed different inflections of the theme according to

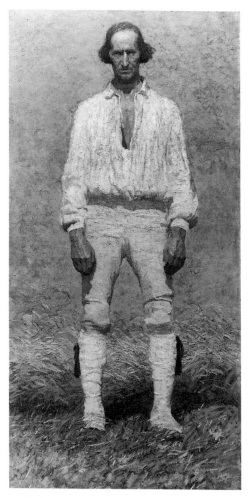

12 Carl Bantzer, *Harvest Worker from Hesse* (Willingshausen), 1907, 95 x 201 cm

the country and region as well as the date of their production but by and large they constituted an image of peasants (and fisherfolk) that was remarkably homogeneous. These paintings presented tamed and, as it were, cleaned-up images of peasants. Villagers were painted leading lives untainted by modernisation, corruption, fashion, politics, wealth or sexuality (aside from the odd shy glance), and above all, by dissatisfaction with their lot. Painted peasants were well proportioned, well fed, neatly dressed, industrious, devout, unerotic and engaged in calm, orderly and often domestic activities. According to artists, villagers were 'happy souls' (in Willingshausen) or 'a cheerful and light-hearted lot ... comforted by their simple faith' (in Laren).[32] It is debatable whether such appellations can ever adequately describe actual communities, but they are certainly attributes of the peasants *as painted*.

Destitution or any sign at all of rural disharmony was excluded from the paintings. Even rural labour was missing – that is, labour shown *as* labour. It is true that there are quite a number of images of locals ostensibly 'at work' – harvesting, gleaning, ploughing, fishing, and so forth. However, as Griselda Pollock argues, paintings like Gauguin's *Seaweed Gatherers* (1889, Museum Folkwang, Essen), produced in Le Pouldu, were part of a scopic economy of tourism. One of the key images for sightseers in their leisure time is 'the labour of others in non-modern systems of production'.[33]

> But what they do does not signify 'work', in its modernized, capitalist sense. It is not waged labour; it seems to obey other rhythms and necessities. It is therefore not perceived as work but as seasonal tasks, obedient to natural cycles rather than to social relations.[34]

Understanding the representation of rural work as images of 'not-work' provides a key to paintings of herding livestock and poultry, an especially popular subject with rural painters. One reason why shepherds, cowherds and gooseherds were preferred may have been that they *looked* to an outsider as though they weren't working at all; in fact, many paintings of herders come close to being paintings of peasants resting or simply standing.[35] Herders were seen by most non-villagers in bucolic terms. Jean-Georges Gassies remembered as an idyllic event the daily passing of the cowherd through Barbizon in 1852.[36] Alfred Sensier, Millet's biographer, attributed mystic qualities to shepherds:

> The shepherd is not a countryman after the pattern of the labourers and other fieldhands; he is an enigma, a mystery; he lives alone, his only companions his dog and his flock. ... He is the guardian, the guide, the physician of the flock. Besides, he is a man of contemplation. He knows the stars, watches the sky, and predicts the weather. The whole life of the atmosphere is familiar to him.[37]

Indeed, herders were perfectly suited to being appropriated as the kind of contemplative figures, immersed in nature and standing in for the artists themselves that will be discussed in chapter 5. The American painter John Leslie Breck's

intensely pastoral *Autumn, Giverny (The New Moon)* is a very good example of the type (figure 13). The shepherd commands attention by his central location on the composition's horizontal axis, his dark colour and the vertical accent of his upright posture. However, his own size is actually fairly small compared to the size of the canvas, and he is shown surrounded by nature on all sides. Furthermore, he is turned away from us, and his posture, leaning on his staff, suggests that he is gazing at the landscape and sky and possibly, at the sheep as part of that landscape.

Images of shepherds or cowherds that do not adhere to a similar romantic notion of Sensier's 'man of contemplation' are rare. Among them might be counted Anton Mauve's *Changing Pasture*, painted in Laren and evoking the physical discomforts involved in an outdoor activity which needed to be performed regardless of weather conditions (figure 14) and Serafien De Rijcke's *Cows at Pasture*, painted near Sint-Martens-Latem (figure 15). De Rijcke was one of the very few painters who did not come from an urban background; he was himself a local, born in nearby Deurle. His father was variously registered as a basket-maker and a *land-bouwer* or peasant. De Rijcke was likewise registered as a peasant until 1866 when he appeared in the Deurle register as *kunstschilder* (painter).[38] This largely self-taught local artist appears to have emulated contemporary pastorals in his *Cows at Pasture*, awkwardly balancing trees to the right with thin-legged cows to the left, but the kind of running and stick-waving animal herder seen here was otherwise unknown in peasant painting. This cowherd seems to be a genuine piece of experienced rural life, disrupting artistic notions of a pastoral *vita contemplativa*.

13 John Leslie Breck, *Autumn, Giverny (The New Moon)*, 1889, 130.8 x 215.9 cm

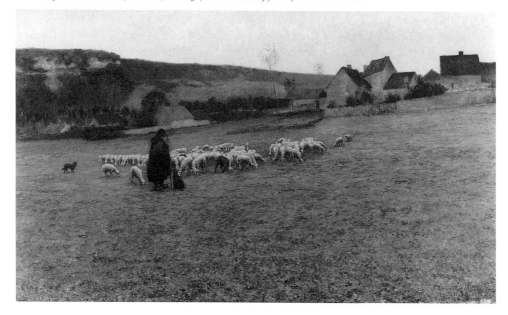

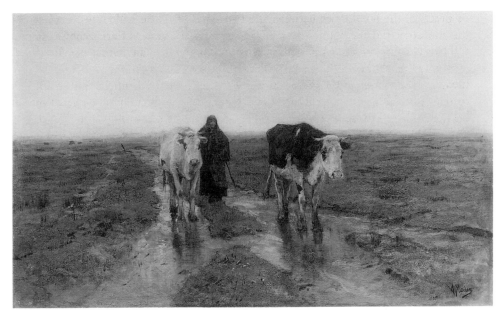

14 Anton Mauve, *Changing Pasture* (Laren), date unknown, 61 x 100.6 cm

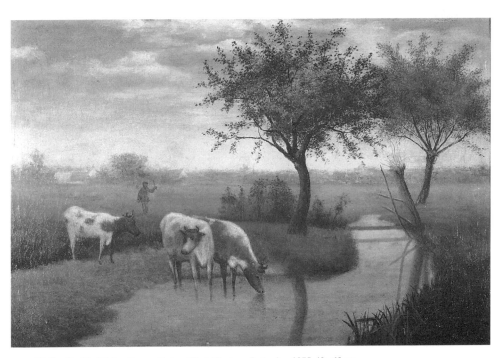

15 Serafien De Rijcke, *Cows at Pasture* (Sint-Martens-Latem), *c.* 1875, 40 x 60 cm

In practice, the boundaries between the two types of image I identified earlier, the anecdotal and the heroic, were fluid, and canvases such as Carl Jacoby's *An Old Story*, combine aspects of both in what might be called an 'heroic anecdote', involving tragedy at sea (figure 9). What both categories share is their efficacy at involving the viewer in the pictorial scene. The effect of authenticity and 'truth to reality' came about not because these paintings were accurate documents of village life but because they were so successful at feeding into and continuing to shape dominant urban ideas of what that life should look like. Processes of selection and exclusion were crucial in creating a unified picture of the rural scene, and, as I will now show, artists turned the local population into acceptable subjects for painting by transforming the varied village community they encountered in two crucial ways: turning peasants into bourgeois subjects, and turning villagers into peasants.

Peasants, as painted in rural artists' colonies, on the whole occupied a middleground between wealthy gentlemen farmers and destitute paupers, and in occupying this position they took on much of the look, the manners and the morals of that other 'middle' group, the middle class. The girls being schooled in domestic

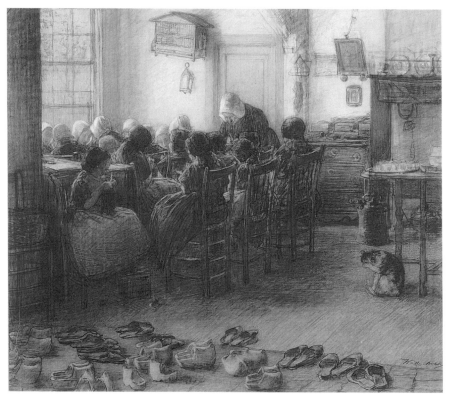

16 Wally Moes, *Knitting School in Huizen* (Laren), date unknown, 56 x 63 cm

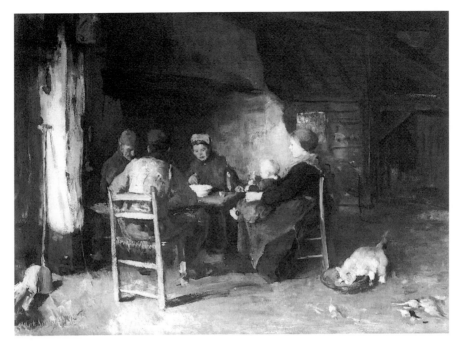

17 Albert Neuhuys, *Meal* (Laren), 1892, 75 x 102 cm

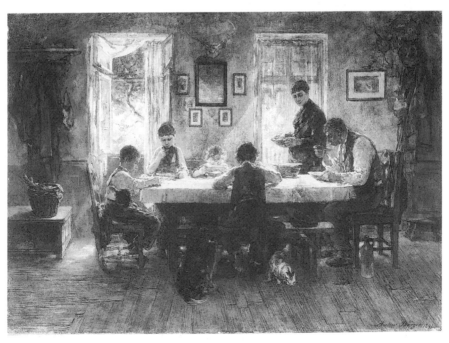

18 Anton Burger, *The Country Meal* (Kronberg), 1894, 60 x 85 cm

feminine virtues in Wally Moes' *Knitting School in Huizen* and the family group in Albert Neuhuys' *Meal*, both painted in Laren, have more in common with the bourgeois who painted them and who bought the paintings than with the agrarian estate they ostensibly portrayed (figures 16, 17). This is especially striking in another example, Anton Burger's *The Country Meal*, painted in Kronberg (figure 18). A nuclear family enjoys an orderly repast; the *pater familias* presides over a neatly laid table, complemented by obedient children and an attentively serving housewife-mother; furnishings and fittings conform to bourgeois decorum, complete with gauze curtains, framed pictures and (a touch of rusticity) mounted antlers. Even the cat and dog look more like middle-class pets than farmyard animals.

These painted peasants were even more bourgeois than the real bourgeoisie; or more precisely, they represented an ideal state of *Bürgerlichkeit* or 'bourgeoisdom' which the nineteenth-century urban bourgeoisie longed for or imagined to have lost: frugal, industrious, orderly, enjoying intact family relations, maintaining the separation of the sexes. By contrast, the private sphere of the urban bourgeois was increasingly perceived as besieged by the pressures of marital estrangement or wayward sexuality, as thematised in nineteenth-century novels.[39] The historian Susanne Rouette argues that by identifying the peasant with tradition and conservatism, nineteenth-century bourgeois subjects could confirm their own progressive modernity. The peasant came to stand for the bourgeoisie's own past.[40] Peasants and fisherfolk were a living reminder of what the bourgeoisie took to be its own origins. These origins being now transcended, no middle-class viewer wanted to return to that state of manual labour and supposed ignorance but at the same time the image of the peasant was laden with powerful nostalgic affect.

As a result of this ambivalent over-determination, peasants as imagined and as painted were at once bourgeois and not bourgeois. Paradoxically, the actual rural bourgeoisie was omitted from the majority of representations of village life. The countryside was envisioned by artists and their urban public to be the place where peasants were to be found, to the exclusion of all other groups. While nineteenth-century writers of fiction set in the countryside might include an array of village occupations and types in their texts, contemporary artists focused overwhelmingly on the figure of the peasant. Artists working in rural artists' villages often evacuated even the built environment of the village itself from their images and reduced the diversity of occupations and demographic groups to one common denominator, that of peasant (or fisherperson). This can be demonstrated very clearly with regard to the colony at Skagen.

Census returns show Skagen's population to have been 2,323 in 1890. Skagen at this time was Denmark's largest fishing community. Over half of its inhabitants were active in fishing; still, that leaves over one thousand people who were otherwise employed, for example, as artisans (12 per cent), in agriculture (5 per cent) or in trade (5 per cent) (table 1).

Table 1: The population of Skagen in 1890

Fishing	1,296
Artisanal trade and industry	289
Day labourers	227
Administration and related tasks	147
Agriculture	130
Trade	110
Shipping	44
Rentiers	43
On welfare	29
Gardening	7
In gaol	1
Total	2,323

Source: *Künstlerkolonie Skagen*, ed. G. Kaufmann, Hamburg, 1989

In addition to permanent residents, Skagen also had summer visitors: in 1900, the population increased from 2,400 to 3,000 within one month during the summer vacation (an increase that implies around 20,000 overnight stays).[41]

As one would expect, when Skagen artists painted locals they chose in most cases to paint fisherfolk. While this reflected the undoubted importance of fishing to the local community, it did have the effect of concealing from view the other half of Skagen's inhabitants. The non-artistic tourists recorded as having visited Skagen in great numbers are also almost completely absent from artists' paintings. Nowhere do we see the 'wild whirl' of day trippers encounted by one visitor to Brøndum's inn in the 1890s.[42] The other professions represented by Skagen painters included that of artist (that is, pictures of each other), of innkeeper (in the person of artists' friend and patron, Degn Brøndum), and a substantial number of undefinable marginal figures who may have belonged in the 'welfare' category. Constructing an image of the local community involved the selection of some kinds of person and the elimination of others. Similar processes of selection and exclusion can be observed in every artists' village, and they are the subject of part IV.

The point is that artists in villages did not only make peasants into bourgeois, but also made locals into peasants (or fisherfolk); they 'peasantified' the countryside. This is how rural colonists (and, indeed, most other peasant painters of the nineteenth century) differed from someone like Gustave Courbet who famously included members of the provincial bourgeoisie in some of his paintings of Ornans.[43] Except for the inclusion of the occasional parish priest or artisan, paintings produced in rural colonies rarely acknowledged the presence of anybody else but peasants and fisherfolk.

But what of the exceptions (figures 19, 20)? At least stylistically, paintings by Modersohn-Becker, Gauguin, Gustave van de Woestijne or Adolf Hölzel, do not

appear to fit into this overall picture of agrarian romanticism. However, in their choice of models and subject matter as well as in their very opposition to prevailing practice, these avant-garde practitioners were closely tied to the artist-colonial context they were working in. Notwithstanding formal differences, their pictures also continued to function as purveyors of non-bourgeois, non-urban, pre-industrial existences to a section of the bourgeois, urban, modern audience, this time in a new guise of the

19 Paula Modersohn-Becker, *Head of an Old Woman with Black Headscarf* (Worpswede), *c.* 1904, 39 x 37.5 cm

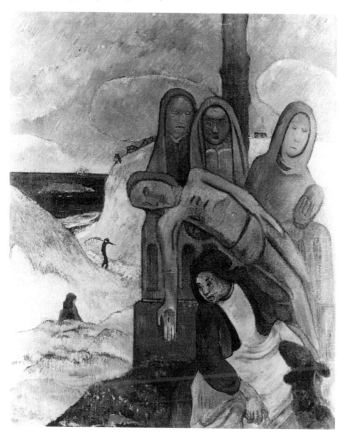

20 Paul Gauguin, *Breton Calvary/ The Green Christ* (Le Pouldu), 1889, 92 x 73.5 cm

'authentic': primitivism. Indeed, I would argue that primitivism was a permutation of agrarian romanticism. For some, the image of European peasantry and nature had exhausted itself by the end of the nineteenth century. Nostalgia had now to cast its net wider and beyond rural Europe. Initially, the new audience for primitivism was a small minority within the cultural classes of cities but in the first decades of the twentieth century, as villages in northern and western Europe were transforming themselves too obviously into tourist sites and suburban outposts for the metropolitan bourgeoisie, the horizons of nostalgia started to expand to embrace Africa, Asia and Oceania. These points lead us beyond the scope of this book. Suffice it to note that primitivism may be seen as the legacy of artists' colonies to the twentieth century.[44]

Contradictions

After having discussed the ways in which paintings fashioned a peasant ideal removed from actual village reality, I will now double back on those claims and analyse the mismatches evident between painting and practice. Visual representations aimed to eliminate conflict but *textual* accounts offered a very different story. In artists' writings, the fissures between the agrarian ideal (as painted) and village reality (as experienced by artists, not locals) frequently shine through. I will now introduce some of these texts and allow them to elucidate a different, perhaps usefully corrective, picture of the encounter between artists and locals.

The reader will not be surprised to learn that artist-colonists' written accounts of their meetings with villagers were invariably couched in the anecdotal mode. A short humorous yarn was the preferred vehicle for the airing of confusing or frustrating confrontations. Laura Knight's memoir of a social engagement with two of her village models in Laren reveals the cultural and linguistic gulf between the two parties, and also the attitude of benevolent condescension the artist chose to deal with the awkwardness:

> One night [the American painter Joseph] Raphael, Harold [Knight] and I gave a party to our farmer and his wife. We all sat in our best clothes, so properly, round the table till twelve o'clock. They had never been up so late before. They understood as little of our conversation as we did of theirs, but we roared at their jokes as if we knew what they were about, just as they did at ours. … Our party was a great success.[45]

Needless to say, this mixed *soirée* was never painted by either Laura or Harold Knight. Painters also told funny tales about the recalcitrance or slyness of their rustic models, playing on stereotypes of the wily peasant. The American Birge Harrison recounted the following amusing tale about Grèz:

> The peasants are a shrewd but not unkindly people, liking the artists well enough, but with a keen eye to the possible sou; disposed, for instance to appear inopportunely with a scythe just when the unfortunate painter is well advanced with his study of a daisy field, and cannot afford to drop it and begin another. In this conjunction of circumstances nothing but a hundred sou piece will keep those daisies afoot. I remember

well one old heathen with a hooked nose, a seductive smile and an extraordinary *patois*, who for a long time had regularly mulcted the artists in this way, until at length his cupidity overreached itself and led to the discovery that he owned not one rood of the land in the whole region.[46]

There are no pictorial records of such Shakespearean low life. By contrast, texts discuss a variety of issues and minorities, such as Jews and gypsies, rural destitution, child abuse, crime and even murder, and we find descriptions of countryfolk who are venal, ignorant, insane, bigoted, superstitious, primitive, ugly and lice-ridden.[47] Unlike the cleaned-up peasants of visual representation, textually-described locals were frequently dirty.[48] At times, the very activities necessary for the natives' livelihoods seemed to get in the way of the artistic enterprise. Stanhope Forbes fretted when the fisherfolk of Newlyn got too caught up in actual fishing and its economic contingencies: 'bad smells and I long for rain'.[49]

In these writings, we now and again receive glimpses of artists grappling with contrariness and otherness, but in the paintings, the locals are safely returned to the world of agrarian romanticism or primitivism. It is tempting to read the contradictions between texts and images as clashes between reality and myth. This is an argument easily made, and those writers on rural artists' colonies who have resisted being entirely drawn in by the rhetoric of authenticity and agrarian romanticism, have generally made it very convincingly.[50] However, I want to move beyond the opposition of myth versus reality in order to expose the underlying ideological commitments shared by both written and painted representations.

What must be borne in mind is that the paintings of peasants produced in rural contexts were part of European art worlds in the heyday of bourgeois cultural self-confidence. These paintings were bourgeois art *par excellence* – much more so, by the way, than the paintings of Manet and the Impressionists which are today mostly discussed as the key instances of bourgeois art in the latter nineteenth century.[51] It would be misleading to assume that the middle-class urban audiences for rural art were fooled into believing the painted myth. Artists' writings, as discussed in this and the previous chapter, were circulated as part of the promotion of artistic village communities and were widely read. Middle-class audiences also read novels and the national press, and were no doubt fully aware of the much-debated problems regarding the depopulation of the land and other agrarian crises. Juxtaposing texts and images results neither in reality replacing the myth nor in the myth suppressing reality. It is rather a case of two different registers.

The point about two registers, the textual and the visual, may best be elaborated by a close look at the article by American artist George Henry Boughton describing his exploits travelling through the Netherlands in the early 1880s. Here is one anecdote from Volendam, suggesting the extent to which locals could cater to the appetite of artists:

We soon came to a narrow bridge over a small but powerful canal, which our chariot could not pass ... Just then, as we alighted, came to us a fussy little man, who asked Jacob [the artists' Dutch guide] if we were artists, and would we like to see inside one

of the houses? perhaps also we might like to buy some costumes. Bless the man! what *else* had we come for? – and he to guess our dearest wishes! He led the way to his own house, followed by us and half of the entire population. Although we came at a critical moment upon his good vrouw – she was 'tubbing' the two babies – she received us kindly. The children howled at first, but soon got reconciled to us, and we to them, innocent of costume as they were. The husband stated our wishes, and out of the great wooden *garderobe* came stores of Sunday-best and every-day attire. There arose questions of how certain garments were got on or into. Madame would oblige us by showing us then and there – assisted by her excited husband with such vigor and zeal that the poor woman was in danger several times of coming unhooked and untied too suddenly for strict decency. She was obliged to check him at one time with a sounding whack on the ear, much to the delight of the wildly grinning and chattering crowd at the doors and windows. We wanted a young man's dress complete, silver buttons and all. In a jiffy his eldest son was sent for, and was disrobed and disbuttoned before he knew what had happened to him. He soon came in with the things neatly done up in a bundle all ready for us.

During all this time everybody, including the outside crowd, talked and screamed at the tops of their lungs … It was deafening and hot and exciting, but when it came to settling up – the prices, by-the-way, were reasonable enough – there seemed to arise a very howl of enthusiasm. The bundles were neatly pinned up in gorgeous cotton handkerchiefs.[52]

The episode resounds with touristic excitement at having penetrated a back region of the host society. Boughton and his friend did not only gain a glimpse of what they understood to be genuine local life but also came away with a material souvenir of the experience – moreover, a souvenir which was literally the shirt off a native's back and thus 'authentic' beyond a doubt. This encounter between artists and locals is also telling in another respect: it is an encounter structured around commercial exchange, and this kind of exchange is typical of a great many, if not quite all, encounters between artists and natives.

When artists painted rural life they painted the back regions as if they had revealed themselves to their gaze without changing into a staged performance in any way. In other words, the type of *encounter*, with its mutual accommodations, misunderstandings and chaotic performances on both sides, as described in Boughton's text, was never painted. This is not to claim that the artist's experience was actually as chaotic as described in his words, and that the painted representations distort this 'reality'. Rather, different conventions existed for the anecdotal textual recounting of experiences and for the picturing of rural folk for exhibition purposes. The crying babies and cacophonous crowds suit the narrative codes of Boughton's prose text. The illustrations accompanying his series of articles, purportedly based on sketches done on the spot by Boughton himself or his travel companion Edwin Abbey, show no such unruliness, nor do they divulge any of the negotiations between artists and locals in order to obtain the costume and models represented. Immediately adjacent to the above anecdote is reproduced *An Idyl – Island of Walcheren*, showing three fully-costumed and clog-shod natives in the

context of a light-hearted flirtatious anecdote (figure 21). Text and pictures convey two slightly contradictory, but ultimately mutually reinforcing messages: the pictures present the countryside as if outsiders never came there; the text is all about the meetings of outsiders with natives. Both, however, imply that rural life itself goes on unchanged. The text foregrounds the artist's privileged access to this unchanging life which, in turn, 'authenticates' the artist's pictorial productions.

Audiences could hold both 'realities', textual and visual, in their minds and allow the contradictions between them to coexist. This has to do with the role of art in late nineteenth-century Europe. Contradictions, crises, problems and boisterous chaos could filter through and be aired in the channels of the press and other publications but painting was located in another register, that of 'High Art'. It was enclosed in a kind of cultural bubble. By the end of the century, the notion of social, economic or political urgency had all but been expunged from the concept of High Art whose function for the bourgeoisie was to confirm, affirm and celebrate their own cultural identity and aesthetic expertise. Painted peasants were a projection

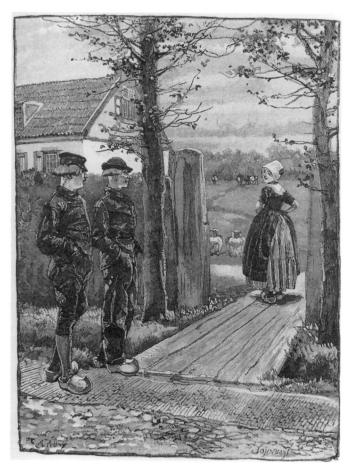

21 Edwin Houston Abbey, *An Idyl – Island of Walcheren, c.* 1883, engraving by Johnson, 1883

screen for the bourgeoisie's wishes, dreams and reveries. Art, and in particular art showing traditional rural life, served a compensatory purpose and provided a refuge in a rapidly modernising world with its attendant anxieties.

Furthermore, the writings of artists were, perhaps, after all not so radically different from their paintings and drawings. First, instances of confrontation and confusion constitute a relatively small sample of the writing overall (most of which conforms more to Bantzer's eulogy to the Willingshausen hero–peasant, quoted above, pp. 48–9). If texts do thematise the collision of two different classes, they do so in the humorous anecdotal mode (Boughton's cosume episode) that served to take the edge off potentially awkward scenarios in both print and paint. Second, talking about rural folk as dirty, bigoted or silly does not in itself counteract urban bourgeois ideas of the countryside in the slightest. These, too, are familiar stereotypes of the peasant, this time not in the guise of well-behaved ideal but as country bumpkin, village idiot or provincial buffoon. It is the very contradictions within the overall stereotype that kept the painting of peasant subjects vital for so many decades. However, taken together, the several seemingly conflicting views of villagers all fed into a unified discourse about agrarian or fishing communities, presenting an image of the rural population as benign, apolitical and safely pre-industrial. What was really missing from the picture was something else.

The real 'other' of the painted peasant was not so much the bourgeois as the urban industrial worker: the proletarian. A French visitor to Volendam contrasted the Volendamers, poor yet happy and healthy (figures 10, 11) with city workers who succumb to alcohol, lust, and the lure of senseless consumerism.

> Aan die hardwerkende lieden, moedig en sterk, wier leven ruw is, maar vrij van de onrust en losbandigheid van onze grote steden! In die eenvoudige hutten heerst oprechte vreugde; de tevredenheid, een stralende gezondheid tekenen hun gezonde gezichten. Elders rondom die weelderige paleizen, waar de industrie een overvloed en mateloze luxe heeft geschapen, toont de drankzucht de diepe ellende en de verpaupering van de menigte arbeiders! Hièr het geluk; daàr de tegenspoed en de ontucht! Kan men niet met recht zeggen: Inwoners van Volendum, u bent prinsen, koningen, vergeleken met die ongelukkigen, wier aantal zonder ophouden groeit in onze moderne maatschappij.[53]

> (To the hard-working people, brave and strong, whose life is rough but free of the restlessness and unruliness of our large cities! There is sincere joy in those simple huts; contentedness, glowing health mark their healthy faces. Elsewhere, all around the luxurious palaces where industry has created abundance and excessive luxury, alcoholism shows the deep misery and pauperisation of the crowd of labourers! Here there is happiness; there misfortune and indecency! Can't one say rightly: Inhabitants of Volendam, you are princes, kings, compared to the unfortunates whose number grows incessantly in our modern society.)

Fisherfolk and peasants were safely located in the countryside where they belonged – an observation rendered all the more pertinent by the concurrent mass

flight of peasants from agricultural to industrial employment which seemed to be decimating rural communities across northern and central Europe. It is interesting to note that on the rare occasions when nineteenth-century painters did represent industrial labourers (never within artists' colonies), they tended to call on conventions familiar from peasant paintings to articulate their subjects.[54] Peasants and fisherfolk had a secure position within a traditional world order into which the late nineteenth-century proletarian could not be incorporated. The former presented themselves to the nineteenth-century imagination as individuals or in small groups who could appeal to the observer as the protagonists of personal struggles with adversity, or in romantic or humorous narratives. The sometime Willingshausen painter Ludwig Knaus praised German (peasant) genre painting because it showed an interest in individuals, 'where people speak and act and have intimate relations with each other'.[55] The proletariat, by contrast, was perceived as an impersonalized, undifferentiated mass. 'As one cycles along the road on the way to Mons', an English travel writer in Belgium observed,

> one meets at sundown the stunted generation of miners flowing in their hundreds and thousands out of the colliery gates, dull with fatigue and often bemused with the effects of the *schnick* they have been drinking all day.[56]

Village communities were seen to embody the interpersonal warmth and support of traditional societies, untainted by modern class divisions and alienated labour relations. They also represented the type of community artists themselves were seeking to enact when settling in the countryside, as described in chapter 1. In conclusion, it is worth noting that it was the artists' communities themselves that encapsulated the (urban) ideal of unalienated relations, much more so than the actual indigenous village communities.

3

Patrons and publicans

Rural artists' colonies did not consist only of artists. Indeed, artists' communities could not have survived without the substantial contribution of local inhabitants. Locals interacted with the colonial enterprise in three main ways. First and most obviously, they provided the subject matter for paintings, as we saw in the previous chapter. Second, to continue as a viable artists' community, a village needed to provide an infrastructure to serve the artistic population. To list some examples: when the first painters descended on Pont-Aven, the village had three *aubergistes* and one *maître d'hotel*; twenty years and hundreds of artists later, provision had expanded to three hotels, one pension, one *Café des Arts* as well as forty-two *débitants* or licensed venues.[1] In the 1870s, Barbizon was visited on a weekly basis by 'Desprez, the colourman from Fontainebleau', who supplied paints and canvas.[2] In the mid-1890s, artists in St Ives could buy colours from a store in the high street whose proprietor, James Lanham, also exhibited their pictures in a gallery above his shop.[3] In Egmond, the local bookshop stocked 'schildersbenoodigheden uit de fabriek van Dr. Fr. Schoenfeld & Co, te Düsseldorf' (painters' necessities from Schoenfeld's factory in Düsseldorf).[4] In addition, there were various ancillary helpers, such as procurers of paints, artists' equipment, costumes and props, lessors of property and animal models, and finally, children to carry artists' bulky outdoor sketching apparatus and to busy themselves as brush washers, boot cleaners and, intriguingly, as 'model holders'.[5] The supply of economic and professional essentials was absolutely vital for the establishment and continuing success of a rural artists' colony.

Finally, local residents were central in the processes that transformed their villages in the wake of the artists' arrival. Far from being simply the passive instruments of artistic will (as models) or the country yokels bemused by the activities of sophisticated urban painters (as described by artists in written anecdotes), villagers took an active part in the modernisation and re-shaping of their home communities. Food was provided, lodgings rented out, models procured and studios purpose-built. By 1900, most of the villages discussed in this book harboured several hotels, pubs, studios, exhibition venues and shops selling artists' supplies; many had developed tourist facilities, including footpaths, benches, signposts, bathing huts, boats for hire and postcards for sale. In sum, by the turn of the century most of these villages had ceased to be the timeless, pre-modern enclaves of peasant or fisherfolk mores that dominated artists' representations.

Local entrepreneurship – in which innkeepers often played a prominent role – provided the infrastructure necessary not only for artists' colonies' survival but also for subsequent tourist exploitation. Natives were frequently at odds with the artists: although artists needed the services provided, they were rarely happy with the touristification of their villages and wished to preserve the pre-industrial character of their location. For example, as Ahrenshoop turned into a popular seaside resort, the painters campaigned (unsuccessfully) for local ordinance regulations, prohibiting the construction of multi-storeyed houses, wire fences and roofs made of modern materials.[6] It is precisely the development of villages as tourist destinations that ultimately marks them out as unmistakably modern. While some European rural locations became industrialised agrarian centres and others turned into suburban outposts of cities, artists' villages in particular tended to turn themselves into prime sites of nostalgic modernity. In their attempt to freeze modernisation and preserve local life as a pre-industrial relic (in paint but on occasion in deed as well), artists were unwittingly participating in precisely that brand of modernisation associated with preserving the past: touristic romanticism. As this chapter will demonstrate, local residents were key players in this process.

Before I go on to examine the interactions between locals and artists in further detail, I want to cast a brief look over the attitude of villagers to art in general. Locals rarely produced art themselves, or at least not the type of art exhibited by colonists. They were not part of that circuit of bourgeois imagining discussed in chapter 2 – although this claim will need to be qualified presently. However, some of the villages had their own circuits of aesthetic production and consumption that were in place prior to the arrival of artists. In some cases, original paintings were owned by villagers, especially seafaring folk who had brought them back as souvenirs from abroad. In St Ives, nearly every house of any size apparently contained a painting with a Neapolitan subject, preferably a picture of the erupting Vesuvius. These were cultural by-products of the lively local pilchard trade with Italy. One well-to-do captain owned a painting depicting the ducal palace of Venice in flames that he prized highly.[7] On the other side of the Cornwall peninsula, Laura Knight was approached in 1917 by a fisherman from Mousehole (near Newlyn), a Mr Pentreath, who offered to lend her a picture he had in his home for copying; he had specially had the frame mended so that the picture was now worth 'as much as £2'; it depicted the Infant Jesus and the Infant Samuel, 'naked but girt about the loins'.[8] Captains' cottages in Ahrenshoop contained works of craft and art, including fayence, glassware, ceramics painted with shipping motifs, and as *objets de résistance*, a pair of English stoneware 'fireplace dogs'. Another highlight in an Ahrenshoop home was the *Kapitänsbild* or captain's picture, an oil painting commissioned by the captain and depicting the ship under his command in front of a picturesque background, often evocative of the foreign countries he had visited. These *Kapitänsbilder* were part of a specific signifying process when hung in cottagers' hallways: when the captain was at sea the depicted ship pointed outwards, towards the door; upon his return, the picture was moved to the opposite wall so that the ship now pointed inwards (figure 22).[9]

22 F. Wettering, *Captain's Picture: The Barque Peter Suppicich* (Ahrenshoop), 1877

Such tantalising glimpses into local art-use are all too rare but they do reveal one thing, that local village art worlds had little to do with the art worlds imported from urban contexts by artist-colonists. Conversely, artists almost never seem to have taken their inspiration from contemporary local visual manifestations. The afore-mentioned Mr Pentreath's profound misunderstanding of what preoccupied his artist neighbours points to the gulf which probably existed in most communities between the villagers' idea of what consituted art and artist-colonists' practice and priorities.

There are a number of reports of similar misunderstandings in artists' writings, told in the familiar form of anecdotes. For example, Stanhope Forbes told an inter-viewer how his study for *The Smithy* (1892) was used for many years as a fire-screen in a labourer's cottage.[10] Jean-Georges Gassies recalled how a well-to-do Barbizon farmer known as Père Bellon observed the artist painting a chimneystack on one of Bellon's own cottages and advised him: 'Celle-là, ce n'est pas la peine de la faire, elle fume trop, on ne s'en sert jamais.'[11] (That one there isn't worth painting, it smokes too much, we never use it.) The villager Anne-Kathring Oppermann who posed for the foremost woman on the right in Carl Bantzer's *Communion in a Village Church in Hesse* (figure 23), allegedly exclaimed in broad dialect:

> Herr Bantzer, wann ich Ihne so zuguck beim Male un seh', wie veelmol Sie da den Arm ruff un runner mache, da muß ich sage, Sie hon doch e schweres Handwerk, aber das kann ich Ihne spreche, so schlimm wie gedrosche is es als noch nit![12]

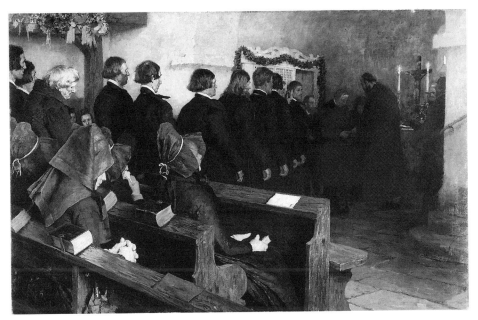

23 Carl Bantzer, *Communion in a Village Church in Hesse* (Willingshausen), 1890–92, 160 x 249 cm

(Mr Bantzer, when I watch you paint and see how many times you move your arm up and down, then I must say, yours is a laborious craft, but I can tell you one thing, it's still not half as bad as threshing!)

For this villager, the work of painting consisted in no more than the actual manual labour of moving the arm which she compared to a type of labour familiar to herself, measuring both tasks with an agricultural worker's yardstick of physical exertion.

These anecdotes can be read in several ways. On the one hand, they may well reveal something of the puzzlement experienced by countryfolk when confronted with the professional activities of fine artists from a different cultural milieu. On the other hand, these are tales told not by locals but by painters, and they feed all too neatly into the urban discourse of agrarian romanticism. All firmly anchor the native person, whether in the guise of yokel or charming naive, in the rural environment, and villagers' inability to understand High Art on its proper level testifies to their alleged distinctness from the bourgeoisie and to their own incurable rusticity. And, of course, the anecdotes confirm once again the teller's (that is, the artist's) privileged access to the 'authentic' life of countryfolk. Gassies' chimneystack story, in particular, has the flavour of one of Kris and Kurz's oft-recycled 'typical anecdotes' (see chapter 1), and indeed, crops up in different guises in various texts.[13] A variant of the chimneystack tale is the anecdote told by Fritz Mackensen of how he approached a man sowing seeds in a field near Worpswede and entreated him to look at the

wonderful landscape all around. The man looked at Mackensen 'as if encountering a madman' and answered in dialect: 'Düsse Nach früßt et'.[14] (There'll be frost tonight.) Both stories establish the prosaic functionalism of the 'peasant' in the face of aesthetic experiences and reaffirm the bourgeoisie as the privileged and only class with the key to true cultural knowledge and sensibilities.

Artists' anecdotes notwithstanding, there were, in fact, significant portions of the native population who did gain access to the bourgeois circuits of cultural production. As noted in the previous chapter, indigenous village communities were much more varied and stratified than the categories of 'peasant' or 'fisherfolk' admit. All harboured at least some members of a rural bourgeoisie (teachers, clerics, merchants and so forth). It was the professional class of village innkeeper who proved to be the most energetic and resourceful supporters of artists within the local community, and in many cases evolved into regular patrons and even dealers of art, constituting a new kind of nineteenth-century Maecenas.

In the overwhelming majority of artists' villages, one or more local inns played a crucial role in enticing artists thither and in keeping them coming back.[15] A large number of innkeepers allowed artists to decorate their inns' dining rooms or parlours with murals and paintings on the furnishings (figure 24).[16] Hoteliers also

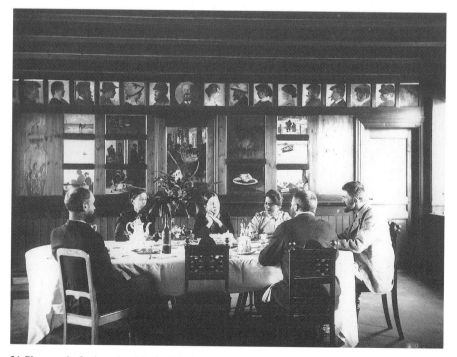

24 Photograph of artists at lunch in the dining room of Brøndum's inn, Skagen, *c.* 1890; from left to right: Degn Brøndum, Hulda Brøndum (Anna Ancher's sister), Anna Ancher, Marie Krøyer, Michael Ancher (from rear), Peder Severin Krøyer

frequently extended generous credit to artists, in many cases accepting paintings in lieu of cash payment.[17] This generosity was not a purely magnanimous gesture on the part of the innkeepers, but also a shrewd business move which proved entirely successful in luring further lodgers to their inns. Gauguin, for example, came to Pont-Aven partly because of the credit facilities he had apparently been told about by the painter Felix Jobbé-Duval.[18]

It should be noted, though, that in many cases innkeepers' patronage exceeded purely financial interest: hoteliers often became personal friends with artists, and several innkeepers and innkeepers' daughters married painters.[19] In effect, what publicans received in return for their generosity and commitment to the artistic enterprise was access to the bourgeois social sphere of their guests. This not only contributed to a concomitant rise in their status within the village but was also an affirmation of their own sense of bourgeois identity. In this sense, many rural publicans were patrons not only on a material level but also in the sense of an engagement with art as cultural capital. Let me elaborate on these points with respect to three case studies, two Dutch, one Danish.

Jan Hamdorff, born in Laren in 1860 as the eldest son of a cartwright and an innkeeper, inherited from his mother the proprietorship of the ex-postchaise stop, *De Vergulde Postwagen* (The Gilded Stagecoach), located on Laren's central square.[20] In 1882, the steam tram line between Hilversum and Laren opened, connecting the village to Amsterdam. Hamdorff's inn, graced by a new sign painted by the artist Frans Langeveld, became the village's tram station. Hamdorff was quick to realise the benefits of lodging artists, reputedly serving them free drinks in the hope that their presence would attract other curious folk and make his inn widely known. The innkeeper also accepted paintings and drawings as payment, bought property which he converted into studios, arranged for models, and helped artists find buyers for their work, pocketing a commission. From 1891, Hamdorff put on annual exhibitions of paintings in his hotel. Wally Moes recalled that all members of the Hamdorff family had a preference for artists and that painters were served meals at a special table.[21] By 1893, the inn was described by one artist as 'the pulse of the place' whose east room was reserved for painters, set apart from the public bar, *Het kroegje*, which catered to villagers.[22]

Over the years, Hamdorff's hotel business expanded, boosted by its artistic associations, just as the hotelier had hoped. The enterprising villager built two more hotels as well as several luxurious annexes to what was by now called *Hotel Hamdorff*.[23] He also bought land cheaply from peasants and resold it to the wealthy Amsterdamers who had begun to flock to Laren and to build villas there.

The innkeeper's patronage of Laren artists paid off. Around 1900, Hamdorff took a painting by Albert Neuhuys to London, intending to sell it for 500 guilders; he managed to get almost ten times that amount, and prices for Neuhuys' paintings continued to spiral upward.[24] The art exhibitions held in the hotel and accompanied by music, dancing and the sale of alcohol proved to be more successful than those of a professional gallery, set up in Laren by a dealer from

Amsterdam in 1905: its proprietor closed his business in 1917, full of resentment for his village rival.[25]

Jan Hamdorff was also active in local politics, serving as district councillor from 1896 to 1922 in which capacity he was largely responsible for the installation in Laren of street lighting, road paving, a sewage system and a garbage disposal system – modernising improvements which no doubt attracted further tourists and villa buyers but met with dismay from some of the very artists Hamdorff championed.[26] On his death in 1931, the innkeeper was lauded in the local newspaper as the man who had been intimately connected with Laren as a 'world-famous painters' centre'.[27]

Two aspects of Jan Hamdorff's patronage deserve to be noted. First, his activities had a significant wider impact on Laren as a whole. The advent of artists, tourists and metropolitan villa builders transformed the village irreversibly, and Hamdorff was a principal agent in all three processes. His work for the improvement of the local infrastructure made him into a provincial reformer and moderniser of a kind no doubt found in rural regions all over Europe – just the kind of personage suppressed almost completely from the paintings of rural colonists. Second, Hamdorff allied himself not only to local economic and material improvements but, significantly, also to the artistic community itself. As one visitor observed in 1903, the hotel-owner liked to dine with his painter-guests, presiding over the company 'like King Arthur among his knights of the Holy Grail' and participating with energy in the 'high jinks and jokes' of the occasion.[28] Jan Hamdorff was central to both the artists' colony *and* the local community of Laren, and his case exemplifies the new hybrid kind of art world that could develop in an artists' village.

The meteoric career of Hamdorff's colleague Leendert Spaander in Volendam was even more extraordinarily bound up with the careers of his artist-lodgers.[29] Leendert Spaander (1855–1955 [*sic*]) was the son of a ropemaker. After some years spent shipping cargo to Amsterdam, Spaander and his wife Aaltje Spaander-Kout bought a Volendam coffeehouse in 1881, which they furnished with an extra storey and turned into a small hotel. Their lodgers in the first couple of decades were nearly all English artists. Very few of them actually settled in Volendam, which meant that almost all stayed at Hotel Spaander which in 1907 was still the only inn in the village and an increasingly successful business. The hotelier did more than just provide beds and meals. He built a number of studios in and near his hotel, arranged for models and regulated models' tariffs. In his hotel, he also fitted out several rooms as Volendam cottage interiors for the use of artists.[30] A sign, hand-painted by Carl Windels, proclaimed the hotel's friendly welcome to artists: 'Artist kom binne' (Artist, come in) (figure 25). Around 1895, Spaander organised a remarkable publicity coup for his hotel when he travelled to the opening of a London art exhibition by one of his lodgers, Nico Jungman, accompanied by two of his daughters who walked around the exhibition in Volendam costume, apparently attracting considerable attention (figure 26). The energetic hotel-manager also arranged for the printing of picture postcards featuring reproductions of Volendam

25 Carl Windels, *Artist, Come In* (Volendam), date unknown

26 Photograph of Leendert Spaander (left) with two of his daughters and artist Nico Jungman at an exhibition opening in London, 1897

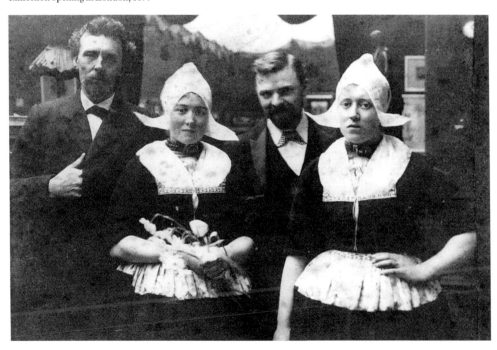

paintings as well as views of the village and, of course, of his hotel; these he sent to art academies abroad. Of the Spaanders' nine children, three married painters.

Spaander's close involvement with and patronage of artists proved excellent for business: the Hotel Spaander is still going strong today, boasting over 82 rooms with 175 beds, a restaurant, a bar, and several large dining halls capable of dealing with the busloads of tourists who visit Volendam on day-trips. Every available inch of free wall space in the hotel's public rooms is decorated with paintings and sketches dating from the 1880s to the 1930s, done directly on the wooden panelling or given to Spaander as thank-you gifts or as payment of hotel debts.[31] Leendert Spaander himself shrewdly summed up his business attitude in 1952:

> Schilders, dat betekende doeken met het dorp erop. Met Volendammers erop. Die schilderijen zouden op tentoonstellingen komen hangen en de ogen openkrabben van mensen, die dat dorp met die inwoners in dat wonderlijke costuum wilden zien.[32]

> (Painters, that meant canvases with the village on them. With Volendamers on them. These paintings were destined to hang in exhibitions and to open the eyes of people who wanted to see the village with its inhabitants and its wondrous costume.)

As far as Spaander was concerned, every painting by one of his lodgers, exhibited in any city of the world, was a free advertisement for his hotel.

It needs to be noted that neither Hamdorff nor Spaander was a 'typical' villager. Interestingly, both of these entrepreneurial innkeepers were not old-established natives of their villages, and in various ways, they both did not completely 'fit in' with the village community. Leendert Spaander was not a born Volendamer but had moved there from Nieuwendam, albeit at a young age, and he married outside the village. The Spaanders were Protestants in the Catholic village of Volendam.[33] Jan Hamdorff was born in Laren but his grandfather had migrated to the village from Westphalia, and, like Spaanders, he was a Protestant in a Catholic village and attended church outside the local parish, in nearby Eemnes. In the small rural community of Laren where intermarriage between the two Christian creeds was unheard of and details in regional costume marked wearers out as one or the other, an awareness of his own outsider status no doubt entered into Hamdorff's sense of affiliation with other outsiders, namely artists.[34] Both innkeepers' mindfulness of a world beyond the village and alternative patterns of living may have enabled them to regard their co-villagers with a certain degree of detachment and to respond with empathy to artists' needs for costumed models, 'authentic' cottages and so forth. The arrival of artists and tourists allowed Hamdorff and Spaander to side-step the confines of the provincial social circle, improve their social and economic status and change the village in the process. Such an enterprise may well have seemed more enticing to someone who was a bit of an outsider than to someone firmly entrenched within village hierarchies.

My final case study concerns Brøndum's inn in Skagen, Denmark. Erik Brøndum (1820–90) and his wife, the millwright's daughter Ane Hedvig *née*

Møller (1826–1916), ran a grocery store in Skagen which also functioned as the local pub and lodging house. Brøndum also let rooms to lodgers.[35] Like the Hamdorffs and Spaanders in the Netherlands, the family was not completely rooted in the village, Ane Hedvig Brøndum's father, the millwright and later town councillor Søren Pedersen Møller (1801–76), having moved to Skagen from southern Jutland in 1823. What was remarkable about the Brøndums was the extent to which they became personally involved with the art and artists of Skagen. The couple had six children, including Degn (1856–1932) who took over the inn from his father and became a close personal friend of many of the artists, and Anna (1859–1935) who in 1880 married the painter Michael Ancher, a lodger at her parents' hotel. Anna Brøndum was not the only European innkeeper's daughter to marry an artist but she was the only one to become an artist herself. Her two cousins, Martha and Henrietta Møller, also trained as painters and married Skagen artists.[36] By the mid-1880s, every member of the Brøndum–Møller family was either married or related in some way to a painter. When Degn Brøndum bequeathed his hotel dining room to the Skagen Museum in 1908, the walls of this room were fitted with over eighty panels painted by more than a dozen different artists (figure 24).

The Brøndums, too, were not driven primarily by financial motives when encouraging artists to stay at their inn. They were probably as keen to keep artists returning to Skagen for the culture as for the money they brought. An early visitor to the fishing village, the writer Hans Christian Andersen, remembered the innkeeper Erik Brøndum (Degn's and Anna's father) as someone who enjoyed socialising and conversing with his guests.[37] Ane Hedvig Brøndum's brother, Laurits Møller, a farmer, was considered by his family to be unsuited to the farming life; he apparently liked to spend his time reading, writing, drawing, doing arithmetic and playing the violin, often in the company of his father, Søren Pedersen Møller (the man who had moved to Skagen in 1823).[38] Anna Ancher certainly felt superior to the fishing population of her birthplace: in a letter of 1882, she wrote that it was 'so agreeable for once to move away from the ordinary fisherfolk and to deal with civilised people'.[39] The Brøndum–Møller family was upwardly mobile: the millwrights and shopkeepers of Søren Pedersen Møller's generation became the parents and parents-in-law of company owners, textile merchants, school teachers, painters, art critics and of Denmark's first political scientist.[40] Befriending, marrying and championing artists was clearly an integral part of the family's overall *embourgeoisement*.

The Brøndums, Hamdorffs, Spaanders and their many colleagues in artists' villages across Europe were neither rural aristocrats nor were they old-established wealthy farmers with extensive land and livestock holdings. Instead, these innkeepers and other rural art patrons occupied a pivotal position at a tangent to traditional village hierarchies and, indeed, were instrumental in overcoming the old social structures altogether and in inaugurating modern commercial forms of capitalist organisation, based on tourism.

Local entrepreneurs' efforts at improving the infrastructure were primarily directed at outsiders coming into the village, that is, urban tourists. In catering to artists' interests, these locals were also to some extent buying into the urban discourses of agrarian romanticism. However, here too, village art patrons took on an ambivalent role: on the one hand, the procurement of models, the construction of specially fitted-up 'local' interiors, the parading of innkeepers' daughters in regional costume and so forth were designed to feed the urban visitors' nostalgia for a pre-industrial rusticity. On the other hand, the very efforts needed to stage this nostalgia exposed its performative character, thereby undermining its claim to authenticity. The discovery of a performance could be experienced as downright trickery, as evidenced by Phil May's story of Volendam:

> I saw a little girl in a doorway, the first day after my arrival, and she was standing knitting; the whole thing was very pretty – the composition perfect. I made her understand that I wanted her to stay as she was while I made a rapid sketch. I was very pleased with the result, until I got back to the hotel and found that every artist who had ever visited Volendam … had painted that same child, had been caught by the knowing kiddie in the same way as I had.[41]

Birge Harrison's anecdote about the cunning peasant with his scythe (reported in chapter 2) also needs to be read in this context. In Laren, shrewd villagers systematically exploited artists' thirst for seeing back-regions, as observed by Laura Knight in 1904:

> It was the custom to rent a place for 5 Gulden a week. This gave you the privilege of invading the privacy of any part of a house. You could just walk into any room and set up your easel, even if it were to paint a sick person lying in a cupboard-bed.
> Any peasant belonging to the farm would pose for you, if they were not busy; one woman made it her main occupation. To have painters working in the house was usual. You were part of the household, no more encumbrance than the animals, actually wanted as contribution to the yearly income.[42]

In this type of primarily visual involvement with rural natives, artists in villages resembled modern tourists. In his study of late twentieth-century tourism, the sociologist John Urry has characterised the 'tourist gaze' as predetermined by stereotypical expectations. Tourists see what they expect to see, and they choose places to gaze upon which answer to their anticipations.[43] Locals tended to play along with these expectations imposed from outside and often continued to perform their ethnicity for the artistic–touristic gaze.[44] One visitor to Brittany encountered women who wore costume 'for the especial benefit of travellers' in the late 1870s, and Willingshausen artists organising a festive procession for a non-rural audience in 1895 paid the locals to participate in this staged costume spectacle.[45]

Local entrepreneurial activities inevitably revolved around financial transactions and, by reordering local economies, were in themselves responsible for the modernisation of agrarian life. In sum, the staging of agrarian romanticism *in situ*

could ultimately unravel the belief in its authentic existence, at least for some. Paul Signac visited Pont-Aven in 1891 and sneered: 'It's ridiculous countryside with little nooks and cascades, as if made for female English watercolourists. ... Everywhere painters in velvet garments, drunk and bawdy. The tobacco merchant has a sign in the form of a palette: "Artist's Materials" [in English], the maidservants in the inns wear arty ribbons in their headdresses and probably are syphilitic.'[46] Laura Knight condescendingly noted that Volendam around 1905 was 'a showplace full of beggars and peasants dressed up specially for tourists to look at ... everywhere we looked there was someone sketching a picturesque bit'.[47] This was the paradox of rural modernisation in terms of the tourism of nostalgia. Artificially preserving and staging the agrarian myth for outsiders fuelled the influx of bourgeois visitors but at the same time sounded the death knell for whatever remnants of agrarian life there were left in the place. It should be remembered that this by no means troubled everybody. Signac, Knight and others may have been appalled but the visitors kept coming and the myth kept flourishing, as we shall see in part IV.

PART III

ARTISTS IN NATURE

Artists in rural locations interacted with their environment primarily by painting and sketching it. They generally did so out of doors, and the resultant images nearly always represented an aspect of the local topography, with or without local inhabitants. The activity of drawing and painting in the open air formed the backbone of artistic practice in rural artists' communities, and, as we have seen in chapter 1, artists went out into field or forest practically every day, weather permitting. It is worth stressing that the constant contact artists had with the natural environment arose not only out of a desire to paint it but also out of a desire simply to be 'in nature'. As we shall see, the experience of being immersed in the sights and sounds of 'nature' was central to the artist-colonial project. Plein-air work and experiencing nature at first hand were mutually reinforcing: being outside gave meaning to the artists' work, and sketching from nature gave a purpose to the experience of being in it.

The practice of plein-air painting was, of course, neither invented in nor confined to nineteenth-century artists' colonies. European artists and art students had been journeying into the countryside on sketching excursions at least since the late eighteenth century.[1] By the middle of the nineteenth century, the casually attired sketcher seated in a field before his easel had become the paradigmatic figure of the artist, depicted and caricatured in numerous popular illustrations, and more prevalent even than his Bohemian counterpart shivering in a garret.[2] But artists' colonies were more than the sub-set of a wider trend. They developed their own brand of plein-air practice that in turn exerted a powerful pull on open-air painting in general. The impossibility of obtaining reliable and pan-European statistics means that one can only speculate whether, in the late nineteenth century, more painters worked out-of-doors in the context of an artists' colony than singly. Still, the large numbers of artists active in colonies, the popularity of the kinds of painting they produced and the attention they received in the printed media suggest that rural artists' colonies lay at the heart of the nineteenth-century plein-air painting boom.

This claim may come as a surprise to those who are used to associating nineteenth-century outdoor painting primarily with the Impressionists.[3] Interestingly, the first open-air attempts by some of the future Impressionists were carried out in the artists' villages of Chailly and Marlotte.[4] Pursuing this line of enquiry lies outside the scope of this book; suffice it to note that Impressionist plein-air practice may well have developed out of contact with and knowledge of patterns of work established in rural artists' communities.

The notion that artists painting in the countryside were engaged in a rediscovery of nature is a commonplace in much of the writing on artists' colonies.[5] My aim in this part is to break open the seemingly self-evident character of the notion of 'nature' in order to arrive at a more differentiated understanding of the meanings that the concept held for nineteenth-century rural artists (in particular those working in colonies) and for their urban audiences.

It is no coincidence that the informal supportive collectives of artists' colonies were formed in rural settings. For artist-colonists, as for all urban visitors, the countryside was synonymous with nature, and, by the middle of the nineteenth

century, 'nature' had come to be associated with just the kind of unconstrained and nurturing environment which artists tried to erect and sustain in these small groups. The setting (nature) and the social formation (group based on friendship) reinforced each other, each ingredient strengthening the individual's sense of sub-jecthood. Opening the investigation out from the sociological focus of the previous chapters, this part closely examines paintings produced in artists' communities, taking into account the works' technical and formal components as well as their conditions of production and their significance as key instances of modern metro-politan sensibilities.

What was significant for the concept of nature within the rural artistic project was the way the non-built environment around a village was understood to work upon human subjectivity and on the very foundations of artistic production. For Will Hicok Low, work in the natural environment was 'continuous and sincere' in a way that studio work was not.[6] Otto Modersohn wrote in Worpswede in 1895: 'In der Natur liegt das große Urgesetz, aus dem der Künstler schöpft.'[7] (In nature lies the great elemental law out of which the artist creates.) It is this view of nature as the ultimate source for creativity that underlay the need felt by artists to live all year round in the countryside, so as to absorb as much of 'nature's' essence as possible. Modersohn's choice of the word 'schöpfen' for 'creating' (rather than the more usual 'schaffen') is interesting in this context, for this German verb denotes both the act of creating and the act of scooping or drawing water (or breath). 'Schöpfen' sums up well the view of many nineteenth-century artists working 'in nature': that the process of producing art was both an operation of individual agency, of active *making* on the one hand, and an extraction of (painted) fragments from a larger totality, the totality of 'nature', on the other hand. This view foreshadowed twen-tieth-century conceptions of the artistic process as analogous to the reproductive processes of nature, especially when one takes into consideration the remainder of Modersohn's diary entry: 'Das Bild muß ähnlich entstehen wie die Natur selbst.'[8] (A picture has to come into being in the manner of nature herself.)

Artists working in rural colonies never themselves defined the term 'nature'. They felt no need to: it was a concept that was too embedded in nineteenth-century European (and North American) cultures to seem to require explanation or justifi-cation. Furthermore, an attempt on our part to affix a definitive dictionary meaning to the word would miss the point, as Raymond Williams has pointed out.[9] However, it would be equally misleading to abandon the analysis of the idea of 'nature' altogether and simply to follow in the footsteps of artist-colonists and accept 'nature' as a given. The latter course has been, unfortunately, the one most frequently followed by the majority of writers on rural artists' communities. With the notable exception of Nicholas Green, there is almost no text that tackles the meaning of rural nature for artists in colonies with any analytical rigour. The point is that although nineteenth-century artists and writers on art used the word 'nature' with a certain vagueness and as if it explained itself, the meanings they attributed to the concept were by no means arbitrary.

In the introduction to *The Spectacle of Nature*, Nicholas Green states that his book is 'about the ways the countryside was imagined and experienced in early nineteenth-century France, and the effective appropriation of the category *nature* to describe these sensations'.[10] Rather than presupposing a fixed reality called nature, the author employs Michel Foucault's theory of discourse to arrive at a historically, geographically and ideologically specific *construction* of 'nature'. Green argues that during the early decades of the nineteenth century a certain type of nature was discursively elaborated in France, a type he designates *natura naturans*.[11] This particular category of nature emerged as a subset of an urban Parisian vision in the 1830s and 1840s. *Natura naturans* is nature-as-countryside but it involved transforming the countryside from land to be worked on (by a farmer) or a piece of property to be managed (by an aristocratic owner) into a spectacle to be consumed visually by city-dwellers. The object of this consumption could take a variety of forms, such as printed and published views and travel prints, advertisements for country houses, panoramas and dioramas, the transplanting of bits of countryside into the city in the shape of public parks and gardens, train trips into the surroundings of Paris, and finally, nature paintings. Although this discourse of nature is all about the countryside, it emerged from new, modern and above all, metropolitan habits of viewing and consuming the city (of Paris). Nature was cast as a health-giving and refreshing tonic for the tired urbanite.

Green's argument is historically and geographically located in the years 1820 to 1850 in Paris and its environs. He devotes special sections to case studies of Barbizon and the forest of Fontainebleau but the bulk of his study predates much of the artistic activity in artists' colonies. However, Green's arguments can be extended very fruitfully to the latter half of the century as well as to other regions of France and Europe. My argument in the next chapters is indebted to Green's pioneering analysis and offers a confirmation but also an extension and refinement of its premises.

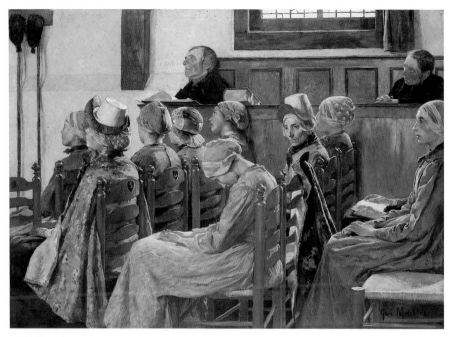

1 Gari Melchers,
The Sermon (Egmond), 1886,
156.5 x 216 cm

2 László Paál,
Path in the Forest of Fontainebleau
(Barbizon), 1876, 91.5 x 63 cm

3 Karl Nordström, *Forest Glade*
(Grèz), 1882, 114 x 92 cm

4 Hippolyte Boulenger, *Avenue of Old
Charms, Tervueren*, 1871–72, 130.5 x
93 cm

Forest interiors

The usual category for paintings of nature is that of landscape. However, many of the paintings produced in mid- to late nineteenth century rural artists' locations do not follow the traditional recipe for landscape composition. Instead, artists developed and elaborated new ways of representing nature that, in some instances, came close to negating the concept of landscape altogether. In this chapter, I propose the kind of painting known in French as *sous-bois* (forest interior, literally underwood or undergrowth) as a key instance of a new, nineteenth-century perception of and response to nature. *Sous-bois* paintings were an attempt to capture the multi-sensual (not just visual) character of the experience of nature, an experience that was predicated upon the human subject's immersion in the natural setting.

Landscape implies a vista, a panorama, a view onto a stretch of terrain, preferably bounded by a distant horizon line, and the inclusion of a relatively large proportion of sky; up until the middle of the nineteenth century, finished landscape compositions nearly always included some sort of staffage in the form of more or less tiny figures and animals.[1] Paul Flandrin's *Landscape: Souvenir of Provence* may serve as an example of a traditional landscape (figure 27). Flandrin has arranged the natural elements (trees, bushes, hills) into a composition that harks back to Claude Lorrain: there is a repoussoir shadow to lead the eye into the painting in the left foreground; the left and right trees act as framing devices; the central tree is another coulisse. Areas of foliage and sand alternate in a rhythmic pattern that leads the gaze progressively into and across the picture until it loses itself in the hazy distance.

A painting such as Ottilie Reylaender's *In the Birch Wood*, painted in Worpswede, is strikingly different (figure 28). Reylaender zooms in on the landscape; this is a nature close-up, with painter's and viewer's nose, as it were, thrust right into the mushrooms and grasses on the ground. The artist seems to have ducked into the undergrowth of the wood to obtain this image. It is a woodland interior rather than a landscape. Instead of a panorama with aerial perspective, we see a dense thicket of vegetation and brushmarks. Instead of a tree as a coulisse in the middle distance, we are confronted with the rough and juicy texture of birch bark in the immediate foreground. The figures are merged with their natural setting: the girl in the centre seated in the tall grass, and the two girls at right are only noticeable at second or third glance.

It is this kind of nature painting that is, I will argue, emblematic of the nature experience artists were seeking in rural artists' colonies. At the heart of the rural

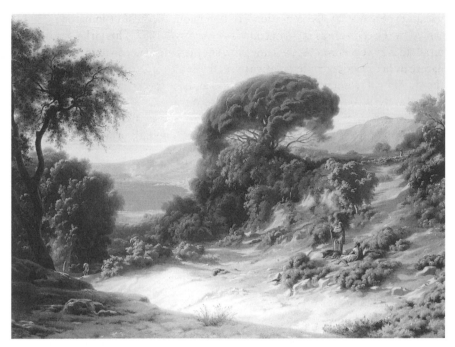

27 Paul Flandrin, *Landscape: Souvenir of Provence*, c. 1874, 90 x 118 cm

28 Ottilie Reylaender, *In the Birch Wood* (Worpswede), c. 1904, 52 x 72 cm

nature experience lay the sensation of immersion, the kind of immersion represented by the central girl in Reylaender's *In the Birch Wood*. This girl is surrounded on all sides by vegetation. At the same time, she thematises her own embeddedness in nature by her inactive, contemplative pose (the hand-to-chin gesture reminiscent of the traditional iconography of melancholy) and the fact that her gaze is directed inward at the wood, at the leaves or at what seems to be a sunlit spot of earth before her. This is more or less exactly what artists in the countryside expected to be doing there: plunging themselves into the undergrowth and absorbing the sights and sounds of their environment in receptive idleness.

The following passage may serve to illustrate the intense affective relationship artists could enjoy with the rural environment. It is part of the Belgian painter Gustave van de Woestijne's memoir of his first visit to Sint-Martens-Latem in 1899, in the company of his brother Karel:

> De zon deed me deugd en ik voelde me herleven. Ik deed mijn hoed af en liet mijn lang kroezelhaar in de stille wind waaien. Dan deed Karel hetzelfde en we zagen elkander eens vriendelijk aan. We waren alle twee gelukkig, misschien omdat we nu eens in de vrije lucht gingen leven, zonder enige bekommernis, tussen de eerlijke boeren in Gods schone natuur.[2]

> (The sun did me good, and I felt myself revive. I took off my hat and let my long curly hair blow in the breeze. Then Karel did the same, and we gazed at each other fondly. We were both of us happy, perhaps because we were now going to go and live in the open air, without any cares, among the honest peasants in God's beautiful nature.)

Woestijne's memoir encapsulates most of the elements relevant to the experience of late nineteenth-century urban visitors to the countryside: the doffing of city dress and, along with it, that of prescribed and constrictive modes of behaviour; a sense of freedom arising from being in the open air ('de vrije lucht' is literally: the free air); the sensuous character of that freedom (hair blowing in the breeze); the harmony between environment and personal relationships (the brothers exchanging affectionate looks); the apparent simplicity and sincerity of the local inhabitants; and finally, the subsumption of all of these sensations and experiences under the heading of 'nature'.

Artists and their friends in rural locations often wrote of painting outdoors in terms of this kind of experience of immersion in the natural world. The writer Robert Louis Stevenson's evocation of a summer's day in the forest of Fontainebleau conjures up the sensations of being *in* and surrounded *by* vegetation, sunshine and shadow (figure 29).

> Perhaps you may set yourself down in the bay between two spreading beech-roots with a book on your lap, and be awakened all of a sudden by a friend: 'I say, just keep where you are, will you? You make the jolliest motive.' And your reply: 'Well, I don't mind, if I may smoke.' And thereafter the hours go idly by. Your friend at the easel labours doggedly, a little way off, in the wide shadow of the tree; and yet farther, across a strait of glaring sunshine, you see another painter, encamped in the shadow of another tree, and up to his waist in the fern.[3]

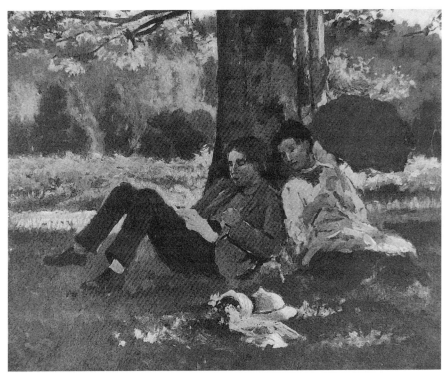

29 Will Hicok Low, *Robert Louis Stevenson in the Bas Bréau, Fontainebleau*, 1875, sketch from Will Hicok Low, *A Chronicle Of Friendships, 1873–1900*, 1908

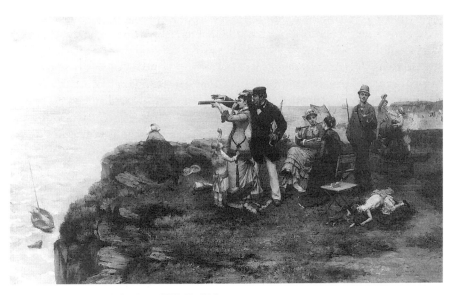

30 Pierre Outin, *The Look-Out Point*, 1878, 59 x 98.5 cm

Again, note the conjoining of immersion in nature and a relaxed, tactful convivi-
ality. Solitary enjoyment here seems to mesh perfectly with the reassurance of kin-
dred company and the sense of social belonging described in chapter 1.

Artists sitting or standing in high grass or, at times, even lying on the ground
adopted a very different viewing position from the traditional landscape viewpoint.
The latter was very often an *elevated* viewpoint, affording a commanding view of
large tracts of terrain and of the horizon. This was the viewpoint of the *vedutisti* or
view-painters of Rome and other painters of the classical landscape tradition. It was
also, and this is crucial, the viewpoint of nineteenth-century tourists. Guidebooks
like Baedeker or Joanne guided travellers to specially chosen look-out points (of the
kind which is still familiar to tourists of today), and enterprising resort managers
laid out paths along hillsides and carved out stairways in cliffs in order to facilitate
tourists' upward movement to reach 'the view' (compare figure 30).[4]

Painters in rural communities rejected both the older classical landscape tradition
and the contemporary tourist convention by climbing down from elevated vantage
points (or never bothering to climb them in the first place) and immersing themselves
in the close-up views of grasses and tree trunks. The experience afforded by such
immersion is most vividly encapsulated in the *sous-bois*. Paintings of this type are
often in a vertical format, not the traditional horizontal 'landscape' format, and they
presuppose a close-up look at vegetation. Typically, a *sous-bois* eliminates the horizon
and reduces the sky to small patches glimpsed between branches (if at all).

Although forest interiors were depicted now and again as long ago as the six-
teenth century (most famously by Albrecht Altdorfer in *Deciduous Forest with Saint
George*, 1510, Alte Pinakothek, Munich), this kind of picture emerged as a distinct
type around the middle of the nineteenth century. Initially, *sous-bois* tended to be
associated with the forest of Fontainebleau and the group of artists at Barbizon.
The association of *sous-bois* with the Fontainebleau region came about in part
because of the new kind of landscape attempted there: *sous-bois* are a pre-eminently
'forest' genre. It is difficult to imagine how the experience of entering a forest could
actually be adequately painted using received landscape formulae. Persons
standing *in* a forest cannot see the wood for the trees; Claudian and Poussinian
devices such as coulisses, gradually receding planes, atmospheric perspective and
balanced masses of foliage, buildings and sky, all worked out in response to the
largely deforested landscape of the Roman Campagna, are of little use when the
artist is standing amidst tree trunks and faced with a limited depth of field and little
or no sky above. Although painters in Barbizon did not theorise their practice, *sous-
bois* were in effect signs of artists straining against the constraints of the classical
landscape traditions. In a sense, they were no longer 'landscapes' at all. In German,
the term used for compositions of this kind is *Waldinneres*, and indeed, an enclosed
woodland space is more of a nature interior than a landscape.[5]

Let us look at one of these *sous-bois* more closely, the Hungarian artist László Paál's
Path in the Forest of Fontainebleau (colour plate 2). A path marked by two parallel
wheel ruts leads the eye along a slight diagonal around the vertical axis into the depth

of the forest. The path is flanked by tall pale tree trunks which are cropped by the top edge of the canvas. A male figure in a pale blue top, black trousers, shoes and a cap stands facing us in the middle distance, on the left rut of the path. The sky is visible only in some thickly impastoed white patches among the foliage, and the sunlight enters the composition in the form of bright spots on tree trunks and bands of colour across the path. The man stands in one of these pools of sunlight which lies to the right of him like a negative cast shadow. These patches of sunshine are the reverse of the device of the foreground shadow cast by an object outside the picture frame, found in paintings such as the Impressionist Claude Monet's *The Meadow* (1874, Neue Nationalgalerie, Berlin). In Paál's *Path in the Forest*, the entire scene is cast in shadow, and the patches of lighter colour are indices of the sunlit sky presumed to be beyond and outside the thick canopy of foliage. In this painting, the artist captures the sensation of being located under the tree canopy, and in this way, we viewers can share in his experience in the forest. The shaded area that continues into the foreground and, by extension, into our space, the path that invites us into the picture, the cropped tree tops that reinforce the feeling of being right inside the forest, and the figure facing us are all strategies drawing the spectator into the scene and into the experience.

Note also that the path is not going anywhere in particular (to a town or a house), unlike Meindert Hobbema's much earlier famous path in *The Avenue, Middelharnis*

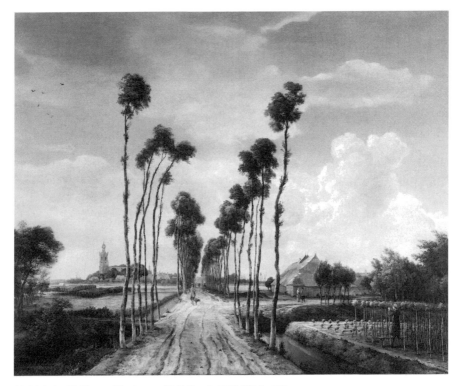

31 Meindert Hobbema, *The Avenue, Middelharnis*, 1689, 103.5 x 141 cm

(figure 31). Paál's path ends abruptly in a patch of green and seems to lead ever deeper into the undergrowth where the sun does not penetrate. In this respect, this path is akin to paths into forests painted by Caspar David Friedrich some fifty to sixty years earlier, such as his *Chasseur in the Forest* (1813–14, private collection, Bielefeld). However, the overall effect is very different. *Path in the Forest* has neither the grandeur nor the existential sadness of Friedrich's compositions. Also, in front of Friedrich's paintings we are not located within the wood: the open sky above seems to suggest a vantage point at the margin of the forest or in a glade. In *Chasseur in the Forest*, the raven and the *Rückenfigur* (figure seen from the back), dressed in the uniform of the Napoleonic cavalry, suggest allegorical possibilities of meaning.[6] The figure in *Path in the Forest*, on the other hand, is resolutely of this world, recognisable by smock and cap as a local man who, unlike Friedrich's cavalryman, is entirely a part of his environment. Paál's *sous-bois* does not gesture toward a world or an experience beyond the everyday and the physical presence of the material world. This point, however, will need to be tempered in the light of further analysis, and I will return to it later.

Paál's painting is exemplary of a substantial body of similar *sous-bois*, painted during the last half of the nineteenth century by artists of all nationalities (colour plate 3, figure 32). The type remained most closely associated with the forest of

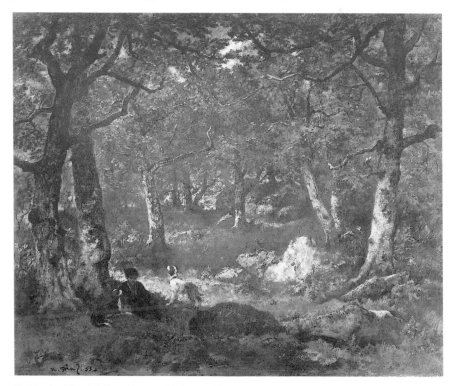

32 Narcisse Diaz de la Peña, *Sous-bois* (Barbizon), 1855, 50 x 61 cm

Fontainebleau but was soon exported to other locations as well (colour plate 4, figure 28).[7] These pictures provide a collective portrait of the forest and of the artists' experience while painting it. In order to understand what exactly constituted this experience, it is worthwhile attending closely to the written testimonies produced by the artists themselves as well as by visiting critics and writers, like Robert Louis Stevenson quoted above. They provide a clue to what it was that artists were seeking in nature and what they were trying to reproduce on canvas.

What is striking about these writings is the way they foreground a primarily sensual experience of nature. Will Hicok Low, in the forest of Fontainebleau, presents us with a veritable catalogue of events impinging on each one of the subject's senses. Sight, hearing, smelling, tasting and haptic sensation are all addressed.

> The *stillness* of the morning, the *spicy odours* of the trees, welcomed the matinal painter. ... after the lunch disposed of and sundry *cigarettes* burned on the altar of the arts, the industrious painter resumed his task. ... In the midsummer the *golden light* in the tree-tops sent you on your way through the *cool shadow* below as though your head were a halo. ... Later in the autumn ... [i]t was glorious, though sometimes a trifle weird, as far off in the distance you might hear the *roaring of a wild boar* or the *booming of the deer*; and a sense of solitude rose from the *rhythmic beat* of your feet. (my emphases)[8]

Similarly, the art writer Maurice Talmeyr, walking through the forest of Fontainebleau in the winter of 1888, singled out silence and far-away animal sounds to summon up the sense of vast space enclosing the individual in the forest.[9] Gaston Bachelard characterises the peculiar sense of space in forests as one of 'intimate immensity'. The subject in the forest experiences the contradictory impressions of being at once in a closed-off space, prevented from seeing very far, and in a limitless world that extends seemingly forever in every direction.[10] Low and Talmeyr attempted to capture this experience by juxtaposing descriptions of distant sounds with those close by that throw the subject back on itself: hearing one's own footsteps in secluded silence.

Sous-bois paintings are the visual equivalents of such written evocations of the forest. Hippolyte Boulenger's *Avenue of Old Charms* (1871–72) affords glimpses of a yellowish space beyond the immediate surroundings of the wooded avenue but this realm seems remote and impenetrable as if one could not be sure that there was actually a real world outside the forest (colour plate 4). Note how the human figures are merged with their vegetal setting to the extent that they are only discernible on second or third sight. They are submerged and immersed in nature, much as the artist, and by implication the viewer, imagines being immersed in the nature experience. Of course, the images are not precisely 'equivalents' in the sense of being translations of text into image. Both texts and images were attempts to record or to evoke the experience of being in the forest. The *sous-bois* were attempts to render in two-dimensional form on canvas the multi-dimensional and synaesthetic experience of immersion in a natural environment.

The geographer Paul Rodaway draws attention to the multi-sensual character of an individual's experience of place in his book *Sensuous Geographies*.[11] Rodaway discusses the importance of *all* the senses (with the exclusion of taste) for the way we apprehend our surroundings and our place within them: smelling, hearing, seeing, and haptic sensations, such as kinaesthesis and tactile receptivity via the skin. The sense of sight is important but it interrelates with the other senses to give us an in-the-round sense of our environment. A good illustration of the contribution of non-visual stimuli to a subject's experience of being outdoors is this description of a breezy day as experienced by a blind person:

> The leaves are rustling, bits of paper are blowing along the pavement, the walls and corner of large buildings stand out under the impact of the wind, which I feel in my hair and on my face, in my clothes. ... A sighted person always has a roof overhead, in the form of the blue sky or the clouds, or the stars at night. The same is true of the blind person of the sound of wind in the trees. It creates trees; one is surrounded by trees whereas before there was nothing.[12]

There are two points to be noted about this passage. First, it reminds us of how fundamental non-visual experiences can be to a sense of space, despite the primacy generally attributed to sight. Low's evocation of spicy odours, cool shadows and distant noises, or Maurice Talmeyr's 'perfect silence' attest to the importance people placed (and place) on non-visual senses when outdoors. Second, the blind person's description draws attention to the actual specifics of sight. In Rodaway's words: 'Sight ... sets a world, as an object or series of objects in front of the eyes. ... By contrast, we are always at the centre of auditory space, listening out with the ear.'[13] Auditory input is fragmentary but the visual world provides a constant back-cloth that gives continuity to discontinuous sounds. For a blind person, the trees simply disappear when there is no wind and they cannot be heard. On the other hand, the ears can give us an all-round auditory receptivity that the forward-facing eyes cannot.[14] The *sous-bois* try to re-enact a sense of this experience of all-round sense stimulation in nature, coupled with the visual experience of apprehending the world in the form of objects in front of our eyes.

In Grèz, the Swede Karl Nordström produced *Forest Glade*, in which the overwhelming effect is one of greenness (colour plate 3). The pigment is applied to the canvas in a scattering of small dabs and dots, blurring outlines and producing an effect of hazy foliage. Spindly branches jut into the picture diagonally at right. The role of the figure in this composition is crucial: although the white-bonneted, probably female figure is tiny, it is placed at the exact mathematical centre of the pictorial rectangle, its prominence enhanced by a circle of light (a patch of sky?) hovering above and behind it in the distance. The dialectic of the figure's diminished size versus its prominent position points to the central importance of the human presence in these *sous-bois*. The figure anchors the composition: covering it up results in a tangled mass of green speckles and undefined white and black lines flowing towards the top left corner (the branches). Absenting the figure would

mean almost too much of a good thing: too much nature. Or, to phrase it differently, vegetation as such is not, in fact, 'nature' at all. The various trees, shrubs and stones covering the earth's surface are only transformed into a unified substance conceived of as nature by the presence – overt or implicit – of a human subject. Only through the experience of the subject does nature come into being.

This brings me back to Nicholas Green's hypothesis that *natura naturans* consisted of a 'structure of *experience* … rather than a set of objects or themes' (my emphasis).[15] It is precisely this structure of experience that is at the core of *sous-bois* paintings and other paintings of nature produced in artists' colonies. Although one could order these images into iconographic categories (forest interior, birch tree, path, and so on), the fundamental project of painting one's own experience in the outdoors cuts across such divisions according to motif. In this sense, the *sous-bois* exemplifies in particularly radical and suggestive form the kind of nature experience and nature painting prevalent in artists' colonies. Representations of other kinds of artist-colonial terrain – beaches, moors, quarries – share the '*sous-bois* feeling', as will be elaborated in the next chapter.

Of course, these paintings do not create a three-dimensional multi-sensual experience: they remain flat rectangles covered in oil paint and hung in a frame on a gallery wall. But they are, within the limits of their medium, attempts to evoke *memories* of the viewer's own experience of nature. They propose, and presuppose, that this is the way nature should be apprehended: through immersing oneself in its sights, sounds and sensations. This is the central dilemma at the heart of the nineteenth-century nature painting project: how to transfer the intense experience of being immersed in nature and also the plein-air experience of being immersed in it *while* painting it on to the final product of the easel painting.

Most recent theoretical and critical literature on representation has focused on the gaze, that is, on the *visual* apprehension of the world. The gaze is predominantly figured as active, masterful, and distanced from its object. This is the controlling gaze of the panorama painter, situated on a look-out point and viewing the scene spread out beneath him (figures 27, 30). Geographers such as Denis Cosgrove, Stephen Daniels and Gillian Rose have argued for a conception of landscape as primarily a visual or pictorial construct.[16] When perceiving a scene as a 'landscape', the unruly givens of the terrain are ordered into a visual composition, and it is the emphasis on seeing and viewing (rather than, for example, working) the land that turns the terrain into a landscape. That is, a landscape is primarily something *seen*, not something heard, felt, walked through or otherwise apprehended. Max J. Friedländer argued as early as 1947 that the term 'land' defined the earth's surface but the term 'landscape' referred to the face of the land, its appearance.[17] Furthermore, the elevated gaze onto the land is implicated in hierarchical power structures, dividing those who work the land from those who own it.[18] Cosgrove described landscape as 'a way of seeing which separates subject and object, giving lordship to the eye of a single observer'.[19] The deployment of central perspective, elaborated in fifteenth-century Italy, locates the subject outside the landscape.[20]

Theories predicated on the power of the gaze have yielded helpful insights into the nature of traditional landscapes. However, they are of limited use when dealing with paintings of nature immersion, such as the *sous-bois*. These nature paintings resist readings in terms of one controlling gaze. If a landscape is, in the words of Cosgrove, 'a way of seeing which separates subject and object', then a *sous-bois* attempts to transcribe a way of experiencing which *fuses* subject and object, individual and environment. My argument here is indebted to Nicholas Green's singularly astute analysis of nature's dual mode of address. In mid-nineteenth-century French city-dwellers' experience of nature, Green discerns two complementary dispositions: on the one hand, nature is apprehended as a series of visual tableaux, conferring a sense of visual mastery onto the apprehending subject; on the other hand, nature is experienced as an all-encompassing totality which submerges the individual in a flux of sounds, smells and colours. Green concludes:

> These two ways of seeing and feeling work along distinct axes. Yet at their meeting-point they seem to be mutually reinforcing, producing a sense of *centred* subjectivity; the one through an ordering perspective, the other through being enveloped within the natural world. It is that double movement which is so characteristic of nature's mode of address.[21]

It becomes clear why, for Green, nineteenth-century notions of *natura naturans* revolve crucially around the experience of nature: because it is through this experience that the subject is thrown back upon itself, at once passively surrendering to larger forces, and at the same time feeling the self expand. This analysis of the 'double movement' of 'nature's mode of address' is richly suggestive for how artists in rural colonies experienced their environment. However, I want to take this argument further. Green's model of the double dialogue with nature, elaborated with reference to artistic and other social practices of early nineteenth-century Paris, is not entirely adequate in explaining *sous-bois* type of paintings. Green insists on the complementarity of the two dynamics – the sensual and the visual, immersion and distance, the 'twinning [of] immersion with pictorialism'.[22] Ultimately, however, he ends up privileging the second term in this coupling. He asserts that nature's 'intrinsic appeal was built on *being* a visual commodity', and that 'being in the country and viewing images of nature in paint and print were equally set up as a *pictorial* treat, to be pleasurably consumed with the eyes'.[23]

There are two points to be made in response to Green's argument. First, the artist-colonial enterprise was founded on the conviction that 'being in the country and viewing images of nature in paint and print' were precisely *not* the same thing. Green's conclusion that these experiences *were* in some way equivalent arises basically from his premise that all of the different practices he discusses – railway journeys, dioramas and panoramas, advertisements for country houses and the purchase of them, lithographs of Fontainebleau forest sold in Parisian galleries, and so forth – were part of the same discourse of nature. Because he is interested in discourse, he views these disparate objects and activities as sites of articulation of discourse. Seen

through this theoretical and methodological lens, discursive similarities are more important than differences at the level of the real and the materiality of objects. Geographical distance and specificity of place play a subordinate role in Green's argument. According to Green, one did not have to go to the countryside to experience nature; one could experience nature right here, in the city, looking at a landscape print: 'the subject in nature was dependent less on the actuality of the "visit" to the countryside than on activating that particular structure of experience.'[24] Artists in artists' colonies, though, *did* need to be in the countryside in order to activate a particular kind of experience. Indeed, the entire project of working and settling in villages turned upon the perceived urgency of physically being on the spot, as is attested by the insistence on the crucial importance of living and working continually in nature.[25] Even though ultimately the various manifestations of nature may have been part of one overarching discourse, participants in the rural painting enterprise were far from equating them.

My contention in this part is that materiality and specificity of place has to be returned to both the objects, that is the paintings dealt with in this book, and the natural environment of the villages where these objects were made. By this I mean that my project is not (as is Green's) to trace discursive effects but rather to examine what happened when discursive effects and constructs were tested against the material reality of a given terrain. This, I think, constitutes the difference between the practice and productions of painters in rural artists' colonies and other discourses of nature circulating in urban contexts. Green's aim was to extract commonality from a range of archives, mine is to pinpoint differences and to identify the specificity of the artist-colonial experience.

My second point in response to Green is that artists in rural colonies in the second half of the nineteenth century did *not* perceive their relationship to nature in terms of two equal and complementary axes of experience, that of controlling perspective and that of enveloped immersion. On the contrary, they emphatically rejected the distanced masterful gaze, associated with views, panoramas and landscape painting. One reason Green's assumption of complementarity does not hold for artists' colonies is that it was developed with a view to an earlier period, the first half of the nineteenth century. Indeed, a look at one of the only two paintings discussed by Green, Théodore Rousseau's *An Avenue, L'Isle-Adam Forest*, painted a good twenty-five years before the majority of fully-fledged *sous-bois* of the type discussed above, would seem to corroborate this hypothesis (figure 33). The oscillation between framing devices (serving to pictorialise the image) and perspectival vistas (drawing the viewer into the image as 'nature'), observed here so astutely by Green, is much less in evidence in later forest interiors by Paál, Boulenger or Nordström. It is as if in these later images the trees have grown together across the canvas, shutting out the open and distant space and all but covering it over with dabs and skeins of crusty pigment.

One could, of course, argue that ultimately the *sous-bois* painters' rejection of the masterful gaze was doomed to failure because these artists were, after all, engaged

33 Théodore Rousseau, *An Avenue, L'Isle-Adam Forest*, 1848–49, 101 x 82 cm

in making pictures, that is, objects for *visual* contemplation. One way around the dilemma of wishing to abjure the masterful gaze and giving oneself over to nature while at the same time 'masterfully' arranging nature's sights in two-dimensional marks on paper or canvas was to turn to the role of memory.

Two-dimensional paintings cannot approximate the experience of being *in* nature; they can, however, evoke the memory of such an experience. Nostalgia for the rural region near Sint-Martens-Latem runs through a letter written by the Belgian painter Emile Claus from Paris, turning his paintings into memory prompts for a multi-sensory experience of immersion in nature:

> As I read your letter, I looked at my paintings, and no matter how much they are a pale reflection of nature, I enjoyed dreamily looking at the sweeping meadows full of flowers, the sweet-smelling hay (a fragrance which no Parisian perfumier can equal), the richly coloured farms, and the shining red roofs. Without any pretence, I must admit that those splashes of colour from the country round the Leie river in Flanders often take me back to the rich Flemish countryside while I am here in Paris; I am only able, and only wish to paint there. ... I love my peasants and my land.[26]

Will Hicok Low advised the dissatisfied outdoor painter not to throw away any of his studies and appealed to the pictures' powers of conjuring up past experience:

> In after years, with the memory of the scene that he [the artist] endeavoured to depict dimmed by the mists of time, he shall perchance look upon his despised study and, through its darkened tones, the sunlight of the morning in the Bas Bréau or upon the plain, or the sharp storm when, crouching in the shelter of a wheatrick, he dashed a few rapid colour notes on his canvas, will live again for him, and, happily, through revived memory, aided by enlarged experience, may be the foundation of a definite achievement.[27]

Ostensibly, Low was offering a recipe for successful painting but his words of advice are crowded out by a nostalgic evocation of his past experience in the forest of Fontainebleau. It is quite clear that, for him, the painting did not serve as an accurate illustration of the forest but rather as a trigger for memory. The image may be 'darkened' and of inferior quality but the memory is detailed, clear and full of multi-sensual experience: sunlight, wind, rain, immersion in a storm and enclosure in a wheatrick.

A passage by the American Eliza Leypold Good who had spent a summer holiday in the artists' village of Rijsoord illustrates the mood of nostalgia that could be called up by paintings:

> A year later, as I was strolling through a picture gallery in New York, I stopped with a cry of pleasure before a familiar avenue of elms. It was twilight; the road was in deep shadow, and there was the turn; and I peered hard into the canvas for a glimpse of the inn and Frau Warendorp smiling at the door. But the artist had stopped short of them. In the corner of the canvas I read his name. It was that of our guide and friend, the artist we met that first day at the Rotterdam station.[28]

Good's reverie contains some marvellous slippages between painting and reality. She stops, not before a picture, but before a 'familiar avenue of elms'. She then examines the 'canvas' closely for traces of her own experience in the village depicted, as if she could actually enter into the painting and relive her memories. Finally, however, she is brought up against the limits of the picture as a made thing, only to find that the maker of it is the same man who had introduced her to the experience of Rijsoord in the first instance. Viewing the image transports her in time and place to that holiday experience: 'it was twilight … and there was *the* turn', that is, not just *a* turn, painted by an artist, but the turn she, Good, remembers: *her* turn. Her own memories exceed the information provided by the painting.

Eliza Leypold Good was not a painter herself. She was a member of that broad viewing public who responded to the kind of nature paintings produced by artists in rural locations and circulated back to city dealers and exhibition venues. Paintings could not duplicate the experience of being in nature but they could conjure powerful memories of such an experience, and these remembered experiences

were shared by rural artists and their audience alike. Such memories did not even necessarily have to correspond to viewers' own itineraries: Good had visited Rijsoord but viewers who had never been to Barbizon, Worpswede or Laren could get involved in paintings produced in these locations. Still, place was not entirely arbitrary; the nature experience was, for the viewers who responded most strongly to these kinds of nature images, tied to specific locations and countries. On the one hand, engagement with a set of paintings representing a particular location could fuel the viewers' desire to visit that location for themselves, as will be examined further in part IV. On the other hand, these locations could be cathectic sites of viewers' personal biographies. Louis Couperus, the Dutch novelist from The Hague who had been resident in Italy for a long time, entered a room full of Hague School paintings at the International Exhibition in Rome in 1911, and found himself powerfully affected:

> It was so strange: it was as if I had returned to my own country. That far off, damp, cold country that was sometimes so uncordial to me, that country full of cold Dutchmen, so stiff and severe to me, who was so used to southern sun and southern cordiality ... For I felt around me the atmosphere of my country which, strangely, I love, although I do not live there, although I am seldom there: I felt around me the atmosphere that had woven itself round the years of my boyhood and youth.[29]

The powerful tone of nostalgia running through Couperus' account is, I would argue, an essential ingredient in the modern experience of nature. Nature was something that had perhaps been there in one's childhood but that was now lost. The experience of nature was, in some ways, integrally bound up with this feeling of loss, and in this sense, nostalgia and memory were the most appropriate structures of feeling for the representation of and encounter with nature. The impossibility of the painterly project, mentioned above – turning the multi-sensual, kinaesthetic experience of wood, wind and rain into two-dimensional, static canvases – was therefore not necessarily a dilemma faced by the painters alone. The impossibility of being able to hold onto the nature experience was the dilemma of nineteenth-century urban Westerners *per se*. Going to the countryside and immersing oneself in its sights, sounds and sensations was a way of closing the gap between loss and presence – temporarily. The experience of nature was, intrinsically, a nostalgic experience, even for those artists who settled permanently in a village.

Painters in rural artists' colonies painted souvenirs of the nature experience. Earlier I made the point that *sous-bois* paintings do not gesture beyond the material world. However, the objects as such – the species of trees and grasses, the exact shape and colouring of a rock or a cloud – were entirely subordinate to the artists' experience of them. Painting the experience of being in nature was not a matter of the impartial recording of external phenomena; it was entirely partial. The Worpswede painter Otto Modersohn declared that he detested those painterly practices that 'confront nature dispassionately, that aim to conquer nature with the eyes without attending to her soul'.[30] Modersohn equated the dispassionate gaze with conquest

and mastery. This he eschewed, in favour of a kind of painting based more on feeling and mood. Gerard Bilders, sometime painter at the Dutch artists' village of Oosterbeek, also thought that plein-air paintings should express the mood of the scene: 'the grave peace or the glowing passion of the evening, or that mood that improves one's spirit and devotion and ... arouses inexplicable longings'.[31]

It is, of course, not the evening itself that feels passion or peace but the artist experiencing the evening and the picture's viewer, remembering such an evening. For Bilders, the experience of nature is uplifting (improves the spirit) and, significantly, deeply nostalgic (arouses longings).

The ultimate impossiblity of achieving an insight or a merging with nature was, significantly, formulated from within an artists' colony itself. In Worpswede, the poet Rainer Maria Rilke came to the conclusion that nature was, in the end, an unknowable and alien quantity:

> Die Landschaft ist ein Fremdes für uns und man ist furchtbar allein unter Bäumen, die blühen, und unter Bächen, die vorübergehen. ... Was bedeutet es, daß wir die äußerste Oberfläche der Erde verändern ... wenn wir uns daneben einer einzigen

34 Albijn Van den Abeele, *Pine Forest in February* (Sint-Martens-Latem), 1899–1900, 69 x 81.5 cm

Stunde erinnern, in welcher die Natur handelte über uns … mit jener erhabenen Hoheit und Gleichgültigkeit, von der alle ihre Gebärden erfüllt sind. Sie weiß nichts von uns.[32]

(Landscape is an alien entity to us and one is terribly lonely among trees that bloom and brooks that go past. … What does it signify that we have changed the outer surface of the earth … if we then remember one single hour in which Nature acted irrespective of us … with that sublime majesty and indifference that permeate all her gestures. She knows nothing of us.)

Albijn Van den Abeele in Sint-Martens-Latem was one of the very few artists who painted this sense of alienation and of nature as closed-off to human penetration (figure 34). In a handful of extraordinary *sous-bois*, produced around 1900, he took the tangled brushwork and limited perspective of the *sous-bois* type and subjected it to a formal geometricisation akin to Piet Mondrian's later canvases. Abeele's anti-*sous-bois* have more in common with those modernist paintings of grids that Rosalind Krauss describes as 'what art looks like when it turns its back on nature' than with multi-sensual immersion.[33] For a few years around the turn of the century, it seemed as if nature painting and avant-garde modernism could enter into a productive liaison. The next chapter continues the exploration of technical experiment linked to plein-air work in rural artists' colonies.[34]

5

Landscapes of immersion

The experience of giving oneself up to the enveloping sights, sounds and textures of the countryside was a new mode of experiencing nature, and it came to be the dominant one for bourgeois city-dwellers of the latter half of the European nineteenth century. This chapter discovers traces of the representation of immersion in nearly all paintings produced in nineteenth-century rural settings, not only those of forest interiors. I will argue that current theories of the gaze are inadequate for explaining these paintings of immersion in nature and suggest new ways of reading these images in terms of a blurring of the boundaries between self and setting.

As we have seen, paintings of *sous-bois* often contain a path leading into the picture's depths, connecting the viewer's space to that of the imagined forest. Such pictorial devices of involving the viewer in the nature experience were characteristic of open-air painting in the latter half of the nineteenth century. Devices like close-up views of flowers and grasses, footprints in the sand or curving lines denoting receding water on the beach, all at the bottom edge of the canvas, serve to bring the immediate foreground of the scene up to the viewer's space and to connect it with more distant attention catchers (figures, surf) in the middle ground (colour plate 5, figures 35, 36, 37). In Otto Strützel's picture *Spring Meadow with Child*, painted in the artists' colony of Dachau (figure 35), the impasto stalks and umbels of the foreground flowers proliferate along the lower edge of the canvas and almost overwhelm the figure of a girl who is submerged in this vegetation up to her hips. The plants form a barrier between viewer and girl; at the same time, they suggest that the viewer is standing similarly submerged in flora in the same space as the girl, drawing the viewer into the scene and into its world of sensual experience. In earlier paintings of the European landscape tradition, the foreground is rarely as close to the picture plane as this. Strützel's *Spring Meadow with Child* combines a close-up view of flowers and grasses with a long-distance view on to a terrain with a horizon. The reason why these two modes – close-up piece of turf and long-view landscape – do not fall apart into two unconnected fragments is the unifying loose brushwork. Still-lifes and botanical close-ups were traditionally distinguished by detailed brushwork, carefully built up to define form, such as Albrecht Dürer's *Large Piece of Turf* (1503, Graphische Sammlung Albertina, Vienna) or Maria Sybilla Merian's scientific illustrations around 1700. Strützel, on the other hand, left his grasses in an undefined sketchy state.

This unfocused immediate foreground appears in many late nineteenth-century paintings, and in almost all paintings of nature produced in rural artists' colonies (colour plates 5, 6, figures 13, 36, 37). I will call this device 'immersive foreground' and propose it as a key marker of late nineteenth-century sensibilities to nature. The dishevelled looseness of these foregrounds mirrors the irregularity that had become intrinsically associated with notions of rural nature. Nowhere in artists' colonies do we find the orderly march of evenly planted trees and rigidly staked pollards celebrated in Hobbema's *Avenue, Middelharnis* (figure 31) or even the precise brushwork of Friedrich earlier in the century (figure 44). The freely applied brushmarks corresponded to the supposed freedom of the individual in 'free' nature. This is an argument hinted at but not explicated by T. J. Clark when he suggests that for many painters in the later nineteenth century, landscape had a 'presence and a unity which agreed profoundly ... with the act of painting'.[1]

Paula Modersohn-Becker noticed an immersive foreground when she first saw Mackensen's *Sermon on the Moor* (figure 50) and attributed the effect to the use of tilted perspective.[2] Indeed, in pictures where the ground in the foreground is not obscured by high vegetation, artists frequently experimented with a view from above not quite consistent with the recession into the distance of pictorial elements in middle ground and background. The effect may be illustrated by comparing

35 Otto Strützel, *Spring Meadow with Child* (Dachau), 1886, 31.5 x 40.5 cm

Paul Wilhelm Keller-Reutlingen's *Early Evening in the Dachau Moor, Late Autumn* or John Leslie Breck's *Autumn, Giverny (The New Moon)* with an earlier painting which does not use the device, for example, Hobbema's seventeenth-century *Avenue, Middelharnis* (colour plate 6, figures 13, 31). The perspective and scale of the immediate foreground in Hobbema's painting are consistent with those of the figures and the far distance, reinforced by the parallel spatial markers of the trees, stakes and furrows. The furrows anchor the scene in a physically consistent space, much as do the geometric patterns of floor tiles in seventeenth-century Dutch interiors.[3] Keller-Reutlingen and Breck have eliminated such anchor points. The distance to be traversed between the picture plane-cum-viewer's standpoint and the figures in the depicted scene is not clearly measurable. These representations do not imply a viewer standing above the landscape, gazing down at it, but one standing, sitting or lying *in* the landscape.

The significance of figures merging with ground and backgrounds moving forward lay in the suggestiveness of these devices for calling up memories of immersion in nature. Pictures such as Keller-Reutlingen's *Early Evening* and Breck's *Autumn, Giverny* rest on the assumption that the artists had themselves been there, had experienced nature in that place (colour plate 6, figure 13). This knowledge reached the viewer in two ways. One was extra-pictorial and consisted of information and stories about the artist's closeness to nature and residence in a rural colony

36 Louis Eysen, *Field Path near Kronberg*, 1877, 50.5 x 70.5 cm

37 Carl Bantzer, *Landscape in the Gerbergrund (Rest in the Shade)* (Goppeln), 1894, 97 x 112 cm

disseminated by the art press. The second way was the effect of the painting itself: by the late nineteenth century, the use of loose and tangled brushwork in undefined foreground zones of landscapes had become one of the hallmarks by which one could recognise a plein-air painting.

Often the effect of immersion is enhanced and reinforced by the insertion of one or more immersed figures into the scene, as in Strützel's *Spring Meadow with Child*, Louis Eysen's *Field Path near Kronberg* and Carl Bantzer's *Landscape in the Gerbergrund* (*Rest in the Shade*), painted in the artists' haunt of Goppeln (figures 35, 36, 37). Reminiscent of Robert Louis Stevenson's painter, 'encamped in the shadow of [a] tree, and up to his waist in the fern' (see chapter 4, p. 83), the mother and child in Bantzer's picture are submerged in grass and tree shade, blending into their surroundings. Such figures are invitations to viewers to imagine themselves into their place. However, it is to be noted that in paintings produced in rural artists' colonies these figures are almost always local villagers, not artists or other members of the urban middle class.

The villagers are often represented in attitudes that had a resonance for artists' own practices within the countryside. We have few visual representations of an

artist gazing at nature. However, there are a great number of paintings showing rural persons seated or even lying in the landscape, gazing out to sea, up at the clouds, or at a piece of vegetation (figures 13, 28, 35, 37, 38). This contemplative pose is sometimes motivated by the most minimal narrative excuses. In Gari Melchers' *Moss and Sand* (figure 38), painted in Egmond, a modicum of anecdote is retained in the form of the basket and rake lying at right angles to one another in the foreground as an alibi for the whimsical lack of action in the scene. Their position, pointing in two different directions, suggests that they have been let fall carelessly, presumably (the viewer is encouraged to speculate) because their carrier followed an impulse to drop to the ground herself and contemplate the sky in abandoned fashion, in the manner of Dill and the Woestijne brothers (discussed below, pp. 108–9). Notwithstanding the presumption that countryfolk do occasionally enjoy moments of rest, I would suggest that this painting is not so much a record of something the artist has 'snatched' from seen reality but a scene arranged to dramatise

38 Gari Melchers,
Moss and Sand
(Egmond), 1887,
95.23 x 69.1 cm

39 Emile Bernard, *Madeleine in the Bois d'Amour* (Pont-Aven), 1888, 138 x 163 cm

his own ideas about interaction with nature. The Egmond model was made to rehearse an attitude and sentiments very similar to those assumed by the urban middle-class visitor to the countryside, like Madeleine Bernard in Pont-Aven's Bois d'Amour, as painted by her brother Emile in 1888 (figure 39). The painted Bernard (and quite likely, her live model) was prevented from abandoning herself entirely to the sights and sounds of the natural environment by the need to appear decorous in her dress and slippers; by contrast, the Egmonder's rustic status allowed the artist to show her with legs slightly akimbo, one knee raised, and one arm flung up towards the tilted head. This is at once a picture of abandon in nature and of muted erotic allusion. However, in contrast to the many producers of mythical nudes and symbolist nymphs adorning the walls of late nineteenth-century exhibitions, rural artist-colonists virtually never painted locals as sexualised beings. Instead, we have a kind of eroticisation of the landscape: sensuality displaced into nature.[4] *Moss and Sand* conflates several connotative functions of the figure to effect an over-determined and therefore highly suggestive image of natural immersion: woman as imagined closer to nature, peasant as imagined closer to nature, and finally, the peasant woman as a stand-in for the artist himself.

I would argue that these contemplative peasants function as surrogate figures for the artists themselves. They are implausible hybrids whose function is to reconcile the peasant's supposed greater proximity to 'nature' with the contemplative – and hence distanced – subjectivity of the bourgeois urban artist. These images bring us closer perhaps than any other to the attractive but contradictory and socially impossible ideal of communion with nature through local subjects perceived as existing 'closer' to nature than non-peasants.

I will now analyse a further mode of nature painting which I should like to propose, along with the *sous-bois*, as one of the representative types generated by rural artists' colonies. This type was the flat landscape or seascape (colour plates 5, 6, figures 40, 41, 42, 43, 46). No technical term equivalent to that of *sous-bois* has been coined for the kind of bisected landscape elaborated by painters in response to flat terrain. I shall refer to these compositions as 'minimal landscapes'.

My discussion of minimal landscape begins with the swampy moorland near Dachau, known in the local dialect as the Dachauer Moos (literally: Dachau Moss). Keller-Reutlingen's *Early Evening in the Dachau Moor* dispenses with nearly all of the traditional markers of place used in landscape painting, such as perspectival and framing devices, foreground repoussoirs, the balance of masses and voids, and so forth (colour plate 6, compare figure 27). The canvas is divided horizontally into

40 Hans am Ende, *Wide Country* (Worpswede), *c.* 1902, 135 x 200 cm

41 Anton Mauve, *The Marsh* (Laren), 1885, 60 x 90 cm

42 Adolf Lier, *After the Storm (Peasant Cart Going into the Dachau Moor after a Summer Storm)* (Dachau), date unknown, 70 x 120 cm

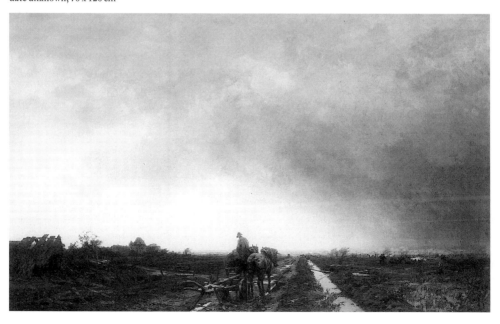

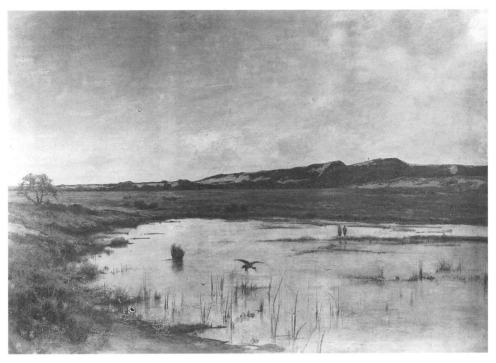

43 Adolphe-Jean Hamesse, *By the Pond in Kempen* (Tervueren), 1883, 142 x 201 cm

two rectangular zones, one with the white sky above and the other with the pre-dominantly green and brown ground below. The two parts meet along an almost completely level horizon line. A third line cuts across the lower rectangle to carve out an adjunct triangular shape at right. This further geometrical subdivision of the quadrangle is thematically motivated by a straight ditch running through the moor into the distance. Miniature sheep with shepherd, a small tree in the back-ground at right and tiny buildings and smokestacks on the horizon slightly liven up the strict geometry of the composition. There is no clearly defined division between foreground and middle ground: the grassy earth stretches unbroken right up to the picture plane. This large area of ground is textured with rough and crusty dabs of pigment to give the impression of a sparse coat of low-rising vegetation cov-ering a loamy soil. The ground is treated with very little attention to detail; there is a sense that the entangled, interwoven tapestry of paint dabs tries to re-enact on canvas the uneven irregularity of natural growth and texture.

The spatial division of the pictorial rectangle into horizontal bands is again rem-iniscent of a picture by Caspar David Friedrich, *The Monk by the Sea* (figure 44). But in Friedrich's picture, the viewer is kept at a greater distance from the scene, and the much greater expanse of sky draws attention away from the foreground which has none of the encrusted tangle of pigment we find in Keller-Reutlingen. The Capuchin monk stands out against Friedrich's landscape as the only vertical

element and asserts his human consciousness against the vast emptiness of nature. The Dachau painter's figure, by contrast, merges into the land, both through his status as rustic shepherd and his pictorial treatment as unassertive smudge. He represents a faint echo of the Romantic confrontation of 'man' with the universe but almost one hundred years of art history and history have transformed the earlier gesture of cosmic import into something less grand and universal, more utilitarian and tentative, and much more at one with the rural environment than Friedrich's troubled mendicant. The Dachau landscape, though blunt and grey, is not terrible in any sense of the sublime; it does not overwhelm the human presence of shepherd (and viewer) but instead surrounds it with synaesthetic sensations.

Joseph Leo Koerner astutely observes that the monk in Friedrich's picture does not erase the 'boundary between self and world' but establishes that boundary and invites the viewer to identify with him as a mark of the separation of the subject from reality and from 'the fullness of life and experience'.[5] By contrast, landscapes of immersion attempt to overcome the separation from the 'fullness of life'. Keller-Reutlingen's painting posits the union of subject (viewer/shepherd) and object (nature/landscape) as an experiential possibility. Friedrich's *Monk by the Sea*, significantly, has no immersive foreground. Indeed, the presence of such a foreground will date almost any landscape painting to the second half of the nineteenth century, and most frequently to the decades after 1870: the heyday of rural artists' colonies.

44 Caspar David Friedrich, *The Monk by the Sea*, 1808–10, 110 x 171.5 cm

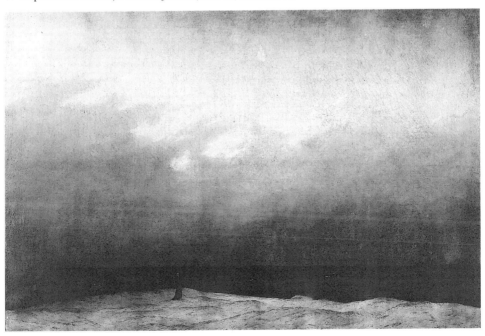

A further comparison may make the specificities of landscape painting in the 1880s and 1890s in contrast to Romantic and other landscapes of the earlier part of the century even more apparent. Peder Severin Krøyer's minimal seascape, *Sun Sparkling over the Sea, Skagen*, ostensibly represents a view of beach and sea similar to that of Friedrich's *Monk by the Sea* (colour plate 5, figure 44). However, apart from the reduction of the area of sky and the replacement of the allegorical friar with figures motivated by the actual place depicted (fishermen and local boys), there is also the transmutation of Friedrich's hard-edged contours into smudged transitions. This is particularly noticeable in the horizon and in the line between sand and sea. Note also the way the immersive foreground in Krøyer's picture draws us into the scene by means of the footsteps in the sand which may well be our own or the painter's traces. The analytical separateness of entities (in Friedrich's *Monk by the Sea*) is in Skagen dissolved into an overall, synthetic sensation of the natural elements. Georg Simmel argued that nature is the infinite connection of things and the flowing unity of events whereas landscape needs delimitation. The fragmenting gaze of the human subject reconstructs the fluidity of nature into the particularity we know as 'landscape', producing a new unity.[6] A painting such as *Sun Sparkling over the Sea, Skagen* holds in balance the two elements: nature and landscape. On the one hand, there is the irregular, the non-bounded, the infinite continuing beyond the edges of the canvas: nature. On the other hand, there is the pictorial construct with its geometry of lines, counter-weighting of forms (boys versus boat) and careful scattering of hue: landscape, with all the historical freight that comes with that aesthetic category.

Minimal landscapes are open-space correlates of the *sous-bois*. Both kinds of painting – minimal and *sous-bois* – represent landscapes in which spatial relationships become difficult to read, either through a surfeit of space or the anarchy of undergrowth. The rectangle of the canvases is filled with *one* kind of element: one dominant colour, one kind of brushwork, one dominant sensation. They do not offer the variety in harmony prized by landscape painters before the nineteenth century. There is nothing much to look at in these paintings, no great variety of form or subject, and it is this which serves to strip the visual sense of some of its primacy and bring to mind the other senses.

Two final points are to be made about these multi-sensory paintings, and in particular minimal landscapes, one concerning the paintings' immersive qualities, the other their formal properties. First, let us return to those experiences of immersion in nature already discussed in chapter 4 with regard to the *sous-bois*. In regions where woods were scarce, the plain and its aquatic equivalent, the sea, could furnish sensations of immersion akin in quality to those experienced in a wood interior. Here, those elements that are blocked out when one is *in* a forest, come into their own: the seeming vastness of the sky and the action of wind and rain, unbroken by the shield of trees.[7] Paintings of skies spoke of and to multi-sensory experiences such as those had by the brothers Woestijne who lay down on the ground to absorb the sky, the odours and the distant animal sounds of Sint-Martens-Latem:

Everything smells fresh. ... The sky was bright blue, and everything was green and bursting with life. We could hear dogs barking, cocks crowing, and cows lowing. ... We felt happy and peaceful, like everyone and everything around us. We lay down on our backs with our faces towards the sky, and saw nothing but the white clouds, drifting gently by in the deep blue sky like sheep. We lay like this for a long time.[8]

The painter Ludwig Dill, too, would lie down in the moss near Dachau and contemplate the shapes of the clouds and tree tops from a supine position, as close to the earth as possible.[9] It seems the experience of being *in* nature (as opposed to *in front of* it or *above* it) was almost more intensely felt when one wasn't actually painting but simply walking, gazing or throwing oneself down on the ground. The art critic Arthur Roeßler's account of Dill evokes a meditative and almost delirious engagement with the sensations of the natural world.

> Den rauhhaarigen Lodenmantel um die Knie gewunden, konnte Dill, wie er mir, mit einem wundersamen Ton der Rührung in der Stimme, erzählte, stundenlang bewegungslos auf den hochgestapelten Torfziegeln sitzen und zwischen den wiegenden Weiden und den dunkelragenden Wacholdern hinausblicken hinweg über das sich weithin dehnende Moor. Der Himmel war von blaßgrauen Wolken verhangen und ein sachter dichtperlender Regen dräuschte hernieder. ... Stunden vergingen so im wortlosen, andächtigen Anschauen. ... Allmählich ließ der Regen nach, es wurde wieder hell und regnete schließlich nicht mehr. In tiefen Zügen sog Dill behaglich die erquickende wohlig-kühle Abendluft ein, die geschwängert war mit dem köstlichen Hauche des dampfenden Erdbodens und den ätherischen Essenzen der abervielen Pflanzen.[10]

> (His rough loden coat wound about his knees, Dill could sit for hours motionless on a high stack of turf bricks, as he told me in a voice trembling with emotion, and gaze out between swaying willows and darkly looming juniper trees over the moor stretching into the distance. The sky was overcast with pale grey clouds and a soft, densely pearling rain was rushing down. ... In this way, many hours passed in wordless, devout contemplation. ... Gradually, the rain eased off, it became light again, and finally it stopped raining. Contentedly, Dill drew in deep draughts of the refreshing, pleasantly cool evening air which was pregnant with the delicious breath of the steaming earth and the ethereal essences of a multitude of plants.)

The sensory density of Roeßler's account is remarkable. All five senses were employed in Dill's apprehension of nature: sight (gazing into the distance), sound (the swoosh of rain), touch (getting drenched, feeling the coolness of the air), smell (the aromas of earth and plants), and even taste (conjured by the adjective 'delicious').

Both *sous-bois* and minimal landscapes attempt to transcribe a way of experiencing the natural environment which fuses subject and object, individual and habitat. Jonathan Crary argued that vision during the eighteenth century was treated as a rational faculty, with emphasis given to the observed world. In the first half of the nineteenth century, however, a significant shift occurred away from this earlier model to the concept of vision as a subjective physical faculty,

responding to material stimuli. The emphasis was now on the observer (no longer on the observed) and on subjective interior experience as opposed to objective exterior fact.[11] Artists, and artist-colonists in particular, found in the field of landscape a genre that promised a conciliation of inner and outer via the immersive experience. The boundaries between subject and object could become blurred. At the death of the painter Emile Claus, a friend exclaimed: 'You were not like a painter standing in front of his impressions. You were so much part of your work that it was as though you became a part of the landscape, a piece of nature.'[12]

This eulogy sums up the self-image of landscape painters in the late nineteenth century. It instates a subject that is so thoroughly immersed in its natural surroundings that it becomes indistinguishable from them. This is immersion taken to its limit, and paintings predicated upon such a premise likewise strained at the limits not only of classical landscape codes but also of the parameters of painting itself.[13] This is what places these paintings not only within the history of modernity but also, surprisingly, within the art history of modernism. If we for the moment ignore the modernists' bias towards radical avant-garde theorising and formal innovation (Kandinsky and others) but extract from the project of critical modernism the idea that each new painting questions the very nature of painting and challenges received notions of the way we see the world, then this is just what landscapes of immersion, produced in rural artists' colonies, were doing. The difference is that these paintings were not produced to challenge widespread urban and middle-class expectations, as were those by avant-garde colleagues. They fed into and helped to form more generally held ideas, as we saw in part II and will pursue in the next part.

The term most commonly used within nineteenth-century German writing to describe the idea of individual subjectivity blending with the environment was *Stimmung*, a word which has no exact counterpart in English but may be paraphrased as mood, atmosphere or sensibility. The founder of ethnography, Wilhelm Heinrich Riehl, called paintings of the Dachau moors 'reine Stimmungsbilder' (pure paintings of mood), drawing attention to the way such landscapes exemplified the four basic elements: water (a pond or ditch), air (the sky), fire (a sunset), and earth – 'eine gestaltlose Fläche Landes' (a formless expanse of land).[14] Riehl's description is also a fairly good evocation of minimal landscapes in general. Otto Friedrich Bollnow, discussing the concept as used by Martin Heidegger, argued that *Stimmung* is a key phenomenon for understanding space as experienced (as opposed to mathematical or mapped space). This experienced space, or 'gestimmter Raum' ('mooded' space), is of a dual character: the space itself conveys a mood to the human subject, but there is also a transference of the subject's own interior mood onto the space. Both make up the particular *Stimmung* that is neither inherently objective nor subjective but contains both within it.[15]

The idea of *Stimmung*, I would argue, dominated the concept and production of late nineteenth-century landscape painting, even in cases where artists or critics

did not use this or an equivalent term. (The word itself is, after all, just a shorthand for a prevalent structure of experience.) It provided a way into thinking about and painting the experience of immersion and proved particularly powerful for artists working in rural colonies. Artist-colonists were committed to the realities of a particular geographical region. They never painted interchangeable generic landscapes but always specific locations. This crucial point is the subject of part IV; suffice it for now to note that the idea of *Stimmung* allowed artist-colonists to describe in paint the physical properties of their chosen site at the same time as instating their own subjectivities as central, indeed essential, to the painting of nature.

This brings me to my second point about minimal landscapes, their formal principles of organisation. Artist-colonists found and developed new ways of evoking the blurring of self and space in their paintings that encompassed the dialectic between interior and exterior *Stimmung* and, in the process, adumbrated the later invention of abstraction. Not only did landscapes of immersion try to capture a real experience, they also drew attention in a new way to the visual principles of organising a picture. Let's take another look at Krøyer's *Sun Sparkling over the Sea, Skagen* (colour plate 5). The impasto brushwork at the lower edge and the geometrically precise way of subdividing the rectangle of the painting serve to foreground the technical and formal means of the painter. The boys in the middle ground are suffused with light and atmosphere, immersed in air and sunlight. At the same time, we find ourselves squinting at the bright reflections behind them: the effort to make out the contours of the figures against the glittering backdrop mimics the optical effort required when on an actual beach at sunset. This connects to Crary's point about the nineteenth-century concept of vision as physical response to stimuli. In addition, however, the painted reflections in Krøyer's picture also encourage viewers to stare attentively at the thick white pigment laid over the blue, that is, to become aware of the painting *as* painting. In canvases painted in rural artists' colonies throughout the last few decades of the nineteenth century, the two principles – multi-sensual immersion and visual formalism – were held in productive tension.

In the early twentieth century, Piet Mondrian took the minimal landscape and pressed its formal principles further towards the limits of figuration. Mondrian's dune paintings of 1909–11 flatten the landscape against the picture plane and transform the horizon line into an absolute split between pictorial zones (figure 45). Interestingly, Mondrian's first truly abstract paintings were produced during his stay in the artists' colony of Laren from 1915 to 1919.[16] Two other pioneers of non-objective painting, Adolf Hölzel and Vassily Kandinsky, also arrived at the vocabulary of their early abstract works while painting at Dachau and with a small group of friends–cum–colony of painters in the Bavarian village of Murnau respectively. And we saw, in the previous chapter, how Abeele transformed the *sous-bois* into a quasi-grid in Sint-Martens-Latem.

The step from immersive landscape to abstraction was taken by only a handful of rural artist-colonists. However, the possibility of tipping the balance in favour of

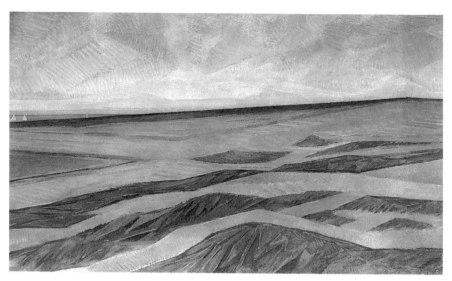

45 Piet Mondrian, *Dune Landscape*, 1910–11, 141 x 239 cm

interiority and formal pictorial qualities was always dormant in this mode of plein-air production. Simmel claimed that the landscape distilled from the fluidity of nature and kept together primarily by its *Stimmung* was itself a 'geistiges Gebilde' (psychic formation), not available to be sensed and stepped into in external reality.[17] And the painter Richard Bergh, one of the founders of the artists' community at Varberg in Sweden, mused as early as 1896: 'Every landscape is a state of mind.'[18]

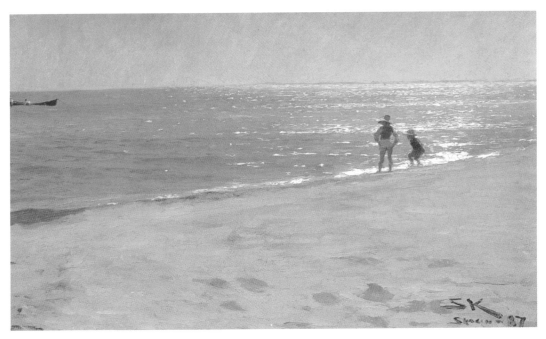

5 Peder Severin Krøyer, *Sun Sparkling over the Sea, Skagen*, 1887, 32 x 55 cm

6 Paul Wilhelm Keller-Reutlingen, *Early Evening in the Dachau Moor, Late Autumn* (Dachau), 1892, 71 x 103 cm

7 Otto Modersohn, *Hamme Meadows with Weyer Mountain* (Worpswede), 1889, 33.5 x 46.5 cm

8 Otto Modersohn, *Autumn Morning on the Moor Canal* (Worpswede), 1895, 96 x 151 cm

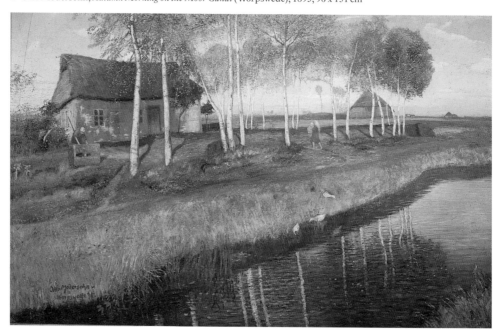

PART IV

ARTISTS AND PLACES

Artists in rural colonies were always intensely conscious of the place they were in. That is, place was an issue, not a given. The rural sites chosen for artistic activity were over-determined nodes of expectations, affects and cultural significance. These aspects have already been touched upon in previous parts that examined the group formations made possible in rural locations, artists' profound personal investments in the experiences of nature and the discourses of agrarian romanticism. This final part draws together these various aspects under the rubric of 'place' because, as I will argue, everything artists and their representations did was in essence related to a distinctive sense of place, experienced by them, communicated in their paintings and embraced by their audiences. In sum, place was never a coincidental adjunct to rural artistic activity; rather, artists' interactions with the place formed the ideological centre of the entire artist-colonial enterprise.

Questions of place and space, and how people make sense of places, have in the 1980s and 1990s been the subject of revived scholarly interest, in particular among geographers and sociologists but also among some historians of literature and art.[1] Common to the reappraisals of spatiality is the conviction that space and place are socially produced. Geography has, of course, always concerned itself primarily with places but, as Allan Pred points out, the discipline had traditionally conceived of place 'as an inert, experienced scene … an object for a subject'.[2] However, as Pred, John Urry and others argue, humans do not simply inhabit a static territory as background; rather, they ceaselessly construct and conceptualise place.[3] As Urry notes, a complex net of interdependencies operates between individual subjectivities, social relations, and the physical and built environments (and I would add pictorial and textual representations).[4] This dynamic conception of place underpins all of my arguments in this part.

Chapter 6 examines the ways in which artists produced the dominant image of their villages through pictorial representations. The analysis is developed through a detailed case study of one location as paradigm, the village of Worpswede, followed by comparisons to two other locations, Pont-Aven and Dachau. Having scrutinised the micro-environments of individual sites, chapter 7 opens out the horizon to consider all of Europe. Why some landscapes were chosen and others rejected for artistic purposes and how these choices were determined by a growing tourist culture forms the subject of this final chapter.

6

Painting place-myths

A small but growing number of art historians has begun to reconstruct the complex ways that geographical locations intersected with the production of cultural representations, particularly in late nineteenth-century France.[1] What emerges is a complex picture of artists negotiating a representational and cultural terrain, admitting certain aspects of the environment and rejecting others, moving between the realities of a place, the ideal image of what that place should be like, and the possibilities opened or foreclosed by the conventions of pictorial tradition. With two exceptions, there are no comparable studies of rural artists' colonies.[2] Writers on colonies tend to read art and place as reinforcing one another in more or less unproblematic fashion. For example, Peter Phillips writes that Joseph Richard Bagshawe's boat trips with Staithes fishermen 'gave him the deep understanding of the sea which is reflected in his paintings'.[3] Doris Bachmeier suggests that Bantzer's images of Willingshausen faithfully document traditional forms of life.[4] These writers perpetuate patterns of reception inaugurated in the late nineteenth century by the artists themselves.

In this chapter, I introduce Worpswede as a paradigmatic case study in order to show in detail how artists did *not* simply 'reflect' what they saw. The progressive crystallisation of the entity 'Worpswede' in the collective *oeuvre* of five or six painters during the first half of the 1890s constituted the construction in paint of a specific locality. By a trial-and-error process, the first artists in the village invented the Worpswede of their paintings and of subsequent visitors' imaginations. In doing so, they used and developed what Ernst Gombrich called a pictorial schema. In his famous discussion in *Art and Illusion*, Gombrich argued that every image-maker needs a pictorial schema or prototype which is then applied, adapted and modified, according to circumstance and in continual comparison with reality.[5] This account is highly suggestive for illuminating the way in which artists forged a collective image of 'Worpswede'. It was a dialectical process involving an alternation between the artists' own expectations of rural nature and the actualities they encountered *in situ*. This process resulted in the collective construction of a place-myth not only in Worpswede but in all rural artists' colonies.

The notion of place-myth, coined by the sociologist Rob Shields, is a useful key to unravelling the skein of expectations, hopes, stereotypes and associations attached to a place. According to Shields, people attribute certain characteristics to places. By a process involving over-simplification, stereotyping, labelling and

activating prejudices, these conceptions crystallise into symbolic formations, which Shields calls place-images. Collectively, a group of place-images makes up a place-myth: a set of widely-held and distributed core-images toward which individuals orient their own experiences. Place-myths are powerful motors of meaning, and they stubbornly continue to govern what people think of a place even when it no longer conforms to the images.[6]

Shields argues that images and myths of places need not be directly linked to those places; they are 'the various discrete meanings associated with real places or regions regardless of their character in reality'.[7] This assertion echoes Nicholas Green's emphasis on the discursive character of the concept of 'nature' (discussed in chapter 4), and is heir to a general post-Foucault interest in notions of discourses, texts and ideologies rather than in investigations of 'the real', prevalent among cultural historians since the 1980s. While my own analysis is, of course, deeply indebted to these writings, I wish to steer beyond readings of 'nature', 'landscape' and 'place' as purely discursive formations just as I wish to reject the uncritical 'reflection' mode of explanation. Instead, I want to probe the interplay *between* the real and the discursive, between so-called fact and so-called fiction. I suggest that the practices of rural artist-colonists were enacted in precisely this interval, moving back and forth all the time from art to nature and back again. As we saw in chapter 2, artists' activities were grounded in claims to 'truth', that is, reality, and it was the images' relationship to real physical locations that formed the framework for urban audiences' reception.

Artists' representations were not the only statements about a rural place in existence. As suggested in chapter 3, different groups of locals could promote their own ideas of what 'their' village was all about. Beyond that, there were other outsiders who staked their claim to a place, the most notable being tourists and tourist entrepreneurs. Some of these dissenting voices will be heard in what follows. However, indigenous claims (if not geared to a tourist audience and hence subsumed into the artists' rhetoric) remained on a local level, and tourist images were themselves largely the product of artists' representations. It is only in the twentieth century that a few of the villages were overlaid with other place-myths, most notoriously in the case of Dachau. However, in the heyday of rural artists' colonies, the mythology of artists' villages as elaborated by painters, held hegemonic sway over all other kinds of accounts.

It was possible for artists to monopolise the representation of a village to the outside world because most of the places chosen as colonies were relatively unknown outside their immediate region before the establishment of an artists' colony there. When Millet and Charles Jacque set out for the forest of Fontainebleau in 1849, they allegedly only knew that they were looking for a village ending in 'zon'.[8] 'Not mentioned by Baedeker', was Fritz Overbeck's verdict regarding Worpswede.[9] I will return to the ideology of 'discovery' that this entailed. At this point, it is enough to observe that part of the place-myth of a rural location involved the consciousness of stepping into unknown artistic territory.

The last claim has to be modified to accommodate the influence of regional place-myths. Perhaps Millet and Jacque had never heard of Barbizon but the forest of Fontainebleau as an old royal hunting preserve and a site of 'natural nature' would have been familiar to most Parisians by mid-century.[10] Similarly, the specific village of Worpswede may have been unknown to most before the artists' arrival but the country it was in was not. Regional place-myths, about the north of Germany in general and about moor regions in particular, asserted their influence on local place-images, and we will see how they were assimilated into a place-myth of the village.

The mechanisms of collective work on place-myths were embedded in the group character of artists' colonies, as outlined in chapter 1. We saw that collective activities included the mutual criticism of each other's work, informal dinner-time discussions, and working together *en plein air*. The selection and repeated iteration of a few key motifs is not mentioned by Shields but I would contend that it was a principal ingredient in the pictorial construction of a rural place-myth. Carl Olof Petersen recalled that around the turn of the century the landscape around Dachau revealed a painter's umbrella every fifty metres and went on:

> An besonders beliebten Stellen stand man sogar tagelang Polonäse, bis jeder an die Reihe kam. Viele Motive wurden derart oft abgemalt, um nicht zu sagen abgefieselt, daß die Bauern oder sonstigen Eigentümer auf Schadenersatz klagten. Ja, es kam selbst vor, daß die Herren Professoren vom Überdruß an dem ständig wiederkehrenden Bild die Korrektur verweigerten.[11]

> (In particularly popular spots, one even queued up for days before everybody had a turn. Many motifs were copied so often, not to say churned out, that the peasants or other proprietors sued for compensation. Yes, it even happened that the professors refused to do a correction because they were tired of the constantly repeated image.)

One particularly popular subject in Dachau was an old cottage surrounded by wizened poplars, known as the Moosschwaige or moss hut. According to Petersen, this cottage acquired the nickname 'Motiv Nr. 1' (number one motif) and appeared in countless paintings, many of which ended up in galleries (and no doubt inspired yet more visits to Dachau). Petersen's account is illuminating:

> Jeder Schüler ging am ersten Tage seines Aufenthalts in Dachau umher und suchte sich ein Motiv. Und jeder kam glücklich mit einer großen Entdeckung zurück. Sie alle wollten die Moosschwaige malen![12]

> (On his first day in Dachau, every student walked about, looking for a motif. And everyone returned, happy with a big discovery. They all wanted to paint the Moosschwaige!)

All of these newcomers walked about Dachau with quite precise ideas of what was paintable already fully formed in their minds, and the Moosschwaige fulfilled these preconceived definitions of the suitable and the paintable perfectly.

Expectations of suitable motifs imported from outside the village intersected with colleagues' paintings seen in the village itself and with ideas gleaned from conversation with other colonists. The choice of motif was a collective choice, despite individual artists' delight at having 'discovered' something new for themselves.[13] This is why it makes no sense to study artists' colonies only in terms of the biographies of selected individuals: they were *collective* formations, and all critical interpretation must turn on that circumstance.

Constructing a place-myth: Worpswede

Of the initial group of Worpswede painters, Fritz Mackensen was the first to visit this village in the Teufelsmoor region of Lower Saxony. He stayed there in the summers of 1884, 1886 and 1887, and in 1889 was joined by his friends and co-students at the Düsseldorf academy, Otto Modersohn and Hans am Ende. Modersohn and Mackensen both stressed in their writings that this was a landscape such as they had never encountered before. 'Highly original' and 'exotic' ('fremdartig') was Modersohn's verdict.[14] Mackensen said that he had 'never seen anything like' the reflections in the Wümme river near Worpswede.[15]

However, if there was an originality about Worpswede, it did not imprint itself immediately onto the artists' canvases. Indeed, it is difficult to ascertain whether the painters even experienced Worpswede as 'original' when they first saw it. It is important to note that the testimonies cited above were penned after the event, in Mackensen's case in 1938, that is, a full fifty-four years after his first visit.[16] The one extant piece of writing actually dating from the time is a postcard Mackensen wrote to his mother the day after his very first arrival in Worpswede in 1884:

> Hier in Worpswede ist es sehr hübsch, weit im Umkreise sieht man die malerischen Heideflächen, hübsche, alte Häuser mit Strohdächern kann ich hier in Hülle und Fülle sehen. Auch Bremen habe ich mir angesehen.[17]

> (It's very pretty here in Worpswede, all around one sees the picturesque heaths, here I can see old pretty thatched cottages in abundance. I also looked around Bremen.)

The epithet 'hübsch' (pretty) is rather generic, and the mention of Worpswede and Bremen in one breath is another sign that the distinct character of the village had not yet been established in the artist's mind. In the later memoir of this first visit (the one written in 1938), Mackensen was at pains to stress the difference between the two places, urban Bremen and rural Worpswede, describing the journey in detail and drawing especial attention to the border separating the Hanseatic city of Bremen from the countryside of Lower Saxony: 'Von der Bremer Grenze ab wurde der Weg sehr schlecht, er war damals noch nicht gepflastert.'[18] (From the Bremen border onwards, the road became very bad, it hadn't yet been paved.) Judging from the 1884 postcard, however, the two locations seem to have been equally interesting as unfamiliar sights to the newcomer.

The point is that upon first arriving in the unfamiliar place, both Mackensen and Modersohn made sense of it in terms of what was familiar. It was only later that they constructed Worpswede as an 'original' place and put together a representative set of 'typical' motifs and attributes. This constructed type proved so powerful that it coloured the artists' own reminiscences. A close examination of some of the Worpsweders' paintings will illuminate the elements of this stereotype.

Hamme Meadows with Weyer Mountain is one of the many small studies produced by Modersohn in his first few weeks in Worpswede during July and August 1889 (colour plate 7). It presents a view of a landscape on an overcast day, comparable in its grey tonality, leaden sky, loose handling of paint and compositional scheme to works by the Hague School painters in the Netherlands, such as *Allotments near The Hague* by Jacob Maris (1870s, Haags Gemeentemuseum, The Hague).[19] There is none of the colour exuberance found in later paintings of the region. The play of reflection on the water's mostly opaque surface is kept to a minimum. There is also no attempt at rendering sunlight or clouds chasing across a blue sky. This small study and its companion, *On the Hamme River* (1889, private collection),[20] are vistas in the conventional sense: they include local landmarks, such as the Weyerberg or Weyer Mountain (the low hill on the horizon line) and the spire of the village church to the left.

These early studies are full of tentative dabs. The impasto is thickly applied as if the brush kept returning to the same spot on the canvas, nervously working out ways of rendering a new and unfamiliar locality. There are, to be sure, one or two signifiers of 'Worpswede' in these studies – *On the Hamme River*, for example, contains the lugsails of two peat boats – but these do not coalesce to form a coherent statement of the place. The cow, the ducks, the windmill, the muddy path and the cottage among the trees are generic markers of the countryside not immediately identifiable as place markers peculiar and particular to Worpswede alone. By contrast, Modersohn's later painting *Autumn Morning on the Moor Canal* (colour plate 8) breathes 'Worpswede' in every one of its brush marks.

Autumn Morning on the Moor Canal was exhibited together with other Worpswede paintings at the international annual exhibition, the *Jahresausstellung*, in Munich's Glaspalast (Glass Palace) in 1895. This was the exhibition that catapulted the group of painters in Worpswede to national fame and founded their reputation as nature painters of the moor. It earned them the label 'Worpsweders', and Modersohn's painting is a virtual compendium of all that was thenceforth to be associated with that North German village and the region surrounding it, the so-called Teufelsmoor. The painting contains many of the motifs that recurred in all Worpswede pictures: the rows of birch trees, the flat horizon, the cloud-streaked sky, the moor canals, the thatched cottages, the peasants dressed in red, the piles of peat stacked to dry. In fact, about the only 'typical' elements missing are the small wooden canal bridges and the rectangular sails of the local peat barges – but these return in abundance in other paintings by Modersohn and company.

Autumn Morning on the Moor Canal shows a scene along one of Worpswede's moor canals (colour plate 8). Most of the incident in the landscape is concentrated in the middle ground, along a triangular shape of terrain receding into the distance at right. Here, we see a woman with an implement (a rake?) bent over a box-like construction, a thatched timber-framed cottage, a row of slender-trunked birch trees with their tops cropped by the upper edge of the canvas, and a barefoot girl carrying a baby along a path to the cottage. The bright ochre foliage of the trees indicates that the season is autumn. The foreground is dominated by a large wedge of water, covered in scattered autumn leaves and reflecting the sky, the trees, the shoreline and some ducks along its edge. A clump of grass in the lower right corner anchors the composition and also indicates the painter's and the viewer's position on the other side of the canal, or perhaps on a bridge. The surface of the water is agitated by horizontal ripples, suggesting the presence of a light breeze. In the middle distance, we see more birch trees and two more thatched cottages. These are the only objects rising above the flat plain of the moors. The sky is pale blue, streaked with cloud. There are few attached shadows but the trees cast long shadows that converge towards the centre of the canvas, implying that the sun is low in the sky and situated somewhere behind us, the viewers. Much is also made of the play of shade and dappled sunlight on the wall of the near cottage. A warm glowing colour scheme unifies the composition. Light green and yellow-beige hues spread across the canvas in moist, textured strokes. The white birch trunks are crisply delineated, the foliage feathery. The figures complement their natural surroundings, seeming intent on appropriately rural activities and not large enough or detailed enough to detract from the landscape. The hues of their red and blue clothes and their yellowish-white hair (or, in the woman's case, headdress?) are echoed throughout the painting. In this way, the people are made to be part of the landscape. The cottages themselves also do not obtrude on to nature. The near cottage is contoured in similar irregular fashion to the shoreline of the canal, its colour is that of the earth and rushes, and it nestles among vegetation. Buildings are made to appear as natural outcrops.

The overall impression is one of a vast expanse of sky and space, open to the wind and light, but made homely by the domestic scene in the middle ground and the cheerfully coloured birch leaves. There are few details. All is saturated in colour and atmosphere. This is a painting of immersion in nature *par excellence*. The crisp textures and outlines, the glowing colours and avoidance of the admixture of black, the foreground bringing grass and water close to the beholder's position, the open sky moving around and through the foliage: all combine to make viewers imagine that they can hear the rustle of the leaves and feel the freshness of the autumn breeze on their own skins.

Apart from specific motifs, the other principal elements that came to be associated with Worpswede were the colour and the reflections on the waterways. In his memory of his first visit to Worpswede, Mackensen listed the familiar landmarks – birch trees, wide horizon, peat stacks, canals, black sails, peasant women in red

blouses and white headdresses – but also remarked upon the magical quality of the colours and the water's reflections.

> Als wir in die Nähe von Lilienthal kamen, wurde der Farbenzauber immer herrlicher. Als der Weg dann über die Wümme führte, war das Luftgespiegel im Wasser so zauberhaft, daß ich aus dem Staunen nicht heraus kam.[21]

> (When we came into the vicinity of Lilienthal [near Worpswede], the colour magic became ever more wonderful. When the way then led across the Wümme river the airy reflections in the water were so magical that I couldn't stop being astonished.)

Both colour and reflections were frequently attributed to the special character of the sky above the moors. Fritz Overbeck rhapsodised:

> Was hülfen uns unsere Strohhütten, Birkenwege und Moorkanäle, wenn wir diesen Himmel nicht hätten, welcher alles, selbst das Unbedeutendste adelt, ihm seinen unsagbar koloristischen Reiz verleiht, der Worpswede schließlich erst zu dem macht, was es ist.[22]

> (What good would be our thatched huts, birch-lined paths and moor canals if we didn't have this sky which ennobles everything, even the most insignificant things, which gives everything its unspeakable colour charm, which in the end makes Worpswede what it is.)

Colour magic, golden light, spellbinding reflections: this was what artists singled out as the special attributes of Worpswede. The motifs described by Overbeck and the qualities remembered by Mackensen were to be invoked in almost every painting and text regarding Worpswede from 1895 onward. They were the stuff of the fully elaborated place-myth. What is striking, however, is how few of these characteristics are to be seen in the very first paintings produced in Worpswede in the late 1880s. *Autumn Morning on the Moor Canal*, painted six years after Modersohn's first sojourn in the region, is instantly recognisable as a typically 'Worpswedish' image. *Hamme Meadows with Weyer Mountain* is not (colour plates 7, 8).

The sketchy efforts by Modersohn of July and August 1889, though they contain the germs for later developments, resemble previous studies done by the artist in other German localities. For example, the sunless atmosphere and disposition of a dark figure to the right of a white opaque river, visible in *Hamme Meadows with Weyer Mountain*, are also found in an earlier study executed in Modersohn's home town of Münster, *Near Wien Castle* (1887, Otto-Modersohn-Museum, Fischerhude).[23] These continuities indicate that painting in a new location was not a matter of the artist instantly recognising the peculiar characteristics of the unfamiliar place and changing his style in accordance with his 'discoveries'. On the contrary, it took Modersohn several years to work out what was to be the typical 'Worpswedish' atmosphere. The painter's first studies

show how he worked at fusing disparate experiences into a composition. Six years later, another study like *Hamme Meadows* points up the contrast to the earlier efforts (figure 46). This work is a fluent jotting-down of some essential elements that have been filtered out from the earlier studies and have come to signify 'Worpswede'. The palette has become lighter, the paint application crisper, the colours purer and containing a greater admixture of white. The water curving into depth in the earlier work has been straightened, and the wooded hills in the background and the repoussoir trees clustering at right have been removed in favour of an uncluttered expanse of meadow and sky – a prime instance of a minimal landscape of immersion (see chapter 5). Little attempt at topographical accuracy remains. We do not need to see the spire of Worpswede's church to know that this is Worpswede. In fact, the flat horizon, luminous sky and linear canal came to denote something much more 'Worpswedish' than any topographical landmark in the traditional sense.

A similar process can be seen in all the other Worpswede painters' *oeuvres*. For example, an early study by Mackensen, *Landscape with Moor Canal* (figure 47), done on his third solitary summer visit in 1887 and inscribed on the back 'Die erste in Worpswede gemalte Landschaft' (The first landscape painted in Worpswede), includes some of the later 'typical' features of Worpswede – birch trees, canal with wooden bridge – but the trees are given no prominence as significant specimens. They are clustered together at right, with little attention given to the surface texture of their bark, the distinctive silhouettes of their tree trunks, or their evenly-spaced distribution along a straight line: features which were emphasised in almost all later

46 Otto Modersohn, *Hamme Meadows* (Worpswede), 1898, 37.5 x 58 cm

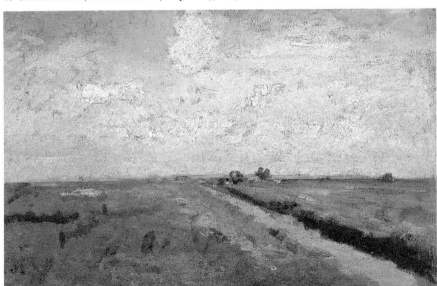

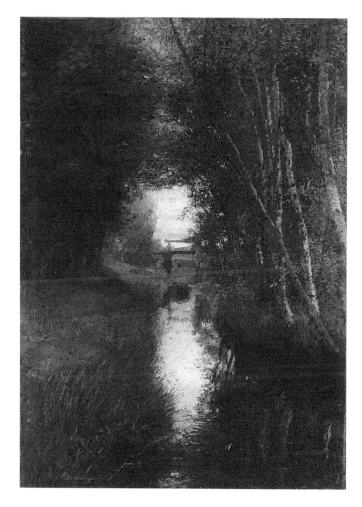

47 Fritz Mackensen,
*Landscape with Moor
Canal* (Worpswede),
1887, 33 x 23 cm

Worpswede birch-tree pictures (colour plate 8, figures 48, 56).[24] By contrast, the
viewpoint of Mackensen's later *The Moor Ditch (On Bergedorf Bridge)* (1895) has
been 'zoomed back' to include a prospect of the horizon, an expanse of moor, more
characteristically contoured birch trees as well as the canal's accelerated recession
into depth (figure 48). This had by then become the standard way of representing a
moor canal and partakes of the thoroughly worked-out place-myth.[25]

Finally, let us have a look at how a figure composition was gradually 'Worps-
wedised'. Mackensen first conceived of the idea for his painting *Sermon on the Moor*
in the summer of 1887 on a visit to a missionary sermon held in the village of
Schlußdorf, not far from Worpswede. An ink sketch made shortly after this visit
includes virtually no 'Worpswede' elements (figure 49). In the final version (figure
50), Mackensen has opened up the background to reveal the horizon, discarded the
closely-spaced nondescript trees in favour of distinctively silhouetted birch trees,

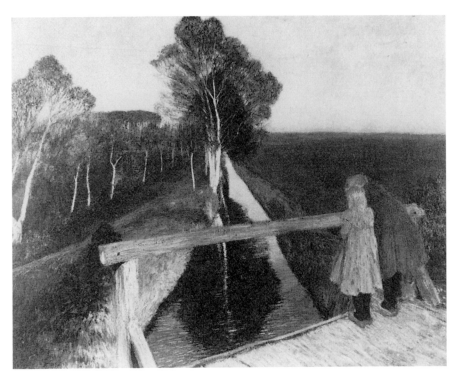

48 Fritz Mackensen, *The Moor Ditch (On Bergedorf Bridge)* (Worpswede), 1895

and replaced the imposing half-timbered façade of the building in the sketch with
more obviously thatched and unsophisticated cottages. He also paid more attention
to emphasising peculiarities of costume. A painting based closely on the original
sketch would not have looked very 'Worpswedish' at all.[26]

Of course, at the time when Mackensen first produced this sketch, there *was* as
yet nothing that was 'Worpswedish'. The typicality of the region had still to be con-
structed. The first artists in Worpswede were faced with an inchoate collection of
objects, people and impressions. One might argue that surely there is nothing
remarkable about having to get used to a new place, and that the change in the
Worpsweders' mode of painting from something like *Hamme Meadows with Weyer
Mountain* to something like *Autumn Morning on the Moor Canal* (colour plates 7, 8)
came about because the painters' understanding of the landscape grew increasingly
profound the longer they lived there. This argument loses its force, however, when
one considers later painters in Worpswede. For example, Paula Modersohn-Becker
and Ottilie Reylaender who first came to Worpswede in 1897 and 1898 respectively,
almost immediately settled into working in the 'Worpswedish' mode in front of the
by-then characteristic motifs. They did not need a period of acclimatisation
because the schemata for 'Worpswede' were already in place for them to utilise.
These painters' earliest sketches and drawings already include thatched huts,

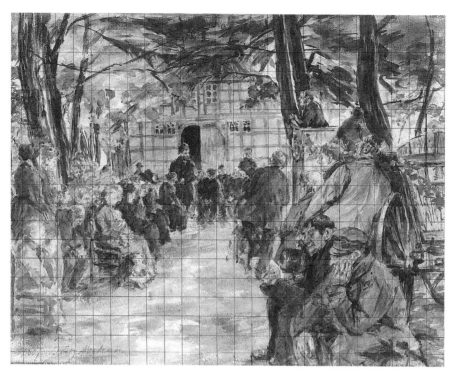

49 Fritz Mackensen, Study for *Sermon on the Moor* (Worpswede), 1887

50 Fritz Mackensen, *Sermon on the Moor* (Worpswede), 1895, 235 x 376 cm

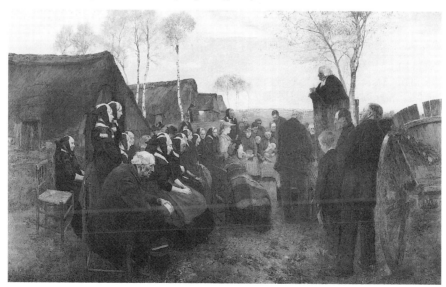

fields, birches, flat horizons, costumed peasant girls and other elements of the fully-fledged place myth of Worpswede.[27]

The Worpswede story stands as a representative example for all rural artists' communities. The principal components of the process of place-mythmaking can be found in all of the villages: the accumulation of a repertoire of stock motifs and atmospheric effects, the collective development of such a repertoire (through painting together in front of the motif, communal criticism or conversation), the availability of these patterns to all artists coming to a village (even if they only stayed for a few weeks), and the dissemination of the images thus produced to a wider audience via exhibitions, postcards, reproductions and textual elaboration in periodicals and books. The experimental mixing-and-matching of myth and reality in Camille Corot's Barbizon pictures of the 1830s (some of the earliest paintings to be done in an artists' colony *tout court*) gave way to the settled stereotypes of Karl Bodmer's oak, Louis Cabat's boulder and all the other familiar landmarks of the place-myth Barbizon. In Grèz, it was the 'famous bridge' that was painted by dozens of artists, in Sint-Martens-Latem a particular bend in the Leie river, in Pont-Aven the harbour, the mills, the Bois d'Amour and the costumed locals – and so forth.[28] As Denise Delouche has pointed out, very few of Gauguin's subjects in Pont-Aven were not derived from the flourishing place-myth that had been elaborated by a succession of artists for twenty years before Gauguin's 1886 arrival in the village.[29] Just like Modersohn in Worpswede, it took Gauguin one or two seasons to determine what was to be his particular mode of painting in this new environment, and, much as in the case of Modersohn, his very first pictures of Pont-Aven look a lot like the paintings he had done during the immediately preceding period in Normandy in terms of composition and technique.[30] However, unlike Modersohn, Gauguin enjoyed the benefits of a long-established artists' community which meant that not only were there inns and social networks galore but also well-worn protocols of sketching. Any new arrival could slip quickly and easily into the routines set up for him and spend his energies working with, through or against the existing place-myth.

Nature seen through art: Worpswede and Pont-Aven

We have seen how, once in place, a set of stock motifs and themes was readily available for all later artists and visitors to make use of. Together, these stock motifs add up to what visitors and viewers have come to recognise as the 'typical' Worpswede (or Pont-Aven, Grèz and so forth). However, the first 'pioneer' artists, too, came with prior expectations. Mackensen later hailed the Worpswede he first encountered as 'malerisches Neuland' (artistic virgin territory).[31] As we have seen, both he and Modersohn claimed that they had never seen anything resembling Worpswede. However, both artists had, in fact, seen similar landscapes before: in art. The Teufelsmoor itself was, perhaps, 'virgin territory' but the expectations of rural nature and pictorial habits inherited from previously seen pictures were not. For

example, Mackensen's early Worpswede picture, *Landscape with Moor Canal*, has a distinctly *sous-bois* look about it (figure 47). The first Worpswede painters were wont to describe their new environment in terms of previously seen pictures, in particular those by the Barbizon painters Jules Dupré, Millet and others. Fritz Overbeck recounted how one evening, he saw an enormous cloud, glowing as if coated in liquid gold, just like the cloud in a painting by Dupré.[32] Mackensen wrote to Modersohn that around Worpswede he had seen 'pictures, as original as only those painted by Millet are'.[33] Imperceptibly, art merged with life: Modersohn acclaimed a peasant girl he had seen on his first visit as 'a real Millet'.[34] Several weeks later, he noted that he saw the most exquisite pictures or images ('Bilder') in all directions and that he often stood still before the beauty and greatness of these pictures.

> Herrlicher grauer Tag; Weib auf dem Acker, gegen die Luft – Millet. Bleiben auf der Brücke, die dort über den Kanal führt, stehen, nach allen Seiten die köstlichsten Bilder. … Es waren unvergleichliche Tage. Grau der Himmel, eilig jagten die Wolken, die dunklen tiefen satten Ockertöne, die Mistfahrer, ganze Schwärme von Krähen wie gebannt, blieb wie oft stehen vor der Schönheit und Großartigkeit dieser Bilder. Einmal gegen Abend mit am Ende auf dem Weg nach Nordwede … ein unbeschreiblich nobles Kolorit.[35]

> (Wonderful grey day; woman on the field, against the air – Millet. Stood still on the bridge that goes across the canal there, in all directions the most exquisite pictures. … Those were incomparable days. The sky grey, the clouds hurried quickly, the dark deep saturated ochre tones, the drivers of dung, whole swarms of crows as if frozen, as often, [I] stood still before the beauty and magnificence of these pictures. Once, toward evening, with am Ende on the way to Nordwede … an indescribably noble *Kolorit*.)

Note particularly the artist's use of the technical term *Kolorit* (normally referring only to colour in a painting) to describe the actual colour of the landscape. Modersohn described the landscape he traversed as if it consisted of a series of pic-torial motifs, almost as if it already *were* a picture, waiting to be realised in paint.

The reflex of viewing the landscape through the lens of paintings points to the fact that artists needed to make reference to other art in order to make sense of the environment around them. To the first artists in Worpswede, the village offered a sufficient number of motifs and subjects that corresponded to particular familiar schemata of nature painting. The correspondence was at times so close that it seemed to the artists as if their pictorial ideals had materialised in reality.

Nearly all contemporary writers on Worpswede (and, indeed, on any other artists' village) prefaced their accounts with an often lengthy description of the actual village, the landscape and the weather.[36] The inevitable descriptions-of-place preceding descriptions-of-paintings (or complementing illustrations) all conformed to the stereotype first elaborated *by* the paintings. This results in a closed circular argumentation: landscape causes paintings – paintings then look

like the landscape (which they have actually instantiated) – we see the landscape
through the lens of the paintings, and so it continues. Because of the prevalence of
this interpretative model in the writings on Worpswede as well as on all other rural
artists' colonies it is worthwhile analysing one of the most eloquent and frequently
quoted examples of the type in detail. It is the account written by the Berlin art his-
torian Richard Muther, on the occasion of his visit to Worpswede in 1901.[37]

Muther begins his essay with a discussion of 1880s plein-air painting and the
impact made by Arnold Böcklin's paintings and by the Scottish group of painters
known as the 'Glasgow Boys' when they exhibited their paintings at the Munich
Glaspalast exhibition some years earlier. He links the saturated colour found in the
Scots' paintings to the Worpswede artists' own style, saying they had gone to look
for 'Scottish' motifs in Germany. Here we are still within the purview of familiar
art-historical argument: earlier art influences later art. However, in his very next
sentence, Muther retracts that argument: '[I]n Wirklichkeit war die Geschichte
anders.' (In reality, the story was different.) In place of the art-historical narrative
of stylistic influence he now offers the 'real' explanatory tale of Worpswede art:
their art was 'actually' not caused at all by the mediating influence of other art but
by the landscape itself.[38] Muther insists that one can only understand the
Worpsweders' paintings once one has been in person to the soil 'from which they
grew'.[39] Leaving behind the traditional explanatory tools of art history, Muther
boards the carriage to Worpswede and looks around him in wonderment. His
description of the journey from Bremen to Worpswede deserves to be quoted here
at length:

> Eine Fahrt nach Worpswede ist eine Staroperation: als schwinde plötzlich ein grauer
> Schleier, der sich zwischen die Dinge und uns gebreitet. Gleich wenn man der
> Zweigbahn entstiegen ist, die von Bremen nach Lilienthal führt, beginnt ein selt-
> sames Flimmern und Leuchten. Haben diese Bauern einen Farbendämon im Leib?
> Oder ist's nur die Luft, die weiche, feuchtigkeitsdurchsättigte Luft, die alles so farbig
> macht, so tonig und strahlend? Ich blicke auf die blauen Zügel, die mein Kutscher
> hält. Sie phosphoreszieren und flirren. Ich blicke auf die blauwollenen Handschuhe,
> auf das tiefrote Brusttuch eines Bauernpaares, das ganz fern auf der Landstraße
> daherkommt – sie leuchten und strahlen wie von innerem Feuer durchglüht. Da
> steht ein Arbeiter in hellblauem Kittel neben einem perlgrauen Birkenstamm. Dort
> hängt an einer Leine ein roter Unterrock, und er sprüht Farbe wie Purpur. Dort ist
> eine Bauernhütte blutigrot gestrichen, ähnlich denen, die es in Norwegen gibt. Doch
> während dort in der dünnen durchsichtigen Luft alles klar sich abzeichnet, wird es in
> Worpswede zur Tonsymphonie.[40]

(A drive to Worpswede is an operation for cataracts: as if a grey veil that had been
spread between all things and us were suddenly to disappear. As soon as one alights
from the branch line that runs from Bremen to Lilienthal, there begins a strange
shimmering and glowing. Do these peasants have a colour demon in their bodies? Or
is it just the air, that soft air, saturated with moisture, that makes everything so
colourful, so tonal and radiant? I gaze at the blue reins held by my coachman. They

phosphoresce and scintillate. I gaze at the blue woollen mittens, at the deep red shawl of a peasant couple who are walking along the countryroad in the far distance – they glow and shine as if animated by a burning inner fire. Here stands a worker in a light blue smock next to a pearl-grey birch tree. There, on a washing line, hangs a red petticoat, and it sprays colour like crimson. There is a peasant hut, painted blood red, similar to those in Norway. But while in that country everything is delineated clearly in the thin transparent air, in Worpswede it turns into a tonal symphony.)

The contrast of Muther's confident, poetic evocation of Worpswede with Mackensen's conventional remarks about the prettiness of the village back in 1884 is striking (see above, p. 118). The difference is that Muther was entering the Teufelsmoor fully equipped with the requisite expectations and mental images to help him make sense of what he encountered. He stepped into the place-myth, and for Muther it was as if he had stepped into one of the Worpsweders' paintings come to life. There is actually nothing in his description that had not already been represented in one or more Worpswede pictures. What is remarkable is how a professional art historian could discard the devices of his trade (formal analysis, tracing influences, classifying style) when explaining the artists' colony of Worpswede. It is an example of the potency of place exerting its hold over a writer who is otherwise most art-historically disciplined.[41]

The habit of locating explanatory value for works of art within the landscape itself persists in the literature on all rural artists' colonies to this day. Indeed, the notion that the landscape had somehow caused the art still is the dominant interpretative model for art historians, critics, curators and other viewers attempting to understand the productions of rural artists. Most present-day accounts have uncritically taken on board the nineteenth-century model of attributing the look of the art to the look of the land. Indeed, some even take this view to extremes. For example, three doctoral dissertations claim that the colours and forms in Worpswede paintings directly resulted from the prevailing atmospheric conditions and the character of the moor land.[42] Countless publications on European rural artists' colonies devote considerable space to the description of the village and the countryside, as is and was.[43] Descriptions of the place based on the author's personal experience, historical photographs of costumed locals and fishing boats, detailed maps, inventories of important landmarks and statistical information on the village population are offered as supplements and complements to the art produced there. Such information is, of course, invaluable for any scholar wishing to find out more about conditions in artists' rural locations. However, the assumption made in most of the literature is that this kind of historical material provides the background, the 'reality', as it were, of which the artists' pictures are a faithful rendering.

This point may be illustrated using the example of Judy Le Paul's book, *Gauguin and the Impressionists at Pont-Aven*. Here, turn-of-the-century photographic postcards are reproduced side by side with paintings of the same motif seen from the same viewpoint. For example, Le Paul reproduces different picture postcards of

51 Postcard showing the Ty-Meur Mill at Pont-Aven, view from upstream, *c.* 1890 , from Judy Le Paul, *Gauguin and the Impressionists at Pont-Aven*, 1987

52 Paul Gauguin, *Washerwomen at Pont-Aven* (Pont-Aven), 1886, 71 x 90 cm

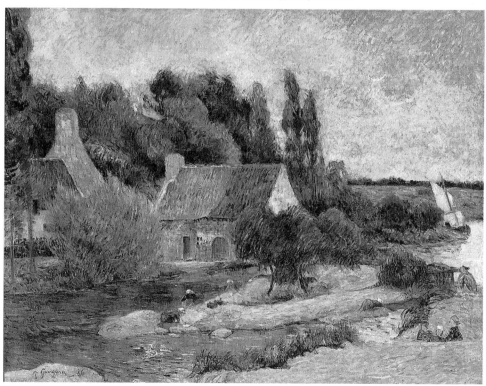

the Ty-meur mill on the Aven river (dated around 1895 and 1900) with paintings of
that mill by Eugène Boudin, Adolphe Marie Beaufrère, Gauguin and Ernest
Ponthier de Chamaillard (figures 51, 52, 53).[44] The assumption seems to be that the
photographs represent the 'real' Pont-Aven and the paintings the artists' (accurate)
perception of it. These juxtapositions confirm the belief that the artist depicted
Pont-Aven 'as it was', with the photograph acting as a documentary eyewitness.
But it also shows something rather different and much more interesting, namely
the extent to which the marketing of Pont-Aven in the form of picture postcards
had by 1900 assimilated itself to the place-myth produced by artists. The Ty-meur
place-image had been elaborated by repetition and convinced photographers that
this particular mill, seen from this particular standpoint, was 'typical' of Pont-
Aven.

Picture postcards are an interesting and under-researched resource: their
addressees were, presumably, tourists.[45] The very existence of a fair number of dif-
ferent picture postcards of a place is an indication to what extent that place had

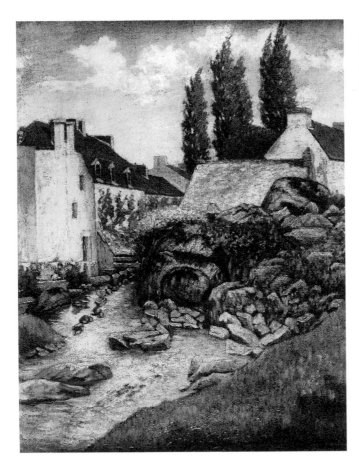

53 Ernest Ponthier de
Chamaillard, *View of
Pont-Aven*, 1889,
52.5 x 42 cm

become a tourist destination. Picture postcards function as souvenirs of but also as markers for sights. Dean MacCannell argued that tourists collect souvenirs as relics of sights they have seen. Sights are marked out to visitors. An unmarked sight is not a sight: if sights were not marked, they would often be indistinguishable from less famous relatives.[46] The Ty-Meur mill postcards reproduced a sight that had already been marked and sacralised by artists' paintings but they also reiterated that marking by their very presence in a village shop. Tourists may have seen the postcard and read the caption before they had seen the actual mill itself; seeing the postcard may have provided the stimulus sending them off to find the sight in the first place.

Le Paul also reiterates the topos of attributing causal powers to the land itself. She states that the fields of Pont-Aven, 'worked by the peasants and surrounded by uneven granite walls ... lent themselves to the development of cloisonnism and Synthetism'.[47] This assessment is interesting because it relates not only the artist' subject matter to the land but also their style. Just as writers on Worpswede since 1895 have attributed the Worpswede painters' use of rich, glowing colours to the coloristic properties of the Teufelsmoor, so do writers on Pont-Aven tend to ascribe the use of dark outlines to subdivide the canvas into blocks of colour (as practised by Emile Bernard, Paul Sérusier, Maxime Maufra, Gauguin and others) to the look of the Breton countryside (figures 20, 54). In 1898, Delphi Fabrice made the familiar claim that those people who accused Maufra and his colleagues of using strident colour had obviously never seen or understood the actual Breton landscape.[48] This echoes Muther's declaration that one has to visit Worpswede to understand the art made there. In 1903, Armand Séguin, friend of Sérusier's and one-time denizen of Pont-Aven and Le Pouldu, voiced the same sentiment:

> the landscape they [the Pont-Aven painters around Gauguin] saw before them every day was a wonderful help in reaching the goal of their desires: synthesis, and the characteristic feature. Round them was the soil, with its bony structure showing; the stone walls sketched the shapes of the fields they surrounded, forming *cloisonné* patches of red, green, yellow or violet, according to season, hour and weather.[49]

Wladyslawa Jaworska in her much-quoted monograph on the Pont-Aven School devotes one paragraph to describing the landscape of Brittany – the 'blazing yellow and emerald green of the fields', the 'oblong patches of yellow' – and offers the following explanatory closure: 'Thus the landscape imposes its own synthesis of form and colour.'[50] In this account, the 'synthesis' of the land causes the 'Synthetism' of artistic style.

Even when disregarding the complex mediating processes involved in representing reality pictorially, it would be difficult to uphold the notion that the look of the local landscape was solely responsible for the style of the paintings, in view of the different styles of painting coexisting and succeeding each other in any one artists' colony. For example, if we compare Sérusier's *Dedication of Notre-Dame at*

Châteauneuf-du-Faou with William Lamb Picknell's *On the Borders of the Marsh* (figures 54, 55), we must conclude that other factors besides seeing the walled fields of Brittany were instrumental in Sérusier's use of opaque fields of colour and dark outlines. If the walled fields were such an outstanding feature of the landscape, why were they not painted by Picknell and other earlier painters in Brittany? As Delouche has pointed out, there were almost no artists before Gauguin who paid attention to the *bocage* patchwork shapes of the local agricultural terrain.[51] Sérusier's (and other Synthetists') formal idiom owes much to the *cloisonnisme* based on stained-glass windows and enamel painting, developed by Louis Anquetin and Bernard in Paris in the late 1880s, and arguably it was this avant-garde formal language that initially alerted Sérusier to the *cloisonniste* potential of the Breton fields, not the other way round. The walled fields then entered the place-myth as a new motif for all subsequent painters to exploit. We recall that Muther, too, could only see the Worpswede landscape as a 'symphony' of tonal values and colour patches because he had first seen the Worpsweders' paintings.

Throughout this chapter I have disputed the belief that the physical properties of a given place somehow caused the art made there. What I do want to hold on to,

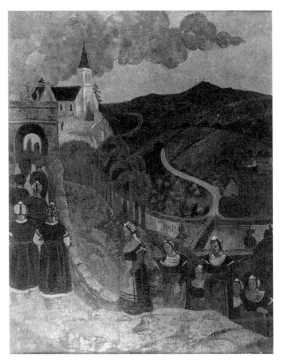

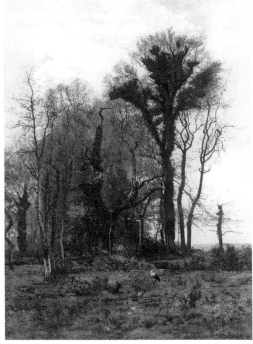

54 Paul Sérusier, *Dedication of Notre-Dame at Châteauneuf-du-Faou*, 1896, 91 x 72 cm

55 William Lamb Picknell, *On the Borders of the Marsh* (Pont-Aven), 1880, 200.7 x 151.1 cm

however, is the intense commitment to the real givens of a place, on the part of the artists and their art as well as on the part of the audience, and their psychic and affective investments in that art. Both parties needed place to be central to the determination of meanings residing in the images coming out of rural artists' colonies. The meanings woven into the fabric of the pictures melded the general with the particular: the specific irreducibilities of a certain topography and its inhabitants (birch tree, Ty-meur mill) inflecting the more inclusive categories of agrarian romanticism and immersive nature. The latter were the same in all artists' colonies, the former provided the 'local colour' that promised a link to reality.

The key to how diverse locations were assimilated to general ideals of pre-modern nature and agrarian tradition was selection. Selection of certain elements implies exclusion of others. We have already seen many of the aspects that were chosen, so I now want to cast a brief look over what was excluded. The processes of choice on a Europe-wide level are the subject of the next chapter; here, I will again focus on the micro-environment of Worpswede.

The village of Worpswede itself was rarely depicted, neither the local poorhouse building nor the residences of its wealthier inhabitants. These structures were not deemed 'Worpswedish' enough, although they were prominent buildings in the centre of the village, owned or run by local dignitaries. The Stoltes, Fritz Mackensen's hosts on his first sketching stays in Worpswede, were one of the wealthy local families. Stolte was a widely-respected merchant and chairman of the parish council. The Stolte residence was a substantial two-storeyed house with large casement windows, situated in a park-like garden and entered through a gateway made of two gigantic whale jawbones. Above the front door was a coat of family arms, colourfully painted.[52] Another stately modern building (erected in 1875/76) was the house of a certain Johann Monsees (now the Galerie Cohrs-Zirus). Heinrich Vogeler remembered that many of the villagers had relatives who had emigrated to America; one of these had become a 'millionaire' dealing arms in the American Civil War and was living in Worpswede in the 1890s.[53] The village also boasted a number of large farms with extensive buildings and well-kept gardens, handsome shops, a comfortable vicarage, a pharmacy, several inns and, after 1900, the artists' own newly-erected villas.[54] But neither local dignitaries nor ostentatious mansions excited the pictorial interest of the painters. They were there to paint nature and pre-industrial life. The only kind of architecture deemed to be consistent with nature was a thatched cottage on the moor, and the only vocation consistent with pre-industrial life was that of peat peasant, the least privileged occupational group of the region.

Worpswede was represented by artists as a natural place, untouched by modern civilisation and untouched by prosperity. It was a view that had preceded the arrival of artists. In 1857, the Lower-Saxon regional poet Hermann Allmers had represented the Teufelsmoor near Worpswede as a primordial and spooky territory. The moor's inhabitants, according to Allmers, were either superstitious peat peasants,

desperately poor and completely isolated, or sinister riff-raff.[55] Ideas about the primeval character of the region were assimilated into the artists' own image of the place. Modersohn-Becker described the Worpswede villagers as an ancient race, tied to the soil, and Rilke called the country 'grausig' (ghastly) on his first visit.[56] This is a good example of how artist-colonists absorbed regional place-myths that were already in circulation before the establishment of an artists' community and assimilated them to the specific place-myth they were constructing of 'their' village. More on this kind of assimilation follows below.

Perhaps the moor could seem isolated and empty when compared with nearby Bremen but primordial it was not. The moor was a thoroughly cultivated landscape, and it looked the way it did because of human interference with topography. In the mid-eighteenth century, the electorate of Hannover had appointed a royal commissioner of the moor to colonise and cultivate the underpopulated region. This man, Jürgen Christian Findorff, was responsible for the modern appearance of the Teufelsmoor. He began surveying the area in 1751, and then dug canals to drain the moor and built settlements along the new canals. He probably also planted many of the birch avenues along the canals for timber, as wind breaks and to anchor the soil. As a result of this activity, Worpswede became a small regional centre for the outlying moor hamlets.[57]

It is illuminating to read Hans am Ende's *Summer's Day* against the background of this history of cultivation (figure 56). The painting conveys an effect of seclusion from the modern world and evokes the experience of immersion in nature. The

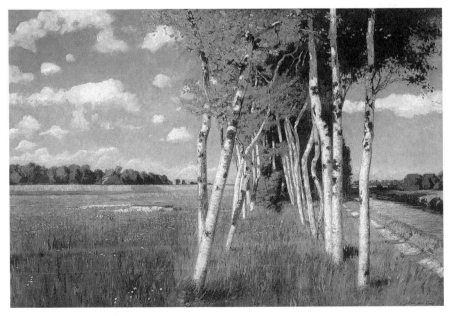

56 Hans am Ende, *Summer's Day* (Worpswede), 1901, 135 x 200 cm

perspectivally receding avenue of birch trees is a kind of miniature *sous-bois* so that the picture combines the sense of enclosure afforded by a forest interior and the sense of wide open plains and skies associated with the moor. The landscape is pristine and empty of people but traces of human habitation appear in the form of a towpath and a low hut, although the latter is so squat and brown that it merges with the background of trees and becomes a part of nature. Interestingly, though, am Ende's painting reveals – despite itself – the highly cultivated character of Findorff's landscape. No 'natural' stream would flow so straight, and no wild group of birch trees would grow in such a straight line. The stereotypical view of canals and straight birch avenues, so often painted by the Worpsweders, actually indexed an artifical and relatively modern landscape.

Worpswede painters such as am Ende did not efface the signs of human manipulation of the landscape. The point is that they painted them *as* 'nature', not as triumphs of human mechanical power *over* nature.[58] They did not eliminate moor canals from their representations as they eliminated the wealthy villas. This kind of evidence of labour could be subsumed into ideologies of the 'natural' just as agriculture could be (provided it did not involve any modern machinery). In the Worpsweders' paintings, the moor could be both: artificial creation *and* natural nature. Painting the artificial *as* nature is not a mythical move or one involving misrepresentation. It is a metaphorical move. A metaphor preserves both the original referent and the substituted signifier. For example, when someone tells us that 'the sky weeps', we understand 'tears' and 'rain' simultaneously, which makes for the poetic power of the figure. In Worpswede, too, we see 'Findorff's canals' and 'primordial untouched nature' simultaneously. There is no point in prising them apart or in assigning more truth value to the historical fact than to the artistically produced poetry.

At this point, I need to return to Shields' concept of place-myth in order to modify it in one crucial regard. The designation 'myth' is problematic if it is taken to imply that it is possible to peel away the 'mythical' trappings of a set of representations and reveal a kernel of 'truth' inside. To be sure, if understood as a formation that generates meanings and produces certain forms of knowledge, the word 'myth' retains its potency, and it is in this latter sense that I use it throughout this book. However, it may possibly be more illuminating to talk about paintings produced in rural artists' colonies as place-metaphors. We may even go further and call them metaphors of a modern nostalgia for the pre-modern. The collective bodies of representation issuing from the various artists' villages across Europe anchored the powerful but vague yearnings for an alternative to modernity in particular real places on the map. This is how the metaphor of the pictures fulfilled a metonymic function as well, as indices for reality.[59] The paintings discussed in this book are not only images of immersion that viewers may dream themselves into, they are also actual physical sites that anyone may visit and traverse in real space and time. We will follow in the footsteps of this tourism of nostalgia in the next chapter.

Competing claims: Pont-Aven and Dachau

Artist-colonists were not the only ones laying claim to a specific rural place. This section examines how artists used, opposed and negotiated their way around alternative place-images, using the two case studies of Pont-Aven (to illustrate the pull of wider regional stereotypes) and Dachau (to examine alternative local views of one place).

Images of Pont-Aven cannot easily be disentangled from stereotypes about the Breton province as a whole, which inevitably spilled over into how visitors saw any single place within that province. The activities and paintings of artists in Pont-Aven, Le Pouldu and other Breton villages were part of the wider network of artist-colonial practice but they were also part of the network of representations of Brittany. Fred Orton and Griselda Pollock in their seminal essay on stereotypes of Brittany offer a persuasive explanation of the relationship of Gauguin's paintings and the socio-economic conditions of the province in the 1880s and 1890s.[60] The authors criticise curatorial and critical practice of the 1980s for stereotyping Brittany as a harsh, primitive and pious region. This embalms the region as a fixed and mythical entity and removes Brittany as a real place from the historical circumstances of production and change. Orton and Pollock outline an alternative image of a prosperous Brittany to counteract Gauguin's representation of the province as savage and primitive. I will refine this argument with regard to the place-myth of Pont-Aven. Some of the authors' claims need to be modified in order to be applicable to all of the Pont-Aven artists, not just the sub-group around Gauguin.

I would argue that it is not so much a question of identifying a mythical Brittany and one which is historically more plausible. No doubt, there were two Brittanys, and more than that. There were, to be sure, guidebooks that describe Brittany as a prosperous, picturesque region but this is as much a trope of guidebook literature as it is a statement about the world. Furthermore, there were also other guidebook and travel writers who represented Brittany as a primitive, uncivilised place. Almost all writers were unanimous in representing Pont-Aven itself as a picturesque and prosperous village (as noted by Orton and Pollock)[61] but many also characterised the Breton people in general as agriculturally backward, superstitious, poor and dirty.[62] The discrepancies are partly due to highlighting different aspects of the local economy, and partly arise from the different place-myths in circulation about Brittany.

Catherine Bertho demonstrates that the French image of Brittany as a distinctive province had emerged by 1830.[63] Brittany was cast as a primarily rural region with distinctive folkloric customs and costumes, marked by a different language and endowed with a large number of ancient monuments. While this framework continued into the twentieth century, there were historical shifts within the iconography chosen to embody Brittany's stereotypical characteristics. As Bertho shows, the dominant image of Brittany in the first half of the nineteenth century crystallised around the masculine figure of the long-haired, savage-looking peasant in

baggy Breton knickerbockers, armed with a so-called *penn-bazh* or club and prefer-
ably pictured before a stormy sky and against a Gothic ruin. After mid-century,
during the Second Empire, this image was replaced with a feminine stereotype: the
young Bretonne in costume and *coiffe* (the local headdress), kneeling piously at the
foot of a calvary. As memory of Breton monarchist *chouan* revolts during the
French Revolution faded, the image of a romantic but savage Brittany made way for
an image of a pleasant and picturesque land, peopled with simple traditional folk.
Bertho makes clear that the Breton stereotype was neither elaborated by nor
addressed to actual Bretons remaining on the land. Its audience was the rest of
France, particularly urban France. Tourism was a decisive factor in shaping the
formation of the picturesque (as opposed to the savage) stereotype of Brittany as
leisure space.

Gauguin's paintings were part of an intersecting pattern of different practices
and stereotypical expectations. On the one hand, the painter was engaged in elabo-
rating the national Breton stereotype, and this had little to do with the actual locals
he encountered (partaking of a general artist-colonial habit, as discussed in chapter
2). On the other hand, he was also engaged in an artistic search for pictorial sources
outside the Western tradition and for alternative modes of being an artist. When
Gauguin wrote that he had found 'the savage, the primitive' in Pont-Aven, he was
reactivating an earlier image of Brittany as a savage place, an image that (*pace*
Bertho) continued to surface throughout the late nineteenth century, alongside the
image of Brittany as a picturesque spectacle.[64]

Place-myths can persist in the face of reality. As Orton and Pollock point out,
Brittany did support a thriving seaweed industry, a buoyant fishing economy,
improved agriculture and a modern road and railway network, all factors that
would seem to militate against a notion of the province as primitive. However, the
region nevertheless continued to occupy a peripheral situation *vis-à-vis* the rest of
France, economically, culturally and linguistically.[65] No matter that some parts of
Brittany prospered agriculturally: to people outside the region, Brittany seemed
irredeemably pre-modern. Artists who travelled to a rural region and the audience
who viewed, bought and reviewed the art they produced there did not care about
the actual economic development of that region in any direct sense. That is, they
did care, but only in so far as any industry present should not impinge on the char-
acter of the place as a site for pre-modern nature. Seaweed gathering, for example,
was an activity that lent itself to being represented as a non-modern, non-industrial
task, as did haymaking or fishing by sailboat, and it is these activities that appear in
numerous paintings.[66] The railway, unsurprisingly, does not. As in Worpswede,
only certain aspects of the region were selected for the purposes of image-making,
and they were the ones that accorded with the various place-myths. Orton and
Pollock discern a sign of agricultural fertility in the *cloisonné* landscape described
by Séguin but, as I argued above with regard to am Ende's *Summer's Day* (figure
56), a representation of a cultivated landscape does not necessarily cancel out its
effectiveness as a signifier for the uncultured and primordial.

Both the 'picturesque' and the 'savage' Brittanys were, for outside visitors, part of the tourist matrix of meanings. This will be explored further in the next chapter. At this point, one last remark about different constituencies of travellers needs to be made, concerning the large numbers of non-French painters in Breton artists' colonies. Foreign visitors, especially the Americans who started the colony of Pont-Aven and were also present in force in Concarneau, were not necessarily familiar with the Breton stereotype as described by Bertho. They came with their own, divergent expectations of the place. Americans, particularly, tended to view all rural locations on the continent as manifestations of the pre-modern 'Old World' of Europe. Will Hicok Low observed that the French country

> even to-day is largely agricultural, devoted to culture on a small scale where man remains close to nature in his daily toil; a retention of quasi-primitive conditions which we have lost in our immense tracts cultivated by machinery, where the farmer is more familiar with profit and loss as shown by his ledger than he is with the furrow through which he drives the plough.[67]

Edward Wheelwright gazed about with 'his unfamilar eyes of a stranger from the New World' and was amazed at finding that Millet's 'biblical' paintings repre-sented real Barbizon scenes: 'Many of the images that illustrate so profusely the sacred writings and which to us are mere figures of speech, are in the old countries of Europe, as well as in the East, actual facts.'[68] The artists' eyewitness status to these 'facts' also incidentally anchored their pictorial claims to authenticity with regard to American audiences.

There is no scope to go into detail here, but the differing national stereotypes of particular countries and regions no doubt played a significant role in shaping the experiences of artists, audiences and the place-myths in circulation, especially in international colonies like Barbizon, Pont-Aven or Volendam.[69] In less polyglot vil-lages, like Worpswede, Skagen and Nagybánya in Hungary, painters' place-myths could serve to articulate ideas more focused on national identity. As the historian Alon Confino argues, the abstract concept of the nation could be very effectively represented through images of the locality and the region. Such images are the 'fundamental vehicle for internalising the impersonal nation by placing it within the familiar local world'.[70] Confino does not mention artists' colonies but one of the keys to the international success of these formations and the images they generated was the way in which specific places could be co-opted by an array of more general ideologies. As John Rennie Short points out, 'in most countries, the countryside has become the embodiment of the nation'.[71] Representations of specific rural sites anchored vaguely-held beliefs of nation or ethnicity in concrete 'reality'.[72] Generic interpellative devices, such as pictorial anecdotes and immersive foregrounds (see chapters 2 and 5), could be inserted into any painting of any village and call up asso-ciations with specific national and regional identities. For example, some critics hailed the Worpsweders' paintings as a national art that was 'German through and through' and could 'revive the tree of German art'[73] while others emphasised the

regional 'nordic' character of the Worpsweders.[74] One way of describing the paint-
ings issuing from artists' colonies would be to identify them as standard modules
with flexible ingredients that could be introduced into a wide variety of interna-
tional, national and local mythologies of place.

I turn now to Dachau. As we have already seen, paintings of Dachau represented
the region as offering opportunities for immersion in nature in the context of a
minimal landscape (chapter 5). As in all other rural colonies, archaic agrarian activ-
ities were emphasised as were irregular fences and rickety cottages. The collective
effect of these images is the message that Dachau was a picturesque pre-modern
village surrounded by an empty landscape, worked by hard-working peasants with
outdated tools. It is the Dachau of art history, recoverable in texts such as Arthur
Roeßler's *Neu-Dachau*:

> Wie ein Traumgebilde ragt die Stadt an Frühlings-, Herbst- und sommerlichen
> Regentagen auf ihrem schroffen Hügel über die unten im Moor brauenden Nebel.
> … In ihrer altertümlichen, graufarbigen Schlichtheit … bildet die alte Stadt die
> vollkommenste Verwirklichung eines uralten Menschensitzes im weiten Moor.[75]

> (On spring, autumn and rainy summer days, the town rises like a dream above the
> fogs brewing down in the moor. … The old town with its antiquated, grey simplicity
> … forms the most perfect realisation of an ancient human dwelling in the wide moor.)

The point is that here, as in Pont-Aven, the image of a place lost in the past was not
entirely mythical. Dachau (and Bavaria) *did* experience relatively slow industrial
development compared with the rest of Germany after unification in 1871.[76] In this
sense, people visiting the area from elsewhere were not only seeing it through a
mythical lens but were also confronting real economic differences. Nevertheless,
what outsiders rarely grasped and what artists never painted were those signs of
modernisation that did exist in Dachau.

Between 1867 and 1905, Dachau experienced a population increase of 177 per
cent.[77] Most of this increase was due to inhabitants from the surrounding country-
side moving into Dachau for employment in one of the local industries. In 1875, the
region employed 328 workers in its three paper factories, the area's largest single
labour group.[78] The leading company, the MD (or Munich–Dachau) paper factory,
expanded its operations by buying at least two more mills, widening the mill creek,
bringing in turbines and paper machines, and erecting new buildings in Dachau.[79]
At the same time, there was a marked decline in the number of persons making
their livelihood from agriculture.[80] MD's plans to build yet another large cellulose
factory in nearby Olching led to resistance on the part of the municipal government
of Dachau because locals feared increased chemical pollution of the river. Dachau
fought a legal battle over several years; the town lost, however, and the MD factory
rose to become Germany's largest paper manufacturer by the turn of the century.
The company was also instrumental in introducing or forcing further modernising

changes in Dachau, notably the laying of a telephone line (begun in 1885), the building of a new bridge over the Amper river, and connection to the Munich–Ingolstadt railway line (in 1903).[81]

Although the level of industrialisation may have been unusually high for an artists' village, the pattern in Dachau resembles that of other artists' colonies: yes, modernisation reached Dachau but no, it proceeded more slowly or arrived later than in other parts of Germany. For example, while it is true that the MD paper factory introduced electricity in the early 1880s, the average electrification of private Dachau households in 1911 was still well below the average of the rest of Bavaria.[82]

The reader will by now not be surprised to learn that artists avoided representing the paper factories or local industrial workers present in their midst. Interestingly, artists were equally selective as far as the agricultural landscape was concerned. The region around Dachau comprised two different kinds of landscape: there was the loamy soil of the hilly region behind the old market square, the Hügelland, and there was the swampy moorland toward Munich, the Dachauer Moos. The Hügelland was fertile and rich in small fields, meadows, pastureland, woods and streams; the Moos was infertile and underpopulated, its few inhabitants eking out a living from peat digging, potato farming and rearing small amounts of livestock.[83] The Hügelland held little interest for painters. It was the Moos that was painted most frequently and that came to constitute the dominant place-myth of Dachau, at least until 1945 (see chapter 5, colour plate 6 and figure 42).

It is to be noted that in Dachau there were a number of different constituencies, all staking their claims to the region on their own terms. It is not so much a case of two opposing factions (artists versus locals) but a crisscrossing of a number of divergent demands, rights and contestations. The industrialists (the local economic elite) proposed a version of the place that emphasised its proximity to Munich and, via the railway line, to other urban centres of manufacturing. For them, Dachau was a conveniently located site with a welcome pool of cheap labour. Many of the local peasants, no doubt, also welcomed the factories as alternative sources of employment when faced with a gruelling existence in the Moos. Other peasants and locals, however, vehemently opposed changes in their territory. One hotly debated topic was the railway.

Dachau was unusual for a rural artists' place in that it possessed a railway station as early as 1867. This was due largely to the influence wielded by the paper manufacturers. Enough residents protested against the rail station that it had to be built outside the town centre itself. Local peasants whose land was being bisected by railway tracks also lodged complaints, and in 1877 unknown persons blocked the railway line near Petershausen with hop poles.[84] These protesters wanted to preserve the place as it had been. This is, of course, exactly what the artists also wanted. However, there was a crucial difference between locals who were small-townfolk and artists who were urbanites from elsewhere. Artists saw the place as a region of pre-modern nature and thus eminently paintable. To be viewed as pre-modern, the artists' image

of Dachau needed the foil of the modern city, or the perceived modernisation of other parts of the country. Conservative villagers, on the other hand, did not view their land against such a foil. Local activities, such as debating in municipal government, laying obstructions across railway lines and other political initiatives do not accord with the kind of timeless pre-modernity envisioned by artists in their paintings (colour plate 6, figures 7, 35).[85] For locals, the resistance to change was not so much a nostalgic wish to preserve the past as a political struggle that was being waged over who had the say in the region.

As we saw in part III, when going into the countryside artists looked for a natural nature, owned by nobody, sufficient unto itself, a realm of sights, sounds and sensations. What they were entering in economic and social terms was an owned country, a territory parcelled out to various individuals and local interest groups. This is how the rural countryside differed from the fragments of nature encountered in cities in the form of municipal parks. In Nicholas Green's argument, the parks of the city (Paris, in his case) are important parts of the discourse of natural nature because they are like pieces of the countryside within the city fabric.[86] However, the forest of Fontainebleau was not the Jardin du Luxembourg, and the Dachauer Moos was not the Englische Garten in Munich. This was not only because of different geographical distances from the city and different topographical and botanical conditions but also because of different property relations. Urban parks were not owned by anyone in particular. Or rather, they were owned and managed by the city government *for* use of the citizens, that is, ideologically for use by everybody. Some urban parks (like the Bois de Boulogne in Paris) were former royal properties, expropriated and turned over to the people in a symbolic gesture, others were purposely inaugurated as democratic greenery (like the Volksparks or People's Parks of Berlin or the Bürgerpark or Citizen's Park of Bremen).[87]

The agriculturally cultivated countryside, on the other hand, was not public property. It was subdivided into smaller and larger estates, fenced-in fields and commons, all furnished with sets of rules about who was allowed to do what on which parts of land.[88] In Willingshausen, a complicated system of rights and duties regulated access to fields and common pasture lands in a district with few common roads (so that it was necessary to pass through someone else's land in order to pasture one's own livestock). The system was not always honoured, and there were constant arguments and legal battles over infringements.[89] This kind of local problem was of almost no interest to painters, neither in Willingshausen nor anywhere else (figures 12, 23).

My point is that artists produced a particular image of the rural place that differed in specific ways from other, contemporaneously articulated images of the same place. I do not wish to suggest that property relations were the only matrix through which locals related to their home terrain but they were one major structuring factor in the way the village was both perceived symbolically and managed physically. Even those locals who did not own any land were part of this local

economy of place. This property-oriented viewpoint was inflected and traversed by many other claims and investments, for example, the sense of identity arising from one's abode. The writer Ludwig Thoma who grew up in a Bavarian village wrote a fictional account of a boy who only found out what his personal surname was when he entered school; common village usage identified everybody by the name of the house they lived in. If you moved house, you changed name.[90] No pictorial equivalent was evolved for this kind of significance of place for local identities.

Artists came to villages initially as outsiders but the maturation of their paintings from initial exploratory efforts to competent exercises in a fully elaborated idiom are not explained simply by attributing it to their increased 'knowledge' or 'love' of the place. Of course, artists were responding to the realities of their rural environment but these responses were woven into a fabric of preconceived notions, habits of pictorial making, and schemata available in the painting tradition. The process of elaborating a rural place-myth in pictorial form was dialectical: place formed the artists' productions as much as they formed the image of the place.

7

Significant landscapes:
tourists in the countryside

Having examined a selection of individual villages at close range in the last chapter, I now assume a broader viewpoint and survey the entire map of Europe. This chapter sets out to answer the question: why were certain regions singled out for the establishment of artists' colonies? In order to arrive at an answer, we shall have to consider the relationships between the choices made by artist-colonists and the network of tourist routes and destinations that was extending across the map of Europe. We shall see that the kinds of places selected and the virtues these places were deemed to possess represented a rejection of the values associated with the tourist matrix. However, despite this, artists were caught up in the modernisation processes of leisure travel whether they liked it or not and themselves constituted a particular class of tourist.

Artists' choice of place was animated by the desire to match a real place as closely as possible to the pre-formed anticipations of an ideal nature experience. No place could ever entirely fulfil the expectations brought to it. As we saw in previous chapters, artists edited out some elements that did not fit in with their idea of what the place should be like and assembled others into place-myths. However, the success of particular villages as sites for rural artists' colonies was based on the circumstance that the real place chosen by one pioneering group of artists continued to match up more or less to the collective place-myth of subsequent artists. In this way, rural artists' sites exemplified a duality reflected in the very term 'landscape' which denotes both a specific physical terrain and a genre of painting.[1]

A glance at a map of nineteenth-century artists' colonies in Europe shows that artists' villages tended to be clustered in specific regions and landscape types (see map). The greatest concentration was to be found in Brittany, in the forest of Fontainebleau, in Cornwall, and around the Dutch North Sea and Zuiderzee coasts; these areas also contained the largest and the most international artists' colonies. Germany was host to the greatest number of rural artists' communities; they were scattered throughout, with a string of colonies along the Baltic coast of Mecklenburg. The most striking observation to be made is that there was no European rural artists' colony south of the forty-sixth parallel.[2] Mediterranean regions did not attract large numbers of the kinds of nature artists who formed the

core of rural colonies. Vincent van Gogh's forlorn call for a 'studio of the south', a Provençal equivalent to Pont-Aven, predictably met with little response.[3] Nor were there any colonies in mountainous regions like the Alps or the Caledonian Mountains of Norway, nor in river gorges like the Rhine Valley. Outside of Scotland, only three nineteenth-century artists' villages were situated in hilly terrain. By contrast, twenty-three were found on coasts and thirteen near flat moors, marshes or heath.[4] In Michael Jacobs' words, 'this generation of painters ... loved relatively flat and often bleak countryside lit by grey skies'.[5]

There is almost no literature that examines the geographical spread of nineteenth-century plein-air painting. The only study that systematically measures the quantitative distribution of landscape motifs is Peter Howard's statistical analysis of 75,000 pictures of British landscapes, exhibited at the Royal Academy in London between 1770 and 1980.[6] Howard maps the paintings according to the location of their subject and arrives at clusters of landscape types which he groups into six chronological periods.[7] He identifies an abrupt change of taste in landscape between 1860 and 1880 from the 'picturesque' and 'romantic' predilection for rivers, lakes, waterfalls and valleys to a marked preference for 'moorlands, heaths, fens, fells and marshes' which held sway until about 1910.[8] This period coincides with the heyday of rural artists' colonies, and Howard's findings concerning the popularity of flat and coastal places in Britain are borne out by colonists' preference for such regions throughout Europe. However, Howard approaches the issue from a geographer's perspective; as he states, he is 'not concerned with the pictures but what they can tell us about landscape in reality'.[9] I want to pay closer attention to what specific geographical terrains meant in terms of pictorial representation. As we shall see, artists' choices of particular landscapes were motivated by a rejection of tourism, on the one hand, and of Romantic aesthetics, on the other. How these two are interlinked, will become clearer as we proceed through the chapter.

Journeys

Tourists are people who leave their places of residence for a period of time with the sole purpose of gazing at and experiencing difference in another location. In the nineteenth century, for the first time in history, large numbers of people outside the upper classes travelled to other places for reasons other than business, pilgrimage, visiting relatives, or emigration.[10] Tourists go to experience alterity in the context of leisure: but it is a contained and regulated alterity – different but not too different from their home environment. Tourists are not explorers or adventurers; they travel to places that have been already mapped out and marked as touristically interesting. As we have seen, this also applied to rural artists. European painters of rural locations did not paint Greenland or Tahiti.[11] They painted the countryside that was reachable by train and tram. Theirs was a tamed, and in the end, comfortingly familiar nature. It was a nature that was not so much located far away in distant lands but long ago in the past. The countryside was imagined as a realm where

modernity had not yet left its mark. When bourgeois urban tourists, artists and non-artists alike, travelled into the countryside in order to experience nature, they were travelling into the pre-modern past.

It is worthwhile noting at this point that, for nineteenth-century nature tourists, the pre-modern past was located within reach of the modern railway system. The establishment of a network of artists' colonies across Europe was dependent on an equally extensive network of railway lines. However, what is also crucial is the fact that almost no artists' village was located *directly* on a railway route (at least not initially).[12] The journey to villages with artists' colonies was generally just a little difficult but not too arduous. If one departed from a capital city or regional centre, as most artists did, the journey seems to have been typically divided into two legs, the first one being covered by rail, and the second by some sort of non-steam-powered locomotion, such as a boat, a horse and cart, or one's own feet. The switch from the modern train or tram to a more old-fashioned mode of transport amounted to a move from the modern world to the non-modern world of the countryside.

This circumstance alone was enough to make the trip a noteworthy build-up to the place itself which frequently figured in visitors' written accounts, as may be illustrated by the following two artists' memoirs of their first journey to Skagen (the first by Christian Krohg, the second by Hanna Rönnberg).

> Saa kom jeg seilende did en deilig Sommerdag med en Lodsbaad, Dampskibene kan jo ikke lægge til der, da der ikke findes Noget, som ligner en Havn og Lodsbaaden maatte ogsaa holde sig adskillig hundrede alen udenfor. Men vi satte Flag, og saa kom der en Robaad ud. Heller ikke den kunde komme helt ind. Det sidste Stykke maatte vi bæres iland paa Ryggen af Fiskerne og stod saa endelig paa Skagens Strand. Jeg havde aldrig traadt paa Noget, som ligned den.[13]

> (Then I sailed there one lovely summer's day with a pilot boat, for the steamships cannot dock there, as there is nothing which even appears to be a harbour, and the pilot boat had to remain several hundred feet outside. But we raised a flag, and then a rowing boat came. Even that could not go all the way in [to the coast]. For the last stretch we had to be carried on the back of the fishermen and then finally we stood on the beach of Skagen. I have never stepped on anything like it.)

> I slutet av åttitalet hade Skagen ännu varken järnväg eller hamn, kommunikationerna voro, om inte precis medeltida, dock så primitiva och efterblivna, att våra dagars bortskämda resenärer skulle våndas, om de bleve tvungna att resa som vi reste på den tiden. … Då vi kommo fram till Frederikshavn hade diligensen till Skagen redan avgått, och vi voro tvungna att vänta ett helt dygn på nästa tur. … Då förklarade värden på stadens förnämsta 'Krog', att saken kunde arrangeras, han skulle skaffa en 'vagnman' med ett par duktiga hästar, och så kunde vi tillryggalägga den sex mil långa vägen från Frederikshavn till Skagen på en dag …
>
> Gladeligen gåvo vi oss av, och den första sträckan av vägen tillryggalades under munterhet, både hästarna och vi voro pigga. Men så kommo vi ut på sanddynerna och allt långsammare blev farten, det var som att åka i mjöl, klitt upp och klitt ned, fot för fot. Ibland stego vi ur åkdonet och gingo i den mjuka sanden, tills vi blevo så trötta, att

vi helt nöjda togo plats i vår vagn, därifrån betraktande den storslagna naturen i all dess ödslighet.

... och man förstod, att här hade alla de gamla historierna och sagorna sitt hem, här hade Andersen inspirerats till sin berättelse från 'Klitterna' ... Ja, sagoland var det, och nu åkte vi rakt in i det, mödan och tröttheten glömde vi, sinnet var öppet och mottagligt för nya intryck och upplevelser.[14]

(At the end of the eighties Skagen had as yet neither railway nor harbour, the means of communication were, if not exactly temporary, then so primitive and old-fashioned, that the pampered travellers of our days would suffer if they were forced to travel as we did at that time. ... When we reached Frederikshavn the mail coach to Skagen had already left, and we were forced to wait a full twenty-four hours for the next. ... Then the landlord of the city's most distinguished inn explained that this matter could be resolved, he would find a carrier with a pair of doughty horses, and then we should be able to put behind us the sixty kilometres between Frederikshavn and Skagen in a day ...

Happily we set off, and the first part of the road we put behind us with great cheer, both the horses and we were feeling spirited. But then we came out into the dunes and the speed decreased greatly, it was like riding in flour, up dune and down dune, foot by foot. Amongst other things we left our carriage and walked in the soft sand, until we became so tired that we had to return to our coach, and from it look upon magnificent nature in all its abundance.

... and one understood that here was the home of all the old stories and fairytales, this was where Andersen was inspired to write his tale of the 'Dunes' ... Yes, it was a land of sagas, and now we drove straight into it, forgetting weariness and tiredness, the mind was open and receptive to new impressions and experiences.)

These memoirs suggest how the journey itself activated expectations and structured visitors' experiences before they had even set foot in their destination. (Compare Mackensen's and Muther's journeys to Worpswede, chapter 6.) One significant factor in this structure of anticipation was the exotic nature of the last stretch of the expedition.

The journey from a city to a village was a journey through time as well as through space.[15] The railway served as a kind of feeder road to an intermediate stop that was already further away and further in the past than the point of departure in the city. Transit stations like Frederikshavn (on the way to Skagen), Melun (Barbizon), Quimperlé (Pont-Aven), Edam (Volendam), Hilversum (Laren), Lilienthal (Worpswede), Neustadt (Willingshausen), Whitby (Staithes) and Penzance (Newlyn) were gateways to the world of the village, last outposts of modernity before the final destination. The last stage of the journey was like a physical rite of passage into the pre-modern: travellers left the smooth, even and speedy experience of the train compartment for a pre-industrial mode of transport that offered fewer comforts but more in the way of picturesqueness and 'authenticity', such as a ride through the dunes or on a fisherman's back (Skagen), the horse-drawn omnibus known as *patache* or boneshaker (Barbizon), a tow-boat along a canal (Volendam, figure 57), or simply a long hike on Shanks's pony (Barbizon, Willingshausen).

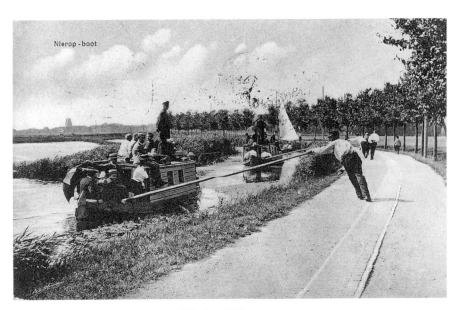

57 Photograph of a *trekschuit* on its way to Volendam, 1906

Despite most artists' places relative proximity to regional or national centres, the fact that the villages were not accessible by rail locomotion removed them from the modern map into a pre-modern world. One visitor in the early 1870s remarked that the Volendamers, despite their nearness to Edam (a mere two or three kilometres up the coast), were more isolated from the world than the inhabitants of New Caledonia.[16] A later traveller to the Zuiderzee marvelled:

> Barely half an hour's journey by steam-tram [to Edam], and you are transferred into another world, – from the modern capital [Amsterdam], with its fast life and advanced civilisation … to the calm and peacefulness of these old-world settlements.[17]

In 1898, it still took eight and a half hours to travel from London's Paddington station to Penzance while the journey-time to Edinburgh, eighty miles further from London, was only six and a half hours.[18] Still, Penzance did provide a link to the wider world, a circumstance that prompted Stanhope Forbes to comment on the convenient location of Newlyn: 'it is one of the greatest merits of this place that we are so near to Penzance and yet far enough for the place to be quite primitive and suitable for artistic purposes'.[19]

Forbes' text is an instance of the recurring trope of 'near-yet-far', used in conjunction with the meaning of 'near-yet-long-ago' to describe the peculiar experience of being in a pre-modern village. Forbes found pleasurable the distant-yet-proximate character of Newlyn. The sub-text in Forbes' letter is that Penzance itself would not be suitable for 'artistic purposes'. Even though there were only two miles between Newlyn and Penzance, the fact that the traveller had

to step off the train and change into some form of horse-drawn vehicle was enough to encourage a sense of primitivity and remoteness.

The oft-repeated trope of 'near-yet-far' seems to correspond to what Nicholas Green has called the temporal continuum between the city and the countryside but it actually describes a fundamentally different experience.[20] Green argues that train travel in the 1840s could close up distances, thereby 'synchronising' the space of nature with city life:

> In the morning you are gambling on the stock exchange or seated at Tortoni [a Paris café]; by the afternoon you are walking solitary among woods and fields ... It is precisely that counterpoint between moving (physically) away from the city and yet remaining in touch with it which gives a distinctive shape to the urban experience of nature.[21]

Two crucial points of this analysis remain forceful: that train travel was essential for the opening up of these new spaces of non-urban experience, and that travellers' sense of the rural place was bound up closely with their sense of the city as an opposite pole of existence. However, what artists and other visitors to artists' villages from the 1870s onward did significantly *not* want to do was to 'synchronise' urban experience with rural life. These two spheres were to be distinctly separate. This is also what differentiates artists' colonies from the kinds of modern leisure localities near Paris (Asnières, Bougival), discussed by T. J. Clark.[22]

The journey out to one of these suburban leisure destinations was only important inasmuch as it was short and trouble free. One summer excursionist to Bougival, a certain G.B., wrote: 'It's not even an hour since we left the boulevard des Italiens and already we feel far away from Paris.'[23] These sentiments are superficially similar to the 'near-yet-far' of Forbes and colleagues. However, G.B. felt himself to be 'far away' from Paris only in terms of urban weekday routines, contrasting the city's dreariness with Bougival's carnival holiday atmosphere.[24] Travellers to artists' colonies, however, felt themselves to be 'far away' from modern civilisation *tout court*. While the weekend trippers to the environs of Paris met up with the same Parisian crowds to be found on the boulevards of the city but dressed and acting in 'holiday mode', visitors to artists' villages encountered peasants or fisherfolk and *natura naturans*. Travel from Paris to Bougival meant travel from urban to semi-urban or sub-urban forms of modernity. Travel from Paris to Barbizon or Pont-Aven signified a flight from modernity altogether into pre-modern forms of existence.

Artists going to rural communities did not travel along a smooth temporal continuum, as evoked by Green. At best, it was a continuum with a nick in it, and the nick can be located at the junction between railway and non-modern forms of transport. It is at that point that a journey through space became a form of time travel. Changing from railway to horse-drawn vehicle or to walking was the means of marking the disjuncture between times and articulating the difference between modern and pre-modern as a difference along both a temporal and a spatial axis of meaning.

What must be emphasised is that none of the pre-industrial vehicles and pathways delivered artists into a truly remote spot, and that none of the conveyances really constituted an adventurous risk. This was not a matter of seeking out sherpa mountain guides or hiring dug-out canoes. Trams, mail coaches and boats were registered and mostly state-run businesses, and nearly all operated according to a regular scheduled timetable and charged fixed prices. It was only to the urban or foreign visitor that these vehicles seemed exotic.

Tourists and anti-tourists

In his seminal book *The Tourist*, Dean MacCannell proposed tourism as a key aspect of modern culture.[25] MacCannell observes that the experience of modernity has involved, for most people, an anxiety about the authenticity of experiences and interpersonal relationships in a constantly changing world. If modernity is fragmented and uprooted, then tourism offers one of the central modern experiences of continuity and unity. MacCannell argues that all tourists are engaged in a quest for authentic experiences, of the kind they believe to have lost in their own modern home environments – a fundamentally nostalgic enterprise, I might add. Tourism is not to be understood solely in economic terms as an industry therefore, nor to be disparaged as a trivial by-product of modern leisure lifestyles but analysed as a culture with its own ideological and symbolic structures.[26] One element of this culture was the search for sensations of being immersed in nature in the countryside.

In order to pursue this strand of thought, one must first differentiate between various types of tourism. J. A. Walter identified two basic forms of tourism, linked either to 'positional goods' or to 'material goods'. The very same good can be positional or material, depending on how it is viewed, as Walter explains:

> Take *mountains*. Mountains can be valued for their grandeur, their beauty, their conformity to the idealised Alpine glaciated 'horn'. These are material goods: no matter how many people are looking at the Matterhorn it still retains these qualities. But mountains can also be valued as places of solitude, as shrines where Nature replaces man, where snows symbolise the purity of an earth-*sans*-man. This is a positional good, for the more people want this solitudinous communion with Nature, the less they can have it.[27]

Walter calls the latter attitude the 'romantic conception of nature'.[28] An important variant of the former conception is that of the 'gregarious' notion of tourism: for examples, on the beach of Brighton or in Rio at carnival time, other tourists are welcomed and contribute to the pleasure of the experience.[29] Rural artists' colonies twinned both kinds of experience: artists in colonies encountered fellow-artists at least as (if not more) often than locals, and they enjoyed and sought out the community of their colleagues. This was the 'gregarious' aspect of life in a colony. Even when sketching from nature, artists frequently painted together or near one another. But the images of nature they produced represent a solitary experience,

stripped of fellow-artists and focused on the subjective encounter with 'nature'. This is the 'romantic' concept, discussed by Walter. It is interesting that Walter characterises the multi-sensual apprehension of the environment ('the smell of the pinewood, the feel of the breeze on one's cheek, the roughness of an uneven path underfoot') as material goods that are not threatened by the presence of others.[30] I would suggest that this depends in a large measure on the kinds of 'others' present. As we have seen, artists often wrote in warm terms of their fellow-colonists as kindred spirits with related aims and similar sensibilities to nature. The mass incursion of non-artists, day-trippers and other tourists was much less welcome.

John Urry has further refined Walter's two concepts of the 'material' and the 'positional' touristic goods. Urry discusses the two notions under the rubrics of the 'romantic tourist gaze' and the 'collective tourist gaze.[31] He argues that the countryside has become the privileged object for the romantic gaze:

> A particular feature of this construction of the rural landscape has been to erase from it farm machinery, labourers, tractors, telegraph wires, concrete farm buildings, motorways, derelict land, polluted water, and more recently nuclear power stations. What people see is therefore highly selective, and it is the gaze which is central to people's appropriation.[32]

Mutatis mutandis, artists in rural locations were applying the same selective procedures. Signs of modernisation were eliminated from their paintings, and in the pictures of natural immersion, we are left with very little besides vegetation and the earth's surface. As one commentator observed in 1882:

> So many pictures and so many illustrations seem to proceed on the assumption that steam-plough and reaping-machine do not exist, that the landscape contains nothing but what it did a 100 years ago. … Everyone who has been 50 miles into the country, if only by rail, knows while looking at them that they are not real.[33]

Why, then, did artists and the viewers of their pictures persist in painting these selective images? Urry suggests that the romantic gaze is not necessarily predicated upon the reality of the object encountered. What people 'gaze upon' are ideal representations of an internalised concept.[34] Two points need to be made here. First, Urry's concept of the tourist gaze privileges the act of looking over other modes of apprehending the environment. In focusing almost exclusively on visual structures, it misses the importance of all-round sensory stimulus that is so central to the nature experience (see chapter 4).[35] Second, the notion of an idealised inner concept of a sight (and site) is vital in understanding the urban public's response to nature paintings. Nearly all of the images produced in rural artists' colonies were circulated back to urban art centres, some of them travelling considerable distances from the villages of their origin, and most of their viewers and buyers had not themselves been to the places depicted. However, the particular appeal of artist-colonial pictures lay precisely in the possibility that anyone *might* travel there, that these places *did* exist in reality. Artists had, in the first place, travelled to villages in order to experience the

ideal notion in reality. We have seen to what extent they assimilated the real to their ideal in the production of pictorial place-myths.

The painted place-myths turned out to be more successful than most of the artists might have wished. Many viewers did enter into the implicit invitation of the paint-ings to come and see for themselves.[36] They came as tourists, in the wake of artists, and artists and tourists then shared the same facilities (see chapter 3), walks and experiences in nature. In this way, many artists' villages became tourist attractions. This happened in Katwijk, Laren and Volendam, in Worpswede and Ahrenshoop, in Giverny, Barbizon, Pont-Aven and Concarneau, in St Ives and in Skagen.

Let us turn to Katwijk as a case study. In 1891, Karl Baedeker billed the village as a popular 'but not cheap' watering place, that is, a tourist resort. He marked out the sluice-works on the mouth of the Rhine as Katwijk's principal sight, praised as a magnificent feat of modern engineering from whose gates issued 100,000 cubic feet of water per second.[37] In the 1890s, Katwijk sported at least six hotels and pen-sions, including the *Groot Bad Hotel* and the *Grand Hotel Du Rhin*, all located directly on the dunes, facing the sea, as well as numerous private lodgings. In 1890, the township registered five hundred hotel guests; by 1908, there were over two thousand. Over eight hundred of these were artists.[38] Katwijk published its own bath-guide for summer guests.[39] One photograph of 1890 shows pleasure seekers playing croquet on the beach, another dated 1905 reveals the beach covered in crowds of straw-hatted holiday makers.[40] Painters jostled for space among the dunes (figure 58).

None of this is visible in Jozef Israëls' painting *Fishergirl on the Beach*, painted in Katwijk around 1881 (figure 59). This girl is another example of a hybrid figure, part local model and part surrogate for the artist himself (see chapter 5). The expe-rience of immersion in nature conjured here is patterned on the notion of the soli-tary, 'romantic' tourist gaze. The picture is framed so as to afford us a view restricted to sky, sea and sand, that is, a view without ships, buildings, beach hotels, tourists, dykes or sluice-works. Like the figure, the artist turns his back on moder-nity and immerses himself in a pre-modern nature. All over Europe, hotels and tourist facilities were springing up to cater to the influx of visitors to the country-side and seaside; almost nowhere did artists paint them. There are exceptions, such as Frederik Kaemmerer's and Anton Mauve's scenes of elegant urbanites on Scheveningen beach or the paintings of Trouville in Normandy, including its fash-ionable tourists and hotels, by Eugène Boudin, Claude Monet and Alfred Stevens.[41] But Trouville and Scheveningen, though popular with painters, were not artists' colonies, nor do they seem to have been places for solitary immersion in nature. Both resorts conformed more to the 'collective' and 'gregarious' type of tourist site. In 1868, for example, one commentator called Trouville 'the boulevard des Italiens of Norman beaches', and others described a hectic round of bathing and casino-going.[42] Katwijk, *Grand Hotel du Rhin* notwithstanding, retained the image of pre-modern fishing village so crucial to the production of images of agrarian romanticism and nature immersion.

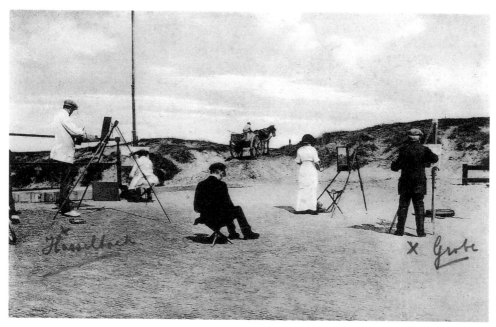

58 Postcard showing painters at work in Katwijk aan Zee

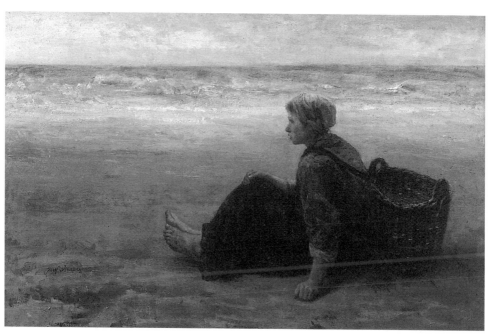

59 Jozef Israëls, *Fishergirl on the Beach* (Katwijk), *c.* 1881, 78 x 120 cm

Artists on the whole did not identify themselves as tourists. Indeed, written remarks suggest that most artists scorned tourists and the changes they brought in their wake. However, artists were none the less imbricated in the rhetoric of a particular kind of tourism, the kind that the literary historian James Buzard terms 'anti-tourism'. In his book *The Beaten Track*, Buzard argues that modern tourism, from its very beginnings in the early nineteenth century, has consisted of two interdependent strands, tourism and anti-tourism.[43] Anti-tourists set themselves and their project up as the diametrical opposite of what they denigrate as superficial tourism. The distinction between the two modes of journeying can be equally articulated under the headings 'traveller' and 'tourist'. Buzard shows how these two words, in the late eighteenth century still used synonymously, had hardened into a dichotomy by the mid-nineteenth century. The word 'tourist' had by then also acquired distinctly negative connotations as opposed to the positive values associated with the word 'traveller'. Buzard summarises the values associated with each term: a 'traveller' has authentic experiences, goes about with open eyes and mind, is independent, bold and original; a 'tourist', alas, is the dupe of fashion and cliché, follows blindly where others lead and goes about *en masse*, the cautious and pampered unit of the leisure industry.[44]

The important point that Buzard makes is that the opposition between 'traveller' and 'tourist' is a false one. According to Buzard, both the 'formation of modern tourism *and* the impulse to denigrate tourists [is] a single complex phenomenon'.[45] The purpose of the anti-touristic rhetoric was to secure, for self-professed anti-tourists, a measure of cultural cachet. If, as Dean MacCannell argued, the aim of tourists is to collect authentic experiences, then the aim of anti-tourists is to demonstrate that their own experiences are 'truly' genuine, 'more' authentic than those had by the others, the tourists. Ideologically, the practitioners of anti-tourism were consolidating privileged cultural identities for themselves which (according to Buzard) transcended class identities. It is useful to turn here to T. J. Clark's argument about the environs of Paris in the 1870s. Clark argues that the Sunday strollers out for a day in the country at Asnières and Bougival were engaged in the struggle for the right to a bourgeois identity. What blood had been to the aristocrat, nature was to be for the bourgeois. Bourgeois participants in this ritually performed struggle marked out their differences from an emergent *petite* bourgeoisie by claiming for themselves a more 'genuine' access to nature. The *petits* bourgeois were lumped together by critics in ironical mode into vulgar hordes who tried to do something they did 'not possess as a matter of form'.[46] Buzard makes a similar point about the tourist and the anti-tourist:

> the criteria for separating authentic from touristic experience have not been those visibly based on advantages of birth (in contrast to the overt privileges of the pre-1800 Grand Tour), but rather a loosely defined set of inner personal qualities that amounts to a superior emotional-aesthetic sensitivity.[47]

Artists in rural colonies marshalled such loosely defined 'inner personal qualities' and 'superior emotional-aesthetic sensitivity' to mark them out from other

visitors to their rural place of work. The idea that 'nature' could only be 'truly' understood by people who lived in villages all year round and who had privileged antennae for the essences of nature in that place was constitutive of colonists' identities as nature painters.[48]

If we combine Clark's analysis of bourgeois class delimitation by way of a 'true' access to nature and Buzard's discussion of anti-touristic rhetoric of 'true' access to travel experience, we have a powerful model for comprehending the practices and self-understanding of artists in rural communities. Artists fitted, for the most part, into the mould of the anti-tourist. The artists' quest for an unmediated communion with and immersion in nature was a symbolic move against the perceived superficiality of tourism and, at the same time, served to consolidate a classed and vocational identity that became intelligible by virtue of its difference to the 'vulgarity' of (lower class, less sensitive) 'tourists' or artistic day-trippers. I want to insist on the equally important factor of vocational identity as a counterpoint to class identity. In artists' self-estimation, a significant factor separating them from non-artistic tourists in the countryside was the activity of painting, that is, of *working* at making representations rather than of simply strolling around for relaxation. The American Clement Nye Swift who painted for ten years in Pont-Aven wrote:

> Thus to have the quiet of my little rustic paradise broken by the aimless bustle of summer tourists and to see the ridicule they bestowed upon observances which, now that I understood them I was willing to commend, irritated me, the more as I was now obliged to carry on my chosen work in the midst of a company of idlers.[49]

Artists were adamant that they themselves were not idlers and not on holiday. Like the 'non-work' of painted rural labourers (see chapter 2), artists' own plein-air work could come precariously close to not being identified as work at all within the discourses of capitalist economies and bourgeois ideologies of meaning in nineteenth-century Europe. After all, on the surface of it, sitting under a tree at an easel was perhaps not so very different from sitting under a tree with a picnic. The very proximity of non-artistic tourists in the countryside no doubt activated colonists' anxieties about being mistakenly lumped together with these 'aimless bustlers'. The rigorous routines artists adhered to while on location can be read, in part, as designed to underscore this difference between themselves and the leisure seekers, as can the bohemian jinks and semi-rustic garb, described in chapter 1.

Artists' journeyings took place within a geography that was increasingly mapped out by tourism. Moreover, many of the villages in which artists established themselves were becoming tourist centres in their own right. Most artists' villages attracted tourists *because* they were artists' villages: both because their names and images had been disseminated through the press and exhibition circuit and because the presence of large numbers of artists encouraged locals to create an infrastructure that could deal with tourists and to advertise their village as an attractive tourist destination (see chapter 3). Everywhere, the artists in a village

were dismayed by the influx of non-villagers who were not part of their own artistic circle. Significantly, artists included other artists in their disdain, the kinds of artists they derided as 'daubers', 'water-colourists' or 'Sunday painters'. In the 1890s, Overbeck, Modersohn and Modersohn-Becker all variously lamented the undoing of Worpswede by an influx of amateur painters and tourists, a 'Künstlerproletariat' (artistic proletariat) and 'Gelichter' (riff-raff).[50] As we have seen, Clement Nye Swift and Laura Knight denigrated the presence of idlers and amateur sketchers in Pont-Aven and Volendam respectively (above and chapter 3). In 1909, Gustave van de Woestijne complained about the arrival of tourists and vacationers in Sint-Martens-Latem:

> Ik ook ben veertien maanden te Latem gebleven. Langer zou ik niet gekund hebben, daar het er onverdraaglijk werd. De Gentenaren begonnen er villa's te bouwen, van één kamen er twee, en stillekensaan was ons lief Leiedorpje gelijk een badstad geworden, gelijk Knokke De Zoute.[51]

> (I also stayed for fourteen months in Latem. I couldn't cope any longer because it became unbearable there. The residents of Ghent have started to build villas there, first one, then two, and before you know it our dear Leie village has turned into something like a bathing resort, like Knokke De Zoute.)

The value of the category of anti-tourist and its artistic counterpart, the colonial 'anti-dauber', lies in the way that it helps us to integrate both within the history of the mass phenomenon to which they were equally opposed. The hostility to 'tourism' and mass leisure in artistic guise is yet another sign of the modern sensibility that informed the colonial enterprise.

Significant choices

How do the practices of tourism impinge on artists' predilection for moor and plains? The identity of anti-tourist did not only derive from a privileged access to 'nature' in general but also from access to privileged places. Artists in rural artists' colonies were convinced of their superior choice of place *vis-à-vis* the choices made by the 'vulgar hordes'; in this case, the vulgar hordes of *other* landscapists. One commentator denigrated the inferior masses:

> I am not sure that there are not spirits so perfectly unable … to bear the weight of their own responsibility, that when looking for subjects, they only recognize them by their drift of empty colour-tubes and old paint rags. Then they know there must be something in the vicinity, for somebody had been there before.[52]

Rural artists' colonies managed to sustain, in a unique way, the ideal that the villages where *they* were located harboured special and distinct motifs and subjects that were completely other to the hackneyed sights turned out by those inferior 'spirits'. Place-myths constructed by colonists were able to cast 'their' locations as

havens of anti-tourism despite their numerically substantial popularity, and despite the fact that most of the motifs in any given artists' colony were painted by dozens of painters.

Buzard proposes that we should see anti-tourism as an 'adversary culture', that is, a culture that develops alongside another culture but criticises many of the dominant culture's assumptions while sharing its structures and *modi operandi*.[53] The proximity of anti-tourism to tourism explains, in Buzard's view, the dominance of the idea that 'genuine' experiences lie just 'off the beaten track' of mass tourism. One doesn't need to travel the globe to find authenticity: it can be encountered by literally just taking a step to the right. This may also help to explain the trope of 'near-yet-far'.

It is important to note that artist-colonists did *choose* specific landscapes. This is the crucial difference between artists like Modersohn, van de Woestijne and even Millet who waxed eloquent about how rooted they felt in a landscape they had specially travelled to in adult life, and the tiny minority of local amateur painters like Albijn Van den Abeele and Serafien De Rijcke who *were* rooted in the landscape they painted in the sense that they had grown up there, had not passed through the filter of a metropolitan art school, and knew the place in ways more reminiscent, perhaps, of Ludwig Thoma's local boy.[54] Second, it should be noted that artists' choice of a particular region was as much an aesthetic choice as it was one predicated upon anti-tourism. One of the most eloquent spokesmen for such an aesthetic choice was the poet Rainer Maria Rilke in his enthusiasm for minimal landscape. Rilke argued that the predilection for the flat plain was not only a matter of personal taste but expressed the sensitivities of a whole generation:

> Unsere Seele ist eine andere als die unser Väter; wir können noch die Schlösser und Schluchten verstehen, bei deren Anblick sie wuchsen, aber wir kommen nicht weiter dabei. Unsere Empfindung gewinnt keine Nuance hinzu, unsere Gedanken vertausendfachen sich nicht, wir fühlen uns wie in etwas altmodischen Zimmern, in denen man sich keine Zukunft denken kann. Woran unsere Väter in geschlossenen Reisewagen, ungeduldig und von Langerweile geplagt, vorüberfuhren, das brauchen wir. Wo sie den Mund auftaten, um zu gähnen, da tun wir die Augen auf, um zu schauen; denn wir leben im Zeichen der Ebene und des Himmels. ... die Ebene ist das Gefühl, an welchem wir wachsen. ... da ist uns alles bedeutsam: der große Kreis des Horizontes und die wenigen Dinge, die einfach und wichtig vor dem Himmel stehen.[55]

> (Our soul is different from that of our fathers; we can still understand their castles and gorges in whose presence they grew, but we do not get anywhere further with these. Our sensibility does not gain any extra nuance, our thoughts do not multiply, we feel as if we were in somewhat old-fashioned rooms in which one can't imagine a future. We need that which our fathers drove by in closed carriages, impatient and plagued by boredom. Where they opened their mouth to yawn, we open our eyes to see; because we live in the sign of the plain and the sky ... the plain is the feeling by which we grow ... there everything is significant for us: the great circle of the horizon and the few things that stand simply and importantly in front of the sky.)

Rilke historicised the preference for flat landscape (embodied for him in the work of the Worpswede painters), discerning in it a taste that was modern in opposition to the earlier Romanticism of castles and gorges. We can see that Rilke's opposition of mountains to plains was not only a contrast between a touristic landscape and an anti-touristic one. It also implied the 'adversarial' rejection of the landscape convention of Romanticism. The gorges and castles deplored by Rilke evoke early nineteenth-century landscape paintings, like those by Joseph Anton Koch and Ernst Ferdinand Oehme, showing either Italianate, classicising views of the Roman Campagna with pastoral staffage figures or Alpine regions with waterfalls and craggy heights.[56]

Romanticism as an aesthetic movement is generally dated to the first half of the nineteenth century but the romantic mode continued to be popular. Consider the painting *An Alpine Lake* (1896) by the virtually unknown German artist Joseph Jansen (figure 60), or *Stretch of Mountains in the Carpathians* by the equally obscure Hungarian Karl von Telepy (exhibited in Budapest in 1896).[57] This is not the place to provide a detailed analysis of the differences between the earlier models of Koch, Oehme and others and their heirs several decades later. In discussing the *places* chosen for representation, it is enough to note the continued popularity, among some, of mountain ranges with their peaks shrouded in clouds, waterfalls among large boulders and pine trees dwarfed by geological formation.[58]

60 Joseph Jansen, *An Alpine Lake*, 1896, 94 x 130.8 cm

More significant than a number of paintings of mountains continuing to appear in urban art exhibitions is the migration of mountain scenery from the realm of high art and literature into the popular realm of tourism.[59] Mountains were not only a Romantic topos but also a touristic one. This can be traced particularly in the history of Alpine tourism but also applies to other regions like the Lake District.[60] The touristic preference for mountains or at least hills persisted into the twentieth century, and was noted by Roland Barthes in his essay on the French guidebooks, *Guides bleus*:

> The picturesque is found any time the ground is uneven. … Among the views elevated by the Blue Guide to aesthetic existence, we rarely find plains (redeemed only when they can be described as fertile), never plateaus. Only mountains, gorges, defiles and torrents can have access to the pantheon of travel, inasmuch, probably, as they seem to encourage a morality of effort and solitude.[61]

One travel writer wrote in 1870, that one of Brittany's greatest charms was the 'undulation of surface' and stated that 'flat country never exhibits attractive scenery'.[62] Artist-colonists held the exact opposite viewpoint. In 1888, Maurice Talmeyr praised the forest of Fontainebleau because it was *not* a Romantic landscape:

> The eye may, and usually soon does, tire of mountains and gorges, of rocky heights crowned with feudal ruins like the banks of the Rhine and the Belgian Meuse. Even pastoral scenery with its homely pathetic delights may become monotonous.[63]

The almost automatic way in which Talmeyr reeled off the stock attributes of Romantic scenery suggests that by the 1880s this landscape type had solidified into a pervasive place-myth that had perhaps little to do with actual landscapes seen by anybody.

Fritz Overbeck's 1895 article on Worpswede may serve to illustrate the extent to which tourism and anti-tourism were dependent on one another. Overbeck began his 'Letter from Worpswede' with the kind of description of the topographical peculiarities of the region that would become *de rigueur* for all later writings on Worpswede. His description contrasted the village with what he saw as conventionally touristic destinations. This is the textual strategy of an anti-tourist because although the author was keen to stress that Worpswede was the opposite of a tourist spot, he could not do so without discussing it in terms of tourism. It seems as if Worpswede's attractions could only become intelligible to the painter if they were cast as the antithesis to touristic attractions. This accords with Buzard's argument that anti-tourists need tourism in order to define themselves against it. It is worth quoting Overbeck at length:

> Worpswede ist ein sehr bescheidenes Örtchen, zwischen Bremen und Hamburg gelegen, in einer Gegend, deren landschaftliche Reize Bädeker, soviel mir bekannt ist, mit keinem Worte Erwähnung thut. Und er thut recht daran, denn es giebt dort weder Berge von so und soviel tausend Metern Erhebung, deren Gipfel den Genuß eines

'Panoramas' bieten, weder Wälder, durchzogen von sauber gehaltenen Wegen und gespickt mit Ruhebänken eines Verschönerungsvereines, weder liebliche Seen, die zu Kahnpartien im Mondschein Gelegenheit böten, noch all die anderen Requisiten, deren es bedarf, um einer Gegend das Epitheton 'schön' (das in solcher Verbindung neuerdings etwas in Mißkredit zu geraten anfängt) einzutragen. Diese betrübenden Mängel erklären ferner zur Genüge das Fehlen von mit allem Komfort der Neuzeit eingerichteten Hotels, von Restaurants und Kaffeehäusern, von Lustfuhrwerk u.s.w. u.s.w.; kurz, wenn ein Sommerfrischler bisher etwa gehofft haben sollte, dort ein Asyl finden zu können, so hat er sich verrechnet. Solcherlei Hoffnungen muß ich als gewissenhafter Berichterstatter unbarmherzig im Keime ersticken. Allzu rauh würden ihm da die Winde um die Nase wehen, denen weite Moore und Heiden einen willkommenen Tummelplatz bieten, und allzusehr würde er in den kümmerlichen Hütten der Torfbauern die gewohnte Bequemlichkeit vermissen.[64]

(Worpswede is a very humble little place, situated between Bremen and Hamburg, in a region whose landscape charms Baedeker does not mention with a single word, as far as I know. And he is right – because in that place there are neither mountains of so and so many metres in height whose summits offer the enjoyment of a 'panoramic view', nor are there forests crossed by neatly kept paths and dotted with benches donated by a beautification society, nor are there any lovely lakes which would offer the opportunity of boating trips by moonshine, nor are there any of those other props which are needed to endow a region with the epithet of 'beautiful' [although the latter seems to have been begun to be discredited recently in such an association]. These distressing deficiencies also suffice to explain the absence of any hotels furnished with all the modern conveniences, of any restaurants and coffee houses, of open carriages, etc., etc.; in short, if a summer holidaymaker should have hoped until now to be able to find asylum there, he has miscalculated. As a conscientious reporter, I must mercilessly quench such hopes in the bud. He would be blown about all too roughly by the winds which find a welcome play area on the wide moors and heaths, and he would miss the usual luxuries he is accustomed to all too painfully in the wretched huts of the peat peasants.)

It is remarkable how dependent Overbeck's account of his village as an anti-tourist spot is on the assumed existence of tourism and tourist destinations. The very first sentence of his article advises the reader that the village was not 'mentioned by Baedeker'. Overbeck then proceeds to list those features which, in his eyes and drawing on accumulated experience and perhaps also place-myths, constitute a tourist spot: forests with neat paths and benches, lakes, and, of course, mountains affording the standard panoramic view. In other words, Worpswede did not look like Joseph Jansen's *Alpine Lake* (figure 60), and in that lay its attraction to the rural colonists. (Ironically, only a few years later Worpswede *did* establish its own beautification society, spearheaded by artists, which duly installed those very benches and paths abhorred by Overbeck.)[65]

To conclude: what is crucial for the artist-colonial enterprise as a whole is the relationship of place-mythmaking to reality. The relative closeness of place-myth to place was, in the first instance, assured by artists' choice of particular landscapes

and rejection of others. It is perhaps impossible to disentangle the chicken-and-egg problem of which came first, the pictorial invention of minimal landscape or the discovery of moors and plains, the trip to the forest of Fontainebleau or the *sous-bois* painting. As I argued in the last chapter, it is not simply a case of replacing pictorial 'myths' of place with alternative constructions of the 'real' place in historical, social or economic terms. My juxtaposition of Israëls' *Fishergirl on the Beach* with the image of tourist hotels on the beach of Katwijk would invite such readings across the board but I would again caution that they are too easy.

Throughout this book, I have argued for the inextricably interdependent connection between pictorial imaginings and real geographical places on the map, and the way in which aesthetic choices and configurations fed off reality as well as off the notions of the 'real' and the 'authentic'. In a suggestive essay, Griselda Pollock asserts that Vincent van Gogh learned from his 'mistakes' in the isolated (non-colonial) backwater of Hoogeveen in the Dutch province of Drenthe (where he spent three months in 1883): 'He had learnt that art, not Nature – in the raw – makes art. Nature is a rhetorical figure for an aesthetic renovation.'[66] I would suggest that, *pace* Pollock, nineteenth-century nature was *not only* a rhetorical figure. If van Gogh had gone to a proper artists' colony, the contradictions inherent in his artistic quest for painterly and personal authenticity would have been smoothed away by the collectivity, all working together to bring the two terms – painting and reality – as close in conjunction as possible. Part of the function of the many artists' writings discussed in this book was to convince each other of the convergence, yes even the identity, of art and life. This is why Arthur Bell could discern the seventeenth-century artists Wouwermans and Snyders even in the horses and hounds of contemporary Holland, and why the band of merry painters, walking across the meadows from Neustadt's train station to Willingshausen, recognised their master Carl Bantzer's paintings all around them, up to the very clouds in the sky.[67]

Epilogue:
artists' villages today

Artists' colonies have had a curious after-life. After the First World War, the artist-colonial project ceased to be the central force within European art worlds that it had been. The increasing consequence of avant-garde modernisms and the growing rift between those who pursued serious and innovative artistic projects and the general bourgeois public played a pivotal role in the process, as did the shift from nostalgic rural idylls to utopian urban ideals. In sum, after 1918, artists and bourgeois nature tourists no longer spoke the same language.

Still, artists continued to work and arrive in many of the villages discussed until at least 1945, although, with a handful of exceptions, their paintings tended to reproduce *ad nauseam* the pioneering generations' compositions and were increasingly out of touch with the art of their time (as happened in Volendam, Katwijk, Tervueren, Concarneau, Pont-Aven, Willingshausen, Kronberg, Ahrenshoop, Schwaan and, to some extent, Worpswede). A few colonies experienced a revival just before or after the Great War with the advent of a new, second or third, generation of artists. This was the case at Worpswede where the *Jugendstil* and Expressionist architecture and sculpture of Bernhard Hoetger transformed the appearance of the village in the 1920s. In the immediate post-war years, Heinrich Vogeler's Barkenhoff briefly turned into a socialist commune and a haven for Communists and revolutionaries of all stripes. In the 1920s and 1930s, the artist's wife and daughter, Martha and Bettina Vogeler, initiated a craft workshop tradition that endures in Worpswede to this day. Sint-Martens-Latem, too, was host to a second generation from around 1905, the Belgian Expressionists who included Albert Servaes, Constant Permeke, Jozef Cantré and Gustave De Smet. Some of these (Cantré, De Smet) ended up at a kind of artists' colony-in-exile in Blaricum near Laren, which saw an influx of Belgian modernists during the Great War. Painters working in Cubist, Expressionist and Constructivist idioms formed a third wave of artistic activity at Nagybánya in the inter-war decades. And, of course, in the 1930s and 1950s, the second and third generations of artists at St Ives ended up eclipsing their predecessors in fame. Arguably, the modernist St Ives of Barbara Hepworth, Patrick Heron and Peter Lanyon was essentially a variation on the original place-myth, not an antithetical replacement.

The early twentieth century also witnessed the establishment of a number of new colonies, most notably the 'Bergense School' in the Dutch coastal village of Bergen, and the *Blue Rider* group of Expressionists and proto-abstractionists in the Bavarian village of Murnau, not far from Munich.[1] The Hungarian foundations with their state-subsidised studios at Szolnok, Hódmezővásárhely and elsewhere represented a similar institutionalisation of the colonial project.[2]

It is striking how many of the villages discussed in this book have retained their artistic stamp until today. The communities of Worpswede, Fischerhude, Ahrenshoop, Willingshausen, Skagen, Barbizon, Sint-Martens-Latem, Volendam, Laren and Katwijk maintain local museums, organise exhibitions, lectures and other events, and publicise the artistic character of their villages via books, tourist brochures, websites, calendars and postcards. (For details, see the Gazetteer.) In other villages, like Pont-Aven, Le Pouldu, Grèz, Giverny, Tervueren, Schwaan and Kronberg, cultural entrepreneurs have more recently 'rediscovered' the artistic heritage and are belatedly establishing galleries, restoring artists' inns, documenting activities, founding 'Friends of ...' societies, and buying works of art in an attempt to reactivate the original atmosphere for touristic exploitation.[3] Only Dachau labours under the radical reversal of its original place-myth, with the municipality desperately promoting its nineteenth-century artistic image to offset the presence of the better-known concentration camp memorial site.

Tourism has come to shape the twentieth century in more profound and far-reaching ways than even those untiring entrepreneurs Leendert Spaander and Jan Hamdorff could have foreseen. In Volendam, fishing (and painting) stopped when the dam of the Afsluitdijk cut off the Zuiderzee from the ocean in 1927–32. Today, tourism is the town's largest source of income. Day-trippers are bussed in for a quick lunch in the dining rooms of the now hugely expanded Hotel Spaander whose walls are still decorated with the paintings of those who first made its fortune. Craft and souvenir shops line the harbour promenade. With their miniature clog key-rings, wing-capped figurines and photography studios where visitors don the local costume, these shops offer eloquent testimony to the potency of the images elaborated and disseminated by generations of artists.

Artists' villages have changed from being sites primarily of natural nature to tourist destinations that combine nature with art, and thus they provide a hybrid form of heritage tourism particularly popular with the educated middle classes of today. As late twentieth-century developers have discovered, rural artists' colonies provide a perfect day out. Culture can be imbibed, followed by a pleasant stroll along well-kept paths through forests, moors or along the seaside, crowned by afternoon coffee or a meal in a local café or former artists' inn. More determined culture tourists can take art classes in Willingshausen, Kronberg, Worpswede, Fischerhude, Ahrenshoop, St Ives and elsewhere, placing their easels in front of motifs familiar from the nineteenth century or recreating a 'local' craft like lace making.

What all of these visitors are participating in is a kind of meta-nostalgia, a nostalgia for the original nostalgia of the decades before World War One. Artists'

colonies have long ceased to exert a pull on the artistic imagination of younger gen-
erations, and they now have little purchase on the international market of contem-
porary art. Those colonies that have survived (or been revived) owe their continued
existence to the tourist industry. Artists' colonies stimulated tourism and, for a
while, tourism stimulated artists' colonies. Ultimately, however, the travel business
destroyed rural communities as viable artistic centres while preserving them in
amber for today's tourists of nostalgia.

Gazetteer

This gazetteer provides a brief guide to eighteen selected rural artists' colonies. Each entry gives an outline of the colony's history and distinctive features, a list of venues that display salient works, an indication of the number of artists present over the lifespan of the colony until 1907, a list of selected artists, and key reading. All statistical information is of a purely indicative nature, based on my own compilations of data. Other artists' colonies, mentioned in the book but not covered in the gazetteer, include Genk and Tervueren (Belgium), Betws-y-Coed and Cranbrook (Wales and England), Cambuskenneth, Cockburnspath and Stirling (Scotland), Hornbæk (Denmark), Varberg (Sweden), Cernay-la-Ville, Chailly-en-Bière, Marlotte, Sevray-sur-Vallais, Auvers-sur-Oise, Étaples, Étretat, Honfleur, Douarnenez and Le Pouldu (France), Ekensund, Etzenhausen, Fischerhude, Frauenchiemsee (or Frauenwörth), Goppeln, Kleinsassen, Röllshausen, Kronberg im Taunus, Schwaan, and Wörth (Germany), Nagybánya (formerly Austria-Hungary, now Romania and known as Baia Mare), Szolnok (Hungary), Dongen, Heeze, Oosterbeek, Rijsoord, Urk and Zandvoort (Netherlands), and Škofia Loka (Slovenia). Key reading on these places (if accessible) is included in the Bibliography.

Ahrenshoop

In the summer of 1889, the painters Paul Müller-Kaempff and Oskar Frenzel happened upon the German fishing village of Ahrenshoop while on vacation near the Baltic coast. Here, they met another painter, Carl Malchin, at his easel in the dunes. Delighted with his discovery, Müller-Kaempff returned year after year, built himself a house and studio there in the 1890s and opened a painting school for women with purpose-built lodgings. Other artists followed and by the turn of the century, around sixteen had settled there, erecting studio houses or renovating fishing cottages. Many others lodged in Hotel Bogislav (today, the Kurhaus) where they hosted parties and painted the interior (destroyed). Some artists worked in specially built studios on wheels. Partly due to Müller-Kaempff's art school, Ahrenshoop had an unusually high proportion of women painters many of whom donned the local *Holländerhut* or 'Dutch bonnet'. One anonymous visitor noted that painters 'sprouted all around like mushrooms' and that 'behind every bush' there was a *Malweib* or woman dauber (quoted in Bohn, *Ahrenshoop*). As fishing declined from the 1880s onward, the village remodelled itself as a bathing resort. Artists continued to come at intervals, including the regional writer Käthe Miethe.

The Kunstkaten, founded by artists, has exhibited local art and craft since 1909. Other galleries (mostly showing contemporary art) include Neues Kunsthaus, Bunte Stube, Strandhalle and Galerie im Hof. A number of artists' residences have been renovated and

include some exhibition space as well as tourist accommodation, such as the Dünenhaus and the Haus Elisabeth von Eicken. The Künstlerhaus Lukas, housed in Müller-Kaempff's former painting school, provides studio facilities for grant holders.

Recorded: 24 artists. 38 per cent women. Virtually 100 per cent German.

Selected artists: Elisabeth von Eicken; Anna Gerresheim; Carl Malchin; Paul Müller-Kaempff; Eva von Pannewitz; Eva Stort; Fritz Wachenhusen.

Key reading: Bohn *et al.*, *Ahrenshoop*; Müller-Kaempff, 'Erinnerungen'; Schulz, *Ahrenshoop*; E. Venzmer, 'Ahrenshoop und die Halbinsel Darß an der Ostsee', in Wietek, *Deutsche Künstlerkolonien*, pp. 122–9.

Barbizon

Artists had been painting in the forest of Fontainebleau to the south of Paris since the eighteenth century but from the 1820s these scattered excursions began to coalesce into a cohesive practice. It is unclear who was the first painter to work in Barbizon at the edge of the forest near the plain of Chailly in the 1820s but by the 1830s a growing number of artists lodged at the local inn on a regular basis each summer. In 1848, twenty-eight painters stayed with the innkeeper François Ganne; in the following year the number rose to forty. Several artists bought property in the village and settled permanently, including Jean-François Millet and Charles Jacque. The growing international fame of the Barbizon masters, especially of Millet, soon attracted even more artists of many nationalities (especially American and British). By the 1870s, there were three establishments catering to artists' needs – Ganne's inn as well as two new hotels, the Hôtel Siron and the appropriately named Villa des Artistes. The Hôtel Siron hosted annual exhibitions of Barbizon painters. A colourman by the name of Desprez visited once a week to provide the artists in Barbizon as well as its offshoots in Marlotte and Grèz-sur-Loing with painting materials. Especially during the summer months, the forest was 'bedotted with artists' sunshades as with unknown mushrooms' (Stevenson, 'Forest notes'). The artists' social life revolved around the inns' dining rooms whose walls were decorated with painted scenes by their hands.

In Barbizon, paintings and artefacts by artist-colonists are displayed in the former Auberge Ganne, now the Municipal Museum of the Barbizon School, as well as in the houses and studios of Théodore Rousseau and Jean-François Millet.

Recorded: 253 artists. 3 per cent women. 53 per cent French, 11 per cent American, 6 per cent British, 8 other nationalities.

Selected artists: Karl Bodmer; Xavier De Cock; Camille Corot; Charles Daubigny; Narcisse Diaz de la Peña; Wyatt Eaton; Jean-Georges Gassies; Carl Frederik Hill; William Morris Hunt; Charles Jacque; Max Liebermann; Will Hicok Low; Jean-François Millet; Mihály Munkácsy; László Paál; Théodore Rousseau; Georg Saal; Edward Simmons; Robert Louis Stevenson (writer); Robert Mowbray Stevenson; Constant Troyon; Edward Wheelwright.

Key reading: Adams, *Barbizon School*; Bouret, *Barbizon School*; *Barbizon au temps*; Burmester *et al.*, *Barbizon*; Caille, *Ganne Inn*; Dubuisson, *Les Échos du bois sacré*; Gassies,

Le vieux Barbizon; Green, *Spectacle*; Heilmann *et al.*, *Corot, Courbet*; R. L. Herbert, *Barbizon Revisited*; Jacobs, *Good and Simple Life*, ch. 2; Low, *Chronicle*; Sillevis and Kraan, *Barbizon School*; Stevenson, 'Fontainebleau'; Stevenson, 'Forest notes'.

Concarneau

The artists' community started around 1870 with a native painter, Alfred Guillou, who returned to his hometown with a couple of studio friends from Paris, both of whom married into the local community. By 1889, there were at least thirty-eight French and seventy-nine international artists working in Concarneau. Most of the latter were Americans, drawn to Concarneau by Blanche Willis Howard's enormously popular novel *Guenn* (1884), which was set in the fictional town of Plouvenec (Concarneau) and treated of the tragic romance between the artist-colonist Everett Hamor (based on Edward Simmons) and a local woman, Guenn Rodellec, who became his model. Numerous Anglo-Saxon visitors fancied they had spotted 'Guenn' among the local fishing women. Artists lived at the Hôtel des Voyageurs whose dining room was decorated with paintings, or in one of two other hotels. By the mid-1890s, the town boasted 'lodgings, studios, artists' materials, and a well-known art-connoisseur and photographer ... not to mention scores of little Bretons who beg to carry one's apparatus' (Emanuel). There was a friendly rivalry between Concarneau and nearby Pont-Aven which resulted in at least one American baseball game played between artists from the two places, in August 1885. Favourite motifs were the harbour and the fishmarket, although not a few commented on the unpleasant odours emanating from the local sardine canning factory.

Some works are on display at the Musées des beaux-arts in Brest, Rennes and Quimper.

Recorded: 130 artists. 14 per cent women. 44 per cent American, 17 per cent French, 12 per cent Scandinavian, 8 per cent British, 8 other nationalities.

Selected artists: Cecilia Beaux; Charles Cottet; Alfred Delobbe; Théophile Deyrolle; Charles Fromuth; Alfred Guillou; Alexander Harrison; Robert Henri; Peder Severin Krøyer; Amelie Lundahl; Theodore Robinson; Earl Shinn; Edward Simmons; Henry Jones Thaddeus; Helen Mabel Trevor; Eugene Vail.

Key reading: Beaux, *Background with Figures*; Champney, *Sixty Years*; Delouche, *Les Peintres de la Bretagne*; Delouche, *Artistes étrangers*; Emanuel, 'Letters to artists'; Harrison, 'Quaint artist haunts'; Howard, *Guenn*; Jacobs, *Good and Simple Life*, ch. 3; J.Q., 'Studio-talk: Concarneau'; R.P., 'Concarneau'; Sellin, *Americans*; Simmons, *From Seven to Seventy*.

Dachau

Dachau near Munich was one of the largest and most international artists' colonies of Europe. One exhaustive compilation lists 2,407 names from the Middle Ages to 1989 (Reitmeier). Artists had been coming intermittently since the early nineteenth century but in the century's final decades numbers shot up dramatically. 110 artists came in the 1880s, over 300 in the 1890s, and 434 in the five-year period 1900–1905 alone. Artists were attracted by the local costume and especially by the moor landscape of the Dachauer Moos. A great number of visitors settled in Dachau as permanent residents, some in purpose-built artists' villas. One of those acquiring property was the artist Carl Bössenroth who

established a small colour factory around 1905, specialising in the manufacture of artists' pigments. Dachau's private painting schools were particularly renowned among aspiring women artists, especially those of Adolf Hölzel and Hans von Hayek. In the 1890s, the community received a boost in the direction of modernist Secessionist painting by the trio Adolf Hölzel, Ludwig Dill and Arthur Langhammer, soon grouped by critics under the rubric 'Neu-Dachau' (New Dachau). The village was the subject of Paul Grabein's best-selling novel *Dachauer Künstlerroman* which featured Dill and Hölzel in a sentimental love story. Dachau proved so popular that artists branched off into at least three subsidiary out-posts (in Etzenhausen, Schleißheim and Graßlfing).

A collection of paintings may be seen at the Dachauer Gemäldegalerie.

Recorded: 228 artists. 16 per cent women. 69 per cent German, 10 per cent Austrian, 17 other nationalities.

Selected artists: Carl Bantzer; Tina Blau; Lovis Corinth; Ludwig Dill; Heinrich Gogarten; Robert von Haug; Hans von Hayek; Thomas Theodor Heine; Adolf Hölzel; Leopold von Kalckreuth; Paul Wilhelm Keller-Reutlingen; Ida Kerkovius; Arthur Langhammer; Max Liebermann; Adolf Lier; Adolf Lins; Emilie Mediz-Pelikan; Carl Olof Petersen; Hermann Stockmann; Otto Strützel; Fritz von Uhde; Josef Wenglein; Josef Wopfner.

Key reading: E. Boser, 'Von München nach "Neu-Dachau": Eine Künstlerkolonie und ihre Voraussetzungen', in *Deutsche Künstlerkolonien 1890–1910*; Göttler, *Sozialgeschichte*; Heres, *Dachauer Gemäldegalerie*; Reitmeier, *Dachau*; Roeßler, *Neu-Dachau*; Thiemann-Stoedtner, *Dachauer Maler*; E. Venzmer, 'Dachau bei München', in Wietek, *Deutsche Künstlerkolonien*, pp. 46–57.

Egmond aan Zee

Egmond aan Zee lies between dunes on the Dutch North Sea shore, near Alkmaar. It is part of a conglomerate of three villages, the others being Egmond aan den Hoef and Egmond Binnen. The first artists there were the two Americans George Hitchcock and Gari Melchers who settled in the village in 1883–84. Their success brought others, mostly Americans and mostly in the decade from 1895 to 1905. The artists were instrumental in boosting the locality's tourist trade. By 1903, the erstwhile fishing village had lodgings and at least four hotels, including the Hotel Zeezicht and J. Kraakman's hotel, both of which provided studio facilities. N. Schild's bookstore sold artists' materials. In 1980, a local resi-dent, Ronald van Vleuten, interviewed a number of surviving artists' models; his reports reveal that a close rapport existed between Melchers and the locals who identified strongly with the 'parts' they were asked to perform, especially for religious pictures.

A pair of painted doors from Hotel Zeezicht (which has been torn down) can be seen at Egmond's municipal museum. The bulk of Melchers' work is in Fredericksburg, Virginia, at Belmont: The Gari Melchers Estate and Memorial Gallery.

Recorded: 38 artists. 49 per cent women. At least 18 Americans, 5 other nationalities.

Selected artists: George Hitchcock; Walter MacEwen; Gari Melchers; Letitia Crapo Smith; Florence Kate Upton.

Key reading: Dreiss, *Gari Melchers*; *Gari Melchers*; Hitchcock, 'The picturesque quality of Holland'; Lannoy and Denneboom, *Derper, hoever, binder*; Stott, 'American painters'; Vleuten, 'Egmond remembers'.

Giverny

Giverny, north-west of Paris on the Seine and Epte rivers, owes its fame to the residence of the Impressionist painter Claude Monet. However, Monet had little to do with the largely American artists' colony that was centred on the Hôtel Baudy. It appears that the first artists to arrive in 1886 and 1887 (John Leslie Breck, Theodore Robinson and other students from the Académie Julian in Paris) discovered the village by chance and were initially unaware of Monet's presence. By the early 1890s, though, Monet had acquired guru status for many of Giverny's visitors. The local innkeepers Angélina and Lucien Baudy transformed their establishment into an artists' haven, building studios and annexes, selling artists' materials and cooking special American meals like Christmas pudding and Boston baked beans. After initial contacts, Monet became disenchanted with the crowd at Baudy's and was suspicious of romances between his stepdaughters and the American artists (Suzanne Hoschedé did marry Theodore Earl Butler in 1892). Meanwhile, artists decorated the hotel, played croquet and tennis, celebrated American Thanksgiving and published an illustrated quarterly. In 1910, a group of six Americans, including Frederick Frieseke and Guy Rose, exhibited as the Giverny Group in New York.

The Musée Américain Giverny, a branch of the Terra Museum of American Art in Chicago, shows work by the American artists. The Monet House and Gardens may also be visited.

Recorded: 92 artists. 15 per cent women. 87 per cent American.

Selected artists: John Leslie Breck; Theodore Earl Butler; Dawson Dawson-Watson; Mary Fairchild-MacMonnies; Alexander Harrison; Birge Harrison; Will Hicok Low; Claude Monet; Lilla Cabot Perry; Theodore Robinson; Theodore Wendel.

Key reading: Gerdts, *Lasting Impressions*; Low, *Chronicle*; Meixner, *International Episode*; Sellin, *Americans*.

Grèz-sur-Loing

In August 1875, a handful of artists, disaffected with the growing crowds and lack of 'amphibious activities' (Low) at Barbizon, decamped to nearby Grèz, situated on the Loing river in the forest of Fontainebleau. Grèz soon grew into a substantial artists' colony of its own, witnessing two waves of artistic activity. The first was dominated by British and Americans, including Will Hicok Low, the Stevenson cousins and the Harrison brothers; the second consisted almost entirely of Scandinavians, mainly from Sweden and Norway (from 1882). Although Low apostrophised the colony in its early days as 'an Eve-less Paradise', Grèz ended up as a rather domestic community with a fair number of trysts and artistic marriages. Painters lodged either at the Pension Chevillon or at Laurent's Hôtel Beauséjour, both situated on the river and surrounded by gardens. The German painter Jelka Rosen posed nude models in another overgrown garden, spied on by the village priest

from the nearby church terrace. Convivial life included the usual dinner gatherings, and also boat races, singsongs, dancing, masked balls and parties that went on for days.

The Hôtel Chevillon was restored by a Swedish foundation in the early 1990s and has since offered studio space and accommodation to scholarship holders, among others. There is, however, no art left in the village; works are scattered all over the world.

Recorded: 119 artists. 18 per cent women. 33 per cent Scandinavian (23 per cent Swedish), 30 per cent American, 21 per cent British, 7 per cent Irish, 3 per cent French.

Selected artists: Asai Chu; Frank Chadwick; Frederick Delius (composer); Ida Gerhardi; Alexander Harrison; Birge Harrison; Carl Frederik Hill; Christian Krohg; Peder Severin Krøyer; Kuroda Seiki; Carl Larsson; John Lavery; Will Hicok Low; Emma Löwstadt-Chadwick; Karl Nordström; Frank O'Meara; Jelka Rosen; Robert Louis Stevenson (writer); Robert Mowbray Stevenson; August Strindberg (writer); Robert Vonnoh.

Key reading: Campbell, *The Irish Impressionists*; Carley, *Delius*; Harrison, 'In search of paradise'; Harrison, 'With Stevenson at Grez'; Jacobs, *Good and Simple Life*, ch. 2; Larsson, *Carl Larsson*; Low, *Chronicle*; Rittmann (ed.), *Briefe. Ida Gerhardi*; Stevenson, 'Forest notes'; Stevenson, 'Fontainebleau'; Stevenson, 'Grez'; *Svensk konst i Grez*; Wright, 'Bohemian days'.

Katwijk

The meticulous compilation of visitors' data, assembled by J. P. Brakel from hotel registers and other archival sources (*Katwijk in de schilderkunst*), means that we have detailed information on 879 artists who visited Katwijk on the Dutch North Sea coast from the sixteenth century to the 1980s. The artists' colony's heyday fell in the years 1880–1910 during which period at least 517 artists stayed in the village. The same years saw the transformation of Katwijk from a small fishing village to bustling seaside resort with twelve hotels, numerous private lodgings and a diverse international group of artists. Artists continued to paint fisherfolk and fishing boats among the dunes.

A collection of paintings is on show at the Katwijks Museum.

Recorded: 517 artists. 15 per cent women. 26 per cent Dutch, 24 per cent German, 19 per cent British, 19 per cent American, 15 other nationalities.

Selected artists: Hans von Bartels; Bernardus Johannes Blommers; German Grobe; Charles Paul Gruppe; Jozef Israëls; Max Liebermann; Gerhard Morgenstjerne Munthe; Evert Pieters; Philip Sadée; Willy Sluiter; Alphonse Stengelin; Charley (Annie Caroline) Toorop; Jan Toorop.

Key reading: Boughton, 'Artist strolls in Holland'; Brakel, *Vissen*; *Katwijk in de schilderkunst*; Vellekoop, 'Is er een Katwijkse School?'.

Laren

In 1877, the Dutch painter Albert Neuhuys arrived in the hamlet of Laren in the Dutch region of the Gooi. In 1883, he came back and settled in a villa there. His colleague Anton

Mauve visited and worked with him during the summer months and, in 1886, settled in Laren permanently. The immense success of Neuhuys' and Mauve's paintings of peasants on the Dutch and American art market alerted other painters to the existence of Laren which soon grew into an international art and tourist centre. The local innkeeper Jan Hamdorff expanded his hotel business to accommodate the increasing number of visitors and was instrumental in bringing the railway to Laren. In 1896, Hamdorff was elected into the Laren Town Council in recognition of all he had done for the local tourist trade.

Works may be seen at the Singer Museum in Laren.

Recorded: 128 artists. 19 per cent women. 44 per cent Dutch, 38 per cent American, 9 other nationalities.

Selected artists: Etha Fles; Charles Paul Gruppe; Arina Hugenholtz; Walter Castle Keith; Harold Knight; Laura Knight; Max Liebermann; Anton Mauve; Wally Moes; Albert Neuhuys; Ferdinand Hart Nibbrig; Evert Pieters; Henry Ward Ranger; Joseph Raphael; Sigisbert Bosch Reitz; William Henry Singer; Jan Veth; Marcia Oakes Woodbury.

Key reading: Heyting, 'De geschiedenis'; Heyting, *De wereld*; Knight, *Oil Paint*; Koenraads, *Laren*; Pol, 'De "Larense School"'; Ranger, 'Artist life'; Seumeren-Haerkens, 'Kunstenaars'; Stott, 'American painters'; *'Zij waren in Laren…'*.

Newlyn

After a summer spent sketching in Brittany (where he also visited the artists' communities in Pont-Aven and Concarneau), the Irish painter Stanhope Forbes arrived in Newlyn on the south coast of Cornwall in early 1884. Artists had been living and working in the fishing village since 1875, and Forbes wrote shortly after his arrival, 'Newlyn is a sort of English Concarneau and is the haunt of a great many painters' (quoted in Bendiner). A number of the artists had, in fact, been to Concarneau or Pont-Aven previously. Although there was no inn to congregate in, lively social gatherings took place at artists' homes, including the preparation of theatrical performances. Painters displayed their works to the locals every year at a 'private view'. By the turn of the century, Newlyn boasted at least two art schools and a gallery.

Little trace of the artists' colony remains today; the Newlyn Art Gallery, opened in 1895, now shows only contemporary art. However, work may be seen in nearby Penzance at the Penlee House Gallery and Museum.

Recorded: 73 artists. 18 per cent women. 94 per cent British, 5 other nationalities.

Selected artists: Frank Wright Bourdillon; Frank Bramley; Percy Craft; Elizabeth Armstrong Forbes; Stanhope Forbes; Norman Garstin; Edwin Harris; Harold Knight; Laura Knight; Walter Langley.

Key reading: Bednar, *'Every Corner was a Picture'*; Bendiner, *Victorian Painting*, pp. 103–19, 161–3; Fox and Greenacre, *Artists of the Newlyn School (1880–1900)*; Fox and Greenacre, *Painting in Newlyn*; Fox, *Stanhope Forbes*; *Frank Bramley*; Jacobs, *Good and Simple Life*, ch. 8; Knight, *Oil Paint*; Langley, *Walter Langley*; Lübbren, '"Toilers"'.

Pont-Aven

In the spring of 1866, a handful of young American art students arrived in Paris and set in motion the bureaucratic process which would eventually, so they hoped, admit them to the École des Beaux-Arts. Two of them, Earl Shinn and Howard Roberts, had been encouraged by their erstwhile Philadelphia art teacher Robert Wylie to visit the village of Pont-Aven in Brittany in the summer. Word of mouth spread to their compatriots and comrades in Paris, with the result that about twelve American and English artists stayed in Pont-Aven in the summer of 1866. They seem to have been very popular with the villagers who readily posed for them and provided them with suitable studio space in a dilapidated country house called Château de Lezaven. Everyone stayed at the Hôtel des Voyageurs and the Pension Gloanec, or lodged with villagers. Many of the artists returned year after year, some (including Wylie and Frederick Bridgman) settled there permanently or for a period of some years, and all broadcast their delight with the village to their colleagues. French artists started to frequent Pont-Aven in the mid- to late 1870s; however, when Paul Gauguin first stayed in the village in June 1886, he still encountered 'hardly any French, all foreigners' at the Pension Gloanec (Merlhès). Around 1900, the village was still so popular with artists that Julia Guillou, one of the local innkeepers who had made her fortune from the influx of artists, was opening a private art school of her own, known as the 'Académie Julia'.

Not much art remains in the village but the Musée de Pont-Aven, established in 1885, is building up a small collection and also shows photographs, documents and temporary exhibitions of Pont-Aven artists.

Recorded: 207 artists. 8 per cent women. 37 per cent American, 21 per cent French, 14 per cent British, 7 per cent Scandinavian, 13 other nationalities.

Selected artists: Cuno Amiet; Emile Bernard; Eugène Boudin; Frederick Bridgman; Benjamin Champney; Helen Corson; Arthur Wesley Dow; Paul Gauguin; Alexander Harrison; Birge Harrison; Thomas Hovenden; Hugh Bolton Jones; Peder Severin Krøyer; William Henry Lippincott; Amelie Lundahl; Maxime Maufra; Henry Moret; Roderic O'Conor; William Lamb Picknell; Marianne Preindlsberger-Stokes; Howard Roberts; Helene Schjerfbeck; Paul Sérusier; Earl Shinn; Edward Simmons; Clement Nye Swift; Henry Jones Thaddeus; Helen Mabel Trevor; Jan Verkade; Julian Alden Weir; Maria Wiik; Jens Ferdinand Willumsen; Robert Wylie.

Key reading: Appelberg, *Helene Schjerfbeck*; Blackburn, 'Pont-Aven and Douarnenez'; Blackburn, *Breton Folk*; Delouche, *Les Peintres de la Bretagne*; Delouche, 'Pont-Aven avant Gauguin'; Delouche, *Les Peintres et le paysan breton*; Delouche, *Pont-Aven*; Delouche, *Artistes étrangers*; Goater, 'A summer'; Harrison, 'Quaint artist haunts'; Jacobs, *Good and Simple Life*, ch. 3; Le Paul, *Gauguin*; Merlhès, *Correspondance de Paul Gauguin*; Sellin, *Americans*.

St Ives

Artists, including veterans of Concarneau, Pont-Aven and Grèz, began to arrive in substantial numbers in the fishing port of St Ives in the north of Cornwall from 1886. They

were attracted primarily by the sea view from the curving harbour and the picturesqueness of the steep lanes, fishing cottages and local 'salts'. By 1887, the colony had become quite international, and artists were so numerous that 'it was difficult to have the moon to oneself' (Emma Lamm, Anders Zorn's wife, quoted in Jacobs). Fishing lofts were converted into studios, cricket matches played against the 'rivals' in nearby Newlyn, and an Arts Club was founded in 1888. The local merchant James Lanham sold artists' materials and exhibited paintings in a small gallery. Every March, there was an exhibition and open-studio day, and this Show Day became so popular that extra trains had to be scheduled.

In the 1920s and again in the 1940s and 1950s, new generations of modernist and abstract artists and potters moved to St Ives. Their work may be seen at the Barbara Hepworth Museum and the Tate Gallery St Ives. Few traces remain of the nineteenth-century pioneers except for paintings in the private homes of locals, though some work is shown at the Sims Gallery. St Ives also has a Museum and at least eight other commercial galleries, most showing modern and contemporary art and craft.

Recorded: 106 artists. 16 per cent women. 51 per cent British, 24 per cent American, 10 per cent Australian, 5 other nationalities.

Selected artists: Howard Russell Butler; Emanuel Phillips Fox; Louis Grier; Alexander Harrison; Emma Löwstadt-Chadwick; Mary McCrossan; Henry Moore (not to be confused with the modernist sculptor); Julius Olsson; Marianne Preindlsberger-Stokes; Helene Schjerfbeck; Edward Simmons; Adrian Stokes (not to be confused with the art critic); William Holt Yates Titcomb; Anders Zorn.

Key reading: Bartlett, 'Summer time'; Jacobs, *Good and Simple Life*, ch. 8; Simmons, *From Seven to Seventy*; Whybrow, *St Ives 1883–1993*; Wortley, *British Impressionism*.

Sint-Martens-Latem (in French: Laethem-Saint-Martin)

Sint-Martens-Latem is situated on the winding Leie River (or Lys) in the Flemish part of Belgium. In 1874, the village mayor, Albijn Van den Abeele, who had up until then been active as a writer of fiction, decided to devote his spare time exclusively to painting. Twenty years later, the first non-local painters started to congregate around Abeele in the village. Valerius de Saedeleer was the first to settle permanently in Latem in 1898, followed by the sculptor George Minne, the critic Maurits Niekerk, the writer Karel van de Woestijne and his brother, the painter Gustave, as well as a growing number of painters, mostly from art schools in Ghent. Most of the artists had or started large families in the village, and cultural life was permeated with religious crises and revived devotion, focused around the former Catholic pastor Van Wambeke and the monk Pater Jeroom, and exemplified by Gustave's donation of an altarpiece to the local church in 1905 (*Our Lady Presents Saint Dominic with a Rosary*, still *in situ* today). In 1902, Karel founded the artistic circle 'Open Wegen' (Open Paths) whose members met in the inn 'In den veloclub' (Cycling club) where they kept books and magazines in a special room and regularly invited guest speakers on topics ranging from Maeterlinck to microbes. During and after the First World War, a new generation of Expressionist painters settled in Latem.

A collection of paintings is on view at the Gemeentehuis near Latem's church, and there are also some works at the Galerij Oscar De Vos.

Recorded: 39 artists. 5 per cent women. 97 per cent Belgian, 2 other nationalities.

Selected artists: Albijn Van den Abeele; George Minne; Serafien De Rijcke; Valerius De Saedeleer; Gustave van de Woestijne; Karel van de Woestijne (writer).

Key reading: Boyens, *Flemish Art*; *De eerste groep*; Haesarts, *Laethem-Saint-Martin*; *Het Latemse landschap voor 1918*; *Latems kunstleven rond 1900*; *Serafien De Rijcke*.

Skagen

Skagen is situated amongst sand dunes at the northernmost tip of the Danish peninsula, 'where the waves of the North Sea lap over your one foot, and the waves of the Kattegat over the other' (Andersen). Individual artists had visited the Skaw since the 1830s, but the life of Skagen as a community of painters began in 1872 when five Danish and Norwegian painters stayed there. The word spread by the usual word of mouth; the artists related enthusiastic descriptions to their fellow students and colleagues in Copenhagen during the winter months. The result was a growing influx of painters to Skagen over the following years, until it turned into a veritable stream of tourists in the mid-1890s. Skagen's appeal reached beyond the boundaries of Denmark, especially to Norway and Sweden, but there were occasional visitors from Finland, Austria, England, and even as far away as Greece. Brøndum's inn became a focus for a lively social life, including masquerades and parties, often organised by the painter Peder Severin Krøyer. The innkeeper's family became very involved with artistic life in Skagen, with three Brøndum women becoming painters themselves and marrying other painters.

The foremost place to see Skagen art is in the Skagens Museum which incorporates Brøndum's inn with its dining room decorated by artists. Anna and Michael Ancher's house and Drachmann's house are also open to the public. Further works may be seen in Copenhagen, especially at the Hirschsprung Collection.

Recorded: 75 artists. 12 per cent women. 94 per cent Scandinavian (overwhelmingly Danish, 9 per cent Norwegian, some Swedish, 1 Finnish), 4 other nationalities.

Selected artists: Anna Ancher; Michael Ancher; Holger Drachmann (poet); Viggo Johansen; Christian Krohg; Oda Krohg; Peder Severin Krøyer; Carl Locher; Karl Madsen; Christian Skredsvig; Frits Thaulow; Laurits Tuxen.

Key reading: Andersen, *H. C. Andersens Dagbøger*; *Das Licht des Nordens*; Hornung, *P.S. Krøyer*; Jacobs, *Good and Simple Life*, ch. 4; *Künstlerkolonie Skagen*; Madsen, 'Skagen'; Carit Andersen, *Skagen*; Schwartz, *Skagen*; Voss, *Skagens Museum*; Voss, *Painters of Skagen*; Wivel, *Anna Ancher*.

Staithes

The artists' community in the fishing village of Staithes on the North Yorkshire coast flourished between 1894 and 1909. Among the first artists were Laura and Harold Knight who came there from Nottingham and (with intervals in Laren) stayed for over ten years before

moving to Newlyn. Not all of the artists involved with the Staithes group actually lived in the village; Fred Jackson, for example, stayed at and eventually married into nearby Hinderwell. Artists were charmed by the combination of landscape, seascape and steep village, 'unspoilt by summer visitors' (Knight). Models were easily recruited, both from among the fishing population and the mining community at the top of the village. In 1901, the Staithes Art Club was founded, and at least seven annual exhibitions were held in the Fishermen's Institute and in nearby Whitby.

The Pannett Art Gallery in nearby Whitby has some paintings but most are dispersed into public and private collections across England. The commercial gallery of Phillips & Sons in Cookham, Berkshire, has shown works by Staithes artists.

Recorded: 44 artists. 9 per cent women. 100 per cent British.

Selected artists: Ernest Dade; Arthur Friedenson; Frederic William Jackson; Robert Jobling; Harold Knight; Laura Knight; Ernest Higgins Rigg.

Key reading: Knight, *Oil Paint*; Lübbren, '"Toilers"'; Phillips, *Staithes Group*; Wortley, *British Impressionism*.

Volendam

The fishing village of Volendam, situated just south of Edam on the coast of the former Dutch inland sea of Zuiderzee (now the Ijsselmeer), began to attract artists in the 1880s and 1890s. By 1900, the number of (primarily American and English) annual visitors had swollen to 50–60. Artists were mainly enchanted by the quaint red-roofed timber cottages and by the local costume. Indeed, images of Volendamers in wing-tipped hats and baggy trousers became so prevalent in the Western world that the indigenous costume was soon identified with Dutchness *per se*. All artists stayed at Leendert Spaander's hotel. Spaander proved to be one of the most successful of Europe's innkeeper-entrepreneurs, expanding his establishment to cater for ever-growing numbers of painters and, in their wake, tourists. On the eve of World War One, 'droves' of foreigners were already coming 'to do Volendam' on day-trips, (Tussenbroek) always having lunch at Spaander's, and the stream of tourists continues unabated to this day.

Works may be seen at Volendams Museum and at the Zuiderzee Museum in Enkhuizen. The walls of Hotel Spaander's several dining rooms and bar are still adorned with paintings and murals, and the rooms fitted up by Spaander as Volendam cottage interiors for the use of artists have been turned into special period suites with all the mod-cons.

Recorded: 136 artists. 15 per cent women. 30 per cent American, 15 per cent British, 28 per cent Dutch, 10 per cent German, 8 other nationalities.

Selected artists: Franz Althaus; Hans von Bartels; Cecilia Beaux; Tina Blau; Henry Cassiers; George Clausen; Elizabeth Armstrong Forbes; Stanhope Forbes; Johannes Gabriëlse; Augustin Hanicotte; Carl Jacoby; Robert Jobling; Rudolf Jordan; Nico Jungman; Leopold von Kalckreuth; Friedrich Kallmorgen; Vassily Kandinsky; Walter Langley; Elizabeth Nourse; Bernard Partridge; Edward Penfield; Evert Pieters; Paul Rink; Paul Signac; Willy Sluiter; Marcia Oakes Woodbury.

Key reading: Boughton, 'Artist strolls in Holland'; Konody, 'A Dutch Barbizon'; Penfield, 'The magenta village'; Quigley, 'Volendam as a sketching ground'; Simons, *Hotel Spaander*; Tussenbroek, 'Volendam als "sketching ground"'; Veurman, *Volendammer schilderboek*; *Vreemde gasten*.

Willingshausen

The first artist to paint in the village of Willingshausen in the Schwalm region of Hesse in Germany was Gerhardt von Reutern, a frequent guest of the local aristocratic family from 1814 onward. From the 1840s, the number of artists in Willingshausen increased considerably. Many of them were students of Carl Bantzer who followed their teacher to the countryside during the summer vacation. Only one painter, Wilhelm Thielmann, settled permanently. The rest found lodgings with locals or stayed at Haase's inn which became the focus of artistic social life. A small collection of paintings and a painted door may be seen in the Willingshäuser Malerstübchen, the former artists' inn.

Recorded: 205 artists. 4 per cent women. Virtually 100 per cent German.

Selected artists: Carl Bantzer; Jakob Becker; Anton Burger; Jakob Fürchtegott Dielmann; Caroline von der Embde; Heinrich Giebel; Dora Hitz; Bernhard Klapp; Ludwig Knaus; Adolf Lins; Theodor Matthei; Hugo Mühlig; Heinrich Otto; Karl Raupp; Otto Strützel; Wilhelm Thielmann; Otto Ubbelohde; Hans von Volkmann; Martha Wenzel.

Key reading: B. von Andrian, 'Die Willingshäuser Künstlerkolonie', in *Deutsche Künstlerkolonien 1890–1910*; Andrian-Werburg, 'Schwälmer Arbeitswelt'; Bantzer (ed.), *Carl Bantzer*; Bantzer, *Hessen*; *Die Künstlerkolonie Willingshausen*; K. Kaiser, 'Willingshausen in der hessischen Schwalm', in Wietek, *Deutsche Künstlerkolonien*, pp. 14–27; Küster, *Carl Bantzer*; Raupp, 'Willingshausen'; Wollmann and Willingshäuser Gemäldekabinett Wollmann, *Die Willingshäuser Malerkolonie*.

Worpswede

In 1884, Fritz Mackensen, a student of art at the Düsseldorf Art Academy, was invited to spend the summer vacation in Worpswede, in the north of Germany near Bremen. Mackensen was delighted with the village and surrounding countryside. He spent the next three summers there, and in 1889 he encouraged his classmates Otto Modersohn, Hans am Ende and Otto Ubbelohde to join him there. The painters talked a lot about their growing disillusionment with the style of teaching offered at the Academy. In a momentary burst of enthusiasm, Mackensen, Modersohn and am Ende decided to stay in Worpswede over the winter months and longer, emulating the model of Barbizon. Over the next few years, they were joined by a growing number of other German artists. All of them rented rooms from villagers which they used as studios and lodgings, and some built their own houses. The painters' first joint exhibition at the annual international art show in Munich in 1895 was a tremendous success and advertised Worpswede throughout Germany, bringing yet more artists and tourists to the village. Around 1900, there were at least twenty artists living and working there, including Paula Modersohn-Becker and the poet Rainer Maria Rilke. Worpswede continued to be an artistically active and growing village until the late 1920s,

and the buildings erected by Heinrich Vogeler and Bernhard Hoetger after the First World War still dominate the look of the village today.

The best collections of paintings are in the Worpsweder Kunsthalle Friedrich Netzel, the Große Kunstschau Worpswede, the Museum am Otto-Modersohn-Haus (collection Bernhard Kaufmann), the Galerie Cohrs-Zirus and the Haus im Schluh. Further sights in Worpswede include the Barkenhoff (Vogeler's house) and Bernhard Hoetger's expressionist First World War memorial, the Niedersachsenstein. In nearby Bremen, the Kunsthalle Bremen and the Paula Modersohn-Becker-Museum have good collections, and in Fischerhude there is the Otto-Modersohn-Museum.

Recorded: 68 artists. 38 per cent women. Virtually 100 per cent German, 1 Romanian.

Selected artists: Walter Bertelsmann; Marie Bock; Hans am Ende; Karl Krummacher; Fritz Mackensen; Emmy Meyer; Otto Modersohn; Paula Modersohn-Becker; Fritz Overbeck; Hermine Overbeck-Rohte; Ottilie Reylaender; Rainer Maria Rilke (poet); Clara Rilke-Westhoff (sculptor); Otto Ubbelohde; Heinrich Vogeler; Sophie Wencke.

Key reading: Boulboullé and Zeiss, *Worpswede*; K. Erling, 'Worpswede', in *Deutsche Künstler-kolonien 1890–1910*; Jacobs, *Good and Simple Life*, ch. 6; Kirsch, *Worpswede*; Modersohn-Becker, *In Briefen und Tagebüchern*; Overbeck, 'Ein Brief'; Perry, *Paula Modersohn-Becker*; Perry, 'Primitivism'; K. V. Riedel, 'Worpswede im Teufelsmoor', in Wietek, *Deutsche Künstlerkolonien*, pp. 100–13; Riedel, *Worpswede*; Rilke, *Worpswede*; *Worpswede 1889–1989*; *Worpswede: Aus der Frühzeit*; *Worpswede: Eine deutsche Künstlerkolonie*, 1986; *Worpswede: Eine deutsche Künstlerkolonie um 1900. 150 Werke*.

Notes

Notes to Introduction

1 This is a conservative estimate based on my own compilation. A recent exhibition catalogue lists 879 names for Katwijk alone, and Lorenz Josef Reitmeier catalogues 2,407 names for Dachau (admittedly, over a period of a thousand years but the overwhelming majority came to Dachau between 1870 and 1920). See L. J. Reitmeier, *Dachau – Der berühmte Malerort: Kunst und Zeugnis aus 1200 Jahren Geschichte*, Munich, 1990; *Katwijk in de schilderkunst*, ed. W. van der Plas, Katwijk, 1995.

2 Many contemporary witnesses simply referred to 'lady students' or 'lady artists' without mention of names or numbers. Most books on Worpswede record two women artists (Paula Modersohn-Becker and Clara Rilke-Westhoff); my own research uncovered twenty-four. N. Lübbren, 'Ottilie Reylaender: Eine Malerin in Worpswede um die Jahrhundertwende', Magister thesis, Berlin, 1990.

3 According to the data available to me: Rijsoord had 54 per cent women artists, Egmond 49 per cent, Ahrenshoop, Schwaan and Worpswede 38 per cent, Laren, Grèz, Newlyn, Dachau and St Ives 16–19 per cent, Kronberg, Volendam, Giverny, Katwijk, Concarneau, Skagen and Cernay 12–15 per cent, Staithes, Pont-Aven, Douarnenez and Sint-Martens-Latem 5–9 per cent, Willingshausen, Barbizon and Szolnok 3–4 per cent, Le Pouldu, Kleinsassen and many other under-researched colonies 0 per cent.

4 I have catalogued the following nationalities: Algerian, American, Australian, Austrian, Belgian, Canadian, Croatian, Czech, Danish, Dutch, English, Estonian, Finnish, French, German, Greek, Hungarian, Irish, Italian, Japanese, Luxembourgian, New Zealand, Norwegian, Polish, Romanian, Russian, Scottish, Siberian, Slovenian, Spanish, Swedish, Swiss, Turkish, and Ukrainian. See N. Lübbren, 'Rural artists' colonies in nineteenth-century Europe', Ph.D. dissertation, University of Leeds, 1996, vol. 2, Appendix II.

5 Americans constituted 20 per cent (in France and the Netherlands, some in England), Germans 20 per cent (in Germany and the Netherlands), British 14 per cent (in Britain and France, some in the Netherlands), Dutch 13 per cent (in the Netherlands), French 11 per cent (in France), Scandinavian 5 per cent (in Denmark and France), assorted other 17 per cent. Anglo-Saxons and Germans together made up 59 per cent of artist-colonists.

6 Of 100 artists' colonies with known dates, 3 were founded in the 1820s, none in the 1830s, 4 in the 1840s, 8 in the 1850s, 7 in the 1860s, 18 in the 1870s, 32 in the 1880s, 19 in the 1890s and 9 in the 1900s.

7　For example, in the summer of 1876, Pont-Aven harboured 50 to 60 artists; by 1886, it was well over 100. Dachau attracted around 110 artists during the 1880s, a figure that rose to 306 in the 1890s and to 932 in the quinquennium 1900 to 1905 alone – after which numbers fell again. Katwijk's population of first-time artist visitors rose from 7 in the 1870s to 93 in the 1880s, 180 in the 1890s and 187 in the 1900s. M. Jacobs, *The Good and Simple Life: Artist Colonies in Europe and America*, Oxford, 1985; Reitmeier, *Dachau*; *Katwijk in de schilderkunst*.

8　C. A. White and H. C. White, *Canvases and Careers: Institutional Change in the French Painting World*, Chicago and London, [1965] 1993; R. Lenman, 'Painters, patronage and the art market in Germany 1850–1914', *Past & Present*, 128 (1989), 109–40.

9　On the Millet cult, see L. Meixner, *An International Episode: Millet, Monet and their North American Counterparts*, Memphis, Tenn., 1982; N. McWilliam, 'Mythologising Millet', in A. Burmester, C. Heilmann and M. F. Zimmermann (eds), *Barbizon: Malerei der Natur – Natur der Malerei*, Munich, 1999, pp. 437–47; and B. P. Fratello, 'Henry Chapu's rural monuments to Jean-François Millet: Legitimising the peasant painter through tourism', in N. Lübbren and D. Crouch (eds), *Visual Culture and Tourism*, Oxford, 2001 (forthcoming). On rising prices, see A. Reverdy, *L'École de Barbizon: Évolution du prix des tableaux de 1850 à 1960*, Paris, The Hague and Mouton, 1973.

10　L. Hevesi, 'Barbizon: Das Malernest bei Fontainebleau', in *Altkunst-Neukunst: Wien 1894–1908*, Vienna, [1907] 1909, p. 588.

11　See, for example, K. Belgum, *Popularizing the Nation: Audience, Representation and the Production of Identity in 'Die Gartenlaube', 1853–1900*, Lincoln, Nebr., 1998.

12　66 in Skagen, 74 in Newlyn, 107 in Grèz, 120 in Concarneau, 128 in Laren, 137 in Volendam, 140 in Willingshausen, over 200 in Barbizon, 205 in Pont-Aven, 516 in Dachau and 632 in Katwijk. See also Lübbren, 'Rural artists' colonies', vol. 2, Appendix I.

13　The registers of Katwijk and Pont-Aven have been systematically evaluated but most others are only mentioned in the literature. See *Katwijk in de schilderkunst*; D. Delouche, *Les Peintres de la Bretagne avant Gauguin*, 3 vols, Lille, [1975] 1978.

14　*Katwijk in de schilderkunst*; Reitmeier, *Dachau*; J. A. Wollmann and Willingshäuser Gemäldekabinett Wollmann (eds), *Die Willingshäuser Malerkolonie und die Kleinsassener Malerkolonie*, Schwalmstadt-Treysa, *c.* 1991; Delouche, *Les Peintres de la Bretagne*.

15　O. Thiemann-Stoedtner, *Dachauer Maler: Der Künstlerort Dachau von 1801–1946*, Dachau, 1981.

16　L. Jürß, *Schwaan: Eine mecklenburgische Künstlerkolonie*, Fischerhude, [1992] rev. edn 1995.

17　D. Dawson-Watson, 'The real story of Giverny', quoted in D. Sellin, *Americans in Brittany and Normandy*, Phoenix, Ariz., 1983, pp. 66–7.

18　Forbes continued: 'I had just returned from Brittany, and was looking around for a fresh sketching ground. A friend suggested the Cornish coast. We settled at Manaccan … but finding the place lacked interest for a figure painter I took my knapsack, went exploring on my own account, and ultimately found myself at Newlyn … Perhaps I should not have settled at Newlyn, however, if I had not met my wife here.' Porthleven was also briefly considered. S. Forbes in F. Dolman, 'Illustrated interviews 76: Mr. Stanhope A. Forbes, A.R.A.', *Strand Magazine*, 22:131 (1901), 483–4; and Forbes, letter from Penzance, quoted in C. Fox and F. Greenacre, *Painting in Newlyn 1880–1930*, London, 1985, p. 54.

19 *Worpswede: Eine deutsche Künstlerkolonie um 1900*, ed. W.-D. Stock, Ottersberg–Fischerhude, 1986, p. 10; U. Hamm and B. Küster, *Fritz Mackensen 1866–1953*, Worpswede, 1990, pp. 38–9.

20 P. Müller-Kaempff, 'Erinnerungen an Ahrenshoop', *Mecklenburgische Monatshefte*, 2 (1926), 333.

21 T. H. Bartlett, 'Barbizon and Jean-François Millet', *Scribner's Magazine*, 7:5 (1890), 536.

22 F. T. Overbeck, *Eine Kindheit in Worpswede*, Bremen, 1975, pp. 249–50, 256–7.

23 H. R. Butler, letter, 3 July 1885, quoted in Sellin, *Americans*, p. 10.

24 See G. Bott, 'Darmstadt und die Mathildenhöhe', in G. Wietek (ed.), *Deutsche Künstlerkolonien und Künstlerorte*, Munich, 1976, pp. 154–61; *Ein Dokument deutscher Kunst: Darmstadt 1901–1976*, 3 vols, Darmstadt, 1976/77.

25 See C. Pese, '"Im Zeichen der Ebene und des Himmels": Künstlerkolonien in Europa. Ein Forschungs- und Ausstellungsprojekt des Germanischen Nationalmuseums', *Anzeiger des Germanischen Nationalmuseums* (1999), 50–7.

26 More on the label 'school' in chapter 1 and in Lübbren, 'Rural artists' colonies', pp. 26–30.

27 F. McCarthy, *The Simple Life: C. R. Ashbee in the Cotswolds*, London and Berkeley, 1981; J. Szabadi, *Jugendstil in Ungarn: Malerei, Graphik, Plastik*, Vienna and Munich, [1979] 1982; K. Keserü, 'The workshop of Gödöllő: Transformations of a Morrisian theme', *Journal of Design History*, 1:1 (1988), 1–23; G. Éri and Z. Jobbágy, *A Golden Age: Art and Society in Hungary 1896–1914*, London, 1989, pp. 122–9.

28 For example, Heinrich Vogeler's *Jugendstil* designs in Worpswede or the 'Newlyn Industrial Class' in Newlyn, started in 1890. Barkenhoff-Stiftung Worpswede, C. Baumann and V. Losse (eds), *Heinrich Vogeler und der Jugendstil*, Cologne, 1997; Fox and Greenacre, *Painting in Newlyn*, p. 35.

29 M. B. Green, *Mountain of Truth: The Counterculture Begins – Ascona 1900–1920*, Hanover, New Hampshire, 1986; L. Heyting, *De wereld in een dorp: Schilders, schrijvers en wereldverbeteraars in Laren en Blaricum 1880–1920*, Amsterdam, 1994. See also C. Hepp, *Avantgarde: Moderne Kunst, Kulturkritik und Reformbewegungen nach der Jahrhundertwende*, Munich, 1987.

30 Jacobs, *Good and Simple Life*, ch. 5: 'In the nest of the gentry: Abramtsevo (Russia)'; E. Paston, 'Der Künstlerkreis von Abramcevo inmitten der europäischen Künstlerkolonien', in *Anzeiger des Germanischen Nationalmuseums*, Nuremberg (1999), 77–83; N. Broude, *The Macchiaioli: Italian Painters of the Nineteenth Century*, New Haven and London, 1987, pp. 100, 124ff; P. Dini, 'Die Schulen von Castiglioncello und Piagenta und ihre Bezüge zur europäischen Malerei', in *Landschaft im Licht: Impressionistische Malerei in Europa und Nordamerika*, ed. G. Czymmek, Cologne, 1990, pp. 179–84; A. Crawford, 'New life for an artist's village: Broadway, Worcestershire', *Country Life*, 167 (1980), 252–4, 308–10.

31 L. Nochlin, 'Why have there been no great women artists?' in *Women, Art, and Power and Other Essays*, London, [1971] 1989, pp. 145–78.

32 Jacobs, *Good and Simple Life*. On Germany, see following notes. On Breton colonies, see D. Delouche (ed.), *Artistes étrangers à Pont-Aven, Concarneau et autres lieux de Bretagne*, Rennes, 1989; *La Route des peintres en Cornouaille – 1850–1950*, eds Groupement touristique de Cornouaille *et al.*, Faou, 1993. See also A. Repp-Eckert, 'Europäische Künstlerkolonien des 19. Jahrhunderts', in *Landschaft im Licht*, pp. 56–66.

33 See, for example, *Deutsche Künstlerkolonien 1890–1910: Worpswede, Dachau, Willings-hausen, Grötzingen, Die 'Brücke', Murnau*, eds E. Rödiger-Diruf and B. Baumstark, Karlsruhe, 1998.

34 Wietek, *Deutsche Künstlerkolonien*.

35 The curatorial team at the Germanische Nationalmuseum in Nuremberg include such widely disparate formations as Skagen, Abramtsevo, the Russian Futurists and Jewish artists at the Nazi concentration camp of Theresienstadt. Section '"Im Zeichen der Ebene und des Himmels": Künstlerkolonien in Europa', ed. C. Pese, *Anzeiger des Germanischen Nationalmuseums* (1999), 49–121.

36 J. Rewald, *Post-Impressionism: From Van Gogh to Gauguin*, London, [1956] 1978, p. 173.

37 T. J. Clark, *The Painting of Modern Life: Paris in the Art of Manet and His Followers*, London, [1984] rev. edn 1999.

38 S. Eisenman, 'Introduction: Critical art and history', in Eisenman *et al.*, *Nineteenth Century Art: A Critical History*, London, 1994, p. 13.

39 N. Broude (ed.), *World Impressionism: The International Movement, 1860–1920*, New York, 1990; G. P. Weisberg, *Beyond Impressionism: The Naturalist Impulse in European Art 1860–1905*, New York and London, 1992.

40 Weisberg, *Beyond Impressionism*, p. 7.

41 A trap that many early feminist art historians fell into, for example, E. Tufts, *Our Hidden Heritage: Five Centuries of Women Artists*, London, 1974; K. Petersen and J. J. Wilson, *Women Artists: Recognition and Reappraisal from the Middle Ages to the Twentieth Century*, New York, 1976. For a critique of these approaches, see R. Parker and G. Pollock, *Old Mistresses: Women, Art and Ideology*, London, 1981, pp. 45–9, and G. Pollock, *Differencing the Canon: Feminist Desire and the Writing of Art's Histories*, London and New York, 1999.

42 N. McWilliam, 'Limited revisions: Academic art history confronts academic art', *Oxford Art Journal*, 12:2 (1989), 71–86, quotations on p. 84.

43 See the discussion in P. Macnaghten and J. Urry, *Contested Natures*, London, Thousand Oaks, Calif. and New Delhi, 1998, ch. 6: 'Nature as countryside'.

44 F. Orton and G. Pollock, 'Les Données bretonnantes: la prairie de représentation', *Art History*, 3:3 (1980), 314–44; R. Lenman, 'Art and tourism in southern Germany, 1850–1930', in A. Marwick (ed.), *The Arts, Literature and Society*, London and New York, 1990, pp. 163–80; G. Pollock, *Avant-Garde Gambits 1888–1893: Gender and the Colour of Art History*, London, 1992; R. L. Herbert, *Monet on the Normandy Coast: Tourism and Painting, 1867–1886*, New Haven and London, 1994. See also J. House, 'Framing the landscape', in J. House and J. Skipwith (eds), *Landscapes of France: Impressionism and Its Rivals*, London, 1995, esp. pp. 14–16, and J. D. Herbert, 'Recon-siderations of Matisse and Derain in the classical landscape', in R. Thomson (ed.), *Framing France: The Representation of Landscape in France, 1870–1914*, Manchester and New York, 1998, pp. 173–93.

45 D. MacCannell, *The Tourist: A New Theory of the Leisure Class*, Berkeley, Los Angeles and London, [1976] 1999.

46 Pioneered in art history by E. Castelnuovo and C. Ginzburg, 'Centro e perifera', in G. Previtali and F. Zeri (eds), *Storia dell'arte italiana*, vol. 1, Turin, 1979, pp. 285–352; tr. as 'Centre and periphery' in *History of Italian Art*, vol. 1, preface P. Burke, tr. E. Bianchini and C. Dorey, Cambridge, 1994, pp. 29–112; and N. Hadjinicolaou,

'Kunstzentren und periphere Kunst', *Kritische Berichte*, 4 (1983), 36–56. A discussion on renewed attention to place is found in D. Massey, 'Politics and space/time', in M. Keith and S. Pile (eds), *Place and the Politics of Identity*, London and New York, 1993, pp. 141–61.

47 Clark, *Painting*; G. Pollock, 'Modernity and the spaces of femininity', in *Vision and Difference: Femininity, Feminism and the Histories of Art*, London, 1988, pp. 50–90, 205–9; Pollock, *Avant-garde Gambits*; R. L. Herbert, *Impressionism: Art, Leisure, and Parisian Society*, New Haven and London, 1988; Herbert, *Monet on the Normandy Coast*; Orton and Pollock, 'Données'; P. H. Tucker, *Monet at Argenteuil*, New Haven and London, 1982; R. R. Brettell, *Pissarro and Pontoise: The Painter in a Landscape*, New Haven and London, 1990; *Modern Starts: People, Places, Things*, New York, 1999.

48 On the United States, see Jacobs, *Good and Simple Life*, ch. 9: 'Victorians in the modern world'; S. Shipp, *American Art Colonies, 1850–1930*, Westport, Conn. and London, 1996; D. E. Solon and W. South, *Colonies of American Impressionism: Cos Cob, Old Lyme, Shinnecock and Laguna Beach*, Laguna Beach, 1999. On Australia, see H. Topliss, *The Artists' Camps: Plein Air Painting in Melbourne 1885–1889*, Melbourne, 1984; J. Clark and B. Whitelaw, *Golden Summers: Heidelberg and Beyond*, Sydney, 1986. The Japanese artists' colony of Dzushi is mentioned in A. Fischer, 'Die "Secession" in Japan', *Die Kunst für Alle*, 15:14 (1900), 321–6.

49 C. Shaw and M. Chase, 'The dimensions of nostalgia', in Shaw and Chase (eds), *The Imagined Past: History and Nostalgia*, Manchester and New York, 1989, p. 9.

50 K. Tester, *The Life and Times of Post-Modernity*, London and New York, 1993, p. 64. See also R. Felski, *The Gender of Modernity*, Cambridge, Mass. and London, 1995, p. 40.

51 S. Stewart, *On Longing: Narratives of the Miniature, the Gigantic, the Souvenir, the Collection*, Baltimore and London, 1984, pp. 23–4.

52 For example, R. Hewison, *The Heritage Industry*, London, 1987. A critique of this attitude in D. Lowenthal, 'Nostalgia tells it like it wasn't', in Shaw and Chase, *Imagined Past*, pp. 18–32.

53 Tester, *Life and Times*, p. 66; Felski, *Gender of Modernity*, p. 59.

54 S. Kracauer, 'The little shopgirls go to the movies', in *The Mass Ornament: Weimar Essays*, tr. and ed. T. Y. Levin, Cambridge, Mass. and London, [1927] 1995, p. 299.

Notes to Chapter 1

1 Recalling the summer of 1881, spent in Pont-Aven and Concarneau. H. J. Thaddeus, *Recollections of a Court Painter*, London and New York, 1912, p. 25.

2 A useful text remains N. Pevsner, 'Gemeinschaftsideale unter den bildenden Künstlern des 19. Jahrhunderts', *Deutsche Vierteljahresschrift für Literaturwissenschaft und Geistesgeschichte*, 9 (1931), 125–54.

3 K. van de Woestijne, writing in the *Nieuwe Rotterdamsche Courant* (26 October 1921), quoted in P. Boyens, *Flemish Art: Symbolism to Expressionism at Sint-Martens-Latem*, Sint-Martens-Latem, 1992, p. 113.

4 O. Modersohn, circular, Worpswede, 25 July 1899, quoted in *Otto Modersohn 1865–1943: Monographie einer Landschaft*, eds C. Modersohn *et al.*, Hannover, 1978, p. 154.

5 R. Williams, 'The Bloomsbury fraction', in *Problems in Materialism and Culture: Selected Essays*, London, 1980, pp. 148–69.

6 *Ibid.*, p. 148.

7 *Ibid.*, pp. 164–5.

8 F. Neidhardt, 'Das innere System sozialer Gruppen', *Kölner Zeitschrift für Soziologie und Sozialpsychologie*, 31:4 (1979), 639–60.

9 The Hôtel des Voyageurs was favoured by Americans; the Hôtel du Lion d'Or attracted a mainly French clientele.

10 A. Stott, 'American painters who worked in the Netherlands, 1880–1914', Ph.D. dissertation, Boston University, 1986, p. 203.

11 L. Knight, *Oil Paint and Grease Paint*, London, 1936, p. 154.

12 Similar impulses animated the ritualised rivalries between the neighbouring artists' communities of Newlyn and St Ives and those of Pont-Aven and Concarneau, played out in the form of cricket matches and baseball games respectively. See Jacobs, *Good and Simple Life*, pp. 75, 154–5.

13 A. C. Goater, 'A summer in an artistic haunt', *Outing*, 7:1 (1885), 10–12.

14 H. W. Ranger, 'Artist life by the North Sea', *Century Magazine*, 45, 99:5 (1893), 754.

15 For texts including descriptions of daily routines, see the Primary Sources section in the Bibliography.

16 W. H. Low, *A Chronicle of Friendships 1873–1900*, London, 1908.

17 S. Greenblatt, *Marvelous Possessions: The Wonder of the New World*, Oxford, 1991, pp. 2–3.

18 *Ibid.*

19 E. Kris and O. Kurz, *Die Legende vom Künstler: Ein geschichtlicher Versuch*, Frankfurt am Main, [1934] rev. edn 1980; tr. as *Legend, Myth and Magic in the Image of the Artist: A Historical Experiment*, tr. A. Lang, New Haven and London, 1979.

20 *Ibid.*, pp. 31–3.

21 Bottle dance anecdote (Corot was the artist) in Bartlett, 'Barbizon', 545. Jokes and pranks: J.-G. Gassies, *Le vieux Barbizon: souvenirs de jeunesse d'un paysagiste 1852–1875*, Paris, 1907, pp. 122–8 and Low, *Chronicle*, pp. 144–8. Leap-frog: Low, *Chronicle*, p. 132. Ants: Gassies, *Le vieux Barbizon*, pp. 37–8.

22 Greenblatt, *Marvelous Possessions*, p. 3.

23 A. Hoeber, 'A summer in Brittany', *Monthly Illustrator*, 4:2 (1895), 79. For other after-dinner discussion scenes, see, for example: K. de Mattos, 'Apple-tree corner' [Sevray-sur-Vallais], *Magazine of Art* (1886), 510–11; B. L. Harrison, 'Quaint artist haunts in Brittany: Pont-Aven and Concarneau', *Outing*, 24:1 (1894), 30–1; E. Shinn ['L'Enfant Perdu'], 'Rash steps, XVI', *Philadelphia Evening Bulletin* (3 November 1866), repr. in D. Delouche (ed.), *Pont-Aven et ses peintres à propos d'un centenaire*, Rennes, 1986, pp. 239–40; Low, *Chronicle*, pp. 446–7.

24 Low, *Chronicle*, pp. 34–5.

25 Kris and Kurz, *Legende*, p. 33.

26 Low, *Chronicle*, p. 32. Low was in Barbizon in the summers of 1873, 1874 and 1875, and again for a brief visit in October 1886.

27 H. P. Thurn, 'Die Sozialität der Solitären: Gruppen und Netzwerke in der bildenden Kunst', *Kunstforum International*, 116 (November/December 1991), 109.

28 Gassies, *Le vieux Barbizon*, p. 119.

29 Hoeber, 'A summer', 76.

30 Low, *Chronicle*, p. 129.

31 R. L. Stevenson, 'Forest notes', *Cornhill Magazine*, 33:197 (1876), 548. Stevenson was at Barbizon in the summer of 1875. He also spent time at nearby Grèz in 1875, 1876 and 1877.

32 Goater, 'A summer', 10–11.

33 *Ibid.*, 10.

34 T. Nipperdey, 'Verein als soziale Struktur in Deutschland im späten 18. und frühen 19. Jahrhundert. Eine Fallstudie zur Modernisierung I', in *Gesellschaft, Kultur, Theorie: Gesammelte Aufsätze zur neueren Geschichte*, Göttingen, [1972] 1976, pp. 174–205, 439–47; M. Agulhon, *Le Cercle dans la France bourgeoise 1810–1848: Étude d'une mutation de sociabilité*, Paris, 1977.

35 I thank Robert L. Herbert for teasing out this point in response to an earlier draft of the text. See also C. C. Caesar, 'Auf der Suche nach Heimat: Umbrüche im künstlerischen Selbstverständnis als Motivation für die Gründung von Künstlerkolonien', paper given at the symposium 'Im Zeichen der Ebene und des Himmels': Künstlerkolonien in Europa, Germanisches Nationalmuseum, Nuremberg, 6 November 1997.

36 Gassies, *Le vieux Barbizon*, p. 36.

37 Low, *Chronicle*, pp. 34, 65, 103.

38 B. Harrison, 'With Stevenson at Grez', *Century Magazine*, 69 (1916), 307–9.

39 C. Larsson, *Carl Larsson: The Autobiography of Sweden's Most Popular Artist*, ed. John Z. Lofgren, tr. Ann B. Weissmann, Iowa City, Iowa [1931] 1992, p. 107.

40 Goater, 'A summer', 10–11.

41 Jakob Maurer was a fellow colonist. P. Franck, *Vom Taunus zum Wannsee: Erinnerungen*, Braunschweig and Hamburg, 1920, pp. 41–2.

42 M. Menpes, 'In the days of my youth', *Mainly about People* (8 July 1899); repeated almost verbatim by his daughter, D. Menpes, *Mortimer Menpes: Brittany*, London, 1905, pp. 138–139. I quote the latter.

43 Menpes, *Mortimer Menpes*, p. 138.

44 Mattos, 'Apple-tree corner', 512.

45 For evocative accounts of urban atelier hierarchies and rivalry as well as the stressful struggle for a place or a medal at annual exhibitions, see Low, *Chronicle*, pp. 3–28, 159–171; E. Simmons, *From Seven to Seventy: Memories of a Painter and a Yankee*, New York and London, 1922, pp. 118–28; M. Bashkirtseff, *The Journal of Marie Bashkirtseff*, London, [1890] 1985, pp. 289–95, 392–405; L. Corinth, 'Un étudiant allemand à Paris à l'Académie Julian (1884–1887)', tr. B. Pagès, *Gazette des Beaux-Arts*, 97:123, 6th series (1981), 219–25. See also White and White, *Canvases and Careers*.

46 Rewald, *Post-Impressionism*, pp. 183, 266.

47 M. Denis, 'Paul Sérusier: Sa vie, son oeuvre', in P. Sérusier, *ABC de la Peinture*, Paris, 1942, quoted in R. Brettell *et al.*, *The Art of Paul Gauguin*, Washington and Chicago with New York and Boston, 1988, p. 107. The painting is Gauguin's *Still-Life: Fête Gloanec* (1888, Musée des Beaux-Arts, Orléans).

48 This is not to deny the difference of Gauguin's avant-garde artistic choices and allegiances from the majority of his colonial peers. However, if viewed from the perspective of the colony of Pont-Aven as a whole, Gauguin was neither the undisputed leader nor the disruptive force among fellow-painters that he is sometimes made out to be. For more on Gauguin's role, see ch. 1, pp. 35–6. On Gauguin's avant-garde manoeuvrings, see Orton and Pollock, 'Données', and Pollock, *Avant-Garde Gambits*.

49 F. Mackensen, 'Worpswede und seine ersten Maler', *Stader Archiv*, N.S., 30 (1940), 8.

50 Special song at Barbizon reprinted, with musical score, in *Barbizon au temps de J.-F. Millet (1849–1875)*, ed. Municipalité de Barbizon, Barbizon, 1975, pp. 53–7. Plays

staged in Newlyn, Kronberg and elsewhere: Fox and Greenacre, *Painting in Newlyn*, p. 23; Franck, *Vom Taunus*, pp. 39–40.

51 For photos of eccentric dress worn in Pont-Aven, Grèz and Sint-Martens-Latem, see: Delouche, *Pont-Aven*, pp. 33, 110; J. Le Paul, *Gauguin and the Impressionists at Pont-Aven*, New York, 1987, p. 40; Jacobs, *Good and Simple Life*, pp. 31, 63; Boyens, *Flemish Art*, p. 8.

52 Shinn, 'Rash steps' in Delouche, *Pont-Aven*, p. 239.

53 Robert Henri Papers, Yale University, letter, 16 September 1889, quoted in Sellin, *Americans*, p. 56.

54 Hoeber, 'A summer', 78. In 1874, Julian Alden Weir found the artists at Pont-Aven dressed 'much like the peasants, wearing the *sabots* or large wooden shoes, and blue blouse'. Weir, letter to his mother, 21 April 1874, quoted in D. W. Young, *The Life and Letters of J. Alden Weir*, New Haven, 1960, p. 35.

55 W. Rothenstein, *Men and Memories*, vol. I, Cambridge, 1931, pp. 49ff, quoted in Sellin, *Americans*, pp. 67–8.

56 P. Gauguin, letter to Émile Schuffenecker, end of February or 1 March 1888, in V. Merlhès (ed.), *Correspondance de Paul Gauguin: Documents, témoignages*, Paris, 1984, letter no. 141, p. 172.

57 I take the term 'charismatic leader' from B. Zablocki, *Alienation and Charisma: A Study of Contemporary American Communes*, New York, 1980.

58 McWilliam, 'Mythologising Millet'; Meixner, *International Episode*; Lübbren, 'Rural artists' colonies', pp. 68–79.

59 Wylie showed his medal to at least one artist; see Julian Alden Weir's letter to his father, 30 August 1874, quoted in Young, *J. Alden Weir*, p. 46.

60 E. Shinn, letter to his sister Elizabeth, 1866, quoted in Sellin, *Americans*, p. 22.

61 B. Champney, *Sixty Years' Memories of Art and Artists*, Woburn, Mass., 1900, pp. 121, 125. Champney was in Pont-Aven in 1866.

62 Julian Alden Weir Papers, American Archives of Art, 8 August 1874, quoted in Sellin, *Americans*, p. 32.

63 W. L. Picknell, 1897, quoted in Jacobs, *Good and Simple Life*, p. 60.

64 See, for example, letters to Mette Gad, nos 107, 110 and 112, July and September 1886, in Merlhès, *Correspondance de Paul Gauguin*, pp. 133–4, 136–7, 139. Compare other artists' letters from Pont-Aven: E. Shinn, 10 August 1866, and H. R. Butler, 23 August 1885, both quoted in Sellin, *Americans*, pp. 22, 48–49; J. A. Weir, 21 September 1874, quoted in Young, *J. Alden Weir*, p. 49; Helene Schjerfbeck, March 1884, quoted in E. Appelberg and H. Appelberg, *Helene Schjerfbeck: En biografisk konturteckning*, Stockholm, 1949, pp. 60, 62, 64, 66–7; Cuno Amiet, 21 December 1892, quoted in J. Benington, *Roderic O'Conor: A Biography, with a Catalogue Raisonné of His Work*, Blackrock, Co. Dublin, 1992, p. 49.

65 Etzenhausen was an offshoot of Dachau, Kleinsassen a subsidiary of Willingshausen, and Trefriw a branch of Betws-y-Coed. The colony in Grèz was founded by Barbizon artists looking for a change of scenery. Samuel John (Lamorna) Birch moved from Newlyn to Lamorna Cove in the mid-1890s with several others in tow. Modersohn left Worpswede for Fischerhude around 1907, founding another colony there.

66 C. Duncan, 'Virility and domination in early twentieth-century vanguard painting', in *The Aesthetics of Power: Essays in Critical Art History*, Cambridge, [1973] 1993, pp. 81–108.

Notes to Part II: introduction

1 K. Bergmann, *Agrarromantik und Großstadtfeindschaft*, Meisenheim am Glan, 1970.

2 I. Weber-Kellermann, *Landleben im 19. Jahrhundert*, Munich, 1987, pp. 388–401.

3 R. L. Herbert, 'City vs. country: The rural image in French painting from Millet to Gauguin', *Artforum*, 8 (1970), 44–55, quotation on p. 44.

4 Theodore Zeldin suggests that urban worries about rural depopulation in France were perhaps out of proportion to actual statistics (Zeldin, *France 1848–1945: Ambition and Love*, Oxford and New York, [1973] 1979, p. 171) which reinforces the argument that the painting of peasants served a compensatory function for city-dwellers.

5 N. Lübbren, '"Toilers of the sea": Fisherfolk and the geographies of tourism in England, 1880–1900', in D. Peters Corbett, Y. Holt and F. Russell (eds), *The Geography of Englishness: Landscape and the National Past in English Art 1880–1940*, New Haven and London, 2001 (forthcoming).

Notes to Chapter 2

1 Mrs L. Birch, *Stanhope A. Forbes, A.R.A., and Elizabeth Stanhope Forbes, A.R.W.S.*, London, Paris, New York and Melbourne, 1906, pp. 87–8.

2 E. Goffman, *The Presentation of Self in Everyday Life*, Harmondsworth, [1959] 1990.

3 P. Warncke, *Worpswede*, Leipzig and Berlin, 1902, p. 21.

4 K. Krummacher, 'Die Malerkolonie Worpswede', *Westermanns Illustrierte Deutsche Monatshefte*, 86 (1899), 22; Champney, *Sixty Years*, p. 115.

5 The cult of Millet in particular reached fever pitch after his death in 1876. Although Millet was not born in or near Barbizon, his farming childhood and youth qualified him for 'peasant painter' *par excellence*. The Millet myth is discussed in depth in McWilliam, 'Mythologising Millet'. See also C. Parsons and N. McWilliam, '"Le paysan de Paris": Alfred Sensier and the myth of rural France', *Oxford Art Journal*, 6:2 (1983), 38–58, and Lübbren, 'Rural artists' colonies', pp. 132–7.

6 Kalckreuth, letter, *c.* July 1882, quoted in H. Heres, *Dachauer Gemäldegalerie*, Dachau, 1985, p. 54.

7 Titcomb, 1904, quoted in D. Tovey, *W.H.Y. Titcomb: Artist of Many Parts*, Bushey, Herts. and Tewkesbury, 1985, p. 22.

8 *Ibid.*

9 D. MacCannell, 'Staged authenticity: Arrangements of social space in tourist settings', *American Journal of Sociology*, 79:3 (1973), 589–603 (590–5).

10 S. A. Forbes, 'A Newlyn retrospect', *Cornish Magazine*, 1 (August 1898), 83.

11 Ranger, 'Artist life', 576.

12 Knight, *Oil Paint*, p. 139.

13 The term 'reality effect' (applied to literature) was coined by Roland Barthes who also emphasised the use of redundancy as a key component. Barthes, 'The reality effect' in L. R. Furst, *Realism*, Harlow, [1968] 1992.

14 This type of gap is known as a *Leerstelle* (blank) or *Unbestimmtheitsstelle* (site of indeterminacy) in literary reception theory. For an application of the category to painting, see W. Kemp, 'Death at work: On constitutive blanks in nineteenth-century painting', *Representations*, 10 (1985), 102–23.

15 R. van Vleuten, 'Egmond remembers Gari Melchers', in *Gari Melchers: A Retrospective Exhibition*, eds D. Lesko and E. Persson, St Petersburg, Florida, 1990, pp. 162–3.

16 T. Child, 'American artists at the Paris exhibition', *Harper's Magazine* (1889), quoted in A. Stott, 'The Holland years', in *Gari Melchers*, p. 56.

17 Weber-Kellermann, *Landleben*, pp. 226–43; Lübbren, 'Rural artists' colonies', pp. 122–32. On Willinghausen: G. Böth, *Kleidungsverhalten in hessischen Trachtendörfern: Der Wechsel von der Frauentracht zur städtischen Kleidung 1969–1976 am Beispiel Mardorf. Zum Rückgang der Trachten in Hessen*, Frankfurt am Main, Berne and Cirencester, 1980; R. Helm, 'Die Schwälmertracht' [1932], in Wollmann and Willingshäuser Gemäldekabinett Wollmann, *Die Willingshäuser Malerkolonie*, pp. 499–504; J. H. Schwalm, 'Die Schwalm', in C. Heßler (ed.), *Hessische Volkskunde*, Frankfurt am Main, [1904] 1979; A. Bantzer, 'Entwicklung der Schwälmer Tracht', *Schwälmer Jahrbuch* (1985), 182–95. On Brittany: R. Y. Creston, *Le Costume breton*, Paris, 1974; E. Weber, *Peasants into Frenchmen: The Modernisation of Rural France 1870–1914*, London, [1977] 1979, pp. 225ff. On Volendam: B. W. E. Veurman, 'Iets over de Volendammer klederdracht', in *Volendammer Schilderboek*, The Hague, 1979, pp. 72–83.

18 G. Reichwein, in *Vreemde gasten: Kunstschilders in Volendam 1880–1914*, ed. Vereniging. 'Vrienden van het Zuiderzeemuseum', Enkhuizen, 1986, p. 29.

19 *Ibid.*, p. 9.

20 Stott, 'American painters', p. 263; Veurman, *Volendammer schilderboek*, pp. 72, 74.

21 C. Bantzer, *Hessen in der deutschen Malerei: Erster Teil. Die Maler der Schwalm, mit Kunstchronik von Willingshausen*, Marburg, [1935] rev. edn 1979, p. 68.

22 A twentieth-century heir to the success of the formula 'Volendam-as-Dutch' was Pablo Picasso who spent a few weeks in the village of Schoorl near Alkmaar in North Holland in 1905 where he painted a nude model wearing nothing but a Volendam [!] winged cap (in *La Belle Hollandaise*, 1905, Queensland Art Gallery, Brisbane, and *Nude with Dutch Bonnet*, 1905, location unknown). H. Kraan, *Als Holland Mode war: Deutsche Künstler und Holland im 19. Jahrhundert*, Bonn, 1985, p. 27; J. Richardson with M. McCully, *A Life of Picasso, Volume I: 1881–1906*, London, 1991, pp. 376–382.

23 Weber, *Peasants into Frenchmen*, pp. 226–31; J. J. Sheehan, *German History 1770–1866*, Oxford, 1989, pp. 765–6; Böth, *Kleidungsverhalten*.

24 Bantzer, *Hessen*, p. 136.

25 K. Hanusch, 'Erinnerungen an Bantzer in Willingshausen', in Bantzer, *Hessen*, p. 12.

26 The most striking instance is one author's assertion that the formal deformations of Paula Modersohn-Becker's Worpswede figure paintings represent naturalistic renderings of the allegedly physically deformed and 'incestuous' Worpsweders; P. Becker-Vohl, 'Figur und Landschaft in der "Worpsweder Malerschule"', Ph.D. dissertation, Aachen, 1985, p. 128.

27 L. Althusser, 'Ideology and ideological state apparatuses', in Althusser, *Lenin and Philosophy and Other Essays*, tr. Ben Brewster, London, [1970] 1971, pp. 160–5.

28 C. Rosen and H. Zerner, *Romanticism and Realism: The Mythology of Nineteenth-Century Art*, New York and London, 1984, p. 164.

29 *Ibid.*, pp. 164–5.

30 Bantzer, *Hessen*, pp. 60, 62.

31 See *ibid.*, p. 71.

32 'Happy souls' are mentioned by Bantzer, *Hessen*, p. 60; the 'cheerful and light-hearted lot' appear in W. Moes, *Heilig ongeduld: Herinneringen uit mijn leven*, Amsterdam and Antwerp, 1961, p. 186.

33 Pollock, *Avant-garde Gambits*, p. 62.

34 *Ibid.*, p. 65.

35 A list of examples in Lübbren, 'Rural artists' colonies', p. 115 n. 75.

36 Gassies, *Le vieux Barbizon*, pp. 33–4. For an appreciation of shepherds, see K. Raupp, 'Willingshausen: Ein Studienplatz deutscher Künstler', *Die Kunst für Alle*, vol. 2, no. 1, October 1886, p. 14.

37 A. Sensier, *Jean-François Millet: Peasant and Painter*, tr. H. de Kay, London, [1881] 1881, p. 120.

38 *Serafien De Rijcke tussen Xavier De Cock en Albijn Van den Abeele*, eds J. D'Haese and R. Van den Abeele, Sint-Martens-Latem, 1985, pp. 5, 7.

39 Pictorial example of bourgeois domestic anxieties are Augustus Egg's series of three paintings *Past and Present I–III*, 1858, London, Tate Gallery, and William Quiller Orchardson's marriage series (incl. *Mariage de Convenance*, 1883, Art Gallery and Museum, Kelvingrove, Glasgow, and *Mariage de Convenance – After!*, 1886, City of Aberdeen Art Gallery).

40 The affirmative function of the peasant underwent a hiccup during the 1848 revolutions but continued, if anything, even more intensely soon after. S. Rouette, 'Die Bürger, der Bauer und die Revolution: Zur Wahrnehmung und Deutung der agrarischen Bewegung 1848/49', in C. Jansen and T. Mergel (eds), *Die Revolutionen von 1848/49: Erfahrung – Verarbeitung – Deutung*, Göttingen, 1998, pp. 190–205.

41 *Künstlerkolonie Skagen*, ed. G. Kaufmann, Hamburg, 1989, p. 20.

42 H. Mendelsohn, 'Die nördlichste Feste dänischer Kunst', *Die Kunst für Alle*, 11:21 (1896), 325.

43 Notably in his *Burial at Ornans*, 1849–50, Musée d'Orsay, Paris. See T. J. Clark, *Image of the People: Gustave Courbet and the 1848 Revolution*, London, 1973, ch. 5.

44 Gill Perry seems to hint at this when she discusses Worpswede under the rubric of primitivism but does not draw it out explicitly. Perry, 'Primitivism and the "modern"', in C. Harrison *et al.*, *Primitivism, Cubism, Abstraction: The Early Twentieth Century*, New Haven and London, 1993, esp. pp. 9–45.

45 Knight, *Oil Paint*, pp. 156–7.

46 B. L. Harrison, 'In search of paradise with camera and palette', *Outing*, 21 (1893), 313.

47 For example, S. Forbes, letter to his mother, Newlyn, February 1884, quoted in K. Bendiner, *An Introduction to Victorian Painting*, New Haven and London, 1985, p. 162 n. 11 (bigotry); A. Schwartz, *Skagen: Den svundne tid i sagn og billeder* [1912], quoted in *Künstlerkolonie Skagen*, pp. 37–8 (lice); V. Johansen, quoted in K. Voss, *The Painters of Skagen*, tr. P. Shield, Tølløse, [1986] 1990, p. 131 (primitive and ugly people); Raupp, 'Willingshausen', p. 13 (Jews); Bantzer, *Hessen*, pp. 30, 73, 116 (Jews, gypsies and murderers); Harrison, 'With Stevenson at Grez', 311 (murder); P. Modersohn-Becker, *In Briefen und Tagebüchern*, eds G. Busch and L. von Reinken, Frankfurt am Main, 1979, texts 20 August 1897 to 25 March 1902, pp. 104–5, 137–8, 146–8, 316; tr. as *Paula Modersohn-Becker: The Letters and Journals*, tr. A. S. Wensinger and C. C. Hoey, New York, 1983; selected excerpts in *The Letters and Journals of Paula Modersohn-Becker*, tr. J. D. Radycki, New York and London, 1980 (on locals who are mentally unstable, disabled, child abusers, abused, and ex-prisoners). See also Jacobs, *Good and Simple Life, passim*.

48 Simmons, *From Seven to Seventy*, pp. 141–2; A. G. Bell, 'Letters from artists to artists. – Sketching grounds, no.2: Holland', *Studio*, 1:3 (1893), 116–17.

49 S. Forbes, letter to his mother, Newlyn, 22 June 1884, quoted in Bendiner, *Victorian Painting*, p. 117.

50 For example, B. von Andrian-Werburg, 'Schwälmer Arbeitswelt in der Sicht Willingshäuser Künstler des 19. und frühen 20. Jahrhunderts', Ph.D. dissertation, Philipps-Universität, Marburg, 1990; Orton and Pollock, 'Données'.

51 One exception is D. Edler, *Vergessene Bilder: Die deutsche Genremalerei in den letzten Jahrzehnten des 19. Jahrhunderts und ihre Rezeption durch Kunstkritik und Publikum*, Münster and Hamburg, 1992.

52 G. H. Boughton, 'Artist strolls in Holland: II', *Harper's New Monthly Magazine*, 66/5 (1883), 700.

53 H. Maho, *D'Amsterdam à l'île de Marken: Notes et impressions*, Brussels, n.d., pp. 184–5, quoted in Dutch translation in *Vreemde gasten*, p. 11.

54 See, for example, the Belgians Léon Frédéric's *Slag Collectors*, n.d., Musée de l'Art Wallon, Liège, and Cécile Douard's *Woman Haulier Seated, Resting*, n.d., Université du Travail Paul Pastur, Charleroi, both reprod. in *Arbeit und Alltag: Soziale Wirklichkeit in der belgischen Kunst 1830–1914*, Berlin, 1979.

55 L. Knaus, letter from Italy to Barthold Suermondt, 14 January 1858, quoted in B. Unger-Richter, 'Ludwig Knaus und Willingshausen', in *Schwälmerisch: Kunst & Volkskultur einer hessischen Landschaft*, eds Elisabeth Abreß *et al.*, Dachau, 1991, p. 50.

56 C. Holland, *The Belgians at Home*, London, 1911, p. 126, quoted in G. Pollock, 'The dangers of proximity: The spaces of sexuality in word and image', *Discourse*, 16:2 (1993–94), 26.

Notes to Chapter 3

1 D. Delouche, *Les Peintres de la Bretagne*, p. 795.

2 Stevenson, 'Forest notes', 552.

3 N. Garstin, 'Studio talk: St Ives', *Studio*, 8:42 (1896), 242.

4 Advertisement no. 14, *De Egmondsche Badbode*, 15 July 1903, reprod. in K. Lannoy and B. Denneboom, eds, *Derper, hoever, binder: Over geschiedenis en volksleven van de drie Egmonden*, The Hague, 1969.

5 C. Beaux, *Background with Figures: Autobiography*, Boston and New York, 1930, p. 147; F. L. Emanuel, 'Letters to artists: Concarneau, Brittany, as a sketching ground', *Studio*, 4:24 (1895), 183; A. Theuriet, 'Douarnenez: Paysages et impressions', *Revue des Deux Mondes*, 43, 51:3 (1881), 349; R. Gönner, 'Wörth und die Zügelschule', *Die Kunst für Alle*, 19:22 (1904), 525. The model-holders were holding cows, hired out for fixed tariffs as 'models' by locals in Wörth.

6 The campaigning began around 1908. In 1909, Ahrenshoop's beautification society which was dominated by artists, built a thatch-roofed art gallery, the *Kunstkaten*, in what was perceived as the traditional regional style; this was intended to provide a model for other builders. F. Schulz, *Ahrenshoop: Die Geschichte eines Dorfes zwischen Fischland und Darss*, Fischerhude and Ahrenshoop, 1992, pp. 63–4. *Cf.* Barbizon artists' campaign to prevent the commercial exploitation of the forest of Fontainebleau, resulting in the establishment of protected zones, the *réserves artistiques*, from 1853; *Zurück zur Natur: Die Künstlerkolonie von Barbizon. Ihre Vorgeschichte und ihre Auswirkung*, Bremen, 1977, unpag.

7 W.H. Bartlett, 'Summer time at St. Ives, Cornwall', *Art Journal* (1897), 294.

8 Knight, *Oil Paint*, pp. 209–10.

9 The English dogs allegedly served a similar purpose; placed in the window, they showed whether the seaman was at home or at sea. W. Karge, 'Ahrenshoop: Ein vorpommersches Grenzdorf zu Mecklenburg', in B. Bohn *et al.*, *Ahrenshoop: Eine Künstlerkolonie an der Ostsee*, Fischerhude, 1990, pp. 13, 16, 111 n. 4.

10 Dolman, 'Illustrated interviews', 486.

11 Gassies, *Le vieux Barbizon*, p. 132.

12 Bantzer, *Hessen*, p. 64.

13 As noted by Gassies in a footnote, *Le vieux Barbizon*, p. 132. One example of recycling occurs in Hevesi, 'Barbizon', p. 590. Numerous anecdotes of similar type are recounted in F. Henriet, *Le Paysagiste aux champs*, Paris, [1867] rev. edn 1876, esp. pp. 24–32.

14 Mackensen, 'Worpswede', 7.

15 At least sixty-six inns, hotels and cafés are documented in forty villages but there were doubtless more. There were important artists' inns in Barbizon, Grèz, Marlotte, Pont-Aven, Le Pouldu, Douarnenez, Giverny, Honfleur, Skagen, Laren, Rijsoord, Volendam, Dachau, Willingshausen, Frauenchiemsee, and Ahrenshoop. A list of selected inns appears in Lübbren, 'Rural artists' colonies', vol. 2, Appendix III.

16 For example, in Barbizon, Grèz, Chailly, Cernay-la-Ville, Marlotte, Sevray-sur-Vallais, Giverny, Honfleur, Pont-Aven, Le Pouldu, Rochefort, Saint-Briac, Egmond, Volendam, Rijsoord, Skagen, Ahrenshoop, Kronberg, Willingshausen, St Ives, and Betws-y-Coed in Wales.

17 To give just a handful of examples: around 1850, Théodore Rousseau owed over 1,000 francs to the innkeeper François Ganne in Barbizon, and took over a year to clear the debt. The American painter Charles Fromuth sometimes received credit for over two years from Madame Coatalen, the proprietress of the Hôtel de France in Concarneau. Marie-Jeanne Gloanec in Pont-Aven apparently allowed one unnamed artist to lodge and board on credit at her inn for a period of ten years. J. Bouret, *The Barbizon School and 19th Century French Landscape Painting*, tr. J. Brenton, London, [1972] 1973, p. 88; Sellin, *Americans*, p. 59; Jacobs, *Good and Simple Life*, p. 63. The innkeeper Madame Baudy in Giverny accepted pictures for payment of outstanding bills, as did Julie Correlleau, manager of the Hôtel de la Poste in Pont-Aven and numeous others. C. Joyes, 'Giverny's meeting house, the Hôtel Baudy', in Sellin, *Americans*, p. 101; W. Jaworska, *Gauguin and the Pont-Aven School*, tr. P. Evans, London, [1971] 1972, p. 247 n. 153; L. Heyting, 'De geschiedenis van het Larense Hamdorff', *Nieuwe Rotterdamse Courant Handelsblad* (23 February 1979), cultural supplement, 1–2.

18 Gauguin, letter to Mette Gad, *c.* 25 July 1886, in Merlhès, *Correspondance de Paul Gauguin*, letter no. 107, p. 133. The information concerning Jobbé-Duval appears in M. Malingue (ed.), *Paul Gauguin: Letters to His Wife and Friends*, tr. H. J. Stenning, London, [1946] n.d., p. 68 n. 2. See also Jacobs, *Good and Simple Life*, p. 76.

19 Louise and Victoire Ganne, the daughters of one of Barbizon's foremost innkeepers, both married painters. In Pont-Aven, the hotelier Julie Correlleau married a painter, and in nearby Le Pouldu the innkeeper Marie Henry had a child with the painter Jacob Meyer de Haan. A maid in Berger's café in the Transylvanian artists' colony of Nagybánya married the painter Simon Hollósy. The son of the owner of the Hôtel de la Cloche in the Flemish artists' village of Genk married the painter Valérie Pholien. See

Lübbren, 'Rural artists' colonies', ch. 4; Jacobs, *Good and Simple Life*, pp. 139–40. I discuss Spaanders' and Brøndums' marriages later in this chapter.

20 On Hamdorff, see Heyting, 'De geschiedenis'; Heyting, *De wereld*; G. Koekkoek, *Larense dorpspraat: Dorpsvertellingen*, Zaltbommel, 1983, pp. 180–4; M. van Seumeren-Haerkens, 'Kunstenaars rond Hamdorff', *Tableau* (December 1985), 72–5.

21 Moes, *Heilig ongeduld*, p. 190.

22 Ranger, 'Artist life', 753.

23 Various dates are given for the expansion of Hamdorff's hotel (1905, 1912 and others). There were probably numerous extensions built: in the early 1890s, one visitor observed that Hamdorff 'built addition after addition to his house'; Ranger, 'Artist life', 753. The new 'Hotel Garni' next to the original inn was opened either in 1900, 1901, or 1905. In 1916, Hamdorff built the 'Stationshotel' for his brother Chris. See Heyting, 'De geschiedenis', 1; Seumeren-Haerkens, 'Kunstenaars', p. 74; J. P. Koenraads, *Laren en zijn schilders: Kunstenaars rond Hamdorff*, Laren, 1985, p. 80; K. Verboeket, 'Introduction', in *'Zij waren in Laren…': Buitenlandse kunstenaars in Laren en 't Gooi*, Laren, 1989, pp. 5, 6.

24 Koekkoek, *Larense dorpspraat*, pp. 181–2. In 1885, a Mauve or a Neuhuys fetched about 1,500 guilders, in the mid-1890s twice that amount, and by around 1905, up to 7,000 guilders. J. van der Pol, 'De "Larense School": Kunst voor de markt?', *Tableau*, 7:2 (1984), 62.

25 The dealer was Nico van Harpen, former chief-editor of the *Amsterdamsche Courant*, his gallery the 'Larensche Kunsthandel', established in the so-called Villa Mauve. See Heyting, *De wereld*, pp. 103–16; Pol, 'De "Larense School"'.

26 In his novel, *De ondergang van het dorp* (Amsterdam, 1913), set in the village of Aarlo (a fictionalised Laren) with its innkeeper Dirk Boersink (a thinly disguised Jan Hamdorff), P. H. van Moerkerken branded the hotelier's doings as power- and money-hungry machinations, leading to the downfall of the village. Heyting, *De wereld*, pp. 141–9; A. Loosjes-Terpstra, 'Mondriaan in een donkere spiegel', *Jong Holland*, 5:5 (1989), 4–15. See also Moes, *Heilig ongeduld*, pp. 186–7.

27 *Laarder Courant De Bel*, 11 August 1931, quoted in Heyting, 'De geschiedenis', 2.

28 Anonymous, 'Wally Moes en Laren', *De Amsterdammer* (8 November 1903), quoted in Heyting, *De wereld*, pp. 99–100.

29 On Spaander, see Veurman, *Volendammer schilderboek*, pp. 32–4, 50–2; K. Simons, *Hotel Spaander 100 jaar, 1881–1981*, Volendam, 1981; and G. Reichwein's text in *Vreemde gasten*, pp. 13–15.

30 At least one of these is still in use today as a 'period' luxury suite with added mod-cons such as a telephone and en suite designer bathroom.

31 In this way, the hotel continues to market itself as an artists' haunt although today hardly any artists come to Volendam.

32 L. Spaander, in *Het Parool* (17 September 1952), quoted in *Vreemde gasten*, p. 13.

33 Simons, *Hotel Spaander*, pp. 15, 17.

34 On hostilities between the Catholic villagers of Laren and nearby Protestant Huizen, see Ranger, 'Artist life', 755.

35 In the census of 1845, two years before his wedding, Erik was registered as 'forret-ningsdrivend' – a shopkeeper or business person. P. Carit Andersen, *Skagen i fortid og nutid*, Copenhagen, 1980, p. 35. On the Brøndum–Møllers, see also Voss, *Painters of Skagen* and *Dansk biografisk leksikon*, ed. S. Cedergreen Bech, 3rd edn, Copenhagen,

[1887] 1979, entries on Christen Degn Brøndum (by K. Madsen) and Anna Kirstine Ancher (by O. Wivel).

36 Viggo Johansen and Karl Madsen respectively, both in 1880.

37 Voss, *Painters of Skagen*, p. 91.

38 *Ibid.*

39 Quoted in *ibid.*, p. 114 (tr. and modified by myself).

40 *Dansk biografisk leksikon*; Voss, *Painters of Skagen*. The political scientist was Johan Henrik Møller.

41 P. May, 'The children of Volendam', *Magazine of Art* (1900), 502.

42 Knight, *Oil Paint*, p. 137. See also Ranger, 'Artist life', 756.

43 J. Urry, *The Tourist Gaze: Leisure and Travel in Contemporary Societies*, London, Newbury Park, Calif. and New Dehli, 1990, p. 3.

44 The concept of performed ethnicity is taken from D. MacCannell, *Empty Meeting Grounds: The Tourist Papers*, London and New York, 1992, pp. 18–19, 31ff, 134, 172–9.

45 H. Blackburn, *Breton Folk: An Artistic Tour in Brittany*, London, 1880, p. 105; Andrian-Werburg, 'Schwälmer Arbeitswelt', pp. 253–4.

46 Letter to Maximilien Luce, summer 1891, quoted in Rewald, *Post-Impressionism*, pp. 266–7.

47 Knight, *Oil Paint*, p. 152.

Notes to Part III: introduction

1 P. Conisbee, 'Pre-Romantic *plein-air* painting', *Art History*, 2:4 (1979), 413–28, plates 23–33; P. Galassi, *Corot in Italy: Open-Air Painting and the Classical Landscape Tradition*, New Haven and London, 1991.

2 For example, Honoré Daumier's lithographs published in *Charivari* in the 1840s or Wilhelm Busch's comic picture story *Maler Klecksel* of 1883. B. Laughton, *The Drawings of Daumier and Millet*, New Haven and London, 1991; W. Busch, *Sämtliche Werke*, ed. O. Nöldeke, 8 vols, Munich, 1943.

3 The Barbizon painters are today frequently valued primarily because they are billed as precursors of Impressionism: Bouret, *Barbizon School*, pp. 223–43; S. Adams, *The Barbizon School and the Origins of Impressionism*, London, 1994. Of course, some of the Impressionist artists actively contributed to this image of themselves as plein-air pioneers; see, for example, J. House, *Monet: Nature into Art*, New Haven and London, 1986, p. 135.

4 Claude Monet, Auguste Renoir, Alfred Sisley and Frédéric Bazille.

5 It is particularly prevalent in the German literature: *Zurück zur Natur*; Repp-Eckert, 'Europäische Künstlerkolonien'; *Deutsche Künstlerkolonien 1890–1910*; Pese, 'Im Zeichen'.

6 Low, *Chronicle*, p. 115.

7 O. Modersohn, diary, February 1895, quoted in B. Küster, 'Pan stirbt im Moor: Worpswede als Malerkolonie des deutschen Naturalismus', in *Worpswede 1889–1989: Hundert Jahre Künstlerkolonie*, ed. Landkreis Osterholz, Lilienthal, 1989, p. 33.

8 *Ibid.* For the twentieth century, see the artists Paul Klee or Hans Arp.

9 R. Williams, 'Ideas of nature' [1972], in *Problems in Materialism*, p. 67.

10 Nicholas Green, *The Spectacle of Nature: Landscape and Bourgeois Culture in Nineteenth-Century France*, Manchester and New York, 1990, p. 2.

11 The term *natura naturans* ultimately derives from the seventeenth-century Dutch philosopher Baruch Spinoza who established the distinction between *natura naturans* and *natura naturata* in his treatise *Ethica, ordine geometrico demonstrata* (1677). Spinoza's *natura naturans* (literally 'nature naturing') refers to God, or nature, as the fundamental substance and cause of everything while *natura naturata* ('nature natured') refers to the created world. Both are dimensions of God. B. Spinoza, scholium to proposition 29, Part I, *Ethics: Treatise on The Emendation of the Intellect, and Selected Letters*, tr. S. Shirley, ed. and intro. S. Feldman, Indianapolis and Cambridge, 1992, pp. 51–2. Green does not mention Spinoza and takes his cue from Théophile Thoré's use of the term in 1847; *Spectacle*, pp. 80–1. The way Green and Thoré make use of the concept of *natura naturans* has little direct connection to Spinoza's original coinage. Instead of the perception of God in all things we now have a replacement of the divine in nature by the 'natural' in nature.

Notes to Chapter 4

1 Surprisingly few analytical, theoretical or even interesting accounts of the overall history and transformations of pictorial landscape conventions exist, and those that do tend to focus on the period 1780–1840. But see M. Smuda (ed.), *Landschaft*, Frankfurt am Main, 1986; M. Warnke, *Politische Landschaft: Zur Kunstgeschichte der Natur*, Munich and Vienna, 1992, tr. as *Political Landscape: The Art History of Nature*, tr. D. McLintock, London, 1994; W. J. T. Mitchell (ed.), *Landscape and Power*, Chicago and London, 1994; P. Howard, *Landscapes: The Artist's Vision*, London and New York, 1991; P. Howard, 'Artists as drivers of the tourbus', in Lübbren and Crouch, *Visual Culture and Tourism*. A useful overview of some of the main issues in M. Andrews, *Landscape and Western Art*, Oxford and New York, 1999.

2 G. van de Woestijne, *Karel en ik. Herinneringen*, Brussels and Amsterdam, 1979, quoted in *De eerste groep van Sint-Martens-Latem 1899–1914*, ed. Koninklijke Academie voor Wetenschappen, Letteren en Schone Kunsten van België, Brussels, 1988, p. 15.

3 Stevenson, 'Forest notes', 551.

4 See, for example, Herbert, *Monet on the Normandy Coast*, ch. 3.

5 H. Lehmann, 'Die Physiognomie der Landschaft', *Studium Generale*, 3:4/5 (1950), 184.

6 See J. L. Koerner, *Caspar David Friedrich and the Subject of Landscape*, London, 1990, ch. 9: 'Entering the wood'.

7 For a list of examples of *sous-bois*, see Lübbren, 'Rural artists' colonies', pp. 220, 223. A useful collection is reprod. in J. Sillevis and H. Kraan (eds), *The Barbizon School*, tr. J. R. Mengarduque, The Hague, [1985] 1985, and in *Barbizon au temps*.

8 Low, *Chronicle*, pp. 127–9.

9 'Wherever we turn perfect peace, perfect silence! … A faint rustle, to be sure, may still be heard, but it is not the rustle of leaves, and the crow of a cock from some farmstead is the only sound that now and then pierces the utter stillness.' M. Talmeyr, 'The forest of Fontainebleau: Winter', *Magazine of Art* (1888), 39.

10 G. Bachelard, *The Poetics of Space*, Boston, 1994, pp. 183–8.

11 P. Rodaway, *Sensuous Geographies: Body, Sense and Place*, London and New York, 1994. Rodaway breaks his discussion down into that of haptic, olfactory, auditory and visual geographies.

12 J. Hull, *Touching the Rock: An Experience of Blindness*, London, 1990, p. 12, quoted in
 Rodaway, *Sensuous Geographies*, p. 103.

13 Rodaway, *Sensuous Geographies*, p. 102.

14 *Ibid.*, p. 94.

15 Green, *Spectacle*, p. 184.

16 D. Cosgrove and S. Daniels (eds), *The Iconography of Landscape: Essays on the Symbolic
 Representation, Design and Use of Past Environments*, Cambridge, New York and
 Oakleigh, Melbourne, Victoria, 1988, esp. Introduction; G. Rose, *Feminism and
 Geography: The Limits of Geographical Knowledge*, Cambridge and Oxford, 1993, ch. 5.
 A useful summary of theories of the gaze in relation to landscape and recent critiques
 thereof in C. Crawshaw and J. Urry, 'Tourism and the photographic eye', in C. Rojek
 and J. Urry (eds), *Touring Cultures: Transformations of Travel and Theory*, London and
 New York, 1997, pp. 176–85.

17 M. J. Friedländer, *Essays über die Landschaftsmalerei und andere Bildgattungen*, The
 Hague and Oxford, 1947, p. 12; tr. as *Landscape, Portrait, Still-Life: Their Origin and
 Development*, tr. R. F. C. Hudl, Oxford, 1949.

18 O. Bätschmann, *Entfernung der Natur: Landschaftsmalerei 1750–1920*, Cologne, 1989,
 p. 82.

19 D. Cosgrove, *Social Formation and Symbolic Landscape*, London and Sydney, 1984,
 p. 262.

20 *Ibid.*, p. 27.

21 Green, *Spectacle*, p. 131.

22 *Ibid.*, p. 184. See also pp. 94, 130–3, 138, 147, 152.

23 *Ibid.*, p. 94. Emphases in the original.

24 *Ibid.*, p. 133.

25 Examples in N. Lübbren, 'Ottilie Reylaender', vol. 1, pp. 42–3, and in 'Lübbren,
 'Rural artists' colonies', pp. 199–202. See also Low, *Chronicle*, p. 115.

26 E. Claus, letter to Albijn Van den Abeele from Paris, 1 April 1889, quoted in Boyens,
 Flemish Art, pp. 20–1.

27 Low, *Chronicle*, p. 125.

28 E. L. Good, 'A Holland art village, *Catholic World*, 70:418 (1900), 526.

29 L. Couperus, 'De Hollandse schilders', *Van en over alles en iederen: Rome II*,
 Amsterdam, n.d., English translation quoted in R. de Leeuw, J. Sillevis, and C. Dumas
 (eds), *The Hague School: Dutch Masters of the Nineteenth Century*, London, 1983, p. 99.

30 O. Modersohn, diary, 15 February 1895, quoted in Küster, 'Pan stirbt', p. 34. 'Der
 Naturalismus, der leidenschaftslos der Natur gegenübersteht, sie mit den Augen
 erobern will, ohne auf ihre Seele zu achten, stieß mich von jeher ab.' For a more
 detailed discussion of the issues raised by the stylistic label of 'naturalism', see Küster,
 'Pan stirbt'.

31 G. Bilders, letter to J. Kneppelhout, 6 June 1862, quoted in Leeuw *et al.*, *Hague School*,
 p. 57.

32 R. M. Rilke, *Worpswede: Fritz Mackensen, Otto Modersohn, Fritz Overbeck, Hans am
 Ende, Heinrich Vogeler*, vol. 5 of *Sämtliche Werke*, eds Rilke-Archiv in association
 with R. Sieber-Rilke, Frankfurt am Main, [1903] 1965, pp. 10–12; tr. in Rilke, *Rodin
 and Other Prose Pieces*, tr. G. C. Houston, London, Melbourne and New York, 1986.
 See also Rilke, 'Concerning landscape' [1902], in *Rodin and Other Prose Pieces*,
 pp. 77–81.

33 R. Krauss, 'Grids', in *The Originality of the Avant-Garde and Other Modernist Myths*, Cambridge, Mass. and London, [1978] 1985, p. 9.

34 As this book was nearing completion, I became acquainted with Claudia Einecke's suggestive work on French *sous-bois* in the 1830s and 1840s many of whose conclusions reinforce the points made in my own chapter, although the emphasis is different. Einecke detects a paradigm shift from the 'visio-centric' landscapes of the eighteenth and early nineteenth century to the 'somatic' landscapes of the *School of 1830*, i.e. Rousseau, Dupré *et al.*, and explains it as a renewal of national identification after the fall of the Napoleonic Empire. C. Einecke, 'Das *sous-bois*: Motiv und Strategie der Natürlichkeit', in D. Christmann *et al.* (eds), *RückSicht: Festschrift für Hans-Jürgen Imiela zum 5. Februar 1997*, Mainz, 1997, pp. 129–39; and C. Einecke, 'Beyond seeing: The somatic experience of landscape in the "School of 1830"', in Burmester *et al.*, *Barbizon*, pp. 58–71. I thank Claudia Einecke and Neil McWilliam for kindly sending me copies of the cited essays.

Notes to Chapter 5

1 Clark, *Painting*, p. 182. Clark's emphasis is on the materiality of paint and the flatness of modernist painting, a somewhat different focus to mine.

2 Letter to her brother Kurt, 27 April 1895, in Modersohn-Becker, *In Briefen und Tagebüchern*, p. 65.

3 Hobbema's painting does contain its own brand of spatial inconsistencies, on which see M. Imdahl, 'Ein Beitrag zu Meindert Hobbemas "Allee von Middelharnis"', in Imdahl, *Zur Kunst der Tradition: Gesammelte Schriften, Band 2*, ed. G. Winter, Frankfurt am Main, [1961] 1996, pp. 327–44.

4 I owe this point to John House and Adrian Rifkin who suggested it in response to my Ph.D. dissertation. Exceptions to the trend of avoiding nudes are discussed in Lübbren, 'Ottilie Reylaender' and Lübbren, 'Rural artists' colonies', ch. 6: 'The peasant's body'.

5 Koerner, *Caspar David Friedrich*, p. 211.

6 G. Simmel, 'Philosophie der Landschaft', in *Brücke und Tür: Essays des Philosophen zur Geschichte, Religion, Kunst und Gesellschaft*, eds M. Landmann and M. Susman, Stuttgart, [1912/13] 1957, pp. 141–2.

7 For an extensive list of examples, see Lübbren, 'Rural artists' colonies', p. 309 n. 297.

8 G. van de Woestijne, quoted in Boyens, *Flemish Art*, p. 45.

9 A. Roeßler, *Neu-Dachau: Ludwig Dill, Adolf Hölzel, Arthur Langhammer*, Leipzig and Bielefeld, 1905, p. 48.

10 *Ibid.*, p. 47.

11 J. Crary, *Techniques of the Observer: On Vision and Modernity in the Nineteenth Century*, Cambridge, Mass., 1990.

12 C. Buysse, 1925, quoted in Boyens, *Flemish Art*, p. 123. For a similar eulogy to Théodore Rousseau, see W. Gensel, 'Die Meister des Paysage intime, I', *Die Kunst für Alle*, 19 (1903–4), 233.

13 A similar argument *vis-à-vis* Monet's *Waterlilies* is advanced very briefly in G. Boehm, 'Das neue Bild der Natur: Nach dem Ende der Landschaftsmalerei', in Smuda, *Landschaft*, p. 91.

14 Riehl was referring to the works of Anton Zwengauer who worked in Dachau from around 1850. W. H. Riehl, *Culturstudien aus drei Jahrhunderten*, Stuttgart, [1859] 1873, p. 70.

15 O. F. Bollnow, *Mensch und Raum*, Stuttgart, Berlin, Cologne and Mainz [1963] 1980, pp. 230–1.

16 Heyting, *De wereld*, ch. 10.

17 Simmel, 'Philosophie der Landschaft', pp. 149–50.

18 Quoted in *Dreams of a Summer Night: Scandinavian Painting at the Turn of the Century*, eds Nordic Council of Ministers and Arts Council of Great Britain, London, 1986, p. 22.

Notes to Part IV: introduction

1 The texts I have found most suggestive are: R. Shields, *Places on the Margin: Alternative Geographies of Modernity*, London, 1991; J. R. Short, *Imagined Country: Environment, Culture and Society*, London and New York, 1991; M. L. Pratt, *Imperial Eyes: Travel Writing and Transculturation*, London and New York, 1992; A. D. Wallace, *Walking, Literature and English Culture: The Origins and Uses of Peripatetic in the Nineteenth Century*, Oxford, Clarendon Press, 1993; J. Urry, *Consuming Places*, London and New York, 1995; Macnaghten and Urry, *Contested Natures*. For art history, see note 1 below.

2 A. Pred, 'Place as historically contingent process: structuration and the time-geography of becoming places', *Annals of the Association of American Geographers*, 74:2 (1984), 279.

3 *Ibid.*, 280.

4 Urry, *Consuming Places*, p. 1.

Notes to Chapter 6

1 Most saliently, Tucker, *Monet*; Clark, *Painting*; Brettell, *Pissarro*; Herbert, *Monet on the Normandy Coast*; J. Taylor, *A Dream of England: Landscape, Photography and the Tourist Imagination*, Manchester and New York, 1994; Herbert, 'Reconsiderations'.

2 Orton and Pollock, 'Données', and Green, *Spectacle*, pp. 116–20, 154–81.

3 P. Phillips, *The Staithes Group*, [Cookham, Berkshire], 1993, p. 30.

4 D. Bachmeier, 'Carl Bantzer und die Willingshäuser Malerkolonie', in *Schwälmerisch*, p. 58.

5 E. H. Gombrich, *Art and Illusion: A Study in the Psychology of Pictorial Representation*, London, [1959] 1977, pp. 55–78.

6 Shields, *Places on the Margin*, pp. 46–7, 60–1.

7 *Ibid.*, p. 60.

8 Un Ancien Ami [Benézit-Constant], *Le Livre d'or de J.-F. Millet*, Paris, 1891, quoted in Sillevis and Kraan, *Barbizon School*, p. 45.

9 F. Overbeck, 'Ein Brief aus Worpswede', *Die Kunst für Alle*, 11:2 (1895/96), 20.

10 Green, *Spectacle*, pp. 116–120, 154ff.

11 C. O. Petersen, *Lebenslexikon*, quoted in Heres, *Dachauer Gemäldegalerie*, p. 66.

12 *Ibid.*, p. 111.

13 More on recurring motifs in Lübbren, 'Rural artists' colonies', pp. 265–7.

14 Modersohn, diary entry for 3 July 1889, quoted in *Otto Modersohn: Das Frühwerk 1884–1889*, eds P. Altmann and R. Noeres, Fischerhude and Munich, 1989, p. 243.

15 Mackensen, 'Worpswede', 6.

16 Modersohn's text, although billed as a diary, was revised by the artist at an indeterminate later date.

17 Mackensen, postcard to his mother, Worpswede, 14 September 1884, quoted in *Worpswede: Eine deutsche Künstlerkolonie*, p. 10.

18 Mackensen, 'Worpswede', 5.

19 Reprod. in R. de Leeuw *et al.*, *Hague School*, p. 68.

20 Reprod. in *Otto Modersohn: Das Frühwerk*, colour plate 90.

21 Mackensen, 'Worpswede', 6.

22 Overbeck, 'Ein Brief', 22. Further references to Worpswede's sky, colour and reflections in *Worpswede: Aus der Frühzeit der Künstlerkolonie*, Bremen, 1970, pp. 36–48.

23 Reprod. in *Otto Modersohn: Das Frühwerk*, colour plate 33.

24 See Becker-Vohl, 'Figur und Landschaft', pp. 59–63, and *Paula Modersohn-Becker zum hundertsten Geburtstag*, Bremen, 1976, section 'Landschaft'.

25 For lists of similar canal pictures, see Lübbren, 'Rural artists' colonies', pp. 275–6, notes 211–16.

26 Interestingly, one early writer commented that *Sermon on the Moor* did 'not yet sound the distinctive Worpswede note': H. Rosenhagen, 'Die Worpsweder', *Die Woche*, 4:7 (1902), 298.

27 See *Paula Modersohn-Becker zum hundertsten*, section 'Frühe Landschaften'; A. Röver, *Paula Modersohn-Becker: Das Frühwerk*, Bremen, 1985; Lübbren, 'Ottilie Reylaender', pp. 42–56. Additional images reprod. in B. Doppagne, *Ottilie Reylaender: Stationen einer Malerin*, ed. Worpsweder Kunsthalle Friedrich Netzel, Lilienthal, 1994, pp. 14, 15, 68.

28 Examples cited in Lübbren, 'Rural artists' colonies', pp. 265–7, 277–81.

29 D. Delouche, 'Gauguin au regard d'autres peintres ses prédécesseurs en Bretagne', in Delouche, *Pont-Aven*, pp. 51–80.

30 Compare, for example, Gauguin's *Willow Trees* (*c.* 1885, Rotterdam, Museum Boymans-van Beuningen) with his *Alley in the Forest (Bois d'Amour)* (1886, priv. coll., Paris).

31 Quoted in H.-C. Kirsch, *Worpswede: Die Geschichte einer deutschen Künstlerkolonie*, Munich, 1987, p. 31.

32 Overbeck, 'Ein Brief', 22.

33 Letter, 9 November 1889, quoted in *Otto Modersohn: Das Frühwerk*, p. 253.

34 Diary, 11 August 1889, quoted in *ibid.*, p. 245.

35 Modersohn, diary, 25, 26 or 27 August 1889 [*sic*] and September 1889, quoted in *Worpswede: Eine deutsche Künstlerkolonie*, 1986, p. 16.

36 Examples from Worpswede: Overbeck, 'Ein Brief'; Krummacher, 'Die Malerkolonie'; A. Gildemeister, 'Worpswede', *Die Kunst für Alle*, 15:12 (1900), 267–80; P. Warncke, *Worpswede*, Leipzig and Berlin, 1902; A. Koeppen, *Die moderne Malerei in Deutschland*, Bielefeld and Leipzig, 1902, pp. 56–57; Rilke, *Worpswede*; F. Picker, 'Das Worpsweder Teufelsmoor und seine Maler', *Die Gartenlaube*, 27 (1904), 472–6; H. Bethge, *Worpswede (Hans am Ende, Fritz Mackensen, Otto Modersohn, Fritz Overbeck, Carl Vinnen, Heinrich Vogeler)*, Berlin, [1904] 1907.

37 R. Muther, 'Worpswede', in *Studien*, ed. H. Rosenhagen, Berlin, [before 1909] 1925, pp. 639–49.

38 *Ibid.*, p. 639.

39 *Ibid.*

40 *Ibid.*, pp. 640–1.

41 When Muther visited Worpswede, he had already made his name through numerous weighty as well as popular publications, including *Anton Graff: Ein Beitrag zur Kunstgeschichte des 18. Jahrhunderts*, Leipzig, 1881; *Die deutsche Bücherillustration der Gothik und Frührenaissance*, Munich, 1884; and the magisterial *History of Modern Painting*, 3 vols, London, [1894] 1895–96. He had been a professor for art history at the University of Breslau since 1895.

42 L. Schüßler, 'Die Worpsweder Malerei um 1900 und ihre entwicklungsgeschichtliche Stellung', Ph.D. dissertation, Philipps-Universität, Marburg, 1951; U. Hamm, 'Studien zur Künstlerkolonie Worpswede 1889–1908 unter besonderer Berücksichtigung von Fritz Mackensen', Ph.D. dissertation, Munich, 1978; Becker-Vohl, 'Figur und Landschaft'. Becker-Vohl devotes an entire sub-chapter to the 'unusual climatic conditions' of Worpswede.

43 A sampling: Bohn *et al.*, *Ahrenshoop*; L. Jürß, *Schwaan*, Fischerhude, 1992; *Schwälmerisch*; *Künstlerkolonie Skagen*; *Barbizon au temps*; Fox and Greenacre, *Painting in Newlyn*; Phillips, *Staithes Group*; Boyens, *Flemish Art*.

44 Le Paul, *Gauguin*, pp. 10, 11, 48, 49, 50, 51.

•45 There are some interesting points on postcards in N. Schor, '*Cartes postales*: Representing Paris', *Critical Inquiry*, 18 (1992), 188–244; A. Confino, *The Nation as a Local Metaphor: Württemberg, Imperial Germany, and National Memory, 1871–1918*, Chapel Hill and London, 1997, pp. 179–85.

46 MacCannell, *The Tourist*, p. 41.

47 Le Paul, *Gauguin*, p. 273.

48 D. Fabrice, *Les Peintres de la Bretagne*, Paris, 1898, quoted in Schüßler, 'Die Worpsweder Malerei', p. 172.

49 A. Séguin, 'Paul Gauguin', *L'Occident* (1903), 166, quoted in Jaworska, *Gauguin*, p. 229.

50 *Ibid.*, p. 228.

51 Delouche, 'Gauguin au regard', in *Pont-Aven*, pp. 57, 79 n. 20.

52 H. Wohltmann, 'Zur 75jährigen Wiederkehr der Gründung der Worpsweder Malerkolonie', *Stader Jahrbuch*, N.S., 54 (1964), 15.

53 H. Vogeler, *Erinnerungen*, ed. E. Weinert, Berlin, 1952, p. 49.

54 Wohltmann, 'Zur 75jährigen Wiederkehr', p. 15; K. V. Riedel, *Worpswede in Fotos und Dokumenten*, Fischerhude, 1988, pp. 76, 82, 94, 108–9. Vogeler was the only artist frequently to paint one of Worpswede's stately villas – his own, the Barkenhoff.

55 H. Allmers, *Das Marschenbuch*, in *Werke*, ed. K. Schulz, Göttingen, [1857] 1965, pp. 7–264, esp. pp. 67–8. The Worpswede artists admired Allmers, and he visited them in Worpswede on at least one occasion; Vogeler, *Erinnerungen*, pp. 59ff; Riedel, *Worpswede*, p. 17.

56 Modersohn-Becker, *In Briefen und Tagebüchern*, diary, April 1903, p. 359; Vogeler, *Erinnerungen*, p. 101.

57 K. Dede and W.-D. Stock, *Kleiner Worpswede-Führer*, Fischerhude, 1980, pp. 8–10.

58 Seventeenth-century Dutch landscapes provide an instructive contrast. For example, Hobbema's *The Avenue, Middelharnis* (figure 31) represents the taking possession of a land that has become prosperous and independent through hard labour and military

struggle; it shows man in control. See also A. J. Adams, 'Competing communities in the "great bog of Europe": Identity and seventeenth-century Dutch landscape painting', in Mitchell, *Landscape and Power*, pp. 35–76.

59 The most suggestive text on metaphor and metonymy remains R. Jakobson, 'The metaphoric and metonymic poles', in Jakobson and M. Halle, *Fundamentals of Language*, The Hague, 1956, pp. 69–96.

60 Orton and Pollock, 'Données'.

61 *Ibid.*, 341 n. 27. For example: Mrs B. Palliser, *Brittany & Its Byways: Some Account of Its Inhabitants and Its Antiquities, During a Residence in that Country*, London, 1869 ('celebrated for the quantity of its salmon', p. 151); Anon. ['An Art Correspondent'], 'Holiday rambles: Roundabout Pont-Aven', *The Parisien*, 4 September 1879, clipping from the archive of Michael Jacobs ('quaint charm', 'The highways are hard and smooth', n.p.); H. Blackburn, 'Pont-Aven and Douarnenez', *Magazine of Art* (1879), 6–9 ('surroundings are delightful', 'climate is generally temperate', 6–7); A. Joanne, *Géographie du Finistère*, Paris, 1895 ('jolis sites le long de l'Aven', p. 68); S. Baring-Gould, *Brittany*, London, 1902 ('picturesquely situated on the Aven', p. 170).

62 C. R. Weld, *A Vacation in Brittany*, London, 1856 (Bretons as 'agriculturally backward', p. 163, and 'renowned ... for their deep-rooted belief in wild legends and strange traditions', p. 3); Palliser, *Brittany* ('Agriculture is very backward in Brittany', p. 87; the priesthood is 'low and ignorant', p. 104); Anon., 'Holiday rambles' (peasants as 'miserably poor, filthy and often stupid', n.p.); Blackburn, 'Pont-Aven and Douarnenez' ('such primitive habitations and such dirt', p. 6); A. W. Dow, 'Modern Brittany' [10 August 1885], *Ipswich Chronicle*, 39 (3 October 1885) ('the land is barren at the best, but the Breton farmer does little work, on account of so many religious fetes', the people are 'brutal and cruel', n.p.); Harrison, 'Quaint artist haunts' (the people are 'stern, almost savage' and 'miserably poor', 25).

63 C. Bertho, 'L'Invention de la Bretagne: Genèse sociale d'un stereotype', *Actes de la Recherche en Sciences Sociales*, 35 (1980), 45–62.

64 Notably in the works of the so-called 'bande noire', including Charles Cottet, René Menard and Lucien Simon who enjoyed a period of Salon success from the mid-1890s. See A. Cariou, 'Le peintre Charles Cottet et la Bretagne', *Annales de Bretagne*, 81:3–4 (1973), 649–61.

65 M. A. Havinden *et al.* (eds), *Centre et périphérie: Bretagne, Cornouailles/Devon – étude comparée/Centre and Periphery: Brittany and Cornwall & Devon Compared*, Exeter, 1991.

66 A list of paintings in Lübbren, 'Rural artists' colonies', p. 302 n. 279.

67 Low, *Chronicle*, p. 80.

68 E. Wheelwright, 'Personal recollections of Jean François Millet', *Atlantic Monthly*, 38:227 (1876), 265.

69 Much work remains to be done in this area. The only text that deals with (American) national stereotypes of Europe is Stott, 'American painters'.

70 Confino, *The Nation*, p. 9.

71 Short, *Imagined Country*, p. 35. On this point, see also D. Lowenthal, 'European and English landscapes as national symbols', in David Hooson (ed.), *Geography and National Identity*, Oxford and Cambridge, Mass., 1994, pp. 15–38.

72 For example, with regard to Worpswede: F. von Ostiny, 'Die Münchener Jahresausstellung im Glaspalast, III', *Münchener Neueste Zeitung* (11 August 1895),

repr. in *Otto Modersohn 1865–1943: Monographie*, p. 133; P. Schultze-Naumburg, 'Die Worpsweder', *Die Kunst für Alle*, 12:8 (1896–7), 117; Gildemeister, 'Worpswede', 272; Warncke, *Worpswede*, p. 41; Bethge, *Worpswede*, p. 8.

73 Ostiny, 'Die Münchener Jahresausstellung', p. 133; A. Freihofer, 'Die Malerei auf den Münchener Ausstellungen von 1895', *Die Kunst unserer Zeit*, 6:2 (1895), quoted in *Worpswede: Eine deutsche Künstlerkolonie*, 1986, p. 25.

74 For example, Schultze-Naumburg, 'Die Worpsweder', p. 116; Gildemeister, 'Worpswede', p. 272; Bethge, *Worpswede*, p. 8.

75 Roeßler, *Neu-Dachau*, pp. 25–6. Similar evocations in B. Feistel-Rohmeder-HD, 'Ludwig Dill', *Deutsche Kunst und Dekoration*, 15 (1904–05), 237–44; L. van der Veer, 'Professor Ludwig Dill: The man and his work', *Studio*, 34:143 (1905), 210–16; Koeppen, *Die moderne Malerei*, p. 56; more recently, W. Venzmer, 'Dachau bei München', in Wietek, *Deutsche Künstlerkolonien*, pp. 46–57.

76 N. Göttler, *Die Sozialgeschichte des Bezirkes Dachau 1870–1920: Ein Beispiel struktureller Wandlungsprozesse des ländlichen Raumes*, Munich, 1988, esp. pp. 100–2.

77 *Ibid.*, pp. 11–12.

78 *Ibid.*, pp. 117–18.

79 *Ibid.*, pp. 127–8.

80 The 1871 Dachau census listed 11,750 persons active in agriculture and gardening; in 1916, this had dropped to 7,323 (compared to 3,587 in industry). *Ibid.*, pp. 94, 128.

81 *Ibid.*, pp. 130–1.

82 *Ibid.*, p. 136.

83 *Ibid.*, pp. 95–6.

84 *Ibid.*, p. 139.

85 See also D. Blackbourn, 'Peasants and politics in Germany, 1871–1914', *European History Quarterly*, 14 (1984), 47–75.

86 Green, *Spectacle*, pp. 68–9. On urban parks, see also Herbert, *Impressionism*, ch. 5.

87 Article 'Gartenkunst', in *Lexikon der Kunst*, Leipzig, 1989, pp. 652–3.

88 For example, the entire forest of Fontainebleau was state-administered and the legal *Code forestier* forbade peasants to enter the forest with woodcutting tools, to light fires, graze sheep and goats, hunt or fell trees. The gathering of faggots, depicted by so many Barbizon artists as integrated into a *sous-bois* setting, was legally forbidden to unauthorised peasants. T. J. Clark, *The Absolute Bourgeois: Artists and Politics in France 1848–1851*, London, 1972, p. 79; Adams, *Barbizon School*, p. 157.

89 Andrian-Werburg, 'Schwälmer Arbeitswelt', pp. 21–2.

90 L. Thoma, *Kaspar Lorinser*, quoted in Weber-Kellermann, *Landleben*, p. 54.

Notes to Chapter 7

1 G. Hard, *Die 'Landschaft' der Sprache und die 'Landschaft' der Geographen*, Bonn, 1970; R. Gruenter, 'Landschaft: Bemerkungen zur Wort- und Bedeutungsgeschichte', in A. Ritter (ed.), *Landschaft und Raum in der Erzählkunst*, Darmstadt, [1953] 1975; A. Métraux, 'Ansichten der Natur und *Aisthesis*: Einige kritische Bemerkungen zum Landschaftsbegriff', in Smuda, *Landschaft*, pp. 215–38; House, 'Framing the landscape', in House and Skipwith (eds), *Landscapes of France*.

2 The sole exceptions may be the Spanish colonies of Muros de Nalón in Asturia and Olot in the Catalonian foothills of the Pyrenees. I only discovered the existence of these

groups shortly before completion of this book and was unable to ascertain whether they were fully-fledged artists' colonies or outposts of city academies, and to what extent they shared the preoccupations of their Northern counterparts. See M. Valdivieso Rodrigo, 'Die Generation von 98 und die spanische Malerei', *Forum Ibero-Americanum*, 3, Cologne and Vienna; J. Berga, J. Vayreda and M. Vayreda, *L'Escola d'Olot*, Barcelona, 1993. I thank Hans-Günther Pawelcik of Lilienthal for alerting me to these groups and for kindly sending me a copy of the cited article.

3 Rewald, *Post-Impressionism*, p. 209.

4 Coastal: Staithes, Lamorna Cove, Newlyn, St Ives, Hornbæk, Skagen, Ekensund, Ahrenshoop, Schwaan, Étaples, St Siméon's farm near Honfleur, Camaret, Concarneau, Douarnenez, Le Pouldu, Pont-Aven, Egmond, Katwijk, Volendam, Urk, Bergen, Aasgaardsstrand, Varberg. Flat terrain (moorland, puszta, marsh, heath): Genk, Kalmthout, Sint-Martens-Latem, Dachau, Etzenhausen, Fischerhude, Worpswede, Bardowick, Zeven, Szolnok, Barbizon (between forest and plain), Chailly, Laren. Hills: Willingshausen, Kleinsassen, Kronberg, Betws-y-Coed, the Scottish communities. Murnau and Schreiberhau are mountain villages but both were twentieth-century foundations.

5 Jacobs, *Good and Simple Life*, p. 12.

6 Howard, *Landscapes*.

7 Classical, 1770–90; picturesque, 1790–1830; romantic, 1830–70; heroic, 1870–1910; vernacular, 1910–50; formal, 1950–80.

8 By 1880, most of the earlier great sites of artistic activity (the Lake District, Devon, Brighton, Hastings, Welsh lakes and mountains) were deserted by painters; the most popular sites for landscape painting between 1870 and 1910 were the coast near Whitby (which includes Staithes) and the Cornish Coast, areas that had attracted almost no pictorial interest before. Howard, *Landscapes*, pp. 89–102, maps on pp. 59, 81, 104.

9 *Ibid.*, p. 1.

10 A point made by Urry, *Tourist Gaze*, p. 5.

11 Gauguin and Ottilie Reylaender are two of the very few exceptions. Their trajectories – from Paris to Pont-Aven to Le Pouldu to the South Seas and from Worpswede to Paris to Rome to Mexico, respectively – are completely atypical, although it has sometimes been suggested that the move by artists to Brittany somehow adumbrated a primitivist exodus to the colonies (for example by Perry, 'Primitivism'). However, when these artists travelled overseas and started sending back paintings of their non-European subjects to Europe, they entered a different discursive and experiential realm from that occupied by rural artists in Europe. On Reylaender, see Lübbren, 'Ottilie Reylaender'; Doppagne, *Ottilie Reylaender*.

12 Dachau, St Ives and Betws-y-Coed were the exceptions.

13 Christian Krohg, on his first visit to Skagen in 1879, quoted in P. Gauguin, *Christian Krohg*, Oslo, 1932, p. 54. I thank Margit Thøfner of the University of Bristol for kindly translating these passages.

14 H. Rönnberg, *Konstnärslivet i slutet av 1880-talet*, vol. 1, Helsinki, 1931, pp. 9–11. Kindly tr. by M. Thøfner, slightly modified by myself.

15 See the brilliant analysis by W. Schivelbusch, *Geschichte der Eisenbahnreise: Zur Industrialisierung von Raum und Zeit*, Frankfurt am Main, [1977] 1989; tr. as *The Railway Journey: The Industrialization of Time and Space in the Nineteenth Century*, tr. uncredited, Berkeley, [1979] 1986.

16 H. Havard, *La Hollande pittoresque: Voyage aux villes mortes du Zuiderzée*, Paris, [1874] 1875, p. 45.

17 P.G. Konody, 'A Dutch Barbizon', *Pall Mall Magazine*, 18 (1889), 483.

18 E. Hain, letter to the *Cornish Magazine*, 1 (July 1898), 72.

19 Letter, 17 February 1884, quoted in Bendiner, *Victorian Painting*, p. 111.

20 Green, *Spectacle*, p. 93.

21 *Ibid.*

22 Clark, *Painting*, ch. 3: 'The environs of Paris', pp. 147–204.

23 G.B., 'Les Environs de Paris, Bougival', *L'Illustration*, 53 (24 April 1869), 267, quoted in Herbert, *Impressionism*, p. 210.

24 *Ibid.*

25 MacCannell, *The Tourist*.

26 *Ibid.*, pp. 14, 22–4, 104, and *passim*.

27 J. A. Walter, 'Social limits to tourism', *Leisure Studies*, 1:3 (1982), 296.

28 *Ibid.*, 297.

29 *Ibid.*, 298–9.

30 *Ibid.*, 297.

31 Urry, *Tourist Gaze*, pp. 45–6, 86, 89, 97–8, 104, and *passim*. See also Urry, '*The Tourist Gaze* "revisited"', *American Behavioral Scientist*, 36:2 (1992), 172–86, and Urry, *Consuming Places*, p. 191.

32 Urry, *Tourist Gaze*, p. 98.

33 R. Jefferies, 'New facts in landscape', *Magazine of Art*, 5 (1882), 470–1.

34 Urry, *Tourist Gaze*, p. 86.

35 In subsequent texts, Urry has revised and indeed critiqued his own earlier exclusive focus. See Macnaghten and Urry, *Contested Natures*, ch. 4: 'Sensing nature'.

36 Hermine Overbeck-Rohte, for example, came to Worpswede because of Fritz Overbeck's *Moonrise on the Moor* which she had seen in Munich in 1896. Overbeck, *Eine Kindheit*, p. 256.

37 K. Baedeker, *Belgium and Holland: Handbook for Travellers*, Leipzig and London, 10th edn, 1891, p. 285.

38 J. H. Kraan and J. P. van Brakel, *G. Morgenstjerne Munthe in Katwijk*, Katwijk, 1989, p. 44. Precise figures in Gazetteer below.

39 The cover of *Nordzeebad Katwijk aan Zee: Gids voor het Badseizoen 1891* is reprod. in J. P. Brakel, *Vissen voor de kerk: Katwijk vroeger en nu*, Katwijk, 1969, p. 82.

40 Reprod. in *ibid.*, p. 82, and *Katwijk in de schilderkunst*, figure 7.15.

41 Kaemmerer, *The Beach at Scheveningen, Holland*, 1874, Sotheby's, reprod. in Herbert, *Monet on the Normandy Coast*, plate 23. Mauve, *At Scheveningen*, *c.* 1877, Rijksmuseum Hendrik Willem Mesdag, The Hague, reprod. in Lübbren, '"Toilers"'. Boudin, Monet and Stevens reprod. in Herbert, *Impressionism*, ch. 7: 'At the seaside'.

42 Herbert, *Impressionism*, pp. 294–5.

43 J. Buzard, *The Beaten Track: European Tourism, Literature, and the Ways to Culture, 1800–1918*, Oxford, 1993.

44 *Ibid.*, pp. 1–2.

45 *Ibid.*, p. 4.

46 Clark, *Painting*, esp. pp. 147, 155–6, 202–4. Quotation from p. 156.

47 Buzard, *Beaten Track*, p. 6.

48 Krummacher, 'Die Malerkolonie', 18–19, 22. See also Lübbren, 'Rural artists' colonies', pp. 197–9, 201–2.

49 C. N. Swift, 'Kroas ar laer krow', unpubl. ms (n.d.), Clement Swift Papers, Archives of American Art, Smithsonian Institution, quoted in Sellin, *Americans*, p. 90.

50 Overbeck to Modersohn, 12 July 1894, and Modersohn to Mackensen, 13 September 1894, both quoted in Hamm, 'Studien', pp. 14–15; Modersohn-Becker to her parents, 10 September 1899, in Modersohn-Becker, *In Briefen und Tagebüchern*, p. 168.

51 Woestijne, *Karel en ik*, quoted in *De eerste groep*, p. 40.

52 Y. King, 'A round in France', *Magazine of Art*, 1885, 116–20, quoted in Howard, *Landscapes*, p. 197.

53 Buzard, *Beaten Track*, p. 157. The term 'adversary culture' is culled from L. Trilling, *Beyond Culture: Essays on Literature and Learning*, New York, [1965] 1978.

54 A suggestive discussion in P. Bishop, *An Archetypal Constable: National Identity and the Geography of Nostalgia*, London, 1994.

55 Rilke, *Worpswede*, p. 26.

56 For example, Koch, *Heroic Landscape with Rainbow*, 1805, Badische Kunsthalle, Karlsruhe, and Oehme, *Stolpern Castle*, 1830, Museum der bildenden Künste, Leipzig.

57 Telepy reprod. in *Die Kunst für Alle*, 12 (1896–97), 27.

58 A similar point made by Howard, *Landscapes*, pp. 81, 86–7, 93.

59 See *ibid.*, p.102.

60 M. Wagner, 'Die Alpen: Faszination unwirtlicher Gegenden', in P. Märker *et al.*, *Mit dem Auge des Touristen: Zur Geschichte des Reisebildes*, Tübingen, 1981, pp. 67–79; J. Böröcz, 'Travel-capitalism: The structure of Europe and the advent of the tourist', *Comparative Studies in Society and History*, 34:4 (1992), 719.

61 R. Barthes, 'The *Blue Guide*', in Barthes, *Mythologies*, selected and tr. A. Lavers, London, [1957] 1993, p. 74.

62 The Reverend G. Musgrave, *A Ramble into Brittany*, vol. 2, London, 1870, p. 107.

63 Talmeyr, 'Forest of Fontainebleau', 37. See also Frédéric Henriet's 'typical' anecdote of a clash in opinion on panoramic 'little Switzerlands' between an artist and a society lady, i.e. tourist: Henriet, *Le Paysagiste*, p. 49.

64 Overbeck, 'Ein Brief', 20.

65 The 'Verschönerungsverein Worpswede' was founded in 1903 with Heinrich Vogeler as its chair (1904–12). G. Boulboullé and M. Zeiss, *Worpswede: Kulturgeschichte eines Künstlerdorfes*, Cologne, 1989, p. 90. *Cf.* the beautification society of Ahrenshoop, discussed in ch. 3.

66 G. Pollock, 'On not seeing Provence: Van Gogh and the landscape of consolation, 1888–9', in Thomson, *Framing France*, p. 84.

67 A. G. Bell, 'Letters from artists', 117; K. Hanusch, 'Erinnerungen an Bantzer in Willingshausen, in Bantzer, *Hessen*, p. 9.

Notes to Epilogue

1 A handful of artists settled in Bergen in 1902 but the main artistic activity set in from 1908 with a group of Dutch Expressionists. A. Venema, *De Bergense School*, Baarn, 1976; Stott, 'American painters', pp. 165–6; *Rond het 'Oude Hof': Schilders en beeldhouwers in Bergen 1910–1940*, eds A. Fleischer *et al.*, Bergen, 1993. The group in

Murnau (Marianne Werefkin, Gabriele Münter, Erma Bossi, Alexey Jawlensky, Vassily Kandinsky and others) existed only for six years or so and does not fit into the pattern of the type of colonies discussed in this book (although it is included in Wietek, *Deutsche Künstlerkolonien* and in *Deutsche Künstlerkolonien 1890–1910*). Their fame today rests largely on their contribution to the activities of the Expressionist *Blue Rider* almanac and exhibition. No research has yet been done on the significance of Murnau as a location.

2 See Jacobs, *Good and Simple Life*, p. 142; O. Mezei, 'Ecoles d'art libres en Hongrie entre 1896 et 1944', *Acta Historiae Artium*, ed. Academiae Scientiarum Hungaricae, 28:1–2 (1982), 175–209.

3 For example, the reconstruction of Marie Henry's inn in Le Pouldu; the opening of the museum in Pont-Aven in 1985; the refurbishment of the Hôtel Chevillon in Grèz, as documented in *The Happy Years of Grèz*, a series of three programmes for Sveriges Television, Gothenburg, by Nils Chöler, *c.* 1992; the opening of the Musée Américain in Giverny in June 1992; the establishment of a small permanent exhibition in the 'Franz-Bunke-Haus' in Schwaan in 1995; the archive, website and tireless lobbying for a *Malermuseum* by the 'Museumsgesellschaft Kronberg', founded in 1979; the promotion of the West-Norwegian Balestrand as an 'art village', from 1997 onwards (I am grateful to Pawel Pawelcik for sending me information on Balestrand). See also *'all together now': Zeitgenössische Kunst aus europäischen Künstlerkolonien zu Gast in Ahrenshoop 1995 – Ahrenshoop, Barbizon, Christchurch, Kronberg, Tervuren, Worpswede*, ed. Förderkreis Ahrenshoop e.V. and EURO-ART, Ahrenshoop and Fischerhude, 1995.

Select bibliography

Where relevant, square brackets denote original date and/or place of publication.

Primary sources: Letters, diaries, memoirs
and other eyewitness accounts of life in rural artists' colonies

Amiet, Cuno, 'Erinnerungen aus der Bretagne', *Das Werk*, 9:1 (1922), 7–9.

Andersen, Hans Christian, *H.C. Andersens Dagbøger*, vol. 4, ed. Tue Gad, Copenhagen, G.E.C. Gads Forlag, 1974.

Anonymous, 'A visit to the Bois d' Amour', *Belgravia*, 80:316 (1893), 283–93.

Anonymous ['From our Paris correspondent'], 'In an artists' country' [Giverny], *Morning Advertiser*, London (9 July 1892).

Bantzer, Andreas (ed.), *Carl Bantzer – Ein Leben in Briefen: Briefe – Berichte – Werkverzeichnis*, Willingshausen, Vereinigung Malerstübchen Willingshausen, [1985] rev. edn 1998.

Bantzer, Carl, *Hessen in der deutschen Malerei. Erster Teil. Die Maler der Schwalm: Mit Kunstchronik von Willingshausen* [1st edn 1935], Marburg an der Lahn, N. G. Elwert Verlagsbuchhandlung, [1935] 1979.

Bartlett, T. H., 'Barbizon and Jean-François Millet', *Scribner's Magazine*, 7:5 (1890), 531–55 [Parts I–III]; 7:6 (1890), 735–55 [Part IV].

Bartlett, W. H., 'Summer time at St. Ives, Cornwall', *Art Journal* (1897), 292–5.

Beaux, Cecilia, *Background with Figures: Autobiography*, Boston and New York, Houghton Mifflin Company, 1930.

Bell, Arthur G., 'Letters from artists to artists. – Sketching grounds, no. 2: Holland', *Studio*, 1:3 (1893), 116–21.

Bethge, Hans, *Worpswede (Hans am Ende, Fritz Mackensen, Otto Modersohn, Fritz Overbeck, Carl Vinnen, Heinrich Vogeler)*, Berlin, Marquardt & Co, [1904] 1907.

Birch, Mrs Lionel [Constance Mary Birch, *née* Innes], *Stanhope A. Forbes, A.R.A., and Elizabeth Stanhope Forbes, A.R.W.S.*, London, Paris, New York and Melbourne, Cassell and Company, 1906.

Blackburn, Henry, 'Pont-Aven and Douarnenez: Sketches in lower Brittany', illus. by Randolph Caldecott, *Magazine of Art* (1879), 6–9.

Blackburn, Henry, *Breton Folk: An Artistic Tour in Brittany*, illus. by Randolph Caldecott, London, Sampson Low, Marston, Searle & Rivington, 1880.

Boughton, George H[enry], A.R.A., *Sketching Rambles in Holland*, illus. by author and Edwin A. Abbey, London, Macmillan and Company, 1885.

Boughton, George Henry, 'Artist strolls in Holland: II–IV, VI', *Harper's New Monthly Magazine*, 66 (American edn)/5 (European edn) (1883), 387–405, 520–39, 683–705; 69 (American edn)/8 (European edn) (1884), 523–36.

Carley, Lionel, *Delius: A Life in Letters, I: 1862–1908*, London, Scolar Press in association with the Delius Trust, 1983.
Champney, Benjamin, *Sixty Years' Memories of Art and Artists*, Woburn, Mass., 1900.

Dolman, Frederick, 'Illustrated interviews 76: Mr. Stanhope A. Forbes, A.R.A.', *Strand Magazine*, 22:131 (1901), 483–94.
Dow, Arthur Wesley, 'Modern Brittany' [10 August 1885], *Ipswich Chronicle*, 39 (3 October 1885).
Dubuisson, A., *Les Échos du bois sacré: Souvenirs d'un Peintre de Rome à Barbizon*, Paris, Presses universitaires de France, 1924.

Eaton, Wyatt, 'Recollections of Jean François Millet: With some account of his drawings for his children and grandchildren, *Century Magazine*, 37 (1889), 90–104.
Emanuel, Frank L., 'Letters from artists to artists, V: Holland from a Canadian canoe', *Studio*, 2:11 (1894), 166–70.
Emanuel, Frank L., 'Letters to artists: Concarneau, Brittany, as a sketching ground', *Studio*, 4:24 (1895), 180–6.

Fizelière, Albert de la, 'Les Auberges illustrées', *L'Illustration* (24 December 1853), 423–6.
Forbes, Stanhope A., 'A Newlyn retrospect', *Cornish Magazine*, 1 (1898), 81–93.
Franck, Philipp, *Vom Taunus zum Wannsee: Erinnerungen*, Braunschweig and Hamburg, Georg Westermann, 1920.

Garstin, Norman, 'Studio talk: St Ives', *Studio*, 8:42 (1896), 242–4.
Gassies, J[ean]-G[eorges], *Le vieux Barbizon: souvenirs de jeunesse d'un paysagiste 1852–1875*, Paris, Librairie Hachette et Cie, 1907.
Gildemeister, Andreas, 'Worpswede', *Die Kunst für Alle*, 15:12 (1900), 267–80.
Goater, Anne C., 'A summer in an artistic haunt', *Outing*, 7:1 (1885), 2–12.
Gönner, R., 'Wörth und die Zügelschule', *Die Kunst für Alle*, 19:22 (1904), 523–7.
Good, Elizabeth Leypold, 'A Holland art village' [Rijsoord], *Catholic World*, 70:418 (1900), 514–26.
Grier, Louis, 'A painters' club' [St Ives], *Studio*, 5 (1895), 110–12.

Harrison, Birge L., 'In search of paradise with camera and palette', *Outing*, 21:4 (1893), 310–16.
Harrison, Birge L., 'Quaint artist haunts in Brittany. Pont Aven and Concarneau', *Outing*, 24:1 (1894), 25–32.
Harrison, Birge, 'With Stevenson at Grez', *Century Magazine*, 69 (1916), 306–14.
Hartrick, A[rchibald] S[tandish], *A Painter's Pilgrimage through Fifty Years*, Cambridge, Cambridge University Press, 1939.
Haushofer, Karl, 'Sommerfrischen Münchener Künstler. I. Frauenchiemsee', *Die Kunst für Alle*, 1:1 (1885), 7–10.
Herterich, Ludwig, 'Aus meinem Leben', *Kunst und Künstler*, 7:6 (1909), 239–49.

Hetsch, Rolf (ed.), *Paula Modersohn-Becker: Ein Buch der Freundschaft*, Berlin, Rembrandt Verlag, 1932.

Hevesi, Ludwig, 'Barbizon. Das Malernest bei Fontainebleau', in *Altkunst-Neukunst, Wien 1894–1908*, Vienna, Carl Konegen, [1907] 1909.

Hitchcock, George, 'The picturesque quality of Holland', *Scribner's Magazine*, 2 (1887), 160–8.

Hoeber, Arthur, 'A summer in Brittany', *Monthly Illustrator*, 4:12 (1895), 74–80.

Howard, Blanche Willis, *Guenn: A Wave on the Breton Coast*, London, Frederick Warne and Co., 1884.

Knight, Laura, *Oil Paint and Grease Paint*, London, Ivor Nicholson & Watson, 1936.

Konody, P. G., 'A Dutch Barbizon', *Pall Mall Magazine*, 18 (August 1899), 482–90.

Krausse, Alexis, 'An English art colony in France' [Étaples], *Black and White*, 14:347 (1897), 384–5.

Krummacher, Karl, 'Die Malerkolonie Worpswede', *Westermanns Illustrierte Deutsche Monatshefte*, 86 (1899), 17–28.

Krummacher, Karl, 'Worpsweder Bauernstudien', *Niederdeutsche Heimatblätter*, 1 (1924), 63–7.

Krummacher, Karl, 'Meine Bauernmodelle', *Niedersachsen*, 1 (1927), 258–65.

Larsson, Carl, *Carl Larsson: The Autobiography of Sweden's Most Popular Artist*, ed. John Z. Lofgren, tr. Ann B. Weissmann, Iowa City, Iowa, Penfield Press, [1931] 1992.

Low, Will H(icok), *A Chronicle Of Friendships, 1873–1900*, London, Hodder & Stoughton, 1908.

Mackensen, Fritz, 'Worpswede und seine ersten Maler', *Stader Archiv*, N.S. 30 [1938] (1940), 5–15.

Madsen, Karl, 'Skagen', *American–Scandinavian Review*, 19:6 (1931), pp. 346–57.

Malingue, Maurice (ed.), *Paul Gauguin: Letters to His Wife and Friends*, tr. Henry J. Stenning, London, Saturn Press, [1946] n.d.

Mattos, Katherine de, 'Apple-tree corner' [Sevray-sur-Vallais], *Magazine of Art* (1886), 508–13.

May, Phil, 'The children of Volendam', *Magazine of Art* (1900), 499–502.

Mendelsohn, Henriette, 'Die nördlichste Feste dänischer Kunst', *Die Kunst für Alle*, 11:21 (1896), 324–6.

Menpes, Dorothy, *Mortimer Menpes: Brittany*, London, Adam & Charles Black, [1899] 1905.

Merlhès, Victor (ed.), *Correspondance de Paul Gauguin: Documents, témoignages*, Paris, Fondation Singer-Polignac, 1984.

Meynell, Alice, 'Newlyn', *Art Journal*, April (1889), 97–102; May (1889), 137–42

Middleton, G. A. T., 'On the Shores of the Zuyder Zee', *Magazine of Art* (1893), 64–9.

Millet, Pierre, 'Millet's life at Barbizon: Described by his younger brother', *Century Magazine*, 46:117 (1897), 908–15.

Modersohn-Becker, Paula, *In Briefen und Tagebüchern*, eds Günter Busch and Liselotte von Reinken, Frankfurt am Main, S. Fischer Verlag, 1979; tr. as *Paula Modersohn-Becker: The Letters and Journals*, tr. Arthur S. Wensinger and Carol Clew Hoey, New York, Taplinger, 1983; selected excerpts in *The Letters and Journals of Paula Modersohn-*

Becker, tr. J. Diane Radycki, New York and London, Scarecrow Press and Metuchen, 1980.

Moes, Wally, *Heilig ongeduld: Herinneringen uit mijn leven*, Amsterdam and Antwerp, Wereldbibliotheek NV, 1961.

Müller-Kaempff, Paul, 'Erinnerungen an Ahrenshoop', *Mecklenburgische Monatshefte*, 2 (1926), 333–6.

Muther, Richard, 'Worpswede', in *Studien*, ed. and introd. Hans Rosenhagen, Berlin, Erich Weiss Verlag, [before 1909] 1925.

Overbeck, Fritz, 'Ein Brief aus Worpswede', *Die Kunst für Alle*, 11:2 (1895/96), 20–4.

Overbeck, Fritz Th. (jun.), *Eine Kindheit in Worpswede*, Bremen, Friedrich Röver, 1975.

Pecht, Friedrich, 'Karl Raupp', *Die Kunst für Alle*, 2:12 (1887), 181–4.

Pecht, Friedrich, 'Zu Ludwig Knaus' 60. Geburtstage', *Die Kunst für Alle*, 5:5 (1889), 65–72.

Penfield, Edward, 'The magenta village', *Scribner's Magazine*, 40 (1906), 25–33.

Picker, Friedrich, 'Das Worpsweder Teufelsmoor und seine Maler', *Die Gartenlaube*, Leipzig, 27 (1904), 472–6.

Pigeory, Félix, 'Barbison: Notes et Souvenirs', *La Revue des Beaux-Arts*, 5 (1854), 229–35.

Quigley, Jane, [as 'J.Q.'], 'Studio-Talk: Concarneau', *Studio*, 33 (1905), 174–8.

Quigley, Jane, 'Volendam as a sketching ground for painters', *Studio*, 38:160 (1906), 118–25.

Ranger, Henry Ward, 'Artist life by the North Sea', *Century Magazine*, 45, 99:5 (1893), 753–9.

Raupp, K[arl], 'Willingshausen: Ein Studienplatz deutscher Künstler', *Die Kunst für Alle*, 2:1 (1886), 11–14.

Raupp, K[arl], 'Auf Frauenchiemsee', *Die Kunst für Alle*, 4:1 (1888), 9–12.

Richards, Frank, 'Newlyn as a sketching ground', *Studio*, 5 (1895), 174–81.

Rilke, Rainer Maria, *Worpswede: Fritz Mackensen, Otto Modersohn, Fritz Overbeck, Hans am Ende, Heinrich Vogeler*, vol. 5 of *Sämtliche Werke*, eds Rilke Archiv in association with Ruth Sieber-Rilke, Frankurt am Main, Insel, [1903] 1965; tr. in Rilke, *Rodin and Other Prose Pieces*, tr. G. Craig Houston, London, Melbourne and New York, Quartet, 1986.

Rittmann, Annegret (ed.), *Briefe. Ida Gerhardi (1862–1927): Eine westfälische Malerin zwischen Paris und Berlin*, Münster, Ardey, 1993.

Roeßler, Arthur, *Neu-Dachau: Ludwig Dill, Adolf Hölzel, Arthur Langhammer*, Bielefeld and Leipzig, Velhagen & Klasing, 1905.

Rönnberg, Hanna, *Konstnärslivet i slutet av 1880-talet*, vol. 1, Helsinki, Söderström, 1931.

Rosenhagen, Hans, 'Die Worpsweder', *Die Woche*, Berlin, 4:7 (1902), 295–300.

R.P., 'Concarneau', *Studio*, 33 (1904–5), 174–9

Satterlee, Walter, 'A French sketching ground' [Étretat], *Art Amateur*, 19:4 (1888), 80.

Schwartz, Alba, *Skagen: Den svundne tid i sagn og billeder*, Copenhagen, Carit Andersen Forlag, [1912], n.d.

Shinn, Earl [as 'L'Enfant Perdu'], 'Rash steps' [series of letters written for the *Philadelphia Evening Bulletin*, 28 September–15 December 1866], repr. in Delouche, *Pont-Aven*, pp. 225–52.

Simmons, Edward, *From Seven to Seventy: Memories of a Painter and a Yankee*, New York and London, Harper & Brothers, 1922.

Stevenson, R[obert] A. M[owbray], 'Grez', *Magazine of Art* (1893), 27–32.

Stevenson, Robert Louis [as 'R.L.S.'], 'Forest notes', *Cornhill Magazine*, 33:197 (1876), 545–61.

Stevenson, Robert Louis, 'Fontainebleau: Village communities of painters', *Magazine of Art*, 7 (1884), 265–72 [Part I], 340–5 [Part IV].

Stevenson, Robert Louis and Lloyd Osbourne, *The Wrecker*, London, New York, Toronto and Melbourne, Cassell and Company, [1892] 1913, esp. pp. 48–51, 283–9, and 'Epilogue: To Will H. Low', pp. 367–72.

Strindberg, August, *Strindberg's Letters*, ed. and tr. Michael Robinson, vol. I: 1862–92, London, Athlone, 1992.

Symons, W. Christian, 'Newlyn and the Newlyn School', *Magazine of Art* (1890) 199–205.

Talmeyr, Maurice, 'The forest of Fontainebleau: Winter', *Magazine of Art* (1888), 37–42.

Talmeyr, Maurice, 'The forest of Fontainebleau: Summer', *Magazine of Art* (1888), 273–6.

Thaddeus, H. Jones, *Recollections of a Court Painter*, London and New York, John Lane, The Bodley Head and John Lane Company, 1912.

Theuriet, André, 'Douarnenez: Paysages et impressions', *Revue des Deux Mondes*, 43, 51:3 (1881), 334–80.

Thielmann, Wilhelm, 'Ein Brief aus der "Schwalm"', *Die Kunst für Alle*, 15:11 (1900), 251–3.

Trevor, Helen Mabel, *The Ramblings of an Artist: Selections from the Letters of H.M. Trevor to E.H.*, London, Gay and Bird, 1901.

Tussenbroek, Otto van, 'Volendam als "Sketching Ground"', *Elsevier's Maandschrift*, 51 (1916), 275–90.

Tuxen, Laurits, *En Malers Arbejde gennem tredsinstyve Aar fortalt af ham selv*, Copenhagen and Oslo, Jespersen og Pios Forlag, 1928.

Vogeler, Heinrich, *Erinnerungen*, ed. Erich Weinert, Berlin, Rütten & Loening, 1952.

Warncke, Paul, *Worpswede*, Leipzig and Berlin, Meyer & Wunder im Heimatverlage, 1902.

Wheelwright, Edward, 'Personal recollections of Jean François Millet', *Atlantic Monthly*, 38:227 (1876), 257–76.

Wright, Margaret Bertha, 'Bohemian days [Grèz]', *Scribner's Monthly*, 16:1 (1878), 121–30.

Wright, Margaret Bertha, 'An artist's country' [Honfleur], *Art Amateur*, 17:4 (1887), 78.

Young, Dorothy Weir, *The Life and Letters of J. Alden Weir*, ed. Lawrence W. Chisolm, New Haven, Yale University Press, 1960.

Secondary sources: books, articles, exhibition catalogues, guidebooks, and critical reviews, 1850–2001

Edited exhibition catalogues are ordered by catalogue title.

Adams, Steven, *The Barbizon School and the Origins of Impressionism*, London, Phaidon, 1994.

Agulhon, Maurice, *Le Cercle dans la France bourgeoise 1810–1848: Étude d'une mutation de sociabilité*, Paris, Librairie Armand Colin, 1977.

Allmers, Hermann, *Marschenbuch* (3rd edn 1891) in *Werke*, ed. Kurd Schulz, Göttingen, Sachse & Pohl, 1965, pp. 7–264.

'all together now': Zeitgenössische Kunst aus europäischen Künstlerkolonien zu Gast in Ahrenshoop 1995 – Ahrenshoop, Barbizon, Christchurch, Kronberg, Tervuren, Worpswede, ed. Förderkreis Ahrenshoop e.V. and EURO-ART, Ahrenshoop and Fischerhude, Verlag Atelier im Bauernhaus, 1995.

Althusser, Louis, 'Ideology and ideological state apparatuses', in *Lenin and Philosophy and Other Essays*, tr. Ben Brewster, London, New Left Books [1970] 1971, pp. 160–5.

Andrian-Werburg, Bettina von, 'Schwälmer Arbeitswelt in der Sicht Willingshäuser Künstler des 19. und frühen 20. Jahrhunderts: Ideologiekritische Studien zur volkskundlichen Bildquellenforschung', Ph.D. dissertation, Philipps-Universität, Marburg, 1990.

Appelberg, E. and H. Appelberg, *Helene Schjerfbeck: En biografisk konturteckning*, Stockholm, Hugo Gebers Förlag, 1949.

Bachelard, Gaston, *The Poetics of Space*, foreword John R. Stilgoe, tr. Maria Jolas, Boston, Beacon Press, [1958] 1994.

Baedeker, Karl, *Northern France from Belgium and the English Channel to the Loire Excluding Paris and Its Environs: Handbook for Travellers*, Leipzig and London, Karl Baedeker, Publisher and Dulau and Co., 1889.

Baedeker, K[arl], *Belgium and Holland: Handbook for Travellers*, Leipzig and London, Karl Baedeker Publishers and Dulau, 10th edn, 1891.

Bantzer, Andreas, 'Entwicklung der Schwälmer Tracht', *Schwälmer Jahrbuch* (1985), 182–95.

Barbizon au temps de J.-F. Millet (1849–1875), ed. Municipalité de Barbizon, foreword Jean Bouret, catalogue text Guy Isnard, Barbizon, Salle des Fêtes de Barbizon, 1975.

The Barbizon School, eds John Sillevis and Hans Kraan, tr. J. R. Mengarduque, The Hague, Haags Gemeentemuseum, [1985] 1985.

Baring-Gould, S[abine], *Brittany*, illus. J. Wylie, London, Methuen & Co., 1902.

Barthes, Roland, *Mythologies*, selected and tr. Annette Lavers, London, Vintage [1957], 1993.

Barthes, Roland, 'The Reality Effect', in *Realism*, ed. Lilian R. Furst, tr. R. Carter, Harlow, Essex, Longman, [1968] 1992.

Bätschmann, Oskar, *Entfernung der Natur: Landschaftsmalerei 1750–1920*, Cologne, DuMont, 1989.

Bausinger, Hermann, Klaus Beyrer, and Gottfried Korff (eds), *Reisekultur: Von der Pilgerfahrt zum modernen Tourismus*, Munich, C. H. Beck, 1991.

Becker-Vohl, Petra, 'Figur und Landschaft in der "Worpsweder Malerschule"', Ph.D. dissertation, Aachen, Rheinisch-Westfälische Technische Hochschule, 1985.

Bednar, George, *'Every Corner was a Picture': 50 Artists of the Newlyn Art Colony 1880–1900. A Checklist*, Penzance, Patten Press for West Cornwall Art Archive, 1999.

Bendiner, Kenneth, *An Introduction to Victorian Painting*, New Haven and London, Yale University Press, 1985.

Benington, Jonathan, *Roderic O'Conor: A Biography, with a Catalogue of His Work*, Blackrock, Co. Dublin, Irish Academic Press, 1992.

Bergmann, Klaus, *Agrarromantik und Großstadtfeindschaft*, Meisenheim am Glan, Verlag Anton Hain, 1970.

Bertho, Catherine, 'L'Invention de la Bretagne: Genése sociale d'un stereotype', *Actes de la Recherche en Sciences Sociales*, 35 (1980), 45–62.

Bishop, Peter, *An Archetypal Constable: National Identity and the Geography of Nostalgia*, London, Athlone, 1994.

Blackbourn, David, 'Peasants and politics in Germany, 1871–1914', *European History Quarterly*, 14 (1984), 47–75.

Bohn, Barbara, Vera Bombor and Wolf Karge, *Ahrenshoop: Eine Künstlerkolonie an der Ostsee*, Fischerhude, Galerie-Verlag, 1990.

Bollnow, Otto Friedrich, *Mensch und Raum*, Stuttgart, Berlin, Cologne and Mainz, W. Kohlhammer, [1963] 1980.

Böth, Gitta, *Kleidungsverhalten in hessischen Trachtendörfern: Der Wechsel von der Frauentracht zur städtischen Kleidung 1969–1976 am Beispiel Mardorf. Zum Rückgang der Trachten in Hessen*, Frankfurt am Main, Berne, and Cirencester, Peter D. Lang, 1980.

Boulboullé, Guido and Michael Zeiss, *Worpswede: Kulturgeschichte eines Künstlerdorfes*, Cologne, DuMont, 1989.

Bouret, Jean, *The Barbizon School and 19th Century French Landscape Painting*, tr. Jane Brenton, London, Thames and Hudson, [1972] 1973.

Boyens, Piet, *Flemish Art: Symbolism to Expressionism at Sint-Martens-Latem*, Sint-Martens-Latem, Iannoo/art book company, 1992.

Brakel, J. P., *Vissen voor de kerk: Katwijk vroeger en nu*, Katwijk, Genootschap 'Oud Katwijk', 1969.

Brettell, Richard, Françoise Cachin, Claire Frèches-Thory, Charles F. Stuckey, with assistance from Peter Zegers, *The Art of Paul Gauguin*, Washington and Chicago with New York and Boston, National Gallery of Art, Washington and Art Institute of Chicago in association with New York Graphic Society Books and Little, Brown and Company, 1988.

Brettell, Richard R., *Pissarro and Pontoise: The Painter in a Landscape*, New Haven and London, Yale University Press, 1990.

Broude, Norma (ed.), *World Impressiomism: The International Movement, 1860–1920*, New York, Harry Abrams, 1990.

Burmester, Andreas, Christoph Heilmann and Michael F. Zimmermann (eds), *Barbizon: Malerei der Natur – Natur der Malerei*, Munich: Klinkhardt & Biermann, 1999.

Buzard, James, *The Beaten Track: European Tourism, Literature, and the Ways to Culture, 1800–1918*, Oxford, Clarendon Press, 1993.

Caesar, Claudia C., 'Auf der Suche nach Heimat: Umbrüche im künstlerischen Selbstverständnis als Motivation für die Gründung von Künstlerkolonien', paper given at the symposium '"Im Zeichen der Ebene und des Himmels": Künstlerkolonien in Europa', Germanisches Nationalmuseum, Nuremberg, 6–8 November 1997.

Caille, Marie-Thérèse, *Ganne Inn: Municipal Museum of the Barbizon School*, Moisenay, Editions Gaud, 1994.

Campbell, Julian, *The Irish Impressionists: Irish Artists in France and Belgium, 1850–1914*, Dublin, National Gallery of Ireland, 1984.

Cariou, André, 'Le peintre Charles Cottet et la Bretagne', *Annales de Bretagne*, 81:3–4 (1973), 649–61.

Carit Andersen, Poul, *Skagen i fortid og nutid*, Copenhagen, Carit Andersens Forlag, 1980.

Castelnuovo, Enrico and Carlo Ginzburg, 'Centro e perifera', in Giovanni Previtali and Federico Zeri (eds), *Storia dell' arte italiana*, vol. 1, Turin, Giulio Einaudi, pp. 285–352; tr. as 'Centre and periphery', in *History of Italian Art*, vol. 1, preface Peter Burke, tr. Ellen Bianchini and Claire Dorey, Cambridge, Polity Press, 1994.

Clark, T. J., *The Painting of Modern Life: Paris in the Art of Manet and His Followers*, London, Thames and Hudson, [1984] rev. edn 1999.

Confino, Alon, *The Nation as a Local Metaphor: Württemberg, Imperial Germany, and National Memory, 1871–1918*, Chapel Hill and London, University of North Carolina Press, 1997.

Conisbee, Philip, 'Pre-Romantic *plein-air* painting', *Art History*, 2:4 (1979), 413–28, plates 23–33.

Corinth, Lovis, 'Un étudiant allemand à Paris à l'Académie Julian (1884–1887)', tr. Béatrice Pagès, *Gazette des Beaux-Arts*, 6th series, 97:123 (1981), 219–25.

Corot, Courbet und die Maler von Barbizon: 'Les amis de la nature', eds Christoph Heilmann, Michael Clarke and John Sillevis, Munich, Klinkhardt & Biermann, 1996.

Cosgrove, Daniel and Stephen Daniels (eds), *The Iconography of Landscape: Essays on the Symbolic Representation, Design and Use of Past Environments*, Cambridge, New York and Oakleigh, Melbourne, Victoria, Cambridge University Press, 1988.

Cosgrove, Denis, *Social Formation and Symbolic Landscape*, London and Sydney, Croom Helm, 1984.

Crary, Jonathan, *Techniques of the Observer: On Vision and Modernity in the Nineteenth Century*, Cambridge, Mass., MIT Press, 1990.

Crawshaw, Carol and John Urry, 'Tourism and the Photographic Eye', in Chris Rojek and John Urry (eds), *Touring Cultures: Transformations of Travel and Theory*, London and New York, Routledge, 1997.

Creston, René Yves, *Le Costume breton*, Paris, Tchou, 1974.

Dansk biografisk leksikon, ed. S. Cedergreen Bech, 3rd edn, Copenhagen, Gyldendal, [1887] 1979.

Das Licht des Nordens: Skandinavische und norddeutsche Malerei zwischen 1870 und 1920, Hamburg, Altonaer Museum in Hamburg, Norddeutsches Landesmuseum, 1993.

Dede, Klaus and Wolf-Dietmar Stock, *Kleiner Worpswede-Führer*, Fischerhude, Atelier im Bauernhaus, 1980.

De eerste groep van Sint-Martens-Latem 1899–1914, ed. Koninklijke Academie voor Wetenschappen, Letteren en Schone Kunsten van België, Brussels, Koninklijke Musea voor Schone Kunsten van België, 1988.

Delouche, Denise, *Les Peintres de la Bretagne avant Gauguin*, 3 vols, Lille, Service de repro-duction des thèses, [1975] 1978.

Delouche, Denise, 'Pont-Aven avant Gauguin', *Bulletin des Amis du Musée de Rennes* (1978), 30–41.

Delouche, Denise, *Les Peintres et le paysan breton*, Baillé, Editions URSA, 1988.

Delouche, Denise (ed.), *Pont-Aven et ses peintres à propos d'un centenaire*, Rennes, Presses universitaires Rennes 2, 1986.

Delouche, Denise (ed.), *Artistes étrangers à Pont-Aven, Concarneau et autres lieux de Bretagne*, Rennes, Presses universitaires Rennes 2, 1989.

Deutsche Künstlerkolonien 1890–1910: Worpswede, Dachau, Willingshausen, Grötzingen, Die 'Brücke', Murnau, eds Erika Rödiger-Diruf and Brigitte Baumstark, Karlsruhe, Städtische Galerie, 1998.

Die Künstlerkolonie Willingshausen, ed. Konrad Kaiser, Kassel, Orangerie, 1980.

Doppagne, Brigitte, *Ottilie Reylaender: Stationen einer Malerin*, ed. Worpsweder Kunsthalle Friedrich Netzel, Lilienthal, Worpsweder Verlag, 1994.

Dreams of a Summer Night: Scandinavian Painting at the Turn of the Century, ed. Nordic Council of Ministers and Arts Council of Great Britain, London, Hayward Gallery, 1986.

Dreiss, Joseph G., *Gari Melchers: His Works in the Belmont Collection*, ed. Richard S. Reid, Charlottesville, University Press of Virginia, 1984.

Duncan, Carol, 'Virility and domination in early twentieth-century vanguard painting', in *The Aesthetics of Power: Essays in Critical Art History*, Cambridge, Cambridge University Press, [1973] 1993.

Edler, Doris, *Vergessene Bilder: Die deutsche Genremalerei in den letzten Jahrzehnten des 19. Jahrhunderts und ihre Rezeption durch Kunstkritik und Publikum*, Münster and Hamburg, Lit Verlag, 1992.

Einecke, Claudia, 'Das *sous-bois*: Motiv und Strategie der Natürlichkeit', in Daniela Christmann, Gabriele Fiesewetter, Otto Martin and Andreas Weber (eds), *RückSicht: Festschrift für Hans-Jürgen Imiela zum 5. Februar 1997*, Mainz, Hermann Schmidt, 1997.

Einecke, Claudia, 'Beyond seeing: The somatic experience of landscape in the "School of 1830"', in Burmester *et al.*, *Barbizon*.

Eisenman, Stephen F. with Thomas Crow, Brian Lukacher, Linda Nochlin and Frances K. Pohl, *Nineteenth Century Art: A Critical History*, London, Thames and Hudson, 1994.

Feistel-Rohmeder-HD, B., 'Ludwig Dill', *Deutsche Kunst und Dekoration*, 15 (1904–05), 237–44.

Felski, Rita *The Gender of Modernity*, Cambridge, Mass. and London, Harvard University Press, 1995.

Fox, Caroline, *Stanhope Forbes and the Newlyn Art School*, Newton Abbot, Devon, David & Charles, 1993.

Fox, Caroline and Francis Greenacre, *Artists of the Newlyn School (1880–1900)*, Newlyn, Newlyn Orion Galleries, 1979.

Fox, Caroline and Francis Greenacre, *Painting in Newlyn 1880–1930*, London, Barbican Art Gallery, 1985.

Frank Bramley R.A., 1857–1915, ed. Lincolnshire County Council, Lincoln, Usher Gallery and Lincolnshire County Council Education and Cultural Services Directorate, 1999.

Friedländer, Max J., *Essays über die Landschaftsmalerei und andere Bildgattungen*, The Hague and Oxford, A.A.M. Stols and Bruno Cassirer, 1947; tr. as *Landscape, Portrait, Still-Life: Their Origin and Development*, tr. R. F. C. Hudl, Oxford, B. Cassirer, 1949.

Galassi, Peter, *Corot in Italy: Open-Air Painting and the Classical Landscape Tradition*, New Haven and London, Yale University Press, 1991.

Gari Melchers: A Retrospective Exhibition, eds Diane Lesko and Esther Persson, St Petersburg, Florida, Museum of Fine Arts, 1990.

Gauguin, Pola, *Christian Krohg*, Oslo, Gyldendal, 1932.

Gerdts, William H., *Lasting Impressions: American Painters in France, 1865–1915*, Giverny and Evanston, Ill., Musée Americain Giverny and Terra Foundation for the Arts, 1992.

Goffman, Erving, *The Presentation of Self in Everyday Life*, Harmondsworth, Middlesex, Penguin, [1959] 1990.

Gombrich, Ernst H., *Art and Illusion: A Study in the Psychology of Pictorial Representation*, London, Thames and Hudson, [1959] 1977.

Göttler, Norbert, *Die Sozialgeschichte des Bezirkes Dachau 1870–1920: Ein Beispiel struktureller Wandlungsprozesse des ländlichen Raumes*, Munich, Stadtarchiv, 1988.

Green, Nicholas, *Théodore Rousseau, 1812–1867: Loan Exhibition of Paintings, Drawings and Prints from English and Scottish Collections*, Norwich and London, University of East Anglia, Sainsbury Centre for Visual Arts and Hazlitt, Gooden & Fox, 1982.

Green, Nicholas, *The Spectacle of Nature: Landscape and Bourgeois Culture in Nineteenth-Century France*, Manchester and New York, Manchester University Press, 1990.

Greenblatt, Stephen, *Marvelous Possessions: The Wonder of the New World*, Oxford, Clarendon Press, 1991.

Gruenter, Rainer, 'Landschaft: Bemerkungen zur Wort- und Bedeutungsgeschichte', in Ritter (ed.), *Landschaft und Raum in der Erzählkunst*.

Hadjinicolaou, Nikos, 'Kunstzentren und periphere Kunst', *Kritische Berichte*, 4 (1983), 36–56.

Haesaerts, Paul, *Laethem-Saint-Martin: Le village élu de l'art flamand*, Brussels, Editions 'Arcade', 1965.

The Hague School: Dutch Masters of the 19th Century, eds Ronald de Leeuw, John Sillevis and Charles Dumas, London, Royal Academy of Arts in association with Weidenfeld and Nicolson, 1983.

Hamm, Ulrike, 'Studien zur Künstlerkolonie Worpswede 1889–1908 unter besonderer Berücksichtigung von Fritz Mackensen', Ph.D. dissertation, Ludwig-Maximilians-Universität, Munich, 1978.

Hamm, Ulrike and Bernd Küster, *Fritz Mackensen 1866–1953*, Lilienthal, Worpsweder Verlag, 1990.

Hard, Gerhard, *Die 'Landschaft' der Sprache und die 'Landschaft' der Geographen: Semantische und forschungslogische Studien zu einigen zentralen Denkfiguren in der deutschen geographischen Literatur*, ed. Geographisches Institut der Universität Bonn, Bonn, Ferdinand Dümmler Verlag, 1970.

Havard, Henry, *La Hollande pittoresque: Voyage aux villes mortes du Zuiderzée*, Paris, E. Plon et Cie and D. A. Thieme, [1874] 1875.

Havinden, M. A., J. Quéniart and J. Stanyer (eds), *Centre et périphérie: Bretagne, Cornouailles/Devon – étude comparée/Centre and Periphery: Brittany and Cornwall & Devon Compared*, Exeter, University of Exeter Press, 1991.

Henriet, Frédéric, *Le Paysagiste aux champs*, Paris, A. Lévy, [1867] rev. edn 1876.

Herbert, James D., 'Reconsiderations of Matisse and Derain in the classical landscape', in Thomson (ed.), *Framing France*.

Herbert, Robert L., 'City vs. country: The rural image in French painting from Millet to Gauguin', *Artforum*, 8 (February 1970), 44–55.

Herbert, Robert L., *Impressionism: Art, Leisure, and Parisian Society*, New Haven and London, Yale University Press, 1988.

Herbert, Robert L., *Monet on the Normandy Coast: Tourism and Painting, 1867–1886*, New Haven and London, Yale University Press, 1994.

Herbert, Robert Louis, *Barbizon Revisited*, San Francisco, Palace of the Legion of Honor, 1962.

Heres, Horst, *Dachauer Gemäldegalerie*, Dachau, Museumsverein Dachau, 1985.

Het Latemse landschap voor 1918 gezien door Latemse schilders, ed. Latemse Kunstkring, Sint-Martens-Latem, Gemeentehuis, 1972.

Heyting, Lien, 'De geschiedenis van het Larense Hamdorff', *Nieuwe Rotterdamsche Courant Handelsblad* (23 February 1979), cultural supplement, 1–2.

Heyting, Lien, *De wereld in een dorp: Schilders, schrijvers en wereldverbeteraars in Laren en Blaricum 1880–1920*, Amsterdam, Meulenhoff, 1994.

Hornung, Peter Michael, *P. S. Krøyer*, Copenhagen, Stokholm, 1987 (incl. English text).

House, John, *Monet: Nature Into Art*, New Haven and London, Yale University Press, 1986.

Howard, Peter, *Landscapes: The Artist's Vision*, London and New York, Routledge, 1991.

Jacobs, Michael, *The Good and Simple Life: Artist Colonies in Europe and America*, Oxford, Phaidon, 1985.

Jacobs, Michael, 'Die Künstlerkolonie Worpswede in internationalem Zusammenhang', in *Worpswede 1889–1989*.

Jaworska, Wladyslawa, *Gauguin and the Pont-Aven School*, tr. Patrick Evans, London, Thames and Hudson, [1971] 1972.

Jefferies, Richard, 'New facts in landscape', *Magazine of Art*, 5 (1882), 470–1.

Joanne, Adolphe, *Géographie du Finistère*, Paris, Hachette et Cie, 1895.

Jürß, Lisa, *Schwaan: Eine mecklenburgische Künstlerkolonie*, Fischerhude, Verlag Atelier im Bauernhaus, [1992] rev. edn 1995.

Katwijk in de schilderkunst, ed. W. van der Plas, Katwijk, Katwijks Museum and Genootschap 'Oud Katwijk', 1995.

Keith, Michael and Steve Pile (eds), *Place and the Politics of Identity*, London and New York, Routledge, 1993.

Kirsch, Hans-Christian, *Worpswede: Die Geschichte einer deutschen Künstlerkolonie*, Munich, Bertelsmann, 1987.

Knupp-Uhlenhaut, Christine, *Ekensund und die Flensburger Förde*, Hamburg-Altona, Altonaer Museum, Norddeutsches Landesmuseum, 1979.

Koekkoek, Gerard, *Larense dorpspraat: Dorpsvertellingen*, Zaltbommel, Europese Bibliotheek, 1983.

Koenraads, Jan P., *Laren en zijn schilders: Kunstenaars rond Hamdorff*, Laren, Boekhandel Judi Kluvers, 1985.

Koeppen, Alfred, *Die moderne Malerei in Deutschland*, Bielefeld and Leipzig, Velhagen & Klasing, 1902.

Koerner, Joseph Leo, *Caspar David Friedrich and the Subject of Landscape*, London, Reaktion, 1990.

Kracauer, Siegfried, 'The little shopgirls go to the movies', in *The Mass Ornament: Weimar Essays*, tr. and ed. Thomas Y. Levin, Cambridge, Mass. and London, Harvard University Press, [1927] 1995.

Kraan, Hans, *Als Holland Mode war: Deutsche Künstler und Holland im 19. Jahrhundert*, Series 'Nachbarn', vol. 31, Bonn, Kgl. Niederländische Botschaft, 1985.

Kraan, J. H. and J. P. van Brakel, *G. Morgenstjerne Munthe in Katwijk*, Katwijk, Katwijks Museum and Genootschap 'Oud Katwijk', 1989.

Krauss, Rosalind E., 'Grids', in *The Originality of the Avant-Garde and Other Modernist Myths*, Cambridge, Mass. and London, MIT Press, [1978] 1985.

Kris, Ernst and Otto Kurz, *Die Legende vom Künstler: Ein geschichtlicher Versuch*, Frankfurt am Main, Suhrkamp, [1934] rev. edn 1980; tr. as *Legend, Myth and Magic in the Image of the Artist: A Historical Experiment*, tr. Alastair Lang, New Haven and London, Yale University Press, 1979.

Künstlerkolonie Skagen, ed. Gerhard Kaufmann, Hamburg, Altonaer Museum, Norddeutsches Landesmuseum, 1989.

Küster, Bernd, 'Pan stirbt im Moor: Worpswede als Malerkolonie des deutschen Naturalismus', in *Worpswede 1889–1989*.

Küster, Bernd, *Carl Bantzer*, Marburg, Hitzeroth, 1993.

Landscapes of France: Impressionism and its Rivals, eds John House and Joanna Skipwith, London, Hayward Gallery, 1995.

Landschaft im Licht: Impressionistische Malerei in Europa und Nordamerika, ed. Götz Czymmek, Cologne, Wallraf-Richartz-Museum, 1990.

Langley, Roger, *Walter Langley: Pioneer of the Newlyn Art Colony*, ed. Elizabeth Knowles, Clifton, Bristol and Penzance, Samson & Company, in association with Penlee House Gallery & Museum, 1997.

Lannoy, Kathinka and Bob Denneboom (eds), *Derper, hoever, binder: Over geschiedenis & volksleven van de drie Egmonden*, The Hague, Kruseman's, 1969.

La Route des peintres en Cornouaille – 1850–1950, eds Groupement touristique de Cornouaille, J.-P. Brumeaux, M. Garry and X. Mével, Faou, [Groupement touristique de Cornouaille], 1993.

Latems kunstleven rond 1900, ed. Latemse Kunstkring, Sint-Martens-Latem, Gemeente Sint-Martens-Latem, 1960.

Laughton, Bruce, *The Drawings Of Daumier And Millet*, New Haven and London, Yale University Press, 1991.

Lehmann, Herbert, 'Die Physiognomie der Landschaft', *Studium Generale*, 3:4/5 (1950), 182–95.

Lenman, Robin, 'Painters, patronage and the art market in Germany 1850–1914', *Past & Present*, 128 (1989), 109–40.

Lenman, Robin, 'Art and tourism in southern Germany, 1850–1930', in Arthur Marwick (ed.), *The Arts, Literature and Society*, London and New York, Routledge, 1990.

Le Paul, Judy, *Gauguin and the Impressionists at Pont-Aven*, with the collaboration of Charles-Guy Le Paul, New York, Abbeville Press, [1983] 1987.

Licht und Landschaft: Bilder aus zwei europäischen Künstlerkolonien. Künstlerkolonie Ahrenshoop – Kunstenaarsdorp Tervuren/ Licht en landschap: Schilderijen van twee Europese Kunstenaarskolonies, Brussels, Musée Charlier, 1997.

Loosjes-Terpstra, Aleid, 'Mondriaan in een donkere spiegel', *Jong Holland*, 5:5 (1989), 4–15.

Lord, Peter, *The Betws-y-Coed Artists' Colony 1844–1914: Clarence Whaite and the Welsh Art World*, Aberystwyth, National Library of Wales, 1998.

Lowenthal, David, 'Nostalgia tells it like it wasn't', in Shaw and Chase, *The Imagined Past*.

Lowenthal, David, 'European and English landscapes as national symbols', in David Hooson (ed.), *Geography and National Identity*, Oxford and Cambridge, Mass., Blackwell, 1994.

Lübbren, Nina, 'Ottilie Reylaender: Eine Malerin in Worpswede um die Jahrhundertwende', Magister thesis, Kunsthistorisches Institut, Freie Universität Berlin, 1990.

Lübbren, Nina, 'Rural artists' colonies in nineteenth-century Europe', Ph.D. dissertation, University of Leeds, 1996.

Lübbren, Nina, 'Touristenlandschaften: Die Moderne auf dem Lande', *Anzeiger des Germanischen Nationalmuseums*, Nuremberg (1999), 63–9.

Lübbren, Nina, '"Toilers of the sea": Fisherfolk and the geographies of tourism in England, 1880–1900', in David Peters Corbett, Ysanne Holt and Fiona Russell (eds), *The Geography of Englishness: Landscape and the National Past in English Art 1880–1940*, New Haven and London, Yale University Press, 2001 (forthcoming).

Lübbren, Nina and David Crouch (eds), *Visual Culture and Tourism*, Oxford, Berg, 2001 (forthcoming).

MacCannell, Dean, 'Staged authenticity: Arrangements of social space in tourist settings', *American Journal of Sociology*, 79:3 (1973), 589–603.

MacCannell, Dean, *Empty Meeting Grounds: The Tourist Papers*, London and New York, Routledge, 1992.

MacCannell, Dean, *The Tourist: A New Theory of the Leisure Class*, Berkeley, Los Angeles and London, University of California Press, [1976] 1999 (new foreword by Lucy Lippard, new epilogue by the author).

Macnaghten, Phil and John Urry, *Contested Natures*, London, Thousand Oaks, Calif. and New Delhi, Sage, 1998.

Mcwilliam, Neil, 'Limited revisions: Academic art history confronts academic art', *Oxford Art Journal*, 12:2 (1989), 71–86.

McWilliam, Neil, 'Mythologising Millet', in Burmester *et al.*, *Barbizon*.

Madsen, Karl, 'Skagen', *American–Scandinavian Review*, 19:6 (1931), 346–57.

Märker, Peter, Monika Wagner, Gerd Brinkhus, and Heide-Marie Garthe-Hochschild, *Mit dem Auge des Touristen: Zur Geschichte des Reisebildes*, Tübingen, Kunsthistorisches Institut der Universität Tübingen and Kunsthalle Tübingen, 1981.

Meixner, Laura L., *An International Episode: Millet, Monet and their North American Counterparts*, Memphis, Tenn., The Dixon Gallery and Gardens, 1982.

Mitchell, W. J. T. (ed.), *Landscape and Power*, Chicago and London, University of Chicago Press, 1994.

Musgrave, Reverend George, *A Ramble into Brittany*, 2 vols, London, Hurst and Blackett, 1870.

Nagybánya művészete: Kiállítás a nagybányai művésztelep alapításának 100. evfordulója alkalmából/Die Kunst von Nagybánya: Ausstellung zur Hundertjahrfeier der Gründung der Künstlerkolonie von Nagybánya/The Art of Nagybánya: Centennial Exhibition in Commemoration of the Artists' Colony in Nagybánya, ed. Ildikó Nagy, cat. eds Géza Csorba and György Szücs, Budapest, Hungarian National Gallery, 1996.

Neidhardt, Friedhelm, 'Das innere System sozialer Gruppen', *Kölner Zeitschrift für Soziologie und Sozialpsychologie*, 31:4 (1979), 639–60.

Nipperdey, Thomas, 'Verein als soziale Struktur in Deutschland im späten 18. und frühen 19. Jahrhundert: Eine Fallstudie zur Modernisierung I', in *Gesellschaft, Kultur, Theorie: Gesammelte Aufsätze zur neueren Geschichte*, Göttingen, Vandenhoeck & Ruprecht, [1972] 1976.

Nochlin, Linda, *Women, Art, and Power and Other Essays*, London, Thames and Hudson, 1989.

Orton, Fred and Griselda Pollock, 'Les Données bretonnantes: la prairie de representation', *Art History*, 3:3 (1980), 314–44.

Ostiny, Fritz von, 'Die Münchener Jahresausstellung im Glaspalast, III', *Münchener Neueste Zeitung* (11 August 1895), repr. in *Otto Modersohn: Monographie*, p. 133.

Otto Modersohn 1865–1943: Monographie einer Landschaft, eds Christian Modersohn, Antje Noeres-Modersohn and Rainer Noeres, Hannover, Kunstverein Hannover, 1978.

Otto Modersohn: Das Frühwerk 1884–1889, eds Petra Altmann and Rainer Noeres, Fischerhude, Otto-Modersohn-Museum and Munich, Bruckmann, 1989.

Palliser, Mrs Bury, *Brittany & Its Byways: Some Account of Its Inhabitants and Its Antiquities, During a Residence in that Country*, London, John Murray, 1869.

Parker, Rozsika and Griselda Pollock, *Old Mistresses: Women, Art and Ideology*, London, Pandora, 1981.

Parsons, Christopher and Neil McWilliam, '"Le paysan de Paris": Alfred Sensier and the myth of rural France', *Oxford Art Journal*, 6:2 (1983), 38–58.

Paula Modersohn-Becker zum hundertsten Geburtstag, Bremen, Kunsthalle Bremen and Die Böttcherstraße, 1976.

Perry, Gill, 'Primitivism and the "modern"', in Charles Harrison, Francis Frascina and Gill Perry, *Primitivism, Cubism, Abstraction: The Early Twentieth Century*, New Haven and London, Yale University Press in association with the Open University, 1993.

Perry, Gillian, *Paula Modersohn-Becker: Her Life and Work*, London, The Women's Press, 1979.

Pese, Claus, '"Im Zeichen der Ebene und des Himmels": Künstlerkolonien in Europa. Ein Forschungs- und Ausstellungsprojekt des Germanischen Nationalmuseums', *Anzeiger des Germanischen Nationalmuseums* (1999), 50–7.

Pevsner, Nikolaus, 'Gemeinschaftsideale unter den bildenden Künstlern des 19. Jahrhunderts', *Deutsche Vierteljahresschrift für Literaturwissenschaft und Geistesgeschichte*, 9 (1931), 125–54.

Phillips, Peter, *The Staithes Group*, [Cookham, Berkshire], Phillips & Sons, 1993.

Pol, Joke van der, 'De "Larense School": Kunst voor de markt?', *Tableau*, 7:2 (1984), 50–64.

Pollock, Griselda, 'Modernity and the spaces of femininity', in *Vision and Difference: Femininity, Feminism and the Histories of Art*, London and New York, Routledge, 1988.

Pollock, Griselda, *Avant-garde Gambits 1888–1893: Gender and the Colour of Art History*, London, Thames and Hudson, 1992.

Pollock, Griselda, 'The dangers of proximity: The spaces of sexuality and surveillance in word and image', *Discourse*, 16:2 (1993–4), 3–50.

Pollock, Griselda, 'On not seeing Provence: Van Gogh and the landscape of consolation, 1888–9', in Thomson, *Framing France*.

Pollock, Griselda, *Differencing the Canon: Feminist Desire and the Writing of Art's Histories*, London and New York, Routledge, 1999.

Pratt, Mary Louise, *Imperial Eyes: Travel Writing and Transculturation*, London and New York, Routledge, 1992.

Pred, Allan, 'Place as historically contingent process: Structuration and the time-geography of becoming places', *Annals of the Association of American Geographers*, 74:2 (1984), 279–97.

Reitmeier, Lorenz Josef, *Dachau – Der berühmte Malerort: Kunst und Zeugnis aus 1200 Jahren Geschichte*, Munich, Süddeutscher Verlag, 1990.

Repp-Eckert, Anke, 'Europäische Künstlerkolonien des 19. Jahrhunderts', in *Landschaft im Licht*, pp. 55–66.

Reverdy, Anne, *L'École de Barbizon: Évolution du prix des tableaux de 1850 à 1960*, Paris, The Hague and Mouton, École Pratique des Hautes Études, 1973.

Rewald, John, *Post-Impressionism: From Van Gogh to Gauguin*, London, Secker & Warburg, [1956, 1962] 3rd rev. edn 1978.

Riedel, Karl Veit, *Worpswede in Fotos und Dokumenten*, Fischerhude, Galerie-Verlag, 1988.

Ritter, Alexander (ed.), *Landschaft und Raum in der Erzählkunst*, Darmstadt, Wissenschaftliche Buchgesellschaft, 1975.

Rodaway, Paul, *Sensuous Geographies: Body, Sense and Place*, London and New York, Routledge, 1994.

Rose, Gillian, *Feminism and Geography: The Limits of Geographical Knowledge*, Cambridge and Oxford, Polity Press, 1993.

Rosen, Charles and Henri Zerner, *Romanticism and Realism: The Mythology of Nineteenth-Century Art*, New York and London, W. W. Norton, 1984.

Rouette, Susanne, '"Die Bürger, der Bauer und die Revolution": Zur Wahrnehmung und Deutung der agrarischen Bewegung 1848/49', in Christian Jansen and Thomas Mergel (eds), *Die Revolutionen von 1848/49: Erfahrung – Verarbeitung – Deutung*, Göttingen, Vandenhoeck & Ruprecht, 1998.

Röver, Anne, *Paula Modersohn-Becker: Das Frühwerk*, Bremen, Kunsthalle Bremen, 1985.

Schivelbusch, Wolfgang, *Geschichte der Eisenbahnreise: Zur Industrialisierung von Raum und Zeit*, Frankfurt am Main, Fischer Verlag, [1977] 1989; tr. as *The Railway Journey: The Industrialization of Time and Space in the Nineteenth Century*, tr. uncredited, Berkeley, University of California Press, [1979] 1986.

Schor, Naomi, '*Cartes postales*: Representing Paris', *Critical Inquiry*, 18 (1992), 188–244.

Schultze-Naumburg, Paul, 'Die Worpsweder', *Die Kunst für Alle*, 12:8 (1896–97), 116–19.

Schulz, Friedrich, *Ahrenshoop: Die Geschichte eines Dorfes zwischen Fischland und Darss*, Fischerhude and Ahrenshoop, Verlag Atelier im Bauernhaus and Bunte Stube, 1992.

Schüßler, Luise, 'Die Worpsweder Malerei um 1900 und ihre entwicklungsgeschichtliche Stellung', Ph.D. dissertation, Philipps-Universität, Marburg, 1951.

Schwalm, J. H., 'Die Schwalm', in Carl Heßler (ed.), *Hessische Volkskunde*, Frankfurt am Main, Weidlich Reprints, [1904] 1979.

Schwälmerisch: Kunst & Volkskultur einer hessischen Landschaft, eds Elisabeth Abreß, Ursula K. Nauderer and Birgitta Unger-Richter, Dachau, Zweckverband 'Heimatmuseum Dachau', 1991.

Sellin, David, *Americans in Brittany and Normandy*, Phoenix, Ariz., Phoenix Art Museum, 1983.

Sensier, Alfred, *Jean-François Millet: Peasant and Painter*, tr. Helena de Kay, London, Macmillan and Co., [1881] 1881.

Serafien De Rijcke tussen Xavier De Cock en Albijn Van den Abeele, eds J. D'Haese and R. Van den Abeele, Sint-Martens-Latem, Latemse Kunstkring, 1985.

Seumeren-Haerkens, Margriet, 'Kunstenaars rond Hamdorff', *Tableau* (December 1985), 72–5.

Shaw, Christopher and Malcolm Chase (eds), *The Imagined Past: History and Nostalgia*, Manchester and New York, Manchester University Press, 1989.

Shields, Rob, *Places on the Margin: Alternative Geographies of Modernity*, London, Routledge, 1991.

Short, John Rennie, *Imagined Country: Environment, Culture and Society*, London and New York, Routledge, 1991.

Simmel, Georg, 'Philosophie der Landschaft' in *Brücke und Tür: Essays des Philosophen zur Geschichte, Religion, Kunst und Gesellschaft*, eds Michael Landmann and Margarete Susman, Stuttgart, K. F. Koehler, [1912/13] 1957.

Simons, K., *Hotel Spaander 100 jaar, 1881–1981*, Volendam, Hotel Spaander, 1981.

Smuda, Manfred (ed.), *Landschaft*, Frankfurt am Main, Suhrkamp, 1986.

Stewart, Susan, *On Longing: Narratives of the Miniature, the Gigantic, the Souvenir, the Collection*, Baltimore and London, Johns Hopkins University Press, 1984.

Stott, Annette, 'American painters who worked in the Netherlands, 1880–1914', Ph.D. dissertation, Boston University and Ann Arbor, Michigan, University Microfilms International, 1986.

Svensk konst i Grez i Kring det återuppväckta Hôtel Chevillon/Art suedois à Grez: Le réveil de l'Hôtel Chevillon, eds Bo Sylvan and Gunvor Bonds, Paris, Kungl Akademien för de fria konsterna and Centre Culturel Suédois, Paris, 1991.

Taylor, John, *A Dream of England: Landscape, Photography and the Tourist Imagination*, Manchester and New York, Manchester University Press, 1994.

Tester, Keith, *The Life and Times of Post-Modernity*, London and New York, Routledge, 1993.

The Cranbrook Colony, Wolverhampton, Central Art Gallery and Newcastle-upon-Tyne, Laing Art Gallery, 1977.

Thiemann-Stoedtner, Ottilie, *Dachauer Maler: Der Künstlerort Dachau von 1801–1946*, Dachau, Verlagsanstalt 'Bayerland' Dachau, 1981.

Thomson, Richard (ed.), *Framing France: The Representation of Landscape in France, 1870–1914*, Manchester and New York, Manchester University Press, 1998.

Thurn, Hans Peter, 'Die Sozialität der Solitären: Gruppen und Netzwerke in der bildenden Kunst', *Kunstforum International*, 116 (November/December 1991), 100–29.

Tovey, David, *W. H. Y. Titcomb: Artist of Many Parts*, Bushey, Herts. and Tewkesbury, The Bushey Museum Trust and D. C. W. Tovey, 1985.

Tucker, Paul Hayes, *Monet at Argenteuil*, New Haven and London, Yale University Press, 1982.

Urry, John, *The Tourist Gaze: Leisure and Travel in Contemporary Societies*, London, Newbury Park, Calif. and New Delhi, Sage Publications, 1990.

Urry, John, '*The Tourist Gaze* "revisited"', *American Behavioral Scientist*, 36:2 (1992), 172–86.

Urry, John, *Consuming Places*, London and New York, Routledge, 1995.

Veer, Ludwig van der, 'Professor Ludwig Dill: The man and his work', *Studio*, 34:143 (1905), 210–16.

Vellekoop, Piet, 'Is er een Katwijkse School?', *De Katwijksche Post* (2 April, 9 April, 16 April, 23 April, 29 April, 7 May, 14 May, 21 May, 27 May, 4 June, 11 June, 1992).

Veurman, B. W. E., *Volendammer Schilderboek*, The Hague, Kruseman's Uitgevers-maatschappij, 1979.

Vleuten, Ronald van, 'Egmond remembers Gari Melchers', in *Gari Melchers*, pp. 159–63.

Voss, Knud, *Skagens Museum: Illustreret Katalog*, Skagen, Skagens Museum, 1981 (incl. English introd.).

Voss, Knud, *The Painters of Skagen*, tr. Peter Shield, Tølløse, Stok-Art, [1986] 1990.

Vreemde gasten: Kunstschilders in Volendam 1880–1914, ed. Vereniging 'Vrienden van het Zuiderzeemuseum', Enkhuizen, Rijksmuseum Zuiderzeemuseum, 1986.

Wagner, Monika, 'Die Alpen: Faszination unwirtlicher Gegenden', in Märker *et al.*, *Mit dem Auge des Touristen*, pp. 67–79.

Wallace, Anne D., *Walking, Literature and English Culture: The Origins and Uses of Peripatetic in the Nineteenth Century*, Oxford, Clarendon Press, 1993.

Walter, J. A., 'Social limits to tourism', *Leisure Studies*, 1:3 (1982), 295–304.

Warnke, Martin, *Politische Landschaft: Zur Kunstgeschichte der Natur*, Munich and Vienna, Carl Hanser, 1992; tr. as *Political Landscape: The Art History of Nature*, tr. David McLintock, London, Reaktion, 1994.

Weber, Eugen, *Peasants into Frenchmen: The Modernisation of Rural France 1870–1914*, London, Chatto and Windus, [1977] 1979.

Weber-Kellermann, Ingeborg, *Landleben im 19. Jahrhundert*, Munich, C.H. Beck, 1987.

Weisberg, Gabriel P., *Beyond Impressionism: The Naturalist Impulse in European Art 1860–1905*, New York and London, Harry N. Abrams and Thames and Hudson, 1992.

Weld, Charles Richard, *A Vacation in Brittany*, London, Chapman and Hall, 1856.

White, Cynthia A. and Harrison C. White, *Canvases and Careers: Institutional Change in the French Painting World*, Chicago and London, Chicago University Press, [1965] new edn, 1993.

Whybrow, Marion, *St Ives 1883–1993: Portrait of an Art Colony*, Woodbridge, Antique Collectors' Club, 1994.

Wietek, Gerhard (ed.), *Deutsche Künstlerkolonien und Künstlerorte*, Munich, Karl Thiemig, 1976.

Williams, Raymond, *Problems in Materialism and Culture: Selected Essays*, London, Verso, 1980.

Wivel, Ole, *Anna Ancher 1859–1935*, Lyngby, Herluf Stokholms Forlag, 1987.

Wohltmann, Hans, 'Zur 75jährigen Wiederkehr der Gründung der Worpsweder Malerkolonie', *Stader Jahrbuch*, N.S., 54 (1964), 15–31.

Wollmann, Jürgen A. and Willingshäuser Gemäldekabinett Wollmann (eds), *Die Willingshäuser Malerkolonie und die Kleinsassener Malerkolonie*, Schwalmstadt-Treysa, Neidhardt, Herzig & Richter, *c.* 1991.

Worpswede 1889–1989: Hundert Jahre Künstlerkolonie, ed. Landkreis Osterholz, Lilienthal, Worpsweder Verlag, 1989.

Worpswede: Aus der Frühzeit der Künstlerkolonie, Bremen, Kunsthalle Bremen, 1970.

Worpswede: Eine deutsche Künstlerkolonie um 1900, ed. Wolf-Dietmar Stock, Ottersberg–Fischerhude, Galerie Verlag Fischerhude, 1986.

Worpswede: Eine deutsche Künstlerkolonie um 1900. 150 Werke aus dem Besitz der Kunsthalle Bremen, Bremen, Kunsthalle Bremen, 1980.

Wortley, Laura, *British Impressionism: A Garden of Bright Images*, London, The Studio Fine Art Publications, 1988.

'Zij waren in Laren...': Buitenlandse kunstenaars in Laren en 't Gooi, Laren, Singer Museum, 1989.

Zurück zur Natur: Die Künstlerkolonie von Barbizon. Ihre Vorgeschichte und ihre Auswirkung, Bremen, Kunsthalle Bremen, 1977.

Index

Note: Titles of paintings can be found under the artists' names; page numbers in *italic* refer to illustrations; page numbers in **bold** refer to main entries in the Gazetteer; 'n.' after a page reference indicates the number of a note on that page.

ACCA

Financial Management (FM)

Practice & Revision Kit

For exams in September 2020,
December 2020, March 2021 and June 2021

First edition 2007
Thirteenth edition February 2020

ISBN 9781 5097 8393 9
(previous ISBN 9781 5097 2402 4)
e-ISBN 9781 5097 2930 2

Cataloguing-in-Publication Data
A catalogue record for this book
is available from the British Library

Published by

BPP Learning Media Ltd
BPP House, Aldine Place
London W12 8AA

www.bpp.com/learningmedia

Printed in the United Kingdom

Your learning materials, published by BPP
Learning Media Ltd, are printed on paper
obtained from traceable, sustainable sources.

We are grateful to the Association of Chartered
Certified Accountants for permission to reproduce
past examination questions. The suggested
solutions in the Practice & Revision Kit have been
prepared by BPP Learning Media Ltd, except
where otherwise stated.

Contents

Question index

The headings in this checklist/index indicate the main topics of questions, but questions sometimes cover several different topics.

BPP LEARNING MEDIA

Topic index

Listed below are the key *Financial Management* (FM) syllabus topics and the numbers of the questions in this Kit covering those topics.

If you need to concentrate your practice and revision on certain topics or if you want to attempt all available questions that refer to a particular subject, you will find this index useful.

Syllabus topic	Question numbers	Workbook chapter
Asset replacement decisions	125, 132–133, 142–143, 155, 164	8
Business valuation	186, 208, 223–231, 237–9, 241, 242–244, 246–249, 252–260, 264	13
Capital rationing	128–130, 134, 140–141, 155–156, 158–159	8
Capital structure	196–205, 262	12
Cash management	56–58, 82, 86, 88	4
Cash operating cycle	41, 43, 84, 87	3
Cost of capital	187–195, 206-7, 212–217, 219–220, 250–251	11
Dividend policy	171–175, 213b, 217, 220, 261	10
Economics	21–25, 32, 36–40, 161	2
Financial intermediaries and markets	24, 26–33, 33-35	2
Financial management	2, 6, 15	1
Foreign currency risk	267–276, 282–285, 287–301, 304	14
Gearing	176–181, 211–212	12
Interest rate risk	265–266, 277–281, 286, 302-3, 305-6	15
Inventory management	46–48, 53, 55, 62–63, 66–67, 76–77, 83	3
IRR	103-106, 108, 139, 149, 154, 164-165	5
Leasing	107, 126–127, 131, 155, 157	8
Market efficiency	222, 232–236, 240, 245, 263	13
NPV	93–95, 99–102, 109–119, 147, 150–153, 156, 160–162, 164–165	5,6,7
Objectives	5, 7, 9, 10–13, 19–20, 160	1
Overtrading	70, 74, 85	3
Payables management	54, 86	3
Payback	91, 96, 97, 148, 164	5
Ratio analysis	1, 3, 4, 8, 14, 16–18, 71	3,9,12
Receivables management	49–52, 64–65, 68, 78, 82–84, 86, 89	3

Syllabus topic	Question numbers	Workbook chapter
ROCE	90, 92, 97, 98, 145–146	5
Risk and uncertainty	120–124, 135–138, 144, 157, 159–160, 161–163	7
Sources of finance	166–176, 182–185, 209–212, 213, 215, 217–219, 221	9
Working capital financing	59–60, 80–81, 85, 87	4
Working capital management	42, 44, 45, 61, 69, 72–73, 75, 79, 83, 85	3

The exam

Computer-based exams

Applied Skills exams are all computer-based exams.

Approach to examining the syllabus

The technical articles section on ACCA's website include one called 'Financial Management Examiners approach'. This article outlines the key features of the syllabus, and the qualities candidates should demonstrate when answering FM questions. We reproduce some of the main points here.

Candidates who successfully pass the *Financial Management* exam will be able to:

- Discuss the role and purpose of the financial management function
- Assess and discuss the impact of the economic environment on financial management
- Discuss and apply working capital management techniques
- Carry out effective investment appraisal
- Identify and evaluate alternative sources of business finance
- Discuss and apply principles of business and asset valuations
- Explain and apply risk management techniques in business.

Summarising the advice ACCA's examining team gives for FM:

In order to pass *Financial Management*, candidates should:

- Clearly understand the objectives of *Financial Management*, as explained above, and in the *Syllabus* and in the accompanying *Study Guide*

- Read and study thoroughly a suitable financial management textbook

- Read relevant articles flagged by *Student Accountant*

- Practise exam-standard and exam-style questions on a regular basis

- Be able to communicate their understanding clearly in an examination context

Format of the exam

The exam will have a duration of 3 hours, and will comprise three exam sections:

Section	Style of question type	Description	Proportion of exam, %
A	Objective test (OT)	15 questions × 2 marks	30
B	Objective test (OT) case	3 questions × 10 marks Each question will contain 5 subparts each worth 2 marks	30
C	Constructed Response (Long questions)	2 questions × 20 marks	40
Total			100

Section A and B questions will be selected from the entire syllabus. The responses to each question or subpart in OT cases are marked automatically as either correct or incorrect by computer. In Sections A and B, it is important that candidates do not spend too much time on any one question that they may be struggling with. It is important to remember that each question is only worth two marks.

Sections A and B are designed to test your broad understanding of the whole of the FM syllabus.

Section C questions will **mainly** focus on the following syllabus areas but may include material from other areas of the syllabus:

- Working capital management (syllabus area C)
- Investment appraisal (syllabus area D)
- Business finance (syllabus area E)

The responses to these questions are human marked, so it continues to be absolutely vital that all workings are shown and assumptions are stated.

The balance of the marks in the exam will be approximately evenly split between marks for discussion and marks for calculations.

Syllabus and Study Guide

The complete FM syllabus and study guide can be found by visiting the exam resource finder on the ACCA website.

Helping you with your revision

BPP Learning Media – ACCA Approved Content Provider

As an ACCA **Approved Content Provider**, BPP Learning Media gives you the **opportunity** to use revision materials reviewed by the ACCA examining team. By incorporating the ACCA examining team's comments and suggestions regarding the depth and breadth of syllabus coverage, the BPP Learning Media Practice & Revision Kit provides excellent, **ACCA-approved** support for your revision.

These materials are reviewed by the ACCA examining team. The objective of the review is to ensure that the material properly covers the syllabus and study guide outcomes, used by the examining team in setting the exams, in the appropriate breadth and depth. The review does not ensure that every eventuality, combination or application of examinable topics is addressed by the ACCA Approved Content. Nor does the review comprise a detailed technical check of the content as the Approved Content Provider has its own quality assurance processes in place in this respect.

BPP Learning Media do everything possible to ensure the material is accurate and up to date when sending to print. In the event that any errors are found after the print date, they are uploaded to the following website: www.bpp.com/learningmedia/Errata.

The structure of this Practice & Revision Kit

FM exam questions mainly focus exclusively or mainly on one single syllabus area. Therefore questions in this Kit have been grouped according to the section of the syllabus to which they mainly relate.

There are also four mock exams which provide you the opportunity to refine your knowledge and skills as part of your final exam preparations.

Question practice

Question practice under timed conditions is absolutely vital. We strongly advise you to create a revision study plan which focuses on question practice. This is so that you can get used to the pressures of answering exam questions in limited time, develop proficiency in the Specific FM skills and the Exam success skills. Ideally, you should aim to cover all questions in this Kit, and very importantly, all four mock exams.

Selecting questions

To help you plan your revision, we have provided a full **topic index** which maps the questions to topics in the syllabus (see page viii).

We provide signposts to help you plan your revision.

- A full **question index**

- A **topic index** listing all the questions that cover key topics, so that you can locate the questions that provide practice on these topics, and see the different ways in which they might be examined

Making the most of question practice

At BPP Learning Media we realise that you need more than just questions and model answers to get the most from your question practice.

- Our **top tips** included for certain questions provide essential advice on tackling questions, presenting answers and the key points that answers need to include.

- We include **marking guides** to show you what the examining team rewards.

- We include **comments from the examining team** to show you where students struggled or performed well in the actual exam.

Attempting mock exams

There are four mock exams that provide practice at coping with the pressures of the exam day. We strongly recommend that you attempt them under exam conditions. We strongly recommend that you attempt them under exam conditions. All the mock exams reflect the question styles and syllabus coverage of the exam.

Topics to revise

The structure of the exam is designed to test your understanding of the whole syllabus.

However, it is especially important to have a comprehensive understanding of all aspects of syllabus sections C (working capital), D (investment appraisal) and E (Business Finance) because these are commonly examined as the major component of the twenty marks Section C exam questions.

The aim of the *Financial Management* exam is to develop the knowledge and skills expected of a finance manager in relation to investment, financing and dividend decisions.

You need to be able to communicate your understanding clearly in an exam context. Calculations and discussions are equally important so do not concentrate on the numbers and ignore the written parts.

Gaining the easy marks

Some OTQs are easier than others. Answer those that you feel fairly confident about as quickly as you can. Come back later to those you find more difficult. This could be a way of making use of the time in the examination most efficiently and effectively.

Many OTQs will not involve calculations. Make sure that you understand the wording of 'written' OTQs before selecting your answer.

The calculations within a section C question will get progressively harder and easy marks will be available in the early stages. Set our your calculations clearly and show all your workings in a clear format. Use a proforma, for example in complex NPV questions and slot the simpler figures into the proforma straight away before you concentrate on the figures that need a lot of adjustment.

A Section C question may separate discussion requirements from calculations, so that you do not need to do the calculations first in order to answer the discussion part. This means that you should be able to gain marks from making sensible, practical comments without having to complete the calculations.

Discussions that are focused on the specific organisation in the question will gain more marks than regurgitation of knowledge. Read the question carefully and more than once, to ensure you are actually answering the specific requirements.

Pick out key words such as 'describe', 'evaluate' and 'discuss'. These all mean something specific.

- 'Describe' means to communicate the key features of
- 'Evaluate' means to assess the value of
- 'Discuss' means to examine in detail by argument

Clearly label the points you make in discussions so that the marker can identify them all rather than getting lost in the detail.

Essential skills areas to be successful in Financial Management

We think there are three areas you should develop in order to achieve exam success in Financial Management (FM):

(1) Knowledge application

(2) Specific FM skills

(3) Exam success skills

These are shown in the diagram below.

At the revision and exam preparation phases these should be developed together as part of a comprehensive study plan of focussed question practice.

Specific FM skills

These are the skills specific to FM that we think you need to develop in order to pass the exam.

In the BPP Workbook, there are five **Skills Checkpoints** which define each skill and show how it is applied in answering a question. A brief summary of each skill is given below.

Skill 1: Approach to objective test (OT) questions

Section A of the exam will include 15 OT questions worth two marks each. Section B of the exam will include three OT cases, worth 10 marks each. Each OT case contains a group of five OT questions based around a single scenario. 60% of your FM exam is therefore made up of OT questions. It is essential that you have a good approach to answering these questions. OT questions are auto-marked, your workings will therefore not be considered, you have to answer the whole question correctly to earn their two marks.

A step-by-step technique for tackling OT questions is outlined below:

Step 1	**General guidance for approaching OT questions**	

Answer the questions you know first.

If you're having difficulty answering a question, move on and come back to tackle it once you've answered all the questions you know. It is often quicker to answer discursive style OT questions first, leaving more time for calculations.

Step 2 **Answer all questions.**

There is no penalty for an incorrect answer in ACCA exams, there is nothing to be gained by leaving an OT question unanswered. If you are stuck on a question, as a last resort, it is worth selecting the option you consider most likely to be correct and moving on. Make a note of the question, so if you have time after you have answered the rest of the questions, you can revisit it.

Step 3 **Guidance for answering specific OT questions**

Read the requirement first!

The requirement will be stated in bold text in the exam. Identify what you are being asked to do, any technical knowledge required and **what type of OT question** you are dealing with. Look for key words in the requirement such as "which TWO of the following," " which of the following is NOT".

Step 4 **Apply your technical knowledge to the data presented in the question.**

Work through calculations taking your time and read through each answer option with care. OT questions are designed so that each answer option is plausible. Work through each response option and eliminate those you know are incorrect

Skills Checkpoint 1 in the BPP Workbook for FM covers this technique in detail through application to an exam-standard OT case question. Consider revisiting Skills Checkpoint 1 to improve this skill.

Skill 2: Technique for investment appraisal calculations

Section C of the FM exam often includes a question on investment appraisal. You may be asked to calculate the net present value (NPV) of a project and advise whether the investment is financially acceptable. Section C is human marked and therefore it is important that your calculations are laid out clearly.

Key steps in preparing an NPV calculation are outlined below:

Step 1 Use a standard NPV proforma. This will help the marker to understand your workings and allocate the marks easily. It will also help you to work through the figures in a methodical and time-efficient way.

Step 2 Input easy numbers from the question directly onto your proforma. This will make sure that you pick up as many easy marks as possible before dealing with more detailed calculations.

Step 3 Always use formulae to perform basic calculations. Do not write out your workings, this wastes time and you may make a mistake. Use the spreadsheet functions instead!

Step 4 Show clear workings for any complex calculations. More complex calculations such as the tax relief on capital allowances will require a separate working. Keep your workings as clear and simple as possible and ensure they are cross-referenced to your NPV proforma.

Skills Checkpoint 2 in the BPP Workbook for FM covers this technique in detail through application to an exam-standard question. Consider revisiting Skills Checkpoint 2 to improve this skill.

Skill 3: Handling complex calculations

The business finance section of the syllabus often involves complex calculations such as the weighted average cost of capital (WACC) or ungearing and re-gearing beta factors.

A step-by-step technique for handling complex calculations is outlined below.

Step 1 Understanding the data in the question. Where a question includes a significant amount of data, read the requirements carefully to make sure that you understand clearly what the question is asking you to do. You can use the highlighting function to pull out important data from the question. Use the data provided to think about what formula you will need to use. For example, if you are given a beta factor you will use CAPM to calculate the cost of equity, if you are given a dividend growth rate it will be the dividend growth model. If the question states that the debt is redeemable you will need to use the IRR formula to calculate the cost of debt.

Step 2 Use a standard proforma working. For example, if you are asked to calculate the WACC use your standard proforma for calculating WACC and separately work through the individual parts of the calculation (Ke, Kd, Ve, Vd).

Step 3 Use spreadsheet formulae to perform basic calculations.

 Do not write out your workings, this wastes time and you may make a mistake. Use the spreadsheet formulae instead!

Skills Checkpoint 3 in the BPP Workbook for FM covers this technique in detail through application to an exam-standard question. Consider revisiting Skills Checkpoint 3 to improve this skill.

Skill 4: Effective discussion of key financial topics

The balance of the FM exam will be approximately 50:50 in terms of the number of marks available for discussion and the number of marks available for numerical calculations. It is very tempting to only practise numerical questions, as they are easy to mark because the answer is right or wrong, whereas written questions are more subjective, and a range of different answers will be given credit. Even when attempting written questions, it is tempting to write a brief answer plan and then look at the answer rather than writing a full answer to plan. Unless you practise written questions in full to time, you will never acquire the necessary skills to tackle discussion questions.

A step-by-step technique for effective discussion of key financial topics is outlined below.

Step 1 **Read and analyse the requirement.**

 The active verb used often dictates the approach that written answers should take. For example, discuss means examine in detail by using arguments in favour or against. Work out how many minutes you have to answer each sub requirement.

Step 2 **Read and analyse the scenario.**
 Identify the type of company you are dealing with and how the financial topics in the requirement relate to that type of company. As you go through the scenario you should be highlighting key information which you think will play a key role in answering the specific requirements.

Step 3 **Plan your answer.**
 Ensure your answer is balanced in terms of identifying the potential benefits **and** limitations of topics that are being discussed or recommended.

Step 4	Write your answer

As you write your answer, try wherever possible to apply your analysis to the scenario, instead of simply writing about the financial topic in generic, technical terms. As you write your answer, explain what you mean – in one (or two) sentence(s) – and then explain why this matter in the given scenario. This should result in a series of short paragraphs that address the specific context of the scenario.

Skills Checkpoint 4 in the BPP Workbook for FM covers this technique in detail through application to an exam-standard question. Consider revisiting Skills Checkpoint 4 to improve this skill.

Skill 5: How to approach your FM exam

You can answer your FM exam in whatever order you prefer. It is important that you adopt a strategy that works best for you. We would suggest that you decide on your preferred approach and practice it by doing a timed mock exam before your real exam.

A suggested approach to tackling your FM exam is outlined below.

Complete section A first - allocated time 54 minutes

Tackle any easier OT questions first. Often discursive style questions can be answered quickly, saving more time for calculations. Do not leave any questions unanswered. Even if you are unsure make a reasoned guess.

Complete section B next - allocated time 54 minutes

You will have 18 mins of exam time to allocate to each of the three OT case questions in section B. Use the same approach to OT questions as discussed for section A.

There will normally be three discursive and two numerical questions within each case. Again, it is better to tackle the discursive type questions first and make a reasoned guess for any questions you are unsure on.

Finally, complete section C – allocated time 72 minutes

Start with the question you feel most confident with. The first sub requirement will normally involve some detailed calculations, these tend to be very time pressured. If possible, answer the discursive sub requirements first. This will ensure that you don't spend too much time on the calculations and then lose out on the easier discursive marks. Make it clear to your marker which sub requirement you are answering.

Skills Checkpoint 5 in the BPP Workbook for FM covers this technique in detail. Consider revisiting Skills Checkpoint 5 to improve this skill.

Exam success skills

Passing the FM exam requires more than applying syllabus knowledge and demonstrating the specific FM skills; it also requires the development of excellent exam technique through question practice. We consider the following six skills to be vital for exam success. These skills were introduced in the BPP Workbook for FM and you can revisit the five Skills Checkpoints in the Workbook for tutorial guidance on how to apply each of the six Exam success skills in your question practice and in the exam.

Try to consider your performance in all six Exam success skills during your revision stage question practice, and reflect on your particular strengths, and your weaker areas, which you can then work on.

Exam success skill 1

Managing information

Questions in the exam will present you with a lot of information. The skill is how you handle this information to make the best use of your time. The key is determining how you will approach the exam and then actively reading the questions.

Advice on developing Managing information

Approach

The exam is 3 hours long. There is no designated 'reading' time at the start of the exam. However, one approach that can work well is to start the exam by spending 5 minutes familiarising yourself with the exam.

Once you feel familiar with the exam consider the order in which you will attempt the questions; always attempt them in your order of preference. For example, you may want to leave to last the question you consider to be the most difficult.

If you do take this approach, remember to adjust the time available for each question appropriately – see Exam success skill 6: Good time management.

If you find that this approach doesn't work for you, don't worry – you can develop your own technique.

Active reading

You must take an active approach to reading each question. Focus on the requirement first, underlining key verbs such as 'evaluate', 'analyse', 'explain', 'discuss', to ensure you answer the question properly. Then read the rest of the question, underlining and annotating important and relevant information, and making notes of any relevant technical information you think you will need.

Exam success skill 2

Correct interpretation of the requirements

The active verb used often dictates the approach that written answers should take (eg 'explain', 'discuss', 'evaluate'). It is important you identify and use the verb to define your approach. The **correct interpretation of the requirements** skill means correctly producing only what is being asked for by a requirement. Anything not required will not earn marks.

Advice on developing the Correct interpretation of the requirements

This skill can be developed by analysing question requirements and applying this process:

Step 1	**Read the requirement**

Firstly, read the requirement a couple of times slowly and carefully and highlight the active verbs. Use the active verbs to define what you plan to do. Make sure you identify any sub-requirements.

In FM, it is important that you do this not only for section C questions but also for OT questions in sections A and B.

Step 2	**Read the rest of the question**

By reading the requirement first, you will have an idea of what you are looking out for as you read through the case overview and exhibits. This is a great time saver and means you don't end up having to read the whole question in full twice. You should do this in an active way – see Exam success skill 1: Managing Information.

Step 3	**Read the requirement again**

Read the requirement again to remind yourself of the exact wording before starting your written answer. This will capture any misinterpretation of the requirements or any missed requirements entirely. This should become a habit in your approach and, with repeated practice, you will find the focus, relevance and depth of your answer plan will improve.

Exam success skill 3

Answer planning: Priorities, structure and logic

This skill requires the planning of the key aspects of an answer which accurately and completely responds to the requirement.

Advice on developing Answer planning: Priorities, structure and logic

Everyone will have a preferred style for an answer plan. For example, it may be a mind map or bullet-pointed lists. Choose the approach that you feel most comfortable with, or, if you are not sure, try out different approaches for different questions until you have found your preferred style.

For a discussion question, annotating the question paper is likely to be insufficient. It would be better to draw up a separate answer plan in the format of your choosing (eg a mind map or bullet-pointed lists).

Exam success skill 4

Efficient numerical analysis

This skill aims to maximise the marks awarded by making clear to the marker the process of arriving at your answer. This is achieved by laying out an answer such that, even if you make a few errors, you can still score subsequent marks for follow-on calculations. It is vital that you do not lose marks purely because the marker cannot follow what you have done.

Advice on developing Efficient numerical analysis

This skill can be developed by applying the following process:

Step 1

Use a standard proforma working where relevant

If answers can be laid out in a standard proforma then always plan to do so. This will help the marker to understand your working and allocate the marks easily. It will also help you to work through the figures in a methodical and time-efficient way.

Step 2

Show your workings

Keep your workings as clear and simple as possible and ensure they are cross-referenced to the main part of your answer. Where it helps, provide brief narrative explanations to help the marker understand the steps in the calculation. This means that if a mistake is made you do not lose any subsequent marks for follow-on calculations.

Step 3

Keep moving!

It is important to remember that, in an exam situation, it can sometimes be difficult to get every number 100% correct. The key is therefore ensuring you do not spend too long on any single calculation. If you are struggling with a solution then make a sensible assumption, state it and move on.

Exam success skill 5

Effective writing and presentation

Written answers should be presented so that the marker can clearly see the points you are making, presented in the format specified in the question. The skill is to provide efficient written answers with sufficient breadth of points that answer the question, in the right depth, in the time available.

Advice on developing Effective writing and presentation

Step 1 **Use headings**

Using the headings and sub-headings from your answer plan will give your answer structure, order and logic. This will ensure your answer links back to the requirement and is clearly signposted, making it easier for the marker to understand the different points you are making. Underlining your headings will also help the marker.

Step 2 **Write your answer in short, but full, sentences**

Use short, punchy sentences with the aim that every sentence should say something different and generate marks. Write in full sentences, ensuring your style is professional.

Step 3 **Do your calculations first and explanation second**

Questions often ask for an explanation with suitable calculations. The best approach is to prepare the calculation first but present it on the bottom half of the page of your answer, or on the next page. Then add the explanation before the calculation. Performing the calculation first should enable you to explain what you have done.

Exam success skill 6

Good time management

This skill means planning your time across all the requirements so that all tasks have been attempted at the end of the time available and actively checking on time during your exam. This is so that you can flex your approach and prioritise requirements which, in your judgement, will generate the maximum marks in the available time remaining.

Advice on developing good time management

The exam is 3 hours long, which translates to 1.8 minutes per mark. Each OT question in section A should be allocated 3.6 mins. Some OT questions involving calculations may take slightly longer than this however this will be balanced out with other discursive type OT questions that can be answered more quickly. Each OT case in section B should be allocated 18 minutes to answer the five questions totalling ten marks. Each section C question is worth 20 marks and therefore should be allocated 36 minutes. It is also important to allocate time between each sub requirement.

Keep an eye on the clock

Aim to attempt all requirements, but be ready to be ruthless and move on if your answer is not going as planned. The challenge for many is sticking to planned timings. Be aware this is difficult to achieve in the early stages of your studies and be ready to let this skill develop over time.

If you find yourself running short on time and know that a full answer is not possible in the time you have, consider recreating your plan in overview form and then add key terms and details as time allows. Remember, some marks may be available, for example, simply stating a conclusion which you don't have time to justify in full.

Exam formulae

Set out below are the formulae which you will be given in the exam, and formulae which you should learn. If you are not sure what the symbols mean, or how the formulae are used, you should refer to the appropriate chapter in the BPP FM workbook.

Exam formulae	Chapter in Workbook

Economic Order Quantity — 3

$$= \sqrt{\frac{2C_0 D}{C_h}}$$

Miller-Orr Model — 4

Return point = Lower limit + (1/3 × spread)

$$\text{Spread} = 3\left[\frac{\frac{3}{4} \times \text{transaction cost} \times \text{variance of cash flows}}{\text{interest rate}}\right]^{\frac{1}{3}}$$

The Capital Asset Pricing Model — 11

$$E(r_i) = R_f + \beta_i(E(r_m) - R_f)$$

The Asset Beta Formula — 12

$$\beta_a = \left[\frac{V_e}{(V_e + V_d(1-T))}\beta_e\right] + \left[\frac{V_d(1-T)}{(V_e + V_d(1-T))}\beta_d\right]$$

The Growth Model — 13

$$P_0 = \frac{D_0(1+g)}{(r_e - g)} \qquad r_e = \frac{D_0(1+g)}{P_0} + g$$

Gordon's Growth Approximation — 11,13

$$g = br_e$$

The weighted average cost of capital — 11

$$\text{WACC} = \left[\frac{V_e}{V_e + V_d}\right]k_e + \left[\frac{V_d}{V_e + V_d}\right]k_d(1-T)$$

The Fisher formula — 5

$$(1+i) = (1+r)(1+h)$$

Purchasing Power Parity and Interest Rate Parity

$$S_1 = S_0 \times \frac{(1+h_c)}{(1+h_b)}$$ — 14

$$F_0 = S_0 \times \frac{(1+i_c)}{(1+i_b)}$$ — 14

Formulae to learn

Profitability ratios include:

$$\text{ROCE} = \frac{\text{Profit before interest and tax (PBIT)}}{\text{Capital employed}}$$

$$\text{ROCE} = \frac{\text{PBIT}}{\text{Revenue}} \times \frac{\text{Revenue}}{\text{Capital employed}}$$

Debt ratios include:

$$\text{Gearing} = \frac{\text{Debt}}{\text{Equity}} \text{ or } \frac{\text{Debt}}{\text{Debt} + \text{Equity}} \text{ (and either book values or market values can be used)}$$

$$\text{Interest coverage} = \frac{\text{PBIT}}{\text{Interest}}$$

Liquidity ratios include:

Current ratio = Current assets: Current liabilities

Acid Test ratio = Current assets less inventory: Current liabilities

Shareholder investor ratios include:

$$\text{Dividend yield} = \frac{\text{Dividend per share}}{\text{Market price per share}} \times 100$$

$$\text{Earnings per share} = \frac{\text{Profits distributable to ordinary shareholders}}{\text{Number of ordinary shares issued}}$$

$$\text{Price earnings (P/E) ratio} = \frac{\text{Market price per share}}{\text{EPS}}$$

$$\textbf{Accounts receivable days} = \frac{\text{Receivables}}{\text{(credit) sales}} \times 365 \text{ days}$$

Inventory days

(a) $\text{Finished goods} = \dfrac{\text{Finished goods}}{\text{Cost of sales}} \times 365 \text{ days}$

(b) $\text{WIP} = \dfrac{\text{Average WIP}}{\text{Cost of sales}} \times 365 \text{ days}$

(c) $\text{Raw material:} \dfrac{\text{Average raw material inventory}}{\text{Annual raw material purchases}} \times 365 \text{ days}$

$$\textbf{Accounts payable period} = \frac{\text{Payables}}{\text{Credit purchases (or cost of sales if purchases unavailable)}} \times 365 \text{ days}$$

$$\text{IRR} = a + \frac{\text{NPV}_a}{\text{NPV}_a - \text{NPV}_b} (b - a)$$

$$\textbf{Equivalent annual cost} = \frac{\text{PV of cost over one replacement cycle}}{\text{Annuity factor for the number of years in the cycle}}$$

$$\textbf{Cost of debt} = K_d = \frac{i(1 - T)}{P_0}$$

Cost of preference shares $= K_{pref} = \dfrac{\text{Preference Dividend}}{\text{Market Value}_{(ex\,div)}} = \dfrac{d}{P_0}$

Profitability index $= \dfrac{\text{PV of cash flows (or NPV of project)}}{\text{Capital investment}}$

Questions

PART A: FINANCIAL MANAGEMENT FUNCTION

Questions 1 to 20 cover Financial management function, the subject of Part A of the BPP Financial Management Workbook.

OTQ bank 1 – Financial management and financial objectives
18 mins

1 Last year ABC Co made profits before tax of $2,628,000. Tax amounted to $788,000.

ABC Co's share capital was $2,000,000 (2,000,000 shares of $1) and $4,000,000 6% preference shares.

What was the earnings per share (EPS) for the year (insert your answer to two decimal places)?

$ ☐ **(2 marks)**

2 Which of the following statements describes the main objective of financial management?

Sep/Dec 15

☐ Efficient acquisition and deployment of financial resources to ensure achievement of objectives

☐ Providing information to management for day to day functions of control and decision making

☐ Providing information to external users about the historical results of the organisation

☐ Maximisation of shareholder wealth **(2 marks)**

3 A company has recently declared a dividend of 12c per share. The share price is $3.72 cum div and earnings for the most recent year were 60c per share.

What is the P/E ratio?

☐ **(2 marks)**

4 The following information relates to a company: 6/15

Year	0	1	2	3
Earnings per share (cents)	30.0	31.8	33.9	35.7
Dividends per share (cents)	13.0	13.2	13.3	15.0
Share price at start of year ($)	1.95	1.98	2.01	2.25

Which of the following statements is correct?

☐ The dividend payout ratio is greater than 40% in every year in the period

☐ Mean growth in dividends per share over the period is 4%

☐ Total shareholder return for the third year is 26%

☐ Mean growth in earnings per share over the period is 6% per year **(2 marks)**

BPP
LEARNING
MEDIA

5 Which of the following is **LEAST** likely to fall within financial management? 12/14

 ☐ The dividend payment to shareholders is increased.

 ☐ Funds are raised to finance an investment project.

 ☐ Surplus assets are sold off.

 ☐ Non-executive directors are appointed to the remuneration committee. **(2 marks)**

 (Total = 10 marks)

OTQ bank 2 – Financial management and financial objectives
 36 mins

6 PT Co has just paid a dividend of 15 cents per share and its share price one year ago was $3.00 per share. The total shareholder return for the year was 25%. 12/14

 What is the current share price (to two decimal places)?

 $ ☐ **(2 marks)**

7 Which of the following does **NOT** form part of the objectives of a corporate governance best practice framework?

 ☐ Separation of chairperson and CEO roles

 ☐ Establishment of audit, nomination and remuneration committees

 ☐ Minimisation of risk

 ☐ Employment of non-executive directors **(2 marks)**

8 Are the following statements true or false? 12/14

		True	False
1	Maximising market share is an example of a financial objective.	☐	☐
2	Shareholder wealth maximisation is the primary financial objective for a company listed on a stock exchange.	☐	☐
3	Financial objectives should be quantitative so that their achievement can be measured.	☐	☐

 (2 marks)

9 ARP is a charity providing transport for people visiting hospitals.

Which of the following performance measures would BEST fit with efficiency in a value for money review?

☐ Percentage of members who re-use the service

☐ Cost per journey to hospital

☐ A comparison of actual operating expenses against the budget

☐ Number of communities served (2 marks)

10 H Co's share price is $3.50 at the end of 20X1 and this includes a capital gain of $0.75 since the beginning of the period. A dividend of $0.25 has been paid for 20X1.

What is the shareholder return (to 1 decimal place)?

[] % (2 marks)

11 Are the following statements true or false?

		True	False
1	Accounting profit is not the same as economic profit.	☐	☐
2	Profit takes account of risk.	☐	☐
3	Accounting profit can be manipulated by managers.	☐	☐

(2 marks)

12 A government body uses measures based upon the 'three Es' to measure value for money generated by a publicly funded hospital.

Which of the following relates to efficiency?

☐ Cost per successfully treated patient

☐ Cost per operation

☐ Proportion of patients readmitted after unsuccessful treatment

☐ Percentage change in doctors' salaries compared with previous year (2 marks)

13 Which of the following statements is NOT correct?

☐ Return on capital employed can be defined as profit before interest and tax divided by the sum of shareholders' funds and prior charge capital

☐ Return on capital employed is the product of net profit margin and net asset turnover

☐ Dividend yield can be defined as dividend per share divided by the ex dividend share price

☐ Return on equity can be defined as profit before interest and tax divided by shareholders' funds (2 marks)

14 Geeh Co paid an interim dividend of $0.06 per ordinary share on 31 October 20X6 and
 declared a final dividend of $0.08 on 31 December 20X6. The ordinary shares in Geeh Co
 are trading at a cum-div price of $1.83. 9/17

 What is the dividend yield (to one decimal place)?

 ┌──────────┐ % (2 marks)
 └──────────┘

15 Increasing which **TWO** of the following would be associated with the financial objective of
 shareholder wealth maximisation? 6/19

 ☐ Share price
 ☐ Dividend payment
 ☐ Reported profit
 ☐ Earnings per share
 ☐ Weighted average cost of capital

 (2 marks)
 (Total = 20 marks)

ABC Co **18 mins**

The following scenario relates to questions 16–20.

Summary financial information for ABC Co is given below, covering the last two years.

STATEMENT OF PROFIT OR LOSS (EXTRACT)

	20X8	20X7
	$'000	$'000
Revenue	74,521	68,000
Cost of sales	28,256	25,772
Salaries and wages	20,027	19,562
Other costs	11,489	9,160
Profit before interest and tax	14,749	13,506
Interest	1,553	1,863
Tax	4,347	3,726
Profit after interest and tax	8,849	7,917
Dividends payable	4,800	3,100

	20X8	20X7
STATEMENT OF FINANCIAL POSITION (EXTRACT)	$'000	$'000
Shareholders' funds	39,900	35,087
Long-term debt	14,000	17,500
	53,900	52,587
Other information		
Number of shares in issue ('000)	14,000	14,000
P/E ratio (average for year)		
ABC Co	14.0	13.0
Industry	15.2	15.0
Shareholders' investment		
EPS	$0.63	$0.57
Share price	$8.82	$7.41
Dividend per share	$0.34	$0.22

16 What is the percentage increase in return on capital (ROCE) for ABC Co between 20X7 and 20X8 (to one decimal place)?

⬚ % (2 marks)

17 What is the operating profit margin for 20X8 (to one decimal place)?

⬚ % (2 marks)

18 What is the total shareholder return?

☐ 14.4%
☐ 19.0%
☐ 19.8%
☐ 23.6% (2 marks)

19 As well as the information above, the following extra data is available:

	20X8	20X7
Gearing (debt/equity)	35.1%	49.9%
Interest cover (PBIT/interest)	9.5	7.2
Inflation	3%	3%

Based on all of the information available, are the following statements true or false?

1 Employees may be unhappy with their wages in 20X8.

2 Financial risk for shareholders appears to be a problem area.

☐ Statement 1 is true and statement 2 is false.
☐ Both statements are true.
☐ Statement 1 is false and statement 2 is true.
☐ Both statements are false. (2 marks)

20 Accounting profits may not be the best measure of a company's performance.

Which of the following statements support this theory?

1 Profits are affected by accounting policies.

2 Profits take no account of risk.

3 Profits take no account of the level of investment made during the year.

4 Profits are measures of short-term historic performance.

☐ 2 and 4 only
☐ 1, 2, 3 and 4
☐ 2 and 3 only
☐ 1 only (2 marks)

 (Total = 10 marks)

PART B: FINANCIAL MANAGEMENT ENVIRONMENT

Questions 21 to 40 cover Financial management environment, the subject of Part B of the BPP Financial Management Workbook.

OTQ bank 1 – Financial management environment

18 mins

21 A government has adopted a contractionary fiscal policy.

How would this typically affect businesses?

☐ Higher interest rates and higher inflation

☐ Lower taxes and higher government subsidies

☐ Higher taxes and lower government subsidies

☐ Lower inflation and lower interest rates

(2 marks)

22 A government follows an expansionary monetary policy.

How would this typically affect businesses?

☐ Higher demand from customers, lower interest rates on loans and increased availability of credit

☐ A contraction in demand from customers, higher interest rates and less available credit

☐ Lower taxes, higher demand from customers but less government subsidies/available contracts

☐ Lower interest rates, lower exchange rates and higher tax rates

(2 marks)

23 As the economy booms and approaches the limits of productivity at a point in time, are the following statements a true or false description of the impact of this?

		True	False
1	Increased inflation (higher sales prices and higher costs), difficulty in finding suitable candidates to fill roles and higher interest rates.	☐	☐
2	High export demand, increasing growth rates, high inflation and high interest rates.	☐	☐
3	Reducing inflation, falling demand, reducing investment, increasing unemployment.	☐	☐
4	Higher government spending, lower tax rates, high inflation and low unemployment.	☐	☐

(2 marks)

24　Are the following statements true or false?

		True	False
1	Monetary policy seeks to influence aggregate demand by increasing or decreasing the money raised through taxation.	☐	☐
2	When governments adopt a floating exchange rate system, the exchange rate is an equilibrium between demand and supply in the foreign exchange market.	☐	☐
3	Fiscal policy seeks to influence the economy and economic growth by increasing or decreasing interest rates.	☐	☐

(2 marks)

25　Which of the following organisations is most likely to benefit from a period of high price inflation?

☐　An organisation which has a large number of long-term payables

☐　An exporter of goods to a country with relatively low inflation

☐　A supplier of goods in a market where consumers are highly price sensitive and substitute imported goods are available

☐　A large retailer with a high level of inventory on display and low rate of inventory turnover

(2 marks)

(Total = 10 marks)

OTQ bank 2– Financial management environment
18 mins

26　Indicate which of the following statements correctly describe the functions that financial intermediaries fulfil for customers and borrowers.

		True	False
1	Maturity transformation	☐	☐
2	Fund aggregation	☐	☐
3	Dividend creation	☐	☐
4	Pooling of losses	☐	☐

(2 marks)

27 A listed company is to enter into a sale and repurchase agreement on the
 money market.

 The company has agreed to sell $10 million of treasury bills for $9.6 million and will buy
 them back in 50 days' time for $9.65 million.

 Assume a 365-day year.

 What is the implicit annual interest rate in this transaction (to the nearest 0.01%)?

 [] %

 (2 marks)

28 What role would the money market have in a letter of credit arrangement?

 ☐ Initial arrangement of the letter of credit
 ☐ Acceptance of the letter of credit
 ☐ Issuing of a banker's acceptance
 ☐ Discounting the banker's acceptance (2 marks)

29 AB plc, a company listed in the UK and Australia, decides to issue unsecured US dollar
 bonds in Australia.

 Which of the following is the correct definition for these bonds?

 ☐ Junk bonds
 ☐ Commercial paper
 ☐ Eurobonds
 ☐ Intercontinental bills (2 marks)

30 Rank the following from highest risk to lowest risk from the investor's perspective.

 1 Preference share
 2 Treasury bill
 3 Corporate bond
 4 Ordinary share

 ☐ 1, 4, 3, 2
 ☐ 1, 4, 2, 3
 ☐ 4, 2, 1, 3
 ☐ 4, 1, 3, 2 (2 marks)
 (Total = 10 marks)

OTQ bank 3 – Financial management environment

18 mins

31 Are the following statements true or false? **12/14**

		True	False
1	Securitisation is the conversion of illiquid assets into marketable securities.	☐	☐
2	The reverse yield gap refers to equity yields being higher than debt yields.	☐	☐
3	Disintermediation arises where borrowers deal directly with lending individuals.	☐	☐

(2 marks)

32 Governments have a number of economic targets as part of their fiscal policy. **12/14**

Which of the following government actions relate predominantly to fiscal policy?

1 Decreasing interest rates in order to stimulate consumer spending.

2 Reducing taxation while maintaining public spending.

3 Using official foreign currency reserves to buy the domestic currency.

4 Borrowing money from the capital markets and spending it on public works.

☐ 1 only

☐ 1 and 3

☐ 2 and 4 only

☐ 2, 3 and 4

(2 marks)

33 Which of the following statements are correct? **6/15**

1 A certificate of deposit is an example of a money market instrument.

2 Money market deposits are short-term loans between organisations such as banks.

3 Treasury bills are bought and sold on a discount basis.

☐ 1 and 2 only

☐ 1 and 3 only

☐ 2 and 3 only

☐ 1, 2 and 3

(2 marks)

34 Are the following statements true or false? **6/15**

		True	False
1	Capital market securities are assets for the seller but liabilities for the buyer	☐	☐
2	Financial markets can be classified into exchange and over-the-counter markets	☐	☐
3	A secondary market is where securities are bought and sold by investors	☐	☐

(2 marks)

35 Which of the following statements relating to money markets is/are true?

1 Lending is for periods greater than one year.

2 Lending is securitised.

3 Borrowers are mainly small companies.

☐ 1 and 2

☐ 2 and 3

☐ 1 and 3

☐ 2 only

(2 marks)

(Total = 10 marks)

OTQ bank 4– Financial management environment

18 mins

36 The following statements relate to fiscal policy and demand management.

Are the statements true or false?

	True	False
1 If a government spends more by borrowing more, it will raise demand in the economy.	☐	☐
2 If demand in the economy is high then government borrowing will fall.	☐	☐

(2 marks)

37 If the US dollar weakens against the pound sterling, will UK exporters and importers suffer or benefit?

	Benefit	Suffer
UK exporters to US	☐	☐
UK importers from US	☐	☐

(2 marks)

38 Which of the following represent forms of market failure where regulation may be a solution?

1 Imperfect competition

2 Social costs or externalities

3 Imperfect information

☐ 1 only

☐ 1 and 2 only

☐ 2 and 3 only

☐ 1, 2 and 3

(2 marks)

39 Which **TWO** of the following are among the main goals of macroeconomic policy?

☐ Encouraging waste recycling

☐ Low and stable inflation

☐ Achievement of a balance between exports and imports

☐ Encouraging an equitable distribution of income **(2 marks)**

40 If a government has a macroeconomic policy objective of expanding the overall level of economic activity, which **TWO** of the following measures would be consistent with such an objective?

☐ Increasing public expenditure

☐ Increasing interest rates

☐ Increasing the exchange rate

☐ Decreasing taxation **(2 marks)**

 (Total = 10 marks)

PART C: WORKING CAPITAL MANAGEMENT

Questions 41 to 89 cover Working capital management, the subject of Part C of the BPP Financial Management Workbook.

OTQ bank – Working capital

18 mins

41 A company's typical inventory holding period at any time is: 3/17

Raw materials: 15 days

Work in progress: 35 days

Finished goods: 40 days

Annual cost of goods sold as per the financial statements is $100m of which the raw materials purchases account for 50% of the total.

The company has implemented plans to reduce the level of inventory held, the effects of which are expected to be as follows:

1 Raw material holding time to be reduced by 5 days

2 Production time to be reduced by 4 days

3 Finished goods holding time to be reduced by 5 days

Assuming a 365-day year, what will be the reduction in inventory held?

☐ $2.603m

☐ $3.836m

☐ $1.918m

☐ $3.151m (2 marks)

42 Which **TWO** of the following are correct descriptions of net working capital? 3/19

☐ Current assets – current liabilities

☐ Inventory days + accounts receivable days – accounts payable days

☐ Current assets / current liabilities

☐ The long term capital invested in net current assets (2 marks)

43 WW Co has a current ratio of 2. Receivables are $3m and current liabilities are $2m.

Assume a 365-day year.

What are inventory days if cost of sales is $10m per year and WW Co has a zero cash balance (to one decimal place)?

(to one decimal place)

☐☐☐☐☐☐ days

(2 marks)

44 Which **TWO** of the following statements about overcapitalisation and overtrading are correct? 6/18

☐ Overtrading often arises from a rapid increase in sales revenue

☐ Overcapitalisation results in a relatively low current ratio

☐ Overtrading may result in a relatively high accounts payable turnover period

☐ Overcapitalisation is the result of too much short-term capital (2 marks)

45 A company has annual credit sales of $27m and related cost of sales of $15m. The company has the following targets for the next year: 12/14

Trade receivables days: 50 days

Inventory days: 60 days

Trade payables: 45 days

Assume there are 360 days in the year.

What is the net investment in working capital required for the next year?

☐ $8,125,000

☐ $4,375,000

☐ $2,875,000

☐ $6,375,000 (2 marks)

(Total = 10 marks)

OTQ bank – Managing working capital 36 mins

46 TS Co has daily demand for ball bearings of 40 a day for each of the 250 working days (50 weeks) of the year. The ball bearings are purchased from a local supplier for $2 each. The cost of placing an order is $64 per order, regardless of the size of the order. The inventory holding costs, expressed as a percentage of inventory purchase price, is 25% per year.

What is the economic order quantity (EOQ)?

☐ ball bearings (2 marks)

47 EE Co has calculated the following in relation to its inventories.

Buffer inventory level 50 units
Reorder size 250 items
Fixed order costs $50 per order
Cost of holding onto one item pa $1.25 per year
Annual demand 10,000 items
Purchase price $2 per item

What are the total inventory related costs for a year (to the nearest whole $)?

$ ☐ (2 marks)

48 Which of the following statements concerning working capital management are correct?

12/14

 1 Working capital should increase as sales increase.

 2 An increase in the cash operating cycle will decrease profitability.

 3 Overtrading is also known as undercapitalisation.

☐ 1 and 2 only

☐ 1 and 3 only

☐ 2 and 3 only

☐ 1, 2 and 3 (2 marks)

49 Wallace Co has annual credit sales of $4,500,000 and on average customers take 60 days to pay, assuming a 360-day year. As a result, Wallace Co has a trade receivables balance of $750,000. The company relies on an overdraft to finance this at an annual interest rate of 10%.

9/15

Wallace Co is considering offering an early settlement discount of 1% for payment in 30 days. It expected that 25% of its customers (representing 35% of the annual credit sales figure) will pay in 30 days in order to obtain the discount.

If Wallace Co introduces the proposed discount, what will be the **NET** impact?

☐ $1,875 saving

☐ $1,875 cost

☐ $2,625 saving

☐ $2,625 cost (2 marks)

50 Which of the following statements is/are correct? 6/15

 1 Factoring with recourse provides insurance against bad debts.

 2 The expertise of a factor can increase the efficiency of trade receivables management for a company.

☐ 2 only

☐ 1 only

☐ Neither 1 nor 2

☐ 1 and 2

51 Which of the following is **LEAST** likely to be used in the management of foreign accounts receivable?

☐ Letters of credit

☐ Bills of exchange

☐ Invoice discounting

☐ Commercial paper (2 marks)

52 L Co is considering whether to factor its sales invoices. A factor has offered L Co a non-recourse package at a cost of 1.5% of sales and an admin fee of $6,000 per year. Bad debts are currently 2% of sales per year and sales are $1.5m per year.

What is the cost of the package of L Co?

$ ☐ (2 marks)

53 Which of the following is **NOT** a drawback of the EOQ model?

☐ Assumes certain or zero lead times

☐ Assumes certainty in demand

☐ Assumes a small number of close suppliers

☐ Ignores hidden costs such as the risk of obsolescence (2 marks)

54 Which of the following is **NOT** a potential hidden cost of increasing credit taken from suppliers?

☐ Damage to goodwill

☐ Early settlement discounts lost

☐ Business disruption

☐ Increased risk of bad debts (2 marks)

55 Which **TWO** of the following would be most likely to arise from the introduction of a just-in-time inventory ordering system?

☐ Lower inventory holding costs

☐ Less risk of inventory shortages

☐ More frequent deliveries

☐ Lower ordering costs (2 marks)

(Total = 20 marks)

OTQ bank – Working capital finance 18 mins

56 JP Co has budgeted that sales will be $300,100 in January 20X2, $501,500 in February, $150,000 in March and $320,500 in April. Half of sales will be credit sales. 80% of receivables are expected to pay in the month after sale, 15% in the second month after sale, while the remaining 5% are expected to be bad debts. Receivables who pay in the month after sale can claim a 4% early settlement discount.

What level of sales receipts should be shown in the cash budget for March 20X2 (to the nearest $)?

$ ☐ (2 marks)

BPP
LEARNING
MEDIA

57 A company needs $150,000 each year for regular payments. Converting the company's short-term investments into cash to meet these regular payments incurs a fixed cost of $400 per transaction. These short-term investments pay interest of 5% per year, while the company earns interest of only 1% per year on cash deposits.

According to the Baumol Model, what is the optimum amount of short-term investments to convert into cash in each transaction (to the nearest $'000)?

$ []

58 The treasury department in TB Co has calculated, using the Miller-Orr model, that the lowest cash balance they should have is $1m, and the highest is $10m. If the cash balance goes above $10m they transfer the cash into money market securities.

Are the following true or false?

		True	False
1	When the balance reaches $10m they would buy $6m of securities.	☐	☐
2	When the cash balance falls to $1m they will sell $3m of securities.	☐	☐
3	If the variance of daily cash flows increases the spread between upper and lower limit will be increased.	☐	☐

(2 marks)

59 Which statement best reflects an aggressive working capital finance policy?

☐ More short-term finance is used because it is cheaper although it is risky.

☐ Investors are forced to accept lower rates of return.

☐ More long-term finance is used as it is less risky.

☐ Inventory levels are reduced.

(2 marks)

60 What are the **TWO** key risks for the borrower associated with short-term working capital finance?

☐ Rate risk

☐ Renewal risk

☐ Inflexibility

☐ Maturity mismatch

(2 marks)

(Total = 10 marks)

Section B questions

PKA Co (12/07, amended) 18 mins

The following scenario relates to questions 61–65.

PKA Co is a European company that sells goods solely within Europe. The recently appointed financial manager of PKA Co has been investigating working capital management objectives and the working capital management of the company, and has gathered the following information about the inventory policy and accounts receivable.

Inventory management

The current policy is to order 100,000 units when the inventory level falls to 35,000 units. Forecast demand to meet production requirements during the next year is 625,000 units. The cost of placing and processing an order is $250, while the cost of holding a unit in stores is $0.50 per unit per year. Both costs are expected to be constant during the next year. Orders are received two weeks after being placed with the supplier. You should assume a 50-week year and that demand is constant throughout the year.

Accounts receivable management

Customers are allowed 30 days' credit, but the financial statements of PKA Co show that the average accounts receivable period in the last financial year was 75 days. This is in line with the industry average. The financial manager also noted that bad debts as a percentage of sales, which are all on credit, increased in the last financial year from 5% to 8%. The accounts receivables department is currently short staffed.

61 What are the main objectives of working capital management at PKA?

 1 To ensure that PKA Co has sufficient liquid resources

 2 To increase PKA Co's profitability

 3 To ensure that PKA Co's assets give the highest possible returns

 ☐ 1 only

 ☐ 1 and 2 only

 ☐ 2 and 3 only

 ☐ 1, 2 and 3 (2 marks)

62 What is the current minimum inventory level at PKA Co?

 ☐ 10,000

 ☐ 12,500

 ☐ 22,500

 ☐ 35,000 (2 marks)

63 What is the economic order quantity?

 ☐ 250

 ☐ 3,536

 ☐ 17,678

 ☐ 25,000 (2 marks)

64 What are the best ways for PKA Co to improve the management of accounts receivable?

 1 Assess the creditworthiness of new customers

 2 Introduce early settlement discounts

 3 Take legal action against the slow payers and non-payers

- ☐ 1 and 2 only
- ☐ 2 only
- ☐ 1 and 3 only
- ☐ 1, 2 and 3 (2 marks)

65 In order to improve the management of receivables, PKA Co is considering using a debt factor on a 'with-recourse' basis.

Which of the following are benefits of 'with-recourse' factoring for PKA Co?

 1 A fall in bad debts

 2 A reduction in accounts receivable staffing costs

 3 An improvement in short-term liquidity

- ☐ 2 only
- ☐ 1, 2 and 3
- ☐ 2 and 3 only
- ☐ 1 and 3 only (2 marks)

 (Total = 10 marks)

Plot Co **18 mins**

The following scenario relates to questions 66–70.

Plot Co sells Product P with sales occurring evenly throughout the year.

Product P

The annual demand for Product P is 300,000 units and an order for new inventory is placed each month. Each order costs $267 to place. The cost of holding Product P in inventory is 10 cents per unit per year. Buffer inventory equal to 40% of one month's sales is maintained.

Other information

Plot Co finances working capital with short-term finance costing 5% per year. Assume that there are 365 days in each year.

66 What is the total annual cost of the current purchasing policy (to the nearest whole number)?

$ ☐

 (2 marks)

67 What is the total annual cost of a policy based on using the economic order quantity (EOQ) (to the nearest $100)?

$ ☐

 (2 marks)

68 Plot Co is considering offering a 2% early settlement discount to its customers. Currently sales are $10m and customers take 60 days to pay. Plot Co estimates half the customers will take up the discount and pay cash. Plot is currently financing working capital using an overdraft on which it pays a 10% charge. Assume 365 days in a year.

What will be the effect of implementing the policy?

☐ Benefit of $17,808

☐ Cost of $17,808

☐ Benefit of $82,192

☐ Benefit of $182,192 **(2 marks)**

69 Plot Co managers are considering the cost of working capital management.

Are the following statements about working capital management true or false?

		True	False
1	A conservative working capital finance approach is low risk but expensive.	☐	☐
2	Good working capital management adds to the wealth of shareholders.	☐	☐

(2 marks)

70 If Plot Co were overtrading, which **TWO** of the following could be symptoms?

☐ Decreasing levels of trade receivables

☐ Increasing levels of inventory

☐ Increasing levels of long-term borrowings

☐ Increasing levels of current liabilities **(2 marks)**

(Total = 10 marks)

Gorwa Co (12/08, amended) **18 mins**

The following scenario relates to questions 71–75.

The financial manager of Gorwa Co is worried about the level of working capital and that the company may be overtrading.

The following extract financial information relates to the last two years:

	20X7	20X6
	$'000	$'000
Sales (all on credit)	37,400	26,720
Cost of sales	(34,408)	(23,781)
Operating profit	2,992	2,939

	20X7		20X6	
	$'000	$'000	$'000	$'000
Current assets				
Inventory	4,600		2,400	
Trade receivables	4,600		2,200	
		9,200		4,600
Current liabilities		7,975		3,600

71 What is the sales/net working capital ratio for 20X7 (to two decimal places)?

 [] times

 (2 marks)

72 What is the increase in inventory days between 20X6 and 20X7 (to the nearest whole day)?

 [] days

 (2 marks)

73 Are the following statements true or false for Gorwa Co?

 True False

 1 Accounts receivable days have increased [] []

 2 Inventory turnover has slowed down [] []

 (2 marks)

74 Gorwa Co is concerned about overtrading.

 Which **TWO** of the following are symptoms of overtrading?

 [] Rapid reduction in sales revenue

 [] Slowdown in inventory turnover

 [] Shortening of payment period to accounts payables

 [] A fall in the current ratio

 (2 marks)

75 Gorwa Co's net working capital (ie current assets less current liabilities) is most likely to
 increase in which of the following situations?

 [] Payments to suppliers are delayed

 [] The period of credit extended to customers is reduced

 [] Non-current assets are sold

 [] Inventory levels are increased

 (2 marks)

 (Total = 10 marks)

Cat Co **18 mins**

The following scenario relates to questions 76–80.

Cat Co places monthly orders with a supplier for 10,000 components which are used in its
manufacturing processes. Annual demand is 120,000 components. The current terms are
payment in full within 90 days, which Cat Co meets, and the cost per component is $7.50. The
cost of ordering is $200 per order, while the cost of holding components in inventory is $1.00 per
component per year.

The supplier has offered a discount of 3.6% on orders of 30,000 or more components. If the bulk
purchase discount is taken, the cost of holding components in inventory would increase to $2.20
per component per year due to the need for a larger storage facility.

76 What is the current total annual cost of inventory?

$ []

(2 marks)

77 What is the total annual inventory cost if Cat Co orders 30,000 components at a time?

$ []

(2 marks)

78 Cat Co has annual credit sales of $25m and accounts receivable of $5m. Working capital is financed by an overdraft at 10% interest per year. Assume 365 days in a year.

What is the annual finance cost saving if Cat Co reduces the collection period to 60 days (to the nearest whole number)?

$ []

(2 marks)

79 Cat Co is reviewing its working capital management.

Which **TWO** of the following statements concerning working capital management are correct?

☐ The twin objectives of working capital management are profitability and liquidity.

☐ A conservative approach to working capital investment will increase profitability.

☐ Working capital management is a key factor in a company's long-term success.

☐ Liquid assets give the highest returns leading to conflicts of objectives.

(2 marks)

80 Management at Cat Co are considering an aggressive approach to financing working capital.

Which of the following statements relate to an aggressive approach to financing working capital management?

1 All non-current assets, permanent current assets and part of fluctuating current assets are financed by long-term funding.

2 There is an increased risk of liquidity and cash flow problems.

☐ Both statements

☐ Neither statement

☐ Statement 1 only

☐ Statement 2 only

(2 marks)

(Total = 10 marks)

Section C questions

81 APX Co (12/09, amended) 36 mins

APX Co achieved a revenue of $16m in the year that has just ended and expects revenue growth of 8.4% in the next year.

The financial statements of APX Co for the year that has just ended contain the following statement of financial position:

	$m	$m
Non-current assets		22.0
Current assets		
Inventory	2.4	
Trade receivables	2.2	
		4.6
Total assets		26.6
Equity finance:		
Ordinary shares	5.0	
Reserves	7.5	
		12.5
Long-term bank loan		10.0
		22.5
Current liabilities		
Trade payables	1.9	
Overdraft	2.2	
		4.1
Total equity and liabilities		26.6

The long-term bank loan has a fixed annual interest rate of 8% per year. APX Co pays taxation at an annual rate of 30% per year.

The following accounting ratios have been forecast for the next year:

Gross profit margin:	30%
Operating profit margin:	20%
Dividend payout ratio:	50%
Inventory turnover period:	110 days
Trade receivables period:	65 days
Trade payables period:	75 days

Overdraft interest in the next year is forecast to be $140,000. No change is expected in the level of non-current assets and depreciation should be ignored.

Required

(a) Prepare the following forecast financial statements for APX Co using the information provided:

 (i) A statement of profit or loss for the next year

 (ii) A statement of financial position at the end of the next year **(9 marks)**

(b) Analyse and discuss the working capital financing policy of APX Co. **(6 marks)**

(c) Discuss the role of financial intermediaries in providing short-term finance for use by business organisations. **(5 marks)**

(Total = 20 marks)

82 Pangli Co Mar/Jun 17 36 mins

It is the middle of December 20X6 and Pangli Co is looking at working capital management for January 20X7.

Forecast financial information at the start of January 20X7 is as follows:

Inventory	$455,000
Trade receivables	$408,350
Trade payables	$186,700
Overdraft	$240,250

All sales are on credit and they are expected to be $3.5m for 20X6. Monthly sales are as follows:

November 20X6 (actual)	$270,875
December 20X6 (forecast)	$300,000
January 20X7 (forecast)	$350,000

Pangli Co has a gross profit margin of 40%. Although Pangli Co offers 30 days credit, only 60% of customers pay in the month following purchase, while remaining customers take an additional month of credit.

Inventory is expected to increase by $52,250 during January 20X7.

Pangli Co plans to pay 70% of trade payables in January 20X7 and defer paying the remaining 30% until the end of February 20X7. All suppliers of the company require payment within 30 days. Credit purchases from suppliers during January 20X7 are expected to be $250,000.

Interest of $70,000 is due to be paid in January 20X7 on fixed rate bank debt. Operating cash outflows are expected to be $146,500 in January 20X7. Pangli Co has no cash and relies on its overdraft to finance daily operations. The company has no plans to raise long-term finance during January 20X7.

Assume that each year has 360 days.

Required

(a) (i) Calculate the cash operating cycle of Pangli Co at the start of January 20X7.

 (2 marks)

 (ii) Calculate the overdraft expected at the end of January 20X7. **(4 marks)**

 (iii) Calculate the current ratios at the start and end of January 20X7. **(4 marks)**

(b) Discuss FIVE techniques that Pangli Co could use in managing trade receivables.**(10 marks)**

 (Total = 20 marks)

83 WQZ Co (12/10, amended) 36 mins

WQZ Co is considering making the following changes in the area of working capital management:

Inventory management

It has been suggested that the order size for Product KN5 should be determined using the economic order quantity (EOQ) model.

WQZ Co forecasts that demand for Product KN5 will be 160,000 units in the coming year and it has traditionally ordered 10% of annual demand per order. The ordering cost is expected to be $400 per order while the holding cost is expected to be $5.12 per unit per year. A buffer inventory of 5,000 units of Product KN5 will be maintained, whether orders are made by the traditional method or using the EOQ model.

Receivables management

WQZ Co could introduce an early settlement discount of 1% for customers who pay within 30 days and, at the same time, through improved operational procedures, maintain a maximum

average payment period of 60 days for credit customers who do not take the discount. It is expected that 25% of credit customers will take the discount if it were offered.

It is expected that administration and operating cost savings of $753,000 per year will be made after improving operational procedures and introducing the early settlement discount.

Credit sales of WQZ Co are currently $87.6m per year and trade receivables are currently $18m. Credit sales are not expected to change as a result of the changes in receivables management. The company has a cost of short-term finance of 5.5% per year.

Required

(a) Calculate the cost of the current ordering policy and the change in the costs of inventory management that will arise if the EOQ is used to determine the optimum order size for Product KN5. **(5 marks)**

(b) Calculate and comment on whether the proposed changes in receivables management will be acceptable. Assuming that only 25% of customers take the early settlement discount, what is the maximum early settlement discount that could be offered? **(7 marks)**

(c) Discuss the factors that should be considered in formulating working capital policy on the management of trade receivables. **(8 marks)**

(Total = 20 marks)

84 Oscar Co (Sept/Dec 18) 36 mins

Oscar Co designs and produces tracking devices. The company is managed by its four founders, who lack business administration skills.

The company has revenue of $28m, and all sales are on 30 days' credit. Its major customers are large multinational car manufacturing companies and are often late in paying their invoices. Oscar Co is a rapidly growing company and revenue has doubled in the last four years. Oscar Co has focused in this time on product development and customer service, and managing trade receivables has been neglected.

Oscar Co's average trade receivables are currently $5.37m, and bad debts are 2% of credit sales revenue. Partly as a result of poor credit control, the company has suffered a shortage of cash and has recently reached its overdraft limit. The four founders have spent large amounts of time chasing customers for payment. In an attempt to improve trade receivables management, Oscar Co has approached a factoring company.

The factoring company has offered two possible options:

Option 1

Administration by the factor of Oscar Co's invoicing, sales accounting and receivables collection, on a full recourse basis. The factor would charge a service fee of 0.5% of credit sales revenue per year. Oscar Co estimates that this would result in savings of $30,000 per year in administration costs. Under this arrangement, the average trade receivables collection period would be 30 days.

Option 2

Administration by the factor of Oscar Co's invoicing, sales accounting and receivables collection on a non-recourse basis. The factor would charge a service fee of 1.5% of credit sales revenue per year. Administration cost savings and average trade receivables collection period would be as Option 1. Oscar Co would be required to accept an advance of 80% of credit sales when invoices are raised at an interest rate of 9% per year.

Oscar Co pays interest on its overdraft at a rate of 7% per year and the company operates for 365 days per year.

Required

(a) Calculate the costs and benefits of each of Option 1 and Option 2 and comment on your findings. **(8 marks)**

(b) Discuss reasons (other than costs and benefits already calculated) why Oscar Co may benefit from the services offered by the factoring company. (6 marks)

(c) Discuss THREE factors which determine the level of a company's investment in working capital. (6 marks)

(Total = 20 marks)

85 Wobnig Co (6/12, amended) 36 mins

The following financial information relates to Wobnig Co.

	20X1 $'000	20X0 $'000
Revenue	14,525	10,375
Cost of sales	(10,458)	(6,640)
Profit before interest and tax	4,067	3,735
Interest	355	292
Profit before tax	3,712	3,443
Taxation	(1,485)	(1,278)
Distributable profit	2,227	2,165

	20X1 $'000	20X1 $'000	20X0 $'000	20X0 $'000
Non-current assets		15,284		14,602
Current assets				
Inventory	2,149		1,092	
Trade receivables	3,200		1,734	
		5,349		2,826
Total assets		20,633		17,428
Equity				
Ordinary shares	8,000		8,000	
Reserves	4,268		3,541	
		12,268		11,541
Non-current liabilities				
7% bonds		4,000		4,000
Current liabilities				
Trade payables	2,865		1,637	
Overdraft	1,500		250	
		4,365		1,887
Total equity and liabilities		20,633		17,428

Average ratios for the last two years for companies with similar business operations to Wobnig Co are as follows:

Current ratio	1.7 times
Quick ratio	1.1 times
Inventory days	55 days
Trade receivables days	60 days
Trade payables days	85 days
Sales revenue/net working capital	10 times

Required

(a) Using suitable working capital ratios and analysis of the financial information provided, evaluate whether Wobnig Co can be described as overtrading (undercapitalised).

(12 marks)

(b) Critically discuss the similarities and differences between working capital policies in the following areas:

(i) Working capital investment

(ii) Working capital financing (8 marks)

(Total = 20 marks)

86 KXP Co (12/12, amended) 36 mins

KXP Co is an e-business which trades solely over the internet. In the last year the company had sales of $15m. All sales were on 30 days' credit to commercial customers.

Extracts from the company's most recent statement of financial position relating to working capital are as follows:

	$'000
Trade receivables	2,466
Trade payables	2,220
Overdraft	3,000

In order to encourage customers to pay on time, KXP Co proposes introducing an early settlement discount of 1% for payment within 30 days, while increasing its normal credit period to 45 days. It is expected that, on average, 50% of customers will take the discount and pay within 30 days, 30% of customers will pay after 45 days, and 20% of customers will not change their current paying behaviour.

KXP Co currently orders 15,000 units per month of Product Z, demand for which is constant. There is only one supplier of Product Z and the cost of Product Z purchases over the last year was $540,000. The supplier has offered a 2% discount for orders of Product Z of 30,000 units or more. Each order costs KXP Co $150 to place and the holding cost is 24 cents per unit per year. KXP Co has an overdraft facility charging interest of 6% per year.

Required

(a) Calculate the net benefit or cost of the proposed changes in trade receivables policy and comment on your findings. (5 marks)

(b) Calculate whether the bulk purchase discount offered by the supplier is financially acceptable and comment on the assumptions made by your calculation. (5 marks)

(c) Identify and discuss the factors to be considered in determining the optimum level of cash to be held by a company. (5 marks)

(d) Discuss the factors to be considered in formulating a trade receivables management policy. (5 marks)

(Total = 20 marks)

87 CSZ Co (6/14, amended) 36 mins

The current assets and liabilities of CSZ Co at the end of March 20X4 are as follows:

	$'000	$'000
Inventory	5,700	
Trade receivables	6,575	12,275
Trade payables	2,137	
Overdraft	4,682	6,819
Net current assets		5,456

For the year to end of March 20X4, CSZ Co had sales of $40m, all on credit, while cost of sales was $26m.

For the year to end of March 20X5, CSZ Co has forecast that credit sales will remain at $40m while cost of sales will fall to 60% of sales. The company expects current assets to consist of inventory and trade receivables, and current liabilities to consist of trade payables and the company's overdraft.

CSZ Co also plans to achieve the following target working capital ratio values for the year to the end of March 20X5:

Inventory days:	60 days
Trade receivables days:	75 days
Trade payables days:	55 days
Current ratio:	1.4 times

Required

(a) Calculate the working capital cycle (cash collection cycle) of CSZ Co at the end of March 20X4 and discuss whether a working capital cycle should be positive or negative. **(6 marks)**

(b) Calculate the target quick ratio (acid test ratio) and the target ratio of sales to net working capital of CSZ Co at the end of March 20X5. **(5 marks)**

(c) Analyse and compare the current asset and current liability positions for March 20X4 and March 20X5, and discuss how the working capital financing policy of CSZ Co would have changed. **(9 marks)**

(Total = 20 marks)

88 Flit Co (12/14, amended) 36 mins

Flit Co is preparing a cash flow forecast for the three-month period from January to the end of March. The following sales volumes have been forecast:

	December	January	February	March	April
Sales (units)	1,200	1,250	1,300	1,400	1,500

Notes

1 The selling price per unit is $800 and a selling price increase of 5% will occur in February. Sales are all on one month's credit.

2 Production of goods for sale takes place one month before sales.

3 Each unit produced requires two units of raw materials, costing $200 per unit. No raw materials inventory is held. Raw material purchases are on one month's credit.

4 Variable overheads and wages equal to $100 per unit are incurred during production, and paid in the month of production.

5 The opening cash balance at 1 January is expected to be $40,000.

6 A long-term loan of $300,000 will be received at the beginning of March.

7 A machine costing $400,000 will be purchased for cash in March.

Required

(a) Calculate the cash balance at the end of each month in the three-month period. **(5 marks)**

(b) Calculate the forecast current ratio at the end of the three-month period. **(2 marks)**

(c) Assuming that Flit Co expects to have a short-term cash surplus during the three-month period, discuss whether this should be invested in shares listed on a large stock market. **(3 marks)**

(d) Explain how the Baumol model can be employed to reduce the costs of cash management. **(5 marks)**

(e) Renpec Co, a subsidiary of Flit Co, has set a minimum cash account balance of $7,500. The average cost to the company of making deposits or selling investments is $18 per transaction and the standard deviation of its cash flows was $1,000 per day during the last year. The average interest rate on investments is 5.11%.

Determine the spread, the upper limit and the return point for the cash account of Renpec Co using the Miller-Orr model and explain the relevance of these values for the cash management of the company. **(5 marks)**

(Total = 20 marks)

89 Widnor Co (6/15, amended) 36 mins

The finance director of Widnor Co has been looking to improve the company's working capital management. Widnor Co has revenue from credit sales of $26,750,000 per year and, although its terms of trade require all credit customers to settle outstanding invoices within 40 days, on average customers have been taking longer. Approximately 1% of credit sales turn into bad debts which are not recovered.

Trade receivables currently stand at $4,458,000 and Widnor Co has a cost of short-term finance of 5% per year.

The finance director is considering a proposal from a factoring company, Nokfe Co, which was invited to tender to manage the sales ledger of Widnor Co on a with-recourse basis. Nokfe Co believes that it can use its expertise to reduce average trade receivables days to 35 days, while cutting bad debts by 70% and reducing administration costs by $50,000 per year. A condition of the factoring agreement is that the company would also advance Widnor Co 80% of the value of invoices raised at an interest rate of 7% per year. Nokfe Co would charge an annual fee of 0.75% of credit sales.

Assume that there are 360 days in each year.

Required

(a) Advise whether the factor's offer is financially acceptable to Widnor Co. **(7 marks)**

(b) Briefly discuss how the creditworthiness of potential customers can be assessed. **(3 marks)**

(c) Discuss how risks arising from granting credit to foreign customers can be managed and reduced. **(10 marks)**

(Total = 20 marks)

PART D: INVESTMENT APPRAISAL

Questions 90 to 165 cover Investment appraisal, the subject of Part D of the BPP Financial Management Workbook.

OTQ bank – Investment decisions 36 mins

The following information relates to questions 90 and 91.

NW Co is considering investing $46,000 in a new delivery lorry that will last for 4 years, after which time it will be sold for $7,000. Depreciation is charged on a straight-line basis. Forecast operating profits/(losses) to be generated by the machine are as follows.

Year	$
1	16,500
2	23,500
3	13,500
4	(1,500)

90 What is the return on capital employed (ROCE) for the lorry (using the average investment method, to the nearest %)?

| | % (2 marks)

91 Assuming operational cash flows arise evenly over the year, what is the payback period for this investment (to the nearest month)?

☐ 1 year 7 months

☐ 2 years 7 months

☐ 1 year 5 months

☐ 3 years 2 months (2 marks)

92 Which TWO of the following are benefits of the ROCE method of investment appraisal?

☐ It considers the whole project

☐ It is cash flow based

☐ It is a percentage which, being meaningful to non-finance professionals, helps communicate the benefits of investment decisions

☐ It will not be impacted by a company's accounting polices (2 marks)

93 SW Co has a barrel of chemicals in its warehouse that it purchased for a project a while ago at a cost of $1,000. It would cost $400 for a professional disposal company to collect the barrel and dispose of it safely. However, the chemicals could be used in a potential project which is currently being assessed.

What is the relevant cost of using the chemicals in a new project proposal?

☐ $1,000 cost

☐ $400 benefit

☐ $400 cost

☐ $Nil (2 marks)

94 A new project being considered by BLW Co would require 1,000 hours of skilled labour. The current workforce is already fully employed but more workers can be hired in at a cost of $20 per hour. The current workers are paid $15 per hour on a project that earns a contribution of $10 per hour.

What is the relevant cost of labour to be included in the project appraisal?

☐ $10,000

☐ $15,000

☐ $20,000

☐ $25,000 (2 marks)

95 LW Co has a half empty factory on which it pays $5,000 pa rent. If it takes on a new project, it will have to move to a new bigger factory costing $17,000 pa and it could rent the old factory out for $3,000 pa until the end of the current lease.

What is the rental cost to be included in the project appraisal?

☐ $14,000

☐ $17,000

☐ $9,000

☐ $19,000 (2 marks)

96 Which of the following is a drawback of the payback period method of investment appraisal?

☐ It is cash flow based

☐ It considers the time value of money

☐ It doesn't measure the potential impact on shareholder wealth

☐ It is profit based (2 marks)

97 A project has average estimated cash flows of $3,000 per year with an initial investment of $9,000.

Depreciation is straight-line with no residual value and the project has a five-year life span. The company has a target return on capital employed (ROCE) of 15% and a target payback period of 2.5 years. ROCE is based on initial investment.

Under which investment appraisal method(s), using the company's targets, will the project be accepted?

1 ROCE

2 Payback basis

☐ 1 only.

☐ 2 only.

☐ Both 1 and 2.

☐ Neither 1 nor 2. (2 marks)

98 EE Co is considering investing in a new 40-year project which will require an initial investment of $50,000 (with zero scrap value) and has a payback period of 20 years. The 40-year project has consistent cash flows each year.

What is the ROCE (using the average investment method, to one decimal place)?

[] %

(2 marks)

99 An accountant is paid $30,000 per year and spends 2 weeks working on appraising project Alpha.

Why should the accountant **NOT** charge half of her month's salary to the project?

☐ Because her salary cannot be apportioned

☐ Because her salary is not incremental

☐ Because her salary is not a cash flow

☐ Because her salary is an opportunity cost (2 marks)

(Total = 20 marks)

OTQ bank – Investment appraisal using DCF 36 mins

100 An investor has a cost of capital of 10%. She is due to receive a 5-year annuity starting in 3 years' time of $7,000 per year.

What lump sum amount would you need to offer today to make her indifferent between the annuity and your offer (to the nearest $)?

$ []

(2 marks)

101 A newspaper reader has won first prize in a national competition and they have a choice as to how they take the prize:

Option 1 Take $90,000 per year indefinitely starting in 3 years' time (and bequeath this right to their children and so on); or

Option 2 Take a lump sum of $910,000 in 1 year's time.

Assuming a cost of capital of 10%, which would you advise and why?

☐ Option 1 because $90,000 p.a. indefinitely is an infinite amount of money compared to a one-off payment

☐ Option 1 because it is worth more in present value terms

☐ Option 2 because it is worth more in present value terms

☐ Option 2 because the lump sum has the flexibility to be invested and earn a larger return than $90,000 p.a. (2 marks)

The following information relates to questions 102 and 103.

JCW Co is appraising an opportunity to invest in some new machinery that has the following cash flows.

Initial investment	$40,000
Net cash inflows for 5 years in advance	$12,000 per year
Decommissioning costs after 5 years	$15,000

102 At a cost of capital of 10% what is the net present value of this project (to the nearest $100)?

$ []

(2 marks)

103 What is the internal rate of return of the project, calculated using discount factors for 10% and 15% (to the nearest whole %)?

[] %

(2 marks)

104 Four mutually exclusive projects have been appraised using net present value (NPV), internal rate of return (IRR), return on capital employed (ROCE) and payback period (PP). The company objective is to maximise shareholder wealth.

Which should be chosen?

	NPV	IRR	ROCE	PP
☐ Project A	$1m	40%	34%	4 years
☐ Project B	$1.1m	24%	35%	2.5 years
☐ Project C	$0.9m	18%	25%	3 years
☐ Project D	$1.5m	12%	18%	7 years

(2 marks)

105 Which of the following are correct advantages of the IRR approach to investment appraisal, and which are not?

		Correct	Incorrect
1	Clear decision rule	☐	☐
2	Takes into account the time value of money	☐	☐
3	Assumes funds are reinvested at the IRR	☐	☐
4	Considers the whole project	☐	☐

(2 marks)

106 A project has an initial outflow followed by years of inflows.

What would be the effect on NPV and the IRR of an increase in the cost of capital?

Match the technique described to the expected impact from this increase.

Item
NPV
IRR

Impact
Increase
No change
Decrease

(2 marks)

107 A lease agreement has an NPV of ($26,496) at a rate of 8%. The lease involves an immediate down payment of $10,000 followed by 4 equal annual payments.

What is the amount of the annual payment?

☐ $11,020
☐ $4,981
☐ $11,513
☐ $14,039

(2 marks)

108 Which of the following statements about NPV and IRR is accurate?

☐ Two NPV calculations are needed to estimate the IRR using linear interpolation.

☐ The graphical approach to IRR is only an estimate; linear interpolation using the formula is required for a precise answer.

☐ The IRR is unique.

☐ An IRR graph with NPV on the 'Y' axis and discount rate on the 'X' axis will have a negative slope.

(2 marks)

109 Paulo plans to buy a holiday villa in five years' time for cash. He estimates the cost will be $1.5m. He plans to set aside the same amount of funds each year for five years, starting immediately and earning a rate of 10% interest per year compound.

To the nearest $100, how much does he need to set aside each year?

$ []

<div align="right">(2 marks)</div>

<div align="right">(Total = 20 marks)</div>

OTQ bank – Allowing for tax and inflation 36 mins

110 SW Co has a 31 December year end and pays corporation tax at a rate of 30%, 12 months after the end of the year to which the cash flows relate. It can claim tax-allowable depreciation at a rate of 25% reducing balance. It pays $1m for a machine on 31 December 20X4. SW Co's cost of capital is 10%.

What is the present value on 31 December 20X4 of the benefit of the first portion of tax-allowable depreciation?

☐ $250,000

☐ $227,250

☐ $68,175

☐ $75,000 (2 marks)

111 A company receives a perpetuity of $20,000 per year in arrears, and pays 30% corporation tax 12 months after the end of the year to which the cash flows relate.

At a cost of capital of 10%, what is the after-tax present value of the perpetuity?

☐ $140,000

☐ $145,454

☐ $144,000

☐ $127,274 (2 marks)

112 A project has the following projected cash inflows.

Year 1 100,000
Year 2 125,000
Year 3 105,000

Working capital is required to be in place at the start of each year equal to 10% of the cash inflow for that year. The cost of capital is 10%.

What is the present value of the working capital?

☐ $Nil

☐ $(30,036)

☐ $(2,735)

☐ $33,000 (2 marks)

113 AW Co needs to have $100,000 working capital in place immediately for the start of a 2-year project. The amount will stay constant in real terms. Inflation is running at 10% per year, and AW Co's money cost of capital is 12%.

What is the present value of the cash flows relating to working capital?

- ☐ $(21,260)
- ☐ $(20,300)
- ☐ $(108,730)
- ☐ $(4,090) (2 marks)

114 NCW Co is considering investing $10,000 immediately in a 1-year project with the following cash flows.

Income $100,000

Expenses $35,000

The cash flows will arise at the end of the year. The above are stated in current terms. Income is subject to 10% inflation; expenses will not vary. The real cost of capital is 8% and general inflation is 2%.

Using the money cost of capital to the nearest whole percentage, what is the **NET** present value of the project?

- ☐ $68,175
- ☐ $60,190
- ☐ $58,175
- ☐ $78,175 (2 marks)

115 AM Co will receive a perpetuity starting in 2 years' time of $10,000 per year, increasing by the rate of inflation (which is 2%).

What is the present value of this perpetuity assuming a money cost of capital of 10.2%?

- ☐ $90,910
- ☐ $125,000
- ☐ $115,740
- ☐ $74,403 (2 marks)

116 FW Co is expecting a receipt of $10,000 (in real terms) in 1 year's time.

If FW Co expects inflation to increase, and receipts are expected to rise in line with the general rate of inflation, what impact will this have on the present value of that receipt?

- ☐ Nil
- ☐ Reduce
- ☐ Increase
- ☐ Cannot say (2 marks)

117 Shadowline Co has a money cost of capital of 10%. If inflation is 4%, what is Shadowline Co's real cost of capital (to one decimal place)?

[] %

(2 marks)

118 Juicy Co is considering investing in a new industrial juicer for use on a new contract. It will cost $150,000 and will last 2 years. Juicy Co pays corporation tax at 30% (as the cash flows occur) and, due to the health benefits of juicing, the machine attracts 100% tax-allowable depreciation immediately.

Given a cost of capital of 10%, what is the minimum value of the pre-tax contract revenue receivable in two years which would be required to recover the net cost of the juicer?

☐ $150,000

☐ $105,000

☐ $127,050

☐ $181,500

(2 marks)

119 Which of the following is true about the 'inflation' figure that is included in the money cost of capital?

☐ It is historic and specific to the business

☐ It is historic general inflation suffered by the investors

☐ It is expected and specific to the business

☐ It is expected general inflation suffered by the investors

(2 marks)

(Total = 20 marks)

OTQ bank – Project appraisal and risk **18 mins**

120 Are the following statements true or false? 6/15

		True	False
1	The sensitivity of a project variable can be calculated by dividing the project netpresent value by the present value of the cash flows relating to that project variable.	☐	☐
2	The expected net present value is the value expected to occur if an investment project with several possible outcomes is undertaken once.	☐	☐
3	The discounted payback period is the time taken for the cumulative net present value to change from negative to positive.	☐	☐

121 An investment project has a cost of $12,000, payable at the start of the first year of
 operation. The possible future cash flows arising from the investment project have the
 following present values and associated probabilities: 6/15

PV of Year 1 cash flow $	Probability	PV of Year 2 cash flow $	Probability
16,000	0.15	20,000	0.75
12,000	0.60	(2,000)	0.25
(4,000)	0.25		

 What is the expected value of the net present value of the investment project (to the
 nearest $100)?

 $ [] (2 marks)

122 SAC Co has a cost of capital of 8% and is appraising project Gamma. It has the following
 cash flows.

 T0 Investment 100,000

 T1–5 Net cash inflow 40,000

 What is the adjusted payback period for this project?

 ☐ 2.5 years

 ☐ Just under 3 years

 ☐ 2 years

 ☐ Just over 4 years (2 marks)

123 A project has the following cash flows.

 T0 Outflow $110,000

 T1–4 Inflow $40,000

 At the company's cost of capital of 10% the NPV of the project is $16,800.

 Applying sensitivity analysis to the cost of capital, what percentage change in the cost of
 capital would cause the project NPV to fall to zero?

 ☐ 70%

 ☐ 17%

 ☐ 5%

 ☐ 41% (2 marks)

BPP
LEARNING
MEDIA

124 A company has calculated the NPV of a new project as follows:

	Present value $'000
Sales revenue	4,000
Variable costs	(2,000)
Fixed costs	(500)
Corporation tax at 20%	(300)
Initial outlay	(1,000)
NPV	200

What is the sensitivity of the project decision to a change in sales volume?

☐ 12.5%

☐ 6.3%

☐ 10.0%

☐ 5.0% (2 marks)

(Total = 10 marks)

OTQ bank – Specific investment decisions 36 mins

125 Which of the following statements is correct? 12/14

☐ Tax-allowable depreciation is a relevant cash flow when evaluating borrowing to buy compared to leasing as a financing choice.

☐ Asset replacement decisions require relevant cash flows to be discounted by the after-tax cost of debt.

☐ If capital is rationed, divisible investment projects can be ranked by the profitability index when determining the optimum investment schedule.

☐ Government restrictions on bank lending are associated with soft capital rationing.

(2 marks)

126 PD Co is deciding whether to replace its delivery vans every year or every other year. The initial cost of a van is $20,000. Maintenance costs would be nil in the first year, and $5,000 at the end of the second year. Secondhand value would fall from $10,000 to $8,000 if it held onto the van for 2 years instead of just 1. PD Co's cost of capital is 10%.

How often should PD Co replace its vans, and what is the equivalent annual cost (EAC) of that option?

Replace every EAC

 Year $

☐ 1 10,910

☐ 1 12,002

☐ 2 10,093

☐ 2 8,761 (2 marks)

127 A lease versus buy evaluation has been performed. The management accountant performed the calculation by taking the saved initial outlay and deducting the tax-adjusted lease payments and the lost capital allowances. The accountant discounted the net cash flows at the post-tax cost of borrowing. The resultant net present value (NPV) was positive.

Assuming the calculation is free from arithmetical errors, what would the conclusion for this decision be?

- [] Lease is better than buy
- [] Buy is better than lease
- [] A further calculation is needed
- [] The discount rate was wrong so a conclusion cannot be drawn **(2 marks)**

128 AB Co is considering either leasing an asset or borrowing to buy it, and is attempting to analyse the options by calculating the NPV of each. When comparing the two, AB Co is uncertain whether it should include interest payments in its option to 'borrow and buy' as it is a future, incremental cash flow associated with that option. AB Co is also uncertain which discount rate to use in the NPV calculation for the lease option.

How should AB Co treat the interest payments and what discount rate should it use?

	Include interest?	Discount rate
[]	Yes	After tax cost of the loan if they borrow and buy
[]	Yes	AB Co's weighted average cost of capital
[]	No	After-tax cost of the loan if they borrow and buy
[]	No	AB Co's weighted after cost of capital

(2 marks)

129 Which of the following is always true about capital rationing?

		True	False
1	The profitability index is suitable for handling multiple-period capital rationing problems if projects are divisible.	[]	[]
2	Projects being divisible is an unrealistic assumption.	[]	[]

(2 marks)

The following information relates to questions 130 and 131.

NB Co is faced with an immediate capital constraint of $100m available to invest.

It is considering investing in four divisible projects:

	Initial cost $m	NPV $m
Project 1	40	4
Project 2	30	5
Project 3	50	6
Project 4	60	5

130 What is the NPV generated from the optimum investment programme?

$ [] m

(2 marks)

131 What is the NPV generated from the optimum investment programme if the projects were indivisible?

$ [] m

(2 marks)

132 Which of the following is potentially a benefit to the lessee if they lease as opposed to buy?

☐ Avoiding tax exhaustion

☐ Attracting lease customers that may not have been otherwise possible

☐ Exploiting a low cost of capital

☐ Potential future scrap proceeds

(2 marks)

133 A professional kitchen is attempting to choose between gas and electricity for its main heat source. Once a choice is made, the kitchen intends to keep to that source indefinitely. Each gas oven has an NPV of $50,000 over its useful life of 5 years. Each electric oven has an NPV of $68,000 over its useful life of 7 years. The cost of capital is 8%.

Which should the kitchen choose and why?

☐ Gas because its average NPV per year is higher than electric

☐ Electric because its NPV is higher than gas

☐ Electric because its equivalent annual benefit is higher

☐ Electric because it lasts longer than gas

(2 marks)

134 Which TWO of the following are typically benefits of a shorter replacement cycle?

☐ Higher scrap value

☐ Better company image and efficiency

☐ Lower annual depreciation

☐ Less time to benefit from owning the asset

(2 marks)

(Total = 20 marks)

Section B questions

Sensitivity analysis

The following scenario relates to questions 135–139.

A company is considering a project with the following cash flows.

Year	Initial investment $'000	Variable costs $'000	Cash inflows $'000	Net cash flows $'000
0	(11,000)			(11,000)
1		(3,200)	10,300	7,100
2		(3,200)	10,300	7,100

Cash flows arise from selling 1,030,000 units at $10 per unit. The company has a cost of capital of 9%.

The net present value (NPV) of the project is $1,490.

135 What is the sensitivity of the project to changes in sales volume (to one decimal place)?

☐ 8.2%

☐ 8.4%

☐ 11.9%

☐ 26.5% (2 marks)

136 What is the discounted payback of the project?

☐ 1.18 years

☐ 1.25 years

☐ 1.55 years

☐ 1.75 years (2 marks)

137 What is the internal rate of return (IRR) of the project (using discount rates of 15% and 20%)?

☐ 18.9%

☐ 21.2%

☐ 24.2%

☐ 44.3% (2 marks)

138 Which of the following statements is true? 12/15

☐ The sensitivity of NPV to a change in sales volume can be calculated as NPV divided by the present value of future sales income.

☐ The certainty equivalent approach converts risky cash flows into riskless equivalent amounts which are discounted by a capital asset pricing model (CAPM) derived project-specific cost of capital.

☐ Using random numbers to generate possible values of project variables, a simulation model can generate a standard deviation of expected project outcomes.

☐ The problem with risk and uncertainty in investment appraisal is that neither can be quantified or measured. (2 marks)

139 Which **TWO** of the following statements are true of the IRR and the NPV methods of appraisal?

☐ IRR ignores the relative sizes of investments

☐ IRR is easy to use where there are non-conventional cash flows (eg cash flow changes from negative to positive and then back to negative over time)

☐ NPV is widely used in practice

☐ IRR is technically superior to NPV

(2 marks)

(Total = 10 marks)

Guilder Co 18 mins

The following scenario relates to questions 140–144.

Guilder Co is appraising four different projects but is experiencing capital rationing in Year 0. No capital rationing is expected in future periods but none of the four projects that Guilder Co is considering can be postponed, so a decision must be made now. Guilder Co's cost of capital is 12%.

The following information is available.

Project	Outlay in Year 0 $	PV $	NPV $
Amster	100,000	111,400	11,400
Eind	56,000	62,580	6,580
Utrec	60,000	68,760	8,760
Tilbur	90,000	102,400	12,400

140 Arrange the projects in order of their preference to Guilder using the profitability index, with the most attractive first.

Order of preference (1, 2 etc)

Amster ☐

Eind ☐

Utrec ☐

Tilbur ☐

(2 marks)

141 Which of the following statements about Guilder Co's decision to use PI is true?

☐ The PI takes account of the absolute size of the individual projects.

☐ PI highlights the projects which are slowest in generating returns.

☐ PI can only be used if projects are divisible.

☐ PI allows for uncertainty about the outcome of each project. (2 marks)

142 Several years later, there is no capital rationing and Guilder Co decides to replace an existing machine. Guilder Co has the choice of either a Super machine (lasting four years) or a Great machine (lasting three years).

The following present value table includes the figures for a Super machine.

	0	1	2	3	4
Maintenance costs		(20,000)	(29,000)	(32,000)	(35,000)
Investment and scrap	(250,000)				25,000
Net cash flow	(250,000)	(20,000)	(29,000)	(32,000)	(10,000)
Discount at 12%	1.000	0.893	0.797	0.712	0.636
Present values	(250,000)	(17,860)	(23,113)	(22,784)	(6,360)

Tax and tax-allowable depreciation should be ignored.

What is the equivalent annual cost (EAC) of the Super machine (to the nearest whole number)?

$ []

(2 marks)

143 Which of the following statements concerning Guilder Co's use of the EAC are true?

1 The use of equivalent annual cost is appropriate in periods of high inflation.

2 The EAC method assumes that the machine can be replaced by exactly the same machine in perpetuity.

☐ Both statements are true

☐ Both statements are false

☐ Statement 1 is true and statement 2 is false

☐ Statement 1 is false and statement 2 is true

(2 marks)

144 The following potential cash flows are predicted for maintenance costs for the Great machine:

Year	Cash flow $	Probability
2	19,000	0.55
2	26,000	0.45
3	21,000	0.3
3	25,000	0.25
3	31,000	0.45

What is the expected present value of the maintenance costs for Year 2 (to the nearest whole number)?

$ []

(2 marks)

Trecor Co (Specimen exam 2007, amended) 18 mins

The following scenario relates to questions 145–149.

Trecor Co plans to buy a machine costing $250,000 which will last for 4 years and then be sold for $5,000.

Net cash flows before tax are expected to be as follows.

	T_1	T_2	T_3	T_4
Net cash flow $	122,000	143,000	187,000	78,000

Depreciation is charged on a straight-line basis over the life of an asset.

145 Calculate the before-tax return on capital employed (accounting rate of return) based on the average investment (to the nearest whole percentage).

□ %

(2 marks)

146 Are the following statements on return on capital employed (ROCE) true or false?

		True	False
1	If ROCE is less than the target ROCE then the purchase of the machine can be recommended.	□	□
2	ROCE can be used to compare two mutually exclusive projects.	□	□

(2 marks)

147 Trecor Co can claim tax-allowable depreciation on a 25% reducing balance basis. It pays tax at an annual rate of 30% one year in arrears.

What amount of tax relief would be received by Trecor in time 4 of a net present value (NPV) calculation?

$ □

(2 marks)

148 What is the payback period for the machine (to the nearest whole month)?

□ year(s) □ month(s)

(2 marks)

149 Which **TWO** of the following statements about the internal rate of return (IRR) are **TRUE**?

□ IRR ignores the relative sizes of investments.

□ IRR measures the increase in company value.

□ IRR can incorporate discount rate changes during the life of the project.

□ IRR and NPV sometimes give conflicting rankings over which project should be prioritised.

(2 marks)

(Total = 10 marks)

BRT Co (6/11, amended)

18 mins

The following scenario relates to questions 150–154.

BRT Co has developed a new confectionery line that can be sold for $5.00 per box and that is expected to have continuing popularity for many years. The finance director has proposed that investment in the new product should be evaluated over a four-year time-horizon, even though sales would continue after the fourth year, on the grounds that cash flows after four years are too uncertain to be included.

The variable cost (in current price terms) will depend on sales volume, as follows.

Sales volume (boxes)	Less than 1 million	1–1.9 million	2–2.9 million	3–3.9 million
Variable cost ($ per box)	2.80	3.00	3.00	3.05

Forecast sales volumes are as follows.

Year	1	2	3	4
Demand (boxes)	0.7 million	1.6 million	2.1 million	3.0 million

Tax

Tax-allowable depreciation on a 25% reducing balance basis could be claimed on the cost of equipment. Profit tax of 30% per year will be payable one year in arrears. A balancing allowance would be claimed in the fourth year of operation.

Inflation

The average general level of inflation is expected to be 3% per year for the selling price and variable costs. BRT Co uses a nominal after-tax cost of capital of 12% to appraise new investment projects.

A trainee accountant at BRT Co has started a spreadsheet to calculate the net present value (NPV) of a proposed new project.

	A	B	C	D	E	F	G
1	Year	0	1	2	3	4	5
2		$'000	$'000	$'000	$'000	$'000	$'000
3	Inflated sales						
4	Inflated variable costs						
5	Fixed costs		(1,030)	(1,910)	(3,060)	(4,277)	
6	Net cash flow		556	1,485	1,530	2,308	
7	Taxation						
8	Tax benefits						
9	Working capital	(750)	(23)	(23)	(24)	750	
10	Investment	(2,000)					
11	Project cash flows						
12	Discount factor 12%	1.000	0.893	0.797	0.712	0.636	0.567
13	Present value						

150 What is the sales figure for Year 2 (cell D3 in the spreadsheet), to the nearest $'000?

$ []

(2 marks)

151 What are the variable costs for Year 3 (cell E4 in the spreadsheet), to the nearest $'000?

$ []

(2 marks)

152 What are the tax benefits generated by the tax-allowable depreciation on the equipment in Year 4 (cell F8), to the nearest $'000?

$ []

(2 marks)

153 Which of the following statements about the project appraisal are true/false?

		True	False
1	The trainee accountant has used the wrong percentage for the cost of capital.	☐	☐
2	Ignoring sales after four years underestimates the value of the project.	☐	☐
3	The working capital figure in Year 4 is wrong.	☐	☐

(2 marks)

154 The trainee accountant at BRT Co has calculated the internal rate of return (IRR) for the project.

Are the following statements true or false?

1 When cash flow patterns are conventional, the NPV and IRR methods will give the same accept or reject decision.

2 The project is financially viable under IRR if it exceeds the cost of capital.

☐ Both statements are true

☐ Both statements are false

☐ Statement 1 is true and statement 2 is false

☐ Statement 2 is true and statement 1 is false

(2 marks)

(Total = 10 marks)

Section C questions

155 Melanie Co (Sept/Dec 18) 36 mins

Melanie Co is considering the acquisition of a new machine with an operating life of three years. The new machine could be leased for three payments of $55,000, payable annually in advance.

Alternatively, the machine could be purchased for $160,000 using a bank loan at a cost of 8% per year. If the machine is purchased, Melanie Co will incur maintenance costs of $8,000 per year, payable at the end of each year of operation. The machine would have a residual value of $40,000 at the end of its three-year life.

Melanie Co's production manager estimates that if maintenance routines were upgraded, the new machine could be operated for a period of four years with maintenance costs increasing to $12,000 per year, payable at the end of each year of operation. If operated for four years, the machine's residual value would fall to $11,000.

Taxation should be ignored.

Required

(a) (i) Assuming that the new machine is operated for a three-year period, evaluate whether Melanie Co should use leasing or borrowing as a source of finance.

 (6 marks)

 (ii) Using a discount rate of 10%, calculate the equivalent annual cost of purchasing and operating the machine for both three years and four years, and recommend which replacement interval should be adopted. **(6 marks)**

(b) Critically discuss FOUR reasons why NPV is regarded as superior to IRR as an investment appraisal technique. **(8 marks)**

 (Total = 20 marks)

156 Project E (6/14, amended) 36 mins

Project E is a strategically important project which the board of OAP Co has decided must be undertaken in order for the company to remain competitive, regardless of its financial acceptability. The project has a life of four years. Information relating to the future cash flows of this project are as follows:

Year	1	2	3	4
Sales volume (units)	12,000	13,000	10,000	10,000
Selling price ($/unit)	450	475	500	570
Variable cost ($/unit)	260	280	295	320
Fixed costs ($'000)	750	750	750	750

These forecasts are before taking into account of selling price inflation of 5.0% per year, variable cost inflation of 6.0% per year and fixed cost inflation of 3.5% per year. The fixed costs are incremental fixed costs which are associated with Project E. At the end of 4 years, machinery from the project will be sold for scrap with a value of $400,000. Tax-allowable depreciation on the initial investment cost of Project E is available on a 25% reducing balance basis and OAP Co pays corporation tax of 28% per year, one year in arrears. A balancing charge or allowance is available at the end of the fourth year of operation.

OAP Co has a nominal after-tax cost of capital of 13% per year. The initial investment for Project E is $5,000,000.

Required

(a) Calculate the nominal after-tax net present value of Project E and comment on the
 financial acceptability of this project. (14 marks)

(b) Discuss the reasons why the board of OAP Co may decide to limit the funds that are
 available to finance projects. (6 marks)

(Total = 20 marks)

157 AGD Co (FMC, 12/05, amended) 36 mins

AGD Co is a profitable company which is considering the purchase of a machine costing
$320,000. If purchased, AGD Co would incur annual maintenance costs of $25,000. The
machine would be used for 3 years and at the end of this period would be sold for $50,000.
Alternatively, the machine could be obtained under a 3-year lease for an annual lease rental of
$120,000 per year, payable in advance. The lease agreement would also provide insurance and
maintenance for a three-year period. The lease also contains an annual break clause allowing the
lease to be exited at the lessee's discretion.

AGD Co can claim tax-allowable depreciation on a 25% reducing balance basis. The company
pays tax on profits at an annual rate of 30% and all tax liabilities are paid one year in arrears.
AGD Co has an accounting year that ends on 31 December. If the machine is purchased,
payment will be made in January of the first year of operation. If leased, annual lease rentals will
be paid in January of each year of operation.

Required

(a) Using an after-tax borrowing rate of 7%, evaluate whether AGD Co should purchase or
 lease the new machine. (12 marks)

(b) Discuss whether the lease may also provide non-financial benefits. (5 marks)

(c) Explain the difference between risk and uncertainty in the context of investment appraisal.

(3 marks)

(Total = 20 marks)

158 Basril Co (FMC, 12/03, amended) 36 mins

Basril Co is reviewing investment proposals that have been submitted by divisional managers. The
investment funds of the company are limited to $800,000 in the current year. Details of three
possible investments, none of which can be delayed, are given below.

Project 1

An investment of $300,000 in workstation assessments. Each assessment would be on an
individual employee basis and would lead to savings in labour costs from increased efficiency and
from reduced absenteeism due to work-related illness. Savings in labour costs from these
assessments in money terms are expected to be as follows:

Year	1	2	3	4	5
Cash flows ($'000)	85	90	95	100	95

Project 2

An investment of $450,000 in individual workstations for staff that is expected to reduce
administration costs by $140,800 per year in money terms for the next 5 years.

Project 3

An investment of $400,000 in new ticket machines. Net cash savings of $120,000 per year are
expected in current price terms and these are expected to increase by 3.6% per year due to
inflation during the 5-year life of the machines.

Basril Co has a money cost of capital of 12% and taxation should be ignored.

Required

(a) Determine the best way for Basril Co to invest the available funds and calculate the resultant net present value:

 (i) On the assumption that each of the three projects is divisible. **(7 marks)**

 (ii) On the assumption that none of the projects are divisible. **(3 marks)**

(b) Explain how cash shortages can restrict the investment opportunities of a business.
(5 marks)

(c) Discuss the meaning of the term 'relevant cash flows' in the context of investment appraisal, giving examples to illustrate your discussion. **(5 marks)**

(Total = 20 marks)

159 Degnis Co (Mar/June 16, amended)　　　36 mins

Degnis Co is a company which installs kitchens and bathrooms to customer specifications. It is planning to invest $4,000,000 in a new facility to convert vans and trucks into motorhomes. Each motorhome will be designed and built according to customer requirements.

Degnis Co expects motorhome production and sales in the first four years of operation to be as follows.

Year	1	2	3	4
Motorhomes produced and sold	250	300	450	450

The selling price for a motorhome depends on the van or truck which is converted, the quality of the units installed and the extent of conversion work required.

Degnis Co has undertaken research into likely sales and costs of different kinds of motorhomes which could be selected by customers, as follows:

Motorhome type:	Basic	Standard	Deluxe
Probability of selection	20%	45%	35%
Selling price ($/unit)	30,000	42,000	72,000
Conversion cost ($/unit)	23,000	29,000	40,000

Fixed costs of the production facility are expected to depend on the volume of motorhome production as follows:

Production volume (units/year)	200–299	300–399	400–499
Fixed costs ($'000/year)	4,000	5,000	5,500

Degnis Co pays corporation tax of 28% per year, with the tax liability being settled in the year in which it arises. The company can claim tax-allowable depreciation on the cost of the investment on a straight-line basis over ten years.

Degnis Co evaluates investment projects using an after-tax discount rate of 11%.

Required

(a) Calculate the expected net present value of the planned investment for the first four years of operation. **(7 marks)**

After the fourth year of operation, Degnis Co expects to continue to produce and sell 450 motorhomes per year for the foreseeable future.

Required

(b) Calculate the effect on the expected net present value of the planned investment of continuing to produce and sell motorhomes beyond the first four years and comment on the financial acceptability of the planned investment. **(3 marks)**

(c) Critically discuss the use of probability analysis in incorporating risk into investment appraisal. **(5 marks)**

(d) Discuss the reasons why investment finance may be limited, even when a company has attractive investment opportunities available to it. **(5 marks)**

(Total = 20 marks)

160 Pinks Co (Mar/Jun 2019) 36 mins

Pinks Co is a large company listed on a major stock exchange. In recent years, the board of Pinks Co has been criticised for weak corporate governance and two of the company's non-executive directors have just resigned. A recent story in the financial media has criticised the performance of Pinks Co and claims that the company is failing to satisfy the objectives of its key stakeholders.

Pinks Co is appraising an investment project which it hopes will boost its performance. The project will cost $20 million, payable in full at the start of the first year of operation. The project life is expected to be four years. Forecast sales volumes, selling price, variable cost and fixed costs are as follows:

Year	1	2	3	4
Sales (units/year)	300,000	410,000	525,000	220,000
Selling price ($/unit)	125	130	140	120
Variable cost ($/unit)	71	71	71	71
Fixed costs ($'000/year)	3,000	3,100	3,200	3,000

Selling price and cost information are in current price terms, before applying selling price inflation of 5% per year, variable cost inflation of 3.5% per year and fixed cost inflation of 6% per year.

Pinks Co pays corporation tax of 26%, with the tax liability being settled in the year in which it arises. The company can claim tax-allowable depreciation on the full initial investment of $20 million on a 25% reducing balance basis. The investment project is expected to have zero residual value at the end of four years.

Pinks Co has a nominal after-tax cost of capital of 12% and a real after-tax cost of capital of 8%. The general rate of inflation is expected to be 3.7% per year for the foreseeable future.

Required

(a) (i) Calculate the nominal net present value of Pinks Co's investment project. **(8 marks)**

 (ii) Calculate the real net present value of Pinks Co's investment project and comment on your findings. **(4 marks)**

(b) Discuss **FOUR** ways to encourage managers to achieve stakeholder objectives.

 (8 marks)

 (Total = 20 marks)

161 Copper Co (Mar/Jun 18) 36 mins

Copper Co is concerned about the risk associated with a proposed investment and is looking for ways to incorporate risk into its investment appraisal process.

The company has heard that probability analysis may be useful in this respect and so the following information relating to the proposed investment has been prepared:

Year 1		Year 2	
Cash flow ($)	Probability	Cash flow ($)	Probability
1,000,000	0.1	2,000,000	0.3
2,000,000	0.5	3,000,000	0.6
3,000,000	0.4	5,000,000	0.1

However, the company is not sure how to interpret the results of an investment appraisal based on probability analysis.

The proposed investment will cost $3.5m, payable in full at the start of the first year of operation. Copper Co uses a discount rate of 12% in investment appraisal.

Required

(a) Using a joint probability table:

 (i) Calculate the mean (expected) NPV of the proposed investment. **(8 marks)**

 (ii) Calculate the probability of the investment having a negative NPV. **(1 mark)**

 (iii) Calculate the NPV of the most likely outcome. **(1 mark)**

 (iv) Comment on the financial acceptability of the proposed investment. **(2 marks)**

(b) Discuss **TWO** of the following methods of adjusting for risk and uncertainty in investment appraisal:

 (i) Simulation

 (ii) Adjusted payback

 (iii) Risk-adjusted discount rates **(8 marks)**

(Total = 20 marks)

162 Uftin Co (12/14, amended) 36 mins

Uftin Co is a large company which is listed on a major stock market. The company has been evaluating an investment proposal to manufacture Product K3J. The initial investment of $1,800,000 will be payable at the start of the first year of operation. The following draft evaluation has been prepared by a junior employee.

Year	1	2	3	4
Sales (units/year)	95,000	100,000	150,000	150,000
Selling price ($/unit)	25	25	26	27
Variable costs ($/unit)	11	12	12	13

Note. The above selling prices and variable costs per unit have not been inflated.

	$'000	$'000	$'000	$'000
Sales revenue	2,475	2,605	4,064	4,220
Variable costs	(1,097)	(1,260)	(1,890)	(2,048)
Fixed costs	(155)	(155)	(155)	(155)
Interest payments	(150)	(150)	(150)	(150)
Cash flow before tax	1,073	1,040	1,869	1,867
Tax-allowable depreciation	(450)	(450)	(450)	(450)
Taxable profit	623	590	1,419	1,417
Taxation		(137)	(130)	(312)
Net cash flow	623	453	1,289	1,105
Discount at 12%	0.893	0.797	0.712	0.636
Present values	556	361	918	703

	$'000
Present value of cash inflows	2,538
Cost of machine	(1,800)
NPV	738

The junior employee also provided the following information:

(1) Relevant fixed costs are forecast to be $150,000 per year.

(2) Sales and production volumes are the same and no finished goods inventory is held.

(3) The corporation tax rate is 22% per year and tax liabilities are payable one year in arrears.

(4) Uftin Co can claim tax-allowable depreciation of 25% per year on a reducing balance basis on the initial investment.

(5) A balancing charge or allowance can be claimed at the end of the fourth year.

(6) It is expected that selling price inflation will be 4.2% per year, variable cost inflation will be 5% per year and fixed cost inflation will be 3% per year.

(7) The investment has no scrap value.

(8) The investment will be partly financed by a $1,500,000 loan at 10% per year.

(9) Uftin Co has a weighted average cost of capital of 12% per year.

Required

(a) Prepare a revised draft evaluation of the investment proposal and comment on its financial acceptability. (11 marks)

(b) Explain any **TWO** revisions you have made to the draft evaluation in part (a) above.
 (4 marks)

(c) Discuss **TWO** ways of incorporating risk into the investment appraisal process. (5 marks)

 (Total = 20 marks)

163 Hraxin Co (6/15, amended) **36 mins**

Hraxin Co is appraising an investment project which has an expected life of four years and which will not be repeated. The initial investment, payable at the start of the first year of operation, is $5m. Scrap value of $500,000 is expected to arise at the end of 4 years.

There is some uncertainty about what price can be charged for the units produced by the investment project, as this is expected to depend on the future state of the economy. The following forecast of selling prices and their probabilities has been prepared:

Future economic state	Weak	Medium	Strong
Probability of future economic state	35%	50%	15%
Selling price in current price terms	$25 per unit	$30 per unit	$35 per unit

These selling prices are expected to be subject to annual inflation of 4% per year, regardless of which economic state prevails in the future.

Forecast sales and production volumes, and total nominal variable costs, have already been forecast, as follows:

Year	1	2	3	4
Sales and production (units)	150,000	250,000	400,000	300,000
Nominal variable cost ($'000)	2,385	4,200	7,080	5,730

Incremental overheads of $400,000 per year in current price terms will arise as a result of undertaking the investment project. A large proportion of these overheads relate to energy costs which are expected to increase sharply in the future because of energy supply shortages, so overhead inflation of 10% per year is expected.

The initial investment will attract tax-allowable depreciation on a straight-line basis over the four-year project life. The rate of corporation tax is 30% and tax liabilities are paid in the year in which they arise. Hraxin Co has traditionally used a nominal after-tax discount rate of 11% per year for investment appraisal.

Required

(a) Calculate the expected net present value of the investment project and comment on its financial acceptability. (9 marks)

(b) Distinguish between risk and uncertainty and briefly explain why they should be considered in the investment appraisal process. (5 marks)

(c) Critically discuss if sensitivity analysis will assist Hraxin Co in assessing the risk of the investment project. (6 marks)

 (Total = 20 marks)

164 Vyxyn Co (Mar/Jun 17) 36 mins

Vyxyn Co is evaluating a planned investment in a new product costing $20m, payable at the start of the first year of operation. The product will be produced for four years, at the end of which production will cease. The investment project will have a terminal value of zero. Financial information relating to the investment project is as follows:

Year	1	2	3	4
Sales volume (units/year)	440,000	550,000	720,000	400,000
Selling price ($/unit)	26.50	28.50	30.00	26.00
Fixed cost ($/year)	1,100,000	1,121,000	1,155,000	1,200,00

These selling prices have not yet been adjusted for selling price inflation, which is expected to be 3.5% per year. The annual fixed costs are given above in nominal terms.

Variable cost per unit depends on whether competition is maintained between suppliers of key components. The purchasing department has made the following forecast:

Competition	Strong	Moderate	Weak
Probability	45%	35%	20%
Variable cost ($/unit)	10.80	12.00	14.70

The variable costs in this forecast are before taking account of variable cost inflation of 4.0% per year.

Vyxyn Co can claim tax-allowable depreciation on a 25% per year reducing balance basis on the full investment cost of $20m and pays corporation tax of 28% per year one year in arrears.

It is planned to finance the investment project with an issue of 8% loan notes, redeemable in ten years' time. Vyxyn Co has a nominal after-tax weighted average cost of capital of 10%, a real after-tax weighted average cost of capital of 7% and a cost of equity of 11%.

Required

(a) Discuss the difference between risk and uncertainty in relation to investment appraisal.
 (3 marks)

(b) Calculate the expected net present value of the investment project and comment on its financial acceptability and on the risk relating to variable cost. (9 marks)

(c) Critically discuss how risk can be considered in the investment appraisal process. (8 marks)

 (Total = 20 marks)

165 Pelta Co (Sep/Dec 17) 36 mins

The directors of Pelta Co are considering a planned investment project costing $25m, payable at the start of the first year of operation. The following information relates to the investment project:

	Year 1	Year 2	Year 3	Year 4
Sales volume (units/year)	520,000	624,000	717,000	788,000
Selling price ($/unit)	30.00	30.00	30.00	30.00
Variable costs ($/unit)	10.00	10.20	10.61	10.93
Fixed costs ($/year)	700,000	735,000	779,000	841,000

This information needs adjusting to take account of selling price inflation of 4% per year and variable cost inflation of 3% per year. The fixed costs, which are incremental and related to the investment project, are in nominal terms. The year 4 sales volume is expected to continue for the foreseeable future.

Pelta Co pays corporation tax of 30% one year in arrears. The company can claim tax-allowable depreciation on a 25% reducing balance basis.

The views of the directors of Pella Co are that all investment projects must be evaluated over four years of operations, with an assumed terminal value at the end of the fourth year of 5% of the initial investment cost. Both net present value and discounted payback must be used, with a maximum discounted payback period of two years. The real after-tax cost of capital of Pelta Co is 7% and its nominal after-tax cost of capital is 12%.

Required

(a) (i) Calculate the net present value of the planned investment project. **(9 marks)**

 (ii) Calculate the discounted payback period of the planned investment project.

 (2 marks)

(b) Discuss the financial acceptability of the investment project. **(3 marks)**

(c) Critically discuss the views of the directors on Pelta Co's investment appraisal. **(6 marks)**

(Total = 20 marks)

PART E: BUSINESS FINANCE

Questions 166 to 221 cover Business finance, the subject of Part E of the BPP Financial Management Workbook.

OTQ bank – Sources of finance **18 mins**

166 Are the following statements about bonds are true or false?

		True	False
1	Unsecured bonds are likely to require a higher yield to maturity than equivalent secured bonds.	☐	☐
2	Convertible bonds give the borrower the right but not the obligation to turn the bond into a predetermined number of ordinary shares.	☐	☐
3	A Eurobond is a bond that is denominated in a currency which is not native to where the bond itself is issued.	☐	☐

(2 marks)

167 According to the creditor hierarchy, list the following from high risk to low risk:

Order of risk (1 = highest risk)

Preference share capital ☐

Trade payables ☐

Bank loan with fixed and floating charges ☐

Ordinary share capital ☐

(2 marks)

168 Alpha is a listed company with a share price of $2 per share. It announces a 1 for 4 rights issue at $1.60 per share.

What is the theoretical ex-rights price (to two decimal places)?

$ ☐

(2 marks)

169 Which of the following best describes the term 'coupon rate' as it applies to bonds?

☐ Return received taking into account capital repayment as well as interest payments

☐ Annual interest received as a percentage of the nominal value of the bond

☐ Annual interest received as a percentage of the ex interest market price of the bond

☐ Annual interest received as a percentage of the cum-interest market price of the bond

(2 marks)

170 Which of the following describes a sukuk?

 ☐ A bond in Islamic finance where the lender owns the underlying asset and shares in the risks and rewards of ownership

 ☐ Equity in Islamic finance where profits are shared according to a pre-agreed contract – dividends are not paid as such

 ☐ Trade credit in Islamic finance where a pre-agreed mark-up is agreed in advance for the convenience of paying later

 ☐ A lease in Islamic finance where the lessor retains ownership and the risk and rewards of ownership of the underlying asset **(2 marks)**

(Total = 10 marks)

OTQ bank – Dividend policy **18 mins**

171 Which **TWO** of the following are assumptions for Modigliani and Miller's dividend irrelevance theory?

 ☐ Imperfect capital markets

 ☐ No taxes or tax preferences

 ☐ No transaction costs

 ☐ No inflation

(2 marks)

172 In which of the following situations is a residual dividend most likely to be appropriate?

 ☐ A large publicly listed company

 ☐ A small family-owned private company where the majority of the shareholders use dividend income to pay their living costs

 ☐ A small listed company owned by investors seeking maximum capital growth on their investment

 ☐ In a tax regime where individuals pay less tax on dividend income than on capital gains

(2 marks)

173 In Modigliani and Miller's dividend irrelevance theory, the process of 'manufacturing dividends' refers to which of the following?

 ☐ Dividends from manufacturing businesses

 ☐ Investors selling some shares to realise some capital gain

 ☐ Creative accounting to allow dividends to be paid

 ☐ Investing plans designed to create regular returns to shareholders **(2 marks)**

174 Which of the following statements is correct?

☐ A bonus issue can be used to raise new equity finance.

☐ A share repurchase scheme can increase both earnings per share and gearing.

☐ Miller and Modigliani argued that the financing decision is more important than the dividend decision.

☐ Shareholders usually have the power to increase dividends at annual general meetings of a company.

(2 marks)

175 Three companies (Sun Co, Moon Co and Nite Co) have the following dividend payments history:

Company	20X1	20X2	20X3
Sun Co – Dividend	100	110	121
Sun Co – Earnings	200	200	201
Moon Co – Dividend	50	150	25
Moon Co – Earnings	100	300	50
Nite Co – Dividend	nil	300	nil
Nite Co – Earnings	400	350	500

Which best describes their apparent dividend policies?

	Sun Co	Moon Co	Nite Co
☐	Constant growth	Constant payout	Residual
☐	Constant payout	Constant growth	Residual
☐	High payout	Residual	Constant payout
☐	Constant growth	Residual	Constant payout

(2 marks)

(Total = 10 marks)

OTQ bank – Practical capital structure issues 36 mins

176 A summary of HM Co's recent statement of profit or loss is given below:

	$'000
Revenue	10,123
Cost of sales	(7,222)
Gross profit	2,901
Expenses	(999)
Profit before interest and tax	1,902
Interest	(1,000)
Tax	(271)
Profit after interest and tax	631

70% of cost of sales and 10% of expenses are variable costs.

What is HM Co's operational gearing (as a number to two decimal places)?

☐

(2 marks)

177 The following is an extract of ELW's statement of financial position.

	$m	$m
Total assets		1,000
$1 ordinary share capital	100	
Retained earnings	400	
Total equity	500	
Loan notes	500	
		1,000

The ordinary shares are currently quoted at $5.50, and loan notes are trading at $125 per $100 nominal.

What is ELW's financial gearing ratio (debt/debt + equity) using market values (to the nearest %)?

[] %

(2 marks)

178 The following are extracts from the statement of financial position of a company: 12/14

	$'000	$'000
Equity		
Ordinary shares	8,000	
Reserves	20,000	
		28,000
Non-current liabilities		
Bonds	4,000	
Bank loans	6,200	
Preference shares	2,000	
		12,200
Current liabilities		
Overdraft	1,000	
Trade payables	1,500	
		2,500
Total equity and liabilities		42,700

The ordinary shares have a nominal value of 50 cents per share and are trading at $5.00 per share. The preference shares have a nominal value of $1.00 per share and are trading at 80 cents per share. The bonds have a nominal value of $100 and are trading at $105 per bond.

What is the market value based gearing of the company, defined as prior charge capital/equity?

☐ 15.0%

☐ 13.0%

☐ 11.8%

☐ 7.3% (2 marks)

179 AB Co has an interest cover greater than one and gearing (debt/debt + equity) of 50%.

What will be the impact on interest cover and gearing of issuing shares to repay half the debt?

	Interest cover	Gearing	
☐	Rise	Rise	
☐	Rise	Fall	
☐	Fall	Rise	
☐	Fall	Fall	**(2 marks)**

180 All else being equal, a poor set of results and lower dividends that aren't as bad as shareholders were expecting would probably have the following impact:

	P/E ratio	Dividend yield	
☐	Increase	Increase	
☐	Increase	Decrease	
☐	Decrease	Increase	
☐	Decrease	Decrease	**(2 marks)**

181 The following are extracts from the statement of financial position of a company:

	$'000	$'000
Equity		
Ordinary shares	8,000	
Reserves	20,000	
		28,000
Non-current liabilities		
Bonds	4,000	
Bank loans	6,200	
Preference shares	2,000	
		12,200
Current liabilities		
Overdraft	1,000	
Trade payables	1,500	
		2,500
		42,700

The ordinary shares have a nominal value of 50 cents per share and are trading at $5.00 per share. The preference shares have a nominal value of $1.00 per share and are trading at 80 cents per share. The bonds have a nominal value of $100 and are trading at $105 per bond.

What is the market value based gearing of the company, defined as prior charge capital/equity?

☐ 15.0%

☐ 13.0%

☐ 11.8%

☐ 7.3% **(2 marks)**

182 Which of the following are handicaps that young SMEs face in accessing funds?

1 Uncertainty and risk for lenders

2 Financial statements are not sufficiently detailed

3 Shares cannot be placed privately

☐ 1 and 3 only

☐ 1 and 2 only

☐ 2 and 3 only

☐ 1, 2 and 3 (2 marks)

183 Indicate whether the following statements, relating to small and medium-sized enterprises (SMEs), are true or false?

		True	False
1	Medium-term loans are harder to obtain than longer-term loans for SMEs.	☐	☐
2	SMEs are prone to funding gaps.	☐	☐

(2 marks)

184 Private individuals or groups of individuals can invest directly into a small business.

What is this known as?

☐ Reverse factoring

☐ Supply chain finance

☐ Venture capital

☐ Business angel financing (2 marks)

185 Indicate whether the following statements, relating to supply chain finance (SCF), are true or false?

		True	False
1	SCF is considered to be financial debt.	☐	☐
2	SCF allows an SME to raise finance at a lower interest rate than would normally be available to it.	☐	☐

(2 marks)

(Total = 20 marks)

OTQ bank – The cost of capital

36 mins

186 GG Co has a cost of equity of 25%. It has 4 million shares in issue, and has done for many years.

Its dividend payments in the years 20X9 to 20Y3 were as follows.

End of year	Dividends
	$'000
20X9	220
20Y0	257
20Y1	310
20Y2	356
20Y3	423

Dividends are expected to continue to grow at the same average rate into the future.

According to the dividend valuation model, what should be the share price at the start of 20Y4 (to two decimal places)?

$ []

(2 marks)

187 IPA Co is about to pay a $0.50 dividend on each ordinary share. Its earnings per share was $1.50.

Net assets per share is $6. Current share price is $4.50 per share.

What is the cost of equity (to the nearest whole percentage)?

[] %

(2 marks)

188 Which of the following best describes systematic risk?

☐ The chance that automated processes may fail

☐ The risk associated with investing in equity

☐ The diversifiable risk associated with investing in equity

☐ The residual risk associated with investing in a well-diversified portfolio

(2 marks)

189 A share in MS Co has an equity beta of 1.3. MS Co's debt beta is 0.1. It has a gearing ratio of 20% (debt:equity). The market premium is 8% and the risk-free rate is 3%. MS Co pays 30% corporation tax.

What is the cost of equity for MS Co?

[] %

(2 marks)

190 Are the following statements true or false?

		True	False
1	An increase in the cost of equity leads to a fall in share price.	☐	☐
2	Investors faced with increased risk will expect increased return as compensation.	☐	☐
3	The cost of debt is usually lower than the cost of preference shares.	☐	☐

(2 marks)

191 BRW Co has 10% redeemable loan notes in issue trading at $90. The loan notes are redeemable at a 10% premium in 5 years' time, or convertible at that point into 20 ordinary shares. The current share price is $2.50 and is expected to grow at 10% per year for the foreseeable future. BRW Co pays 30% corporation tax.

What is the best estimate of the cost of these loan notes (to one decimal place)?

[] %

(2 marks)

192 IDO Co has a capital structure as follows.

	$m
10m $0.50 ordinary shares	5
Reserves	20
13% irredeemable loan notes	7
	32

The ordinary shares are currently quoted at $3.00, and the loan notes at $90. IDO Co has a cost of equity of 12% and pays corporation tax at a rate of 30%.

What is IDO Co's weighted average cost of capital (WACC)?

[] %

(2 marks)

193 Which of the following are assumed if a company's current WACC is to be used to appraise a potential project?

		True	False
1	Capital structure will remain unchanged for the duration of the project.	☐	☐
2	The business risk of the project is the same as the current business operations.	☐	☐
3	The project is relatively small in size.	☐	☐

(2 marks)

194 On a market value basis, GFV Co is financed 70% by equity and 30% by debt. The
 company has an after-tax cost of debt of 6% and an equity beta of 1.2. The risk-free rate of
 return is 4% and the equity risk premium is 5%. 6/15

 What is the after-tax weighted average cost of capital of GFV Co (to one decimal place)?

 ☐ %

195 An 8% irredeemable $0.50 preference share is being traded for $0.30 cum-div currently in
 a company that pays corporation tax at a rate of 30%.

 What is the cost of capital for these preference shares (to one decimal place)?

 ☐ % (2 marks)

 (Total = 20 marks)

OTQ bank – Capital structure theories 36 mins

196 Alf Co's gearing is 1:1 debt:equity. The industry average is 1:5. Alf Co is looking to raise
 finance for investment in a new project and it is wondering whether to raise debt or equity.

 Applying the traditional view, which of the following is true?

 ☐ It should take on debt finance, as to do so will save tax

 ☐ It should take on equity finance, as their gearing is probably beyond optimal

 ☐ It doesn't matter, as it won't affect the returns the projects generate

 ☐ More information is needed before a decision can be made (2 marks)

197 Why do Modigliani and Miller (with tax) assume increased gearing will reduce the weighted
 average cost of capital (WACC)?

 ☐ Debt is cheaper than equity

 ☐ Interest payments are tax deductible

 ☐ Reduced levels of expensive equity capital will reduce the WACC

 ☐ Financial risk is not pronounced at moderate borrowing levels (2 marks)

198 Are the following statements true or false? 6/15

 True False

 1 The asset beta reflects both business risk and financial risk ☐ ☐

 2 Total risk is the sum of systematic risk and unsystematic risk ☐ ☐

 3 Assuming that the beta of debt is zero will understate financial ☐ ☐
 risk when ungearing an equity beta

 (2 marks)

199 Director A believes there is an optimal balance of debt:equity whereas Director B does not believe that the gearing decision affects the value of the business.

Match the capital structure theory that best reflects each of directors' beliefs.

Theory	Director
Traditional view	
M&M (no tax)	
M&M (with tax)	
Pecking order	

(2 marks)

200 Shyma Co is a company that manufactures ships. It has an equity beta of 1.6 and a debt:equity ratio of 1:3. It is considering a new project to manufacture farm vehicles. Trant Co is a manufacturer of farm vehicles and has an asset beta of 1.1 and a debt:equity ratio of 2:3. The risk free rate of return is 5%, the market risk premium is 3% and the corporation tax rate is 40%. 12/17

Using CAPM, what would be the suitable cost of equity for Shyma to use in its appraisal of the farm machinery project (to one decimal place)?

[] %

(2 marks)

The following information relates to questions 201 and 202.

TR Co has a gearing level of 1:3 debt:equity. TR is considering diversifying into a new market without changing its existing gearing. B Co is already operating in the new market. B Co has an equity beta of 1.05 and a gearing level of 1:4 debt:equity. Both companies pay 30% corporation tax.

201 What is the asset beta relevant to TR for the new market (to 2 decimal places)?

[]

(2 marks)

202 The risk-free rate is 4% and the market premium is 4%.

What is TR Co's cost of equity for assessing the decision to diversify into the new market (to one decimal place)?

[] %

(2 marks)

203 Leah Co is an all equity financed company which wishes to appraise a project in a new area of activity. Its existing equity beta is 1.2. The industry average equity beta for the new business area is 2.0, with an average debt/debt + equity ratio of 25%. The risk-free rate of return is 5% and the market risk premium is 4%. 3/18

Ignoring tax and using the capital asset pricing model, calculate a suitable risk-adjusted cost of equity for the new project (to one decimal place).

[] %

(2 marks)

204 When should a project-specific cost of capital be used for investment appraisal?

 ☐ If new finance is required before the project can go ahead

 ☐ If the project is small

 ☐ If the project is different from current operations

 ☐ If the project is the same as current operations (2 marks)

205 Leah Co is an all-equity financed company which wishes to appraise a project in a new area of business. Its existing equity beta is 1.2. The average equity beta for the new business area is 2.0, with an average debt/debt plus equity ratio of 25%. The risk-free rate of return is 5% and the market risk premium is 4%. 12/15

 Ignoring taxation and using the capital asset pricing model, what is the risk-adjusted cost of equity for the new project?

 ☐ 8.6%

 ☐ 9.8%

 ☐ 11.0%

 ☐ 13.0% (2 marks)

 (Total = 20 marks)

Section B questions

Tulip Co (Mar/Jun 19) **18 mins**

The following scenario relates to questions 206–210.

Tulip Co is a large company with an equity beta of 1.05. The company plans to expand existing business by acquiring a new factory at a cost of $20 million. The finance for the expansion will be raised from an issue of 3% loan notes, issued at nominal value of $100 per loan note. These loan notes will be redeemable after five years at nominal value or convertible at that time into ordinary shares in Tulip Co with a value expected to be $115 per loan note.

The risk-free rate of return is 2.5% and the equity risk premium is 7.8%.

Tulip Co is seeking additional finance and is considering using Islamic finance and, in particular, would require a form which would be similar to equity financing.

206 What is the cost of equity of Tulip Co using the capital asset pricing model?.

 ☐ 13.3%

 ☐ 10.7%

 ☐ 8.1%

 ☐ 10.3%

 (2 marks)

207 Using estimates of 5% and 6%, what is the cost of debt of the convertible loan notes?

☐ 3.0%

☐ 5.2%

☐ 6.9%

☐ 5.7%

(2 marks)

208 In relation to using the dividend growth model to value Tulip Co, which of the following statements is correct?

☐ The model assumes that all shareholders of Tulip Co have the same required rate of return.

☐ The model assumes a constant share price and a constant dividend growth for Tulip Co.

☐ The model assumes that capital markets are semi-strong form efficient.

☐ The model assumes that Tulip Co's interim dividend is equal to the final dividend.

(2 marks)

209 Which of the following statements about equity finance is correct?

☐ Equity finance reserves represent cash which is available to a company to invest.

☐ Additional equity finance can be raised by rights issues and bonus issues.

☐ Retained earnings are a source of equity finance.

☐ Equity finance includes both ordinary shares and preference shares.

(2 marks)

210 Regarding Tulip Co's interest in Islamic finance, which of the following statements is/are correct?

1 Murabaha could be used to meet Tulip Co's financing needs

2 Mudaraba involves an investing partner and a managing or working partner

☐ 1 only

☐ 2 only

☐ Both 1 and 2

☐ Neither 1 nor 2

(2 marks)

(Total = 10 marks)

Section C questions

211 Bar Co (12/11, amended) 36 mins

Bar Co is a stock exchange listed company that is concerned by its current level of debt finance. It plans to make a rights issue and to use the funds raised to pay off some of its debt. The rights issue will be at a 20% discount to its current ex dividend share price of $7.50 per share and Bar Co plans to raise $90m. Bar Co believes that paying off some of its debt will not affect its price/earnings ratio, which is expected to remain constant.

STATEMENT OF PROFIT OR LOSS INFORMATION

	$m
Revenue	472.0
Cost of sales	423.0
Profit before interest and tax	49.0
Interest	10.0
Profit before tax	39.0
Tax	11.7
Profit after tax	27.3

STATEMENT OF FINANCIAL POSITION INFORMATION

	$m
Equity	
Ordinary shares ($1 nominal)	60.0
Retained earnings	80.0
	140.0
Long-term liabilities	
8% bonds ($100 nominal)	125.0
	265.0

The 8% bonds are currently trading at $112.50 per $100 bond and bondholders have agreed that they will allow Bar Co to buy back the bonds at this market value. Bar Co pays tax at a rate of 30% per year.

Required

(a) Calculate the theoretical ex-rights price per share of Bar Co following the rights issue.
(3 marks)

(b) Calculate and discuss whether using the cash raised by the rights issue to buy back bonds is likely to be financially acceptable to the shareholders of Bar Co, commenting in your answer on the belief that the current price/earnings ratio will remain constant. (7 marks)

(c) Calculate and discuss the effect on the financial risk of Bar Co of using the cash raised by the rights issue to buy back bonds, as measured by its interest coverage ratio and its book value debt to equity ratio. (4 marks)

(d) Discuss the dangers to a company of a high level of gearing, including in your answer an explanation of the following terms:

(i) Business risk

(ii) Financial risk (6 marks)

(Total = 20 marks)

BPP
LEARNING
MEDIA

212 YGV Co (6/10, amended)

YGV Co is a listed company selling computer software. Its profit before interest and tax has fallen from $5m to $1m in the last year and its current financial position is as follows:

	$'000	$'000
Non-current assets		
Property, plant and equipment	3,000	
Intangible assets	8,500	11,500
Current assets		
Inventory	4,100	
Trade receivables	11,100	15,200
Total assets		26,700
Equity		
Ordinary shares	10,000	
Reserves	7,000	17,000
Current liabilities		
Trade payables	5,200	
Overdraft	4,500	9,700
Total equity and liabilities		26,700

YGV Co has been advised by its bank that the current overdraft limit of $4.5m will be reduced to $500,000 in 2 months' time. The finance director of YGV Co has been unable to find another bank willing to offer alternative overdraft facilities and is planning to issue bonds on the stock market in order to finance the reduction of the overdraft. The bonds would be issued at their nominal value of $100 per bond and would pay interest of 9% per year, payable at the end of each year. The bonds would be redeemable at a 10% premium to their nominal value after 10 years. The finance director hopes to raise $4m from the bond issue.

The ordinary shares of YGV Co have a nominal value of $1.00 per share and a current market value of $4.10 per share. The cost of equity of YGV Co is 12% per year and the current interest rate on the overdraft is 5% per year.

Taxation is at an annual rate of 30%.

Other financial information:

Average gearing of sector (debt/equity, market value basis): 10%
Average interest coverage ratio of sector: 8 times

Required

(a) Calculate the after-tax cost of debt of the 9% bonds. (4 marks)

(b) Calculate the effect of using the bond issue to finance the reduction in the overdraft on:

 (i) The interest coverage ratio.

 (ii) Gearing (debt/equity, market value basis). (4 marks)

(c) Evaluate the proposal to use the bond issue to finance the reduction in the overdraft and discuss alternative sources of finance that could be considered by YGV Co, given its current financial position. (12 marks)

(Total = 20 marks)

213 Corfe Co (Mar/Jun 19) 36 mins

The following information has been taken from the statement of financial position of Corfe Co, a listed company:

	$m	$m
Non-current assets		50
Current assets		
Cash and cash equivalents	4	
Other current assets	16	20
Total assets		70

	$m	$m
Equity and reserves		
Ordinary shares	15	
Reserves	29	44
Non-current liabilities		
6% preference shares	6	
8% loan notes	8	
Bank loan	5	19
Current liabilities		7
Total equity and liabilities		70

The ordinary shares of Corfe Co have a nominal value of $1 per share and a current ex-dividend market price of $6.10 per share. A dividend of $0.90 per share has just been paid.

The 6% preference shares of Corfe Co have a nominal value of $0.75 per share and an ex-dividend market price of $0.64 per share.

The 8% loan notes of Corfe Co have a nominal value of $100 per loan note and a market price of $103.50 per loan note. Annual interest has just been paid and the loan notes are redeemable in five years' time at a 10% premium to nominal value.

The bank loan has a variable interest rate.

The risk-free rate of return is 3.5% per year and the equity risk premium is 6.8% per year. Corfe Co has an equity beta of 1.25.

Corfe Co pays corporation tax at a rate of 20%.

Investment in facilities

Corfe Co's board is looking to finance investments in facilities over the next three years, forecast to cost up to $25 million. The board does not wish to obtain further long-term debt finance and is also unwilling to make an equity issue. This means that investments have to be financed from cash which can be made available internally. Board members have made a number of suggestions about how this can be done:

Director A has suggested that the company does not have a problem with funding new investments, as it has cash available in the reserves of $29 million. If extra cash is required soon, Corfe Co could reduce its investment in working capital.

Director B has suggested selling the building which contains the company's headquarters in the capital city for $20 million. This will raise a large one-off sum and also save on ongoing property management costs. Head office support functions would be moved to a number of different locations rented outside the capital city.

Director C has commented that although a high dividend has just been paid, dividends could be reduced over the next three years, allowing spare cash for investment.

Required

(a) Calculate the after-tax weighted average cost of capital of Corfe Co on a market value basis. (11 marks)

(b) Discuss the views expressed by the three directors on how the investment should be financed. (9 marks)

(Total = 20 marks)

214 AQR Co (6/11, amended) 36 mins

The finance director of AQR Co has heard that the market value of the company will increase if the weighted average cost of capital of the company is decreased. The company, which is listed on a stock exchange, has 100 million shares in issue and the current ex div ordinary share price is $2.50 per share. AQR Co also has in issue bonds with a book value of $60m and their current ex interest market price is $104 per $100 bond. The current after-tax cost of debt of AQR Co is 7% and the tax rate is 30%.

The recent dividends per share of the company are as follows.

Year	20X0	20X1	20X2	20X3	20X4
Dividend per share (cents)	19.38	20.20	20.41	21.02	21.80

The finance director proposes to decrease the weighted average cost of capital of AQR Co, and hence increase its market value, by issuing $40m of bonds at their nominal value of $100 per bond. These bonds would pay annual interest of 8% before tax and would be redeemed at a 5% premium to nominal value after 10 years.

Required

(a) Calculate the market value after-tax weighted average cost of capital of AQR Co in the following circumstances:

 (i) Before the new issue of bonds takes place.

 (ii) After the new issue of bonds takes place.

 Comment on your findings. (12 marks)

(b) Discuss the director's view that issuing traded bonds will decrease the weighted average cost of capital of AQR Co and thereby increase the market value of the company.

 (8 marks)

 (Total = 20 marks)

215 BKB Co (12/12, amended) 36 mins

The statement of financial position of BKB Co provides the following information:

	$m	$m
Equity finance		
Ordinary shares ($1 nominal value)	25	
Reserves	15	40
Non-current liabilities		
7% convertible bonds ($100 nominal value)	20	
5% preference shares ($1 nominal value)	10	30
Current liabilities		
Trade payables	10	
Overdraft	15	25
Total liabilities		95

BKB Co has an equity beta of 1.2 and the ex dividend market value of the company's equity is $125m. The ex interest market value of the convertible bonds is $21m and the ex dividend market value of the preference shares is $6.25m.

The convertible bonds of BKB Co have a conversion ratio of 19 ordinary shares per bond. The conversion date and redemption date are both on the same date in five years' time. The current ordinary share price of BKB Co is expected to increase by 4% per year for the foreseeable future.

The overdraft has a variable interest rate which is currently 6% per year and BKB Co expects this to increase in the near future. The overdraft has not changed in size over the last financial year,

although one year ago the overdraft interest rate was 4% per year. The company's bank will not allow the overdraft to increase from its current level.

The equity risk premium is 5% per year and the risk-free rate of return is 4% per year. BKB Co pays profit tax at an annual rate of 30% per year.

Required

(a) Calculate the market value after-tax weighted average cost of capital of BKB Co, explaining clearly any assumptions you make. (12 marks)

(b) Discuss why market value weighted average cost of capital is preferred to book value weighted average cost of capital when making investment decisions. (4 marks)

(c) Discuss the attractions to a company of convertible debt compared to a bank loan of a similar maturity as a source of finance. (4 marks)

(Total = 20 marks)

216 Fence Co (6/14, amended) 36 mins

The equity beta of Fence Co is 0.9 and the company has issued 10 million ordinary shares. The market value of each ordinary share is $7.50. The company is also financed by 7% bonds with a nominal value of $100 per bond, which will be redeemed in 7 years' time at nominal value. The bonds have a total nominal value of $14m. Interest on the bonds has just been paid and the current market value of each bond is $107.14.

Fence Co plans to invest in a project which is different to its existing business operations and has identified a company in the same business area as the project, Hex Co. The equity beta of Hex Co is 1.2 and the company has an equity market value of $54m. The market value of the debt of Hex Co is $12m.

The risk-free rate of return is 4% per year and the average return on the stock market is 11% per year. Both companies pay corporation tax at a rate of 20% per year.

Required

(a) Calculate the current weighted average cost of capital of Fence Co. (7 marks)

(b) Calculate a cost of equity which could be used in appraising the new project. (4 marks)

(c) Explain the difference between systematic and unsystematic risk in relation to portfolio theory and the capital asset pricing model. (4 marks)

(d) Explain the limitations of the capital asset pricing model. (5 marks)

(Total = 20 marks)

217 Tinep Co (12/14, amended) 36 mins

Tinep Co is planning to raise funds for an expansion of existing business activities and in preparation for this the company has decided to calculate its weighted average cost of capital. Tinep Co has the following capital structure:

	$m	$m
Equity		
Ordinary shares	200	
Reserves	650	
		850
Non-current liabilities		
Loan notes		200
		1,050

The ordinary shares of Tinep Co have a nominal value of 50 cents per share and are currently trading on the stock market on an ex dividend basis at $5.85 per share. Tinep Co has an equity beta of 1.15.

The loan notes have a nominal value of $100 and are currently trading on the stock market on an ex interest basis at $103.50 per loan note. The interest on the loan notes is 6% per year before tax and they will be redeemed in six years' time at a 6% premium to their nominal value.

The risk-free rate of return is 4% per year and the equity risk premium is 6% per year. Tinep Co pays corporation tax at an annual rate of 25% per year.

Required

(a) Calculate the market value weighted average cost of capital and the book value weighted average cost of capital of Tinep Co, and comment briefly on any difference between the two values. **(9 marks)**

(b) Discuss the factors to be considered by Tinep Co in choosing to raise funds via a rights issue. **(6 marks)**

(c) Explain the nature of a scrip (share) dividend and discuss the advantages and disadvantages to a company of using scrip dividends to reward shareholders. **(5 marks)**

(Total = 20 marks)

218 Grenarp Co (6/15, amended) 36 mins

Grenarp Co is planning to raise $11,200,000 through a rights issue. The new shares will be offered at a 20% discount to the current share price of Grenarp Co, which is $3.50 per share. The rights issue will be on a 1 for 5 basis and issue costs of $280,000 will be paid out of the cash raised. The capital structure of Grenarp Co is as follows:

	$m	$m
Equity		
Ordinary shares (par value $0.50)	10	
Reserves	75	
		85
Non-current liabilities		
8% loan notes		30
		115

The net cash raised by the rights issue will be used to redeem part of the loan note issue. Each loan note has a nominal value of $100 and an ex interest market value of $104. A clause in the bond issue contract allows Grenarp Co to redeem the loan notes at a 5% premium to market price at any time prior to their redemption date. The price/earnings ratio of Grenarp Co is not expected to be affected by the redemption of the loan notes.

The earnings per share of Grenarp Co is currently $0.42 per share and total earnings are $8,400,000 per year. The company pays corporation tax of 30% per year.

Required

(a) Evaluate the effect on the wealth of the shareholders of Grenarp Co of using the net rights issue funds to redeem the loan notes. **(8 marks)**

(b) Discuss whether Grenarp Co might achieve its optimal capital structure following the rights issue. **(7 marks)**

(c) Discuss THREE sources and characteristics of long-term debt finance which may be available to Grenarp Co. **(5 marks)**

(Total = 20 marks)

219 Dinla Co (Mar/Jun 16, amended) 36 mins

Dinla Co has the following capital structure.

	$'000	$'000
Equity and reserves		
Ordinary shares	23,000	
Reserves	247,000	
		270,000
Non-current liabilities		
5% preference shares	5,000	
6% loan notes	11,000	
Bank loan	3,000	
		19,000
		289,000

The ordinary shares of Dinla Co are currently trading at $4.26 per share on an ex dividend basis and have a nominal value of $0.25 per share. Ordinary dividends are expected to grow in the future by 4% per year and a dividend of $0.25 per share has just been paid.

The 5% preference shares have an ex dividend market value of $0.56 per share and a nominal value of $1.00 per share. These shares are irredeemable.

The 6% loan notes of Dinla Co are currently trading at $95.45 per loan note on an ex interest basis and will be redeemed at their nominal value of $100 per loan note in 5 years' time.

The bank loan has a fixed interest rate of 7% per year.

Dinla Co pays corporation tax at a rate of 25%.

Required

(a) Calculate the after-tax weighted average cost of capital of Dinla Co on a market value basis. (8 marks)

(b) Discuss the connection between the relative costs of sources of finance and the creditor hierarchy. (3 marks)

(c) Discuss the circumstances under which the current weighted average cost of capital of a company could be used in investment appraisal and indicate briefly how its limitations as a discount rate could be overcome. (5 marks)

(d) Explain the differences between Islamic finance and other conventional finance. (4 marks)

(Total = 20 marks)

220 Tufa Co (Sep/Dec 17) 36 mins

The following statement of financial position information relates to Tufa Co, a company listed on a large stock market which pays corporation tax at a rate of 30%.

	$m	$m
Equity and liabilities		
Share capital	17	
Retained earnings	15	
Total equity		32
Non-current liabilities		
Long-term borrowings	13	
Current liabilities	21	
Total liabilities		34
Total equity and liabilities		66

The share capital of Tufa Co consists of $12m of ordinary shares and $5m of irredeemable preference shares.

The ordinary shares of Tufa Co have a nominal value of $0.50 per share, an ex dividend market price of $7.07 per share and a cum dividend market price of $7.52 per share. The dividend for 20X7 will be paid in the near future. Dividends paid in recent years have been as follows:

Year	20X6	20X5	20X4	20X3
Dividend ($/share)	0.43	0.41	0.39	0.37

The 5% preference shares of Tufa Co have a nominal value of $0.50 per share and an ex dividend market price of $0.31 per share.

The long-term borrowings of Tufa Co consists of $10m of loan notes and a $3m bank loan. The bank loan has a variable interest rate.

The 7% loan notes have a nominal value of $100 per loan note and a market price of $102.34 per loan note. Annual interest has just been paid and the loan notes are redeemable in four years' time at a 5% premium to nominal value.

Required

(a) Calculate the after-tax weighted average cost of capital of Tufa Co on a market value basis. (11 marks)

(b) Discuss the circumstances under which it is appropriate to use the current WACC of Tufa Co in appraising an investment project. (3 marks)

(c) Discuss THREE advantages to Tufa Co of using convertible loan notes as a source of long-term finance. (6 marks)

(Total = 20 marks)

221 Tin Co (Mar/Jun 18) 36 mins

Tin Co is planning an expansion of its business operations which will increase profit before interest and tax by 20%. The company is considering whether to use equity or debt finance to raise the $2m needed by the business expansion.

If equity finance is used, a 1 for 5 rights issue will be offered to existing shareholders at a 20% discount to the current ex dividend share price of $5.00 per share. The nominal value of the ordinary shares is $1.00 per share.

If debt finance is used, Tin Co will issue 20,000 8% loan notes with a nominal value of $100 per loan note.

Financial statement information prior to raising new finance:

	$'000
Profit before interest and tax	1,597
Finance costs (interest)	(315)
Taxation	(282)
Profit after tax	1,000

	$'000
Equity	
Ordinary shares	2,500
Retained earnings	5,488
Long-term liabilities:	
7% loan notes	4,500
Total equity and long-term liabilities	12,488

The current price/earnings ratio of Tin Co is 12.5 times. Corporation tax is payable at a rate of 22%.

Companies undertaking the same business as Tin Co have an average debt/equity ratio (book value of debt divided by book value of equity) of 60.5% and an average interest cover of 9 times.

Required

(a) (i) Calculate the theoretical ex rights price per share. (2 marks)

 (ii) Assuming equity finance is used, calculate the revised earnings per share after the
 business expansion. (4 marks)

 (iii) Assuming debt finance is used, calculate the revised earnings per share after the
 business expansion. (3 marks)

 (iv) Calculate the revised share prices under both financing methods after the business
 expansion. (1 mark)

 (v) Use calculations to evaluate whether equity finance or debt finance should be used
 for the planned business expansion. (4 marks)

(b) Discuss **TWO** Islamic finance sources which Tin Co could consider as alternatives to a
 rights issue or a loan note issue. (6 marks)

 (Total = 20 marks)

PART F: BUSINESS VALUATIONS

Questions 222 to 266 cover Business valuations, the subject of Part F of the BPP Financial Management Workbook.

OTQ bank – Business valuations

36 mins

222 ML Ltd is an unlisted accountancy firm owned by three shareholders. One of the shareholders has asked for an independent valuation of the company to be performed.

Which of the following is a valid reason for an independent valuation to be required?

☐ The stock market is thought to be weak form efficient

☐ The realisable value of inventory is felt to be underestimated in the latest financial statements

☐ To evaluate a takeover bid by Company X which is offering to buy ML Ltd in exchange for shares in Company X

☐ The latest published statement of financial position was 11 months ago

(2 marks)

223 The following financial information relates to QK Co, whose ordinary shares have a nominal value of $0.50 per share: 6/15

	$m	$m
Non-current assets		120
Current assets		
Inventory	8	
Trade receivables	12	20
Total assets		140
Equity		
Ordinary shares	25	
Reserves	80	105
Non-current liabilities		20
Current liabilities		15
Total equity and liabilities		140

On an historic basis, what is the net asset value per share of QK Co?

☐ $2.10 per share

☐ $2.50 per share

☐ $2.80 per share

☐ $4.20 per share

(2 marks)

224 ELW Co recently paid a dividend of $0.50 a share. This is $0.10 more than three years ago. Shareholders have a required rate of return of 10%.

Using the dividend valuation model and assuming recent dividend growth is expected to continue, what is the current value of a share (to two decimal places)?

$ ⬚

(2 marks)

225 Cant Co has a cost of equity of 10% and has forecast its future dividends as follows:

Current year: No dividend
Year 1: No dividend
Year 2: $0.25 per share
Year 3: $0.50 per share and increasing by 3% per year in subsequent years
What is the current share price of Cant Co using the dividend valuation model?

☐ $7.35
☐ $5.57
☐ $6.11
☐ $6.28 (2 marks)

226 Jo Co is a company which is financed by equity only. It has just paid a dividend of $60m and earnings retained and invested were 60%. Return on investments is 20% and the cost of equity is 22%.

What is the market value of the company (in millions, to the nearest whole million)?

$ [] million

(2 marks)

227 Alpha Co and Beta Co are two companies in different industries who are both evaluating the acquisition of the same target company called Gamma Co. Gamma Co is in the same industry as Alpha Co.

Alpha Co has valued Gamma Co at $100m but Beta Co has only valued Gamma Co at $90m.

Which of following statements would explain why Alpha Co's value of Gamma Co is higher?

☐ Alpha Co has used more prudent growth estimates
☐ Beta Co could achieve more synergy
☐ Beta Co is a better negotiator than Alpha Co
☐ Gamma Co is a direct competitor of Alpha Co

(2 marks)

228 Black Co has in issue 5% irredeemable loan notes, nominal value of $100 per loan note, on which interest is shortly to be paid. Black Co has a before-tax cost of debt of 10% and corporation tax is 30%.

What is the current market value of one loan note?

☐ $55
☐ $50
☐ $76
☐ $40 (2 marks)

229 A company has 7% loan notes in issue which are redeemable in 7 years' time at a 5% premium to their nominal value of $100 per loan note. The before-tax cost of debt of the company is 9%and the after-tax cost of debt of the company is 6%. 12/14

What is the current market value of each loan note?

- ☐ $92.67
- ☐ $108.90
- ☐ $89.93
- ☐ $103.14 (2 marks)

230 A company has in issue loan notes with a nominal value of $100 each. Interest on the loan notes is 6% per year, payable annually. The loan notes will be redeemed in eight years' time at a 5% premium to nominal value. The before-tax cost of debt of the company is 7% per year. 6/15

What is the ex interest market value of each loan note?

- ☐ $94.03
- ☐ $96.94
- ☐ $102.91
- ☐ $103.10 (2 marks)

231 NCW Co is considering acquiring the ordinary share capital of CEW Co. CEW Co has for years generated an annual cash inflow of $10m. For a one-off investment of $6m in new machinery, earnings for CEW Co can be increased by $2m per year. NCW Co has a cost of capital of 10%.

What is the value of CEW Co?

- ☐ $114 million
- ☐ $120 million
- ☐ $100 million
- ☐ $94 million (2 marks)

(Total = 20 marks)

OTQ bank – Market efficiency 18 mins

232 WC Co announces that it decided yesterday to invest in a new project with a huge positive net present value. The share price doubled yesterday.

What does this appear to be evidence of?

- ☐ A semi-strong form efficient market
- ☐ A strong form efficient market
- ☐ Technical analysis
- ☐ A weak form efficient market (2 marks)

233 PX Co is considering making a takeover bid for JJ Co. Both companies are large listed sportswear retailers that sell to the general public.

The shares of both PX Co and JJ Co are regularly traded and their share prices react quickly to new information.

Which of the following is likely to be needed to allow PX Co to make sure that its bid is not too high?

☐ No information is needed because the stock market is semi-strong form efficient

☐ Estimates of the present value of the synergies that are likely to result from the takeover

☐ An aged accounts receivable summary

☐ The latest published statement of JJ Co's financial position **(2 marks)**

234 Sarah decides to plot past share price movements to help spot patterns and create an investment strategy.

What does Sarah believe the stock market is?

☐ Completely inefficient

☐ Weak form efficient

☐ Semi-strong form efficient

☐ Strong form efficient **(2 marks)**

235 Which of the following is evidence that stock markets are semi-strong form efficient?

☐ Repeating patterns appear to exist

☐ Attempting to trade on consistently repeating patterns is unlikely to work

☐ The majority of share price reaction to news occurs when it is announced

☐ Share price reaction occurs before announcements are made public **(2 marks)**

BPP
LEARNING
MEDIA

Which **TWO** of the following would be evidence of strong form market efficiency?

☐ The lack of regulation on use of private information (insider dealing)

☐ Inability to consistently outperform the market and make abnormal gains

☐ Immediate share price reaction to company announcements to the market

☐ Regulation to ensure quick and timely public announcement of information

(2 marks)

(Total = 10 marks)

Section B questions

Bluebell Co (Mar/Jun 19)　　　　　　　　　　　　　**18 mins**

The following scenario relates to questions 237–241.

Extracts from the financial statements of Bluebell Co, a listed company, are as follows:

	$m
Profit before interest and tax	238
Finance costs	(24)
Profit before tax	214
Corporation tax	(64)
Profit after tax	150

	$m
Assets	
Non-current assets	
Property, plant and equipment	768
Goodwill (internally generated)	105
	873
Current assets	
Inventories	285
Trade receivables	192
	477
Total assets	1,350
Equity and liabilities	
Total equity	688
Non-current liabilities	
Long-term borrowings	250
Current liabilities	
Trade payables	312
Short-term borrowings	100
Total current liabilities	412
Total liabilities	662
Total equity and liabilities	1,350

A similar size competitor company has a price/earnings ratio of 12.5 times.

This competitor believes that if Bluebell Co were liquidated, property, plant and equipment would only realise $600 million, while 10% of trade receivables would be irrecoverable and inventory would be sold at $30 million less than its book value.

Separately, Bluebell Co is considering the acquisition of Dandelion Co, an unlisted company which is a supplier of Bluebell Co.

237 What is the value of Bluebell Co on a net realisable value basis?

☐ $140.8m

☐ $470.8m

☐ $365.8m

☐ $1,027.8m

(2 marks)

238 What is the value of Bluebell Co using the earnings yield method?

☐ $2,675m

☐ $1,200m

☐ $1,875m

☐ $2,975m

(2 marks)

239 When valuing Bluebell Co using asset-based valuations, which of the following statements is correct?

☐ An asset-based valuation would be useful for an asset-stripping acquisition.

☐ Bluebell Co's workforce can be valued as an intangible asset.

☐ Asset-based valuations consider the present value of Bluebell Co's future income.

☐ Replacement cost basis provides a deprival value for Bluebell Co.

(2 marks)

240 Which of the following is/are indicators of market imperfections?

1 Low volume of trading in shares of smaller companies

2 Overreaction to unexpected news

☐ 1 only

☐ 2 only

☐ Both 1 and 2

☐ Neither 1 nor 2

(2 marks)

241 Which of the following statements is correct?

☐ Dandelion Co is easier to value than Bluebell Co because a small number of shareholders own all the shares.

☐ Bluebell Co will have to pay a higher price per share to take control of Dandelion Co than if it were buying a minority holding.

☐ Scrip dividends decrease the liquidity of shares by retaining cash in a company.

☐ Dandelion Co's shares will trade at a premium to similar listed shares because it will have a lower cost of equity.

(2 marks)

(Total = 10 marks)

GWW Co

The following scenario relates to questions 242–246.

GWW Co is a listed company which is seen as a potential target for acquisition by financial analysts. The value of the company has therefore been a matter of public debate in recent weeks and the following financial information is available:

Year	20Y2	20Y1	20Y0	20X9
Profit after tax ($m)	10.1	9.7	8.9	8.5
Total dividends ($m)	6.0	5.6	5.2	5.0

STATEMENT OF FINANCIAL POSITION INFORMATION FOR 20Y2

	$m	$m
Non-current assets		91.0
Current assets		
Inventory	3.8	
Trade receivables	4.5	8.3
Total assets		99.3
Equity finance		
Ordinary shares	20.0	
Reserves	47.2	67.2
Non-current liabilities		
8% bonds		25.0
Current liabilities		7.1
Total liabilities		99.3

The shares of GWW Co have a nominal (par) value of 50c per share and a market value of $4.00 per share. The business sector of GWW Co has an average price/earnings ratio of 17 times.

The expected net realisable values of the non-current assets and the inventory are $86.0m and $4.2m respectively. In the event of liquidation, only 80% of the trade receivables are expected to be collectible.

242 What is the value of GWW Co using market capitalisation (equity market value) (in $m to the nearest whole million)?

$ [] million

(2 marks)

243 What is the value of GWW Co using the net asset value (liquidation basis) (in $m to the nearest whole million)?

$ [] million

(2 marks)

244 What is the value of GWW Co using the price/earnings ratio method (business sector average price/earnings ratio)?

☐ $1.7m

☐ $61.7m

☐ $160m

☐ $171.7m

(2 marks)

245 An investor believes that they can make abnormal returns by studying past share price movements.
In terms of capital market efficiency, to which of the following does the investor's belief relate?

☐ Fundamental analysis

☐ Operational efficiency

☐ Technical analysis

☐ Semi-strong form efficiency (2 marks)

246 Assume that GWW Co's P/E ratio is 15. Its competitor's earnings yield is 6.25%.
When comparing GWW Co to its competitor, which of the following is correct?

	Earnings yield of GWW	P/E ratio of GWW
☐	Higher	Higher
☐	Higher	Lower
☐	Lower	Higher
☐	Lower	Lower

(2 marks)

Corhig Co (6/12, amended) 18 mins

The following scenario relates to questions 247–251.

Corhig Co is a company that is listed on a major stock exchange. The company has struggled to maintain profitability in the last two years due to poor economic conditions in its home country and as a consequence it has decided not to pay a dividend in the current year. However, there are now clear signs of economic recovery and Corhig Co is optimistic that payment of dividends can be resumed in the future. Forecast financial information relating to the company is as follows:

Year	1	2	3
Earnings ($'000)	3,000	3,600	4,300
Dividends ($'000)	nil	500	1,000

The current average price/earnings ratio of listed companies similar to Corhig Co is five times.

The company is optimistic that earnings and dividends will increase after Year 3 at a constant annual rate of 3% per year.

247 Using Corhig Co's forecast earnings for Year 1 and the average P/E ratio of similar companies, what is the value of Corhig Co using the price/earnings ratio method?

$ ☐ million (2 marks)

248 Are the following statements true or false?

	True	False
1 A P/E valuation using average earnings of $3.63m would be more realistic than the P/E ratio method calculated above.	☐	☐
2 Using the average P/E ratio of similar companies is appropriate in this situation.	☐	☐

(2 marks)

BPP
LEARNING
MEDIA

249 Assuming that the cost of equity is 12%, what is the present value of Corhig Co's Year 2 dividend?

$ []

(2 marks)

250 Corhig Co plans to raise debt in order to modernise some of its non-current assets and to support the expected growth in earnings. This additional debt would mean that the capital structure of the company would change and it would be financed 60% by equity and 40% by debt on a market value basis. The before-tax cost of debt of Corhig Co would increase to 6% per year. In order to stimulate economic activity the Government has reduced the tax rate for all large companies to 20% per year.

Assuming that the revised cost of equity is 14%, what is the revised weighted average after-tax cost of capital of Corhig Co following the new debt issue (give your answer to 2 decimal places)?

[] %

(2 marks)

251 Match the description of the risk to the type of risk.

	Business Systematic	Financial
Risk linked to the extent to which the company's profits depend on fixed, rather than variable, costs	☐	☐
Risk that shareholder cannot mitigate by holding a diversified investment portfolio	☐	☐
Risk that shareholder return fluctuates as a result of the level of debt the company undertakes	☐	☐

(2 marks)

(Total = 10 marks)

Close Co (12/11, amended) 18 mins

The following scenario relates to questions 252–256.

Recent financial information relating to Close Co, a stock market listed company, is as follows.

	$m
Profit after tax (earnings)	66.6
Dividends	40.0

STATEMENT OF FINANCIAL POSITION INFORMATION

	$m	$m
Non-current assets		595
Current assets		125
Total assets		720
Equity		
Ordinary shares ($1 nominal)	80	
Retained earnings	410	
		490
Non-current liabilities		
6% bank loan	40	
8% bonds ($100 nominal)	120	
		160
Current liabilities		70
Total equity and liabilities		720

Financial analysts have forecast that the dividends of Close Co will grow in the future at a rate of 4% per year. This is slightly less than the forecast growth rate of the profit after tax (earnings) of the company, which is 5% per year. The finance director of Close Co thinks that, considering the risk associated with expected earnings growth, an earnings yield of 11% per year can be used for valuation purposes.

Close Co has a cost of equity of 10% per year.

252 Calculate the value of Close Co using the net asset value method.

$ [] million

(2 marks)

253 Calculate the value of Close Co using the dividend growth model (DGM).

$ [] million

(2 marks)

254 Calculate the value of Close Co using the earnings yield method (in millions to 1 decimal places).

$ [] million

(2 marks)

255 The DGM has been used by financial analysts to value Close Co.

Are the following statements about the DGM true or false?

		True	False
1	It is very sensitive to changes in the growth rate.	☐	☐
2	It can only be used if dividends have been paid or are expected to be paid.	☐	☐

(2 marks)

256 Close Co is considering raising finance via convertible bonds.

Which of the following statements is correct about the current market value of a convertible bond where conversion is expected?

☐ The sum of the present values of the future interest payments + the present value of the bond's conversion value

☐ The sum of the present values of the future interest payments − the present value of the bond's conversion value

☐ The higher of the sum of the present values of the future interest payments and the present value of the bond's conversion value

☐ The lower of the sum of the present values of the future interest payments and the present value of the bond's conversion value (2 marks)

(Total = 10 marks)

BPP
LEARNING
MEDIA

WAW Co

The following scenario relates to questions 257–261.

WAW Co is an unlisted company that has performed well recently. It has been approached by a number of companies in the industry as a potential acquisition target.

The directors of WAW Co are looking to establish an approximate valuation of the company.

Recent information on the earnings per share and dividend per share of WAW Co is as follows:

Year to September	20X3	20X4	20X5	20X6
Earnings $m	6	6.5	7.0	7.5
Dividend $m	2.4	2.6	2.8	3.0

WAW Co has an estimated cost of equity of 12% and $5m ordinary shares in issue with a par value of $0.50.

There has been no change in the number of ordinary shares in issue over this period.

WAW Co pays corporation tax at a rate of 20%.

Listed companies similar to WAW Co have a price/earnings ratio of 15.

257 What is the value of a share in WAW Co using the dividend growth model?

☐ $5.07

☐ $4.79

☐ $7.55

☐ $15.10

(2 marks)

258 Which of the following statements are problems in using the dividend growth model to value a company?

1 It is difficult to estimate future dividend growth.

2 It cannot be used for unlisted companies as they do not have a cost of equity.

3 It is inaccurate to assume that dividend growth will be constant.

4 It does not adjust for the value of holding a controlling interest in a company.

☐ 1 and 3

☐ 1, 2 and 3

☐ 1, 3 and 4

☐ 1, 2, 3 and 4

(2 marks)

259 What is the value of WAW Co using the price/earnings ratio method?

☐ $56.25 per share

☐ $11.25 per share

☐ $22.50 per share

☐ $45.00 per share

(2 marks)

260 A high price/earnings ratio is usually seen as an indication that:

☐ The company's earnings are expected to be risky

☐ The dividend payout is excessive

☐ The share price is overstated

☐ The company is expected to grow (2 marks)

261 Which of the following statements are true about WAW Co's dividend policy?

1 Shareholders achieve steady dividend growth.

2 The dividend payout ratio is constant.

3 The dividend cover is 2.5.

4 Shareholders are indifferent between reinvesting in the business and the payment of a dividend.

☐ 1, 2 and 3

☐ 1, 2 and 4

☐ 1 and 3

☐ 2, 3 and 4 (2 marks)

(Total = 10 marks)

DFE Co 18 mins

The following scenario relates to questions 262–266.

DFE Co is hoping to invest in a new project. DFE Co's gearing is slightly above the industry average, so when seeking finance for the new project DFE Co opts for equity finance.

The board of DFE Co recently appointed a media liaison officer as they believe the timing and method of public announcements (such as the investment in a large project) is important in managing the value of DFE Co's shares.

DFE Co has 8% convertible loan notes in issue which are redeemable in 5 years' time at their nominal value of $100 per loan note. Alternatively, each loan note could be converted after 5 years into 70 equity shares with a nominal value of $1 each.

The equity shares of DFE Co are currently trading at $1.25 per share and this share price is expected to grow by 4% per year. The before-tax cost of debt of DFE Co is 10% and the after-tax cost of debt of DFE Co is 7%.

262 What is the capital structure theory that DFE Co appears to subscribe to?

☐ Traditional view

☐ Modigliani-Miller (no tax)

☐ Modigliani-Miller (with tax)

☐ Residual view (2 marks)

263 How efficient does the DFE Co board believe the markets to be?

☐ Completely inefficient

☐ Weak form efficient

☐ Semi-strong form efficient

☐ Strong form efficient (2 marks)

264 What is the current market value of each convertible loan note (to 2 decimal places)?

$ ▢ (2 marks)

265 In relation to DFE Co hedging interest rate risk, which of the following statements is correct?

☐ The flexible nature of interest rate futures means that they can always be matched with a specific interest rate exposure.

☐ Interest rate options carry an obligation to the holder to complete the contract at maturity.

☐ Forward rate agreements are the interest rate equivalent of forward exchange contracts.

☐ Matching is where a balance is maintained between fixed rate and floating rate debt. (2 marks)

266 Which of the following could cause the interest yield curve to steepen?

1 Increased uncertainty about the future

2 Heightened expectations of an increase in interest rates

3 The expectation that interest rate decreases will happen earlier than previously thought

☐ 1 and 2 only

☐ 1, 2 and 3

☐ 2 and 3 only

☐ 1 only (2 marks)

(Total = 10 marks)

PART G: RISK MANAGEMENT

Questions 267 to 306 cover Risk management, the subject of Part G of the BPP Financial Management Workbook.

OTQ bank – Foreign currency risk **36 mins**

267 Exporters Co is concerned that the cash received from overseas sales will not be as expected due to exchange rate movements.

What type of risk is this?

☐ Translation risk

☐ Economic risk

☐ Credit risk

☐ Transaction risk **(2 marks)**

268 The current euro/US dollar exchange rate is €1:$2. ABC Co, a Eurozone company, makes a $1,000 sale to a US customer on credit. By the time the customer pays, the euro has strengthened by 20%.

What will the euro receipt be (to the nearest euro)?

€ []

(2 marks)

269 The forward rate is 0.8500 – 0.8650 euros to the 1$.

What will a €2,000 receipt be converted to at the forward rate?

☐ $1,730

☐ $2,312

☐ $2,353

☐ $1,700 **(2 marks)**

270 Which of the following derivative instruments are characterised by a standard contract size? 3/16

1 Futures contract

2 Exchange-traded option

3 Forward rate agreement

4 Swap

☐ 1 and 2

☐ 2 and 3

☐ 3 and 4

☐ 1 and 4 **(2 marks)**

271 A US company owes a European company €3.5m due to be paid in 3 months' time. The spot exchange rate is $1.96 – $2:€1 currently. Annual interest rates in the two locations are as follows:

	Borrowing	Deposit
US	8%	3%
Europe	5%	1%

What will be the equivalent US$ value of the payment using a money market hedge?

- ☐ $6,965,432
- ☐ $6,979,750
- ☐ $7,485,149
- ☐ $7,122,195

 (2 marks)

272 In comparison to forward contracts, which **TWO** of the following are true in relation to futures contracts?

- ☐ They are more expensive.
- ☐ They are only available in a small amount of currencies.
- ☐ They are less flexible.
- ☐ They may be an imprecise match for the underlying transaction. (2 marks)

273 A company whose home currency is the dollar ($) expects to receive 500,000 pesos in 6 months' time from a customer in a foreign country. The following interest rates and exchange rates are available to the company: 12/14

| Spot rate | 15.00 peso per $ |
| Six-month forward rate | 15.30 peso per $ |

	Home country	Foreign country
Borrowing interest rate	4% per year	8% per year
Deposit interest rate	3% per year	6% per year

Working to the nearest $100, what is the 6-month dollar value of the expected receipt using a money market hedge?

- ☐ $32,500
- ☐ $33,700
- ☐ $31,800
- ☐ $31,900

 (2 marks)

274 The current spot rate for the peso (the currency of country P) to the $ (the currency of country A) is 2 peso:$1. Annual interest rates in the two countries are 8% in country P, and 4% in country A.

What is the three months forward rate (to four decimal places) in terms of peso to the $?

☐ 1.9804

☐ 2.0198

☐ 1.9259

☐ 2.0769 (2 marks)

275 Handria is a country that has the peso for its currency and Wengry is a country that has the dollar ($) for its currency. 3/17

The current spot exchange rate is 1.5134 pesos = $1.

Using interest-rate differentials, the one year forward exchange rate is 1.5346 pesos = $1.

The currency market between the peso and the dollar is assumed perfect and the International Fisher Effect holds.

Which of the following statements is true?

☐ Wengry has a higher forecast rate of inflation than Handria.

☐ Handria has a higher nominal rate of interest than Wengry.

☐ Handria has a higher real rate of interest than Wengry.

☐ The forecast future spot rate of exchange will differ from the forward exchange rate.
 (2 marks)

276 An investor plans to exchange $1,000 into euros now, invest the resulting euros for 12 months, and then exchange the euros back into dollars at the end of the 12-month period. The spot exchange rate is €1.415 per $1 and the euro interest rate is 2% per year. The dollar interest rate is 1.8% per year. 6/15

Compared to making a dollar investment for 12 months, at what 12-month forward exchange rate will the investor make neither a loss nor a gain?

☐ €1.223 per $1

☐ €1.412 per $1

☐ €1.418 per $1

☐ €1.439 per $1 (2 marks)
 (Total = 20 marks)

OTQ bank – Interest rate risk

277 Act Co wishes to hedge interest rate movements on a borrowing it intends to make three months from now for a further period of six months. 12/17

Which **TWO** of the following will best help Act Co hedge its interest rate risk?

- ☐ Enter into a 3 v 6 forward rate agreement
- ☐ Enter into a 3 v 9 forward rate agreement
- ☐ Sell interest rate futures expiring in three months' time
- ☐ Buy interest rate futures expiring in three months' time

(2 marks)

278 Which of the following statements are correct? 6/15

1 The general level of interest rates is affected by investors' desire for a real return
2 Market segmentation theory can explain kinks (discontinuities) in the yield curve
3 When interest rates are expected to fall, the yield curve could be sloping downwards

- ☐ 1 and 2 only
- ☐ 1 and 3 only
- ☐ 2 and 3 only
- ☐ 1, 2 and 3

(2 marks)

279 Which of the following statements concerning the causes of interest rate fluctuations is correct? 6/16

- ☐ Liquidity preference theory suggests that investors want more compensation for short-term lending than for long-term lending.
- ☐ According to expectations theory, the shape of the yield curve gives information on how inflation rates are expected to influence interest rates in the future.
- ☐ An inverted yield curve can arise if government policy is to keep short-term interest rates high in order to bring down inflation.
- ☐ Market segmentation theory suggests long-term interest rates depend on how easily investors can switch between market segments of different maturity. (2 marks)

280 A company that has a $10m loan with a variable rate of interest, has acquired a forward rate agreement (FRA) with a financial institution that offered a 3–6, 3.2% – 2.7% spread. 6/18

What would be the payment made to the financial institution under the terms of the FRA if the actual rate of interest was 3% (to the nearest dollar)?

$ ☐

(2 marks)

281 Which of the following statements are correct?

1 Interest rate options allow the buyer to take advantage of favourable interest rate movements

2 A forward rate agreement does not allow a borrower to benefit from a decrease in interest rates

3 Borrowers hedging against an interest rate increase will buy interest rate futures now and sell them at a future date

☐ 1 and 2 only

☐ 1 and 3 only

☐ 2 and 3 only

☐ 1, 2 and 3 (2 marks)

 (Total = 10 marks)

Rose Co (6/15, amended) **18 mins**

The following scenario relates to questions 282–286.

Rose Co expects to receive €750,000 from a credit customer in the European Union in 6 months' time. The spot exchange rate is €2.349 per $1 and the 6-month forward rate is €2.412 per $1. The following commercial interest rates are available to Rose Co:

	Deposit rate	Borrow rate
Euros	4.0% per year	8.0% per year
Dollars	2.0% per year	3.5% per year

Rose Co does not have any surplus cash to use in hedging the future euro receipt. It also has no euro payments to make.

Rose Co is also considering using derivatives such as futures, options and swaps to manage currency risk.

In addition, Rose Co is concerned about the possibility of future interest rate changes and wants to understand how a yield curve can be interpreted.

282 What could Rose Co do to reduce the risk of the euro value dropping relative to the dollar before the €750,000 is received?

☐ Deposit €750,000 immediately

☐ Enter into an interest rate swap for 6 months

☐ Enter into a forward contract to sell €750,000 in 6 months

☐ Matching payments and receipts to the value of €750,000 (2 marks)

283 What is the dollar value of a forward market hedge in six months' time?

☐ $310,945

☐ $319,285

☐ $1,761,750

☐ $1,809,000 (2 marks)

284 If Rose Co used a money market hedge, what would be the percentage borrowing rate for the period?

☐ 1.75%

☐ 2.00%

☐ 4.00%

☐ 8.00% (2 marks)

285 Which of the following statements is correct?

☐ Once purchased, a currency futures contract has a range of settlement dates.

☐ Currency swaps can be used to hedge exchange rate risk over longer periods than the forward market.

☐ Banks will allow forward exchange contracts to lapse if they are not used by a company.

☐ Currency options are paid for when they are exercised. (2 marks)

286 Which of the following statements is correct?

☐ Governments can keep interest rates low by selling short-dated government bills in the money market.

☐ The normal yield curve slopes upward to reflect increasing compensation to investors for being unable to use their cash now.

☐ The yield on long-term loan notes is lower than the yield on short-term loan notes because long-term debt is less risky for a company than short-term debt.

☐ Expectations theory states that future interest rates reflect expectations of future inflation rate movements. (2 marks)

(Total = 10 marks)

Edwen Co 18 mins

The following scenario relates to questions 287–291.

Edwen Co is based in Country C, where the currency is the C$. Edwen is expecting the following transactions with suppliers and customers who are based in Europe.

One month: Expected receipt of 240,000 euros
One month: Expected payment of 140,000 euros
Three months: Expected receipts of 300,000 euros

A one-month forward rate of 1.7832 euros per $1 has been offered by the company's bank and the spot rate is 1.7822 euros per $1.

Other relevant financial information is as follows:

Three-month European borrowing rate: 1.35%

Three-month Country C deposit rate: 1.15%

Assume that it is now 1 April.

287 What are the expected dollar receipts in one month using a forward hedge (to the nearest whole number)?

☐ $56,079

☐ $56,110

☐ $178,220

☐ $178,330 (2 marks)

288 What are the expected dollar receipts in three months using a money market hedge (to the nearest whole number)?

☐ $167,999

☐ $296,004

☐ $166,089

☐ $164,201 (2 marks)

289 Edwen Co is expecting a fall in the value of the C$.

What is the impact of a fall in a country's exchange rate?

1 Exports will be given a stimulus.

2 The rate of domestic inflation will rise.

☐ 1 only

☐ 2 only

☐ Both 1 and 2

☐ Neither 1 nor 2 (2 marks)

290 Edwen Co is considering a currency futures contract.

Which of the following statements about currency futures contracts are true?

1 The contracts can be tailored to the user's exact requirements.

2 The exact date of receipt or payment of the currency does not have to be known.

3 Transaction costs are generally higher than other hedging methods.

☐ 1 and 2 only

☐ 1 and 3 only

☐ 2 only

☐ 3 only (2 marks)

291 Do the following features apply to forward contracts or currency futures?

1 Contract price is in any currency offered by the bank

2 Traded over the counter

☐ Both features relate to forward contracts.

☐ Both features relate to currency futures.

☐ Feature 1 relates to forward contracts and feature 2 relates to currency futures.

☐ Feature 2 relates to forward contracts and feature 1 relates to currency futures.

(2 marks)

(Total = 10 marks)

Zigto Co (6/12, amended) 18 mins

The following scenario relates to questions 292–296.

Zigto Co is a medium-sized company whose ordinary shares are all owned by the members of one family. The domestic currency is the dollar. It has recently begun exporting to a European country and expects to receive €500,000 in 6 months' time. The company plans to take action to hedge the exchange rate risk arising from its European exports.

Zigto Co could put cash on deposit in the European country at an annual interest rate of 3% per year, and borrow at 5% per year. The company could put cash on deposit in its home country at an annual interest rate of 4% per year, and borrow at 6% per year. Inflation in the European country is 3% per year, while inflation in the home country of Zigto Co is 4.5% per year.

The following exchange rates are currently available to Zigto Co:

Current spot exchange rate 2.000 euro per $
Six-month forward exchange rate 1.990 euro per $
One-year forward exchange rate 1.981 euro per $

Zigto Co wants to hedge its future euro receipt.

Zigto Co is also trying to build an understanding of other types of currency risk and the potential impact of possible future interest rate and inflation rate changes.

292 What is the dollar value of a forward exchange contract in six months' time (to the nearest whole number)?

$ []

(2 marks)

293 What is the dollar value of a money market hedge in six months' time (to the nearest whole number)?

$ []

(2 marks)

294 What is the one-year expected (future) spot rate predicted by purchasing power parity theory (to three decimal places)?

[] euro per $

(2 marks)

295 Are the following statements true or false?

		True	False
1	Purchasing power parity tends to hold true in the short term.	☐	☐
2	Expected future spot rates are based on relative inflation rates between two countries.	☐	☐
3	Current forward exchange rates are based on relative interest rates between two countries.	☐	☐

(2 marks)

296 Are the following statements true or false?

		True	False
1	Transaction risk affects cash flows.	☐	☐
2	Translation risk directly affects shareholder wealth.	☐	☐
3	Diversification of supplier and customer base across different countries reduces economic risk.	☐	☐

(2 marks)

(Total = 10 marks)

PGT Co **18 mins**

The following scenario relates to questions 297–301.

PGT Co, whose home currency is the dollar ($), trades with both customers and suppliers in the European Union where the local currency is the euro (€). PGT Co has the following transactions due within the next six months:

	Receipts	**Payments**
3 months	1,000,000 euros	400,000 euros
6 months	500,000 dollars	300,000 euros

The finance director at PGT Co is concerned about the exchange rate due to uncertainty in the economy. He would like to hedge the exchange rate risk and has gathered the following information:

Spot rate (euro per $1) 1.7694 – 1.8306
Three-month forward rate (euro per $1) 1.7891 – 1.8510

PGT Co also has a 12 million loan in dollars. There is increased uncertainty in the economy regarding future interest rates due to impending elections which could lead to a change in political leadership and direction. PGT has never previously managed interest rate risk, but given the uncertainty the finance director is considering using a forward rate agreement.

The following commercial interest rates are currently available to PGT Co:

	Deposit rate	Borrow rate
Euros	4%	8%
Dollars	2%	3.5%

Assume that PGT Co does not have any surplus cash.

BPP
LEARNING
MEDIA

297 What is the three-month dollar receipt of a forward market hedge (to the nearest whole number)?

$ [_____]

(2 marks)

298 What is the cost in six months' time of a money market hedge (to the nearest whole number)?

$ [_____]

(2 marks)

299 Which of the following statements about a forward rate agreement (FRA) is/are true?

		True	False
1	FRAs can be used to manage interest rate risk on borrowings but not interest rate risk on investments.	☐	☐
2	FRAs are over the counter contracts.	☐	☐
3	The user of an FRA has the option to let the contract lapse if the rate is unfavourable.	☐	☐

(2 marks)

300 Which of the following statements are true if interest rate parity theory is used to forecast the forward value of the dollar for the transaction in six months' time (assuming interest rates stay the same)?

☐ The value of the dollar will be forecast to rise compared to the spot rate – leading to a fall in the cost of the transaction.

☐ The value of the dollar will be forecast to rise compared to the spot rate – leading to a rise in the cost of the transaction.

☐ The value of the dollar will be forecast to fall compared to the spot rate – leading to a rise in the cost of the transaction.

☐ The value of the dollar will be forecast to fall compared to the spot rate – leading to a fall in the cost of the transaction.

(2 marks)

301 Which of the following statements are true in relation to purchasing power parity?

		True	False
1	The theory holds in the long term rather than the short term.	☐	☐
2	The exchange rate reflects the different cost of living in two countries.	☐	☐
3	The forward rate can be found by multiplying the spot rate by the ratio of the real interest rates of the two countries.	☐	☐

(2 marks)

(Total = 10 marks)

Peony Co (Mar/Jun 19)

18 mins

The following scenario relates to questions 302–306.

Peony Co's finance director is concerned about the effect of future interest rates on the company and has been looking at the yield curve.

Peony Co, whose domestic currency is the dollar ($), plans to take out a $100m loan in three months' time for a period of nine months. The company is concerned that interest rates might rise before the loan is taken out and its bank has offered a 3 v 12 forward rate agreement at 7.10–6.85.

The loan will be converted into pesos and invested in a nine-month project which is expected to generate income of 580 million pesos, with 200 million pesos being paid in six months' time (from today) and 380 million pesos being paid in 12 months' time (from today). The current spot exchange rate is 5 pesos per $1.

The following information on current short-term interest rates is available:

Dollars 6.5% per year
Pesos 10.0% per year

As a result of the general uncertainty over interest rates, Peony Co is considering a variety of ways in which to manage its interest rate risk, including the use of derivatives.

302 In relation to the yield curve, which of the following statements is correct?

☐ Expectations theory suggests that deferred consumption requires increased compensation as maturity increases.

☐ An inverted yield curve can be caused by government action to increase its long-term borrowing.

☐ A kink (discontinuity) in the normal yield curve can be due to differing yields in different market segments.

☐ Basis risk can cause the corporate yield curve to rise more steeply than the government yield curve.

(2 marks)

303 If the interest rate on the loan is 6.5% when it is taken out, what is the nature of the compensatory payment under the forward rate agreement?

☐ Peony Co pays bank $600,000.

☐ Peony Co pays bank $250,000.

☐ Peony Co pays bank $450,000.

☐ Bank pays Peony Co $600,000.

(2 marks)

304 Using exchange rates based on interest rate parity, what is the dollar income received from the project?

☐ $112.3m

☐ $114.1m

☐ $116.0m

☐ $112.9m

(2 marks)

305 In respect of Peony Co managing its interest rate risk, which of the following statements is/are correct?

1 Smoothing is an interest rate risk hedging technique which involves maintaining a balance between fixed-rate and floating-rate debt.

2 Asset and liability management can hedge interest rate risk by matching the maturity of assets and liabilities.

☐ 1 only

☐ 2 only

☐ Both 1 and 2

☐ Neither 1 nor 2

(2 marks)

306 In relation to the use of derivatives by Peony Co, which of the following statements is correct?

☐ Interest rate options must be exercised on their expiry date, if they have not been exercised before then.

☐ Peony Co can hedge interest rate risk on borrowing by selling interest rate futures now and buying them back in the future.

☐ An interest rate swap is an agreement to exchange both principal and interest rate payments.

☐ Peony Co can hedge interest rate risk on borrowing by buying a floor and selling a cap.

(2 marks)

(Total = 10 marks)

Answers

OTQ bank 1 – Financial management and financial objectives

1 The correct answer is: **$0.80**

	$
Profit before tax	2,628,000
Less tax	788,000
Profit after tax	1,840,000
Less preference dividend (6% × 4,000,000)	240,000
Earnings attributable to ordinary shareholders	1,600,000
Number of ordinary shares	2,000,000
EPS = $1,600,000/2,000,000 =	$0.80

Syllabus area A3(d)(i)

2 The correct answer is: **Efficient acquisition and deployment of financial resources to ensure achievement of objectives**

Notes on incorrect answers:

The second statement is a definition of management accounting.

The third statement is a definition of financial accounting.

The fourth statement is true for a profit seeking organisation but would not be relevant to a not for profit organisation. However, financial management is also relevant to a not for profit organisation.

Syllabus area A1(b)

3 The correct answer is: **6**

$$P/E \text{ ratio} = \frac{MV \text{ ex div}}{EPS} = \frac{\$3.60}{60c} = 6$$

MV ex div = 3.72 – 0.12 = 3.60. The ex div price is used because it reflects the underlying value of the share after the dividend has been paid.

Syllabus area A3(d)

4 The correct answer is: **Mean growth in earnings per share over the period is 6% per year**

Mean growth in earnings per share =

$$\sqrt[3]{\frac{35.7}{30.0}} - 1 = 0.06 \text{ or } 6\%$$

Notes on incorrect answers:

Dividend payout is dividend/earnings, this does not deliver the value of 40%.

Mean growth in dividends per share =

$$\sqrt[3]{\frac{15.0}{13.0}} - 1 = 0.05 \text{ or } 5\%$$

Total shareholder return can be calculated as:

$(P_1 - P_0 + D_1)/P_0$

P_0 is the share price at the beginning of the year 3 = $2.25

P_1 is the share price at the end of period – this is unknown so TSR cannot be calculated.

Syllabus area A3(d)

5 The correct answer is: **Non-executive directors are appointed to the remuneration committee.**

Financial management decisions typically cover dividend decisions (first statement), investment decisions and financing decisions (second and third statements).

<div align="right">Syllabus area A1(a)</div>

OTQ bank 2 – Financial management and financial objectives

6 The correct answer is: **$3.60**

$$\text{Shareholder return} = \frac{P_1 - P_0 + D_1}{P_0}$$

$$\therefore 0.25 = \frac{P_1 - 3.00 + 0.15}{3.00}$$

$$\therefore 0.75 = P_1 - 3.00 + 0.15$$

$$\therefore P_1 = 3.60$$

<div align="right">Syllabus area A3(d)</div>

7 The correct answer is: **Minimisation of risk.**

Corporate governance best practice aims to **manage** risk to desired and controlled levels, not to minimise risk. Running a business implies taking calculated risks in anticipation of a commensurate return.

<div align="right">Syllabus area A3(e)(ii)</div>

8 The correct answers are:

Statement 1 is **false.** Maximising market share is not a financial objective.

Statement 2 is **true.** The primary financial objective of any profit-making company is to maximise shareholder wealth.

Statement 3 is **true.** Financial objectives should be quantifiable. These include, for example, target values for earnings per share, dividend per share and gearing which are all quantifiable measures.

<div align="right">Syllabus area A2(b)</div>

9 The correct answer is: **Cost per journey to hospital.**

Cost per journey to hospital is a measure of efficiency.

Percentage of members who re-use the service is a measure of effectiveness.

A comparison of actual operating expenses against the budget is an economy measure.

Number of communities served is an effectiveness measure.

<div align="right">Syllabus area A4(c)</div>

10 The correct answer is: **36.4%**

Shareholder return	$= (P_1 - P_0 + D_1)/P_0.$
\therefore shareholder return	$= (0.75 + 0.25)/(3.50 - 0.75)$
	$= 36.4\%$

<div align="right">Syllabus area A3(d)(ii)</div>

11 The correct answers are:

Statement 1 is **true.** The economist's concept of profits is broadly in terms of cash, whereas accounting profits may not equate to cash flows.

Statement 2 is **false.** Profit does not take account of risk.

Statement 3 is **true.** Accounting profit can be manipulated to some extent by choices of accounting policies.

Syllabus area A2(b)

12 The correct answer is: **'Cost per successfully treated patient' relates to efficiency.** Efficiency measures relate the resources used to the output produced (getting as much as possible for what goes in).

'Proportion of patients readmitted after unsuccessful treatment' relates to effectiveness. Effectiveness means getting done, by means of economy and efficiency, what was supposed to be done.

'Cost per operation' relates to economy (spending money frugally), as does 'Percentage change in doctors' salaries compared with previous year'.

Syllabus area A4(c)

13 The correct answer is:

Return on equity can be defined as profit before interest and tax divided by shareholders' funds – this is NOT true as return on equity can be defined as profit **AFTER** interest and tax divided by shareholders' funds

Syllabus area A3(d)

14 The correct answer is: **8.0%**

Dividend yield is compares dividend paid over a year to the current ex-div share price. Dividend for the year is $0.08 + $0.06= $0.14

Ex div share price (representing the amount of money being invested in the share) = $1.83 – $0.08 = $1.75.

0.14/1.75 × 100 = 8.0%

Syllabus area A3(d)

15 The correct answer is: **Share price and dividend payment**

The sources of shareholder wealth are share prices and dividend payments, so increasing both of these would be associated with the objective of shareholder wealth maximisation.

Profit and EPS are not directly linked to shareholder wealth maximisation.

Increasing the WACC would reduce shareholder wealth.

Syllabus area A2(b)

ABC Co

16 The correct answer is: **6.6%**

	20X8	20X7
ROCE (PBIT/Long-term capital)	$14,749/($53,900) = 27.4%	$13,506/($52,587) = 25.7%

Percentage increase = $\dfrac{27.4 - 25.7}{25.7}$ = 6.6%

17 The correct answer is: **19.8%**

Operating profit margin $= \dfrac{\text{PBIT}}{\text{Sales}} = \dfrac{\$14,749}{\$74,521} = 19.8\%$

18 The correct answer is: **23.6%**

The total shareholder return is $(P_1 - P_0 + D_1)/P_0 = (8.82 - 7.41 + 0.34)/7.41 = 23.6\%$.

19 The correct answer is: **Statement 1 is true and statement 2 is false.**

The shareholders of ABC would probably be reasonably pleased with the performance over the two years. (For example, share price has increased by 19% ((8.82 – 7.41)/7.41 × 100%).) However, salaries and wages have only increased by 2.4% ((20,027 – 19,562)/19,562 × 100%), which is below the rate of inflation, so employees may be less pleased with the situation. So statement 1 is true.

Statement 2 is false. The financial risk that the shareholders are exposed to does not appear to be a problem area as gearing has decreased from 49.9% to 35.1% and interest cover is more than sufficient.

20 The correct answer is: **1, 2, 3 and 4**

All of the statements support the theory.

Accounting profits can be manipulated to some extent by choices of accounting policies.

Profit does not take account of risk. Shareholders will be very interested in the level of risk, and maximising profits may be achieved by increasing risk to unacceptable levels.

Profits on their own take no account of the volume of investment that it has taken to earn the profit. Profits must be related to the volume of investment to have any real meaning.

Profits are reported every year (with half-year interim results for quoted companies). They are measures of short-term historic performance, whereas a company's performance should ideally be judged over a longer term and future prospects considered as well as past profits.

OTQ bank 1 – Financial management environment

21 The correct answer is: **Higher taxes and lower government subsidies**

Fiscal policy is the balance of government taxation and spending. A contractionary fiscal policy implies a government budget surplus – the Government is reducing demand by withdrawing higher amounts from the economy by way of higher taxation and/or spending less. The second statement would be the result of an expansionary fiscal policy.

The first statement and fourth statements are connected with monetary policy.

Syllabus area B1(c)

22 The correct answer is: **Higher demand from customers, lower interest rates on loans and increased availability of credit**

Monetary policy manages demand by influencing the supply of money (including the availability of credit) and interest rates. An expansionary policy implies low interest rates to encourage borrowing and investment, and to discourage saving. It also implies an increased availability of credit to encourage spending and the stimulation of demand in an economy. Tax rates are a tool of fiscal policy, so the third and fourth statements are incorrect. Statement 2 would be the result of a contractionary monetary policy.

Syllabus area B1(c)

23 The correct answer is: **Only the first statement is true.**

As an economy approaches its peak, inflation increases because price increases 'soak up' high demand as productivity peaks. Unemployment is low so businesses struggle to fill vacancies.

Statement 2 is incorrect – export demand is affected by foreign demand, not domestic, and growth rates are unlikely to be increasing as the economy reaches its peak – they will decrease.

Statement 3 describes a recession.

Statement 4 is incorrect because as an economy peaks a contractionary fiscal policy is likely to be employed implying lower government spending and higher taxation.

Syllabus area B1(c)

24 The correct answers are:

Statement 1 is **incorrect:** it is fiscal policy that involves changing tax rates

Statement 2 is **correct:** in a floating rate system the exchange rate is determined by demand and supply.

Statement 3 is **incorrect:** it is monetary policy that seeks to influence the economy and economic growth by increasing or decreasing interest rates

Syllabus area B1(b)

25 The correct answer is: **An organisation which has a large number of long-term payables**

Rationale: Debts lose 'real' value with inflation: a company that owes a lot of money would effectively pay less (in real terms) over time.

The other organisations would suffer because inflation would make exports relatively expensive and imports relatively cheap; business might be lost due to price rises; and the cost of implementing price changes would be high.

Syllabus area B1(d)

BPP
LEARNING
MEDIA

OTQ bank 2 – Financial management environment

26 The correct answer is: All answers are true <u>except</u> **Dividend creation**

This benefits the intermediaries' investors, not their customers/borrowers.

<div align="right">Syllabus area B2(b)</div>

27 The correct answer is: **3.80%**

The calculation is as follows

Increase in value = $9.65m – $9.6m = $0.05m

As a percentage of the original value = $0.05m/$9.6m = 0.52%

Annualising this value = 0.52% x 365/50 = 3.80%.

<div align="right">Syllabus area B3(c)</div>

28 The correct answer is: **Discounting the banker's acceptance.**

A letter of credit involves a selling company and a buying company (who use the letter of credit reduce the credit risk of the selling company). The first and third statements are incorrect as these would be done by the buying company's bank. The second statement would be done by the selling company's bank.

<div align="right">Syllabus area B2(a)</div>

29 The correct answer is: **Eurobonds**

Eurobonds by definition are bonds issued in a currency other than the domestic currency of the country of issue. The prefix 'Euro' does not refer to the continent Europe or the European currency the euro.

<div align="right">Syllabus area B2(d)</div>

30 The correct answer is: **4, 1, 3, 2**

Ordinary shares are riskiest as all other investors are preferential to ordinary shareholders. Preference shares are riskier than corporate bonds as preference shares are paid after corporate bonds – bonds imply a contractual right to receive a predefined level of return. Treasury bills are short-term government borrowing hence are the lowest risk of all.

<div align="right">Syllabus area B2(d)</div>

OTQ bank 3 – Financial management environment

31 The correct answer is: **Statement 1 is true.**

Statement 2 is false. The reverse yield gap refers to yields on shares being lower than on low-risk debt. A reverse yield gap can occur because shareholders may be willing to accept lower returns on their investments in the short term, in anticipation that they will make capital gains in the future.

Statement 3 is true. Disintermediation means borrowers dealing with lenders directly and has led to a reduction in the role of financial intermediaries.

<div align="right">Syllabus area B2(b)</div>

32 The correct answer is: **Statements 2 and 4 only**

Fiscal policy is action by the Government to spend money, or to collect money in taxes with the purpose of influencing the condition of the national economy.

Incorrect answers:

Decreasing interest rates in order to stimulate consumer spending – Decreasing interest rates relates to monetary policy.

Using official foreign currency reserves to buy the domestic currency – This is government policy on intervention to influence the exchange rate.

<div align="right">Syllabus area B1(b/c)</div>

33 The correct answer is: **All statements are correct.**

Syllabus area B3

34 The correct answers are:

Statement 1 is **incorrect**: a capital market security is like a share, is an asset to a buyer.

Statements 2 and 3 are **correct**.

Syllabus area B2

35 The correct answer is: **Statement 2 is the only correct statement** as lending is securitised.

Statement 1 is **incorrect** as money markets are markets for short-term capital, of less than a year.

Statement 3 is **incorrect**, the money markets are mainly used by large companies.

Syllabus area B3(c)

OTQ bank 4 – Financial management environment

36 The correct answer is: **Both statements are true.**

If a government spends more, for example, on public services such as hospitals, without raising more money in taxation, it will increase expenditure in the economy and raise demand. Although the second statement appears to contradict the first, it is also true. After the government has kick-started demand (as in statement 1) then it should be able to repay the borrowing it has taken on as tax receipts rise due to higher economic activity.

Syllabus area B1(c)

37 The correct answer is: **UK exporters to the US will suffer. UK importers from the US will benefit.**

A weakening dollar implies, for example, an exchange rate that moves from, say, $1:£1 to $2:£1. A UK exporter will therefore receive less £ sterling for their $ revenue. However, a UK company importing from the US will benefit by way of a lower £ cost for any given $ price they need to pay for their imports.

Syllabus area B1(b)

38 The correct answer is: **Options 1, 2 and 3 are all situations which may require regulation, because they are all examples of where the free market has failed.**

Syllabus area B1(d)

39 The correct answer is: **Low & stable inflation, achievement of a balance between exports and imports.**

The four main objectives of macroeconomic policy relate to economic growth, stable inflation, unemployment and the balance of payments (balance between exports and imports). Equitable income distribution is a social/political issue. Recycling is an environmental issue.

Syllabus area B1(a)

40 The correct answer is: **Increasing public expenditure, decreasing taxation.**

Rationale: increasing public spending and cutting taxes should both increase the level of consumer spending which will stimulate economic activity.

Notes on incorrect answers:

Increasing the exchange rate will increase the price of exported goods and lower the price of imported goods; this is likely to lead to a fall in domestic economic activity. Increasing interest rates will cut investment (by companies) and consumer expenditure, even if only after a time lag.

Syllabus area B1(b)

BPP LEARNING MEDIA

OTQ bank – Working capital

41 The correct answer is: **$3.151m**

Current raw material inventory

= 15/365 × purchases of (0.5 × $100m) = **$2.055m**

Current WIP inventory

= 35/365 × cost of goods sold $100m = **$9.589m**

Current finished goods inventory

= 40/365 × cost of goods sold $100m = **$10.959m**

A reduction of 5 days in raw material inventory

= 5/15 × 2.055 = **$0.685m**

A reduction of 4 days in WIP inventory

= 4/35 × 9.589 = **$1.096m**

A reduction of 5 days in finished goods inventory

= 5/40 × 10.959 = **$1.370m**

Total reduction = 0.685 + 1.096 + 1.370 = **$3.151m**

Syllabus area C3(a)

42 The correct answer is:

Current assets – current liabilities

The long term capital invested in net current assets

Notes on incorrect answers:

Inventory days + accounts receivable days – accounts payable days is the cash operating cycle

Current assets/current liabilities is the current ratio.

Syllabus area C1(a)

43 The correct answer is: **36.5 days**

Current ratio	= current assets/current liabilities = 2
Here	= ($3m + inventory)/$2m = 2
So inventory	= $1m

If cost of sales is $10m then inventory days = (1/10) × 365 = 36.5 days

Syllabus area C3(a)

44 The correct answer is: **The first and third statements about overtrading are correct.**

The second statement is **incorrect** as overcapitalisation results in a relatively high current ratio.

The fourth statement is **incorrect** as overcapitalisation is the result of an organisation having too much long-term capital.

Syllabus area C1(a)

45 The correct answer is: **$4,375,000**

Inventory = $15,000,000 \times \dfrac{60}{360}$ = $2,500,000

Trade receivables = $27,000,000 \times \dfrac{50}{360}$ = $3,750,000

Trade payables = $15,000,000 \times \dfrac{45}{360}$ = $1,875,000

Net investment required = 2,500,000 + 3,750,000 − 1,875,000 = $4,375,000

Syllabus area C3(a)

OTQ bank – Managing working capital

46 The correct answer is: **1,600**

Annual demand = 40 × 250 = 10,000 ball bearings = D

Order cost = $64 = C_o

Holding cost per year per unit = 25% of $2 = $0.50 = C_h

$$\text{EOQ} = \sqrt{\frac{2C_oD}{C_h}}$$

$$= \sqrt{\frac{2 \times 64 \times 10,000}{0.5}}$$

= 1,600 ball bearings

Syllabus area C2(c)

47 The correct answer is: **$22,219**

Total cost = Annual purchase costs + annual ordering cost + annual holding cost.

Annual purchase cost = 10,000 units × $2 = $20,000

Annual ordering cost = number of orders × cost per order = (10,000/250) × $50 = $2,000

Annual holding cost = Average inventory level × cost to hold per unit per year

= [(250/2) + 50] × $1.25 = $218.75

Total cost = $20,000 + $2,000 + $218.75 = $22,218.75 = $22,219 (to nearest $).

Syllabus area C2(c)

48 The correct answers are: **1, 2 and 3**

Statement 1 is **correct**. If a business is profitable then an increase in sales should translate to more working capital.

Statement 2 is **correct**. The greater the cash operating cycle, the greater the working capital investment need is. Greater working capital means more cash tied up and therefore not earning profit.

Statement 3 is **correct**. Overtrading (or undercapitalisation) is where a business is over reliant on short-term finance to support its operations. It is trying to do too much too quickly with little long-term capital.

Syllabus area C1(b/c)

49 Correct answer: **$2,625 cost**

Reduction in receivables = $4,500,000 × 30/360 × 35% = $131,250

Alternatively: average receivables days will fall to (60 × 0.65) + (30 × 0.35) = 49.5 days which is a reduction of 10.5 days; $4,500,000 × 10.5/360 = $131,250.

Interest saved at 10% = $131,250 × 0.1 = $13,125
Cost of discount = $4,500,000 × 35% × 1% = $15,750
Net cost = $13,125 – $15,750 = $2,625

$1,875 is incorrectly arrived at by using 25% based on total customers instead of credit customers.

<div align="right">Syllabus area C2(d)</div>

50 The correct answer is: **2 only**

Statement 1 is incorrect because it is factoring with **no recourse** that provides insurance against bad debts

<div align="right">Syllabus area C2(d)</div>

51 The correct answer is: **Commercial paper**

Commercial paper is a source of finance and not directly applicable to the management of foreign debts.

<div align="right">Syllabus area C2(d)</div>

52 The correct answer is: **$28,500**

The cost is (total sales × 1.5%) + $6,000 = ($1.5m × 1.5%) + $6,000 = $28,500

Non-recourse means that the factor carries the risk of the bad debts.

<div align="right">Syllabus area C2(d)</div>

53 The correct answer is: **Assumes a small number of close suppliers**

This relates to just-in-time (JIT). It is not a drawback of EOQ.

<div align="right">Syllabus area C2(c)</div>

54 The correct answer is: **Increased risk of bad debts**

This relates to receivables, not payables.

<div align="right">Syllabus area C2(e)</div>

55 The correct answer is: **Lower inventory holding costs, more frequent deliveries**

Inventory shortages are the most likely problem with a JIT inventory ordering system as inventory is held at a minimal level. Ordering costs should rise because deliveries are more frequent.

<div align="right">Syllabus area C2(c)</div>

CBE style OTQ bank – Working capital finance

56 The correct answer is: **$290,084**

Receipts for March:

	$
50% March sales for cash (50% × $150,000)	75,000
80% × February credit sales less 4% discount (50% × 80% × $501,500 × 96%)	192,576
15% × January credit sales (50% × 15% × $300,100)	22,508
	290,084

<div align="right">Syllabus area C2(b)</div>

57 The correct answer is: **55,000**

Optimum cash conversion =

$$\sqrt{\frac{2 \times 400 \times 150,000}{(0.05-0.001)}} = \$54.772$$

55,000 to the nearest '000.

Syllabus area C2(f)

58 The correct answer is: **They are all true.**

Miller Orr defines the difference between the upper limit and lower limit as the 'spread'.

TB Co's spread is $10m – $1m = $9m.

Miller Orr also defines the return point as the lower limit plus a third of the spread. In this case:

1 + [(1/3) × 9] = $4m

When the upper limit is reached, sufficient securities are purchased to reduce the cash balance back to the return point. In this case $10m – $4m = $6m. Therefore statement 1 is correct.

When the lower limit is reached, sufficient securities are sold to increase the cash balance back up to the return point. In this case $4m – $1 = $3m. Therefore statement 2 is correct.

The spread is calculated as:

$$3 \left[\frac{\frac{3}{4} \times \text{transaction cost} \times \text{variance of cash flows}}{\text{interest rate}} \right]^{\frac{1}{3}}$$

An increase in variance will therefore increase the spread. Therefore statement 3 is correct.

Syllabus area C2(f)

59 The correct answer is: **More short-term finance is used because it is cheaper, although it is risky.**

Aggressive working capital finance means using more short-term finance (and less long-term). Short-term finance is cheaper but it is risky – it may not be renewed when required and finance rates may change when they are renewed. The third statement describes a conservative financing policy. The fourth statement is describing a more aggressive working capital investment policy (not finance).

Syllabus area C3(b)

60 The correct answer is: **Rate risk and renewal risk**

Rate risk refers to the fact that when short-term finance is renewed, the rates may vary when compared to the previous rate. This risk is less with long-term finance as it is renewed less frequently.

Renewal risk refers to the fact that finance providers may not renew the source of finance when it matures. This risk will be more acute with short-term finance as it needs renewing more often.

Short-term finance tends to be more flexible than long-term finance (eg overdraft, or supplier credit) so 'inflexibility' is incorrect. Maturity mismatch is not a risk specifically related to short-term finance so is incorrect.

Syllabus area C3(b)

PKA Co

61 The correct answer is: **1 and 2 only.**

The two main objectives of working capital management are to ensure the business has sufficient liquid resources to continue the business and to increase its profitability. These two objectives will often conflict because liquid assets give the lowest returns. Statement 3 is therefore not correct.

<div align="right">Syllabus area C1(b)</div>

62 The correct answer is: **10,000 units**

Minimum inventory level = reorder level – (average usage × average lead time)
Average usage per week = 625,000 units/50 weeks = 12,500 units
Average lead time = 2 weeks
Reorder level = 35,000 units
Minimum inventory level = 35,000 – (12,500 × 2) = 10,000 units

<div align="right">Syllabus area C2(c)</div>

63 The correct answer is: **25,000 units**

Economic order quantity

$$EOQ = \sqrt{\frac{2C_0D}{C_h}} = \sqrt{\frac{2 \times 250 \times 625,000}{0.5}} = 25,000 \text{ units}$$

<div align="right">Syllabus area C2(c)</div>

64 The correct answer is: **1 and 2 only.**

The key to reducing the percentage of bad debts is to assess the creditworthiness of customers. Since the industry average accounts receivable period is 75 days, PKA needs to be careful not to lose business as a result of over-stringent credit control action (such as legal action). A good approach would be to encourage early payment, for example, through early settlement discounts.

<div align="right">Syllabus area C2(d)</div>

65 The correct answers are:

A reduction in accounts receivable staffing costs

An improvement in short-term liquidity

A factor should be able to accelerate receipts so that they are in line with PKA's terms of trade, this will reduce accounts receivable staffing costs and improve liquidity.

Incorrect answers:

A fall in bad debts

An improvement in relationship with customers

With-recourse factoring does not remove the risk of bad debts.

Customer relationship are more likely to deteriorate rather than improve with the use of a factor as the factor will deal with the customer when chasing debts as opposed to the company.

<div align="right">Syllabus area C2(d)</div>

Plot Co

66 The correct answer is: **$5,454**

Cost of current ordering policy

Total cost = order costs + holding costs

Ordering cost = 12 × $267 = $3,204 per year

Note. One order per month

Monthly order = monthly demand = 300,000/12 = 25,000 units

Buffer inventory = 25,000 × 0.4 = 10,000 units

Average inventory excluding buffer inventory = 25,000/2 = 12,500 units

Average inventory including buffer inventory = 12,500 + 10,000 = 22,500 units

Holding cost = 22,500 × 0.1 = $2,250 per year

Total cost = $3,204 + $2,250 = $5,454 per year

Syllabus area C2(c)

67 The correct answer is: **$5,000**

Cost of ordering policy using economic order quantity (EOQ)

$EOQ = \sqrt{(2 \times C_o \times D)/C_h}$

$EOQ = \sqrt{(2 \times 267 \times 300,000)/0.10}$ = 40,025 per order

Number of orders per year = 300,000/40,025 = 7.5 orders per year

Order cost = 7.5 × 267 = $2,003

Average inventory excluding buffer inventory = 40,025/2 = 20,013 units

Average inventory including buffer inventory = 20,013 + 10,000 = 30,013 units

Holding cost = 30,013 × 0.1 = $3,001 per year

Total cost = $2,003 + $3,001 = $5,004 per year, so $5,000 to the nearest $100

Syllabus area C2(c)

68 The correct answer is: **cost of $17,808**

Current receivables = $10m × (60/365) = $1,643,835.

Overdraft interest charge per year relating to current receivables = $1,643,835 × 10% = $164,383.50 pa

Interest saved when half customers pay cash = 0.5 × $164,383.50 = $82,191.75 per year

Annual cost of the discount = 0.5 × $10m × 2% = $100,000

Net cost of offering the early settlement discount = $100,000 − $82,191.75 = $17,808.25 cost per year

Syllabus area C1(c)

69 The correct answer is: **Both statements are true.**

In terms of working capital finance, organisations can have a conservative (mainly long-term finance) or aggressive (mainly short-term finance) approach. The former is likely to be low risk but expensive, the latter more risky but cheaper (as short-term finance is low risk from an investor's perspective).

Poor financial management of working capital can lead to cash flow difficulties or even the failure of a business. Good working capital management can also create profits and minimise costs, and this ultimately adds to the wealth of shareholders – a key objective in the vast majority of businesses.

Syllabus area C1(b)

70 The correct answers are:

Increasing levels of inventory

Increasing levels of current liabilities

The two symptoms of overtrading are increasing levels of inventory and current liabilities. Trade receivables increase during overtrading, not decrease so the first statement is not a symptom. Most of the increase in assets is financed by credit rather than long-term borrowings so the third statement is not a symptom.

Syllabus area C1(c)

Gorwa Co

71 The correct answer is: **30.53 times**

	20X7
Sales/net working capital	37,400/(9,200 – 7,975) = 30.53 times

Syllabus area C1(b)

72 The correct answer is: **12 days**

20X6 days = 2,400/23,781 × 365 = 36.8

20X7 days = 4,600/34,408 × 365 = 48.8

Increase = 12 days

Syllabus area C1(b)

73 The correct answer is: **Both statements are true.**

	20X7	20X6
Inventory days	4,600/34,408 × 365 = 49 days	2,400/23,781 × 365 = 37 days
Receivables days	4,600/37,400 × 365 = 45 days	2,200/26,720 × 365 = 30 days

Syllabus area C2(d)

74 The correct answer is: **Inventory turnover slows down and the current ratio falls.**

Another symptom of overtrading is a rapid growth in sales revenue (not a rapid reduction). The payment period to accounts payables lengthens as the business takes longer to pay amounts due.

Syllabus area C1(b)

75 The correct answer is: **Non-current assets are sold.**

The other events may have limited or no effect on net working capital. Cash will rise to offset the increase in current liabilities if payments to suppliers are delayed. Cash will increase if credit is reduced, offsetting the fall in receivables. Cash will fall (or liabilities will rise) if inventories increase.

Syllabus area C1(a)

Cat Co

76 The correct answer is: **$907,400**

Current cost = purchase cost + order cost + holding cost

Purchase cost = 120,000 units × $7.50 = $900,000 per year

Order costs = number of orders × fixed order cost = (120,000/10,000) × $200 = $2,400 per year

Holding cost = average inventory level × cost per unit per year = (10,000/2) × $1 = $5,000

Total current cost = $900,000 + $2,400 + $5,000 = $907,400.

Syllabus area C2(c)

77 The correct answer is: **$901,400**

The cost = purchase cost + order cost + holding cost

Purchase cost = 120,000 units × $7.50 × (1 – 3.6%) = $867,600 per year

Order costs = number of orders × fixed order cost = (120,000/30,000) × $200 = $800 per year

Holding cost = average inventory level × cost per unit per year = (30,000/2) × $2.20 = $33,000

Total cost = $867,600 + $800 + $33,000 = $901,400.

Syllabus area C2(c)

78 The correct answer is: **$89,041**

If the credit period is reduced to 60 days, receivables will become
(60/365) × $25 million = $4,109,589.

This is ($5 million – $4,109,589 =) $890,411 lower than before, saving interest of
10% × $890,411 = $89,041 per year.

This interest is saved as lower receivables implies more money (lower overdraft) in the bank.

Syllabus area C2(d)

79 The correct answer is: **Statements 1 and 3 are correct.**

Statement 1 is **correct**. Sufficient working capital should be maintained to ensure bills can be paid on time; however, working capital (receivables, inventory, payables) do not earn a return as such, so excessive working capital is undesirable – spare cash for example should be temporarily placed to earn a return (provided risk is low).

Statement 2 is **incorrect**. A conservative approach to working capital investment implies aiming to keep relatively high levels of working capital. The reason for this is generally to reduce risk (less risk of inventory shortages, give customers plenty of time to pay, pay supplier cash) but it is expensive – it is money tied up not directly earning a return – hence will decrease profitability, not increase it.

Statement 3 is **correct**. Too much or too little working capital leads to poor business performance. Too much reduces profitability, too little is risky. Hence managing it to an appropriate level is important for a business if it is to be successful.

Statement 4 is **incorrect**. The two objectives of working capital management are to ensure the business has sufficient liquid resources and increase profitability. These objectives will often conflict as liquid assets give the lowest returns.

Syllabus area C1(b)

80 The correct answer is: **Statement 2 only relates to an aggressive approach.**

Statement 1 relates to a conservative approach to financing working capital. Statement 2 relates to an aggressive approach.

Syllabus area C3(b)

81 APX Co

Workbook references. Financial intermediaries are covered in Chapter 2. Forecasting and working capital financing are covered in Chapters 3 and 4.

Top tips. This question covers the key skills of forecasting financial statements as well as using and interpreting provided financial information. Part (c) requires a quick, relevant discussion of financial intermediaries which will be straightforward if you can remember the key terminology.

Part (a) may throw you as it requires a forecast financial position statement and statement of profit and loss. However, the format is provided in the question and the workings require logical manipulation of the accounting ratios provided. Fill in as many figures as you can and you will gain a mark for each correct calculation.

Easy marks. This question may look daunting initially but there are plenty of easy marks available if you tackle it logically and move on quickly if you get stuck.

Examining team's comments. For part (a) many answers were of a very good standard and gained full marks. Some candidates ignored the forecast financial ratios and applied the expected revenue growth rate to cost of sales and other expenses. Other candidates showed a lack of knowledge of the structure of the statement of profit or loss by calculating the tax liability before subtracting the interest payments.

Part (b) asked for an analysis and discussion of the working capital financing policy of the company in the question. Many students were not aware of the conservative, aggressive and matching approaches to working capital financing policy, and so were ill-prepared for this question.

Marking scheme

			Marks
(a)	Gross profit	1	
	Net profit	1	
	Profit before tax	1	
	Retained profit	1	
	Inventory	1	
	Trade receivables	1	
	Trade payables	1	
	Reserves	1	
	Overdraft	1	
	Layout and format	1	
		Maximum	9
(b)	Working capital financing policies	2–3	
	Financial analysis	1–2	
	Working capital financing policy of company	2–3	
		Maximum	6
(c)	Relevant discussion on financial intermediaries		5
			20

(a) (i) **Forecast statement of profit or loss**

	$m
Revenue (16.00m × 1.084)	17.344
Cost of sales (17.344m – 5.203m)	12.141
Gross profit (17.344m × 30%)	5.203
Other expenses (5.203m – 3.469m)	1.734
Net profit (17.344m × 20%)	3.469
Interest (10m × 0.08) + 0.140m	0.940
Profit before tax	2.529
Tax (2.529m × 0.3)	0.759
Profit after tax	1.770
Dividends (1.770m × 50%)	0.885
Retained profit	0.885

(ii) Forecast statement of financial position

	$m	$m
Non-current assets		22.00
Current assets		
Inventory (12.141m × (110/365))	3.66	
Trade receivables (17.344m × (65/365))	3.09	
		6.75
Total assets		28.75
Equity finance		
Ordinary shares	5.00	
Reserves (7.5m + 0.885m)	8.39	
		13.39
Long-term bank loan		10.00
		23.39
Current liabilities		
Trade payables (12.141m × (75/365))	2.49	
Overdraft (28.75m − 23.39m − 2.49 = balancing figure)	2.87	
		5.36
Total liabilities		28.75

(b) **Working capital financing policy**

Working capital financing policies can be described as **conservative, moderate** or **aggressive,** depending on the extent to which fluctuating current assets and permanent current assets are financed by short-term sources of finance.

Permanent current assets are the amount required to meet long-term minimum needs and sustain normal trading activity, for example inventory and the average level of accounts receivable.

Fluctuating current assets are the current assets which vary according to normal business activity, for example due to seasonal variations.

A **conservative** working capital financing policy uses **long-term** funds to finance non-current assets and permanent current assets, as well as a proportion of fluctuating current assets.

An **aggressive** working capital financing policy uses **short-term** funds to finance fluctuating current assets and a proportion of permanent current assets as well. This is riskier but potentially more profitable.

A **balance** between risk and return might be best achieved by a moderate policy, which uses long-term funds to finance long-term assets (non-current assets and permanent current assets) and short-term funds to finance short-term assets (fluctuating current assets).

The current statement of financial position shows that APX Co uses **trade payables** and an **overdraft** as sources of **short-term** finance. 89% (100 × 4.1/4.6) of current assets are financed from short-term sources and only 11% are financed from long-term sources. This appears to be a **very aggressive** working capital financing policy which carries significant risk. For example, if the bank called in the overdraft, APX Co might have to resort to more expensive short-term financing.

The **forecast** statement of financial position shows a **reduced** reliance on short-term finance.

79% (100 × 5.36/6.75) of current assets are now financed from short-term sources and 21% are financed from long-term sources. This reduces the risk of the working financing capital policy.

Further moves away from an aggressive policy would be hampered by a lack of ability to pay interest on more long-term debt. The forecast **interest coverage ratio** is only 3.7 times (3.469/0.94). Alternatively, APX Co could consider an **increase in equity funding** to decrease reliance on short-term finance.

BPP
LEARNING
MEDIA

(c) Role of financial intermediaries

Financial intermediaries provide a **link** between investors who have surplus cash and borrowers who have a need for finance.

Financial intermediaries **aggregate** invested funds. This means that they group together the small amounts of cash provided by individual investors, so that borrowers who need large amounts of cash have a convenient and readily accessible route to obtain necessary funds.

Financial intermediaries **reduce** the risk for individual lenders by **pooling**. They will assume the risk of loss on short-term funds borrowed by business organisations. Such losses are shared among lenders in general.

Financial intermediaries also offer **maturity transformation**, in that they bridge the gap between the wish of most lenders for **liquidity** and the desire of most borrowers for loans over longer periods.

82 Pangli Co

> **Workbook references.** Cash flow forecasting is covered in Chapter 4, liquidity ratios in chapter 3, and managing accounts receivables is covered in Chapter 3.
>
> **Top tips.** In part (ai), 2 marks you will need to read the question carefully to identify that you are asked to use 360 days not 365.
>
> Part (aii), this looks to be a very challenging question for the marks available. In fact because the operating cash flows are given, the only calculations required here relate to working capital movements. Ultimately, if you get stuck here you could move on to achieve most of the marks (at least 3 of the 4 marks) in part (aiii) and all of the 10 marks in part b as well.
>
> **Easy marks.** The discussions on trade receivables management in part (b) are straightforward.

Marking scheme

				Marks
(a)	(i)	Cost of sales	0.5	
		Inventory days	0.5	
		Receivables days	0.5	
		Cash operating cycle	0.5	
				2
	(ii)	Inventory 31 January	0.5	
		Receivables 31 January	1	
		Payables 31 January	1	
		Overdraft 31 January	1.5	
				4
	(iii)	Current ratio 1 January	2	
		Current ratio 31 January	2	
				4
(b)		First technique	2	
		Second technique	2	
		Third technique	2	
		Fourth technique	2	
		Fifth technique	2	
				10
				20

(a) (i) The cash operating cycle can be calculated by adding inventory days and receivables days, and subtracting payables days.

Cost of sales = 3,500,000 × (1 − 0.4) = $2,100,000

Inventory days = 360 × 455,000/2,100,000 = 78 days

Trade receivables days = 360 × 408,350/3,500,000 = 42 days

Trade payables days = 360 × 186,700/2,100,000 = 32 days

Cash operating cycle of Pangli Co = 78 + 42 − 32 = 88 days

(ii) Inventory at end of January 20X7 = 455,000 + 52,250 = $507,250

At the start of January 20X7, 100% of December 20X6 receivables will be outstanding ($300,000), together with 40% of November 20X6 receivables ($108,350 = 40% × 270,875), a total of $408,350 as given.

	$
Trade receivables at start of January 20X7	408,350
Outstanding November 20X6 receivables paid	(108,350)
December 20X6 receivables, 60% paid	(180,000)
January 20X7 credit sales	350,000
Trade receivables at end of January 20X7	470,000

	$
Trade payables at start of January 20X7	186,700
Payment of 70% of trade payables	(130,690)
January 20X7 credit purchases	250,000
Trade payables at end of January 20X7	306,010

	$
Overdraft at start of January 20X7	240,250
Cash received from customers	(288,350)
Cash paid to suppliers	130,690
Interest payment	70,000
Operating cash outflows	146,500
Overdraft expected at end of January 20X7	299,090

(iii) Current assets at start of January 20X7 = 455,000 + 408,350 = $863,350

Current liabilities at start of January 20X7 = 186,700 + 240,250 = $426,950

Current ratio at start of January 20X7 = 863,350/426,950 = 2.03 times

Current assets at end of January 20X7 = 507,250 + 470,000 = $977,250

Current liabilities at end of January 20X7 = 306,010 + 299,090 = $605,100

Current ratio at end of January 20X7 = 977,250/605,100 = 1.62 times

(b) Pangli Co could use the following techniques in managing trade receivables: assessing creditworthiness; managing accounts receivable; collecting amounts owing; offering early settlement discounts: using factoring and invoice discounting; and managing foreign accounts receivable.

Assessing creditworthiness

Pangli Co can seek to reduce its exposure to the risks of bad debt and late payment by assessing the creditworthiness of new customers. In order to do this, the company needs to review information from a range of sources. These sources include trade references, bank references, credit reference agencies and published accounts. To help it to review this information, Pangli Co might develop its own credit scoring process. After assessing the

creditworthiness of new customers, Pangli Co can decide on how much credit to offer and on what terms.

Managing accounts receivable

Pangli Co needs to make sure that its credit customers abide by the terms of trade agreed when credit was granted following credit assessment. The company wants its customers to settle their outstanding accounts on time and also to keep to their agreed credit limits. Key information here will be the number of overdue accounts and the degree of lateness of amounts outstanding. An aged receivables analysis can provide this information.

Pangli Co also needs to make sure that its credit customers are aware of the outstanding invoices on their accounts. The company will therefore remind them when payment is due and regularly send out statements of account.

Collecting amounts owing

Ideally, credit customers will pay on time and there will be no need to chase late payers. There are many ways to make payment in the modern business world and Pangli Co must make sure that its credit customers are able to pay quickly and easily. If an account becomes overdue, Pangli Co must make sure it is followed up quickly. Credit control staff must assess whether payment is likely to be forthcoming and if not, a clear policy must be in place on further steps to take. These further steps might include legal action and using the services of a debt collection agency.

Offering early settlement discounts

Pangli Co can encourage its credit customers to settle outstanding amounts by offering an early settlement discount. This will offer a reduction in the outstanding amount (the discount) in exchange for settlement before the due date. For example, if the credit customer agreed to pay in full after 40 days, an early settlement discount might offer a 2% discount for settling after 25 days. Pangli Co must weigh the benefit of offering such an early settlement discount against the benefit expected to arise from its use by credit customers. One possible benefit might be a reduction in the amount of interest the company pays on its overdraft. Another possible benefit might be matching or bettering the terms of trade of a competitor.

Using factoring and invoice discounting

Pangli Co might use a factor to help manage its accounts receivable, either on a recourse or non-recourse basis. The factor could offer assistance in credit assessment, managing accounts receivable and collecting amounts owing. For a fee, the factor could advance a percentage of the face value of outstanding invoices. The service offered by the factor would be tailored to the needs of the company.

Invoice discounting is a service whereby a third party, usually a factor, pays a percentage of the face value of a collection of high value invoices. When the invoices are settled, the outstanding balance is paid to the company, less the invoice discounter's fee.

Managing foreign accounts receivable

Foreign accounts receivable can engender increased risk of non-payment by customers and can increase the value of outstanding receivables due to the longer time over which foreign accounts receivable are outstanding. Pangli Co could reduce the risk of non-payment by assessing creditworthiness, employing an export factor, taking out export credit insurance, using documentary credits and entering into countertrade agreements. The company could reduce the amount of investment in foreign accounts receivable through using techniques such as advances against collections and negotiating or discounting bills of exchange

Examining team's note: Only five techniques were required to be discussed.

83 WQZ Co

Marking scheme

			Marks
(a)	Current policy:		
	Annual ordering cost	0.5	
	Annual holding cost	0.5	
	Total annual cost	1	
	EOQ policy:		
	Annual order size	1	
	Annual ordering cost and holding cost	1	
	Change in inventory management cost	1	
			5
(b)	Reduction in trade receivables	2	
	Financing cost saving	1	
	Cost of early settlement discount	1	
	Comment on net benefit	2	
	Maximum early settlement discount	1	
			7
(c)	Relevant discussion		8
			20

(a) **Current policy**

Order size = 10% × 160,000 = 16,000 units per order

Number of orders = 160,000/16,000 = 10 orders per year

Annual ordering cost = 10 × 400 = $4,000

Average inventory = 5,000 + 16,000/2 = 13,000 units

Holding cost of average inventory = 13,000 × 5.12 = $66,560 per year

Total annual cost = $4,000 + $66,560 = $70,560

EOQ model

Order size = $\sqrt{\dfrac{2 \times 400 \times 160,000}{5.12}}$ = 5,000 units per order

Number of orders = 160,000/5,000 = 32 orders per year

Annual ordering cost = 32 × 400 = $12,800

Average inventory = 5,000 + 5,000/2 = 7,500 units

Holding cost of average inventory = 7,500 × 5.12 = $38,400 per year

Total annual cost = $12,800 + $38,400 = $51,200

Cost savings from EOQ method

70,560 − 51,200 = $19,360 per year

Note. Since the holding cost of buffer stock is a common cost to both models, this could have been omitted from the calculations. Full marks could still be gained from this approach.

(b) **Change of receivables policy**

Receivables payment period is currently (18/87.6) × 365 = 75 days

Under the new policy only 25% will pay in 30 days, so the revised payment period would be

(0.25 × 30) + (0.75 × 60) = 52.5 days

Current trade receivables = $18m

Revised level using the revised payment period = 87.6 × (52.5/365) = $12.6m

Reduction in receivables = 18 − 12.6 = $5.4m

Short-term finance cost is 5.5%

Finance cost savings = 5.4m × 0.055 = $297,000

Administration savings = $753,000

Total savings = 297,000 + 753,000 = $1,050,000

Cost of the discount = credit sales × % customers taking discount × discount %

Cost of the discount = 87.6m × 0.25 × 0.01 = $219,000

Benefit of the discount = 1,050,000 − 219,000 = $831,000

The proposed change in receivables management should be accepted, although this does depend on the forecast cost savings being achieved.

Maximum discount

25% of the customers will take the discount. Therefore the total sales value affected by the discount will be 25% of $87.6m, which is $21.9m.

The maximum discount will be where the costs equal the benefits of $1,050,000. This would occur at:

1.05/21.9 = 0.048 = 4.8%

(c) The policy on the management of trade receivables will depend on a number of factors.

The level of trade receivables

If there is a substantial amount of capital tied up in trade receivables, then the policy may be aimed at reducing the level of investment by not granting credit as freely as before or shortening the credit terms.

The cost of trade credit

Where the cost of trade credit (including opportunity costs) is high, a company will want to reduce the level of investment in trade receivables.

Competitor trade terms

Unless a company can differentiate itself from its competitors, it will need to at least match the credit terms offered by its competitors to avoid a loss of customers.

Liquidity needs

Where a company needs to improve its liquidity it may want to reduce credit terms or consider debt factoring or invoice discounting.

Risk appetite

A company may be prepared to risk higher levels of bad debts by offering credit terms that are relatively relaxed as this will increase sales volume.

Expertise in credit management

If a company lacks expertise in credit management, particularly in monitoring the level of receivables, then it may choose to factor its debts.

84 Oscar Co

Workbook references. Management of working capital in general is covered in Chapter 3 and the management of receivables is also covered in Chapter 3.

Top tips. Take care to lay your workings out clearly in part a, before summarising them in a brief summary table.

Easy marks. This question may look daunting initially but there are plenty of easy marks available if you tackle it logically and move on quickly if you get stuck. Although the discussion marks look like they should be easy, in fact candidates found these hard (see examiner comments).

Examining team's comments. Part (b). Responses were often too brief here; short bullet points, comprising just two to three words each, are not a discussion. There needs to be more focus on the verb used in the requirement (eg 'Discuss') and refinement of the art of reading the question is needed.

There were two main weaknesses in responses to this part question:

- Reasons given for using a factoring company were often simply a restatement of the costs and benefits calculated in the earlier part questions. The requirement specifically precluded this;

- The absence of relating the reasons to the company in the scenario ie the requirement asked why the given company may benefit from the services offered by the factoring company. Too often responses simply listed general reasons why factoring is beneficial without placing them in context.

Part (c) required candidates to discuss factors that determine working capital investment levels. Many answers gained very few marks because the discussion offered was not linked to the question requirement. Some answers were too brief for the marks available, often just a word or two was given per factor. This is insufficient since if there are six marks available for three factors, then it is logical to deduce that two marks are available for each factor. Some confused working capital investment policy with working capital financing policy. Some answers thought that accounting ratios, such as current ratio or quick ratio, were 'factors that determine the level of investment in working capital'.

Marks

(a) **Option 1**
Revised trade receivables 1
Finance cost reduction 1
Admin savings 1
Factor fee 1
Option 2
Bad debt saving 1
Finance cost increase 1
Factor fee 1
Comment 1

8

(b) Benefits 3
Oscar link 3

6

(c) 2 marks per factor

6

20

(a) **Option 1**

	$	
Current trade receivables	5,370,000	
Revised trade receivables (28,000,000 × 30/365)	2,301,370	
Reduction in receivables	3,068,630	
Reduction in financing cost = 3,068,630 × 0.07	214,804	
Reduction in admin costs	30,000	
Benefits		244,804
Factor's fee = 28,000,000 × 0.005		(140,000)
Net benefit		104,804

Option 2

	$	$
Reduction in financing cost = 3,068,630 × 0.07	214,804	
Reduction in admin costs	30,000	
Bad debts saved = 28,000,000 × 0.02	560,000	
Benefits		804,804
Increase in finance cost = 2,301,370 × 0.80 × 0.02	36,822	
Factor's fee = 28,000,000 × 0.015	420,000	
Costs		(456,822)
Net benefit		347,982

Both options are financially acceptable to Oscar Co, with Option 2 offering the greatest benefit and therefore it should be accepted.

(b) Oscar Co may benefit from the services offered by the factoring company for a number of different reasons, as follows:

Economies of specialisation

Factors specialise in trade receivables management and therefore can offer 'economies of specialisation'. They are experts at getting customers to pay promptly and may be able to achieve payment periods and bad debt levels which clients could not achieve themselves. The factor may be able to persuade the large multinational companies which Oscar Co supplies to pay on time.

Scale economies

In addition, because of the scale of their operations, factors are often able to do this more cheaply than clients such as Oscar Co could do on their own. Factor fees, even after allowing for the factor's profit margin, can be less than the clients' own receivables administration cost.

Free up management time

Factoring can free up management time and allow them to focus on more important tasks. This could be a major benefit for Oscar Co, where directors are currently spending a large amount of time attempting to persuade customers to pay on time.

Bad debts insurance

The insurance against bad debts shields clients from non-payment by customers; although this comes at a cost, it can be particularly attractive to small companies who may not be able to stand the financial shock of a large bad debt. This could well be the case for Oscar Co. As a small company which supplies much larger car manufacturing companies, it is particularly exposed to default by customers. On the other hand, it could be argued that large multinational companies are financially secure and default is unlikely, rendering bad debt insurance unnecessary.

Accelerate cash inflow

Factor finance can be useful to companies who have exhausted other sources of finance. This could be useful to Oscar Co if it cannot negotiate an increase in its overdraft limit.

Finance through growth

Although factor finance is generally more expensive than a bank overdraft, the funding level is linked to the company's volume of sales. This can help to finance expansion and protects the company against overtrading. In a rapid growth company such as Oscar Co, this could be a major advantage of factor finance.

(c) A company's working capital investment is equal to the sum of its inventories and its accounts receivable, less its accounts payable.

The following factors will determine the level of a company's investment in working capital:

The nature of the industry and the length of the working capital cycle

Some businesses have long production processes which inevitably lead to long working capital cycles and large investments in working capital. Housebuilding, for example, requires the building company to acquire land, gain government permission to build, build houses and when complete, sell them to customers. This process can often take more than a year and require large investment in work-in-progress and therefore in working capital.

Other industries, such as supermarkets, buy goods on long credit terms, have rapid inventory turnover and sell to customers for cash. They often receive payment from customers before they need to pay suppliers and therefore have little (or negative) investment in working capital.

BPP
LEARNING
MEDIA

Working capital investment policy

Some companies take a conservative approach to working capital investment, offering long periods of credit to customers (to promote sales), carrying high levels of inventory (to protect against stock-outs), and paying suppliers promptly (to maintain good relationships). This approach offers many benefits, but it necessitates a large investment in working capital.

Others take a more aggressive approach offering minimal credit, carrying low levels of inventory and delaying payments to suppliers. This will result in a low level of working capital investment.

Efficiency of management and terms of trade

If management of the components of working capital is neglected, then investment in working capital can increase. For example, a failure to apply credit control procedures such as warning letters or stop lists can result in high levels of accounts receivable. Failure to control inventory by using the EOQ model, or JIT inventory management principles, can lead to high levels of inventory.

85 Wobnig Co

Workbook references. The signs of overtrading are covered in Chapter 3. Working capital financing policy and working capital investment policy are discussed in Chapter 4.

Top tips. In part (a), concentrate on what the question asks for – you will not gain any marks by discussing how Wobnig Co can improve its working capital position! Start by listing the typical signs of overtrading, before calculating the ratios to support each point. In part (b), the question focuses on working capital – no marks for discussing investment appraisal techniques and debt and equity financing. Revise this area if you are unfamiliar with it.

Easy marks. The ratios in part (a) should give some easy marks.

Examining team's comments. Most answers to part (a) gained good marks. Answers that did not focus on the question asked, which was whether or not the company was overtrading, lost marks as a result.

Many answers struggled to gain good marks in part (b). While many answers showed good understanding of working capital financing policy, fewer answers showed understanding of working capital investment policy, and fewer answers still could discuss the similarities and differences between the two policy areas.

Marking scheme

			Marks
(a)	Rapid increase in revenue	1–2	
	Increase in trade receivables days	1–2	
	Decrease in profitability	1–2	
	Rapid increase in current assets	1–2	
	Increased dependence on short-term finance	2–3	
	Decrease in liquidity	2–3	
	Conclusion as regards overtrading	1	
		Maximum	12
(b)	Working capital investment policy	3–4	
	Working capital financing policy	5–6	
		Maximum	8
			20

(a) Signs of overtrading:

Rapid increase in sales revenue: Wobnig Co's sales revenue has increased by 40% from $10,375k in 20X0 to $14,525k in 20X1. This rapid growth in revenue is not supported by a similar increase in long-term financing, which has only increased by 4.7% ($16,268k in 20X1 compared to $15,541k in 20X0).

Rapid increase in current assets: Wobnig Co's current assets have also nearly doubled, increasing from $2,826k in 20X0 to $5,349k in 20X1 (89%). This is striking, given that long-term financing has only increased by 4.7%. Trade receivables have increased by 85% ($1,734k in 20X0 and $3,200k in 20X1), and inventory levels have increased by 97% ($2,149k from $1,092k in 20X0).

Increase in inventory days: Linked to the above, inventory turnover has slowed noticeably, from 60 days in 20X0 to 75 days in 20X1, well above the industry average of 55 days. This may indicate that Wobnig Co is expecting further increases in sales volumes in the future.

Increase in receivable days: Perhaps a matter of greater concern is the fact that trade receivables are being paid much more slowly. Receivable days have increased from 61 days in 20X0 to 80 days in 20X1, again significantly above the industry average. It could be that in order to encourage sales, Wobnig Co has offered more favourable credit terms to its customers. However, the increase in receivable days may also indicate that Wobnig Co is lacking sufficient resources to effectively manage its receivables, and/or that its customers may be unable to settle their debts on time, as they are struggling financially.

Reduction in profitability: Although Wobnig Co's sales revenue has increased by 40% over the past year, its profit before interest and tax (PBIT) has only increased by 8.9%. The net profit margin has actually decreased, from 36% in 20X0 to 28% in 20X1. This may be due partly to the company selling at lower margins to increase sales volumes, but most likely points to increased costs of sales and operating costs.

With the additional costs associated with holding larger inventories, and increasing financing costs from overdrafts (see below), the company's profitability is likely to suffer even more in the future.

Increase in current liabilities: Wobnig Co is increasingly financed through current liabilities, which has increased by 131% (from $1,887k in 20X0 to $4,365k in 20X1) while long-term financing has increased only marginally by 4.7%. The sales revenue/net working capital ratio has increased from 11 times to 15 times in 20X1. In particular, overdraft has increased by 500% from 20X0 to 20X1. Payables days have lengthened from 90 days to 100 days, indicating that Wobnig Co is finding it more difficult to settle trade debts.

All of this will put further strain on financing costs, eroding the distributable profits. The company's interest expense has increased from $292k to $355k.

Reduced liquidity: The cause of Wobnig Co's increasing dependence on overdrafts and lengthening payables days lies in its reduced liquidity. Wobnig Co's current ratio has reduced from 1.5 times to 1.2 times, compared to the industry average of 1.7 times. The more sensitive quick ratio has reduced from 0.9 times to 0.7 times, against the average of 1.1 times. Wobnig Co does not yet have a liquid deficit, though, as its current assets still exceed its current liabilities.

Conclusion

From the trends discussed above, we can conclude that Wobnig Co is overtrading.

Workings

Ratio	Formula	20X1	20X0
Net profit margin	PBIT/Revenue × 100%	28%	36%
Current ratio	Current assets/current liabilities	1.2 times	1.5 times
Quick ratio	(Current assets – inventory)/current liabilities	0.7 times	0.9 times
Inventory days	Inventory/cost of sales × 365	75 days	60 days
Receivables days	Trade receivables/revenue × 365	80 days	61 days
Payables days	Trade payables/cost of sales × 365	100 days	90 days
Net working capital	Current assets – current liabilities	$984,000	$949,000
Revenue/net working capital	Revenue/net working capital	15 times	11 times

BPP
LEARNING
MEDIA

(Note that the Revenue/net working capital ratio can also be calculated excluding cash balances or overdraft.)

(b) Working capital investment policy dictates how much a company chooses to invest in current assets. Working capital financing policy, on the other hand, determines how a company funds its day to day operations: with short-term or long-term sources. The working capital investment policy is therefore an investment decision, while the working capital financing policy is a financing decision.

Both working capital investment policy and working capital financing policy are described in terms of conservative, moderate and aggressive. However, these terms mean different things in the contexts of investment and financing.

In the context of working capital investment, a conservative policy aims to reduce the risk of system breakdown by holding high levels of working capital: generous credit terms for customers, high levels of inventory and quick payment of suppliers. This approach can result in a high financing cost and may give rise to cash flow problems. By contrast, an aggressive approach reduces financing cost and increases profitability by cutting inventories, collecting debts early from customers and delaying payment to suppliers.

In the context of working capital financing, current assets are divided into permanent current assets (the level of current assets that supports a standard level of business activity) and fluctuating assets (the level of current assets that rise and fall due to unexpected business demands). A conservative policy is one that uses long-term funding to finance most of the assets of the company, calling upon short-term financing only when fluctuations in current assets push total assets above a certain level. An aggressive policy, by contrast, is one that finances all fluctuating current assets and some permanent current assets out of short-term sources. This approach presents a greater risk of liquidity issues, but allows for lower financing costs. This is because short-term finance is cheaper than long-term finance.

Working capital investment and working capital financing therefore describe two different aspects of working capital management. In fact, it is possible for a company to adopt an aggressive working capital investment policy and a conservative working capital financing policy, or vice versa.

86 KXP Co

Workbook references. Early settlement discounts, the effect of a change in credit policy, bulk discounts and the factors to be considered in managing trade receivables are all covered in Chapter 3. The optimum level of cash to be held is covered in Chapter 4.

Top tips. The calculations in parts (a) and (b) should pose no problems if you work through them logically.

Easy marks. Parts (a) and (b) contain straightforward calculations. For parts (c) and (d), plan your answers into clearly defined points first, and avoid repeating yourself.

Examining team's comments. In part (a), weaker answers showed a lack of understanding of how the receivables days ratio links credit sales for a period with the trade receivables balance at the end of the period. Some answers, for example, tried to calculate the revised trade receivables balance by applying changed receivables days ratios to current receivables, instead of applying them to credit sales. In part (b), perhaps because information on holding cost and order cost was provided in the question, many candidates calculated the economic order quantity (EOQ). The question made no reference to the EOQ and an EOQ calculation was not necessary. For part (c), many answers failed to gain reasonable marks because they did not discuss factors. For example, some answers explained the workings of the Baumol and Miller-Orr cash management models. The question did not ask for a discussion of these models and such answers gained little or no credit.

		Marks
(a)	Revised trade receivables	0.5
	Reduction in trade receivables	0.5
	Reduction in financing cost	1
	Cost of early settlement discount	1
	Net cost of change in receivables policy	1
	Comment on findings	1
		5
(b)	Current annual ordering cost	0.5
	Current holding cost	0.5
	Total cost of current inventory policy	0.5
	Revised cost of materials	0.5
	Revised number of orders	0.5
	Revised ordering cost	0.5
	Revised holding cost	0.5
	Net benefit of bulk purchase discount	0.5
	Comment on assumptions	1
		5
(c)	Transactions need for cash	1–2
	Precautionary need for cash	1–2
	Speculative need for cash	1–2
	Other relevant discussion	1–2
	Maximum	5
(d)	Credit analysis	1–2
	Credit control	1–2
	Receivables collection	1–2
	Cost and benefits of trade receivables policy	1–2
	Maximum	5
		20

(a) **Cost/benefit of changing trade receivables policy**

Receivables paying within 30 days = 50% × $15m × 30/365 = $616,438

Receivables paying after 45 days = 30% × $15m × 45/365 = $554,795

Total receivables changing their payment patterns = $616,438 + $554,795 = $1,171,233

Original value of these receivables = 80% × $2,466k = $1,972,800

Reduction in receivables = **$801,567**

Cost of early payment discount = 50% × $15m × 1% = $75,000

Reduction in financing cost = $801,567 × 6% = $48,094

Net cost of changing trade receivables policy = $75,000 – $48,094 = **$26,906**

Alternative calculation for the reduction in receivables

Current receivable days = $2,466k/$15,000k × 365 = 60 days

Receivable days under new trade receivables policy = 50% × 30 + 30% × 45 + 20% × 60 = 40.5 days

Decrease in receivable days = 60 – 40.5 = 19.5 days

Reduction in receivables = $15m × 19.5/365 = **$801,370** (difference due to rounding)

Conclusion

The benefit of the new trade receivables policy is outweighed by the associated costs. KXP Co should not adopt the proposed policy. However, the analysis currently excludes bad debts and assumes constant sales throughout the year – the company may need to take these into account. Given that receivables on average are failing to meet the credit period, KXP Co may still want to consider how the trade receivables policy may be changed in order to encourage earlier payment.

(b) Total annual cost of inventory policy = cost of materials + ordering cost + holding cost

Current policy

Annual ordering cost = 12 × $150 = $1,800

Annual holding cost = $0.24 × (15,000/2) = $1,800

Total annual cost = $540,000 + $1,800 + $1,800 = $543,600

Proposed policy

Annual cost of materials = $540,000 × 98% = $529,200

KXP Co currently requires 180,000 units of Product Z per year (12 × 15,000).

To benefit from the bulk discount, KXP Co needs to order 30,000 units each time. This means KXP Co will make 6 orders per year (180,000/30,000).

Revised annual ordering cost = 6 × $150 = $900

Revised annual holding cost = $0.24 × (30,000/2) = $3,600

Total annual cost = $529,200 + $900 + $3,600 = $533,700

Net benefit

Net benefit of taking bulk purchase discount = $543,600 – $533,700 = $9,900

Conclusion

The analysis shows that the bulk discount should be accepted. However, KXP Co may wish to evaluate the appropriateness of a number of key assumptions first:

- Demand for Product Z is constant throughout the year, and does not change from year to year.

- Ordering costs and holding costs are both constant throughout the year.

(c) The optimum level of cash to be held by a company depends on the following factors:

The level of cash required for the company's operations

This includes holding enough cash to:

(i) Pay for the transactions expected to occur during the period (including the payment of suppliers, and finance costs). This can be achieved by drawing up a cash budget.

(ii) Cover unexpected expenditure and account for uncertainty in the cash budget. In addition to the cash needs forecasted in the cash budget, the company needs to have a precautionary 'buffer' for unexpected events. This can be estimated based on previous experience.

The availability of finance

Not all sources of finance may be available to a company. A small or medium-sized company, for example, may not be able to obtain or extend bank loans as easily. An unlisted company will find it very difficult, and expensive, to raise funds through issuing securities. Where it is difficult and/or expensive to raise new finance, a company will need to hold more cash.

The availability and attractiveness of other uses for the cash

The amount of cash that a company holds will also depend on whether there are other, more attractive ways to use the cash. Instead of holding cash for no return, a company usually has the option of putting the cash in a deposit account with a bank, investing it in short- or long-term debt instruments, or investing in equity shares of listed companies. The extent to which the company will consider these alternative uses depends on the amount of

investment required, the expected level of return (interest, dividends or capital growth), the term to maturity and the ease of realising the investment.

A company may also wish to hold cash in order to be able to take advantage of an unexpected speculative opportunity when it arises.

(d) Factors to consider in formulating a trade receivables management policy

The total credit

Each company must determine the level of total credit it is willing to offer. This involves finding a balance between maximising revenue from customers, and minimising the finance costs associated with funding the period of credit and also minimising bad debts.

Allowing a long period of credit may attract more sales, but the company may suffer from high finance costs. A short period of credit will reduce the need for additional finance, but the company may lose out on sales opportunities.

The cost of the additional finance – be it bank overdraft interest, loans or equity – must be considered.

Credit control

Companies need to have a policy in place for assessing the creditworthiness of customers. Verifying that new customers are creditworthy before concluding the sale reduces the risk of customer default.

This may involve requiring references for new customers, checking credit ratings through a credit rating agency, and offering a lower level of credit for new customers. A credit rating system may be devised to determine the appropriate level of credit to offer to new customers based on their characteristics (such as age and occupation).

Collection

A credit policy can only be maintained if it is policed effectively and the amounts owing collected. The company will need to monitor customers' payment records to ensure that the credit limits are maintained. An aged receivables analysis should be performed on a regular basis. Any breaches of credit limits should be brought to the attention of the credit controller.

Factors which would influence how tightly a company polices its credit policy include the number of customers requiring more credit, and the extent to which the company is exposed to accounts receivable.

The associated costs of collection, either internal or external, also need to be considered. The costs of collection should not be greater than the amount collected.

Changes to the credit policy

The credit policy needs to be reviewed regularly and revised as economic conditions and customer payment patterns change. The company may wish to assess whether it is beneficial to offer an early payment discount to encourage customers to pay earlier, or extend the credit period to encourage custom.

The associated costs and impact on the company's working capital must be considered. Only when the financial benefit of the change in policy outweighs the additional costs should the change go ahead.

87 CSZ Co

Workbook references. The working capital cycle and liquidity ratios are covered in Chapter 3.

Top tips. There are two requirements in part (a) and two requirements in part (b). Make sure that you don't accidentally miss out some of the requirements. You may have been thrown by the mention of a negative working capital cycle but, if you think about what the cycle actually means, you should be able to see that a negative cycle is possible.

Easy marks. There are easy marks for calculations in part (a) and part (b) if you know the liquidity ratios.

Marking scheme

			Marks
(a)	Inventory days	0.5	
	Trade receivables days	0.5	
	Trade payables days	0.5	
	Working capital cycle	0.5	
	Discussion of working capital cycle	4	
			6
(b)	Cost of sales	0.5	
	Inventory	0.5	
	Trade receivables	0.5	
	Current assets	0.5	
	Current liabilities	0.5	
	Target quick ratio	1	
	Net working capital cycle	0.5	
	Target sales/net working capital ratio	1	
			5
(c)	Trade payables	1	
	Overdraft	1	
	Analysis of current asset and liability positions	1–3	
	Comparison of current asset and liability positions	1–3	
	Discussion of change in financing policy	1–3	
		Maximum	9
			20

(a)

				Days
Inventory days	$= \dfrac{\text{Average inventory}}{\text{Cost of sales}} \times 365$	$\dfrac{5{,}700}{26{,}000} \times 365$	$=$	80
A/cs receivable days	$= \dfrac{\text{Trade receivables}}{\text{Credit sales revenue}} \times 365$	$\dfrac{6{,}575}{40{,}000} \times 365$	$=$	60
A/cs payable days	$= \dfrac{\text{Trade payables}}{\text{Cost of sales}} \times 365$	$\dfrac{2{,}137}{26{,}000} \times 365$	$=$	(30)
	Working capital cycle:			110

The working capital cycle is the **period of time** which elapses between the point at which **cash begins to be expended** on the production of a product and the **collection of cash from a customer**. Therefore CSZ Co starts spending 110 days (on average) before cash is collected from the customer.

A **negative** working capital cycle would mean that CSZ Co was **paid by customers before** it started to **spend cash** on the **production**. This can sometimes occur. For example, supermarkets often receive payment for goods before they have paid for them.

A business does **not normally have a choice** on whether its working capital cycle is positive or negative because it depends on the inventory, receivables and payables days and these usually **depend** on the **nature of the business**. The length of the working capital cycle is usually **similar between** businesses in the **same sector**.

(b) Quick ratio = $\dfrac{\text{Current assets less inventories}}{\text{Current liabilities}} = \dfrac{8,219}{5,073 + 3,616} = 0.95$ times

Inventory days = $\dfrac{\text{Inventory}}{\text{Cost of sales}} \times 365$ \ $\dfrac{\text{Inventory}}{24,000} \times 365 = 60$ \ Inventory = \$3,945

Receivables days = $\dfrac{\text{Receivables}}{\text{Sales}} \times 365$ \ $\dfrac{\text{Receivables}}{40,000} \times 365 = 75$ \ Receivables = \$8,219

Payables days = $\dfrac{\text{Payables}}{\text{Cost of sales}} \times 365$ \ $\dfrac{\text{Payables}}{24,000} \times 365 = 55$ \ Payables = \$3,616

Current ratio = $\dfrac{3,945 + 8,219}{3,616 + \text{overdraft}} = 1.4$ \ overdraft = \$5,073

Net current assets at the end of March 20X5 = \$3,945k + \$8,219k – \$3,616k – \$5,073k

$$= \$3,475,000$$

Target sales = \$40m

Target ratio of sales to net working capital = 40,000/3,475 = 11.5 times

Note that the sales/net working capital ratio can also be calculated excluding cash balances or overdraft.

(c) The current liabilities at the end of March 20X5, calculated in part (b), can be divided into trade payables and the forecast overdraft balance.

Trade payables using target trade payables days = 24,000,000 × 55/365 = \$3,616,438.

The overdraft (balancing figure) = 8,688,846 – 3,616,438 = \$5,072,408

Comparing current assets and current liabilities:

	March 20X4		March 20X5	
	\$'000	\$'000	\$'000	\$'000
Inventory	5,700		3,945	
Trade receivables	6,575	12,275	8,219	12,164
Overdraft	2,137		3,616	
	4,682	6,819	5,072	8,688
Net current assets		5,456		3,476

The overdraft as a percentage of current liabilities will fall from 69% (4,682/6,819) to 58% (5,702/8,688). Even though the overdraft is expected to increase by 8.3%, current liabilities are expected to increase by 27.4% (8,688/6,819). Most of this increase is expected to be carried by trade payables, which will rise by 69.2% (3,616/2,317), with trade payables days increasing from 30 days to 55 days.

At the end of March 20X4, current liabilities were 56% of current assets (100 × 6,819/12,275), suggesting that 44% of current assets were financed from a long-term source. At the end of March 20X5, current liabilities are expected to be 71% of current assets (100 × 8,688/12,164), suggesting that 29% of current assets are finance from a long-term source. This increasing reliance on short-term finance implies an aggressive change in the working capital financing policy of CSZ Co.

BPP
LEARNING
MEDIA

88 Flit Co

Marking scheme

		Marks	
(a)	Monthly receivables	1	
	Loan	0.5	
	Raw materials	1	
	Variable costs	1	
	Machine	0.5	
	Closing balances	1	
			5
(b)	Closing finished goods inventory	0.5	
	Closing trade receivables	0.5	
	Closing trade payables	0.5	
	Current ratio	0.5	
			2
(c)	Temporary nature of short-term cash surplus	1	
	Investment should have no risk of capital loss	1	
	Shares are not suitable for investment	1	
			3
(d)	Discussion of Baumol model 2–3 marks per valid point	Maximum	5
(e)	Calculation of spread	1	
	Calculation of upper limit	1	
	Calculation of return point	1	
	Explanation of findings	2	
			5
			20

(a)

	Jan $'000	Feb $'000	Mar $'000
Sales revenue (W1)	960	1,000	1,092
Loan income			300
Total cash receipts	960	1,000	1,392
Production costs (W2)	500	520	560
Variable overheads (W3)	130	140	150
Machine purchase			400
Total cash payments	630	660	1,110

Net surplus	330	340	282
Opening balance	40	370	710
Closing balance	370	710	992

Workings

1 *Sales*

Month of sale			Cash received
Dec	1,200 units × $800	= $960,000	Jan
Jan	1,250 units × $800	= $1,000,000	Feb
Feb	1,300 units × $800 × 1.05	= $1,092,000	Mar

2 *Production costs*

Month of production			Cash paid
Dec	1,250 units × 2 units × $200	= $500,000	Jan
Jan	1,300 units × 2 units × $200	= $520,000	Feb
Feb	1,400 units × 2 units × $200	= $560,000	Mar

3 *Variable overheads*

Month of production			Cash paid
Jan	1,300 units × $100	= $130,000	Jan
Feb	1,400 units × $100	= $140,000	Feb
Mar	1,500 units × $100	= $150,000	Mar

(b) Current ratio = $\dfrac{\text{current assets}}{\text{current liabilities}}$

Current assets

Inventory = finished goods for April sales of 1,500 units

Cost of production = materials + variable costs = $400 + $100 = $500 per unit

1,500 units × $500 = $750,000

Cash = $992,000

Trade receivables = March 1,400 units × $800 × 1.05 = $1,176,000

Current liabilities

Trade payables = cash owed for March raw materials = 1,500 units × 2 units × $200 = $600,000

∴ Current ratio = $\dfrac{\$750,000+\$992,000+\$1,176,000}{\$600,000}$ = 4.9 times

(c) When investing a cash flow surplus the company should consider the following.

Liquidity ie how quickly and easily an asset can be converted into cash.

Shares in a listed company on a large stock market should be liquid.

Profitability. The company should seek to obtain a good return for the risk incurred.

A good return on shares usually requires a long-term investment. However, the cash flow surplus is only temporary ie short-term.

Safety ie the risk of the asset reducing in value.

Share values can go down as well as up which could lead to capital losses and this may cause significant problems in meeting future cash outflows if the cash is needed in the short-term, as is the case here.

The question states that the surplus is a short-term surplus. Investing in shares is therefore inappropriate. Placing funds in a deposit account with a bank would be more appropriate.

(d) **The Baumol model and cash management**

A number of different cash management models indicate the **optimum amount of cash** that a company should hold. One such model is based on the idea that deciding on optimum cash balances is like deciding on optimum inventory levels, and suggests the optimum amount to be transferred regularly from investments to current account.

We can distinguish two types of cost which are involved in obtaining cash:

(i) The **fixed cost** represented, for example, by the issue cost of equity finance or the cost of negotiating an overdraft

(ii) The **variable cost** (opportunity cost) of keeping the money in the form of cash

The Baumol approach has the following drawbacks for companies such as Flit Co.

(i) In reality, it is unlikely to be **possible** to **predict amounts required** over future periods with much certainty.

(ii) No **buffer inventory** of cash is allowed for. There may be costs associated with running out of cash.

(iii) There may be other **normal costs** of holding cash, which increase with the average amount held.

(iv) It assumes **constant transaction costs** and **interest rates**.

(e) **Determination of spread**

Daily interest rate = 5.11/365 = 0.014% per day

Variance = (standard deviation)2
so variance of cash flows = 1,000 × 1,000 = $1,000,000 per day

Transaction cost = $18 per transaction

Spread = 3 × ((0.75 × transaction cost × variance)/interest rate)1/3

 = 3 × ((0.75 × 18 × 1,000,000)/0.00014)1/3 = 3 × 4,585.7 = $13,757

Lower limit = $7,500

Upper limit = $(7,500 + 13,757) = $21,257

Return point = $7,500 + ($13,757/3) = $12,086

Relevance of the values

The Miller-Orr model takes account of **uncertainty** in relation to cash flows. The cash balance of Renpec Co is allowed to vary between the lower and upper **limits** calculated by the model.

If the cash balance reaches an **upper limit** the firm **buys sufficient securities** to return the cash balance to a normal level (called the 'return point'). When the cash balance reaches a lower limit, the firm sells securities to bring the balance back to the return point.

The Miller-Orr model therefore helps Renpec Co to decrease the risk of running out of cash, while avoiding the loss of profit caused by having unnecessarily high cash balances.

89 Widnor Co

Marking scheme

			Marks
(a)	Reduction in trade receivables	1	
	Reduction in financing cost	1	
	Reduction in administration costs	1	
	Saving in bad debts	1	
	Increase in financing cost	1	
	Factor's annual fee	1	
	Advice on acceptance of factor's offer	1	
			7
(b)	Bank and other references	1	
	Credit rating	1	
	Other relevant discussion	1	
			3
(c)	Relevant discussion 2–3 marks per valid point	Maximum	10
			20

(a) The factor's offer will be financially acceptable to Widnor Co if it results in a net benefit rather than a net cost.

	$	$
Current trade receivables	4,458,000	
Revised trade receivables = 26,750,000 × 35/360 =	2,600,694	
Reduction in trade receivables	1,857,306	
Reduction in financing cost = 1,857,306 × 0.05 =	92,865	
Saving in bad debts = 26,750,000 × 0.01 × 0.7 =	187,250	
Reduction in administration costs	50,000	
Benefits		330,115
Increase in financing cost = 2,600,694 × 0.8 × 0.07 – 0.05 =	41,611	
Factor's annual fee = 26,750,000 × 0.0075 =	200,625	
Costs		(242,236)
Net benefit		87,879

The factor's offer is therefore financially acceptable.

(b) The creditworthiness of potential customers can be assessed from a range of different sources of information. References are useful in this respect, and potential customers should supply a bank reference and a trade or other reference when seeking credit on purchases. Another source of information is the credit rating of the potential customer, which can be checked by a credit rating agency or credit reference agency. For larger potential customers, a file can be opened where additional information can be located, evaluated and stored, such as the annual report and accounts of the potential customer, press releases and so on.

(c) **Risks arising from granting credit to foreign customers**

Foreign debts raise the following special problems. When goods are sold abroad, the customer might ask for credit. Exports take time to arrange, and there might be complex paperwork. Transporting the goods can be slow, if they are sent by sea. These **delays in foreign trade** mean that exporters often build up **large investments** in inventories and accounts receivable. These working capital investments have to be financed somehow.

The **risk of bad debts** can be greater with foreign trade than with domestic trade. If a foreign customer refuses to pay a debt, the exporter must pursue the debt in the customer's own country, where procedures will be subject to the laws of that country.

How risks can be managed and reduced

A company can reduce its investment in foreign accounts receivable by insisting on **earlier payment** for goods. Another approach is for an exporter to arrange for a **bank to give cash for a foreign debt**, sooner than the exporter would receive payment in the normal course of events. There are several ways in which this might be done.

Where the exporter asks their bank to handle the collection of payment (of a bill of exchange or a cheque) on their behalf, the bank may be prepared to make an **advance** to the exporter against the collection. The amount of the advance might be 80% to 90% of the value of the collection.

Negotiation of bills or cheques is similar to an advance against collection, but would be used where the bill or cheque is payable outside the exporter's country (for example in the foreign buyer's country).

Discounting bills of exchange is where a bank buys the bill before it is due and credits the value of the bill after a discount charge to the company's account.

Export factoring could be considered where the exporter pays for the specialist expertise of the factor in order to reduce bad debts and the amount of investment in foreign accounts receivable.

Documentary credits provide a method of payment in international trade, which gives the exporter a secure risk-free method of obtaining payment. The buyer (a foreign buyer, or a domestic importer) and the seller (a domestic exporter or a foreign supplier) first of all agree a contract for the sale of the goods, which provides for payment through a documentary credit. The buyer then requests a bank in their country to issue a letter of credit in favour of the exporter. The issuing bank, by issuing its letter of credit, guarantees payment to the beneficiary.

Countertrade is a means of financing trade in which goods are exchanged for other goods.

Export credit insurance is insurance against the risk of non-payment by foreign customers for export debts. If a credit customer defaults on payment, the task of pursuing the case through the courts will be lengthy, and it might be a long time before payment is eventually obtained.

Premiums for export credit insurance are, however, very high and the potential benefits might not justify the cost.

OTQ bank – Investment decisions

90 The correct answer is: **49%**

Return on capital employed = Average annual accounting profits/Average investment

Average annual accounting profits = (16,500 + 23,500 + 13,500 − 1,500)/4 = $13,000 p.a.

Note accounting profits are **after** depreciation so no adjustment is required.

Average investment = (initial investment + scrap)/2 = ($46,000 + $7,000)/2 = $26,500

ROCE = 13,000/26,500 = 49%

Syllabus area D1(d)

91 The correct answer is: **1 year 7 months**

Payback period is the amount of time taken to repay the initial investment.

Time		Profit $	Depreciation* $	Cash flow $	Cumulative cash flow $
0	Investment			(46,000)	(46,000)
1	Cash inflow	16,500	9,750	26,250	(19,750)
2	Cash inflow	23,500	9,750	33,250	13,500

* Depreciation = ($46,000 − $7,000)/4

Payback period = 1 + (19,750/33,250) = 1.59 years or 1 year 7 months to the nearest month.

Syllabus area D1(b)

92 The correct answers are:

It considers the whole project – this is true as there is no 'cut-off' point (unlike the payback period calculation).

It is a percentage which, being meaningful to non-finance professionals, helps communicate the benefits of investment decisions – this is a benefit of ROCE and may well help explain ROCE's use in the real world.

Incorrect answers:

It is cash flow based.

It will not be impacted by a company's accounting polices.

ROCE is profit based. Therefore it is not based on cash flow and will be impacted by a company's accounting policies.

Syllabus area D1(d)

93 The correct answer is: **$400 benefit**

The $1,000 is sunk. If the chemical is used in a new project it would save SW Co $400 that it would otherwise have to spend to dispose of the chemical. This equates to an effective net cash inflow (or, more precisely, the avoidance of an outflow) of $400. Thus the project appraisal should show an inflow of $400 in relation to using this chemical.

Syllabus area D1(a)

94 The correct answer is: **$20,000**

We assume BLW Co would choose the cheapest source of labour.

Cost to buy in = $20 × 1,000 hours = $20,000

Cost to divert existing labour = lost contribution + labour cost ie
($10 + $15) × 1,000 hours = $25,000

The cheapest alternative is therefore to buy in at a cost of $20,000.

To calculate how the existing BLW Co project would suffer as a result of diverting labour, the current labour cost is added back to the lost contribution to give the full impact of diverting labour away from its current role.

Syllabus area D1(a)

95 The correct answer is: **$14,000.**

The current rental cost is $5,000. The net new rental cost, should the project proceed, would be ($17,000 + $5,000 − $3,000) = $19,000, so an increment of $19,000 − $5,000 = $14,000.

Syllabus area D1(a)

96 The correct answer is: **It doesn't measure the potential impact on shareholder wealth.**

On the assumption that the basic reason for approving a project is that it will increase shareholder wealth, a major drawback of the payback period is that it does not attempt to measure the impact on shareholder wealth should the project go ahead.

Notes on incorrect answers:

The 1st statement is a benefit, not a drawback.

The 2nd statement is incorrect. The payback period does not take account of the time value of money.

The 4th statement is incorrect. The calculation is not based on profit.

Syllabus area D1(b)

97 The correct answer is: **Neither 1 nor 2**

The ROCE calculation is as follows

Depreciation per year = $9,000/5 years = $1,800

Profit per year = $3,000 − $1,800 = $1,200

ROCE = Profit/Initial investment = $1,200/$9,000 = 13.33%

The target ROCE is 15% therefore the project would be rejected.

Project payback calculation = $9,000/$3,000 = 3 years

Target payback is 2.5 years therefore the project would be rejected.

Therefore the correct answer is neither 1 nor 2.

Syllabus area D1(b,d)

98 The correct answer is: **5.0%.**

A payback of 20 years suggests net annual inflow of 50,000/20 = $2,500 per year.

Return on capital employed (ROCE) = Average annual accounting profit/Average investment.

Average annual accounting profit = $2,500 cash inflows less depreciation.

Depreciation = 50,000/40 = $1,250 per year.

So average annual accounting profit = $2,500 − $1,250 = $1,250.

Average investment = ($50,000 + 0)/2 = $25,000.

Therefore ROCE = $1,250/$25,000 = 0.05 or 5% per year.

Syllabus area D1(d)

99 The correct answer is: **Because her salary is not incremental**

The cost should not feature in the project appraisal as the accountant is paid anyway, ie her salary is not incremental.

Syllabus area D1(a)

OTQ bank – Investment appraisal using DCF

100 The correct answer is: **$21,924**

The present value of the annuity = $7,000 × AF$_{3-7}$

where AF$_{3-7}$ is the 10% annuity factor from years 3–7 inclusive.

$$AF_{3-7} = AF_{1-7} - AF_{1-2}$$
$$= 4.868 - 1.736 \text{ (from tables)}$$
$$= 3.132$$

Therefore the present value = $7,000 × 3.132 = $21,924

<div align="right">Syllabus area D1(e)</div>

101 The correct answer is: **Option 2 because it is worth more in present value terms**

Step 1: Calculate the future value of the perpetuity using the cost of capital

$90,000/0.1 = $900,000

Step 2: Discount it back to today using a discount factor of 10% at the end of year 2

PV = $900,000 × 0.826 = $743,400

Alternatively, the PV can be calculated using a discount factor of [1/r – annuity factor for time periods 1–2]. This gives $90,000 × (1/0.1 – 1.736) = $743,760 which would be the same answer as the PV of $743,400 if the discount factors (in both methods) were calculated to more than 3 decimal places. Either approach would be acceptable.

Option 2

The present value of the lump sum = $910,000 × DF$_1$

Where DF$_1$ is the 1 year 10% discount factor from tables = 0.909

So present value of lump sum = $910,000 × 0.909 = $827,180

The lump sum should be chosen because it has a higher net present value.

<div align="right">Syllabus area D1(e)</div>

102 The correct answer is: **$700**

Remember that a cash outlay or receipt which occurs at the beginning of a time period is taken to occur at the end of the previous year. Therefore an inflow of $12,000 in advance for 5 years (ie starting now) is taken to occur in years 0, 1, 2, 3 and 4.

NPV at 10%:

Time		$	DF 10%	PV $
0	Investment	(40,000)	1	(40,000)
0–4	Net cash inflows	12,000	1 + 3.17 = 4.17	50,040
5	Decommissioning	(15,000)	0.621	(9,315)
	Net present value			725

= $700 to the nearest $100

<div align="right">Syllabus area D1(e)</div>

103 The correct answer is: **12%**

$$IRR = a + \left[\frac{NPV_a}{NPV_a - NPV_b} \times (b-a) \right]\%$$

where a = lower % discount rate
 b = higher % discount rate
 NPV_A = NPV at a%
 NPV_B = NPV at b%

NPV at 10% = $725 (see question above)

NPV at 15%:

Time				DF 15%	PV
			$		$
0	Investment	(40,000)		1	(40,000)
0–4	Net cash inflows	12,000		1 + 2.855 = 3.855	46,260
5	Decommissioning	(15,000)		0.497	(7,455)
	Net present value				(1,195)

Therefore IRR = 10% + [(725/(725 + 1,195)) × (15% − 10%)] = 11.9% (12% to the nearest whole %)

Syllabus area D1(f)

104 The correct answer is: **Project D**

The project with the highest NPV will maximise shareholder wealth as NPV directly measures the impact on shareholder wealth.

Syllabus area D1(g)

105 The correct answer is: **The second and fourth statements are correct.**

Statement 1 is not an advantage. The decision rule depends on the shape of the IRR curve. There could be several IRRs and whether the IRR needs to be higher or lower than the cost of capital depends on the project cash flows.

Statement 2 is an advantage. IRR is a discounting technique hence takes into account the time value of money.

Statement 3 is a disadvantage. The 'reinvestment assumption' is a flaw in IRR. There is no reason to suppose that funds generated early on in a project will be reinvested at the IRR after that point. The funds may well be distributed elsewhere.

Statement 4 is an advantage. Unlike the payback period, the IRR considers **all** of the future incremental cash flows associated with a decision in its calculation.

Syllabus area D1(f)

106 The correct answer is: **The NPV will decrease and there will be no change to the IRR.**

A higher cost of capital will discount future inflows more heavily, reducing the NPV of the project.

The cost of capital does not feature in the calculation of the IRR, only in the decision rule that follows the calculation.

Syllabus area D1(e)(f)

107 The correct answer is: **$4,981**

The net present value of the agreement is $26,496, hence:

$26,496	= ($a × AF$_{1-4}$) + 10,000	Where AF$_{1-4}$ is the 4 year 8% annuity factor
$16,496	= $a × 3.312	(from tables)
$a	= $16,496/3.312	
	= $4,981	

Syllabus area D1(e)

108 The correct answer is: **Two NPV calculations are needed to estimate the IRR using linear interpolation.**

The IRR formula requires two NPV calculations at different rates to estimate the IRR.

The 2nd statement is inaccurate. Linear interpolation is still an estimate. It is not 100% precise.

The 3rd statement is inaccurate. There may be more than one IRR. It depends on whether the cash flows are conventional or not.

The 4th statement is not necessarily true. For example, an unusual project with an initial large inflow followed by years of outflows will have a positive slope.

Syllabus area D1(h)

109 The correct answer is: **$223,400**

The present value of the holiday home = $1.5m × (DF for time 5 at 10%) = $1.5m × 0.621 = $931,500

Therefore the present value of the annuity = $931,500.

$931,500 = $a × AF_{0-4}

Where AF_{0-4} is the annuity factor from time 0 to time 4

AF_{0-4} = 1 + AF_{1-4} = 1 + 3.170 = 4.170

So $931,500 = $a × 4.170

$a = $931,500/4.170

 = $223,381 or $223,400 to the nearest $100

Syllabus area D1(e)

OTQ bank – Allowing for tax and inflation

110 The correct answer is: **$68,175**

The asset is purchased on 31 December 20X4 (T0) so the first portion of tax-allowable depreciation is accounted for on that date (as this is the end of the year). The amount of the depreciation would be $1m × 25% = $250,000.

Claiming this allowance will save ($250,000 × 30% =) $75,000 tax when it is paid at T1 (one-year delay) hence the present value = $75,000 × DF_1 = $75,000 × 0.909 = $68,175.

Syllabus area D2(b)

111 The correct answer is: **$145,454**

As tax is paid one year in arrears, the $20,000 and associated tax are treated separately:

PV of perpetuity: $20,000 × 1/0.1 = $200,000

Less PV of tax: ($20,000 × 30%) × ($AF_{2-\infty}$)

$AF_{2-\infty}$ = (1/0.1) − DF_1 = 10 − 0.909 = 9.091

PV of tax = $20,000 × 30% × 9.091 = $(54,546)

 After tax = $145,454

Syllabus area D2(b)

112 The correct answer is: **$(2,735)**

	Working capital required (10% × sales)	Increments = cash flow	Discount factor 10%	Present value
$				
To	10,000	(10,000)	1	(10,000.00)
T1	12,500	(2,500)	0.909	(2,272.50)
T2	10,500	2,000	0.826	1,652.00
T3	0	10,500	0.751	7,885.50
				(2,735.00)

Syllabus area D1(e)

113 The correct answer is: **$(21,260)**

The working capital required will inflate year on year, then the inflated amount will be 'returned' at the end of the project:

	Working capital required (with 10% inflation)	Increments = cash flow	Discount factor 12%	Present value
$				
To	100,000	(100,000)	1	(100,000)
T1	110,000	(10,000)	0.893	(8,930)
T2	0	110,000	0.797	87,670
				(21,260)

Syllabus area D2(a)

114 The correct answer is: **$58,175.**

As not all cash flows will inflate at the same rate, cash flows will be inflated where necessary and discounted using the money rate.

(1 + money rate) = (1.08) × (1.02) = 1.1016 so m = 10% to the nearest whole percentage

Nominal income = $100,000 × (1 + income inflation) = $100,000 × 1.1 = $110,000

Nominal expenses = $35,000 (zero inflation)

Therefore NPV = $[(110,000 - 35,000) \times DF_1] - 10,000$ where DF_1 = the 1 year 10% discount factor (tables)

 = (75,000 × 0.909) − 10,000 = $58,175

Syllabus area D2(a)

115 The correct answer is: **$115,740**

In order to use the perpetuity factor (1/r) the annual amount must be constant, so the calculation needs to be done in real terms.

The money cost of capital is given in the question, so the real rate needs to be calculated using:

(1 + r) × (1 + h) = (1 + i) where r = real rate, h = inflation, i = money rate, so

(1 + r) × (1.02) = (1.102)

(1 + r) = 1.102/1.02 = 1.08 or 8%.

The perpetuity factor from T2-∞ = (1/r) − DF1 = (1/0.08) − 0.926 = 11.574

Therefore the present value = 10,000 × 11.574 = $115,740

Syllabus area D2(a)

116 The correct answer is: **Nil**

Increased expectation of inflation will have two effects.

1 Higher expected nominal cash flow

2 Higher nominal discount rate

These will cancel each other out exactly.

Syllabus area D2(a)

117 The correct answer is: **5.8%**

(1 + r) × (1 + h) = (1 + i)

where r = real rate, h = inflation, i = money rate, so

(1 + r) × (1.04) = (1.10)

(1 + r) = 1.10/1.04 = 1.058 or 5.8%.

Syllabus area D2(a)

118 The correct answer is: **$181,500**

The value of the tax-allowable depreciation is 150,000 × 100% × 30% = $45,000 receivable immediately so the net initial outlay = 150,000 – 45,000 = $105,000.

The future value of 105,000 in 2 years' time (note...'receivable in 2 years...')

= 105,000 × 1.1^2 = $127,050.

The revenue is taxable, so the pre-tax contract revenue needs to be 127,050/(1 – 0.3) = $181,500.

Syllabus area D2(b)

119 The correct answer is: **It is expected general inflation suffered by the investors.**

The inflation included in the money cost of capital is required by the investors to compensate them for the loss of general purchasing power their money will suffer in the future as a result of investing in the business.

Syllabus area D2(a)

OTQ bank – Project appraisal and risk

120 The correct answer is: **Statements 1 & 3 are correct, statement 2 is incorrect**

Statement 2 is incorrect because the expected net present value is the value expected to occur if an investment project with several possible outcomes is undertaken **many times**.

Syllabus area D3(c)

121 The correct answer is: **$11,100**

Total cash flow	Joint probability	EV of cash flow
$		$
36,000	0.1125	4,050
14,000	0.0375	525
32,000	0.4500	14,400
10,000	0.1500	1,500
16,000	0.1875	3,000
(6,000)	0.0625	(375)
		23,100
Less initial investment		(12,000)
EV of the NPV		11,100

Syllabus area D3(c)

122 The correct answer is: **Just under three years**

Adjusted payback period is payback period based on discounted cash flows:

Time	Cash flow $	DF 8%	Discounted cash flow $	Cumulative discounted cash flow
0	(100,000)		(100,000)	(100,000)
1	40,000	0.926	37,040	(62,960)
2	40,000	0.857	34,280	(28,680)
3	40,000	0.794	31,760	3,080

Syllabus area D3(d)

123 The correct answer is: **70%**

To force an NPV = 0, the 4-year annuity factor, AF_{1-4} = 110,000/40,000 = 2.75

Proof: the NPV calculation would be (2.75 × 40,000) – 110,000 = 0

From tables, the 4-year annuity factor closest to 2.75 is 2.743, corresponding to a discount rate of 17%.

In terms of sensitivity: (17 – 10)/10 = 70% sensitivity

The cost of capital can therefore increase by 70% before the NPV becomes negative.

Note. Alternatively the IRR could be estimated to find the 17% instead of tables.

NPV when cost of capital is 18% = –110,000 + (40,000 × 2.69) = (2,400)

$$IRR = 0.1 + \frac{16,800}{16,800 + 2,400} \times (0.18 - 0.1) = 17\%$$

Syllabus area D3(b)

124 The correct answer is:

Sensitivity = 200,000/((4,000,000 – 2,000,000) × 0.8) × 100 = **12.5%**

A change in sales volume affects sales revenue and variable costs, but not fixed costs. The sensitivity of the NPV to a change in contribution must therefore be calculated. However, a change in contribution will cause a change in the corporation tax liability, so it is essential that the after-tax contribution be considered.

Contribution = 4,000,000 – 2,000,000 = $2,000,000

After-tax contribution = 2,000,000 × 0.8 = $1,600,000

Sensitivity = NPV/PV of project variable = 200,000/1,600,000 × 100 = 12.5%

Syllabus area D3(d)

OTQ bank – Specific investment decisions

125 The correct answer is: **The third statement is correct**

The first statement is **incorrect**. With buying an asset, the company receives tax allowances (tax-allowable depreciation) which results in cash savings on tax. It is the tax saving that is the relevant cash flow as opposed to the tax allowable depreciation. With leasing, the lessor does not receive these allowances. However, the lease rental is allowable for tax purposes which results in cash savings on tax.

The second statement is **incorrect**. They need to be discounted at the cost of capital, not just the cost of debt.

The third statement is **correct**. Ranking using the profitability index can be used if projects are divisible.

The final statement is **incorrect**. Soft capital rationing is brought about by internal factors and decisions by management, not external government decisions.

Syllabus area D4(c)

126 The correct answer is: **The 2-year cycle should be chosen with an equivalent annual cost of $10,093.**

Net present cost of 1-year cycle = 20,000 – (10,000 × 0.909) = $10,910 cost
Net present cost of 2-year cycle = 20,000 – [(8,000 – 5,000) × 0.826] = $17,522 cost
EAC 1-year cycle = $10,910/0.909 = 12,002
EAC 2-year cycle = $17,522/1.736 = 10,093
The 2-year cycle should be chosen with an equivalent annual cost of $10,093.

Syllabus area D4(b)

127 The correct answer is: **Lease is better than buy.**

The saved outlay is a benefit of the lease so if it outweighs the present value of the costs relevant to the lease then the lease is financially worthwhile.

Syllabus area D4(a)

128 The correct answer is: **No – After-tax cost of the loan if they borrow and buy**

Interest should not be included as a cash flow as it is part of the discount rate.

As a financing decision the alternatives should be assessed at the after-tax cost of borrowing – the risk associated with each is the risk of borrowing (or not), and not related to what is done with the asset.

Syllabus area D4(a)

129 The correct answer is: **Both are false.**

The profitability index is only suitable for handling single-period capital rationing problems if projects are divisible.

Whether a project may be considered divisible or not depends on the project – for example investing in a machine is unlikely to be divisible (half a machine will not generate half the return); however, buying a chain of shops could be divisible; it might be possible to buy half the chain for half the cost and expect half the net present value.

Syllabus area D4(c)

130 The correct answer is: **$13m**

Project	Initial cost $m	NPV $m	Profitability index*	Ranking
1	40	4	1.10	3
2	30	5	1.167	1
3	50	6	1.12	2
4	60	5	1.08	4

*(NPV + initial cost)/initial cost

Investment plan:

	Investment $m	NPV $m
100% of Project 2	30	5
100% of Project 3	50	6
50% of Project 1	20	2
	100	13

Syllabus area D4(c)

131 The correct answer is: **$11m**

Projects 2 and 3 give the highest NPV without breaking the $100m constraint.

Syllabus area D4(c)

132 The correct answer is: **Avoiding tax exhaustion**

'Avoiding tax exhaustion' is potentially a benefit. Tax exhaustion is when a business has negative taxable income so it cannot benefit from tax relief such as tax-allowable depreciation. In this case, it may be beneficial to lease the asset from a business that can benefit from the tax-allowable depreciation and share in that benefit via lower lease payments.

'Attracting lease customers that may not have been otherwise possible' is a potential benefit to a lessor, not a lessee.

'Exploiting a low cost of capital' is a potential benefit for the purchaser, not the lessee.

'Potential future scrap proceeds' is a potential benefit for the purchaser, not the lessee, as the lessee is not entitled to scrap proceeds.

<div align="right">Syllabus area D4(a)</div>

133 The correct answer is: **Electric because its equivalent annual benefit is higher**

The NPVs cannot be directly compared as they relate to different time periods. Equivalent annual benefits (EAB) should be compared. This is similar in principle to equivalent annual cost.

EAB gas = \$50,000/AF$_{1-5}$ = 50,000/3.993 = \$12,522 pa

EAB electric = \$68,000/AF$_{1-7}$ = 68,000/5.206 = \$13,062 pa

Therefore electric should be chosen as its EAB is higher.

<div align="right">Syllabus area D4(b)</div>

134 The correct answer is: **Higher scrap value**

Better company image and efficiency

Statement 1 is a benefit. Scrapped assets will be newer hence worth more.

Statement 2 is a benefit. Newer assets look better, motivate employees and are more efficient.

Statement 3 is not true hence not a benefit. Typically depreciation is higher in earlier years, meaning annual depreciation charges will be higher with a shorter replacement cycle.

Statement 4 is inaccurate hence not a benefit. Although owned for a shorter period, the asset will be replaced so ownership of that type of asset will be indefinite.

<div align="right">Syllabus area D4(b)</div>

Sensitivity analysis

135 The correct answer is: **11.9%**

Year	Contribution $'000	Discount factor 9%	PV $'000
1–2	7,100	1.759	12,489
	(10,300 –3,200)		

Sensitivity of project to sales volume = $\dfrac{1,490}{12,489} \times 100\% = 11.9\%$

<div align="right">Syllabus area D3(b)</div>

136 The correct answer is: **1.75 years**

Year	Net cash flow $'000	Discount factor 9%	PV $'000	Cumulative PV $'000
0	(11,000)	1	(11,000.00)	(11,000.00)
1	7,100	0.917	6,510.70	(4,489.30)
2	7,100	0.842	5,978.20	

4,489.30/5,978.20 = 0.75

Therefore the discounted payback = 1.75 years

<div align="right">Syllabus area D3(d)</div>

137 The correct answer is: **18.9%**

Using discount rates of 15% and 20% per the question we have:

Year	Net cash flow $'000	Discount factor 15%	PV $'000	Discount factor 20%	PV $'000
0	(11,000)	1	(11,000)	1	(11,000)
1	7,100	0.870	6,177	0.833	5,914
2	7,100	0.756	5,368	0.694	4,927
			NPV = 545		NPV = (159)

$$IRR = 15 + \left[\frac{545}{545+159} \times (20-15)\right] = 18.9\%$$

Syllabus area D1(f)

138 The correct answer is: **Using random numbers to generate possible values of project variables, a simulation model can generate a standard deviation of expected project outcomes.**

The statement concerning simulation models is true. They use probabilities to carry out a statistical analysis of possible project outcomes.

Notes on incorrect answers:

Sensitivity definition

Selecting this answer indicates a lack of understanding of sensitivity analysis. The sensitivity of NPV to a change in sales volume can be calculated as NPV divided by the present value of contribution. Comparing NPV to the present value of future sales income would be estimating the sensitivity of NPV to a change in selling price.

The certainty equivalent approach

This approach to investment appraisal requires that the riskless equivalent amounts are discounted by a riskless discount rate; that is, the risk-free rate of return. A CAPM-derived project-specific cost of capital is not the risk-free rate of return, but rather a rate of return that reflects the systematic risk of a particular investment project.

Risk and uncertainty

A common way to distinguish between risk and uncertainty is to say that risk can be quantified whereas uncertainty cannot be quantified, so stating that neither can be measured or quantified is not true.

Syllabus area D3

139 The correct answer is: **1 and 3**

The IRR ignores the relative sizes of investments. It therefore does not measure the absolute increase in company value, and therefore shareholder wealth, which can be created by an investment.

Where cash flows change from negative to positive more than once there may be as many IRRs as there are changes in the direction of cash flows. So IRR is not easy to use in this situation.

Syllabus area D1(h)

Guilder Co

140　The correct answer is: **1. Utrec, 2. Tilbur, 3. Eind, 4. Amster**

PI = PV of future cash flows/PV of capital investment

Project	Outlay in Year 0 $	PV $	NPV $	Ratio (PV/ outlay)	Ranking
Amster	100,000	111,400	11,400	1.114	4th
Eind	56,000	62,580	6,580	1.118	3rd
Utrec	60,000	68,760	8,760	1.146	1st
Tilbur	90,000	102,400	12,400	1.138	2nd

Syllabus area D4(c)

141　The correct answer is: **PI can only be used if projects are divisible.**

The weaknesses of the PI method are:

It does not take into account the absolute size of the individual projects. A project with a high index might be very small and therefore only generate a small NPV.

It does not highlight the projects which are slowest in generating returns. It is possible that the project with the highest PI is the slowest in generating returns.

It does not allow for uncertainty about the outcome of each project. In fact it assumes that there is complete certainty about each outcome.

Syllabus area D4(c)

142　The correct answer is: **$105,406**

Present value of cash flows = (250,000 + 17,860 + 23,113 + 22,784 + 6,360) = ($320,117)
Cumulative present value factor = 3.037
Equivalent annual cost = $320,117/3.037 = $105,406

Syllabus area D4(b)

143　The correct answer is: **Statement 1 is false and statement 2 is true.**

The equivalent annual cost method is the most convenient method of analysis to use in a period of **no** inflation, because it is converting the NPV of the cost of buying and using the asset into an equivalent annual cost. In times of high inflation, this cost would keep increasing (so statement 1 is false).

The EAC method assumes that the machine can be replaced by exactly the same machine in perpetuity and this is one of the weaknesses of the EAC method. It is not usually possible to replace something with exactly the same thing as assets are constantly developing. Computers, in particular, are developing very quickly and so it can make sense to replace certain assets more often than the EAC method dictates.

Syllabus area D4(b)

144　The correct answer is: **$17,654**

EV of Year 2 cash flow = (19,000 × 0.55) + (26,000 × 0.45) = 22,150
PV discounted at 12% = 22,150 × 0.797 = $17,654

Syllabus area D3(c)

Trecor Co

145　The correct answer is: **56%**

Depreciation = $250,000 − $5,000 − $245,000
Accounting profit = total cash inflows − depreciation = $530,000 − $245,000 = $285,000
Average profit per year = $285,000/4 = $71,250
Average investment = (250,000 + 5,000)/2 = $127,500
ROCE = 71,250/127,500 × 100 = 56%

Syllabus area D1(d)

146 The correct answer is: **The first statement is false.**

ROCE needs to be higher than the target ROCE for the machine purchase to be recommended. The second statement is true. Two (or more) mutually exclusive projects can be compared using ROCE. The project with the highest ROCE should be selected.

Syllabus area D1(d)

147 The correct answer is: **$10,547**

	Tax-allowable depreciation	$		Tax benefits	$
1	$250,000 \times 0.25 =$	62,500	2	$62,500 \times 0.3 =$	18,750
2	$62,500 \times 0.75 =$	46,875	3	$46,875 \times 0.3 =$	14,063
3	$46,875 \times 0.75 =$	35,156	4	$35,156 \times 0.3 =$	10,547

Syllabus area D2(b)

148 The correct answer is: **1 year 11 months**

Year 1 cumulative balance = $-250,000 + 122,000 = -128,000$

$(128,000/143,000) \times 12$ months = 11 months \therefore payback is 1 year 11 months

Syllabus area D1(b)

149 The correct answer is: **IRR ignores the relative sizes of investments. IRR and NPV sometimes give conflicting rankings over which project should be prioritised.**

The IRR ignores the relative sizes of investments.

It therefore does not measure the absolute increase in company value, and therefore shareholder wealth, which can be created by an investment. Therefore statement 2 is false.

When discount rates are expected to differ over the life of the project, such variations can be incorporated easily into NPV calculations, but not into IRR calculations. Therefore statement 3 is also false.

Statement 4 is true. NPV and IRR methods can give conflicting rankings as to which project should be given priority.

Syllabus area D1(h)

BRT Co

150 The correct answer is: **$8,487 (or $8,488)**

$1,600,000 \times \$5 \times 1.03^2 = \$8,487,200$ or

$1,600,000 \times 5.305 = \$8,488,000$ (if you have rounded the inflated price)

Syllabus area D2(a)

151 The correct answer is: **$6,884**

$2,100,000 \times \$3 \times 1.03^3 = \$6,884,180$

Syllabus area D2(a)

152 The correct answer is: **$84**

Year	Tax-allowable depreciation	Year	Tax benefits
1	$2,000,000 \times 0.25 = \$500,000$	2	$\$500,000 \times 0.3 = \$150,000$
2	$500,000 \times 0.75 = \$375,000$	3	$\$375,000 \times 0.3 = \$112,500$
3	$375,000 \times 0.75 = \$281,250$	4	$\$281,250 \times 0.3 = \$84,375$

Syllabus area D2(b)

153 The correct answer is: The trainee accountant has used the wrong percentage for the cost of capital – **False**

As inflated sales and costs have been used, the cost of capital should be the nominal cost of capital (at 12%).

Ignoring sales after four years underestimates the value of the project – **True**

Cutting off cash flows after four years will underestimate the value of the project as future cash inflows will be ignored.

The working capital figure in Year 4 is wrong – **True**

The final year should recover the total working capital and so should be:
$750k + $23k + $23k + $24k = $820k.

Syllabus area D1(a)

154 The correct answer is: **Both statements are true.**

When there are **unconventional** cash flow patterns there may be multiple IRRs and so the NPV and IRR decisions may not be the same.

A project is financially viable under the IRR criteria if the IRR is greater than the cost of capital (12% in this case).

Syllabus area D1(h)

155 Melanie Co

Workbook references. Equivalent annual costs and leasing are both covered in Chapter 8, and the comparison of NPV to IRR is covered in Chapter 5.

Top tips. In leasing questions, the timing of the cash flows is always important. Always check whether they are in advance or arrears. Also don't rush the calculations, read the requirement very carefully before beginning. It is easy in part a(ii) to miss that this discount rate has changed to 10%.

Easy marks. In part b, the discussion points should be easy however in the exam not enough attention is directed towards achieving these marks (see examiner comments below).

Examining team's comments. For part (b) most answers gained very few marks because they did not adopt a comparative approach to answering the question requirement, for example, by making a statement about NPV without referring to IRR and vice versa, and hence not discussing the superiority of NPV over IRR.

Furthermore, some responses:

- Could not gain full marks because they offered fewer than the number of reasons required by the question;

- Incorrectly stated that IRR is inferior to NPV because IRR ignores the time value of money;

- Were expressed only too briefly and in terms that were too general such as quick, easy, simple to understand.

			Marks
(a)	(i)	Lease timing	1
		PV leasing	1
		Maintenance cost	1
		Purchase cost	0.5
		Residual value	0.5
		PV buy	1
		Decision	1
			6
	(ii)	3-year PV cost	1
		3-year EAC	1
		Maintenance 4-year	0.5
		Residual value 4-year	0.5
		4-year PV cost	1
		4-year EAC	1
		Decision	1
			6
(b)	Each (of four) reasons worth 2 marks each		8
			20

(a) (i)

Time	0	1	2	3
	$	$	$	$
Lease				
Lease payment	(55,000)	(55,000)	(55,000)	
PV factor at 8%	1.000	0.926	0.857	
Present value	(55,000)	(50,930)	(47,135)	
Present value cost	**(153,065)**			
Borrow and buy				
Initial cost	(160,000)			
Residual value				40,000
Maintenance		(8,000)	(8,000)	(8,000)
Total	(160,000)	(8,000)	(8,000)	32,000
PV factor at 8%	1.000	0.926	0.857	0.794
Present value	(160,000)	(7,408)	(6,856)	25,408
Present value cost	(148,856)			

As borrow and buy offers the cheapest present value cost the machine should be financed by borrowing.

(ii) 3-year replacement cycle	Year 0 $	Year 1 $	Year 2 $	Year 3 $	Year 4 $
Initial cost	(160,000)				
Residual value				40,000	
Maintenance		(8,000)	(8,000)	(8,000)	
Total	(160,000)	(8,000)	(8,000)	32,000	
PV factor at 10%	1.000	0.909	0.826	0.751	
Present value	(160,000)	(7,272)	(6,608)	24,032	
Present value cost	(149,848)				
EAC 3-year cycle = PV cost/Annuity factor 3 years at 10%					
EAC = –$149,848/2.487	(60,253)				
4-year replacement cycle					
Initial cost	(160,000)				
Residual value					11,000
Maintenance		(12,000)	(12,000)	(12,000)	(12,000)
Total	(160,000)	(12,000)	(12,000)	(12,000)	(1,000)
PV factor at 10%	1.000	0.909	0.826	0.751	0.683
Present value	(160,000)	(10,908)	(9,912)	(9,012)	(683)
Present value cost	(190,515)				

EAC 4-year cycle = PV cost/Annuity factor 4 years at 10%

EAC = –$190,515/3.170 = (60,099)

Recommendation

The machine should be replaced every four years as the equivalent annual cost is lower.

(b) In most simple accept or reject decisions, IRR and NPV will select the same project.

However, NPV has certain advantages over IRR as an investment appraisal technique.

NPV and shareholder wealth

The NPV of a proposed project, if calculated at an appropriate cost of capital, is equal to the increase in shareholder wealth which the project offers. In this way NPV is directly linked to the assumed financial objective of the company, the maximisation of shareholder wealth. IRR calculates the rate of return on projects, and although this can show the attractiveness of the project to shareholders, it does not measure the absolute increase in wealth which the project offers.

Absolute measure

NPV looks at absolute increases in wealth and thus can be used to compare projects of different sizes. IRR looks at relative rates of return and in doing so ignores the relative size of the compared investment projects.

Non-conventional cash flows

In situations involving multiple reversals in project cash flows, it is possible that the IRR method may produce multiple IRRs (that is, there can be more than one interest rate which would produce an NPV of zero). If decision-makers are aware of the existence of multiple IRRs, it is still possible for them to make the correct decision using IRR, but if unaware they could make the wrong decision.

Mutually-exclusive projects

In situations of mutually-exclusive projects, it is possible that the IRR method will (incorrectly) rank projects in a different order to the NPV method. This is due to the inbuilt reinvestment assumption of the IRR method. The IRR method assumes that any net cash inflows generated during the life of the project will be reinvested at the project's IRR. NPV on the other hand assumes a reinvestment rate equal to the cost of capital. Generally NPV's assumed reinvestment rate is more realistic and hence it ranks projects correctly.

Changes in cost of capital

NPV can be used in situations where the cost of capital changes from year to year. Although IRR can be calculated in these circumstances, it can be difficult to make accept or reject decisions as it is difficult to know which cost of capital to compare it with.

Note. Only four reasons were required to be discussed.

156 Project E

Workbook references. NPV and inflation and tax are covered in Chapters 5 and 6. Payback is covered in Chapter 5.

Top tips. Part (a) is a fairly straightforward NPV question if you organise your workings. Set up an NPV proforma and calculate the inflated sales values and costs in separate workings. Remember that if inflation is 5% in Year 1 (ie multiply sales by 1.05) then in Year 2 the sales will need to be multiplied by 1.052 and so on. The tax-allowable depreciation should also be calculated in the workings. In part (b), don't forget to comment on your calculation.

Easy marks. There are easy marks in part (a) for calculations by following the proforma approach. Don't forget to comment on the financial acceptability of the project.

Examining team's comments. The examining team said that most students did well on part (a) of this question. However, some students used a corporation tax rate of 30% instead of 28%. Make sure that you read the question carefully! Also, some students did not put tax liabilities and benefits one year in arrears. The examining team also said that credit was given for including scrap value whether it was taken as a Year 4 or Year 5 cash flow. But remember that scrap value income is not subject to corporation tax.

(a) As inflation rates differ for revenue and cost, nominal cash flows (ie including inflation) need to be calculated and discounted at the nominal rate (also including inflation).

	Year 0 $'000	Year 1 $'000	Year 2 $'000	Year 3 $'000	Year 4 $'000	Year 5 $'000
Sales (W1)		5,670	6,808	5,788	6,928	
Variable cost (W2)		(3,307)	(4,090)	(3,514)	(4,040)	
Fixed costs (W3)		(776)	(803)	(832)	(861)	
Taxable cash flow		1,587	1,915	1,442	2,027	
Taxation			(444)	(536)	(404)	(568)
Capital expenditure	(5,000)					
Scrap value					400	
Tax benefit of tax depn (W4)			350	263	197	479
	(5,000)	1,587	1,821	1,169	2,220	(89)
Discount factors @ 13%	1	0.885	0.783	0.693	0.613	0.543
Present value	(5,000)	1,405	1,426	810	1,361	(48)

Net present value = −5,000 + 1,405 + 1,426 + 810 + 1,361 − 48 = (46)

The net present value is negative and the investment is not financially worthwhile. However, the board has decided that it is strategically important to undertake this project.

Workings

1 Sales

	Volume	Price $	Inflation	Revenue $
Year 1	12,000 ×	450 ×	1.05	5,670,000
Year 2	13,000 ×	475 ×	1.05^2	6,807,938
Year 3	10,000 ×	500 ×	1.05^3	5,788,125
Year 4	10,000 ×	570 ×	1.05^4	6,928,386

2 Variable costs

	Volume	Price $	Inflation	Revenue $
Year 1	12,000 ×	260 ×	1.06	3,307,200
Year 2	13,000 ×	280 ×	1.06^2	4,089,904
Year 3	10,000 ×	295 ×	1.06^3	3,513,497
Year 4	10,000 ×	320 ×	1.06^4	4,039,926

3 Fixed costs

Fixed costs $750,000 per year inflating at 3.5%

Year		Fixed costs $
1	750 × 1.035	776,250
2	750 × 1.035^2	803,419
3	750 × 1.035^3	831,538
4	750 × 1.035^4	860,642

4 Tax-allowable depreciation tax benefits

Year		Tax-allowable depn $	Tax benefit @ 28% $
1	5,000,000 × 25%	1,250,000	350,000
2	1,250,000 × 75%	937,500	262,500
3	937,500 × 75%	703,125	196,875
4	Balancing allowance	1,709,375	478,625
Scrap value		400,000	
		5,000,000	

Tax benefits and tax charges affect the following period since tax is paid in arrears.

(b) Capital rationing means that a company is unable to invest in all projects with a positive net present value and hence it is not acting to maximise shareholder wealth. When a company restricts or limits investment funds, it is undertaking 'soft' or internal capital rationing.

There are several reasons why the board of OAP Co may decide to limit investment funds.

It may not wish to issue new equity finance in order to avoid diluting earnings per share. Issuing new equity finance may also increase the risk of a company's shares being bought by a potential acquirer, leading to a future takeover bid.

The board of OAP Co may not wish to issue new debt finance if it wishes to avoid increasing its commitment to fixed interest payments. This could be because economic prospects are seen as poor or challenging, or because existing debt obligations are high and so the board does not wish to increase them.

The board of OAP Co may wish to follow a strategy of organic growth, financing capital investment projects from retained earnings rather than seeking additional external finance.

Finally, the board of OAP Co may wish to create an internal market for capital investment funds, so that capital investment proposals must compete for the limited funds made available in the budget set by the board. This competition would mean that only robust capital investment projects would be funded, while marginal capital investment projects would be rejected.

157 AGD Co

Workbook references. Leasing is covered in Chapter 8.

Top tips. This question is in three parts and each part of the question could be answered separately.

Easy marks. Parts (b) and (c) are straightforward regurgitation of textbook knowledge.

Examining team's comments. While many candidates made errors in this question, answers were usually of a satisfactory overall standard. Common errors included timing the investment when borrowing to buy as occurring at the end of the first year, omitting the tax savings on the maintenance costs incurred by buying the asset, and omitting the tax savings on the lease rental payments.

Marking scheme

			Marks
(a)	Purchase price	1	
	Sale proceeds	1	
	Tax-allowable depreciation and balancing allowance	2	
	Tax-allowable depreciation tax benefits	1	
	Maintenance costs after tax	2	
	PV of borrowing to buy	1	
	Lease rentals	1	
	Lease rental tax benefits	1	
	PV of leasing	1	
	Selection of cheapest option	1	
			12
(b)	Explanation and discussion		
	Risk reduction (technological obsolescence, avoid risk of lower residual value, insurance)	2–3	
	Source of finance (speed, availability, lack of loan covenants)	2–3	
		Maximum	5
(c)	Risk and uncertainty		3
			20

(a) (i) **Present value of purchase costs**

	Year 0 $'000	Year 1 $'000	Year 2 $'000	Year 3 $'000	Year 4 $'000
Cash outflows					
Capital costs	(320)				
Annual maintenance costs		(25)	(25)	(25)	
	(320)	(25)	(25)	(25)	0
Cash inflows					
Disposal proceeds				50	
Taxation (at 30% in following year)			8	8	8
Tax-allowable depn (W)			24	18	39
	–	–	32	76	47
Net cash flows	(320)	(25)	7	51	47
Discount at 7%	1.000	0.935	0.873	0.816	0.763
PV of cash flow	(320)	(23)	6	42	36

NPV of cash flow **($259k)**

Working: Tax-allowable depreciation

	$'000	Tax-allowable depn $'000	Tax benefit $'000	Year of cash flow
Initial investment	320			
Allowances at 25% p.a. on a reducing balance basis over 3 years				
Year 1	(80)	(80)	24	Y2
	240			
Year 2	(60)	(60)	18	Y3
	180			
Year 3				
Proceeds on sale	(50)			
Balancing allowance	130		39	Y4

(ii) **Present value of leasing costs**

	Year 0 $'000	Year 1 $'000	Year 2 $'000	Year 3 $'000	Year 4 $'000
Cash outflows					
Annual lease rentals	(120)	(120)	(120)		
	(120)	(120)	(120)		
Cash inflows					
Taxation (at 30% in following year) – tax deduction for lease rentals			36	36	36
Net cash flows	(120)	(120)	(84)	36	36
Discount at 7%	1.000	0.935	0.873	0.816	0.763
PV of cash flow	(120)	(112)	(73)	29	27

NPV of cash flow **($249k)**

Therefore the machine should be **leased** rather than purchased as the NPV of the cost is lower.

(b) **Risk reduction**

The lease is for a three-year term but contains an annual break clause. This will have the impact of reducing risk because if the machinery is no longer needed (perhaps because the project is failing) or if there is a change in technology so better technology is available in future years then it will be easier to exit from the lease agreement than to sell the machinery (if owned).

Also when the machinery needs to be sold (either at the end of the three years or earlier) there is the risk that the residual value is lower than expected. This risk is not faced if lease finance is used.

Finally the inclusion of insurance and maintenance could also be argued to reduce risk.

Source of finance

Lease finance can also be easier and quicker to obtain because the lessor remains the legal owner of the machinery. In addition, if a loan is used then covenants may be imposed (for example on dividend payments, or the use of other debt finance) and this can restrict the flexibility of the firm in future years; the use of lease finance avoids this.

(c) **Risk and uncertainty**

Risk can be applied to a situation where there are several possible outcomes and, on the basis of past relevant experience, probabilities can be assigned to the various outcomes that could prevail. The risk of a project increases as the **variability of returns** increases.

Uncertainty can be applied to a situation where there are several possible outcomes but there is little past relevant experience to enable the probability of the possible outcomes to be predicted. Uncertainty increases as the **project life** increases.

158 Basril Co

Workbook references. Capital rationing is covered in Chapter 8.

Top tips. Calculate the NPVs for each project first and then look at the best combination of divisible or indivisible projects.

Easy marks. These can be achieved by setting out the correct format for calculating NPVs.

Examining team's comments. This question asked for optimal selection under capital rationing. Good answers calculated the NPV and profitability index, and gave the optimum investment schedule and total NPV for the cases of divisible and non-divisible projects. Errors included: failing to calculate profitability indexes, not calculating the total NPV (even though required by the question), failing to account correctly for inflation in the case of the project where real cash flows were provided (inflating real cash flows to money terms or deflating the nominal rate were both acceptable), and using annuity factors rather than discount factors in calculations. Part (c) asked for an explanation, with examples, of 'relevant cost' in the context of investment appraisal. Weaker answers showed a lack of understanding of cost classification.

(a) (i)

	Project 1	*12% discount factor*	
	$		$
Initial investment	(300,000)	1	(300,000)
Year 1	85,000	0.893	75,905
Year 2	90,000	0.797	71,730
Year 3	95,000	0.712	67,640
Year 4	100,000	0.636	63,600
Year 5	95,000	0.567	53,865
			32,740
Profitability index	332,740/300,000		1.11

BPP
LEARNING
MEDIA

	Project 2	12% discount factor	
	$		$
Initial investment	(450,000)	1	(450,000)
Year 1	140,800	0.893	125,734
Year 2	140,800	0.797	112,218
Year 3	140,800	0.712	100,250
Year 4	140,800	0.636	89,549
Year 5	140,800	0.567	79,834
			57,585
Profitability index	507,585/450,000		1.13

	Project 3	12% discount factor	
	$		$
Initial investment	(400,000)	1	(400,000)
Year 1 (120,000 × 1.036)	124,320	0.893	111,018
Year 2 (120,000 × 1.036²)	128,796	0.797	102,650
Year 3	133,432	0.712	95,004
Year 4	138,236	0.636	87,918
Year 5	143,212	0.567	81,201
			77,791
Profitability index	477,791/400,000		1.19

The most profitable projects are Projects 3 and 2, so if they are **divisible** it is suggested that Basril Co invests $400k in Project 3 for an NPV of $77,791, and the remaining $400k in Project 2 for an NPV of 400/450 × $57,585 = $51,187.

(ii) If the projects are **indivisible**, then Basril Co can either invest in Project 1 and Project 2 at a cost of $750,000, or Project 1 and Project 3 at a cost of $700,000 (Project 2 and Project 3 would cost too much). The NPV of 1 + 2 = $32,740 + $57,584 = $90,324. The NPV of 1 + 3 = $32,740 + $77,791 = $110,531. Therefore the best combination is Projects 1 and 3.

(b) **Cash shortages**

A period of capital rationing is often associated with more general problems of cash shortage. Possible reasons for this include the following.

(i) The business has become **loss making** and is unable to cover the depreciation charge. Since one purpose of the depreciation charge is to allow for the cost of the assets used in the statement of profit or loss, the implication is that there will be insufficient cash with which to replace these assets when necessary.

(ii) High inflation may mean that even though the business is profitable in historical cost terms, it is still failing to **generate sufficient funds** to replace assets.

(iii) If the business is growing it may face a **shortage of working capital** with which to finance expansion, and this may result in a period of capital rationing.

(iv) If the business is seasonal or cyclical it may **face times of cash shortage** despite being fundamentally sound. In this situation, there may be a periodic need for capital rationing.

(v) A **large one-off item** of **expenditure** such as a property purchase may mean that the company faces a temporary shortage of cash for further investment.

Investment opportunities

A further reason for capital rationing arises in the situation where the company has **more investment opportunities** available than the **funds allocated** to the capital budget permit. This means that projects must be ranked for investment, taking into account both financial and strategic factors.

(c) When appraising an investment project, it is essential that only those cash flows relevant to the project be taken into account, otherwise an incorrect investment decision could be made. A 'relevant cash flow' is an incremental cash flow that arises or changes as a direct result of the investment being made. Some costs will be sunk before an investment decision is made. An example would be research and development or market research costs into the viability of a new product. Once incurred, such costs become irrelevant to the decision as to whether or not to proceed, and so should be excluded from the analysis. Cash flows that would be relevant include an increase in production overheads or labour costs, new purchases that are necessary, and any incremental tax effects. It is important to note that any interest payments on the finance for a new project are relevant to the project decision, but are not taken into account in any NPV calculation. The interest payments will already be 'built in' to the calculation in the discount factor that is being applied.

159 Degnis Co

Workbook references. Investment appraisal and risk is covered in Chapter 7.

Top tips. Read the question carefully before starting the calculations. Some candidates incorrectly had tax cash flows payable one year in arrears and, although the question required candidates to use straight-line tax-allowable depreciation, some answers used 25% reducing balance instead. Part (c) illustrates the importance of having a clear understanding about the difference between risk and uncertainty in the context of investment appraisal.

Marking scheme

			Marks
(a)	Sales income	1	
	Conversion cost	1	
	Before-tax cash flow	1	
	Tax paid	1	
	Tax-allowable depreciation benefits	1	
	After-tax cash flow	1	
	NPV calculations	1	7
(b)	PV of future cash flows ignoring tax-allowable depreciation	1	
	PV of tax-allowable depreciation benefits	1	
	Comment on financial acceptability	1	
			3
(c)	Risk and uncertainty	1	
	Explanation of probability analysis	2–3	
	Problems – repeatability assumption, difficulty in determining probabilities	2–4	
		Maximum	5
(d)	Reason for hard rationing	1–4	
	Reasons for soft rationing	1–4	Maximum 5
			20

(a) **Calculation of NPV over four years**

Year	1	2	3	4
	$'000	$'000	$'000	$'000
Sales income	12,525	15,030	22,545	22,545
Conversion cost	(7,913)	(9,495)	(14,243)	(14,243)
Contribution	4,612	5,535	8,302	8,302
Fixed costs	(4,000)	(5,000)	(5,500)	(5,500)
Before-tax cash flow	612	535	2,802	2,802
Tax liability at 28%	(171)	(150)	(785)	(785)
Tax-allowable depreciation benefits	112	112	112	112
After-tax cash flow	553	497	2,129	2,129
Discount at 11%	0.901	0.812	0.731	0.659
Present values	498	404	1,556	1,403

	$'000
Sum of present values	3,861
Initial investment	4,000
NPV	(139)

Workings

Average selling price = (30,000 × 0.20) + (42,000 × 0.45) + (72,000 × 0.35) = $50,100 per unit

Average conversion cost = (23,000 × 0.20) + (29,000 × 0.45) + (40,000 × 0.35) = $31,650 per unit

Year	1	2	3	4
Sales volume (units/year)	250	300	450	450
Average selling price ($/unit)	50,100	50,100	50,100	50,100
Sales income ($'000/year)	12,525	15,030	22,545	22,545

Year	1	2	3	4
Sales volume (units/year)	250	300	450	450
Average selling price ($/unit)	31,650	31,650	31,650	31,650
Sales income ($'000/year)	7,913	9,495	14,243	14,243

Contribution may be calculated directly, with small rounding differences. Average contribution = 50,100 − 31,650 = $18,450 per unit.

Year	1	2	3	4
Sales volume (units/year)	250	300	450	450
Average selling price ($/unit)	18,450	18,450	18,450	18,450
Sales income ($'000/year)	4,613	5,535	8,303	8,303

Tax-allowable depreciation = 4,000,000/10 = $400,000 per year

Benefit of tax-allowable depreciation = 400,000 × 0.28 = $112,000 per year

(b) Ignoring tax-allowable depreciation, after-tax cash flow from Year 5 onwards will be: 2,802,000 − 785,000 = $2,017,000 per year

Present value of this cash flow in perpetuity = (2,017,000/0.11) × 0.659 = $12,083,664

There would be a further six years of tax benefits from tax-allowable depreciation. The present value of these cash flows would be 112,000 × 4.231 × 0.659 = $312,282.

Increase in NPV of production and sales continuing beyond the first four years would be 12,083,664 + 312,282 = $12,395,946 or approximately $12.4m.

If only the first four years of operation are considered, the NPV of the planned investment is negative and so it would not be financially acceptable. If production and sales beyond the first four years are considered, the NPV is strongly positive and so the planned investment is financially acceptable. In fact, the NPV of the planned investment becomes positive if only one further year of operation is considered:

NPV = (2,129,000 × 0.593) − 139,000 = 1,262,497 − 139,000 = $1,123,497

(c) Risk in investment appraisal refers to a range of outcomes whose probability of occurrence can be quantified. Risk can therefore be distinguished from uncertainty in investment appraisal, where the likelihood of particular outcomes occurring cannot be quantified.

As regards incorporating risk into investment appraisal, probability analysis can be used to calculate the values of possible outcomes and their probability distribution, the value of the worst possible outcome and its probability, the probability that an investment will generate a positive NPV, the standard deviation of the possible outcomes and the expected value (mean value) of the NPV. Standard deviation is a measure of risk in financial management.

One difficulty with probability analysis is its assumption that an investment can be repeated a large number of times. The expected value of the NPV, for example, is a mean or average value of a number of possible NPVs, while standard deviation is a measure of dispersal of possible NPVs about the expected (mean) NPV. In reality, many investment projects cannot be repeated and so only one of the possible outcomes will actually occur. The expected (mean) value will not actually occur, causing difficulties in applying and interpreting the NPV decision rule when using probability analysis.

Another difficulty with probability analysis is the question of how the probabilities of possible outcomes are assessed and calculated. One method of determining probabilities is by considering and analysing the outcomes of similar investment projects from the past. However, this approach relies on the weak assumption that the past is an acceptable guide to the future. Assessing probabilities this way is also likely to be a very subjective process.

(d) Theoretically, a company should invest in all projects with a positive net present value in order to maximise shareholder wealth. If a company has attractive investment opportunities available to it, with positive net present values, it will not be able to maximise shareholder wealth if it does not invest in them, for example, because investment finance is limited or rationed.

If investment finance is limited for reasons outside a company, it is called 'hard capital rationing'. This may arise because a company is seen as too risky by potential investors, for example, because its level of gearing is so high that it is believed it may struggle to deliver adequate returns on invested funds.

Hard capital rationing could also arise if a company wants to raise debt finance for investment purposes, but lacks sufficient assets to offer as security, leading again to a risk-related problem. During a time of financial crisis, investors may seek to reduce risk by limiting the amount of funds they are prepared to invest and by choosing to invest only in low-risk projects. It is also true to say that companies could struggle to secure investment when the capital markets are depressed, or when economic prospects are poor, for example, during a recession.

If investment funds are limited for reasons within a company, the term 'soft capital rationing' is used. Investing in all projects with a positive net present value could mean that a company increases in size quite dramatically, which incumbent managers and directors may wish to avoid in favour of a strategy of controlled growth, limiting the investment finance available as a consequence. Managers and directors may limit investment finance in order to avoid some consequences of external financing, such as an increased commitment to fixed interest payments if new debt finance were raised, or potential dilution of earnings per share if new equity finance were raised, whether from existing or new shareholders.

Investment finance may also be limited internally in order to require investment projects to compete with each other for funds. Only robust investment projects will gain access to funds, it is argued, while marginal projects with low net present values will be rejected. In this way, companies can increase the likelihood of taking on investment projects which will actually produce positive net present values when they are undertaken, reducing the uncertainty associated with making investment decisions based on financial forecasts.

160 Pinks Co

Marking scheme

			Marks
(ai)	Sales nominal	1	
	Variable costs nominal	1	
	Fixed costs nominal	1	
	Tax liabilities	1	
	TAD	1	
	TAD benefits	1	
	Tax timing	1	
	PVs and nominal NPV	1	
			8
(aii)	Real cash flow before tax	1	
	Tax treatment	1	
	Present values and real NPV	1	
	Comment	1	
			4
(b)	First way	2	
	Second way	2	
	Third way	2	
	Fourth way	2	
			8
			20

(a) (i) Nominal terms appraisal of the investment project

Year	1	2	3	4
	$000	$000	$000	$000
Sales revenue	39,375	58,765	85,087	32,089
Variable cost	(22,047)	(31,185)	(41,328)	(17,923)
Contribution	17,328	27,580	43,759	14,166
Fixed costs	(3,180)	(3,483)	(3,811)	(3,787)
Cash flows before tax	14,148	24,097	39,948	10,379
Tax at 26%	(3,679)	(6,265)		
	(10,387)	(2,699)		
TAD benefits	1,300	975	731	2,194
Cash flows after tax	11,769	18,807	30,292	9,874
Discount at 12%	0.893	0.797	0.712	0.636
Present values	10,510	14,989	21,568	6,280

	$000
Sum of PVs of future cash flows	53,347
Initial investment	20,000
NPV	33,347

Workings

Year	1	2	3	4
Selling price ($/unit)	125	130	140	120
Inflated by 5%/year	131.25	143.33	162.07	145.86
Sales volume (units/year)	300,000	410,000	525,000	220,000
Sales revenue ($000/year)	39,375	58,765	85,087	32,089
Variable cost ($/unit)	71	71	71	71
Inflated by 3.5%/year	73.49	76.06	78.72	81.47
Sales volume(units/year)	300,000	410,000	525,000	220,000
Variable cost ($000/year)	22,047	31,185	41,328	17,923
Fixed costs ($000/year)	3,000	3,100	3,200	3,000
Inflated by 6%/year	3,180	3,483	3,811	3,787
TAD ($000)	5,000	3,750	2,813	8,437
TAD benefits ($000)	1,300	975	731	2,194

Time	1	2	3	4
	$000	$000	$000	$000
Nominal cash flows after tax	11,769	18,807	30,292	9,874
deflated at 3.7% pa (W1)	0.964	0.930	0.897	0.865
Real cash flows after tax	11,345	17,491	27,172	8,541
Discount at real rate 8%	0.926	0.857	0.794	0.735
Present value	10,505	14,990	21,575	6,278

	$000
Sum of the PV of cash inflows	53,348
Investment outlay	(20,000)
NPV	33,348

Comment

The two approaches give the same outcome (there is a small rounding difference).

The first approach has higher cash flows due to inflation, and a higher cost of capital due to inflation. The second approach strips the general rate of inflation out of both the cash flows and the cost of capital and therefor has no impact on the NPV.

Workings

The deflation factors are calculated as $(1 + 0.0.37)^{-n}$, where n is the time period.

(b) The achievement of stakeholder objectives by managers can be encouraged by managerial reward schemes, for example, share option schemes and performance-related pay (PRP), and by regulatory requirements, such as corporate governance codes of best practice and stock exchange listing regulations.

Share option schemes

The agency problem arises due to the separation of ownership and control, and managers pursuing their own objectives, rather than the objectives of shareholders, specifically the objective of maximising shareholder wealth. Managers can be encouraged to achieve stakeholder objectives by bringing their own objectives more in line with the objectives of stakeholders such as shareholders. This increased goal congruence can be achieved by turning the managers into shareholders through share option schemes, although the criteria by which shares are awarded need very careful consideration.

Performance-related pay

Part of the remuneration of managers can be made conditional upon their achieving specified performance targets, so that achieving these performance targets assists in achieving stakeholder objectives. Achieving a specified increase in earnings per share, for example, could be consistent with the objective of maximising shareholder wealth. Achieving a specified improvement in the quality of emissions could be consistent with a government objective of meeting international environmental targets. However, PRP performance objectives need very careful consideration if they are to be effective in encouraging managers to achieve stakeholder targets. In recent times, long-term incentive plans (LTIPs) have been accepted as more effective than PRP, especially where a company's performance is benchmarked against that of its competitors.

Corporate governance codes of best practice

Codes of best practice have developed over time into recognised methods of encouraging managers to achieve stakeholder objectives, applying best practice to many key areas of corporate governance relating to executive remuneration, risk assessment and risk management, auditing, internal control, executive responsibility and board accountability. Codes of best practice have emphasised and supported the key role played by non-executive directors in supporting independent judgement and in following the spirit of corporate governance regulations.

Stock exchange listing regulations

These regulations seek to ensure a fair and efficient market for trading company securities such as shares and loan notes. They encourage disclosure of price-sensitive information in supporting pricing efficiency and help to decrease information asymmetry, one of the causes of the agency problem between shareholders and managers. Decreasing information asymmetry encourages managers to achieve stakeholder objectives as the quality and quantity of information available to stakeholders gives them a clearer picture of the extent to which managers are attending to their objectives.

Monitoring

One theoretical way of encouraging managers to achieve stakeholder objectives is to reduce information asymmetry by monitoring the decisions and performance of managers. One form of monitoring is auditing the financial statements of a company to confirm the quality and validity of the information provided to stakeholders.

Note. Only four ways to encourage the achievement of stakeholder objectives were required to be discussed.

161 Copper Co

Marking scheme

				Marks	Marks
(a)	(i)	Initial present values	1		
		Total present values	2		
		Joint probability analysis (3 sets)	3		
		Expected NPV	2		
				8	
	(ii)	Negative NPV probability		1	
				Marks	
	(iii)	Most likely NPV		1	
	(iv)	Comment on expected NPV	1		
		Comment on risk	1	2	
(b)		First method	4		
		Second method	4		
				8	
				20	

(a) (i) **Expected NPV (ENPV) calculation**

Year	PV of Y1 (see workings) $'000	Prob	PV of Y2 (see workings) $'000	Prob	Total PV $'000	Joint prob	PV × JP $'000	NPV $'000
PV scenario 1	893	0.1	1,594	0.3	2,487	0.03	74.6	(1,013)
			2,391	0.6	3,284	0.06	197.0	(216)
			3,985	0.1	4,878	0.01	48.8	1,378
PV scenario 2	1,786	0.5	1,594	0.3	3,380	0.15	507.0	(120)
			2,391	0.6	4,177	0.30	1,253	1,677
			3,985	0.1	5,771	0.05	288.6	2,271
PV scenario 3	2,679	0.4	1,594	0.3	4,273	0.12	512.8	773
			2,391	0.6	5,070	0.24	1,216.8	1,570
			3,985	0.1	6,664	0.04	266.6	3,164
						Sum of PV		4,365
						Investment		(3,500)
						ENPV =		865

Workings

Discounting at 12%; discount factor time 1 = 0.893, time 2 = 0.797

Time	1	PV	2	PV
Low cash flow	1,000	893	2,000	1,594
Medium cash flow	2,000	1,786	3,000	2,391
High cash flow	3,000	2,679	5,000	3,985

Joint probabilities are calculated by multiplying the probabilities in year 1 and year 2 eg the first joint probability shown of 0.03 is calculated as 0.1 (year 1) × 0.3 (year 2).

(ii) Sum of joint probabilities with negative NPVs = 0.03 + 0.06 + 0.15 = 0.24 or 24%.

(iii) The outcome with the highest joint probability (0.30) has a present value of $4,177 – $3,500 = ($000) 677.0.

(iv) The mean (expected) NPV is positive and so it might be thought that the proposed investment is financially acceptable. However, the mean (expected) NPV is not a value expected to occur because of undertaking the proposed investment, but a mean value from undertaking the proposed investment many times. There is no clear decision rule associated with the mean (expected) NPV.

A decision on financial acceptability must also consider the risk (probability) of a negative NPV being generated by the investment. At 24%, this might appear too high a risk to be acceptable. The risk preferences of the directors of Copper Co will inform the decision on financial acceptability; there is no clear decision rule to be followed here.

(b) **Simulation**

Simulation is a computer-based method of evaluating an investment project whereby the probability distributions associated with individual project variables and interdependencies between project variables are incorporated.

Random numbers are assigned to a range of different values of a project variable to reflect its probability distribution; inevitably this involves a degree of subjectivity. Each simulation run randomly selects values of project variables using random numbers and calculates a mean (expected) NPV.

A picture of the probability distribution of the mean (expected) NPV is built up from the results of repeated simulation runs. The project risk can be assessed from this probability distribution as the standard deviation of the expected returns, together with the most likely outcome and the probability of a negative NPV.

Adjusted (discounted) payback

Discounted payback adjusts for risk in investment appraisal in that risk is reflected by the discount rate employed. Discounted payback can therefore be seen as an adjusted payback method.

The (discounted) payback period can be shortened to increase the emphasis on cash flows which are nearer to the present time and hence less uncertain. A weakness of this approach is that it does not consider cash flows that lie outside the payback period.

Risk-adjusted discount rates

The risk associated with an investment project can be incorporated into the discount rate as a risk premium over the risk-free rate of return. The risk premium can be determined on a subjective basis, for example, by recognising that launching a new product is intrinsically riskier than replacing an existing machine or a small expansion of existing operations.

The risk premium can be determined theoretically by using the capital asset pricing model in an investment appraisal context. A proxy company equity beta can be ungeared and the resulting asset can be regeared to reflect the financial risk of the investing company, giving a project-specific equity beta which can be used to find a project-specific cost of equity or a project-specific discount rate.

(Examiner note: Only two methods were required to be discussed.)

162 Uftin Co

Marking scheme

			Marks
(a)	Sales revenue	1	
	Inflated sales revenue	1	
	Inflated variable costs	1	
	Inflated fixed costs	1	
	Excluding interest payments	1	
	Tax-allowable depreciation	1	
	Balancing allowance	1	
			Marks
	Tax liabilities	1	
	Timing of tax liabilities	1	
	Net present value	1	
	Comment on financial acceptability	1	
			11
(b)	Explanation of first revision	1–3	
	Explanation of second revision	1–3	
		Maximum	4
(c)	Discussion of two methods, 2–3 marks per method	Maximum	5
			20

(a) As inflation rates differ for revenue and cost, nominal cash flows (ie including inflation) need to be calculated and discounted at the nominal rate (also including inflation).

		0	1	2	3	4	5
			$'000	$'000	$'000	$'000	$'000
Revenue	W1		2,474.8	2,714.0	4,413.0	4,774.5	
Variable cost	W2		(1,097.3)	(1,323.0)	(2,083.5)	(2,370.0)	
Fixed cost	W3		(154.5)	(159.1)	(163.9)	(168.8)	
Before-tax cash flows			1,223.0	1,231.9	2,165.6	2,235.7	
Taxation at 22%				(269.1)	(271.0)	(476.4)	(491.9)
Investment		(1,800.0)					
TAD	W4			99.0	74.3	55.7	167.1
Net cash flow		(1,800.0)	1,223.0	1,061.8	1,968.9	1,815.0	(324.9)
12% discount factor (tables)		1.0	0.893	0.797	0.712	0.636	0.567
Present value		(1,800.0)	1,092.1	846.3	1,401.9	1,154.3	(184.2)

NPV = total of the present value line = $2,510.4k. As this is positive, the proposal is financially acceptable and should go ahead.

Workings

1 *Revenue*

	1	2	3	4
Price (Current terms) ($)	25	25	26	27
Inflation factor	× (1.042)	× (1.042)2	× (1.042)3	× (1.042)4
Inflated price ($)	= 26.05	= 27.14	= 29.42	= 31.83
× Volume (units)	95,000	100,000	150,000	150,000
= Nominal sales ($)	2,474,750	2,714,000	4,413,000	4,774,500

2 *Variable cost*

	1	2	3	4
Unit cost (current terms) ($)	11	12	12	13
Inflation factor	× (1.05)	× (1.05)2	× (1.05)3	× (1.05)4
Inflated price	= 11.55	= 13.23	= 13.89	= 15.80
× Volume (units)	95,000	100,000	150,000	150,000
= Nominal variable cost ($)	1,097,250	1,323,000	2,083,500	2,370,000

3 *Fixed cost ($000s): need to be adjusted for inflation*

	1	2	3	4
Fixed cost	150	154.5	159.1	163.9
× Inflation factor	× 1.03	× 1.03	× 1.03	× 1.03
= Nominal fixed cost ($)	154.5	159.1	163.9	168.8

4

	Tax-allowable depreciation	$000	*Tax benefits*	$ 000	*Year*
1	1,800,000 × 0.25 =	450	450 × 0.22 =	99.0	2
2	450,000 × 0.75 =	337.5	337.5 × 0.22 =	74.3	3
3	337,500 × 0.75 =	253.125	253.125 × 0.22 =	55.7	4
4	By difference	759.375	759.375 × 0.22 =	167.1	5
		1,800			

(b) You could have chosen any **two** of the following revisions.

Inflation

Real cash flows (cash flows in current prices) should be discounted at a real discount rate and nominal cash flows should be discounted at a nominal discount rate. The junior has correctly applied one year of inflation in Year 1, but incorrectly applied one year of inflation in each of Years 2 to 4. The inflation in Year 2 should be × (1 + h)2 and in Year 3 should be (1 + h)3 and so on.

Interest payments

Interest repayments on the loan should not be included as these are dealt with via the cost of capital.

Tax-allowable depreciation

Tax-allowable depreciation is calculated on a reducing balance basis and not a straight-line basis as the junior employee has done. There is also a balancing allowance in the final year.

The dates should correspond with the tax payments, so should be received a year in arrears.

Tax timing

The tax liability due in Year 5 was omitted. This is a cash flow which is relevant to the proposal and should therefore be included.

(c) Note. Only two methods are required to be discussed.

Risk and uncertainty

A distinction should be made between the terms risk and uncertainty. Risk can be applied to a situation where there are several possible outcomes and, on the basis of past relevant experience, probabilities can be assigned to the various outcomes that could prevail. Uncertainty can be applied to a situation where there are several possible outcomes but there is little past relevant experience to enable the probability of the possible outcomes to be predicted.

There are a wide range of techniques for incorporating risk into project appraisal.

Probability analysis

Probability analysis involves assigning probabilities to either the outcome of an investment project or different values of variables in a project. The range of NPVs and their associated joint probabilities can be used to calculate an expected NPV which would arise if the project was repeated a number of times. This analysis can also show worst and best case scenario results and their associated probabilities. It can also show the most and least likely outcomes. This would allow managers to consider the risk profile of the project before making a decision.

Risk-adjusted discount rate

In investment appraisal, a risk-adjusted discount rate can be used for particular types or risk classes of investment projects to reflect their relative risks. For example, a high discount rate can be used so that a cash flow which occurs quite some time in the future will have less effect on the decision. Alternatively, with the launch of a new product, a higher initial risk premium may be used with a decrease in the discount rate as the product becomes established.

Sensitivity analysis

The basic approach of sensitivity analysis is to calculate the project's NPV under alternative assumptions to determine how sensitive it is to changing conditions. One variable is considered at a time. An indication is thus provided of those variables to which the NPV is most sensitive (critical variables) and the extent to which those variables may change before the investment results in a negative NPV. Sensitivity analysis therefore provides an indication of why a project might fail.

Management should review critical variables to assess whether or not there is a strong possibility of events occurring which will lead to a negative NPV. As sensitivity analysis does not incorporate probabilities it should not be described as a way of incorporating risk into investment appraisal, although it often is.

163 Hraxin Co

Workbook references. Net present value (NPV) is covered in Chapters 5 and 6. Risk and sensitivity analysis are covered in Chapter 7.

Top tips. As usual, you need to lay out a proforma for the expected net present value (ENPV) calculation in part (a) and show your workings underneath. The main tasks are to deal with the expected selling price, the inflation and the tax-allowable depreciation. Remember that nominal values include inflation already so don't need to be inflated. In part (c) you must explain that sensitivity analysis considers the relative change required in a variable to make the NPV zero.

Easy marks. Part (a) is full of easy calculation marks!

Examining team's comments. The examining team stated that most answers to (a) gained good marks. Although the question stated that tax liabilities were paid in the year they arose, some answers incorrectly deferred the tax liabilities by one year. Many answers stated that the NPV was positive and therefore the project was financially acceptable. This ignores the fact that the ENPV is an average NPV which is not expected to occur in practice. For part (c) the examining team stated that many answers were not able to gain high marks. Many answers attempted to calculate sensitivities but the question asked for a discussion.

(a)		**Marks**
	Mean selling price per unit	0.5
	Inflated selling price per unit	1
	Inflated revenue	1
	Inflated overhead	1
	Tax liabilities	1
	Timing of tax liabilities	1
	Tax-allowable depreciation benefits	1
	Scrap value	0.5
	Present values of future cash flows	1
	Comment on financial acceptability	1
		9
(b)	Discussion of risk and uncertainty distinction	3
	Value of considering risk and uncertainty	2
		5
(c)	Explanation of sensitivity analysis	1–3
	Explanation of risk in investment appraisal	1–2
	Discussion of sensitivity analysis and risk	1–3
	Maximum	6
		20

(a) **Calculation of expected NPV year**

Year	1	2	3	4
	$'000	$'000	$'000	$'000
Revenue	4,524	7,843	13,048	10,179
Variable cost	(2,385)	(4,200)	(7,080)	(5,730)
Contribution	2,139	3,643	5,968	4,449
Overhead	(440)	(484)	(532)	(586)
Cash flow before tax	1,699	3,159	5,436	3,863
Tax	(510)	(948)	(1,631)	(1,159)
Depreciation benefits	338	338	338	338
Cash flow after tax	1,527	2,549	4,143	3,042
Scrap value				500
Project cash flow	1,527	2,549	4,143	3,542
Discount at 11%	0.901	0.812	0.731	0.659
Present values	1,376	2,070	3,029	2,334

	$'000
PV of future cash flows	8,809
Initial investment	(5,000)
ENPV	3,809

The investment project has a positive ENPV of $3,809,000. This is a mean or average NPV which will result from the project being repeated many times. However, as the project is not being repeated, the NPVs associated with each future economic state must be calculated as it is one of these NPVs which is expected to occur. The decision by management on the financial acceptability of the project will be based on these NPVs and the risk associated with each one.

Workings

Mean or average selling price = (25 × 0.35) + (30 × 0.5) + (35 × 0.15) = $29 per unit

Year	1	2	3	4
Inflated selling price ($ per unit)	30.16	31.37	32.62	33.93
Sales volume (units/year)	150,000	250,000	400,000	300,000
Sales revenue ($'000/year)	4,524	7,843	13,048	10,179

Year	1	2	3	4
Inflated overhead ($'000/year)	440	484	532	586

Total tax-allowable depreciation = 5,000,000 – 500,000 = $4,500,000
Annual tax-allowable depreciation = 4,500,000/4 = $1,125,000 per year
Annual cash flow from tax-allowable depreciation = 1,125,000 × 0.3 = $337,500 per year

(b) A project's potential NPV is **one** important piece of management information because it quantifies the expected **return**. However, this return is based on a forecast and is not guaranteed so before a project is accepted the potential **risk or uncertainty** of a project should be assessed.

The terms **risk** and **uncertainty** are often used interchangeably but a distinction should be made between them. With risk, there are **several possible outcomes** which, upon the basis of past relevant experience, can be **quantified**. In areas of uncertainty, again there are several possible outcomes but, with little past experience, it will be **difficult to quantify** its likely effects.

A risky situation is one where we can say that there is a 70% probability that returns from a project will be in excess of $100,000 but a 30% probability that returns will be less than $100,000. If, however, no information can be provided on the returns from the project, we are faced with an uncertain situation. Managers need to exercise caution when assessing future cash flows to ensure that they make appropriate decisions. If a project is too risky, it might need to be rejected, depending upon the prevailing **attitude to risk**.

In general, risky projects are those whose future cash flows, and hence the project returns, are likely to be **variable**. The greater the variability is, the greater the risk. The problem of risk is more acute with capital investment decisions than other decisions because estimates of cash flows might be for several years ahead, such as for major construction projects. Actual costs and revenues may vary well above or below budget as the work progresses.

(c) Sensitivity analysis assesses the extent to which the NPV of an investment project responds to changes in project variables. Sensitivity analysis will normally involve identifying key project variables and determining the percentage change in a project variable which results in a zero NPV. The critical project variables are identified as those to which the NPV is most sensitive, for example, ie those where the smallest percentage change in the variable results in a zero NPV. Sensitivity analysis is therefore concerned with calculating relative changes in project variables.

When discussing risk in the context of investment appraisal, it is important to note that, unlike uncertainty, risk can be quantified and measured. The probabilities of the occurrence of particular future outcomes can be assessed and used to evaluate the volatility of future cash flows, for example, by calculating their standard deviation. The probabilities of the future economic states in the assessment of the investment project of Hraxin Co are an example of probability analysis and these probabilities can lead to an assessment of project risk.

Sensitivity analysis is usually studied in investment appraisal in relation to understanding how risk can be incorporated in the investment appraisal process. While sensitivity analysis can indicate the critical variables of an investment project, sensitivity analysis does not give any indication of the probability of a change in any critical variable. Selling price (or energy prices) may be a critical variable, for example, but sensitivity analysis is not able to say whether a change in selling price is likely to occur. In the appraisal of the investment project of Hraxin Co, the probabilities of different selling prices arising from the related economic states have come from probability analysis, not from sensitivity analysis.

Sensitivity analysis will not therefore directly assist Hraxin Co in assessing the risk of the investment project. However, it does provide useful information which helps management to gain a deeper understanding of the project and which focuses management attention on aspects of the investment project where problems may arise.

BPP
LEARNING
MEDIA

164 Vyxyn Co

Marking scheme

		Marks	
(a)	Explain risk	1	
	Explain uncertainty	1	
	Discuss difference	1	
			3
(b)	Inflated revenue	1	
	Mean variable cost	1	
	Inflated variable cost	1	
	Tax liabilities	1	
	TAD benefits	1	
	Timing of tax flows	1	
	Calculation of PVs	1	
	Comment on variable cost	1	
	Comment on NPV	1	
			9
(c)	Sensitivity analysis	2	
	Probability analysis	2	
	Risk-adjusted rate	2	
	Adjusted payback	2	
			8
			20

(a) The terms risk and uncertainty are often used interchangeably in everyday discussion, however, there is a clear difference between them in relation to investment appraisal.

Risk refers to the situation where an investment project has several possible outcomes, all of which are known and to which probabilities can be attached, for example, on the basis of past experience. Risk can therefore be quantified and measured by the variability of returns of an investment project.

Uncertainty refers to the situation where an investment project has several possible outcomes but it is not possible to assign probabilities to their occurrence. It is therefore not possible to say which outcomes are likely to occur.

The difference between risk and uncertainty, therefore, is that risk can be quantified whereas uncertainty cannot be quantified. Risk increases with the variability of returns, while uncertainty increases with project life.

(b) **NPV calculation**

Year	1 $'000	2 $'000	3 $'000	4 $'000	5 $'000
Sales income	12,069	16,791	23,947	11,936	
Variable cost	(5,491)	(7,139)	(9,720)	(5,616)	
Contribution	6,578	9,652	14,227	6,320	
Fixed cost	(1,100)	(1,121)	(1,155)	(1,200)	
Taxable cash flow	5,478	8,531	13,072	5,120	
Taxation at 28%		(1,534)	(2,389)	(3,660)	(1,434)
TAD tax benefits		1,400	1,050	788	2,362
After-tax cash flow	5,478	8,397	11,733	2,248	928
Discount at 10%	0.909	0.826	0.751	0.683	0.621
Present values	4,980	6,936	8,812	1,535	576

	$'000
PV of future cash flows	22,839
Initial investment	(20,000)
NPV	2,839

Comment

The probability that variable cost per unit will be $12.00 per unit or less is 80% and so the probability of a positive NPV is therefore at least 80%. However, the effect on the NPV of the variable cost per unit increasing to $14.70 per unit must be investigated, as this may result in a negative NPV.

The expected NPV is positive and so the investment project is likely to be acceptable on financial grounds.

Workings

Sales revenue

Year	1	2	3	4
Selling price ($/unit)	26.50	28.50	30.00	26.00
Inflated at 3.5% per year	27.43	30.53	33.26	29.84
Sales volume (000 units/year)	440	550	720	400
Sales income ($000/yearl	12,069	16,791	23,947	11,936

Variable cost

Mean variable cost= (0.45 × 10.80) + (0.35 × 12.00) + (0.20 × 14.70) = $12.00/unit

Year	1	2	3	4
Variable cost ($/unit)	12.00	12.00	12.00	12.00
Inflated at 4% per year	12.48	12.98	13.50	14.04
Sales volume (000 units/year)	440	550	720	400
Variable cost ($000/year)	5,491	7,139	9,720	5,616

Year	1	2	3	4
TAD ($000)	5,000	3,750	2,813	8,437
Tax benefits at 28% ($000)	1,400	1,050	788	2,362*

*(20,000 × 0.28) – 1,400 – 1,050 – 788 = $2,362,000

BPP
LEARNING
MEDIA

Alternative calculation of after-tax cash flow

Year	1	2	3	4	5
	$'000	$'000	$'000	$'000	$'000
Taxable cash flow	5,478	8,531	13,072	5,120	
TAD ($000)	(5,000)	(3,750)	(2,813)	(8,437)	
Taxable profit	478	4,781	10,259	(3,317)	
Taxation at 28%		(134)	(1,339)	(2,873)	929
After-tax profit	478	4,647	8,920	(6,190)	929
Add back TAD	5,000	3,750	2,813	8,437	
After-tax cash flow	5,478	8,397	11,733	2,247	929

(c) There are several ways of considering risk in the investment appraisal process.

Sensitivity analysis

This technique looks at the effect on the NPV of an investment project of changes in project variables, such as selling price per unit, variable cost per unit and sales volume. There are two approaches which are used. The first approach calculates the relative (percentage) change in a given project variable which is needed to make the NPV zero. The second approach calculates the relative (percentage) change in project NPV which results from a given change in the value of a project variable (for example, 5%).

Sensitivity analysis considers each project variable individually. Once the sensitivities for each project variable have been calculated, the next step is to identify the key or critical variables. These are the project variables where the smallest relative change makes the NPV zero, or where the biggest change in NPV results from a given change in the value of a project variable. The key or critical project variables indicate where underlying assumptions may need to be checked or where managers may need to focus their attention in order to make an investment project successful. However, as sensitivity analysis does not consider risk as measured by probabilities, it can be argued that it is not really a way of considering risk in investment appraisal at all, even though it is often described as such.

Probability analysis

This technique requires that probabilities for each project outcome be assessed and assigned. Alternatively, probabilities for different values of project variables can be assessed and assigned. A range of project NPVs can then be calculated, as well as the mean NPV (the expected NPV or ENPV) associated with repeating the investment project many times. The worst and best outcomes and their probabilities, the most likely outcome and its probability and the probability of a negative NPV can also be calculated. Investment decisions could then be based on the risk profile of the investment project, rather than simply on the NPV decision rule.

Risk-adjusted discount rate

It is often said that 'the higher the risk, the higher the return'. Investment projects with higher risk should therefore be discounted with a higher discount rate than lower risk investment projects. Better still, the discount rate should reflect the risk of the investment project.

Theoretically, the capital asset pricing model (CAPM) can be used to determine a project-specific discount rate which reflects an investment project's systematic risk. This means selecting a proxy company with similar business activities to a proposed investment project, ungearing the proxy company equity beta to give an asset beta which does not reflect the proxy company financial risk, regearing the asset beta to give an equity beta which reflects the financial risk of the investing company, and using the CAPM to calculate a project-specific cost of equity for the investment project.

Adjusted payback

If uncertainty and risk are seen as being the same, payback can consider risk by shortening the payback period. Because uncertainty (risk) increases with project life, shortening the payback period will require a risky project to pay back sooner, thereby focusing on cash flows which are nearer in time (less uncertain) and so less risky.

Discounted payback can also be seen as considering risk because future cash flows can be converted into present values using a risk-adjusted discount rate. The target payback period normally used by a company can then be applied to the discounted cash flows. Overall, the effect is likely to be similar to shortening the payback period with undiscounted cash flows.

165 Pelta Co

Workbook references. This question spans a number of investment appraisal topics, which are covered in chapters 5-8.

Top tips. Read the question carefully to ensure that you do not over-complicate it. For example even thought the question clearly says that the project extends beyond four years, the question later says that the directors only want an evaluation over a four year period.

Easy marks. There are many easy marks available here, but as ever the discussion areas should (if related to the scenario) be a relatively easy source of marks.

Examining team's comments. In part (b), stand alone comments such as 'accept' or 'positive NPV' should be explained.

In part (c), a critical discussion should look at a viewpoint or statement in more than one way.

Marking scheme

				Marks
(a)	(i)	Inflated sales	1	
		Inflated VC/unit	1	
		Inflated total VC	1	
		Tax liabilities	1	
		TAD benefits yrs 1–3	1	
		TAD benefits yr 4	1	
		Timing of tax flows	1	
		Terminal value	1	
		Calculate PVs	1	
				9
	(ii)	Cumulative NPV	1	
		Discounted payback	1	
				2
(b)		Acceptability – NPV	1	
		Acceptability – Payback	1	
		Correct advice	1	
				3
(c)		Evaluation period	2	
		Terminal value	2	
		Discounted payback	2	
				6
				20

(a) (i)

Year	1	2	3	4	5
	$'000	$'000	$'000	$'000	$'000
Sales income	16,224	20,248	24,196	27,655	
Variable costs	(5,356)	(6,752)	(8,313)	(9,694)	
Contribution	10,868	13,495	15,883	17,962	
Fixed costs	(700)	(735)	(779)	(841)	
Cash flows before tax	10,168	12,760	15,104	17,121	
Corporation tax		(3,050)	(3,828)	(4,531)	(5,136)
TAD tax benefits		1,875	1,406	1,055	2,789
After-tax cash flow	10,168	11,585	12,682	13,644	(2,347)
Terminal value				1,250	
Project cash flow	10,168	11,585	12,682	14,894	(2,347)
Discount at 12%	0.893	0.797	0.712	0.636	0.567
Present values	9,080	9,233	9,030	9,473	(1,331)
PV of future cash flows ($000)		35,485			
Initial investment ($000)		(25,000)			
NPV		10,485			

Workings

Year	1	2	3	4
Sales volume (units/year)	520,000	624,000	717,000	788,000
Selling price ($/unit)	30.00	30.00	30.00	30.00
Inflated by 4% per year	31.20	32.45	33.75	35.10
Income ($000/year)	16,224	20,248	24,196	27,655

Year	1	2	3	4
Sales volume (units/year)	520,000	624,000	717,000	788,000
Variable cost ($/unit)	10.00	10.20	10.61	10.93
Inflated by 3% per year	10.30	10.82	11.59	12.30
Total ($000/year)	5,356	6,752	8,313	9,694

Year	1	2	3	4
Fixed costs ($000 per year)	700	735	779	841

Year	1	2	3	4
TAD ($000 per year)	6,250	4,688	3,516	9,297
TAD benefits ($000/year)	1,875	1,406	1,055	2,789

(ii)

Year	1	2	3	4	5
	$000	$000	$000	$000	$00
Present values	9,080	9,233	9,030	9,473	(1,33
Cumulative net present value	(15,920)	(6,687)	2,343	11,815	10,485
Discounted payback (years)					

Discounted payback occurs approximately
74% (6,687/9,030) through the third year ie the discounted payback period is about
2.7 years.

(b) The investment project is financially acceptable under the NPV decision rule because it has a substantial positive NPV.

The discounted payback period of 2.7 years is greater than the maximum target discounted payback period of two years and so from this perspective the investment project Is not financially acceptable.

The correct advice is given by the NPV method, however, and so the investment project is financially acceptable.

(c) The views of the directors on investment appraisal can be discussed from several perspectives.

Evaluation period

Sales are expected to continue beyond year 4 and so the view of the directors that all investment projects must be evaluated over four years of operations does not seem sensible. The investment appraisal would be more accurate if the cash flows from further years of operation were considered.

Assumed terminal value

The view of the directors that a terminal value of 5% of the initial investment should be assumed has no factual or analytical basis to it. Terminal values for individual projects could be higher or lower than 5% of the initial investment and in fact may have no relationship to the initial investment at all.

A more accurate approach would be to calculate a year 4 terminal value based on the expected value of future sales.

Discounted payback method

The directors need to explain their view that an investment projects discounted payback must be no greater than two years. Perhaps they think that an earlier payback will indicate an investment project with a lower level of risk. Although the discounted payback method does overcome the failure of simple payback to take account of the time value of money, it still fails to consider cash flows outside the payback period. Theoretically, Pelta Co should rely on the NPV investment appraisal method.

OTQ bank – Sources of finance

166 The correct answer is: **Statements 1 & 3 are true. Statement 2 is false.**

Convertible bonds give the **investor**, not the borrower, the right but not the obligation to turn the bond into a predetermined number of ordinary shares.

<div align="right">Syllabus area E1(a)</div>

167 The correct answer is:

Preference share capital	2
Trade payables	3
Bank loan with fixed and floating charges	4
Ordinary share capital	1

Ordinary shares are most risky from the debt holder's perspective – the company can decide whether and how much of a dividend to pay.

Preference shares are next most risky – dividends are only payable if profit is available to pay dividends from.

Trade payables are next because they have to be paid before shareholders but are typically unsecured.

Finally, **banks** with fixed and floating charges face least risk.

<div align="right">Syllabus area E1(b)</div>

168 The correct answer is: **$1.92**

$2	×	4	=	$8.00
$1.60	×	1	=	$1.60
		5		$9.60

Theoretical ex-rights price = $9.60/5 = $1.92

<div align="right">Syllabus area E1(c)</div>

169 The correct answer is: **Annual interest received as a percentage of the nominal value of the bond**

First statement describes the redemption yield.

Third statement describes the interest yield.

Fourth statement is incorrect.

<div align="right">Syllabus area E1(b)</div>

170 The correct answer is: **A bond in Islamic finance where the lender owns the underlying asset and shares in the risks and rewards of ownership**

A key principle is that charging interest and making money from money lending alone is forbidden under Sharia law, so providers of finance are more directly involved with the risks and rewards of the businesses they finance.

Statement 2 is mudaraba.

Statement 3 is murabaha.

Statement 4 is ijara.

<div align="right">Syllabus area E1(d)</div>

OTQ bank – Dividend policy

171 The correct answer is: **No taxes or tax preferences and no transaction costs**

Modigliani and Miller (M&M) assume **perfect** capital markets so there is no information content in dividend policy. They assume no taxes or tax preferences so investors will be indifferent between income and capital gains. They also assume no transaction costs so investors can switch between income and capital gains without cost – eg if a company withholds a dividend when the investor would prefer cash, the investor can sell some of their shares (known as 'manufacturing a dividend'). M&M's theory is not contingent upon the existence or otherwise of inflation.

Syllabus area E1(e)

172 The correct answer is: **A small listed company owned by investors seeking maximum capital growth on their investment**

A residual dividend will not give a reliable income stream, and is geared to financing investments that will give capital gains.

Syllabus area E1(e)

173 The correct answer is: **Investors selling some shares to realise some capital gain**

M&M stated that income preference is irrelevant in deciding dividend policy because, if you 'assume away' taxation and transaction costs, it is costless for investors to switch from capital gain to dividends by selling some shares.

Syllabus area E1(e)

174 The correct answer is: **The second statement is true**

By reducing the number of shares in issue, the company can increase the earnings per share. This allows debt to be substituted for equity so gearing is raised.

First statement is **false**. A bonus issue is when a company offers free additional shares to existing shareholders. Therefore, it does not raise new equity finance.

Third statement is **false**. In a zero tax world neither the dividend decision nor the financing decision matters (according to Modigliani & Miller theory). Where tax does exist, both decisions are important.

Fourth statement is **false**. Shareholders are entitled to receive a share of any agreed dividends but directors decide on the amount and frequency of dividend payments (if any).

Syllabus area E1(e)

175 The correct answer is:

Company Sun Co = Constant growth.
Company Moon Co = Constant payout.
Company Nite Co = Residual/random.

Company Sun Co dividends are growing at 10% per year even though earnings are not.

Company Moon Co is paying 50% of its earnings out as a dividend consistently.

Company Nite Co's dividends are not obviously connected with reported earnings, so its policy is either residual (ie only paying dividends once investment plans are budgeted for) or random.

Syllabus area E1(e)

OTQ bank – Gearing and capital structure

176 The correct answer is: **2.61**

Operational gearing = Contribution/Profit before interest and tax.
Contribution = Revenue – variable cost = 10,123 – (70% × 7,222) – (10% × 999) = 4,967.70
Operational gearing = 4,967.70/1,902 = 2.61

Syllabus area E3(d)

177 The correct answer is: **53%**

Market value of equity = $5.50 × $100m = $550m
Market value of long-term debt = $500m × (125/100) = $625m
Therefore financial gearing = 625/(625 + 550) = 53%

Syllabus area E3(d)

178 The correct answer is: **15.0%**

$$\text{Gearing} = \frac{\text{Prior charge capital}}{\text{Equity}}$$

Market value of preference shares = 2,000 shares × 80c = $1,600.

Prior charge capital = preference shares + bonds + loan.

∴ Prior charge capital = $1,600 + ($4,000 × ($105/$100)) + $6,200
 = $12,000

Market value of equity:

Number of shares = $8,000 ÷ 50c = 16,000 shares

16,000 shares × $5 = $80,000

$$\text{Gearing} = \frac{\$12,000}{\$80,000} \times 100\% = 15.0\%$$

Syllabus area E3(d)

179 The correct answer is: **Interest cover will rise. Gearing will fall.**

All else being equal, less interest to pay will mean a higher interest cover.

(Interest cover = Profit before interest and tax/Interest)

Reducing debt will reduce the gearing ratio.

Syllabus area E3(d)

180 The correct answer is: **P/E ratio will increase. Dividend yield will decrease.**

In relation to expectations, results being better than expected would boost share price. This would increase the price/earnings ratio.

By the same logic, dividend yield would reduce. Dividend yield is calculated as dividend/share price; hence a higher share price would reduce the ratio.

Syllabus area E3(d)

181 The correct answer is: **15.0%**

Market value of equity = $8m × ($5.00/$0.5) = $80m

Market value of bonds = $4m × ($105/$100) = $4.2m

Market value of preference shares = $2m × ($0.80/$1.00) = $1.6m

Prior charge capital = $4.2m + $6.2m (loan) + $1.6m = $12m

Market value based gearing = 100 × ($12m/$80m) = 15.0%

Syllabus area E(5)

182 The correct answer is: **Statement 1 and Statement 2 are true.**

Statement 1. The main handicap that SMEs face in accessing funds is the problem of uncertainty and risk for lenders. This is because they have neither the business history nor the long trade record that larger organisations possess.

Statement 2. Larger enterprises are subject by law to more public scrutiny and their financial statements have to contain more detail and be audited, giving greater clarity to investors than less detailed financial statements of smaller companies.

Statement 3. Once small firms have become established they do not necessarily need to seek a market listing to obtain equity finance. Shares **can** be placed privately.

Syllabus area E5

183 The correct answer is: **Both statements are true.**

Statement 1 is **true**. For long-term loans, security can be provided in the form of property (eg mortgages) but SMEs may not have suitable security for a medium-term loan due to mismatching of the maturity of assets and liabilities. This problem is known as the maturity gap.

Statement 2 is **true**. A funding gap is a shortfall in capital needed to fund the ongoing operations and this is a common problem for SMEs.

<div align="right">Syllabus area E5</div>

184 The correct answer is: **Business angel financing**

This is known as business angel financing. Business angels are prepared to take high risks in the hope of high returns.

<div align="right">Syllabus area E5</div>

185 The correct answer is: **Statement 1 is false, statement 2 is true.**

Statement 1 is **false**. SCF allows a buyer to extend the time in which it settles its accounts payable. For the supplier, it is a sale of their receivables.

Statement 2 is **true**. The buyer is usually a large company with a good credit rating. This means that low interest rates are charged to the supplier by the intermediary fund provider, for providing the supplier with finance, ie in the form of purchasing its invoices.

<div align="right">Syllabus area E5</div>

OTQ bank – The cost of capital

186 The correct answer is: **$1.73**

20X9 to 20Y3 covers four years of growth, so the average annual growth rate = $\sqrt[4]{(423 / 220)} - 1 = 0.178 = 17.8\%$

$$K_e = \frac{d_0(1+g)}{P_0} + g$$

$$K_e - g = \frac{d_0(1+g)}{P_0}$$

$$P_0 = \frac{d_0(1+g)}{K_e - g}$$

$= (423{,}000 \times 1.178)/(0.25 - 0.178) = \$6{,}920{,}750$ for 4 million shares = $1.73 per share

<div align="right">Syllabus area F2(c)</div>

187 The correct answer is: **31%**

Using Gordon's growth approximation, g = br

g = proportion of profits retained × rate of return on investment

Proportion of earnings retained = ($1.50 − $0.5)/$1.50 = 66.7%

Rate of return on investment = EPS/net assets per share = $1.5/$6 = 0.25 so 25%

g = 66.7% × 25% = 16.7%

$$K_e = \frac{d_0(1+g)}{P_0} + g$$

$$= \frac{(\$0.50 \times 1.167)}{(\$4.50 - \$0.50)} + 0.167$$

= 31%

Note. Share price given is cum div.

<div align="right">Syllabus area E2(a)</div>

188 The correct answer is: **The residual risk associated with investing in a well-diversified portfolio**

'The chance that automated processes may fail' is **incorrect**. Systematic risk refers to return volatility, not automated processes.

'The risk associated with investing in equity' is **incorrect**. This describes **total** risk, which has both systematic and unsystematic elements.

'The diversifiable risk associated with investing in equity' is **incorrect**. Systematic risk cannot be diversified away.

'The residual risk associated with investing in a well-diversified portfolio' is **correct**. It is the risk generated by undiversifiable systemic economic risk factors.

Syllabus area E2(a)

189 The correct answer is: **13.4%**

The equity beta relates to the cost of equity, hence gearing and the debt beta are not relevant.

$E(r_i) = R_f + \beta\ (E(R_m) - R_f) = 3\% + (1.3 \times 8\%) = 13.4\%$

Syllabus area E2(a)

190 The correct answers are: **All of the statements are correct.**

Statement 1 is **correct**. An increase in the cost of equity will lead to a fall in share price. Think about the dividend valuation model and how P0 will be affected if Ke increases.

Statement 2 is **correct**. This is known as the risk-return trade-off.

Statement 3 is **correct**. Preference shares are riskier than debt and therefore a more expensive form of finance.

Syllabus area E3(a/b)

191 The correct answer is: **11.5%**

Conversion value: Future share price = current share price including growth = $\$2.50 \times (1.1)^5$ = $4.03.

So conversion value = 20 × $4.03 = $80.60. The cash alternative = 100 × 1.1 = $110 therefore investors would not convert and redemption value = $110.

K_d = IRR of the after-tax cash flows as follows:

Time	$	DF 10%	Present value 10% $	DF 15%	Present value 15% $
0	(90)	1	(90)	1	(90)
1–5	10(1 – 0.3) = 7	3.791	26.54	3.352	23.46
5	110	0.621	68.31	0.497	54.67
			4.85		(11.87)

$$IRR = a + \frac{NPV_a}{NPV_a - NPV_b}\ (b - a)$$

$$= 10\% + \frac{4.85}{(4.85 + 11.87)}\ (15\% - 10\%)$$

$$= 11.5\%$$

Syllabus area E2(b)

192 The correct answer is: **11.7%**

$K_d = i(1 - T)/P_0 = 13(1 - 0.3)/90 = 10.11\%$

$V_d = \$7m \times (90/100) = \$6.3m$

$K_e = 12\%$ (given)

$V_e = \$3 \times 10m$ shares $= \$30m$

Note. Reserves are included as part of share price.

$V_e + V_d = \$6.3m + \$30m = \$36.3m$

$$WACC = \left[\frac{V_e}{V_e + V_d}\right]k_e + \left[\frac{V_d}{V_e + V_d}\right]k_d$$

$$= [30/36.3]12\% \quad + \quad [6.3/36.3]10.11\% \quad = 11.7\%$$

Syllabus area E2(c)

193 The correct answer is: **All statements are true**

Changes in capital structure will affect the WACC so need to stay constant. The current WACC reflects a risk premium relating to current operations, hence the new project should be of a similar risk profile to current operations. The project should be small in size; large projects are both riskier (commanding a risk premium) and likely to affect the value of equity, in turn affecting the WACC.

Syllabus area E3(e)

194 The correct answer is: **8.8%**

Cost of equity $= 4 + (1.2 \times 5) = 4 + 6 = 10\%$

$WACC = (10 \times 0.7) + (6 \times 0.3) = 7 + 1.8 = 8.8\%$

195 The correct answer is: **15.4%**

Ex div share price $= \$0.30 - (8\% \times \$0.50) = \$0.26$

$K_p = \$0.50 \times 8\%/\$0.26 = 15.4\%$

Note. Dividends are not tax deductible hence no adjustment for corporation tax is required.

Syllabus area E2(b)

OTQ bank – Capital structure

196 The correct answer is: **It should take on equity finance, as their gearing is probably beyond optimal.**

'It should take on debt finance, as to do so will save tax' refers to Modigliani-Miller (MM) with tax: raising debt finance will increase interest payments and hence save tax, adding to the total returns a business generates.

'It should take on equity finance, as their gearing is probably beyond optimal' is **correct**: the traditional view implies that once gearing has gone beyond optimal the weighted average cost of capital (WACC) will increase if more debt is taken on. As A Co is significantly more highly geared than the industry standard, it is probably reasonable to assume its gearing is beyond optimal.

'It doesn't matter, as it won't affect the returns the projects generate' refers to MM with no tax: paying interest or paying dividends does not affect the overall returns generated by a non-tax paying business.

'More information is needed before a decision can be made' is **incorrect**: see earlier comments on the traditional view.

Syllabus area E4(a&b)

BPP
LEARNING
MEDIA

197 The correct answer is: **Interest payments are tax deductible.**

'Debt is cheaper than equity': Although true, higher gearing increases the cost of equity (financial risk) therefore this doesn't in itself explain a reducing WACC.

'Interest payments are tax deductible' is **correct**: The only difference between MM (no tax) and MM (with tax) is the tax deductibility of interest payments. MM demonstrated that when a business does not pay tax, returns are not affected by capital structure. However, as interest is tax deductible (and dividends are not), paying relatively more interest will reduce tax payable and increase total returns to investors.

'Reduced levels of expensive equity capital will reduce the WACC' is similar to Statement A.

'Financial risk is not pronounced at moderate borrowing levels' refers to the traditional view. MM assume financial risk is consistently proportionate to gearing across all levels.

Syllabus area E4(b)

198 The correct answer is: **Only statement 2 is correct**

Statement 1 is **incorrect** because the asset beta is an ungeared beta and therefore reflects **only** business risk.

Statement 3 is **incorrect**: An asset beta will be lower than an equity beta. The difference between an asset beta and an equity beta reflects the impact of financial risk. However, this difference (reflecting financial risk) will be **higher** if a debt beta is assumed to be zero.

Syllabus area E3(e)

199 The correct answer is:

Traditional view – Director A

MM (no tax) – Director B

The traditional view has a 'u' shaped weighted average cost of capital (WACC) curve hence there is an optimal point where WACC is minimised.

MM (with tax) assumes 100% gearing is optimal, so there is no balance with equity.

MM (no tax) assumes the WACC is unaffected by the level of gearing. As the WACC is the discount rate for the projects of the business it follows that the value of the business is unaffected by the gearing decision.

Syllabus area E4(a&b)

200 The correct answer is: **9.0%**

To reflect the business risk of the new investment, Shyma Co's beta of 1.6 should be ignored and instead the proxy beta of 1.1 should be used. This proxy beta is already an asset beta so does not need to be **ungeared**.

The asset beta does need to be **regeared** for Shyma Co's debt:equity ratio.

Equity beta = $1.1 \times (3 + 1(1 - 0.4))/3 = 1.32$

Using CAPM, $k_e = 5 + 1.32 \times 3 = 8.96\% = 9.0\%$ to 1 decimal place.

Syllabus area E3(e)

201 The correct answer is: **0.89**

B Co is being used as a proxy company and has a different level of gearing to TR Co.

Ungear B Co's equity beta:

$$\beta_a = \beta_e \times \frac{V_e}{(V_e + V_d(1-T))}$$

$$= 1.05 \times \frac{4}{(4 + 1(1 - 0.3))}$$

$$= 0.89$$

Syllabus area E3(e)

202 The correct answer is: **8.4%**

Regear β_a using TR Co assumption of a gearing level of 1:3 debt:equity

$$\beta_e = \beta_a \times \frac{V_e + V_d(1-T)}{V_e}$$

$$\beta_e = 0.89 \times \frac{3 + 1(1 - 0.3)}{3}$$

$\beta_e = 1.10$

Put into CAPM:

Ke	=	$R_f + \beta(E(r_m) - R_f)$ $\quad R_f = 4\%, E(R_m) - R_f = 4\%$ (market premium)
Ke	=	$4 + 1.10(4)$
	=	**8.4%**

Syllabus area E3(e)

203 The correct answer is: **11.0%**

In this case, candidates should ignore the existing equity beta of 1.2 and use the industry average equity beta of 2.0. This proxy beta needs to be ungeared.

$\beta_a = 2 \times (75/100) = 1.5$

The asset beta does not need to be regeared.

Using CAPM, $k_e = 5 + 1.5 \times 4 = 8.96\% = 11.0\%$.

Syllabus area E3(e)

204 The correct answer is: **If the project is different from current operations**

A project-specific cost of capital is relevant to appraise a project with a different risk profile from current operations. In these circumstances the current weighted average cost of capital is not relevant – so proxy information is used to calculate a project-specific cost of capital for that particular appraisal.

Syllabus area E3(e)

205 The correct answer is: **11%**

If $V_d/(V_d + V_e) = 0.25$ then $V_d = 0.25$ and $V_e = 0.75$. So $V_e/(V_e + V_d) = 0.75/1 = 0.75$.

Ungearing the equity beta of the new business area gives $\beta_a = 0.75 \times 2 = 1.5$.

As Leah Co is an all-equity financed company, the asset beta of 1.5 does not need regearing.

The project-specific cost of equity is therefore $K_e = 5 + (1.5 \times 4) = 11\%$.

Incorrect answers:

Using the ungeared average equity beta

If the ungeared average equity beta of the new business area of 2.0 is used instead of the asset beta of 1.5 this gives $K_e = 5 + (2 \times 4) = 13.0\%$. This means that the average equity beta for the new business area was not ungeared.

Ungearing the equity beta of Leah Co

$\beta_a = 1.2 \times 0.75 = 0.9$

$K_e = 5 + (0.9 \times 4) = 8.6\%$

Using the equity beta of Leah Co

$K_e = 5 + (1.2 \times 4) = 9.8\%$

Syllabus area E3(e)

BPP
LEARNING
MEDIA

Tulip Co

206 The correct answer is: **10.7%**

$k_e = 2.5 + (1.05 \times 7.8) = 10\cdot7\%$

Syllabus area E2(a)

207 The correct answer is: **15.7%**

Year	$	5%DF	PV	6% DF	PV
0	(100.00)	1.000	(100.00)	1.000	(100.00)
1–5	3.00	4.329	12.99	4.212	12.64
5	115.00	0.784	90.16	0.747	85.91
			3.15		(1.45)

$k_d = 5 + (3.15/(3.15 + 1.45)) = 5.7\%$

Syllabus area E2(b)

208 The correct answer is: **The dividend growth model assumes that all shareholders of a company have the same required rate of return.**

Notes on incorrect answers:

A constant share price is not assumed.

An efficient market would already have an accurate valuation of Tulip.

Syllabus area E2(a)

209 The correct answer is: **Retained earnings are a source of equity finance.**

Notes on incorrect answers:

Equity finance does not represent cash.

A bonus issue does not raise cash.

Preference shares are not a source of equity capital.

Syllabus area E1(e)

210 The correct answer is: **2 only**

Murabaha is similar to trade credit and therefore would not meet Tulip Co's needs. It is correct to state that Mudaraba involves an investing partner and a managing or working partner.

Syllabus area E1(d)

211 Bar Co

> **Workbook references.** Rights issues are covered in Chapter 9. Gearing is covered in Chapter 12.
>
> **Top tips.** For part (b) it is necessary to both calculate and discuss the effect of using the issue proceeds to buy back debt. Ensure that you also address the unlikely assumption that the price/earnings ratio remains unchanged. In part (c) if you follow the direction given in the requirement this should lead you to a good answer. Part (d) needs a discussion of the two types of risk – don't forget to define them.
>
> **Easy marks.** The calculation of the theoretical ex-rights price is straightforward.

Marks

(a)	Rights issue price	1	
	Theoretical ex-rights price	2	
			3
(b)	Nominal value of bonds redeemed	1	
	Interest saved on redeemed bonds	1	
	Earnings after redemption	1	
	Current price/earnings ratio	1	
	Revised share price	1	
	Comment on acceptability to shareholders	1–2	
	Comment on constant price/earnings ratio	1–2	
	Maximum		7
(c)	Current interest coverage	0.5	
	Revised interest coverage	1	
	Current debt/equity ratio	0.5	
	Revised debt/equity ratio	1	
	Comment on financial risk	1	
			4
(d)	Explanation of business risk	1	
	Explanation of financial risk	1	
	Up to 2 marks for each danger of high gearing	4	
			6
			20

(a) The rights issue price is at a 20% discount

$7.5 × 0.8 = $6 per share

Number of shares to be issued = $90m/$6 = 15 million shares

Current number of shares in issue = 60 million

Therefore the rights issue will be a 1 for 4 issue

Theoretical ex-rights price

	$
4 shares @ $7.50	30.00
1 share @ $6.00	6.00
	36.00

Theoretical ex-rights price (TERP) = 36/5 = $7.20

(b) The proposal to buy back the bonds will only be acceptable to shareholders if it increases shareholder wealth.

The bonds would be bought back at market price ($112.50), which is higher than the nominal value ($100). The nominal value of bonds that will be bought back is $90 million/$112.50 × $100 = $80 million.

Interest saved on these bonds = $80m × 0.08 = $6.4m per year

New annual interest charge = $10m − $6.4m = $3.6m

Revised profit before tax = $49m − $3.6m = $45.4m

Revised profit after tax (earnings) = $45.4m × 0.7 = $31.78m

Revised earnings per share = $31.78m/75m = 42.37 cents per share

Current earnings per share = $27.3m/60m = 455 cents per share

BPP
LEARNING
MEDIA

Current price/earnings ratio = 750/455 = 16.48 times

Assuming the price/earnings ratio remains constant, the revised share price will be:

Share price = 16.48 × 42.37 = 698 cents or $6.98 per share.

This revised share price is less than the TERP by $0.22 ($7.20–6.98) and therefore using the issue proceeds to buy back debt will not be acceptable to the shareholders as their wealth will have decreased (by approximately $0.22 × 75m shares = $16.5m).

This conclusion has been reached based on the assumption that the price/earnings ratio remains unchanged. However, the share price will be determined by the stock market and this will determine the price/earnings ratio, rather than the price/earnings ratio determining the share price. Buying back debt would decrease the financial risk of Bar Co and this could cause the cost of equity to fall since shareholders will be taking on less risk. This means the share price is likely to rise and therefore the price/earnings ratio will also increase. If the share price were to increase above the TERP, which would mean the price/earnings ratio would be at least 17 times, the shareholders would find the debt buy back to be an acceptable use of funds as they would experience a capital gain.

Alternative solution to the calculations:

Tutor note. There are a number of ways of dealing with the calculations here. To illustrate this, an **alternative solution** is shown below.

Current shareholder wealth

Shareholders' current wealth can be calculated as the share price × the number of shares in issue:
$7.5 × 60m shares = **$450m**.

Revised shareholder wealth

After the rights issue and debt repayment shareholder wealth could be measured as:

1 The revised value of the company's shares less

2 The amount shareholders invest in the company via the rights issue

The revised value of the shares can be assessed by valuing Bar Co's revised earnings by multiplying them by the current P/E ratio, which we are assuming will be unchanged.

Earnings will change because $90m of debt is bought back. Because the market price of debt is $112.5, this is the same as $80m (ie $90 \times \dfrac{100}{112.5}$) in terms of book value of debt. This saves interest of $80m × 8% = $6.4m, which is a saving after tax of $4.48m (calculated as $6.4m × 0.7). So revised earnings will be $27.3m + $4.5m = $31.8m.

The **current** EPS is $27.3m/60m = 455 cents, so the current P/E ratio is 7.5/0.455 = 16.48.

The new value of the shares can be estimated as $31.78m × 16.48 which is approximately $523.7m. So, after subtracting the $90m invested in the rights issue, shareholders' wealth has become $433.7m.

This is a fall in shareholder wealth of $16.3m compared to current shareholder wealth of $450m.

(c) Current interest coverage ratio = 49m/10m = 4.9 times
 Revised interest coverage ratio = 49m/3.6m = 13.6 times

 Current debt/equity ratio = 125m/140m = 89.3%
 Revised book value of debt = 125m – 80m = $45m
 Revised book value of equity = 140m + 90m – 10m = $220m

 $10m has been deducted because $90m was spent to redeem bonds with a nominal value of $80m.

 Revised debt/equity ratio = 45m/220m = 20.5%

Note. Full credit would also be given for a calculation that omitted the $10m loss. The revised debt/equity ratio would be 45m/230m = 19.6%.

Redeeming the bonds with a book value of $80m would significantly reduce the financial risk of Bar Co. This is shown by the reduction in gearing from 89.3% to 20.5% and the increase in the interest coverage from 4.9 times to 13.6 times.

(d) (i) **Business risk**, the inherent risk of doing business for a company, refers to the risk of making only low profits, or even losses, due to the nature of the business that the company is involved in. One way of measuring business risk is by calculating a company's operating gearing or 'operational gearing'.

$$\text{Operating gearing} = \frac{\text{Contribution}}{\text{Profit before interest and tax (PBIT)}}$$

The significance of operating gearing is as follows.

1 **If contribution is high but PBIT is low**, fixed costs will be high, and only just covered by contribution. Business risk, as measured by operating gearing, will be high.

2 **If contribution is not much bigger than PBIT**, fixed costs will be low, and fairly easily covered. Business risk, as measured by operating gearing, will be low.

(ii) A high level of debt creates financial risk. This is the risk of a company not being able to meet other obligations as a result of the need to make interest payments. The proportion of debt finance carried by a company is therefore as significant as the level of business risk. Financial risk can be seen from different points of view.

1 **The company** as a whole. If a company builds up debts that it cannot pay when they fall due, it will be forced into liquidation.

2 **Payables**. If a company cannot pay its debts, the company will go into liquidation owing payables money that they are unlikely to recover in full.

3 **Ordinary shareholders**. A company will not make any distributable profits unless it is able to earn enough PBIT to pay all its interest charges, and then tax. The lower the profits or the higher the interest-bearing debts, the less there will be, if there is anything at all, for shareholders.

212 YGV Co

Workbook references. Cost of debt is covered in Chapter 11, sources of finance are explained in Chapter 9 and interest coverage and gearing in Chapter 12.

Top tips. In part (a) the choice of discount factors is not crucial and other rates could be used to get a slightly different cost of debt and, therefore, WACC.

Easy marks. The cost of debt calculation in part (a) is quite straightforward as are the interest coverage and gearing calculations in part (b).

Examining team's comments. In part (a) some candidates wrongly used the redemption value of $110 as the issue price, or wrongly used a redemption value of $100, when the question said that redemption was at a 10% premium to nominal value.

For part (b), although the question said 'calculate', many answers chose to discuss their findings, sometimes at length. This discussion was not asked for in this part of the question and students must learn to follow the question requirement.

Part (c) required students to evaluate the proposal to use the bond issue to finance the reduction in the overdraft, and to discuss alternative sources of finance, given the company's current position. Many answers were very brief given the marks on offer.

		Marks	
(a)	Calculation of after-tax interest payment	1	
	Calculation of after-tax cost of debt	3	
			4
(b)	Current interest coverage	1	
	Revised interest coverage	1	
	Current gearing	1	
	Revised gearing	1	
			4
(c)	Comment on interest coverage ratio	1–2	
	Comment on gearing	1–2	
	Comment on need for security	2–3	
	Comment on advisability of bond issue	1–2	
	Discussion of alternative sources of finance	4–5	
	Other relevant discussion	1–2	
	Maximum		12
			20

(a) The after-tax interest charge per bond is $9 × 0.7 = $6.30

Two discounts should be chosen, 6% and 8%

Year	0	1–10	10
	$	$	$
Cash flow	(100)	6.30	110
Discount factor @ 8%	1.000	6.710	0.463
Present value	(100.00)	42.27	50.93

Net present value = (6.80)

Year	0	1–10	10
	$	$	$
Cash flow	(100)	6.30	110
Discount factor @ 6%	1.000	7.360	0.558
Present value	(100.00)	(46.37)	61.38

Net present value = 7.75

Cost of debt = 6 + [(8 − 6) × 7.75/(7.75 + 6.8)] = 6 + 1.1 = 7.1%

(b) (i) The current level of interest charge per year is $4.5m × 5% = $225,000

Current interest coverage ratio = PBIT/Interest

1m/0.225m = 4.4 times

Interest on bonds after issue = $4m × 9% = $360,000

Interest on overdraft = $0.5m × 5% = $25,000

Total interest per year = $385,000

Interest coverage ratio with bond issue = 1m/0.385m = 2.6 times

(ii) The current market capitalisation is $4.10 × 10 million shares = $41 million

Current gearing = zero (as no long-term debt)

Gearing following bond issue (debt/equity) = 4m/41m = 9.8%

Alternatively if the overdraft is included in the calculations

Current gearing = 4.5m/41m = 11.0%

Gearing following bond issue (debt/equity) = 4.5m/41m = 11.0%

(c) Interest coverage ratio

The current interest coverage ratio is almost half of the sector average of 8, although with the prior year profit before tax it was 22 times. Following the bond issue this would drop to 2.6 times which is a low level of cover compared to the sector average and may create operational issues for YGV Co.

Gearing

Whether the overdraft is included in the gearing calculation or not, the revised gearing level of either 9.8% or 11% is not significantly different from the sector average of 10%. As a result, there are no concerns about the level of gearing resulting from the bond issue.

Security

The reduction in profitability will increase the likelihood of the bond issue needing to be secured against the non-current assets of YGV Co. This may create issues as the tangible non-current assets of YGV Co have a net book value of $3 million, which does not cover the value of the bond issue of $4 million. It is unlikely that the intangible assets could be used as security, but their nature has not been disclosed.

Using the bond to reduce the overdraft

Considering the issues raised above, particularly the fall in the interest coverage and the lack of assets to use as security, the bond issue is not recommended as it is unlikely to succeed. As a result, alternative sources of finance should be considered in order to reduce the overdraft.

Alternative sources of finance

There is a lack of availability of additional overdraft finance, so this is not a viable option. The issue with the lack of interest coverage will also rule out any other form of debt finance.

Any provider of finance will first need to be reassured that the fall in profitability is due to short-term reasons and that YGV Co will continue to be a going concern in the long term.

The amount of finance required is the $4 million required to reduce the overdraft, but this amount could be reduced through working capital management, particularly given the amount of working capital tied up in accounts receivable.

No information is given about dividends, but if these are being paid they could be reduced to increase the amount of retained earnings available.

Equity finance is the most likely source of finance to consider. YGV Co may consider a rights issue. The offer price will be lower than the market price and given the situation a fairly large discount may need to be applied. A discount of 25% would give a price for the rights issue of $3.08. A 1 for 7 rights issue at this price would raise $4.4 million which could reduce the overdraft to $100,000 where the interest charge would only be $5,000 per year.

A new issue of shares is a possibility as $4 million is only 9% of the total shares in issue at that point ($45 million). This means that dilution of existing holdings will not be a significant issue. New shareholders may not be attracted to invest if there are no dividends on offer though. A new issue of shares would also be more expensive for YGV Co.

Sale and leaseback is not likely to raise significant levels of finance, given the tangible non-current asset level of $3 million, but could be used alongside another source of finance.

Convertible bonds could also be considered as an alternative.

213 Corfe Co

Workbook references. Cost of capital is covered in Chapter 11. Sources of finance and dividend policy are mainly covered in Chapters 9 and 10.

Top tips. In part (a) if you are using the IRR function to calculate the after-tax cost of debt of the 8% loan notes be careful to apply this to cash flows for each of six years separately.

Examining team's comments. Part (a) provided information which allowed the capital asset pricing model (CAPM) to be used to calculate the cost of equity and most candidates were able to calculate this correctly. Some candidates incorrectly used the equity risk premium as the return on the market, when the equity risk premium is the difference between the return on the market and the risk-free rate of return. Some candidates ignored the cost of debt of the bank loan, even though it was identified in the question as a non-current liability. Some candidates correctly identified the after-tax cost of debt of the loan notes as an appropriate proxy value, while other argued for the after-tax interest rate on the loan notes. Some candidates used a value without providing an explanation for their choice. Whatever approach was adopted, the bank loan could not be ignored. Surprisingly, some candidates used the cost of equity, calculated using the CAPM, as the cost of debt of the bank loan.

In part (b) many candidates incorrectly believed that the company's equity reserves were cash which could be invested... many candidates did not quantify the finance which might be available from a dividend cut, even though information which allowed such a calculation was given in the question.

Marking scheme

		Marks
(a)	Cost of equity set-up	1
	Cost of equity calculation	1
	Cost of preference shares calculation	1
	After-tax cost of interest of loan notes	1
	Cost of debt set-up	1
	Cost of debt calculation	1
	Cost of bank loan	1
	Market value of equity shares	0
	Market value of preference shares	0
	Market value of loan notes	0
	Market value of bank loan	0
	Weighted average cost of capital	<u>2</u>
		11
(b)	Director A	3
	Director B	3
	Director C	<u>3</u>
		<u>9</u>
		<u>20</u>

(a) ke = 3.5% + (1.25 × 6.8%) = 12.00%

kpref = (0.06 × 0.75)/0·64 = 7.03%

Loan notes	
After tax interest payment	8% × (1 – 0·2) = 6.4%
Nominal value of loan notes	100.00
Market value of loan notes	103.50
Time to redemption (years)	5
Redemption premium (%)	10

Year		$	5%DF	PV ($)	10% DF	PV ($)
0	MV	(103.50)	1.000	(103.50)	1.000	(103.50)
1–5	Interest	6.40	4.329	27.71	3.791	24.26
5	Redeem	110.00	0.784	86.24	0.621	68.31
				10.45		(10.93)

IRR = 5 + ((10 – 5) × (10.45/(10.45 + 10.93))) = 7.44%

Alternatively IRR can be calculated using the =IRR spreadsheet function based on these cash flows:

Time	0	1	2	3	4	5
	(103.5)	6.4	6.4	6.4	6.4	116.4

This approach gives an IRR of 7.3%

This figure can also be used for the cost of debt of the bank loan.

Market values and WACC calculation

	BV ($m)	Nominal	MV	MV ($m)	Cost (%)	MV × Cost (%)
Equity shares	15	1.00	6.10	91.50	12.00	1,098.00
Preference shares	6	0.75	0.64	5.12	7.03	35.99
Loan notes	8	100	103.50	8.28	7.44	61.60
Bank loan	5			5.00	7.44	37.20
				109.90		1,232.79

WACC = 100% × 1,232.79/109.90 = 11.22%

(b) **Director A**

Director A is incorrect in saying that $29m of cash reserves are available. Reserves are $29m, but this figure represents backing for all Corfe Co's assets and not just cash.

Corfe Co has $4m of cash. Some of this could be used for investment, although the company will need a minimum balance of cash to maintain liquidity for its day-to-day operations.

Corfe Co's current ratio is (20/7) = 2.86. This may be a high figure (depending on the industry Corfe Co is in), so Corfe Co may have scope to generate some extra cash by reducing working capital. Inventory levels could be reduced by just-in-time policies, trade receivables reduced by tighter credit control and payments delayed to suppliers. All of these have possible drawbacks. Just-in-time policies may result in running out of inventory, and tighter policies for trade receivables and payables may worsen relations with customers and suppliers. Again also, Corfe Co would have to maintain minimum levels of each element of working capital, so it seems unlikely that it could raise the maximum $25m solely by doing what Director A suggests.

Director B

Selling the headquarters would raise most of the sum required for investment, assuming that Director B's assessment of sales price is accurate. However, Corfe Co would lose the benefit of the value of the site increasing in future, which may happen if the headquarters is in a prime location in the capital city. Being able to sell the headquarters would be subject to the agreement of lenders if the property had been used as security for a loan. Even if it has not been used as security, the sale could reduce the borrowing capacity of the company by reducing the availability of assets to offer as security.

An ongoing commitment to property management costs of an owned site would be replaced by a commitment to pay rent, which might also include some responsibility for property costs for the locations rented. It is possible that good deals for renting are available outside the capital city. However, in the longer term, the rent may become more expensive if there are frequent rent reviews.

There may also be visible and invisible costs attached to moving and splitting up the functions. There will be one-off costs of moving and disruption to work around the time of the move. Staff replacement costs may increase if staff are moved to a location which is not convenient for them and then leave. Senior managers may find it more difficult to manage functions which are in different locations rather than the same place. There may be a loss of synergies through staff in different functions not being able to communicate easily face-to-face anymore.

Director C

The dividend just paid of $13.5m seems a large amount compared with total reserves. If a similar level of funds is available for distribution over the next two years, not paying a dividend would fund the forecast expenditure.

However, shareholders may well expect a consistent or steadily growing dividend. A cut in dividend may represent a significant loss of income for them. If this is so, shareholders may be unhappy about seeing dividends cut or not paid, particularly if they have doubts about the directors' future investment plans. They may see this as a signal that the company has poor prospects, particularly if they are unsure about why the directors are not seeking finance from external sources.

The directors' dividend policy may also be questioned if the dividend just paid was a one-off, high payment. Such a payment is normally made if a company has surplus cash and does not have plans to use it. However, the directors are planning investments, and shareholders may wonder why a high dividend was paid when the directors need money for investments.

214 AQR Co

Workbook references. Weighted average cost of capital (WACC) is covered in Chapter 11. Capital structure theories are explained in Chapter 12.

Top tips. Part (b) is a general discussion about capital structure theories.

Easy marks. Part (a) is a WACC calculation that you should be able to obtain good marks for.

Examining team's comments. Some answers treated existing bonds as irredeemable and used the after-tax cost of debt provided as a before-tax interest rate. This implies learning a WACC calculation method without understanding the underlying principles, leading to an attempt to make the information provided fit the calculation method learned. There were also a significant number of errors in calculating the cost of equity using the dividend growth model. Alarm bells should sound if the calculated cost of equity is less than the cost of debt, or if the calculated cost of equity is quite large. A glance through past exams will show that a realistic approach has been used, with the cost of equity lying between, say, 5% and 15%.

		Marks	
(a)	Calculation of historic dividend growth rate	1	
	Calculation of cost of equity using DGM	2	
	Calculation of market weights	1	
	Calculation of pre-issue WACC	2	
	Correct use of tax as regards new debt	1	
	Setting up linear interpolation calculation	1	
	Calculating after-tax cost of debt of new debt	1	
	Calculation of post issue WACC	2	
	Comment	1	
			12
(b)	Marginal and average cost of debt	1–2	
	Traditional view of capital structure	1–2	
	Miller and Modigliani 1 and 2	1–3	
	Market imperfections view	1–2	
	Pecking order theory	1–2	
	Other relevant discussion	1–2	
	Maximum		8
			20

(a) Cost of equity

Geometric average growth rate = $\sqrt[4]{(21.8/19.38)} - 1 = 0.0298 = 2.98\%$ or 3%

Putting this into the dividend growth model gives $k_e = ((21.8 \times 1.03)/250) + 0.03$
= 0.09 + 0.03 = 0.12 = 12%

Market values of equity and debt

Market value of equity = V_e = 100m × $2.50 = $250m

Market value of bonds = V_d = 60m × (104/100) = $62.4m

Total market value = $250m + $62.4m = $312.4m

WACC calculation

The current after-tax cost of debt is 7%

$$WACC = ((k_e \times V_e) + (k_d(1 - T) \times V_d)/(V_e + V_d))$$
$$= ((12 \times 250m) + (7 \times 62.4m))/312.4m$$
$$= 11\%$$

Cost of debt

After-tax interest payment = 100 × 8% × (1 – 30%) = 5.6%

Year		Cash flow $	5% discount factors	PV $	6% discount factors	PV $
0	Market value	(100.00)	1.000	(100.00)	1.000	(100.00)
1–10	Interest	5.60	7.722	43.24	7.360	41.22
10	Capital repayment	105.00	0.614	64.47	0.558	58.59
				7.71		(0.19)

Calculate the cost of debt using an internal rate of return (IRR) calculation.

$$IRR = a\% + \left[\frac{NP_a}{NP_a - NPV_b} \times (b-a) \right]\%$$

$$= 5\% + \frac{7.71}{7.71+0.19}(6\% - 5\%)$$

$$= 5.98\% \text{ or } 6\%$$

BPP
LEARNING
MEDIA

Note. Other discount factors and therefore costs of debt are acceptable.

Alternatively IRR can be calculated using the =IRR spreadsheet function.

Revised WACC calculation

Market value of the new issue of bonds is $40m

New total market value = $312.4m + $40m = $352.4m

Cost of debt of bonds is 6% (from above)

$$\text{WACC} = ((12 \times 250m) + (7 \times 62.4m) + (6 \times 40m))/352.4m$$
$$= 10.4\%$$

The debt issue has reduced the WACC. This is because of the addition of relatively cheap debt. Gearing up in this manner would usually be assumed to increase financial risk. However, this hasn't been included in the above calculations.

(b) There is a relationship between the WACC and the value of a company as the value can be expressed as the present value of the future cash flows with the WACC as the discount rate.

Marginal and average cost of debt

If the marginal cost of capital for the issue of the new capital, in this case the bond issue, is less than the current WACC then it may be expected that the WACC will decrease. However, as new debt increases gearing it will also increase financial risk. This increased risk may lead to an increase in the cost of equity which could offset the effect of the cheaper debt.

Traditional view

Under the traditional view there is an optimal capital mix at which the average cost of capital, weighted according to the different forms of capital employed, is minimised. The traditional view is that the WACC, when plotted against the level of gearing, is saucer shaped. The optimum capital structure is where the WACC is lowest.

As the level of gearing increases, the cost of debt remains unchanged up to a certain level of gearing. Beyond this level, the cost of debt will increase. The cost of equity rises as the level of gearing increases and financial risk increases. There is a non-linear relationship between the cost of equity and gearing.

The WACC does not remain constant, but rather falls initially as the proportion of debt capital increases, and then begins to increase as the rising cost of equity (and possibly of debt) becomes more significant. The optimum level of gearing is where the company's WACC is minimised. Under this theory the finance director may be correct in his view that issuing debt will decrease WACC depending on the position of AQR Co relative to the optimum capital structure.

Modigliani and Miller (MM)

In their 1958 theory, MM proposed that the total market value of a company, in the absence of tax, will be determined only by two factors: the total earnings of the company and the level of operating (business) risk attached to those earnings. The total market value would be computed by discounting the total earnings at a rate that is appropriate to the level of operating risk. This rate would represent the WACC of the company. Thus MM concluded that the capital structure of a company would have no effect on its overall value or WACC.

In 1963, MM modified their theory to admit that tax relief on interest payments does lower the WACC. The savings arising from tax relief on debt interest are the tax shield. They claimed that the WACC will continue to fall, up to gearing of 100%. Under this theory the finance director of AQR is correct in his belief that issuing bonds will decrease the WACC.

Market imperfections

MM's theory assumes perfect capital markets so a company would always be able to raise finance and avoid bankruptcy. In reality, however, at higher levels of gearing there is an increasing risk of the company being unable to meet its interest payments and being declared bankrupt. At these higher levels of gearing, the bankruptcy risk means that shareholders will require a higher rate of return as compensation.

As companies increase their gearing they may reach a point where there are not enough profits from which to obtain all available tax benefits. They will still be subject to increased bankruptcy and agency costs but will not be able to benefit from the increased tax shield.

Pecking order theory

Pecking order theory has been developed as an alternative to traditional theory. It states that firms will prefer retained earnings to any other source of finance, and then will choose debt, and last of all equity. The order of preference is: retained earnings, straight debt, convertible debt, preference shares and equity shares.

215 BKB Co

Workbook references. Weighted average cost of capital (WACC) is covered in Chapter 11. The advantages of issuing convertible bonds are discussed in Chapter 9.

Top tips. If you know your formulas well, the calculations in part (a) should be straightforward. You should know that overdrafts should not be considered as part of the capital structure.

You will need to apply logic in answering part (b). In part (c), briefly plan your answer before you start to answer the question.

Easy marks. Marks are available for straightforward calculations in part (a).

Examining team's comments. In part (a) few answers were able to calculate correctly the cost of the preference shares and some answers chose to use the dividend percentage relative to nominal as the cost of capital, or to assume a value for the cost of capital. Some answers mistakenly calculated the after-tax cost of the preference shares. As preference shares pay a dividend, which is a distribution of after-tax profit, they are not tax efficient. A common error was to mix bond-related values (such as the $4.90 after-tax interest payment) with total debt-related values (such as the $21m market value of the bond issue), producing some very high values in the linear interpolation calculation. Some candidates were unable to calculate the future share price as part of the conversion value calculation. Most candidates were able to calculate a WACC value, although some omitted the cost of preference shares from the calculation. In part (b) many answers were not of a high standard and tried to make some general points about market efficiency or about the window-dressing of financial statements. The important point here is that the weightings used in the WACC calculation need to reflect the relative importance of the different sources of finance used by a company if the WACC is to be used in investment appraisal.

Marking scheme

		Marks
(a)	Calculation of cost of equity using CAPM	2
	Calculation of bond market price	0.5
	Calculation of current share price	0.5
	Calculation of future share price	1
	Calculation of conversion value	1
	After-tax interest payment	1
	Setting up interpolation calculation	1
	Calculation of after-tax cost of debt	1
	Calculation of cost of preference shares	1
	Calculation of after-tax WACC	2
	Explanation of any assumptions made	1
		12

(b)	Market values reflect current market conditions	1–2	
	Market values and optimal investment decisions	1–2	
	Other relevant discussion or illustration	1–2	
		Maximum	4
(c)	Self-liquidating	1	
	Lower interest rate	1	
	Increase in debt capacity on conversion	1	
	Other relevant advantages of convertible debt	1–3	
		Maximum	4
			20

(a) **Equity**

The market value (MV) of equity is given as $125m.

CAPM: $E\left(r_i\right) = R_f + \beta_i \left(E\left(r_m\right) - R_f\right)$

R_f = Risk-free rate = 4%

β_i = Equity beta = 1.2

$\left(E(r_m) - R_f\right)$ = Equity risk premium = 5%

Therefore the cost of equity = 4% + 1.2 × 5% = 10%

Convertible bonds

Assume that bondholders will convert if the MV of 19 shares in 5 years' time is greater than $100.

MV per bond = $100 × $21m/$20m = $105

MV per share today = $125m/25m = $5

MV per share in 5 years' time = $5 × 1.04^5 = $6.08 per share

Conversion value = $6.08 × 19 = $115.52

The after-tax cost of the convertible bonds can be calculated by linear interpolation, assuming the bondholders will convert.

Time	Cash flow $	Discount factor 7%	Present value $	Discount factor 5%	Present value $
0	(105)	1	(105)	1	(105)
1–5	4.9*	4.100	20.09	4.329	21.21
5	115.52	0.713	82.37	0.784	90.57
			(2.54)		6.78

* After-tax interest payment = 7 × (1 – 0.3) = $4.90 per bond

Cost of convertible bonds = 5 + [(7 – 5) × 6.78/6.78 + 2.54)] = 5 + 1.45 = 6.45%

Preference shares

After-tax cost of preference shares = 5% × $10m/$6.25m = 8%

WACC

Total value = $125m + $21m + $6.25m = $152.25m

After-tax WACC = [($125m × 10%) + ($21m × 6.45%) + ($6.25m × 8%)/$152.25m]

After-tax WACC = 9.4% per year

Note. As overdraft represents a short-term source of finance, it has been assumed not to form part of the company's capital and has therefore been excluded from the WACC calculation. The overdraft is large, however, and seems to represent a fairly constant amount. The company should evaluate whether it should be taken into account.

(b) MVs are preferable to book values when calculating WACC, because they reflect the current value of the company's capital.

If book values are used instead of MVs, this will seriously understate the proportion that equity represents in the company's capital structure. This is because the MV of ordinary shares is usually significantly higher than its nominal book value.

Understating the impact of the cost of equity on the WACC will most likely cause the WACC to be understated since, as we can see in the answer above, the cost of equity is greater than the cost of debt. Underestimating the WACC will skew the company's investment appraisal process as a lower discount rate is used, and cause the company to make sub-optimal investment decisions.

Using book values instead of market values will also change the value of debt in the company's capital structure. The impact of understating or overstating the value of debt would be less significant than is the case for equity, because debt instruments are often traded at close to their nominal value.

(c) Convertible bonds are attractive for companies for the following reasons:

(i) **Lower rates of interest:** Investors are normally willing to accept a lower coupon rate of interest on convertible bonds, because of the additional value offered by the conversion rights. This helps to ease the burden on cash flows.

(ii) **The possibility of not redeeming the debt at maturity:** Companies issue convertible bonds with the expectation that they will be converted. If the bonds are converted, this frees the company from a cash repayment at redemption. The cash advantage is further augmented by the greater flexibility that equity shares allow in terms of returns.

(iii) **Availability of finance:** Issuing convertible bonds may allow greater access to finance, as lenders who would otherwise not provide ordinary loan finance may be attracted by the conversion rights.

(iv) **Impact on gearing:** On conversion, the company's gearing will be reduced not only because of the removal of debt, but also because equity replaces the debt. This can send positive signals about the company's financial position.

(v) **Delayed equity:** The fact that convertible bonds allow the issue of shares at a predetermined point in the future permits the company to plan the impact on its earnings per share upon conversion.

216 Fence Co

Workbook references. Cost of debt, capital asset pricing model (CAPM), risk and weighted average cost of capital (WACC) are covered in Chapter 11.

Top tips. Be careful not to miss out the tax effect in part (b). Try not to mix up systematic risk and unsystematic risk in part (c).

Easy marks. There are easy marks for calculations in part (a). The limitations of CAPM should always present straightforward marks.

Examining team's comments. For part (a) the examining team commented that students should aim to calculate a reasonably accurate after-tax cost of debt. For example, if the first cost of debt estimate produces a negative NPV, then the second estimate should be lower as the first estimate was too high.

Marks

(a) Calculation of equity risk premium — 1
Calculation of cost of equity — 1
After-tax interest payment — 1
Setting up IRR calculation — 1
Calculating after-tax cost of debt — 1
Market value of equity — 0.5
Market value of debt — 0.5
Calculating WACC — 1
— 7

(b) Ungearing proxy company equity beta — 2
Regearing equity beta — 1
Calculation of cost of equity — 1
— 4

(c) Risk diversification — 1
Systematic risk — 1
Unsystematic risk — 1
Portfolio theory and the CAPM — 1
— 4

(d) 1–2 marks per point made

Maximum — 5 / 20

(a) After-tax cost of debt (K_d) can be calculated by linear interpolation.

Year		Cash flow $	Discount factor 4%	PV $	Discount factor 5%	PV $
0	Market value	(107.14)	1.000	(107.14)	1.000	(107.14)
1–7	Interest (7 × (1 – 0.2))	5.60	6.002	33.61	5.786	32.40
7	Redemption	100.00	0.760	76.00	0.711	71.10
				2.47		(3.64)

After-tax cost of debt = $4\% + \dfrac{2.47}{2.47 + 3.64} (5\% - 4\%) = 4.4\%$

Alternatively IRR can be calculated using the =IRR spreadsheet function based on these cash flows:

Time	0	1	2	3	4	5	6	7
	(107.14)	5.6	5.6	5.6	5.6	5.6	5.6	105.6

This approach also gives an IRR of 4.4%

Cost of equity (K_e) can be found using CAPM.

$$E(r_i) = R_f + \beta_i(E(r_m) - R_f)$$
$$= 4 + 0.9 (11 - 4)$$
$$= 10.3\%$$

Market value of equity (V_e) = $10m × $7.50 = $75m

Market value of debt (V_d) = $14m × $\dfrac{107.14}{100}$ = $15m

$$\text{WACC} = \left[\frac{V_e}{V_e + V_d}\right] k_e + \left[\frac{V_d}{V_e + V_d}\right] k_d$$

$$= \left[\frac{75}{75 + 15}\right] 10.3 + \left[\frac{15}{75 + 15}\right] 4.4$$

$$= 9.3\%$$

(b) Ungear to remove the financial risk

$$\beta_a = \beta_e \times \frac{V_e}{V_e + V_d(1-T)}$$

$$\beta_a = 1.2 \times \frac{54m}{54m + (12m \times 0.8)}$$

$= 1.019$

Convert back to a geared beta

$$\beta_e = \beta_a \times \frac{V_e + V_d(1-T)}{V_e}$$

$$\beta_e = 1.019 \times \frac{75 + 15(1-0.2)}{75}$$

$= 1.182$

Use CAPM to estimate cost of equity.

Equity or market risk premium = 11 − 4 = 7%

Cost of equity = 4 + (1.182 × 7) = 4 + 8.3 = 12.3%

(c) **Unsystematic** risk can be **diversified away** but even well-diversified portfolios will be exposed to **systematic risk**. This is the risk **inherent in the market as a whole**, which the shareholder cannot mitigate by holding a diversified investment portfolio.

Portfolio theory is concerned with **total risk** (systematic and unsystematic). The **CAPM** assumes that investors will hold a fully diversified portfolio and therefore ignores unsystematic risk.

(d) **Diversification**

Under the CAPM, the return required from a security is **related** to its **systematic risk** rather than its total risk. Only the risks that **cannot be eliminated** by diversification are **relevant**. The assumption is that investors will hold a **fully diversified portfolio** and therefore deal with the unsystematic risk themselves. However, in practice, markets are **not totally efficient** and investors do not all hold fully diversified portfolios. This means that total risk is relevant to investment decisions, and that therefore the relevance of the CAPM may be limited.

Excess return

In practice, it is difficult to determine the excess return $(R_m - R_f)$. **Expected rather than historical returns** should be used, although historical returns are used in practice.

Risk-free rate

It is similarly difficult to **determine the risk-free rate.** A risk-free investment might be a government security; however, interest rates vary with the term of the debt.

Risk aversion

Shareholders are risk averse, and therefore **demand higher returns** in compensation for increased levels of risk.

Beta factors

Beta factors based on historical data may be a **poor basis** for future **decision making,** since evidence suggests that beta values fluctuate over time.

Unusual circumstances

The CAPM is unable to forecast accurately returns for companies with low price/earnings ratios, and to take account of seasonal 'month of the year' and 'day of the week' effects that appear to influence returns on shares.

217 Tinep Co

Marking scheme

			Marks
(a)	Cost of equity	1	
	After-tax interest payment	1	
	Setting up IRR calculation	1	
	After-tax cost of debt of loan notes	1	
	Market values	1	
	Market value WACC	1	
	Book value WACC	1	
	Comment on difference	2	
			9
(b)	Issue price	1–2	
	Relative cost	1–2	
	Ownership and control	1–2	
	Gearing and financial risk	1–2	
		Maximum	6
(c)	Explanation of scrip dividend	1–2	
	Advantages of scrip dividend to company	2–3	
	Disadvantages of scrip dividend to company	2–3	
		Maximum	5
			20

(a) **Cost of equity using CAPM**

$K_e = R_f + \beta(E(r_m) - R_f)$ $R_f = 4\%$, $E(R_m) - R_f = 6\%$ (market premium)

$K_e = 4 + (1.15 \times 6) = 10.9\%$

After-tax cost of debt K_d

Time		Cash flow $	Discount factor 4%	Present value $	Discount factor 5%	Present value $
0	Market value	(103.50)	1	(103.50)	1	(103.50)
1–6	Interest	(6% × 100) × 75% = 4.5	5.242	23.59	5.076	22.84
6	Redemption	106	0.790	83.74	0.746	79.08
				3.83		(1.58)

$$K_d = 4 + \frac{3.83}{3.83 + 1.58} \times 1 = 4.7\%$$

Alternatively IRR can be calculated using the =IRR spreadsheet function based on these cash flows:

Time	0	1	2	3	4	5	6
	(103.5)	4.5	4.5	4.5	4.5	4.5	110.5

This approach also gives an IRR of 4.7%

Market value of equity

Number of shares = $200m/0.5 = 400m

Market value = 400m × $5.85 = $2,340m

Market value of debt

200m loan notes × $\dfrac{103.50}{100.00}$ = $207m

Total market value = $2,340 + $207 = $2,547

Using the formula from the formula sheet:

$$WACC = \left[\frac{V_e}{V_e + V_d}\right]k_e + \left[\frac{V_d}{V_e + V_d}\right]k_d$$

WACC using market values

WACC = (2,340/2,547)10.9% + (207/2,547)4.7% = **10.40%**

WACC using book values

WACC = (850/1,050)10.9% + (200/1,050)4.7% = **9.72%**

The WACC using book values is lower than the WACC using market values. This is because the market values of shares are nearly always higher than the nominal values. Book values are based on historical costs and their use will understate the impact of the cost of equity finance on the average cost of capital. Market values should always be used if data is available. If the WACC is understated then unprofitable projects will be accepted.

(b) **Considerations of rights issue**

Issue price

Tinep Co must set a price which is low enough to secure the acceptance of shareholders but not too low so as to dilute earnings per share. This balance can be difficult to estimate.

Relative cost

Rights issues are cheaper than, say, initial public offerings to the general public. This is partly because no prospectus is normally required, partly because the admin is simpler and partly because the cost of underwriting will be less.

Ownership and control

Relative voting rights are unaffected if shareholders take up their rights.

Gearing and financial risk

The finance raised may be used to reduce gearing by increasing share capital. The shareholders may see this as a positive move depending on their risk preference.

(c) A scrip dividend is a dividend paid by the issue of additional company shares, rather than by cash. It is offered pro rata to existing shareholdings.

From a company point of view there are a couple of main advantages of scrip dividends. They can preserve a company's cash position if a substantial number of shareholders take up the share option and a share issue will decrease the company's gearing, and may therefore enhance its borrowing capacity.

There are two main disadvantages of scrip dividends. Assuming that dividend per share is maintained or increased, the total cash paid as a dividend will increase. Scrip dividends may be seen as a negative signal by the market ie the company is experiencing cash flow issues.

BPP
LEARNING
MEDIA

218 Grenarp Co

Marking scheme

			Marks
(a)	Rights issue price	0.5	
	New shares issued	0.5	
	Net cash raised by rights issue	0.5	
	TERP per share	1	
	Buy-back price of loan notes	0.5	
	Nominal value of loan notes redeemed	1	
	Before-tax interest saving	0.5	
	After-tax interest saving	0.5	
	Revised earnings	0.5	
	Revised earnings per share	0.5	
	Revised share price using P/E ratio method	1	
	Comment on effect of redemption on shareholders' wealth	1	
			8
(b)	Traditional view of capital structure	1–3	
	M&M views of capital structure	1–3	
	Other relevant discussion	1–3	
		Maximum	7
(c)	1–2 marks per source of finance		
		Maximum	5
			20

(a) Rights issue price = 3.50 × 0.8 = $2.80 per share

Grenarp Co currently has 20 million shares in issue ($10m/0.5)
The number of new shares issued = 20m/5 = 4 million shares

Cash raised by the rights issue before issue costs = 4m × 2.80 = $11,200,000
Net cash raised by the rights issue after issue costs = 11,200,000 − 280,000 = $10,920,000

Revised number of shares = 20m + 4m = 24 million shares

Market value of Grenarp Co before the rights issue = 20,000,000 × 3.50 = $70,000,000
Market value of Grenarp Co after the rights issue = 70,000,000 + 10,920,000 = $80,920,000
TERP = 80,920,000/24,000,000 = $3.37 per share

(Alternatively, issue costs are $0.07 per share (280,000/4m) and this is a 1 for 5 rights issue, so the TERP = (5 × 3.50 + (2.80 − 0.07))/6 = 20.23/6 = $3.37 per share.)

Redemption price of loan notes = 104 × 1.05 = $109.20 per loan note

Nominal value of loan notes redeemed = 10,920,000/(109.20/100) = $10,000,000

Before-tax interest saving = 10,000,000 × 0.08 = $800,000 per year
After-tax interest saving = 800,000 × (1 – 0.3) = $560,000 per year

Earnings after redeeming loan notes = 8,400,000 + 560,000 = $8,960,000 per year

Revised earnings per share (EPS) = 100 × (8,960,000/24,000,000) = $0.373 per share

Price/earnings ratio of Grenarp Co before the rights issue = 3.50/0.42 = 8.33 times
This price/earnings ratio is not expected to be affected by the redemption of loan notes.
Share price of Grenarp Co after redeeming loan notes = 8.33 × 0·373 = $3.11 per share
(total market value = $3.11 × 24m shares = $74.64m).

The wealth of shareholders of Grenarp Co has decreased as they have experienced a capital loss of $0.26 per share ($3.37 – $3.11) compared to the TERP per share. This means that shareholder wealth has fallen by $0.26 × 24m shares = $6.24m (excluding issue costs, or $6.24 + $0.28m issue costs = $6.52m after issue costs).

Alternative solution

Revised shareholder wealth

After the rights issue and debt repayment shareholder wealth could be measured as:

1 The revised value of the company's shares **less**

2 The amount shareholders invest in the company via the rights issue

The revised value of the shares can be assessed by valuing Grenarp's revised earnings by multiplying them by the current P/E ratio.

Current earnings are $0.42 × 20m shares = $8.4m. The amount raised net of issue costs is $11.2m – $0.28m = $10.92m. This will be used to buy back debt, and the interest saved will boost earnings.

$10.92m of debt is bought back. The redemption price is 5% above the market price of debt of $104; this is: 1.05 × 104 = $109.2. So $10.92m buys back $10m (ie $10.92 \times \dfrac{100}{109.4}$) in terms of book value of debt.

This saves interest of $10m × 8% = $0.8m, which is a saving after tax of $0.56m (calculated as 0.8 × 0.7). So the revised earnings will be $8.4m + $0.56m = $8.96m.

The **current** EPS is $0.42, so the current P/E ratio is 3.5/0.42 = 8.333.

The new value of the shares can be estimated as $8.96m × 8.333 which is approximately $74.66m.

So, after subtracting the $11.2m invested in the rights issue, shareholders' wealth has become $74.66m – $11.2m = $63.46m.

This is a fall in shareholder wealth of $6.54m.

(b) The capital structure is considered to be optimal when the weighted average cost of capital (WACC) is at a minimum and the market value of a company is at a maximum. The goal of maximising shareholder wealth might be achieved if the capital structure is optimal.

The question of whether Grenarp Co might achieve its optimal capital structure following the rights issue can be discussed from a theoretical perspective by looking at the traditional view of capital structure, the views of Miller and Modigliani on capital structure, and other views such as the market imperfections approach. It is assumed that a company pays out all of its earnings as dividends, and that these earnings and the business risk of the company are constant. It is further assumed that companies can change their capital structure by replacing equity with debt, and vice versa, so that the amount of finance invested remains constant, irrespective of capital structure. The term 'gearing up' therefore refers to replacing equity with debt in the context of theoretical discussions of capital structure.

Traditional view

The traditional view of capital structure, which ignores taxation, held that an optimal capital structure did exist. It reached this conclusion by assuming that shareholders of a company financed entirely by equity would not be very concerned about the company gearing up to a small extent. As expensive equity was replaced by cheaper debt, therefore, the WACC would initially decrease. As the company continued to gear up, shareholders would demand an increasing return as financial risk continued to increase, and the WACC would reach a minimum and start to increase. At higher levels of gearing still, the cost of debt would start to increase, for example, because of bankruptcy risk, further increasing the WACC.

Views of Miller and Modigliani

Miller and Modigliani assumed a perfect capital market, where bankruptcy risk does not exist and the cost of debt is constant. In a perfect capital market, there is a linear relationship between the cost of equity and financial risk, as measured by gearing. Ignoring taxation, the increase in the cost of equity as gearing increases exactly offsets the decrease in the WACC caused by the replacement of expensive equity by cheaper debt, so that the WACC is constant. The value of a company is therefore not affected by its capital structure.

When Miller and Modigliani included the effect of corporate taxation, so that the after-tax cost of debt was used instead of the before-tax cost of debt, the decrease in the WACC caused by the replacement of expensive equity by cheaper debt was greater than the increase in the cost of equity, so that the WACC decreased as a company geared up. The implication in terms of optimal capital structure was that a company should gear up as much as possible in order to decrease its WACC as much as it could.

Market imperfections view

When other market imperfections are considered in addition to the existence of corporate taxation, the view of Miller and Modigliani that a company should gear up as much as possible is no longer true. These other market imperfections relate to high levels of gearing, bankruptcy risk and the costs of financial distress, and they cause the cost of debt and the cost of equity to increase, so that the WACC increases at high levels of gearing.

Grenarp Co

The question of whether Grenarp Co might achieve its optimal capital structure following the rights issue can also be discussed from a practical perspective, by considering if increasing the gearing of the company would decrease its WACC. This would happen if the marginal cost of capital of the company were less than its WACC. Unfortunately, there is no information provided on the marginal cost of capital of Grenarp Co, although its gearing is not high. Before the rights issue, the debt/equity ratio of Grenarp Co was 35% on a book value basis and 45% on a market value basis, while after the redemption of loan notes the debt/equity ratio would fall to 21% on a book value basis and 28% on a market value basis.

(c) Remember that the question only asked for three sources of long-term finance.

Bonds

Bonds are long-term debt capital raised by a company for which interest is paid, usually half yearly and at a fixed rate. Holders of bonds are therefore long-term payables for the company. Bonds issued by large companies are marketable, but bond markets are small. They can be issued in a variety of foreign currencies.

Deep discount bonds

Deep discount bonds are bonds or loan notes issued at a price which is at a large discount to the nominal value of the notes, and which will be redeemable at nominal value (or above nominal value) when they eventually mature. The coupon rate of interest will be very low compared with yields on conventional bonds with the same maturity. For a company with specific cash flow requirements, the low servicing costs during the currency of the bond may be an attraction, coupled with a high cost of redemption at maturity. The main benefit of deep discount bonds for a company is that the interest yield on the bonds is lower than on conventional bonds. However, it will have to pay a much larger amount at maturity than

it borrowed when the bonds were issued. Deep discount bonds defer much of the cost of the debt.

Convertible bonds

Convertible bonds are bonds that give the holder the right to convert to other securities, normally ordinary shares, at a predetermined price/rate and time. The coupon rate of interest is normally lower than on similar conventional bonds. They give the bondholders the right (but not an obligation) to convert their bonds at a specified future date into new equity shares of the company, at a conversion rate that is also specified when the bonds are issued. If the bonds are converted there can be a reduction in the gearing of the issuing company.

Long-term bank loan

A bank loan can be obtained with interest paid annually, bi-annually or quarterly at either a fixed rate or floating rate of interest. Bank loans are often secured and a bank may charge higher interest for an unsecured loan compared with a similar secured loan. Repayments usually include a capital element and an interest element, with the proportion of interest decreasing over time and the proportion of capital increasing over time.

219 Dinla Co

> **Workbook references.** Cost of capital is covered in Chapter 11. Islamic finance is covered in Chapter 9.
>
> **Easy marks.** There are easy marks for calculations in part (a) and you should score well in parts (b) and (c) if you have learnt the material on capital structure.
>
> **Examining team's comments.** Many candidates were able to calculate correctly the after-tax cost of debt of the loan notes by using linear interpolation, based on sensible cost of debt estimates such as 4% and 5%, although some candidates used extreme values such as 1% and 20%. These extreme values give a poor estimate of the cost of debt and should be discouraged. Some candidates incorrectly included the value of reserves when calculating the market value of equity.

Marking scheme

			Marks
(a)	Cost of equity	1	
	Cost of preference shares	1	
	Cost of loan notes	3	
	Cost of bank loan	1	
	Market values	1	
	WACC	1	
			8
(b)	Explanation of creditor hierarchy	1	
	Relative risks and costs of sources of finance	2	
			3
(c)	WACC and business risk	2	
	WACC and financial risk	2	
	CAPM and project-specific risk	1	
			5
(d)	1–2 marks for sharing of risk and reward and riba	2–4	
	Other relevant discussion	1–2	
		Maximum	4
			20

(a) **Cost of equity**

The dividend growth model can be used to calculate the cost of equity.

$K_e = ((0.25 \times 1.04)/4.26) + 0.04 = 10.1\%$

Cost of preference shares

$K_p = (0.05 \times 1.00)/0.56 = 8.9\%$

Cost of debt of loan notes

After-tax annual interest payment = $6 \times (1 - 0.25) = 6 \times 0.75 = \4.50 per year

Time	Cash flow $	5% discount	PV $	6% discount	PV $
0	(95.45)	1.000	(95.45)	1.000	(95.45)
1–5	4.50	4.329	19.48	4.212	18.95
5	100.00	0.784	78.40	0.747	74.70
			2.43		(1.80)

After-tax cost of debt of loan notes:

$K_d = 5 + (1 \times 2.43)/(2.43 + 1.0) = 5 + 0.57 = 5.6\%$

Alternatively IRR can be calculated using the =IRR spreadsheet function based on these cash flows:

Time	0	1	2	3	4	5
	(95.45)	4.5	4.5	4.5	4.5	104.5

This approach also gives an IRR of 5.6%

Cost of debt of bank loan

The after-tax fixed interest rate of the bank loan can be used as its cost of debt. This will be 5.25% (7 × 0.75). Alternatively, the after-tax cost of debt of the loan notes can be used as a substitute for the after-tax cost of debt of the bank loan.

Market values

	$'000
Equity: 4.26 × (23,000,000/0.25) =	391,920
Preference shares: 0.56 × (5,000,000/1.00) =	2,800
Loan notes: 95.45 × (11,000,000/100) =	10,500
Bank loan	3,000
	408,220

After-tax weighted average cost of capital (WACC)

Using the formula from the formula sheet:

$$WACC = \left[\frac{V_e}{V_e + V_d}\right]k_e + \left[\frac{V_d}{V_e + V_d}\right]k_d$$

WACC = (391,920/408,220)10.1% + (2,800/408,220)8.9% + (10,500/408,220)5.6% + (3,000/408,220)5.25% = **9.90%**

(b) The creditor hierarchy refers to the order in which financial claims against a company are settled when the company is liquidated.

The hierarchy, in order of decreasing priority, is secured creditors, unsecured creditors, preference shareholders and ordinary shareholders. The risk of not receiving any cash in a liquidation increases as priority decreases. Secured creditors (secured debt) therefore face the lowest risk as providers of finance and ordinary shareholders face the highest risk.

The return required by a provider of finance is related to the risk faced by that provider of finance. Secured creditors therefore have the lowest required rate of return and ordinary shareholders have the highest required rate of return. The cost of debt should be less than the cost of preference shares, which should be less than the cost of equity.

(c) The current WACC of a company reflects the required returns of existing providers of finance.

The cost of equity and the cost of debt depend on particular elements of the existing risk profile of the company, such as business risk and financial risk. Providing the business risk and financial risk of a company remain unchanged, the cost of equity and the cost of debt, and hence the WACC, should remain unchanged.

In investment appraisal, the discount rate used should reflect the risk of investment project cash flows. Therefore, using the WACC as the discount rate will only be appropriate if the investment project does not result in a change in the business risk and financial risk of the investing company.

One of the circumstances which is likely to leave business risk unchanged is if the investment project were an expansion of existing business activities. WACC could therefore be used as the discount rate in appraising an investment project which looked to expand existing business operations.

However, business risk depends on the size and scope of business operations as well as on their nature, and so an investment project which expands existing business operations should be small in relation to the size of the existing business.

Financial risk will remain unchanged if the investment project is financed in such a way that the relative weighting of existing sources of finance is unchanged, leaving the existing capital structure of the investing company unchanged. While this is unlikely in practice, a company may finance investment projects with a target capital structure in mind, about which small fluctuations are permitted.

If business risk changes as a result of an investment project, so that using the WACC of a company in investment appraisal is not appropriate, a project-specific discount rate should be calculated. The capital asset pricing model (CAPM) can be used to calculate a project-specific cost of equity and this can be used in calculating a project-specific WACC.

(d) Wealth creation in Islamic finance requires that risk and reward, in terms of economic benefit, are shared between the provider of finance and the user of finance. Economic benefit includes wider economic goals such as increasing employment and social welfare.

Conventional finance, which refers to finance which is not based on Islamic principles and which has historically been used in the financial system, does not require the sharing of risks and rewards between the provider of finance (the investor) and the user of finance. Interest (riba) is absolutely forbidden in Islamic finance and is seen as immoral. This can be contrasted with debt in conventional finance, where interest is seen as the main form of return to the debt holder, and with the attention paid to interest rates in the conventional financial system, where interest is the reward for depositing funds and the cost of borrowing funds.

Islamic finance can only support business activities which are acceptable under Sharia law. Murubaha and sukuk are forms of Islamic finance which can be compared to conventional debt finance. Unlike conventional debt finance, however, murubaha and sukuk must have a direct link with underlying tangible assets.

220 Tufa Co

Workbook references. Cost of capital is covered in Chapter 11.

Top tips. This question contains a couple of areas where candidates may get stuck - for example calculating the current dividend, and the cost of the bank loan. In such a case you will have to make a reasonable assumption (eg assuming the cost of the bank loan is the same as the cost of the redeemable debt) in order to make progress. This will be more impressive to the markers than ignoring the issue (eg ignoring the bank loan entirely).

Easy marks. Easy marks are available in parts (b) and (c).

Examining team's comments. In part (b) too many responses simply said 'the WACC can be used if business and financial risk are unchanged' without further development. Whilst correct, the statement needs further discussion.

In part (c) it should be noted that if three advantages are required, then discussing a fourth or even fifth advantage is both poor examination techniques and poor time management.

Marks

(a)	Dividend for 20X7	1	
	Dividend growth rate	1	
	Cost of equity	1	
	Cost of pref shares	1	
	After-tax interest	1	
	Kd calculation setup	1	
	Calculating Kd	1	
	Cost of bank loan	0.5	
	MV ordinary shares	0.5	
	MV pref shares	0.5	
	MV loan notes	0.5	
	WACC calculations	2	
			11
(b)	Business risk	1	
	Financial risk	1	
	Size on investment	1	
			3
(c)	First advantage	2	
	Second advantage	2	
	Third advantage	2	
			6
			20

(a)

Interest rate of loan notes (%)	7	
Nominal value of loan notes ($)	100.00	
Market price of loan notes ($)	102.34	
Time to redemption (year)	4	
Redemption premium (%)	5	
Tax rate (%)	30	

Year	Item	$	5% DF	PV ($)	6% DF	PV ($)
0	MV	(102.34)	1.000	(102.34)	1.000	(102.34)
1–4	Interest	4.90	3.546	17.38	3.465	16.98
4	Redeem	105.00	0.823	86.42	0.792	83.16
				1.45		(2.20)

IRR (%) 5 + (1.45/(1.45 + 2.20)) = 5.40

Alternatively IRR can be calculated using the =IRR spreadsheet function based on these cash flows:

Time	0	1	2	3	4
	(102.34)	4.9	4.9	4.9	109.9

This approach also gives an IRR of 5.4%

Cost of bank loan (%) = 5.40 (assumed)

The total market value of the loan notes = $10m × 102.34/100 = $10.234m

Cost of preference shares = dividend/market price = (0.05 × $0.50)/$0.31 = 8.06%

The total market value of the preference shares = $5m/$0.5 nominal value × $0.31 market value = $3.1m.

Cost of ordinary shares using

$$r_e = \frac{D_0(1+g)}{P_0} + g$$

The current dividend can be calculated as the difference between the ex div and the cum div share price: $7.52 − $7.07 = $0.45.

Annual growth over 4 time periods between 20X3 and 20X7 is $\left(\dfrac{0.45}{0.37}\right)^{\frac{1}{4}} - 1 = 5\%$

Po = the ex div share price of $7.07

So cost of equity = $\dfrac{0.45 \times 1.05}{7.07} + 0.05 = 0.117$ or 11.7%

There are 24m ordinary shares ($12m/$0.5 nominal value), so Ve = 24m shares × $7.07 = $169.68m

Total capital employed using market values = $10.234 loan notes + $3m bank loan + $3.1m preference shares + $169.68m ordinary shares = $186.014m

Overall WACC = (11.7 × 169.68/186.014) + (8.1 × 3.1/186.014) + (5.40 × 10.234/186.014) + (5.4 × 3/186.014) = **11.19%**

(b) The current WACC of Tufa Co represents the mean return required by the company's investors, given the current levels of business risk and financial risk faced by the company.

The current WACC can be used as the discount rate in appraising an investment project of the company provided that undertaking the investment project does not change the current levels of business risk and financial risk faced by the company.

The current WACC can therefore be used as the discount rate in appraising an investment project of Tufa Co in the same business area as current operations, for example, an expansion of current business, as business risk is likely to be unchanged in these circumstances.

Similarly, the current WACC can be used as the discount rate in appraising an investment project of Tufa Co if the project is financed in a way that mirrors the current capital structure of the company, as financial risk is then likely to be unchanged.

The required return of the company's investors is likely to change if the investment project is large compared to the size of the company, so the WACC is likely to be an appropriate discount rate providing the investment is small in size relative to Tufa Co.

(c) The following advantages of using convertible loan notes as source of long-term finance could be discussed.

Conversion rather than redemption

If the holders of convertible loan notes judge that conversion into ordinary shares will increase their wealth, conversion of the loan notes will occur on the conversion date and Tufa Co will not need to find the cash needed to redeem the loan notes. This is sometimes referred to as 'self-liquidation'.

Lower interest rate

The option to convert into ordinary shares has value for investors as ordinary shares normally offer a higher return than debt. Investors in convertible loan notes will therefore accept a lower interest rate than on ordinary loan notes, decreasing the finance costs for the issuing company.

Debt capacity

If Tufa Co issued convertible loan notes, its gearing and financial risk will increase and its debt capacity will decrease. When conversion occurs, its gearing and financial risk will decrease and its debt capacity will increase because of the elimination of the loan notes from its capital structure. However, there will a further increase in debt capacity due to the issue of new ordinary shares in order to facilitate conversion.

Attractive to investors

Tufa Co may be able to issue convertible loan notes to raise long-term finance even when investors might not be attracted by an issue of ordinary loan notes, because of the attraction of the option to convert into ordinary shares in the future.

Facilitates planning

It has been suggested than an issue of fixed-interest debt such as convertible loan notes can be attractive to a company as the fixed nature of future interest payments facilitates financial planning.

221 Tin Co

Workbook references. Rights issues and Islamic finance are covered in Chapter 9; the impact of using debt finance is covered in Chapter 12. Use of the P/E ratio to value shares is covered in Chapter 13.

Top tips. You need to recognise that changing the type of finance potentially affects the interest paid, and therefore the tax paid, and also the number of shares in issue; all of which will impact on EPS.

Easy marks. There are easy marks available for the discussion in part (b) if the relevant types of Islamic finance that are equivalent to a rights issue and a loan note issue are discussed.

Examining team's comments. In part (a) answers 'were of variable quality and the requirement to 'use calculations to evaluate' was sometimes ignored. As the requirement indicted that evaluation and discussion had to be based on calculations, answers offering only discussion were not appropriate, for example general discussion of the relative risk and cost of equity and debt, or of the creditor hierarchy'.

Marking scheme

			Marks	
(a)	(i)	Rights issue price	1	
		Theoretical ex-rights price	1	
				2
	(ii)	Increased PBIT	0.5	
		Revised PBT	0.5	
		Revised PAT	1	
		Number of shares	1	
		Revised EPS	1	
				4
	(iii)	Increased interest	1	
		Revised PAT	1	
		Revised EPS	1	
				3
	(iv)	Equity share price	0.5	
		Debt share price	0.5	
				1
	(v)	Financial analysis	1	
		Gearing	1	
		Interest cover	1	
		Share price effects	1	
				4
(b)		First finance source	2–4	
		Second finance source	2–4	
		Maximum		6
				20

(a) (i)

Currently	2.5 million shares	@$5	= $12.5 million value
Rights issue	0.5 million shares	@$4	= $2 million
After rights issue	3 million shares		$14.5 million value

TERP = $14.5m/3m = $4.83

(ii)

	$'000	Notes
Increased PBIT	1,916	Increase of 20% on 1,597
Finance costs (interest)	(315)	
Revised profit before tax	1,601	
Taxation at 22%	(352)	
Revised profit after tax	1,249	
Total number of shares	3,000,000	1 for 5 rights issue, so 500,000 extra shares
Total number of shares	0.42 (1,249/3,000)	

(iii)

	$'000	
Increased PBIT	1,916	
Finance costs (interest)	(475)	Extra interest of $2m × 0.06 = $160,000
Revised profit before tax	1,441	
Taxation at 22%	(317)	
Revised profit after tax	1,124	
Total number of shares	2,500,000	
Revised EPS ($/share) using debt	0.45 (1,124/2,500)	

(iv) Revised share prices ($/share)

Using equity = 12.5 × 0.42 = 5.25

Using debt = 12.5 × 0.45 = 5.63

(v) **Gearing**

$'000	Current	Equity finance raised	Debt finance raised
Book value of debt	4,500	4,500	4,500 + 2,000 = 6,500
Book value of equity	2,500 + 5,488 = 7,988	7,988 + 2,000 = 9,988	7,988
Debt/equity ratio	4,500/7,988 = 56.3%	4,500/9,988 = 45.1%	6,500/7,988 = 81.4%

Sector average D/E using BV = 60.5%

The gearing of Tin Co at 56.3% is just below the sector average gearing of 60.5%. If equity finance were used, gearing would fall even further below the sector average at 45.1%. If debt finance were used, gearing would increase above the sector average to 84.4%, this may concern shareholders.

Interest cover

$'000	Current	Equity finance raised	Debt finance raised
PBIT	1,597	1,916	1,916
Interest	315	315	315 + 160 = 475
Interest cover	1,597/315 = 5.1	1,916/315 = 6.1	1,916/475 = 4.0

Sector average interest cover = 9 times

Interest cover calculations show that raising equity finance would make the interest cover of Tin Co look much safer. When debt finance is used, interest cover of 4·0 times looks quite risky compared to the sector average.

Share price changes

The shareholders of Tin Co experience a capital gain of $0.63 per share compared to the current share price ($5.63 – $5.00) if debt finance is used, compared to a capital gain of $0.42 per share compared to the TERP ($5.25 – $4.83) if equity finance is used.

Although using debt finance looks more attractive, it comes at a price in terms of increased financial risk. It might be decided, on balance, that using equity finance looks to be the better choice.

(b) The forms of Islamic finance equivalent to a rights issue and a loan note issue are mudaraba and sukuk respectively; although Ijara, which is similar to lease finance, might be an alternative to a loan note issue, depending on the nature of the planned business expansion.

Musharaka is similar to venture capital and hence is not seen as equivalent to a rights issue, which is made to existing shareholders.

Mudaraba

A mudaraba contract is between a capital partner and an expertise partner (the manager) for the undertaking of business operations. The business operations must be compliant with Sharia'a law and are run on a day-to-day basis by the manager. The provider of capital has no role in relation to the day-to-day operations of the business. Profits from the business operations are shared between the partners in a proportion agreed in the contract. Losses are borne by the provider of capital alone, as provider of the finance, up to the limit of the capital provided.

Sukuk

Conventional loan notes are not allowed under Sharia'a law because there must be a link to an underlying tangible asset and because interest (riba) is forbidden by the Quran. Sukuk are linked to an underlying tangible asset, ownership of which is passed to the sukuk holders, and do not pay interest.

Since the sukuk holders take on the risks and rewards of ownership, sukuk also has an equity aspect. As owners, sukuk holders will bear any losses or risk from the underlying asset. In terms of rewards, sukuk holders have a right to receive the income generated by the underlying asset and have a right to dismiss the manager of the underlying asset, if this is felt to be necessary.

Ijara

In this form of Islamic finance, the lessee uses a tangible asset in exchange for a regular rental payment to the lessor, who retains ownership throughout the period of the lease contract. The contract may allow for ownership to be transferred from the lessor to the lessee at the end of the lease period.

Major maintenance and insurance are the responsibility of the lessor, while minor or day-to-day maintenance is the responsibility of the lessee. The lessor may choose to appoint the lessee as their agent to undertake all maintenance, both major and minor.

[**Note** – only two types of finance need to be discussed]

OTQ bank – Business valuations

222 The correct answer is: **To evaluate a takeover bid by Company X which is offering to buy ML Ltd in exchange for shares in Company X.**

The first option is only valid if the company is listed.

The second and fourth options are unlikely because both imply that an asset value will be used and this is unlikely for a service company where most of its assets will be intangible.

Syllabus area F1(a)

223 The correct answer is: **$2.10**

Net asset value (NAV) = 140m – 15m – 20m = $105m

Number of ordinary shares = 25m/0.5 = 50m shares

NAV per share = 105m/50m = $2.10 per share

Syllabus area F2(a)

224 The correct answer is: **$23.41**

$$P_0 = \frac{D_0(1+g)}{(r_e - g)}$$

(Given on the formula sheet)

Growth 'g' – Dividends grew from ($0.50 – $0.10) = $0.40 to $0.50 in 3 years. This is an average annual growth rate of:

$0.40 (1 + g)^3 = $0.50

$(1 + g) = \sqrt[3]{(0.5/0.4)}$

g = 0.077 = 7.7%

$$P_0 = \frac{\$0.50\,(1+0.077)}{(0.10 - 0.077)} = \$23.41$$

Syllabus area F2(c)

225 The correct answer is: **$6.11**

Share price = (0.826 × 0.5)/(0.1 – 0.03) + (0.25 × 0.826) = $6.11 per share

The dividend valuation model states that the ex dividend market value of an ordinary share is equal to the present value of the future dividends paid to the owner of the share. No dividends are to be paid in the current year and in Year 1, so the value of the share does not depend on dividends from these years. The first dividend to be paid is in Year 2 and this dividend is different from the dividend paid in Year 3 and in subsequent years. The present value of the Year 2 dividend, discounted at 10% per year, is (0.25 × 0.826) = $0.2065.

The dividends paid in Year 3 can subsequently be valued using the dividend growth model. By using the formula P0 = D1/(re – g) we can calculate the present value of the future dividend stream beginning with $0.50 per share paid in Year 3. This present value will be a Year 2 value and will need discounting for two years to make it a Year 0 present value.

P0 = (0.826 × 0.5)/(0.1 – 0.03) = 0.826 × 7.1429 = $5.90

$5.90 + 0.2065 = $6.11

Syllabus area F2(c)

BPP
LEARNING
MEDIA

226 The correct answer is: **$672m**

g = br.

g = 0.2 × 0.6 = 0.12

$$MV = \frac{D_0(1+g)}{k_e - g} = \frac{60m \times 1.12}{0.22 - 0.12} = \$672m$$

Syllabus area F2(b)

227 The correct answer is: **Gamma Co is a direct competitor of Alpha Co**

By eliminating a competitor, there is synergy potential for Alpha meaning they would be prepared to pay more for Gamma than Beta would, therefore this statement is correct.

Notes on incorrect answers:

If Alpha Co used more prudent growth estimates, this would reduce the value of Gamma Co.

If Beta Co could achieve more synergy, this would increase the value that Beta Co has placed on the company.

Negotiation skills will determine the final price paid for Gamma Co, not the initial valuation.

Syllabus area F1(a)

228 The correct answer is: **$55**

Discounting the interest of $5 per year at a required return of 10% to perpetuity = $5 × 1/0.1 = present value $50.

In addition a payment of $5 is about to be received

So total present value = $50 + $5 = $55.

Notes on incorrect answers:

$50 is obtained if the imminent interest payment is ignored

$76 is obtained if the post-tax cost of debt is used as the discount factor (which is incorrect because we are calculating the market value of the debt to the investor)

$40 is obtained if the post-tax interest ($5 × 0.7 = $3.5) is used, again this is incorrect because we are calculating the market value of the debt to the investor.

Syllabus area F3(a)

229 The correct answer is: **$92.67**

Discounting the future cash flows at the required return of 9% gives:

[7 × AF_{1-7} 9%] + [105 × DF_7 9%] = 0

[7 × 5.033] + [105 × 0.547] = 0

∴ current MV = $92.67

Syllabus area E2(b)

230 The correct answer is: **$96.94**

Market value = (6 × 5.971) + (105 × 0.582) = 35.83 + 61.11 = $96.94

231 The correct answer is: **$114m**

Should NCW Co purchase CEW Co it will acquire a cash flow of ($10 + 2) = $12m per year, assuming that CEW Co invests the $6m in new machinery. (**Note.** It should do this as its net present value = $2m/0.1 − $6m = $14m.)

Therefore the value would be: $12m/0.1 − $6m = $114m. Note the $12m is a perpetuity.

Syllabus area F2(c)

OTQ bank – Market efficiency

232 The correct answer is: **A strong form efficient market**

As share price reaction appears to have occurred before the information concerning the new project was made public, this suggests a strong form efficient market (and quite possibly insider dealing) because in a strong form efficient market the share price reflects even privately held information.

Syllabus area F4(a)

233 The correct answer is: **Estimates of the present value of the synergies that are likely to result from the takeover**

If PX Co pays more for the whole of JJ Co than its current value + present value of synergies then it will have paid a price at which the investment generates a negative net present value for its shareholders.

Notes on incorrect answers:

No information is incorrect because the current share price of JJ Co is the **minimum** value of JJ Co, and ignores the value of potential synergies.

An aged accounts receivables summary is unlikely given that most retailers sell for cash/credit card.

The latest statement of financial position is more relevant for calculating a minimum value than for a maximum value.

Syllabus area F1(a)

234 The correct answer is: **Completely inefficient**

In a weak form efficient market, all investors know previous share price movements, which will stop patterns consistently and predictably repeating. Sarah must therefore believe the markets are not even weak form efficient.

Syllabus area F4(a)

235 The correct answer is: **The majority of share price reaction to news occurs when it is announced.**

'Repeating patterns appear to exist' supports the view that markets are completely inefficient.

'Attempting to trade on consistently repeating patterns is unlikely to work' supports the view that markets are weak form efficient.

'The majority of share price reaction to news occurs when it is announced' supports the view that markets are semi-strong form efficient because in such a market share prices reflect publicly available information, but not privately held information. Share price will therefore not reflect information before it is announced.

'Share price reaction occurs before announcements are made public' supports the view that markets are strong form efficient: they reflect all available information including that which is privately held.

Syllabus area F4(a)

236 The correct answer is: **The lack of regulation on use of private information (insider dealing), inability to consistently outperform the market and make abnormal gains.**

In a strong form efficient market, insider dealing regulations would not be necessary as all private information is reflected in the share price anyway.

The market can still be outperformed by individual investors, but only by luck and not consistently.

BPP
LEARNING
MEDIA

Share prices will not react to the public announcement as the private information will already be known as the share price would react to the initial decision instead.

There would be no need for quick announcement as the information will already be known and reflected in the share price.

Syllabus area F4(a)

Bluebell Co

237 The correct answer is: **$365.8m**

Net realisable value = 1,350 − (768 − 600) − (192 × 0·1) − 30 − 105 − 662 = $365.8m

Syllabus area F2(a)

238 The correct answer is: **$1,875m**

Earnings yield = 100 × 1/12·5 = 8%

Value = 150/0.08 = $1,875m

Syllabus area F2(b)

239 The correct answer is: **An asset based valuation would be useful for an asset-stripping acquisition**

Notes on incorrect answers:

The workforce are an intangible asset cannot be valued

Cash based valuations discount the value of future cash flows

Replacement costs do not measure deprival value

Syllabus area F1(a)

240 The correct answer is: **Both 1 and 2**

In a perfect market shares are regularly traded, and investors are rational.

Syllabus area F4(a)

241 The correct answer is: **Bluebell will have to pay a higher price to take control of Dandelion**

A control premium will be paid when buying a controlling stake.

Notes on incorrect answers:

Scrip dividends are paid in shares and therefore do not reduce liquidity.

Unlisted company shares are harder to value and generally trade at a discount to a similar listed company's shares.

Syllabus area F4(b)

GWW Co

242 The correct answer is: **$160m**

Market capitalisation = number of shares × market value
 = ($20m/$0.5) × $4.00 = $160m

Syllabus area F2(b)

243 The correct answer is: **$61.7m**

The net realisable value of assets at liquidation = non-current assets + inventory + trade receivables − current liabilities − bonds

= $86m + $4.2m + ($4.5m × 80%) − $7.1m − $25m

= $61.7m

Syllabus area F2(a)

244 The correct answer is: **$171.7m**

Historic earnings based on 20X2 profit after tax = $10.1m

Average P/E ratio in industry = 17 times

P/E ratio value = 17 × $10.1m = $171.7m

Syllabus area F2(b)

245 The correct answer is: **Technical analysis**

Technical analysts work on the basis that past price patterns will be repeated, so that future price movements can be predicted from historical patterns.

Syllabus area F4(a)

246 The correct answer is: **Earnings yield of GWW P/E is lower, earnings yield is higher**

For GWW Co, P/E = 15, Earnings yield (= 1/(P/E ratio) = 6.7%.

For its competitor, P/E (= 1/earnings yield) = 16, Earnings yield = 6.25%.

Syllabus area F2(b)

Corhig Co

247 The correct answer is: **$15m**

The value of the company can be calculated using the P/E ratio valuation as:

Expected future earnings × P/E ratio

Using Corhig Co's forecast earnings for Year 1, and taking the average P/E ratio of similar listed companies, Corhig Co can be valued at $3m × 5 = $15m.

Syllabus area F2(b)

248 The correct answer is: **Statement 1 is true and statement 2 is false.**

The valuation above does not take into consideration the fact that earnings are expected to rise by 43% over the next 3 years. Instead of using Year 1 earnings, we could use average expected earnings over the next 3 years of $3.63m. This would give us a more appropriate valuation of $18.15m.

The P/E ratio of 5 is taken from the average of similar listed companies. However, P/E ratios vary from company to company depending on each company's business operations, capital structures, gearing, and markets. The ratio used here is therefore subject to a high degree of uncertainty. An inaccurate P/E ratio would call the valuation into question, as it is so crucial to the calculation.

Corhig Co is listed, so it would be much more appropriate to use the company's own current P/E ratio instead.

Syllabus area F2(b)

249 The correct answer is: **$398,500**

PV of Year 2 dividend = 500,000 × 0.797 = **$398,500** (using cost of capital of 12%)

Syllabus area F2(c)

250 The correct answer is: **10.32%**

After-tax cost of debt = 6 × (1 − 0.2) = 4.8%

Revised after-tax WACC = 14 × 60% + 4.8 × 40% = 10.32%

Syllabus area E2(c)

251 The correct answer is: **Risk linked to the extent to which the company's profits depend on fixed, rather than variable, costs is business risk.**

Risk that shareholder cannot mitigate by holding a diversified investment portfolio is **systematic risk.**

Risk that shareholder return fluctuates as a result of the level of debt the company undertakes is **financial risk.**

<div align="right">Syllabus area E2(a)</div>

Close Co

252 The correct answer is: **$490m**

Net assets

As no additional information is available, this is based on book values.

Net assets = 720 − 70 − 160 = $490 million

<div align="right">Syllabus area F2(a)</div>

253 The correct answer is: **$693m**

Dividend growth model

Dividends are expected to grow at 4% per year and the cost of equity is 10%.

$$P_0 = \frac{40 \times 1.04}{0.10 - 0.04}$$

$$= 41.6/0.06$$

$$= \$693 \text{ million}$$

<div align="right">Syllabus area F2(c)</div>

254 The correct answer is: **$605.5 million**

Earnings yield

Earnings are the profit after tax figure of $66.6m and the earnings yield that can be used for the valuation is 11%, ie 66.6/0.11 = $605.5m.

<div align="right">Syllabus area F2(b)</div>

255 The correct answer is: **Both statements are true.**

The DGM is very sensitive to changes in the growth rate. A 1% change in the growth rate can give a significantly different valuation.

If dividends are expected to be paid at some point in the future, the DGM can be applied at that point to create a value for the shares which can then be discounted to give the current ex dividend share price.

In a situation where dividends are not paid and are not expected to be paid the DGM has no use.

<div align="right">Syllabus area F2(c)</div>

256 The correct answer is: **The sum of the present values of the future interest payments + the present value of the bond's conversion value**

<div align="right">Syllabus area F3(a)</div>

WAW Co

257 The correct answer is: **$7.55**

$$g = \left(\frac{\text{latest dividend}}{\text{earliest dividend}}\right)^{\frac{1}{\text{time period}}}$$

$$g = \left(\frac{3}{2.4}\right)^{\frac{1}{3}} - 1 = 0.0772$$

$$P_0 = \frac{3 \times 1.0772}{0.12 - 0.0772}$$

$$= \$75.5m$$

Divided by 10 million shares this gives = $7.55/share

Answer A is obtained if you assume that growth has taken place over four years.

Answer B is obtained if you forget to increase the dividend by the growth rate and use four years.

Answer D is obtained if you use the wrong number of shares.

<div align="right">Syllabus area F2(c)</div>

258 The correct answer is: **1, 3 and 4**

The cost of equity can be estimated for an unlisted company

(for example using CAPM based on the beta of a listed company).

<div align="right">Syllabus area F2(c)</div>

259 The correct answer is: **$11.25 per share**

Earnings $7.5m × P/E 15 = Value of $112.5m

There are 10 million shares in issue so this is $112.5/10 = $11.25 per share

<div align="right">Syllabus area F2(b)</div>

260 The correct answer is: **The company is expected to grow**

Assuming an efficient stock market, the high share price indicates confidence in future growth.

<div align="right">Syllabus area F2(b)</div>

261 The correct answer is: **1, 2 and 3**

Indifference between dividend and capital growth would be indicated by a more erratic dividend policy. Also, dividend irrelevancy theory assumes no tax, which is not the case here.

<div align="right">Syllabus area E1(e)</div>

DFE Co

262 The correct answer is: **Traditional view**

The traditional view assumes there is an optimal balance between debt and equity (there is a 'U' shaped weighted average cost of capital (WACC) curve) hence choosing finance to aim for the optimum suggests the traditional view is adopted.

Modigliani-Miller (no tax) concludes the WACC is unaffected by the finance decision hence the choice of debt compared to equity is irrelevant.

Modigliani-Miller (with tax) concludes that due to the tax benefits of paying interest, as much finance as possible should be in the form of debt as increasing gearing will reduce the WACC. Hence equity would never be chosen.

Residual view/theory is not directly relevant to the capital structure decision. This term more directly relates to dividend policy.

263 The correct answer is: **Semi-strong form efficient**

Share price in a semi-strong form market reflects all publicly available information, but not privately held information. Thus the majority of share price reaction occurs to and around public announcements.

264 The correct answer is: **$96.40**

The conversion value is $100 cash or 70 shares, whichever is worth more (as conversion is at the investor's option). The share price on conversion is predicted to be $1.25 \times (1.04)^5 = $1.52, hence if converted the shares would be worth $70 \times \$1.52 = \106.40. As this is more than the cash alternative ($100) investors would choose to convert, the conversion value = $106.40.

The investor pays market price, and they receive the pre-tax interest hence the pre-tax cost of debt is used to value the loan note:

Time		Cash flow $	Discount factor 10%	Present value $
1–5	Interest	8% × $100 = $8	3.791	30.33
5	Conversion value	$106.4	0.621	66.07
				96.40

265 The correct answer is: **Forward rate agreements are the interest rate equivalent of forward exchange contracts.**

Statement 1 is **incorrect**: Although futures are flexible with timing, they are for standardised amounts which may therefore not match the size of the hedge needed exactly.

Statement 2 is **incorrect**: Options afford the holder the right but not the obligation to exercise an option. They can be allowed to lapse. In the case of exchange traded options they can also be sold on mid-term.

Statement 3 is **correct**: A forward rate agreement (FRA) creates an obligation for a 'top-up' payment or receipt. In the case of a loan, when the FRA payment is added to the underlying loan interest payment, the net interest payment is fixed at the FRA rate.

Statement 4 is **incorrect**: The statement refers to smoothing (a mix of fixed and floating rates to make effective interest rates less variable). Matching – generally employed by banks – refers to matching interest rates on assets to the interest rate on liabilities.

266 The correct answer is: **1 and 2 only**

Statement 1: Increased uncertainty will increase the preference for liquidity, and will increase required yields into the future.

Statement 2: If the markets feel interest rates are going to rise, the required return on longer dated bonds will increase in line with these expectations.

Statement 3 is **false**. This will lead to the curve flattening.

OTQ bank – Foreign currency risk

267 The correct answer is: **Transaction risk**

Transaction risk refers to the fact that the spot rate may move between point of sale (denominated in foreign exchange) and when the customer pays, such that the net domestic receipt differs from expected.

Notes on incorrect answers:

Translation risk is a financial reporting implication of retranslating foreign assets/liabilities and not immediately related to cash.

Economic risk is the impact on business value of long-term exchange rate trends.

Credit risk is the risk that the customer fails to pay.

Syllabus area G1(a)

268 The correct answer is: **€417**

A strengthening euro means euros are getting more expensive: they will cost more dollars.

The exchange rate becomes €1:$2.40 ($2 × 1.2)

The euro receipt will be $1,000/2.4 = €416.67 (€417 to the nearest euro).

Note that in the exam the exchange rate is normally given to the $, but you need to be prepared to deal with a situation like this where this is not the case.

Syllabus area G1(a)

269 The correct answer is: **$2,312**

The forward rate for the euro is 0.8500 – 0.8650 to the $.

The rate for buying dollars (selling euros) will be the more expensive/higher rate. Converting into $s will result in there being more dollars than euros. So 2,000/0.8650 = $2,312.

The other answers are a result of using the wrong side of the spread and/or multiplying by the forward rate.

Syllabus area G3(a)

270 The correct answer is: **Futures contract and exchange traded option (1 and 2)**

Derivative hedging instruments that are traded on an exchange or market are standardised in nature. Futures contracts, whether interest rate futures or currency futures, relate to a standard quantity of an underlying asset. Exchange-traded options, by definition, are traded on an exchange and are therefore standardised in nature, whether interest rate options or currency options. A forward rate agreement (FRA) is the interest rate equivalent of a forward exchange contract (FEC). It is an agreement between a bank and a customer to fix an interest rate on an agreed amount of funds for an agreed future period. The FRA is tailored to the customer's needs and so is a bespoke contract rather than a standardised contract. Answers B and C were therefore not correct.

Both currency swaps and interest rate swaps are derivatives that are available to organisations to manage or hedge long-term foreign currency risk and interest rate risk. They are essentially an agreement between two counterparties to exchange interest rate obligations on an agreed amount of funds, whether in the domestic currency or in a foreign currency. A bank will usually act as an intermediary in arranging a swap in exchange for a fee and can even arrange a swap where no counterparty is immediately available. Swaps are therefore tailored to customers' needs and are not standardised in nature. Answers C and D were therefore not correct.

Syllabus area G3(c) & G4(b)

271 The correct answer is: **$7,122,195**

The US company should borrow US$ immediately and send it to Europe. It should be left on deposit in € for three months then used to pay the supplier.

The amount to put on deposit today = €3.5m × 1/(1 + (0.01/4)) = €3,491,272.

This will cost €3,491,272 × $2 = $6,982,544 today (note $2 is the worst rate for buying €).

Assuming this to be borrowed in US$, the liability in 3 months will be:

$6,982,544 × [1 + (0.08/4)] = $7,122,195.

<div align="right">Syllabus area G3(a)</div>

272 The correct answer is: **They are only available in a small amount of currencies and They may be an imprecise match for the underlying transaction**

They are only available in a small amount of currencies. They are probably an imprecise match for the underlying transaction.

Statement 1: **False.** Futures contracts are subject to a brokerage fee only (for example there is no spread on the rate) so are relatively cheap.

Statement 2: **True.** It is not possible to purchase futures contracts from every currency to every other currency – there are only limited combinations available.

Statement 3: **False.** Futures contracts can be 'closed out' so if, for example, customers pay early or late, the timing of the futures hedge can accommodate this.

Statement 4: **True.** Futures contracts are for standardised amounts so may not match the size of the transaction being hedged precisely.

<div align="right">Syllabus area G3(a)</div>

273 The correct answer is: **$32,500**

The borrowing interest rate for 6 months is 8%/2 = 4%.

The company should borrow 500,000 pesos/1.04 = 480,769 today. After 6 months, 500,000 pesos will be repayable, including interest.

These pesos will be converted to $ at 480,769/15 = $32,051. The company must deposit this amount for 6 months, when it will have increased in value with interest.

$32,051 × (1 + (0.03/2)) = $32,532 or $32,500 to the nearest $100.

<div align="right">Syllabus area G3(a)</div>

274 The correct answer is: **2.0198**

Using interest rate parity:

$$F_0 = S_0 \times \frac{(1 + i_c)}{(1 + i_b)}$$

The quarterly rates are: Country P: 8%/4 = 2%; Country A 4%/4 = 1%

Forward rate = 2 × 1.02/1.01 = 2.0198

<div align="right">Syllabus area G2(b)</div>

275 The correct answer is: **Handria has a higher nominal rate of interest than Wengry.**

The stronger forward value of the $ implies that interest rates are lower in Wengry than in Handria. This will be due to lower inflation in Wengry according to the International Fisher Effect.

Notes on incorrect answers:

The International Fisher Effect assumes that real interest rates are the same.

The 4th option is incorrect according to expectations theory (linked to the International Fisher Effect according to four-way equivalence).

<div align="right">Syllabus area G2(a)</div>

276 The correct answer is: **€1.418 per $1**

Twelve-month forward rate = 1.415 × (1.02/1.018) = €1.418 per $1

This is the rate that will be offered on the forward market to prevent a risk free gain being made.

Syllabus area G2(b)

OTQ bank – Interest rate risk

277 The correct answer is: **The second and third statements are correct**

The forward rate agreement (FRA) to be a purchased by a borrower must reflect the period to the commencement of the borrowing and the cessation of the borrowing- hence here the appropriate FRA would be a 3 v 9 FRA.

With respect to futures, to hedge against interest rate increases, interest rate futures should be sold now.

Syllabus area G4(a)

278 The correct answer is: **1, 2 and 3**

Statement 1 – **correct**: interest rates will be influenced by the desire of investors to receive a return that is above the rate of inflation.

Statement 2 – **correct**: market segmentation theory argues that the interest rate will be affected by demand for assets in different segments of the market (short/medium/long-term).

Statement 3 – **correct**, interest rate expectations will affect the slope of the yield curve.

Syllabus area G2(c)

279 The correct answer is: **An inverted yield curve can arise if government policy is to keep short-term interest rates high in order to bring down inflation.**

The term structure of interest rates suggests that the yield curve normally slopes upwards, so that debt with a longer term to maturity has a higher yield than short-term debt. Occasionally, the yield curve can be inverted, indicating that the yield on short-term debt is higher than the yield on longer-term debt. One of the reasons why this can happen is because government policy has increased short-term interest rates with the objective of reducing inflation, an action which falls in the area of monetary policy.

The incorrect responses are now considered.

Liquidity preference theory suggests that investors want more compensation for short-term lending than for long-term lending.

Liquidity preference theory seeks to explain the shape of the yield curve. It suggests that investors prefer to have cash now, rather than lending cash to borrowers, and that they prefer to have their cash returned to them sooner rather than later. The compensation that investors require for lending their cash increases therefore with the maturity of the debt finance provided. Liquidity preference theory does not therefore suggest that investors want more compensation for short-term lending than for long-term lending, in fact the opposite.

According to expectations theory, the shape of the yield curve gives information on how inflation rates are expected to influence interest rates in the future.

Expectations theory suggests that the shape of the yield curve depends upon the expectations of investors regarding future interest rates. An upward-sloping yield curve indicates an expectation that interest rates will rise in the future, while a downward-sloping yield curve indicates that interest rates are expected to fall in the future. Expectations theory does not therefore provide information on how inflation rates are expected to influence interest rates in the future.

BPP LEARNING MEDIA

Market segmentation theory suggests long-term interest rates depend on how easily investors can switch between market segments of different maturity.

Market segmentation theory suggests that the borrowing market can be divided into segments, for example the short-term end and the long-term end of the market. Investors in each segment remain in that segment and do not switch segments because of changes in factors influencing particular segments. The shape of the yield curve relating to each segment depends on the balance between the forces of supply and demand in that segment. Market segmentation theory does not therefore suggest that long-term interest rates depend on how easily investors can switch between market segments, since it states that investors do not switch between segments.

<div align="right">Syllabus area G2(c)</div>

280 The correct answer is: **$5,000.**

The FRA effectively fixes the interest at the upper end of the spread of 3.2%.

The total interest charge is therefore

$10m × 3.2% × 3/12 = $80,000

The actual interest charge on the variable-rate loan is

$10m × 3% × 3/12 = $75,000

Therefore the payment to the financial institution will be the difference of

$80,000 – $75,000 = $5,000

<div align="right">Syllabus area G4(a)</div>

281 The correct answer is: **1 and 2 only**

Statement 3 is **incorrect**. A rise in interest rates (which is what borrowers are hedging against) will cause a fall in futures prices. So, borrowers hedging against an interest rate increase will **sell** interest rate futures now (at a high price) and buy them at a future date (at a lower price) in order to make a profit which will offset the impact of higher interest rate costs on their actual borrowings. So the third statement is incorrect.

<div align="right">Syllabus area G4(a,b)</div>

Rose Co

282 The correct answer is: **Enter into a forward contract to sell €750,000 in 6 months**

Rose Co should enter into a forward contract to sell €750,000 in 6 months.

Statement 1 is **incorrect**. Rose Co could use a money market hedge but €750,000 would have to be borrowed, then converted into dollars and then placed on deposit.

Statement 2 is **incorrect**. An interest rate swap swaps one type of interest payment (such as fixed interest) for another (such as floating rate interest). Therefore it would not be suitable.

Statement 4 is not suitable as Rose Co does not have any euro payments to make.

<div align="right">Syllabus area G3(a)</div>

283 The correct answer is: **$310,945**

Future value = €750,000/2.412 = $310,945.

<div align="right">Syllabus area G3(a)</div>

284 The correct answer is: **4%**

Rose Co is expecting a euro receipt in six months' time and it can hedge this receipt in the money markets by borrowing euros to create a euro liability. Euro borrowing rate for six months = 8.0%/2 = 4%.

<div align="right">Syllabus area G3(a)</div>

285 The correct answer is: **Currency swaps can be used to hedge exchange rate risk over longer periods than the forward market.**

Statement 1 is **incorrect**. Currency futures have a fixed settlement date, although they can be exercised at any point before then.

Statement 3 is **incorrect**. The bank will make the customer fulfil the contract.

Statement 4 is **incorrect**. Buying a currency option involves paying a premium to the option seller. This is a non-refundable fee which is paid when the option is acquired.

Syllabus area G3(c)

286 The correct answer is: **The normal yield curve slopes upward to reflect increasing compensation to investors for being unable to use their cash now.**

The longer the term to maturity, the higher the rate of interest.

Notes on incorrect answers:

Statement 1 is **incorrect**. This reduces the money supply and could put upward pressure on interest rates.

Statement 3 is **incorrect**. Longer term is considered less certain and more risky. It therefore requires a higher yield.

Statement 4 is **incorrect**. Expectations theory states that future interest rates reflect expectations of future interest rate (not inflation rate) movements.

Syllabus area G1 & G2

Edwen Co

287 The correct answer is: **$56,079**

Forward market

Net receipt in one month = (240,000 – 140,000) = 100,000 euros

Edwen Co needs to sell euros at an exchange rate of 1.7832 euros = $1

Dollar value of net receipt = 100,000/1.7832 = $56,079

Syllabus area G3(a)

288 The correct answer is: **$167,999**

Money market hedge

Expected receipt after 3 months = 300,000 euros

Borrowing cost in Europe for 3 months is not given in annual terms and so does not need to be adjusted = 1.35%

Euros to borrow now in order to have 300,000 liability after 3 months = 300,000/1.0135 = 296,004 euros.

Spot rate for selling euros = 1.7822 per $1

Dollar deposit from borrowed euros at spot = 296,004/1.7822 = $166,089

Country C interest rate over 3 months = 1.15%

Value in 3 months of deposit = $166,089 × 1.0115 = $167,999

Syllabus area G3(a)

289 The correct answer is: **Both 1 and 2**

With a fall in a country's exchange rate Edwen Co's exports will be cheaper (and so be more competitive) and imports will become more expensive. Given imports may include raw materials, this pushes local prices up.

<div align="right">Syllabus area G1(a)</div>

290 The correct answer is: **2 only**

'The contracts can be tailored to the user's exact requirements' is false. Futures contracts are standard contracts.

'The exact date of receipt or payment of the currency does not have to be known' is true. The futures contract does not have to be closed out until the actual cash receipt or payment is made.

'Transaction costs are generally higher than other hedging methods' is false. Transaction costs are usually lower than other hedging methods.

<div align="right">Syllabus area G3(c)</div>

291 The correct answer is: **Both features relate to forward contracts**

Futures contracts are exchange traded and are only available in a limited range of currencies.

<div align="right">Syllabus area G3(b,c)</div>

Zigto Co

292 The correct answer is: **$251,256**

Forward exchange contract

500,000/1.990 = $251,256

Using the 6-month forward rate under the forward exchange contract, Zigto Co will receive $251,256.

<div align="right">Syllabus area G3(a)</div>

293 The correct answer is: **$248,781**

Money market hedge

Expected receipt after 6 months = Euro 500,000

Euro interest rate over 6 months = 5%/2 = 2.5%

Euros to borrow now in order to have Euro 500,000 liability after 6 months = Euro 500,000/1.025 = Euro 487,805

Spot rate for selling euros today = 2 euro/$

Dollar deposit from borrowed euros at spot rate = 487,805/2 = $243,903

Dollar deposit rate over 6 months = 4%/2 = 2%

Value of the dollar deposit in 6 months' time = $243,903 × 1.02 = $248,781

<div align="right">Syllabus area G3(a)</div>

294 The correct answer is: **Euro 1.971/$**

Using purchasing power parity:

$F_0 = S_0 \times (1 + i_c)/(1 + i_b)$

Where:

F_0 = expected spot rate

S_0 = current spot rate

i_c = expected inflation in country c

i_b = expected inflation in country b

$F_0 = 2.00 \times 1.03/1.045 = $ Euro 1.971/$

<div align="right">Syllabus area G2</div>

295 The correct answer is: **Statement 1 is false. Statements 2 and 3 are true.**

The expected future spot rate is calculated based on the relative inflation rates between two countries. The current forward exchange rates are set based on the relative interest rates between them.

Expectations theory states that there is an equilibrium between relative inflation rates and relative interest rates, so the expected spot rate and the current forward rate would be the same. Realistically, purchasing power parity tends to hold true in the longer term, so is used to forecast exchange rates a number of years into the future. Short-term differences are not unusual.

<div align="right">Syllabus area G2</div>

296 The correct answer is: **Statement 1 is true. Transaction risk affects cash flows. Statement 2 is false. Translation risk does not affect cash flows so does not directly affect shareholder wealth.**

However, **investors** may be influenced by the changing values of assets and liabilities so a company may choose to hedge translation risk through, for example, **matching the currency of assets and liabilities.** Statement 3 is true. Economic exposure can be difficult to avoid, although **diversification of the supplier and customer base** across different countries will reduce this kind of exposure to risk.

<div align="right">Syllabus area G1</div>

PGT Co

297 The correct answer is: **$324,149**

Transactions to be hedged:

Three months €1,000,000 − €400,000 = €600,000 net receipt

Forward market

Three months €600,000/1.8510 = $324,149

<div align="right">Syllabus area G3(a)</div>

298 The correct answer is: **$169,134**

Transactions to be hedged:

Six months = €300,000 payments (the receipt of $500,000 does not need to be hedged).

Money market

Six months

Step 1 – Invest PV of €300,000
€300,000/1.02 (4% × 6/12) = €294,118

Step 2 – Convert to $ at spot rate (buy €)
€294,118/1.7694 = $166,225

Step 3 – Borrow $
$166,225 × 1.0175 (3.5% × 6/12) = $169,134

<div align="right">Syllabus area G3(a)</div>

299 The correct answer is: **The second statement is true, the others are false**

FRAs can also be used to manage interest rate risk on investments because they protect against the risk of interest rates falling as well as rising.

The user of an FRA does not have the option to let the contract lapse if the rate is unfavourable – this is only true of an interest rate option.

Syllabus area G4(a)

300 The correct answer is: **The value of the dollar will be forecast to rise compared to the spot rate – leading to a fall in the cost of the transaction.**

The three-month forward shows the trend for the dollar to strengthen on the forward market. The interest rate parity formula will predict a stronger exchange rate if the interest rate is lower domestically than it is abroad – and this is the case here. If the $ gets stronger the expected payment in six months' time in euros would be lower.

Syllabus area G1

301 The correct answer is: **Statements 1 and 2 (only) are true**

The third statement is incorrect, and PPP theory relates to inflation rates anyway.

Syllabus area G2(b)

CBE style OT case Peony Co

302 The correct answer is: **A kink in the normal yield curve can be due to differing yields in different market segments**

Notes on incorrect answers:

The comment on expectations theory is incorrect because it applies to liquidity preference theory.

Government action to increase long-term borrowing would be likely to increase long-term interest rates (ie a normal upward slope).

Syllabus area G2(c)

303 The correct answer is: **Peony Co pays bank $450,000**

Company pays bank as interest rate is above the FRA rate.

100m × (9/12) × (7.1 – 6.5)/100 = $450,000

Syllabus area G4(a)

304 The correct answer is: **$112.9m**

12-month forward rate = 5 × 1.1/1.065 = 5.1643 pesos per $1

6-month forward rate = 5 × 1.05/1.0325 = 5.0848 pesos per $1

Income = (200/5.0848) + (380/5.1643) = $112.9m

Syllabus area G3(a)

305 The correct answer is: **Both statements are true.**

Syllabus area G4(a)

306 The correct answer is: **A borrower can hedge interest rate risk by selling interest rate futures now and buying them back in future.**

Notes on incorrect answers:

Options do not have to be exercised, this is optional.

An interest rate swap only involves swapping the interest payments.

As Peony is borrowing it needs to buy a cap (and sell a floor to create a collar if this is desired).

Syllabus area G4(b)

Mock exams

ACCA

FM

Financial Management

Mock Examination 1

September 2016 exam

Questions
Time allowed: 3 hours
ALL questions are compulsory and MUST be attempted

DO NOT OPEN THIS EXAM UNTIL YOU ARE READY TO START UNDER EXAMINATION CONDITIONS

Section A

ALL 15 questions are compulsory and MUST be attempted

Each question is worth 2 marks.

1 The owners of a private company wish to dispose of their entire investment in the company. The company has an issued share capital of $1m of $0.50 nominal value ordinary shares. The owners have made the following valuations of the company's assets and liabilities.

Non-current assets (book value) $30m
Current assets $18m
Non-current liabilities $12m
Current liabilities $10m

The net realisable value of the non-current assets exceeds their book value by $4m. The current assets include $2m of accounts receivable which are thought to be irrecoverable.

What is the minimum price per share which the owners should accept for the company (to the nearest $)?

$ ☐☐☐☐☐☐

2 Which of the following financial instruments will NOT be traded on a money market?

☐ Commercial paper

☐ Convertible loan notes

☐ Treasury bills

☐ Certificates of deposit

3 Andrew Co is a large listed company financed by both equity and debt.

In which of the following areas of financial management will the impact of working capital management be smallest?

☐ Liquidity management

☐ Interest rate management

☐ Management of relationship with the bank

☐ Dividend policy

4 Which TWO of the following are descriptions of basis risk?

☐ It is the difference between the spot exchange rate and currency futures exchange rate.

☐ It is the possibility that the movements in the currency futures price and spot price will be different.

☐ It is the difference between fixed and floating interest rates.

☐ It is one of the reasons for an imperfect currency futures hedge.

BPP
LEARNING
MEDIA

5 Crag Co has sales of $200m per year and the gross profit margin is 40%. Finished goods inventory days vary throughout the year within the following range:

	Maximum	Minimum
Inventory (days)	120	90

All purchases and sales are made on a cash basis and no inventory of raw materials or work in progress is carried.

Crag Co intends to finance permanent current assets with equity and fluctuating current assets with its overdraft.

In relation to finished goods inventory and assuming a 360-day year, how much finance will be needed from the overdraft?

$ ☐ million

6 **In relation to an irredeemable security paying a fixed rate of interest, which of the following statements is correct?**

☐ As risk rises, the market value of the security will fall to ensure that investors receive an increased yield.

☐ As risk rises, the market value of the security will fall to ensure that investors receive a reduced yield.

☐ As risk rises, the market value of the security will rise to ensure that investors receive an increased yield.

☐ As risk rises, the market value of the security will rise to ensure that investors receive a reduced yield.

7 Pop Co is switching from using mainly long-term fixed rate finance to fund its working capital to using mainly short-term variable rate finance.

Which of the following statements about the change in Pop Co's working capital financing policy is true?

☐ Finance costs will increase

☐ Refinancing risk will increase

☐ Interest rate risk will decrease

☐ Overcapitalisation risk will decrease

8 **Which of the following is NOT an advantage of withholding a dividend as a source of finance?**

☐ Retained profits are a free source of finance

☐ Investment plans need less justification

☐ Issue costs are lower

☐ It is quick

9 A company has annual after-tax operating cash flows of $2m per year which are expected to continue in perpetuity. The company has a cost of equity of 10%, a before-tax cost of debt of 5% and an after-tax weighted average cost of capital of 8% per year. Corporation tax is 20%.

What is the theoretical value of the company?

☐ $20m

☐ $40m

☐ $50m

☐ $25m

10 **Which of the following would you expect to be the responsibility of financial management?**

☐ Producing annual accounts

☐ Producing monthly management accounts

☐ Advising on investment in non-current assets

☐ Deciding pay rates for staff

11 Lane Co has in issue 3% convertible loan notes which are redeemable in 5 years' time at their nominal value of $100 per loan note. Alternatively, each loan note can be converted in 5 years' time into 25 Lane Co ordinary shares.

The current share price of Lane Co is $3.60 per share and future share price growth is expected to be 5% per year.

The before-tax cost of debt of these loan notes is 10% and corporation tax is 30%.

What is the current market value of a Lane Co convertible loan note?

☐ $82.71

☐ $73.47

☐ $67.26

☐ $94.20

12 Country X uses the dollar as its currency and country Y uses the dinar.

Country X's expected inflation rate is 5% per year, compared to 2% per year in country Y. Country Y's nominal interest rate is 4% per year and the current spot exchange rate between the two countries is 1.5000 dinar per $1.

According to the four-way equivalence model, which of the following statements is/are true or false?

		True	False
1	Country X's nominal interest rate should be 7.06% per year	☐	☐
2	The future (expected) spot rate after one year should be 1.4571 dinar per $1	☐	☐
3	Country X's real interest rate should be higher than that of country Y	☐	☐

BPP
LEARNING
MEDIA

13 Which TWO of the following government actions would lead to an increase in aggregate demand?

☐ Increasing taxation and keeping government expenditure the same

☐ Decreasing taxation and increasing government expenditure

☐ Decreasing money supply

☐ Decreasing interest rates

14 Peach Co's latest results are as follows:

	$'000
Profit before interest and taxation	2,500
Profit before taxation	2,250
Profit after tax	1,400

In addition, extracts from its latest statement of financial position are as follows:

	$'000
Equity	10,000
Non-current liabilities	2,500

What is Peach Co's return on capital employed (ROCE)?

☐ 14%

☐ 18%

☐ 20%

☐ 25%

15 Drumlin Co has $5m of $0.50 nominal value ordinary shares in issue. It recently announced a 1 for 4 rights issue at $6 per share. Its share price on the announcement of the rights issue was $8 per share.

What is the theoretical value of a right per existing share (to 2 decimal places)?

$ ☐

(Total = 30 marks)

Section B

ALL 15 questions are compulsory and MUST be attempted

Each question is worth 2 marks.

The following scenario relates to questions 16–20.

Herd Co is based in a country whose currency is the dollar ($). The company expects to receive €1,500,000 in 6 months' time from Find Co, a foreign customer. The finance director of Herd Co is concerned that the euro (€) may depreciate against the dollar before the foreign customer makes payment and she is looking at hedging the receipt.

Herd Co has in issue loan notes with a total nominal value of $4m which can be redeemed in 10 years' time. The interest paid on the loan notes is at a variable rate linked to LIBOR. The finance director of Herd Co believes that interest rates may increase in the near future.

The spot exchange rate is €1.543 per $1. The domestic short-term interest rate is 2% per year, while the foreign short-term interest rate is 5% per year.

16 What is the six-month forward exchange rate predicted by interest rate parity (to 3 decimal places)?

$ ☐

17 As regards the euro receipt, what is the primary nature of the risk faced by Herd Co?

☐ Transaction risk

☐ Economic risk

☐ Translation risk

☐ Business risk

18 Which of the following hedging methods will NOT be suitable for hedging the euro receipt?

☐ Forward exchange contract

☐ Money market hedge

☐ Currency futures

☐ Currency swap

19 Which of the following statements support the finance director's belief that the euro will depreciate against the dollar?

		Supports the director's belief	Does not support the director's belief
1	The dollar inflation rate is greater than the euro inflation rate	☐	☐
2	The dollar nominal interest rate is less than the euro nominal interest rate	☐	☐

20　As regards the interest rate risk faced by Herd Co, which of the following statements is correct?

☐　In exchange for a premium, Herd Co could hedge its interest rate risk by buying interest rate options.

☐　Buying a floor will give Herd Co a hedge against interest rate increases.

☐　Herd Co can hedge its interest rate risk by buying interest rate futures now in order to sell them at a future date.

☐　Taking out a variable rate overdraft will allow Herd Co to hedge the interest rate risk through matching.

The following scenario relates to questions 21 to 25.

Ring Co has in issue ordinary shares with a nominal value of $0.25 per share. These shares are traded on an efficient capital market. It is now 20X6 and the company has just paid a dividend of $0.450 per share. Recent dividends of the company are as follows:

Year	20X6	20X5	20X4	20X3	20X2
Dividend per share	$0.450	$0.428	$0.408	$0.389	$0.370

Ring Co also has in issue loan notes which are redeemable in 7 years' time at their nominal value of $100 per loan note and which pay interest of 6% per year.

The finance director of Ring Co wishes to determine the value of the company.

Ring Co has a cost of equity of 10% per year and a before-tax cost of debt of 4% per year. The company pays corporation tax of 25% per year.

21　Using the dividend growth model, what is the market value of each ordinary share?

☐　$8.59

☐　$9.00

☐　$9.45

☐　$7.77

22　What is the market value of each $100 loan note?

$ [_____]

23　The finance director of Ring Co has been advised to calculate the net asset value (NAV) of the company.

Which of the following formulae calculates correctly the NAV of Ring Co?

☐　Total assets less current liabilities

☐　Non-current assets plus net current assets

☐　Non-current assets plus current assets less total liabilities

☐　Non-current assets less net current assets less non-current liabilities

24 Which of the following statements about valuation methods is true?

☐ The earnings yield method multiplies earnings by the earnings yield.

☐ The equity market value is number of shares multiplied by share price, plus the
market value of debt.

☐ The dividend valuation model makes the unreasonable assumption that average
dividend growth is constant.

☐ The price/earnings ratio method divides earnings by the price/earnings ratio.

25 Which of the following statements about capital market efficiency is/are correct?

		Correct	Incorrect
1	Insider information cannot be used to make abnormal gains in a strong form efficient capital market.	☐	☐
2	In a weak form efficient capital market, Ring Co's share price reacts to new information the day after it is announced.	☐	☐
3	Ring Co's share price reacts quickly and accurately to newly released information in a semi-strong form efficient capital market.	☐	☐

The following scenario relates to questions 26 to 30.

The following information relates to an investment project which is being evaluated by the
directors of Fence Co, a listed company. The initial investment, payable at the start of the first
year of operation, is $3.9m.

Year	1	2	3	4
Net operating cash flow ($'000)	1,200	1,500	1,600	1,580
Scrap value ($'000)				100

The directors believe that this investment project will increase shareholder wealth if it achieves a
return on capital employed greater than 15%. As a matter of policy, the directors require all
investment projects to be evaluated using both the payback and return on capital employed
methods. Shareholders have recently criticised the directors for using these investment appraisal
methods, claiming that Fence Co ought to be using the academically preferred net present value
method.

The directors have a remuneration package which includes a financial reward for achieving an
annual return on capital employed greater than 15%. The remuneration package does not include
a share option scheme.

26 What is the payback period of the investment project?

☐ 2.75 years

☐ 1.50 years

☐ 2.65 years

☐ 1.55 years

27 Based on the average investment method, what is the return on capital employed of the investment project?

☐ 13.3%

☐ 26.0%

☐ 52.0%

☐ 73.5%

28 Which of the following statements about investment appraisal methods is correct?

☐ The return on capital employed method considers the time value of money.

☐ Return on capital employed must be greater than the cost of equity if a project is to be accepted.

☐ Riskier projects should be evaluated with longer payback periods.

☐ Payback period ignores the timing of cash flows within the payback period.

29 Which of the following statements about Fence Co is/are correct?

		True	False
1	Managerial reward schemes of listed companies should encourage the achievement of stakeholder objectives.	☐	☐
2	Requiring investment projects to be evaluated with return on capital employed is an example of dysfunctional behaviour encouraged by performance-related pay.	☐	☐
3	Fence Co has an agency problem as the directors are not acting to maximise the wealth of shareholders.	☐	☐

30 Which of the following statements about Fence Co directors' remuneration package is/are correct?

		True	False
1	Directors' remuneration should be determined by senior executive directors.	☐	☐
2	Introducing a share option scheme would help bring directors' objectives in line with shareholders' objectives.	☐	☐
3	Linking financial rewards to a target return on capital employed will encourage short-term profitability and discourage capital investment.	☐	☐

(Total = 30 marks)

Section C

BOTH questions are compulsory and MUST be attempted

31 Nesud Co has credit sales of $45m per year and on average settles accounts with trade payables after 60 days. One of its suppliers has offered the company an early settlement discount of 0.5% for payment within 30 days. Administration costs will be increased by $500 per year if the early settlement discount is taken. Nesud Co buys components worth $1.5m per year from this supplier.

From a different supplier, Nesud Co purchases $2.4m per year of Component K at a price of $5 per component. Consumption of Component K can be assumed to be at a constant rate throughout the year. The company orders components at the start of each month in order to meet demand and the cost of placing each order is $248.44. The holding cost for Component K is $1.06 per unit per year.

The finance director of Nesud Co is concerned that approximately 1% of credit sales turn into irrecoverable debts. In addition, she has been advised that customers of the company take an average of 65 days to settle their accounts, even though Nesud Co requires settlement within 40 days.

Nesud Co finances working capital from an overdraft costing 4% per year. Assume there are 360 days in a year.

Required

(a) Evaluate whether Nesud Co should accept the early settlement discount offered by its supplier. **(4 marks)**

(b) Evaluate whether Nesud Co should adopt an economic order quantity approach to ordering Component K. **(6 marks)**

(c) Critically discuss how Nesud Co could improve the management of its trade receivables. **(10 marks)**

(Total = 20 marks)

32 Hebac Co is preparing to launch a new product in a new market which is outside its current business operations. The company has undertaken market research and test marketing at a cost of $500,000, as a result of which it expects the new product to be successful. Hebac Co plans to charge a lower selling price initially and then increase the selling price on the assumption that the new product will establish itself in the new market. Forecast sales volumes, selling prices and variable costs are as follows:

Year	1	2	3	4
Sales volume (units/year)	200,000	800,000	900,000	400,000
Selling price ($/unit)	15	18	22	22
Variable costs ($/unit)	9	9	9	9

Selling price and variable cost are given here in current price terms before taking account of forecast selling price inflation of 4% per year and variable cost inflation of 5% per year.

Incremental fixed costs of $500,000 per year in current price terms would arise as a result of producing the new product. Fixed cost inflation of 8% per year is expected.

The initial investment cost of production equipment for the new product will be $2.5m, payable at the start of the first year of operation. Production will cease at the end of four years because the new product is expected to have become obsolete due to new technology. The production equipment would have a scrap value at the end of 4 years of $125,000 in future value terms.

Investment in working capital of $1.5m will be required at the start of the first year of operation. Working capital inflation of 6% per year is expected and working capital will be recovered in full at the end of four years.

Hebac Co pays corporation tax of 20% per year, with the tax liability being settled in the year in which it arises. The company can claim tax-allowable depreciation on a 25% reducing balance basis on the initial investment cost, adjusted in the final year of operation for a balancing allowance or charge. Hebac Co currently has a nominal after-tax weighted average cost of capital (WACC) of 12% and a real after-tax WACC of 8.5%. The company uses its current WACC as the discount rate for all investment projects.

Required

(a) Calculate the net present value of the investment project in nominal terms and comment on its financial acceptability. **(12 marks)**

(b) Discuss how the capital asset pricing model can assist Hebac Co in making a better investment decision with respect to its new product launch. **(8 marks)**

(Total = 20 marks)

Answers

DO NOT TURN THIS PAGE UNTIL YOU HAVE
COMPLETED THE MOCK EXAM

A PLAN OF ATTACK

Managing your nerves

As you turn the pages to start this mock exam a number of thoughts are likely to cross your mind. At best, examinations cause anxiety so it is important to stay focused on your task for the next three hours! Developing an awareness of what is going on emotionally within you may help you manage your nerves. Remember, you are unlikely to banish the flow of adrenaline, but the key is to harness it to help you work steadily and quickly through your answers.

Working through this mock exam will help you develop the exam stamina you will need to keep going for 3 hours and 15 minutes.

Managing your time

Planning and time management are two of the key skills which complement the technical knowledge you need to succeed. To keep yourself on time, do not be afraid to jot down your target completion times for each question.

Doing the exam

Actually doing the exam is a personal experience. There is not a single **right way**. As long as you submit complete answers to all questions after the three hours are up, then your approach obviously works.

Looking through the exam

Section A has 15 objective test questions. This is the section of the exam where the examining team can test knowledge across the breadth of the syllabus. Make sure you read these questions carefully. The distractors are designed to present plausible, but incorrect, answers. Don't let them mislead you. If you really have no idea – guess. You may even be right.

Section B has three questions, each with a scenario and five objective test questions.

Section C has two longer questions:

- **Question 31** is a working capital question – show all your workings and don't panic! Part (c) is straightforward.

- **Question 32** requires you to calculate NPV, with inflation. Don't get swamped by inflation – show clear workings and lay your thinking on the page like a road map for the marker. Read the detail in part (a) carefully so that you deal with tax-allowable depreciation correctly.

Allocating your time

BPP's advice is to always allocate your time **according to the marks for the question**. However, **use common sense**. If you're doing a question but haven't a clue how to do part (b), you might be better off reallocating your time and getting more marks on another question, where you can add something you didn't have time for earlier on. Make sure you leave time to recheck the MCQs and make sure you have answered them all.

Section A

1 The correct answer is: **$14**

They should not accept less than NRV: (30m + 18m + 4m – 2m – 12m – 10m)/2m = $14 per share

2 The correct answer is: **Convertible loan notes**

Convertible loan notes are long-term finance and are not traded on a money market.

3 The correct answer is: **Dividend policy**

Working capital management may have an impact on dividend policy, but the other areas will be more significant.

4 The correct answer is: **Second and fourth statements are correct**

Basis risk is the possibility that movements in the currency futures price and spot price will be different. It is one of the reasons for an imperfect currency futures hedge.

5 The correct answer is: **$10m**

$200m × 30/360 × 0.6 = $10m

6 The correct answer is: **First statement is correct**

As risk rises, the market value of the security will fall to ensure that investors receive an increased yield.

7 The correct answer is: **Second statement is correct**

Pop Co is moving to an aggressive funding strategy which will increase refinancing risk.

8 The correct answer is: **Retained profits are a free source of finance**

Although free to raise, using retained earnings as a source of finance (by withholding a dividend) is not free to use. It is equity finance and requires the cost of equity to be generated as a return.

Incorrect answers:

Second statement is an advantage. Other forms of finance require up-front justification to be considered by potential investors before funds are made available for investment.

Third statement is an advantage. There are no issue costs.

Fourth statement is an advantage. As the funds are already on hand, availability is essentially instant.

9 The correct answer is: **$25m**

Theoretical value = 2m/0.08 = $25m. Operating cash flows are before interest so by discounting at the WACC the total value of the company's cash flows to all investors (debt + equity) is obtained.

10 The correct answer is: **Advising on investments in non-current assets** is a key role of financial management.

11 The correct answer is: **$82.71**

Conversion value = 3.60 × 1.055 × 25 = $114.87

Discounting at 10%, loan note value = (3 × 3.791) + (114.87 × 0.621) = $82.71

12 The correct answer is: **First two statements are TRUE.**

1: (1.04 × 1.05/1.02) – 1 = 7.06%

2: 1.5 dinar × 1.02/1.05 = 1.4571 dinar/$

3: Real rates should be the same

13 The correct answer is: **Second and fourth actions would increase aggregate demand.**

Decreasing taxation and increasing government expenditure would lead to increased aggregate demand. Decreasing interest rates reduces the incentive to save and so would lead to an increase in aggregate demand.

14 The correct answer is: **20%**

Operating profit/(D + E) = 100 × 2,500/(10,000 + 2,500) = 20%

15 The correct answer is: **$0.40**

Value of a right = ((5m × $8 + 1.25m × $6)/6.25m − $6)/4 shares = $0.40 per share

Section B

16 The correct answer is: **$1.566**

Forward rate = 1.543 × (1.025/1.01) = €1.566 per $1

17 The correct answer is: **Transaction risk**

The euro receipt is subject to transaction risk.

18 The correct answer is: **Currency swap**

A currency swap is not a suitable method for hedging a one-off transaction.

19 The correct answer is: If the dollar inflation rate is less than the euro inflation rate, purchasing power parity indicates that the euro will appreciate against the dollar: **Does not support director's belief**

If the dollar nominal interest rate is less than the euro nominal interest rate, interest rate parity indicates that the euro will depreciate against the dollar: **Supports director's belief**

20 The correct answer is: 'In exchange for a premium, Herd Co could hedge its interest rate risk by buying interest rate options' is correct. **So the first statement is correct.**

21 The correct answer is: **$9.45**

Historical dividend growth rate = 100 × ((0.450/0.370)0.25 − 1) = 5%

Share price = (0.450 × 1.05)/(0.1 − 0.05) = $9.45

22 The correct answer is: **$112.01**

Market value = (6 × 6.002) + (100 × 0.760) = 36.01 + 76.0 = $112.01

23 The correct answer is: **Non-current assets plus current assets less total liabilities** is the correct formula.

24 The correct answer is: The dividend valuation model makes the unreasonable assumption that average dividend growth is constant **is correct.**

25 The correct answer is: **First and third statements are correct.**

'Insider information cannot be used to make abnormal gains in a strong form efficient capital market' and 'Ring Co's share price reacts quickly and accurately to newly released information in a semi-strong form efficient capital market' are correct.

26 The correct answer is: **2.75**

Payback period = 2 + (1,200/1,600) = 2.75 years

27 The correct answer is: **26.0%**

Average annual accounting profit = (5,880 − 3,800)/4 = $520,000 per year

Average investment = (3,900 + 100)/2 = $2,000,000

ROCE = 100 × 520/2,000 = 26%

28 The correct answer is: **Final statement is correct**

'Payback period ignores the timing of cash flows within the payback period' is correct.

29 The correct answer is: **All the statements are true.**

30 The correct answer is: **The second and third statements are true.**

Directors' remuneration should be determined by non-executive directors.

Section C

Question 31

Marking scheme

			Marks
(a)	Change in trade payables	1	
	Increase in finance cost	1	
	Administration cost increase	0.5	
	Early settlement discount	0.5	
	Comment on financial acceptability	1	
			4
(b)	Annual demand	1	
	Current ordering cost	1	
	Current holding cost	1	
	EOQ	1	
	EOQ ordering cost	0.5	
	EOQ holding cost	0.5	
	Comment on adopting EOQ approach to ordering	1	
			6
(c)	Credit analysis	2	
	Credit control	2	
	Collection of amounts owed	2	
	Factoring of trade receivables	2	
	Other relevant discussion	2	
			10
			20

(a) Relevant trade payables before discount = 1,500,000 × 60/360 = $250,000

Relevant trade payables after discount = 1,500,000 × 30/360 = $125,000

Reduction in trade payables = 250,000 – 125,000 = $125,000

More quickly, reduction in trade payables = 1,500,000 × (60 – 30)/360 = $125,000

The finance needed to reduce the trade payables will increase the overdraft.

Increase in finance cost = 125,000 × 0.04 = $5,000

Administration cost increase = $500

Discount from supplier = $1,500,000 × 0.005 = $7,500

Net benefit of discount = 7,500 − 5,000 − 500 = $2,000 per year

On financial grounds, Nesud Co should accept the supplier's early settlement discount offer.

(b) Annual demand = 2,400,000/5 = 480,000 units per year

Each month, Nesud Co orders 480,000/12 = 40,000 units

Current ordering cost = 12 × 248.44 = $2,981 per year

Average inventory of Component K = 40,000/2 = 20,000 units

Current holding cost = 20,000 × 1.06 = $21,200 per year

Total cost of current ordering policy = 2,981 + 21,200 = $24,181

Economic order quantity = $(2 \times 248.44 \times 480,000/1.06)^{0.5}$ = 15,000 units per order

Number of orders per year = 480,000/15,000 = 32 orders per year

Ordering cost = 32 × 248.44 = $7,950 per year

Average inventory of Component K = 15,000/2 = 7,500 units

Holding cost = 7,500 × 1.06 = $7,950 per year

Total cost of EOQ ordering policy = 7,950 + 7,950 = $15,900

On financial grounds, Nesud Co should adopt an EOQ approach to ordering Component K as there is a reduction in cost of $8,281.

(c) Management of trade receivables can be improved by considering credit analysis, credit control and collection of amounts owing. Management of trade receivables can also be outsourced to a factoring company, rather than being managed in-house.

Credit analysis

Offering credit to customers exposes a company to the risk of bad debts and this should be minimised through credit analysis or assessing creditworthiness. This can be done through collecting and analysing information about potential credit customers. Relevant information includes bank references, trade references, reports from credit reference agencies, records of previous transactions with potential customers, annual reports, and so on. A company might set up its own credit scoring system in order to assess the creditworthiness of potential customers. Where the expected volume of trade justifies it, a visit to a company can be made to gain a better understanding of its business and prospects.

Credit control

The accounts of customers who have been granted credit must be monitored regularly to ensure that agreed trade terms are being followed and that accounts are not getting into arrears. An important monitoring device here is an aged trade receivables analysis, identifying accounts and amounts in arrears, and the extent to which amounts are overdue. A credit utilisation report can assist management in understanding the extent to which credit is being used, identifying customers who may benefit from increased credit, and assessing the extent and nature of a company's exposure to trade receivables.

Collection of amounts owed

A company should ensure that its trade receivables are kept informed about their accounts, amounts outstanding and amounts becoming due, and the terms of trade they have accepted. An invoice should be raised when a sale is made. Regular statements should be sent, for example, on a monthly basis. Customers should be encouraged to settle their accounts on time and not become overdue. Offering a discount for early settlement could help to achieve this.

Overdue accounts should be chased using procedures contained within a company's trade receivables management policy. Reminders of payment due should be sent, leading to a final demand if necessary. Telephone calls or personal visits could be made to a contact within the company. Taking legal action or employing a specialised debt collection agency could be considered as a last resort. A clear understanding of the costs involved is important here, as the costs incurred should never exceed the benefit of collecting the overdue amount.

Factoring of trade receivables

Some companies choose to outsource management of trade receivables to a factoring company, which can bring expertise and specialist knowledge to the tasks of credit analysis, credit control, and collection of amounts owed. In exchange, the factoring company will charge a fee, typically a percentage of annual credit sales. The factoring company can also offer an advance of up to 80% of trade receivables, in exchange for interest.

Question 32

Workbook references. Investment appraisal with tax and inflation is covered in Chapter 6.

Top tips. Make sure that you show your workings for this type of question (in part (a)) to minimise the risk of making careless mistakes.

Easy marks. Part (a), for 14 marks, asked for a net present value (NPV) in nominal terms. This featured all of the normal elements of an NPV calculation – tax, capital allowances, inflation, working capital etc. This question should have been an area of strength for any well-prepared candidate, and many candidates did very well on this part of the question.

Examining team's comments. Answers to part (b) of the question were often unsatisfactory. Candidates seemed unprepared to discuss the required approach. The examining team highlighted the importance of being able to discuss this syllabus area.

Marking scheme

		Marks	
(a)	Inflated selling price per unit	1	
	Sales revenue	1	
	Inflated variable cost	1	
	Inflated fixed costs	1	
	Tax liabilities	1	
	Tax-allowable depreciation benefits Years 1–3	1	
	Tax allowable depreciation benefits Year 4	1	
	Incremental working capital and recovery	2	
	Calculation of present values	1	
	Correct initial investment	1	
	Comment on financial acceptability	1	
			12
(b)	Business risk, financial risk and WACC	2	
	Using a proxy company	1	
	Systematic risk, business risk and financial risk	1	
	Ungearing the equity beta	1	
	Regearing the asset beta	1	
	Project-specific cost of equity and WACC	2	
			8
			20

(a) Calculation of NPV

Year	1 $'000	2 $'000	3 $'000	4 $'000
Sales revenue	3,120	15,576	22,275	10,296
Variable cost	(1,890)	(7,936)	(9,378)	(4,376)
Contribution	1,230	7,640	12,897	5,920
Fixed cost	(540)	(583)	(630)	(680)
Taxable cash flow	690	7,057	12,267	5,240
Taxation	(138)	(1,411)	(2,453)	(1,048)
TAD tax benefits	125	94	70	186
After-tax cash flow	677	5,740	9,884	4,378
Scrap value				125
Working capital	(90)	(95)	(102)	1,787
Net cash flows	587	5,645	9,782	6,290
Discount at 12%	0.893	0.797	0.712	0.636
Present values	524	4,499	6,965	4,000

	$'000	
PV of future cash flows	15,988	
Initial investment	4,000	(2.5m + 1.5m)
NPV	11,988	

The NPV is strongly positive and so the project is financially acceptable.

Workings

1 *Sales revenue*

Year	1	2	3	4
Selling price ($/unit)	15	18	22	22
Inflated at 4% per year	15.60	19.47	24.75	25.74
Sales volume ('000 units/year)	200	800	900	400
Sales revenue ($'000/year)	3,120	15,576	22,275	10,296

2 *Variable cost*

Year	1	2	3	4
Variable cost ($/unit)	9	9	9	9
Inflated at 5% per year	9.45	9.92	10.42	10.94
Sales volume ('000 units/year)	200	800	900	400
Variable cost ($'000/year)	1,890	7,936	9,378	4,376

3 *Tax benefits of tax-allowable depreciation*

Year	1 $'000	2 $'000	3 $'000	4 $'000
Tax-allowable depreciation	625	469	352	929
Tax benefit	125	94	70	186*

*((2,500 – 125) × 0.2) – 125 – 94 – 70 = $186,000

4 *Working capital*

Year	0 $'000	1 $'000	2 $'000	3 $'000	4 $'000
Working capital	1,500				
Inflated at 6%		1,590	1,685	1,787	
Incremental		90	95	102	1,787

5 *Alternative calculation of after-tax cash flow*

Year	1 $'000	2 $'000	3 $'000	4 $'000
Taxable cash flow	690	7,057	12,267	5,240
Tax-allowable depreciation	(625)	(469)	(352)	(929)
Taxable profit	65	6,588	11,915	4,311
Taxation	(13)	(1,318)	(2,383)	(862)
After-tax profit	52	5,270	9,532	3,449
Add back TAD	625	469	352	929
After-tax cash flow	677	5,739	9,884	4,378

(b) A company can use its weighted average cost of capital (WACC) as the discount rate in appraising an investment project as long as the project's business risk and financial risk are similar to the business and financial risk of existing business operations. Where the business risk of the investment project differs significantly from the business risk of existing business operations, a project-specific discount rate is needed.

The capital asset pricing model (CAPM) can provide a project-specific discount rate. The equity beta of a company whose business operations are similar to those of the investment project (a proxy company) will reflect the systematic business risk of the project. If the proxy company is geared, the proxy equity beta will additionally reflect the systematic financial risk of the proxy company.

The proxy equity beta is ungeared to remove the effect of the proxy company's systematic financial risk to give an asset beta which solely reflects the business risk of the investment project.

This asset beta is regeared to give an equity beta which reflects the systematic financial risk of the investing company.

The regeared equity beta can then be inserted into the CAPM formula to provide a project-specific cost of equity. If this cost of capital is used as the discount rate for the investment project, it will indicate the minimum return required to compensate shareholders for the systematic risk of the project. The project-specific cost of equity can also be included in a project-specific WACC. Using the project-specific WACC in appraising an investment project will lead to a better investment decision than using the current WACC as the discount rate, as the current WACC does not reflect the risk of the investment project.

ACCA

FM

Financial Management

Mock Examination 2

Specimen exam

Questions
Time allowed: 3 hours
ALL questions are compulsory and MUST be attempted

DO NOT OPEN THIS EXAM UNTIL YOU ARE READY TO START UNDER EXAMINATION CONDITIONS

Section A – ALL 15 questions are compulsory and MUST be attempted

Each question is worth 2 marks.

1 The home currency of ACB Co is the dollar ($) and it trades with a company in a foreign country whose home currency is the Dinar. The following information is available:

	Home country	Foreign country
Spot rate	20.00 Dinar per $	
Interest rate	3% per year	7% per year
Inflation rate	2% per year	5% per year

What is the six-month forward exchange rate?

- ☐ 20.39 Dinar per $
- ☐ 20.30 Dinar per $
- ☐ 20.59 Dinar per $
- ☐ 20.78 Dinar per $

2 The following financial information relates to an investment project:

	$'000
Present value of sale revenue	50,025
Present value of variable costs	25,475
Present value of contribution	24,550
Present value of fixed costs	18,250
Present value of operating income	6,300
Initial investment	5,000
Net present value	1,300

What is the sensitivity of the net present value of the investment project to a change in sales volume?

- ☐ 7.1%
- ☐ 2.6%
- ☐ 5.1%
- ☐ 5.3%

3 Gurdip plots the historic movements of share prices and uses this analysis to make her investment decisions.

Oliver believes that share prices reflect all relevant information at all times.

Match the level of capital markets efficiency that best reflects each of Gurdip and Oliver's beliefs.

Efficiency	Name
Not efficient at all	
Weak form efficient	
Semi-strong form efficient	
Strong form efficient	

4 Which of the following statements concerning capital structure theory is correct?

☐ In the traditional view, there is a linear relationship between the cost of equity and financial risk.

☐ Modigliani and Miller said that, in the absence of tax, the cost of equity would remain constant.

☐ Pecking order theory indicates that preference shares are preferred to convertible debt as a source of finance.

☐ Business risk is assumed to be constant as the capital structure changes.

5 Which of the following actions is LEAST likely to increase shareholder wealth?

☐ The weighted average cost of capital is decreased by a recent financing decision.

☐ The financial rewards of directors are linked to increasing earnings per share.

☐ The board of directors decides to invest in a project with a positive NPV.

☐ The annual report declares full compliance with the corporate governance code.

6 Which TWO of the following statements are features of money market instruments?

☐ A negotiable security can be sold before maturity.

☐ The yield on commercial paper is usually lower than that on treasury bills.

☐ Discount instruments trade at less than face value.

☐ Commercial paper is often issued by companies to fund long-term expenditure

7 The following are extracts from the statement of profit or loss of CQB Co:

	$'000
Sales income	60,000
Cost of sales	50,000
Profit before interest and tax	10,000
Interest	4,000
Profit before tax	6,000
Tax	4,500
Profit after tax	1,500

60% of the cost of sales is variable cost.

What is the operational gearing of CQB Co?

☐ 5.0 times

☐ 2.0 times

☐ 0.5 times

☐ 3.0 times

8 The management of Lamara Co has annual credit sales of $20m and accounts receivable of $4m. Working capital is financed by an overdraft at 12% interest per year. Assume 365 days in a year.

What is the annual finance cost saving if the management reduces the collection period to 60 days (to the nearest $)?

$ [＿＿＿＿＿＿＿]

9 Are the following statements concerning financial management true or false?

		True	False
1	It is concerned with investment decisions, financing decisions and dividend decisions.	☐	☐
2	It is concerned with financial planning and financial control.	☐	☐
3	It considers the management of risk.	☐	☐
4	It is concerned with providing information on past plans and decisions.	☐	☐

10 SKV Co has paid the following dividends per share in recent years:

Year	20X4	20X3	20X2	20X1
Dividend ($ per share)	0.360	0.338	0.328	0.311

The dividend for 20X4 has just been paid and SKV Co has a cost of equity of 12%.

Using the geometric average historical dividend growth rate and the dividend growth model, what is the market price of SKV Co shares on an ex dividend basis?

☐ $4.67
☐ $5.14
☐ $5.40
☐ $6.97

11 'There is a risk that the value of our foreign currency-denominated assets and liabilities will change when we prepare our accounts.'

To which risk does the above statement refer?

☐ Translation risk
☐ Economic risk
☐ Transaction risk
☐ Interest rate risk

12 The following information has been calculated for A Co:

Trade receivables collection period: 52 days

Raw material inventory turnover period: 42 days

Work in progress inventory turnover period: 30 days

Trade payables payment period: 66 days

Finished goods inventory turnover period: 45 days

What is the length of the working capital cycle?

┌──────────┐
│ │ Days
└──────────┘

13 **Which of the following is/are usually seen as benefits of financial intermediation?**

1 Interest rate fixing

2 Risk pooling

3 Maturity transformation

☐ 1 only

☐ 1 and 3 only

☐ 2 and 3 only

☐ 1, 2 and 3

14 **Which TWO of the following statements concerning working capital management are correct?**

☐ The twin objectives of working capital management are profitability and liquidity.

☐ A conservative approach to working capital investment will increase profitability.

☐ Working capital management is a key factor in a company's long-term success.

☐ The current ratio is a measure of profitability

15 Governments have a number of economic targets as part of their monetary policy.

Which TWO of the following targets relate predominantly to monetary policy?

☐ Increasing tax revenue

☐ Controlling the growth in the size of the money supply

☐ Reducing public expenditure

☐ Keeping interest rates low

(Total = 30 marks)

Section B – ALL 15 questions are compulsory and MUST be attempted

Each question is worth 2 marks.

The following scenario relates to questions 16–20.

Par Co currently has the following long-term capital structure:

	$m	$m
Equity finance		
Ordinary shares	30.0	
Reserves	38.4	
		68.4
Non-current liabilities		
Bank loans	15.0	
8% convertible loan notes	40.0	
5% redeemable preference shares	15.0	
		70.0
Total equity and liabilities		138.4

The 8% loan notes are convertible into eight ordinary shares per loan note in seven years' time. If not converted, the loan notes can be redeemed on the same future date at their nominal value of $100. Par Co has a cost of debt of 9% per year.

The ordinary shares of Par Co have a nominal value of $1 per share. The current ex dividend share price of the company is $10.90 per share and share prices are expected to grow by 6% per year for the foreseeable future. The equity beta of Par Co is 1.2.

16 The loan notes are secured on non-current assets of Par Co and the bank loan is secured by a floating charge on the current assets of the company.

Arrange the following sources of finance of Par Co in order of the risk to the investor with the riskiest first.

	Order of risk (1ˢᵗ, 2ⁿᵈ etc)
Redeemable preference shares	☐
Loan notes	☐
Bank loan	☐
Ordinary shares	☐

17 What is the conversion value of the 8% loan notes of Par Co after seven years (to 2 decimal places)?

$ ☐

18 Assuming the conversion value after 7 years is $126.15, what is the current market value of the 8% loan notes of Par Co?

☐ $115.20

☐ $109.26

☐ $94.93

☐ $69.00

19 Which of the following statements relating to the capital asset pricing model is correct?

☐ The equity beta of Par Co considers only business risk.

☐ The capital asset pricing model considers systematic risk and unsystematic risk.

☐ The equity beta of Par Co indicates that the company is more risky than the market as a whole.

☐ The debt beta of Par Co is zero.

20 Which TWO of the following statements are problems in using the price/earnings ratio method to value a company?

☐ It is the reciprocal of the earnings yield.

☐ It combines stock market information and corporate information.

☐ It is difficult to select a suitable price/earnings ratio.

☐ The ratio is more suited to valuing the shares of listed companies.

The following scenario relates to questions 21–25.

Zarona Co, whose home currency is the dollar, took out a fixed-interest peso bank loan several years ago when peso interest rates were relatively cheap compared to dollar interest rates. Zarona Co does not have any income in pesos. Economic difficulties have now increased peso interest rates while dollar interest rates have remained relatively stable.

Zarona Co must pay interest on the dates set by the bank. A payment of 5,000,000 pesos is due in 6 months' time. The following information is available:

Spot rate 12.500–12.582 pesos per $
Six-month forward rate 12.805–12.889 pesos per $

Interest rates which can be used by Zarona Co:

	Borrow	Deposit
Peso interest rates	10.0% per year	7.5% per year
Dollar interest rates	4.5% per year	3.5% per year

21 What is the dollar cost of a forward market hedge? (to the nearest $)

$ []

22 Indicate whether the following statements apply to interest rate parity theory, purchasing power parity theory, or both,

1	The currency of the country with the higher inflation rate will weaken against the other currency	Interest rate parity theory	Purchasing power parity theory
2	The theory holds in the long-term rather than in the short-term	Interest rate parity theory	Purchasing power parity theory
3	The exchange rate reflects the cost of living in the two countries	Interest rate parity theory	Purchasing power parity theory

23 What are the appropriate six-month interest rates for Zarona Co to use if the company hedges the peso payment using a money market hedge?

	Deposit rate	Borrowing rate
☐	7.50%	4.50%
☐	1.75%	5.00%
☐	3.75%	2.25%
☐	3.50%	10.00%

24 Which TWO of the following methods are possible ways for Zarona Co to hedge its existing foreign currency risk?

☐ Matching receipts and payments

☐ Currency swaps

☐ Leading or lagging

☐ Currency futures

25 Zarona Co also trades with companies in Europe which use the euro as their home currency. In 3 months' time Zarona Co will receive €300,000 from a customer.

Which of the following is the correct procedure for hedging this receipt using a money market hedge?

☐ Step 1 Borrow an appropriate amount in euro now
Step 2 Convert the euro amount into dollars
Step 3 Place the dollars on deposit
Step 4 Use the customer payment to repay the loan

☐ Step 1 Borrow an appropriate amount in dollars now
Step 2 Place the dollars on deposit now
Step 3 Convert the dollars into euro in three months' time
Step 4 Use the customer payment to repay the loan

☐ Step 1 Borrow an appropriate amount in dollars now
Step 2 Convert the dollar amount into euro
Step 3 Place the euro on deposit
Step 4 Use the customer payment to repay the loan

☐ Step 1 Borrow an appropriate amount in Euro now
Step 2 Place the euro on deposit now
Step 3 Convert the euro into dollars in three months' time
Step 4 Use the customer payment to repay the loan

The following scenario relates to questions 26–30.

Ridag Co operates in an industry which has recently been deregulated as the Government seeks to increase competition in the industry.

Ridag Co plans to replace an existing machine and must choose between two machines. Machine 1 has an initial cost of $200,000 and will have a scrap value of $25,000 after 4 years. Machine 2 has an initial cost of $225,000 and will have a scrap value of $50,000 after 3 years. Annual maintenance costs of the two machines are as follows:

Year	1	2	3	4
Machine 1 ($ per year)	25,000	29,000	32,000	35,000
Machine 2 ($ per year)	15,000	20,000	25,000	

Where relevant, all information relating to this project has already been adjusted to include expected future inflation. Taxation and tax-allowable depreciation must be ignored in relation to Machine 1 and Machine 2.

Ridag Co has a nominal before-tax weighted average cost of capital of 12% and a nominal after-tax weighted average cost of capital of 7%.

26 In relation to Ridag Co, which TWO of the following statements about competition and deregulation are true?

☐ Increased competition should encourage Ridag Co to reduce costs.

☐ Deregulation will lead to an increase in administrative and compliance costs for Ridag Co.

☐ Deregulation should mean an increase in economies of scale for Ridag Co.

☐ Deregulation could lead to a decrease in the quality of Ridag Co's products.

27 What is the equivalent annual cost of Machine 1?

☐ $90,412

☐ $68,646

☐ $83,388

☐ $70,609

28 Is each of the following statements about Ridag Co using the equivalent annual cost method true or false?

		True	False
1	Ridag Co cannot use the equivalent annual cost method to compare Machine 1 and Machine 2 because they have different useful lives.	☐	☐
2	The machine which has the lowest total present value of costs should be selected by Ridag Co.	☐	☐

29 Doubt has been cast over the accuracy of the Year 2 and Year 3 maintenance costs for Machine 2. On further investigation it was found that the following potential cash flows are now predicted:

Year	Cash flow $	Probability
2	18,000	0.3
2	25,000	0.7
3	23,000	0.2
3	24,000	0.35
3	30,000	0.45

What is the expected present value of the maintenance costs for Year 3 (to the nearest $)?

$ ☐

30 Ridag Co is appraising a different project, with a positive NPV. It is concerned about the risk and uncertainty associated with this other project.

Which of the following statements about risk, uncertainty and the project is true?

☐ Sensitivity analysis takes into account the interrelationship between project variables.

☐ Probability analysis can be used to assess the uncertainty associated with the project.

☐ Uncertainty can be said to increase with project life, while risk increases with the variability of returns.

☐ A discount rate of 5% could be used to lessen the effect of later cash flows on the decision.

(Total = 30 marks)

Section C – BOTH questions are compulsory and MUST be attempted

31 Vip Co, a large stock exchange listed company, is evaluating an investment proposal to manufacture Product W33, which has performed well in test marketing trials conducted recently by the company's research and development division. Product W33 will be manufactured using a fully automated process which would significantly increase noise levels from Vip Co's factory. The following information relating to this investment proposal has now been prepared:

Initial investment	$2 million
Selling price (current price terms)	$20 per unit
Expected selling price inflation	3% per year
Variable operating costs (current price terms)	$8 per unit
Fixed operating costs (current price terms)	$170,000 per year
Expected operating cost inflation	4% per year

The research and development division has prepared the following demand forecast as a result of its test marketing trials. The forecast reflects expected technological change and its effect on the anticipated life-cycle of Product W33.

Year	1	2	3	4
Demand (units)	60,000	70,000	120,000	45,000

It is expected that all units of Product W33 produced will be sold, in line with the company's policy of keeping no inventory of finished goods. No terminal value or machinery scrap value is expected at the end of four years, when production of Product W33 is planned to end. For investment appraisal purposes, Vip Co uses a nominal (money) discount rate of 10% per year and a target return on capital employed of 30% per year. Ignore taxation.

Required

(a) Calculate the following values for the investment proposal:

 (i) Net present value; **(5 marks)**

 (ii) Internal rate of return; and **(3 marks)**

 (iii) Return on capital employed (accounting rate of return) based on average investment. **(3 marks)**

(b) Briefly discuss your findings in each section of (a) above and advise whether the investment proposal is financially acceptable. **(4 marks)**

(c) Discuss how the objectives of Vip Co's stakeholders may be in conflict if the project is undertaken. **(5 marks)**

Total = 20 marks

32 Froste Co has a dividend payout ratio of 40% and has maintained this payout ratio for several years. The current dividend per share of the company is 50c per share and it expects that its next dividend per share, payable in one year's time, will be 52c per share.

The capital structure of the company is as follows:

	$m	$m
Equity		
Ordinary shares (nominal value $1 per share)	25	
Reserves	35	
		60
Debt		
Bond A (nominal value $100)	20	
Bond B (nominal value $100)	10	
		30
		90

Bond A will be redeemed at nominal value in 10 years' time and pays annual interest of 9%. The cost of debt of this bond is 9.83% per year. The current ex interest market price of the bond is $95.08.

Bond B will be redeemed at nominal value in 4 years' time and pays annual interest of 8%. The cost of debt of this bond is 7.82% per year. The current ex interest market price of the bond is $102.01.

Froste Co has a cost of equity of 12.4%. Ignore taxation.

Required

(a) Calculate the following values for Froste Co:

 (i) Ex dividend share price, using the dividend growth model; **(3 marks)**

 (ii) Capital gearing (debt divided by debt plus equity) using market values; and
 (2 marks)

 (iii) Market value weighted average cost of capital. **(2 marks)**

(b) Discuss whether a change in dividend policy will affect the share price of Froste Co.
 (8 marks)

(c) Explain why Froste Co's capital instruments have different levels of risk and return.
 (5 marks)

 (Total = 20 marks)

Answers

DO NOT TURN THIS PAGE UNTIL YOU HAVE
COMPLETED THE MOCK EXAM

Section A

1 The correct answer is: **20.39 Dinar per $**

 20 × (1.035/1.015) = 20.39 Dinar per $

2 The correct answer is: **5.3%**

 Sensitivity to a change in sales volume = 100 × 1,300/24,550 = 5.3%

3 The correct answer is:

 Gurdip – not efficient at all

 Oliver – strong form

 Gurdip is basing her investment decisions on technical analysis, which means that she believes the stock market is not efficient at all, not even weak form efficient.

 Oliver believes markets are strong form efficient

4 The correct answer is: **The statement about business risk is correct.**

 In the traditional view, there is a curvilinear relationship between the cost of equity and financial risk.

 Modigliani and Miller said that, in the absence of tax, the weighted average cost of capital (not the cost of equity) would remain constant.

 Pecking order theory indicates that any shares are less attractive than debt as a source of finance.

5 The correct answer is: **The financial rewards of directors are linked to increasing earnings per share.**

 Increases in shareholder wealth will depend on increases in cash flow, rather than increases in earnings per share (ie increases in profit). If the financial rewards of directors are linked to increasing earnings per share, for example, through a performance-related reward scheme, there is an incentive to increase short-term profit at the expense of longer-term growth in cash flows and hence shareholder wealth.

6 The correct answer is: **Both statements 1 and 3 are correct.**

 Commercial paper is a source of short-term finance, it is riskier than Treasury Bills and will therefore carry a higher yield.

7 The correct answer is: **3 times**

 Operational gearing = Contribution/PBIT

 = [60,000 – (50,000 × 0.6)]/10m = 3 times

8 The correct answer is: **$85,479**

 Finance cost saving = 13/365 × $20m × 0.12 = $85,479

9 The correct answer is: **The first 3 statements (only) are correct.**

 The first three statements concerning financial management are correct. However, information about past plans and decisions is a function of financial reporting, not financial management.

10 The correct answer is: **$5.40**

 The geometric average dividend growth rate is $(36.0/31.1)^{1/3} - 1 = 5\%$

 The ex div share price = (36.0 × 1.05)/(0.12 – 0.05) = $5.40

11 The correct answer is: **The statement refers to translation risk.**

12 The correct answer is: **103 days**

The length of the operating cycle is 52 + 42 + 30 − 66 + 45 = 103 days.

13 The correct answer is: **2 and 3 only**

Risk pooling and maturity transformation are always included in a list of benefits of financial intermediation.

14 The correct answer is: **Statements 1 and 3 are correct.**

A conservative approach to working capital investment will involve maintaining high levels of working capital which may well not increase profitability.

The current ratio is a measure of liquidity, not profitability.

15 The correct answer is: **Controlling the growth in the money supply & keeping interest rates low**

The other targets relate to fiscal policy.

Section B

16 The correct answer is: **1st Ordinary shares, 2nd Preference shares, 3rd Bank loan, 4th Secured loan notes**

The secured loan notes are safer than the bank loan, which is secured on a floating charge. The redeemable preference shares are above debt in the creditor hierarchy. Ordinary shares are higher in the creditor hierarchy than preference shares.

17 The correct answer is: **$131.12**

Future share price after 7 years = 10.90×1.06^7 = $16·39 per share

Conversion value of each loan note = 16.39×8 = $131.12 per loan note

18 The correct answer is: **$109.26**

Market value of each loan note = $(8 \times 5.033) + (126.15 \times 0.547)$ = 40.26 + 69.00 = $109.26

19 The correct answer is: **The equity beta of Par Co indicates that the company is more risky than the market as a whole.**

An equity beta of greater than 1 indicates that the investment is more risky than the market as a whole.

Notes on incorrect answers:

The equity beta of Par Co considers business and financial risk.

The capital asset pricing model only considers systematic risk.

The debt beta of Par Co is zero - this is not an assumption of the CAPM.

20 The correct answer is: **Statements 3 and 4 only**

It is correct that the price/earnings ratio is more suited to valuing the shares of listed companies, and it is also true that it is difficult to find a suitable price/earnings ratio for the valuation.

Statements 1 and 2 are true but are not problems.

21 The correct answer is: **$390,472**

Interest payment = 5,000,000 pesos

Six-month forward rate for buying pesos = 12.805 pesos per $

Dollar cost of peso interest using forward market = 5,000,000/12.805 = $390,472

22 The correct answer is: **All statements relate to purchasing power parity, statement 2 also applies to interest rate parity.**

Exchange rates reflecting the different cost of living between two countries is stated by the theory of purchasing power parity.

Both theories hold in the long term rather than the short term (IRP also applies in the short-term).

The currency of the country with the higher inflation rate will be forecast to weaken against the currency of the country with the lower inflation rate in purchasing power parity.

23 The correct answer is: **Borrowing rate 2.25% and Deposit rate 3.75%**

Dollars will be borrowed now for 6 months at $4.5 \times 6/12$ = 2.25%

Pesos will be deposited now for 6 months at $7.5 \times 6/12$ = 3.75%

24 The correct answer is: **Currency futures and swaps could both be used.**

As payment must be made on the date set by the bank, leading or lagging are not appropriate. Matching is also inappropriate as there are no peso income streams.

25 The correct answer is: **The first option is correct.**

The correct procedure is to: Borrow euro now, convert the euro into dollars and place the dollars on deposit for three months, use the customer receipt to pay back the euro loan.

26 The correct answer is: **Statements 1 and 4**

Deregulation to increase competition should mean managers act to reduce costs in order to be competitive. The need to reduce costs may mean that quality of products declines.

27 The correct answer is: **$90,412**

Since taxation and capital allowances are to be ignored, and where relevant all information relating to project 2 has already been adjusted to include future inflation, the correct discount rate to use here is the nominal before-tax weighted average cost of capital of 12%.

	0	1	2	3	4
Maintenance costs		(25,000)	(29,000)	(32,000)	(35,000)
Investment and scrap	(200,000)				25,000
Net cash flow	(200,000)	(25,000)	(29,000)	(32,000)	10,000
Discount at 12%	1.000	0.893	0.797	0.712	0.636
Present values	(200,000)	(22,325)	(23,113)	(22,784)	(6,360)

Present value of cash flows ($274,582)

Cumulative present value factor 3.037

Equivalent annual cost = 274,582/3.037 = $90,412

28 The correct answer is: **Both statements are false.**

The machine with the lowest equivalent annual cost should be purchased, not the present value of future cash flows alone. The lives of the two machines are different and the equivalent annual cost method allows this to be taken into consideration.

29 The correct answer is: **$18,868**

EV of Year 3 cash flow = (23,000 × 0.2) + (24,000 × 0.35) + (30,000 × 0.45) = 26,500

PV discounted at 12% = 26,500 × 0.712 = $18,868

30 The correct answer is: **The statement about uncertainty increasing with project life is true.**

Notes on incorrect answers:

Simulation (not sensitivity analysis) takes into account the interrelationship between project variables.

Probability analysis can be used to assess the risk (not uncertainty) associated with the project.

A lower discount rate of 5% would increase the present value of costs incurred in later years and would therefore increase their impact.

Section C

Question 31

			Marks
(a)	Inflated income	2	
	Inflated operating costs	2	
	Net present value	1	
	Internal rate of return	3	
	Return on capital employed	3	
			11
(b)	Discussion of investment appraisal findings	3	
	Advice on acceptability of project	1	
			4
(c)	Maximisation of shareholder wealth	1–2	
	Conflict from automation of production process	1–2	
	Conflict from additional noise	1–2	
	Maximum		5
			20

(a) (i) Calculation of NPV

Year	0	1	2	3	4
	$	$	$	$	$
Investment	(2,000,000)				
Income		1,236,000	1,485,400	2,622,000	1,012,950
Operating costs		676,000	789,372	1,271,227	620,076
Net cash flow	(2,000,000)	560,000	696,028	1,350,773	392,874
Discount at 10%	1.000	0.909	0.826	0.751	0.683
Present values	(2,000,000)	509,040	574,919	1,014,430	268,333
Net present value:	366,722				

Workings

1 Calculation of income

Year	1	2	3	4
Inflated selling price ($/unit)	20.60	21.22	21.85	22.51
Demand (units/year)	60,000	70,000	120,000	45,000
Income ($/year)	1,236,000	1,485,400	2,622,000	1,012,950

2 Calculation of operating costs

Year	1	2	3	4
Inflated variable cost ($/unit)	8.32	8.65	9.00	9.36
Demand (units/year)	60,000	70,000	120,000	45,000
Variable costs ($/year)	499,200	605,500	1,080,000	421,200
Inflated fixed costs ($/year)	176,800	183,872	191,227	198,876
Operating costs ($/year)	676,000	789,372	1,271,227	620,076

3 Alternative calculation of operating costs

Year	1	2	3	4
Variables cost ($/unit)	8	8	8	8
Demand (units/year)	60,000	70,000	120,000	45,000
Variable costs ($/year)	480,000	560,000	960,000	360,000
Fixed costs ($/year)	170,000	170,000	170,000	170,000
Operating costs ($/year)	650,000	730,000	1,130,000	530,000
Inflated costs ($/year)	676,000	789,568	1,271,096	620,025

(ii) **Calculation of internal rate of return**

Year	0	1	2	3	4
	$	$	$	$	$
Net cash flow	(2,000,000)	560,000	696,028	1,350,773	392,874
Discount at 20%	1.000	0.833	0.694	0.579	0.482
Present values	(2,000,000)	466,480	483,043	782,098	189,365

Net present value: ($79,014)

$$IRR = a + \frac{NPV_a}{(NPV_a - NPV_b)} (b - a) = 10\% + [(366,722/(366,722 + 79,014)](20 - 10) =$$

18.2%

Alternatively IRR can be calculated using the =IRR spreadsheet function based on these cash flows:

Time	0	1	2	3	4
$000s	(2,000)	560	696.0	1,350.8	392.9

This approach gives an IRR of 18%.

(iii) **Calculation of return on capital employed**

Total cash inflow = 560,000 + 696,028 + 1,350,773 + 392,874 = $2,999,675

Total depreciation and initial investment are the same, as there is no scrap value.

Total accounting profit = 2,999,675 – 2,000,000 = $999,675

Average annual accounting profit = 999,675/4 = $249,919

Average investment = 2,000,000/2 = $1,000,000

Return on capital employed = 100 × 249,919/1,000,000 = 25%

(b) The investment proposal has a positive net present value (NPV) of $366,722 and is therefore financially acceptable. The results of the other investment appraisal methods do not alter this financial acceptability, as the NPV decision rule will always offer the correct investment advice.

The internal rate of return (IRR) method also recommends accepting the investment proposal, since the IRR of 18.2% is greater than the 10% return required by Vip Co. If the advice offered by the IRR method differed from that offered by the NPV method, the advice offered by the NPV method would be preferred.

The calculated return on capital employed of 25% is less than the target return of 30% but, as indicated earlier, the investment proposal is financially acceptable as it has a positive NPV. The reason why Vip Co has a target return on capital employed of 30% should be investigated. This may be an out of date hurdle rate which has not been updated for changed economic circumstances.

(c) As a large listed company, Vip Co's primary financial objective is assumed to be the maximisation of shareholder wealth. In order to pursue this objective, Vip Co should undertake projects, such as this one, which have a positive NPV and generate additional value for shareholders.

However, not all of Vip Co's stakeholders have the same objectives and the acceptance of this project may create conflict between the different objectives.

Due to Product W33 being produced using an automated production process, it will not meet employees' objectives of continuity or security in their employment. It could also mean employees will be paid less than they currently earn. If this move is part of a longer-term move away from manual processes, it could also conflict with government objectives of having a low rate of unemployment.

The additional noise created by the production of Product W33 will affect the local community and may conflict with objectives relating to healthy living. This may also conflict with objectives from environmental pressure groups and government standards on noise levels as well.

Question 32

			Marks
(a)	Dividend growth rate	1	
	Share price using dividend growth model	2	
	Capital gearing	2	
	Weighted average cost of capital	2	
			7
(b)	Dividend irrelevance	3–4	
	Dividend relevance	3–4	
	Maximum		8
(c)	Discussion of equity	1–2	
	Debt and recognising business risk is not relevant	1–2	
	Time until maturity of bonds	1–2	
	Different value of bonds	1	
	Maximum		5
			20

(a) (i) Dividend growth rate = 100 × ((52/50) − 1) = 100 × (1.04 − 1) = 4% per year

Share price using DGM = (50 × 1.04)/(0.124 − 0.04) = 52/0.084 = 619c or $6.19

(ii) Number of ordinary shares = 25 million

Market value of equity = 25m × 6.19 = $154.75 million

Market value of Bond A issue = 20m × 95.08/100 = $19.016m

Market value of Bond B issue = 10m × 102.01/100 = $10.201m

Market value of debt = $29.217m

Market value of capital employed = 154.75m + 29.217m = $183.967m

Capital gearing = 100 × 29.217/183.967 = 15.9%

(iii) WACC = ((12.4 × 154.75) + (9.83 × 19.016) + (7.82 × 10.201))/183.967 = 11.9%

(b) Miller and Modigliani showed that, in a perfect capital market, the value of a company depended on its investment decision alone, and not on its dividend or financing decisions. In such a market, a change in dividend policy by Froste Co would not affect its share price or its market capitalisation. They showed that the value of a company was maximised if it invested in all projects with a positive net present value (its optimal investment schedule). The company could pay any level of dividend and, if it had insufficient finance, make up the shortfall by issuing new equity. Since investors had perfect information, they were indifferent between dividends and capital gains. Shareholders who were unhappy with the level of dividend declared by a company could gain a 'home-made dividend' by selling some of their shares. This was possible since there are no transaction costs in a perfect capital market.

Against this view are several arguments for a link between dividend policy and share prices. For example, it has been argued that investors prefer certain dividends now rather than uncertain capital gains in the future (the 'bird in the hand' argument).

It has also been argued that real-world capital markets are not perfect, but semi-strong form efficient. Since perfect information is therefore not available, it is possible for information asymmetry to exist between shareholders and the managers of a company. Dividend announcements may give new information to shareholders and as a result, in a semi-strong form efficient market, share prices may change. The size and direction of the share price change will depend on the difference between the dividend announcement and the expectations of shareholders. This is referred to as the 'signalling properties of dividends'.

It has been found that shareholders are attracted to particular companies as a result of being satisfied by their dividend policies. This is referred to as the 'clientele effect'. A company with an established dividend policy is therefore likely to have an established dividend clientele. The existence of this dividend clientele implies that the share price may change if there is a change in the dividend policy of the company, as shareholders sell their shares in order to reinvest in another company with a more satisfactory dividend policy. In a perfect capital market, the existence of dividend clienteles is irrelevant, since substituting one company for another will not incur any transaction costs. Since real-world capital markets are not perfect, however, the existence of dividend clienteles suggests that if Froste Co changes its dividend policy, its share price could be affected.

(c) There is a trade-off between risk and return on Froste Co's capital instruments. Investors in riskier assets require a higher return in compensation for this additional risk. In the case of ordinary shares, investors rank behind all other sources of finance in the event of a liquidation so are the most risky capital instrument to invest in. This is partly why Froste Co's cost of equity is more expensive than its debt financing.

Similarly for debt financing, higher-risk borrowers must pay higher rates of interest on their borrowing to compensate lenders for the greater risk involved. Froste Co has two bonds, with Bond A having the higher interest rate and therefore the higher risk. Since both bonds were issued at the same time, business risk is not a factor in the higher level of risk.

Instead, this additional risk is likely to be due to the fact that Bond A has a greater time until maturity, meaning that its cash flows are more uncertain than Bond B's. In particular where interest rates are expected to increase in the future, longer-term debt will have a higher rate of interest to compensate investors for investing for a longer period.

A further factor is that the total nominal value (book value) of Bond A is twice as large as Bond B and therefore may be perceived to be riskier.

ACCA

FM

Financial Management

Mock Examination 3

December 2016 exam

Questions
Time allowed: 3 hours
ALL questions are compulsory and MUST be attempted

DO NOT OPEN THIS EXAM UNTIL YOU ARE READY TO START UNDER EXAMINATION CONDITIONS

Section A – ALL 15 questions are compulsory and MUST be attempted

Each question is worth 2 marks.

1 Which of the following is an advantage of implementing just-in-time inventory management?

 ☐ Quality control costs will be eliminated.

 ☐ Monthly finance costs incurred in holding inventory will be kept constant.

 ☐ The frequency of raw materials deliveries is reduced.

 ☐ The amount of obsolete inventory will be minimised.

2 Which TWO of the following activities are carried out by a financial intermediary?

 ☐ Transforming interest rates

 ☐ Transforming foreign exchange

 ☐ Transforming maturity

 ☐ Transforming risk

3 Frost Co is planning a 1 for 4 rights issue with an issue price at a 10% discount to the current share price.

 The EPS is currently $0.50 and the shares of Frost Co are trading on a price/earnings ratio of 20 times. The market capitalisation of the company is $50m.

 What is the theoretical ex-rights price per share (to two decimal places)?

 $ []

4 Which of the following statements in relation to business valuation are true or false?

		True	False
1	The earnings yield method and the dividend growth model should give similar values for a company.	☐	☐
2	Market capitalisation represents the maximum value for a company.	☐	☐
3	The price/earnings ratio is the reciprocal of the earnings yield.	☐	☐
4	The price/earnings ratio should be increased if the company being valued is riskier than the valuing company.	☐	☐

5 Small and medium-sized entities (SMEs) have restricted access to capital markets.

What is the term given to the difference between the finance required to operate an SME and the amount obtained?

☐ Forecasted gap

☐ Maturity gap

☐ Funding gap

☐ Asset gap

6 Max Co is a large multinational company which expects to have a $10m cash deficit in one month's time. The deficit is expected to last no more than two months.

Max Co wishes to resolve its short-term liquidity problem by issuing an appropriate instrument on the money market.

Which of the following instruments should Max Co issue?

☐ Commercial paper

☐ Interest rate futures

☐ Corporate loan notes

☐ Treasury bills

7 **In relation to capital markets, which of the following statements is true?**

☐ The return from investing in larger companies has been shown to be greater than the average return from all companies.

☐ Weak form efficiency arises when investors tend not to make rational investment decisions.

☐ Allocative efficiency means that transaction costs are kept to a minimum.

☐ Research has shown that, over time, share prices appear to follow a random walk.

8 The following data is available:

Country Y currency	Dollar
Country X currency	Peso
Country Y interest rate	1% per year
Country X interest rate	3% per year
Country X expected inflation rate	2% per year
Spot exchange rate in Country Y	1.60 peso per $1

What is the current six-month forward exchange rate in Country Y (to two decimal places)?

[_____]

9 Green Co, a listed company, had the following share prices during the year ended 31
 December 20X5:

 At start of 20X5 $2.50
 Highest price in the year $3.15
 Lowest price in the year $2.40
 At end of 20X5 $3.00

 During the year, Green Co paid a total dividend of $0.15 per share.

 What is the total shareholder return for 20X5?

 ☐ 26%

 ☐ 22%

 ☐ 32%

 ☐ 36%

10 Carp Co has announced that it will pay an annual dividend equal to 55% of earnings. Its
 earnings per share is $0.80, and it has 10 million shares in issue. The return on equity of
 Carp Co is 20% and its current cum dividend share price is $4.60.

 What is the cost of equity of Carp Co?

 ☐ 19.4%

 ☐ 20.5%

 ☐ 28.0%

 ☐ 22.7%

11 Mile Co is looking to change its working capital policy to match the rest of the industry. The
 following results are expected for the coming year:

 | | $'000 |
 |----------------|-----------|
 | Revenue | 20,500 |
 | Cost of sales | (12,800) |
 | Gross profit | 7,700 |

 Revenue and cost of sales can be assumed to be spread evenly throughout the year. The
 working capital ratios of Mile Co, compared with the industry, are as follows:

 | | Mile Co | Industry |
 |-----------------|---------|----------|
 | Receivable days | 50 | 42 |
 | Inventory days | 45 | 35 |
 | Payable days | 40 | 35 |

 Assume there are 365 days in each year.

 **If Mile Co matches its working capital cycle with the industry, what will be the
 decrease in its net working capital?**

 ☐ $624,600

 ☐ $730,100

 ☐ $835,600

 ☐ $975,300

BPP
LEARNING
MEDIA

12　Are the following statements true or false?

		True	False
1	A prospective merger would need to result in a company having a market share greater than 80% before it can be described as a monopoly.	☐	☐
2	A government may intervene to weaken its country's exchange rate in order to eliminate a balance of payments deficit.	☐	☐
3	A relatively high rate of domestic inflation will lead to a strengthening currency.	☐	☐
4	Government fiscal policy involves the management of interest rates.	☐	☐

13　Which of the following statements about interest rate risk hedging are correct or incorrect?

	Correct	Incorrect
An interest rate floor can be used to hedge an expected increase in interest rates.	☐	☐
The cost of an interest rate floor is higher than the cost of an interest rate collar.	☐	☐
The premium on an interest rate option is payable when it is exercised.	☐	☐
The standardised nature of interest rate futures means that over- and under-hedging can be avoided.	☐	☐

14　Which of the following statements is true?

☐ Value for money is usually taken to mean economy, efficiency and engagement.

☐ Cum dividend means the buyer of the share is not entitled to receive the dividend shortly to be paid.

☐ The dividend payout ratio compares the dividend per share with the market price per share.

☐ The agency problem means that shareholder wealth is not being maximised.

15　Swap Co is due to receive goods costing $2,500. The terms of trade state that payment must be received within three months. However, a discount of 1.5% will be given for payment within one month.

Which of the following is the annual percentage cost of ignoring the discount and paying in three months?

☐ 6.23%

☐ 9.34%

☐ 6.14%

☐ 9.49%

(Total = 30 marks)

Section B – ALL 15 questions are compulsory and MUST be attempted

Each question is worth 2 marks.

The following scenario relates to questions 16 to 20.

Park Co is based in a country whose currency is the dollar ($). The company regularly imports goods denominated in euro (€) and regularly sells goods denominated in dinars. Two of the future transactions of the company are as follows:

Three months: Paying €650,000 for imported goods
Six months: Receiving 12 million dinars for exported capital goods

Park Co has the following exchange rates and interest rates available to it:

	Bid	Offer
Spot exchange rate (dinars per $1):	57.31	57.52
Six-month forward rate (dinars per $1):	58.41	58.64
Spot exchange rate (€ per $1):	1.544	1.552
Three-month forward rate (€ per $1):	1.532	1.540

Six-month interest rates:

	Borrow	Deposit
Dinars	4.0%	2.0%
Dollars	2.0%	0.5%

The finance director of Park Co believes that the upward-sloping yield curve reported in the financial media means that the general level of interest rates will increase in the future, and therefore expects the reported six-month interest rates to increase.

16 What is the future dollar value of the dinar receipt using a money market hedge?

☐ $197,752

☐ $201,602

☐ $208,623

☐ $210,629

17 In hedging the foreign currency risk of the two transactions, which of the following hedges will Park Co find to be effective?

1 Leading the euro payment on its imported goods

2 Taking out a forward exchange contract on its future dinar receipt

3 Buying a tailor-made currency option for its future euro payment

☐ 2 only

☐ 1 and 3 only

☐ 2 and 3 only

☐ 1, 2 and 3

BPP
LEARNING
MEDIA

18 Which hedging methods will assist Park Co in reducing its overall foreign currency risk?

1 Taking out a long-term euro-denominated loan

2 Taking out a dinar-denominated overdraft

☐ 1 only

☐ 2 only

☐ Both 1 and 2

☐ Neither 1 nor 2

19 Indicate whether the following statements are correct or incorrect.

		Correct	Incorrect
1	Purchasing power parity can be used to predict the forward exchange rate.	☐	☐
2	The international Fisher effect can be used to predict the real interest rate.	☐	☐

20 Which of the following statements is consistent with an upward-sloping yield curve?

☐ The risk of borrowers defaulting on their loans increases with the duration of the lending.

☐ Liquidity preference theory implies that short-term interest rates contain a premium over long-term interest rates to compensate for lost liquidity.

☐ Banks are reluctant to lend short-term, while government debt repayments have significantly increased the amount of long-term funds available.

☐ The Government has increased short-term interest rates in order to combat rising inflation in the economy.

The following scenario relates to questions 21 to 25.

The finance director of Coral Co has been asked to provide values for the company's equity and loan notes. Coral Co is a listed company and has the following long-term finance:

	$m
Ordinary shares	7.8
7% convertible loan notes	8.0
	15.8

The ordinary shares of Coral Co have a nominal value of $0.25 per share and are currently trading on an ex dividend basis at $7.10 per share. An economic recovery has been forecast and so share prices are expected to grow by 8% per year for the foreseeable future.

The loan notes are redeemable after 6 years at their nominal value of $100 per loan note, or can be converted after 6 years into 10 ordinary shares of Coral Co per loan note. The loan notes are traded on the capital market.

The before-tax cost of debt of Coral Co is 5% and the company pays corporation tax of 20% per year.

21 What is the equity market value of Coral Co (to two decimal places)?

$ [] m

22 Assuming conversion, what is the market value of each loan note of Coral Co?

☐ $110.13
☐ $112.67
☐ $119.58
☐ $125.70

23 Which of the following statements about the equity market value of Coral Co is/are true?

1 The equity market value will change frequently due to capital market forces.

2 If the capital market is semi-strong form efficient, the equity market value will not be affected by the release to the public of insider information.

3 Over time, the equity market value of Coral Co will follow a random walk.

☐ 1 only
☐ 1 and 3 only
☐ 2 and 3 only
☐ 1, 2 and 3

24 Indicate whether the following are assumptions made by the dividend growth model.

		Yes	No
1	Investors make rational decisions.	☐	☐
2	Dividends show either constant growth or zero growth.	☐	☐
3	The dividend growth rate is less than the cost of equity.	☐	☐

25 Why might valuations of the equity and loan notes of Coral Co be necessary?

1 The company is planning to go to the market for additional finance.
2 The securities need to be valued for corporate taxation purposes.
3 The company has received a takeover bid from a rival company.

☐ 1 and 2 only
☐ 1 and 3 only
☐ 3 only
☐ 1, 2 and 3

The following scenario relates to questions 26 to 30.

Link Co has been prevented by the competition authorities from buying a competitor, Twist Co, on the basis that this prevents a monopoly position arising. Link Co has therefore decided to expand existing business operations instead and as a result the finance director has prepared the following evaluation of a proposed investment project for the company:

	$m
Present value of sales revenue	6,657
Present value of variable costs	2,777
Present value of contribution	3,880
Present value of fixed costs	1,569
Present value of operating cash flow	2,311
Initial capital investment	1,800
Net present value	511

The project life is expected to be four years and the finance director has used a discount rate of 10% in the evaluation.

The investment project has no scrap value.

The finance director is considering financing the investment project by a new issue of debt.

26 **What is the change in sales volume which will make the NPV zero?**

☐ 7.7%

☐ 13.2%

☐ 18.4%

☐ 22.1%

27 **Which of the following statements relating to sensitivity analysis is/are correct?**

1 Although critical factors may be identified, the management of Link Co may have no control over them.

2 A weakness of sensitivity analysis is that it ignores interdependency between project variables.

3 Sensitivity analysis can be used by Link Co to assess the risk of an investment project.

☐ 1 and 2 only

☐ 1 only

☐ 2 and 3 only

☐ 1, 2 and 3

28 **Using the average investment method and assuming operating cash flows of $729,000 per year, what is the return on capital employed of the investment project?**

☐ 16%

☐ 28%

☐ 31%

☐ 64%

29 Which of the following statements relating to debt finance is correct?

☐ Link Co can issue long-term debt in the euro currency markets.

☐ The interest rate which Link Co pays on its new issue of debt will depend on its weighted average cost of capital.

☐ A new issue of loan notes by Link Co will take place in the primary market.

☐ Link Co will not be able to issue new debt without offering non-current assets as security.

30 Which of the following statements relating to competition policy is/are correct?

1 Scale economies are an advantage of monopoly and oligopoly

2 Social costs or externalities are an example of economic inefficiency arising from market failure

3 Monopoly is discouraged because it can lead to inefficiency and excessive profits

☐ 1 and 2 only

☐ 3 only

☐ 2 and 3 only

☐ 1, 2 and 3

(Total = 30 marks)

Section C – BOTH questions are compulsory and MUST be attempted

31 Gadner Co wishes to calculate its weighted average cost of capital. The company has the following sources of finance:

	$'000
Ordinary shares	8,000
10% preference shares	2,000
8% loan notes	6,000
Bank loan	2,000
	18,000

The ordinary shares have a nominal value of $0.20 per share and are currently trading at $6.35 per share. The equity beta of Gadner Co is 1.25.

The preference shares are irredeemable and have a nominal value of $0.50. They are currently trading at $0.55 per share.

The 8% loan notes have a nominal value of $100 per loan note and a market value of $108.29 per loan note. They are redeemable in six years' time at a 5% premium to nominal value.

The bank loan charges fixed interest of 7% per year.

The yield on short-dated UK treasury bills is 4% and the equity risk premium is 5.6% per year. Gadner Co pays corporation tax of 20%.

Required

(a) Calculate the market value weighted average cost of capital of Gadner Co.

(11 marks)

(b) Explain the meaning of the terms business risk and financial risk. (4 marks)

(c) Discuss the key features of a rights issue as a way of raising equity finance.

(5 marks)

(Total = 20 marks)

32 Dysxa Co is looking to expand the capacity of an existing factory in its Alpha Division by 850,000 units per year in order to meet increased demand for one of its products. The expansion will cost $3.2 million.

The selling price of the product is $3.10 per unit and variable costs of production are $1.10 per unit, both in current price terms. Selling price inflation of 3% per year and variable cost inflation of 6% per year are expected. Nominal fixed costs of production have been forecast as follows:

Year	1	2	3	4
Fixed costs ($)	110,000	205,000	330,000	330,000

Dysxa Co has a nominal after-tax weighted average cost of capital of 10% and pays corporation tax of 20% per year one year in arrears. The company can claim 25% reducing balance tax-allowable depreciation on the full cost of the expansion, which you should assume is paid at the start of the first year of operation.

Dysxa Co evaluates all investment projects as though they have a project life of four years and assumes zero scrap value at the end of four years.

Answers

DO NOT TURN THIS PAGE UNTIL YOU HAVE
COMPLETED THE MOCK EXAM

Section A

1 The correct answer is: **The amount of obsolete inventory will be minimised.**

Inventory should not be held in a JIT environment, and this will be made possible by frequent deliveries from suppliers. Some inspection (quality costs) will still occur.

2 The correct answer is: **Transforming maturity and transforming risk.**

Maturity is transformed by allowing short-term deposits to be lent out for the long term. Risk is transformed because any losses suffered through default by borrowers or capital losses are effectively pooled and borne as costs by the intermediary allowing money to be deposited at financial institutions without incurring substantial risk.

3 The correct answer is: **$9.80**

Current share price = 0.5 × 20 = $10 per share

Rights issue price = 10 × 90/100 = $9 per share

Number of shares to be issued = (50m/10)/4 = 1.25m shares

TERP = (10 × 5 + 9 × 1.25)/6.25 = $9.80 per share

4 The correct answer is:

	True	False
The earnings yield method and the dividend growth model should give similar values for a company.		X
Market capitalisation represents the maximum value for a company.		X
The price/earnings ratio is the reciprocal of the earnings yield.	X	
The price/earnings ratio should be increased if the company being valued is riskier than the valuing company.		X

The only true statement: The price/earnings ratio is the reciprocal of the earnings yield (ie P/E = 1 divided by E/P).

Notes on false statements.

Earnings yield and dividend growth will often give different outcomes eg if a company pays zero dividends.

Market capitalisation is the current market value of a company's shares, a company may be worth more than this in an acquisition if synergies could result from the acquisition.

The price/earnings ratio should be **decreased** if the company being valued is riskier than the valuing company.

5 The correct answer is: **Funding gap**

6 The correct answer is: **Commercial paper**

Commercial paper will be issued at a discount and then repaid at nominal value on the settlement date. It is short term and traded on the money market. Not interest payments are made.

Notes on incorrect answers:

Interest rate futures are not a type of finance.

Loan notes are a source of long-term finance and are therefore not suitable here.

Treasury bills are a source of finance for governments.

7 The correct answer is: **Research has shown that, over time, share prices appear to follow a random walk.**

Notes on incorrect answers:

The **risk** from investing in larger companies has been shown to be **lower** than the average for all companies. The relationship between risk and return suggests that this will translate into lower returns.

Zero form efficiency arises when investors tend not to make rational investment decisions.

Operational efficiency means that transaction costs are kept to a minimum.

8 The correct answer is: **1.62**

Forward rate = $1.60 \times (1.015/1.005) = 1.62$ pesos per \$

(Strictly $1.60 \times (1.03/1.01)0.5$ but same number to 2 decimal places)

9 The correct answer is: **26%**

TSR = $100 \times (3.00 - 2.50 + 0.15)/2.50 = 26\%$

10 The correct answer is: **20.5%**

Dividend to be paid = $0.80 \times 0.55 = \$0.44$ per share

Retention ratio = $100\% - 55\% = 45\%$

Dividend growth rate = $45\% \times 20\% = 9\%$ per year

Ke = $(0.44 \times 1.09)/(4.60 - 0.44) + 0.09 = 20.5\%$

11 The correct answer is: **\$624,600**

Reduced receivables = $8/365 \times 20,500 = \$449,300$

Net inventory/payables effect = $(10 - 5)/365 \times 12,800 = \$175,300$

Total net working capital effect = $449.3 + 175.3 = \$624,600$

12 The correct answer is:

	True	False
A prospective merger would need to result in a company having a market share greater than 80% before it can be described as a monopoly.		X
A government may intervene to weaken its country's exchange rate in order to eliminate a balance of payments deficit.	X	
A relatively high rate of domestic inflation will lead to a strengthening currency.		X
Government fiscal policy involves the management of interest rates.		X

There is one true statement: A government may intervene to weaken its country's exchange rate in order to eliminate a balance of payments deficit.

This is because the effect of a weaker exchange rate is to reduce the price of exports and increase the cost of imports.

Notes on false statements:

A prospective merger would normally need to result in a company having a market share greater than 25% before regulatory authorities would be concerned about monopoly power. Strictly a monopolist has 100% market share.

A relatively high rate of domestic inflation will lead to a **weakening** currency according to purchasing power parity theory.

Government fiscal policy involves the management of tax and spending policies, not interest rates.

13 The correct answer is:

	Correct	Incorrect
An interest rate floor can be used to hedge an expected increase in interest rates.		X
The cost of an interest rate floor is higher than the cost of an interest rate collar.	X	
The premium on an interest rate option is payable when it is exercised.		X
The standardised nature of interest rate futures means that over- and under-hedging can be avoided.		X

There is one correct statement: The cost of an interest rate floor is higher than the cost of an interest rate collar.

This is because a floor involves buying a call option, whereas a collar involves selling a put option as well (which offsets the cost of buying a call).

Notes on incorrect statements:

An interest rate cap (not floor) can be used to hedge an expected increase in interest rates.

The premium on an interest rate option is payable when it is purchased not when it is exercised.

The standardised nature of interest rate futures means that over- and under-hedging occurs because a company is often unable to hedge exactly the amount that it requires.

14 The correct answer is: **The agency problem means that shareholder wealth is not being maximised**

Notes on incorrect answers:

Value for money is usually taken to mean economy, efficiency and effectiveness (not engagement).

Ex (not cum) dividend means the buyer of the share is not entitled to receive the dividend shortly to be paid.

The dividend payout ratio compares the dividend per share with the earnings per share.

15 The correct answer is: **9.49%**

If the discount is accepted, the company must pay $2,462.50 at the end of one month.

Alternatively, the company can effectively borrow the $2,462.50 for an additional 2 months at a cost of $37.50.

The 2-month rate of interest is therefore 37.50/2,462.5 × 100 = 1.5228%

The annual equivalent rate (AER) = (1 + 0.015228)6 – 1 = 0.0949 or 9.49%

Section B

16 The correct answer is: **$201,602**

Dollar value = (12m × 1.005)/(1.04 × 57.52) = $201,602

17 The correct answer is: **All three hedges will allow Park Co to hedge its foreign currency risk.**

18 The correct answer is: **2 only**

Only the dinar-denominated overdraft will be effective, by matching assets and liabilities. The long-term euro-denominated loan will increase payments to be made in euros and hence increase foreign currency risk.

19 The correct answer is: **Both are incorrect**

Purchasing power parity predicts the future spot rate, not the forward exchange rate. The international Fisher effect does not predict 'real' interest rates.

20 The correct answer is: **The risk of borrowers defaulting on their loans increases with the duration of the lending.**

If default risk increases with duration, compensation for default risk increases with time and hence the yield curve will slope upwards.

Notes on incorrect answers:

Liquidity preference theory implies that **long-term** interest rates contain a premium over **short-term** interest rates to compensate for lost liquidity.

If government debt repayments have significantly increased the amount of long-term funds available this will decrease the cost of borrowing in the long-term.

If the Government has increased short-term interest rates in order to combat rising inflation in the economy this may lead to a downward sloping yield curve.

21 The correct answer is: **$221.52m**

Equity market value = 7.10 × (7.8m/0.25) = $221.52m

22 The correct answer is: **$119.58**

Conversion value = 7.10 × 1.086 × 10 = $112.67 per loan note

Market value = (7 × 5.076) + (112.67 × 0.746) = 35.53 + 84.05 = $119.58

23 The correct answer is: **1 and 3 only**

If the capital market is semi-strong form efficient, newly-released insider information will quickly and accurately be reflected in share prices. The other statements are true.

24 The correct answer is: **All three are assumptions made by the dividend growth model**

25 The correct answer is: **1 and 3 only**

A valuation for corporate taxation purposes is not necessary.

26 The correct answer is: **13.2%**

100 × 511/3,880 = 13.2%

27 The correct answer is: **1 and 2 only**

Sensitivity Analysis assesses the **uncertainty** of a project, not the risk (probability analysis does this).

28 The correct answer is: **31%**

The total operating cash flow = 4 × (2,311/3.170) = $2,916,088

The average annual accounting profit = (2,916,088 − 1,800,000)/4 = $279,022

Average investment = 1,800,000/2 = $900,000

ROCE = 100 × 279,022/900,000 = 31%

29 The correct answer is: **A new issue of loan notes by Link Co will take place in the primary market.**

Notes on incorrect answers:

Link Co can issue **short-term** debt in the euro currency markets.

The interest rate which Link Co pays on its new issue of debt will depend factors such as risk and the duration of the debt, not on its weighted average cost of capital.

Link Co will be able to issue new debt using debt covenants or floating charges on its asset base as a whole.

30 The correct answer is: **1, 2 and 3**

Section C

Question 31

Workbook references. Sources of finance are covered in Chapter 9 and cost of capital is covered in Chapter 11.

Top tips. Neat workings will be important to avoid careless errors in part (a).

Read the discussion parts of the question carefully to make sure that you are answering the question that has been set. For example in part (c) you are asked to discuss the features of a rights issue, not the motives for organising a rights issue.

Easy marks. Each part of the calculations in part (a) will gain marks so, if you get stuck, make an assumption and move on.

Marking scheme

			Marks
(a)	Cost of equity	2	
	Cost of preference shares	1	
	After-tax loan note interest cost	1	
	Setting up Kd calculation	1	
	After-tax Kd of loan notes	1	
	Cost of debt of bank loan	1	
	Market value of equity	0.5	
	Market value of preference shares	0.5	
	Market value of loan notes	0.5	
	Total market value of sources of finance	0.5	
	Calculation of WACC	2	
			11
(b)	Nature of business risk	2	
	Nature of financial risk	2	
			4
(c)	One mark per relevant point	Maximum	5
			20

(a) **Cost of equity**

Using the CAPM, $K_e = 4 + (1.25 \times 5.6) = 11.0\%$

Cost of capital of 10% irredeemable preference shares

Preference share dividend = $0.1 \times 0.5 = \$0.05$ per share

Cost of preference shares = $100 \times 0.05/0.55 = 9.1\%$

Cost of debt of loan notes

After-tax interest cost = $8 \times 0.8 = \$6.40$ per $100 loan note

Year	Cash flow	$	5% discount	PV $	6% discount	PV $
0	Market value	(108.29)	1.000	(108.29)	1.000	(108.29)
1–6	Interest	6.40	5.076	32.49	4.917	31.47
6	Redemption	105.00	0.746	78.33	0.705	74.03
				2.53		(2.79)

After-tax Kd = IRR = 5 + (1 × 2.53)/(2.53 + 2.79) = 5 + 0.5 = 5.5%

Alternatively IRR can be calculated using the =IRR spreadsheet function based on these cash flows:

Time	0	1	2	3	4	5	6
	(108.29)	6.4	6.4	6.4	6.4	6.4	111.4

This approach also gives an IRR of 5.5%

Cost of debt of bank loan

The after-tax interest cost can be used as Kd, ie 7 × 0.8 = 5.6%.

Alternatively, the after-tax cost of debt of the loan notes can be used as a substitute.

Appropriate values of the sources of finance

	$'000
Market value of equity = $6.35 × (8m/0.2) =	254,000
Market value of preference shares = 0.55 × (2m/0.5) =	2,200
Market value of loan notes = $108.29 × (6m/100) =	6,497
Book value of debt	2,000
Total market value of sources of finance	264,697

Calculation of WACC

WACC = [(11 × 254,000) + (9.1 × 2,200) + (5.5 × 6,497) + (5.6 × 2,000)]/264,697 = 10.8%

(b) Business risk in financial management relates to the variability of shareholder returns which arises from business operations. It can be measured from a statement of profit or loss perspective by operational gearing, which considers the relative importance of fixed and variable operating costs in relation to operating profit (PBIT). One definition of operational gearing is contribution/profit before interest and tax or PBIT. Business risk is not influenced by the way in which a company is financed; that is, it is not influenced by the capital structure of a company.

Financial risk relates to the variability of shareholder returns which arises from the way in which a company finances itself; that is, from its capital structure. It can be measured from a balance sheet perspective by gearing (financial gearing, debt/equity ratio, debt ratio) and from a statement of profit or loss perspective by interest cover and income gearing.

The combination of business risk and financial risk is referred to as total risk.

(c) **Pre-emptive right of shareholders**

In order to preserve the balance of ownership and control in a company, existing shareholders have a right to be offered new shares before they are offered to other buyers. This is known as the pre-emptive right and an offer of new shares to existing shareholders is consequently referred to as a rights issue.

Rights issue price and cum rights price

The price at which the new shares are offered to existing shareholders is called the rights issue price. The share price following the announcement of the rights issue is called the cum rights price and the rights issue price is at a discount to this price.

Theoretical ex-rights price

The share price after the rights issue has taken place is called the theoretical ex-rights price. This is a weighted average of the cum rights price and the rights issue price. The weighting arises from what is called the form of the rights issue, eg a 1 for 5 issue would allow an existing shareholder to buy 1 new share for every 5 shares already held.

Neutral effect on shareholder wealth

If issue costs and the use or application of the rights issue funds is ignored then, theoretically, rights issues have a neutral effect on shareholder wealth. The rights issue transfers cash from existing shareholders to the company in exchange for shares, so the shareholder will see cash wealth replaced by ordinary share wealth. The theoretical ex-

rights price, rather than the cum rights price, is therefore a benchmark for assessing the effect on shareholder wealth of the use or application to which the rights issue funds are put.

Balance of ownership and control

Providing existing shareholders buy the shares to which they are entitled, there is no change in the balance of ownership and control in a company. Relative voting rights are therefore preserved.

Underwriting

In order to ensure that a company receives the funds it needs, rights issues are underwritten as a form of insurance. Shares which are not taken up by existing shareholders will be taken up, for a fee, by the underwriters.

Question 32

> **Workbook references.** Investment appraisal with tax and inflation is covered in Chapter 6, risk in Chapter 7 and capital rationing in Chapter 8.
>
> **Top tips.** Make sure that you show your workings for this type of question (in part (a)) to minimise the risk of making careless mistakes. If you get stuck in part (b) then quickly move on to parts (c) and (d) which are worth almost half of the total marks for this question.
>
> **Easy marks.** Part (a), for eight marks, asked for a net present value (NPV) in nominal terms. This featured the normal elements of an NPV calculation – tax, capital allowances, inflation etc. This question should have been an area of strength for any well-prepared candidate.

Marking scheme

			Marks
(a)	Inflated sales revenue	1	
	Inflated variable cost	1	
	Tax liabilities	1	
	Tax-allowable depreciation benefits Years 1–3	1	
	Tax-allowable depreciation benefit Year 4	1	
	Timing of tax liabilities and depreciation benefits	1	
	Calculation of present values	1	
	Comment on financial acceptability	1	
			8
(b)	Calculating profitability indexes	1	
	Formulating optimum investment schedule	1	
	NPV of optimum investment schedule	1	
			3
(c)	Soft capital rationing	2	
	Hard capital rationing	2	
	Additional detail	1	
			5
(d)	Risk assessment method 1	2	
	Risk assessment method 2	2	
			4
			20

(a) NPV calculation

Year	1 $'000	2 $'000	3 $'000	4 $'000	5 $'000
Sales revenue	2,712	2,797	2,882	2,967	
Variable costs	(995)	(1,054)	(1,114)	(1,182)	
Contribution	1,717	1,743	1,768	1,785	
Fixed costs	(110)	(205)	(330)	(330)	
Taxable cash flow	1,607	1,538	1,438	1,455	
Taxation at 20%		(321)	(308)	(288)	(291)
TAD tax benefits		160	120	90	270
After-tax cash flow	1,607	1,377	1,250	1,257	(21)
Discount at 10%	0.909	0.826	0.751	0.683	0.621
Present values	1,461	1,137	939	859	(13)

	$'000
PV of future cash flows	4,383
Initial investment	3,200
NPV	1,183

Comment

The NPV is positive and so the investment project is financially acceptable.

Workings

1 *Sales revenue*

Year	1	2	3	4
Selling price ($/unit)	3.1	3.1	3.1	3.1
Inflated at 3% per year	3.19	3.29	3.39	3.49
Sales volume ('000 units/year)	850	850	850	850
Sales revenue ($'000/year)	2,712	2,797	2,882	2,967

2 *Variable cost*

Year	1	2	3	4
Variable cost ($/unit)	1.1	1.1	1.1	1.1
Inflated at 6% per year	1.17	1.24	1.31	1.39
Sales volume ('000 units/year)	850	850	850	850
Variable cost ($'000/year)	995	1,054	1,114	1,182

Year	1	2	3	4
TAD ($'000)	800	600	450	1,350
Tax benefits ($'000)	160	120	90	270*

*(3,200 × 0.2) – 160 – 120 – 90 = $270,000

Alternative calculation of after-tax cash flow

Year	1 $'000	2 $'000	3 $'000	4 $'000	5 $'000
Taxable cash flow	1,607	1,538	1,438	1,455	
TAD	(800)	(600)	(450)	(1,350)	
Taxable profit	807	938	988	105	
Taxation at 20%		(161)	(188)	(198)	(21)
After-tax profit	807	777	800	(93)	(21)
Add back TAD	800	600	450	1,350	
After-tax cash flow	1,607	1,377	1,250	1,257	(21)

(b) **Analysis of profitability indexes**

Project	Initial investment	Net present value	Profitability index*	Rank
A	$3,000,000	$6,000,000	2.0	2nd
B	$2,000,000	$3,200,000	1.6	4th
C	$1,000,000	$1,700,000	1.7	Excluded
D	$1,000,000	$2,100,000	2.1	1st
E	$2,000,000	$3,600,000	1.8	3rd

*NPV divided by initial investment (note that it is also acceptable to calculate the profitability index as the PV of future cash flows/initial investment).

Optimum investment schedule

Project	Initial investment	Rank	Net present value	
D	$1,000,000	1st	$2,100,000	
A	$3,000,000	2nd	$6,000,000	
E	$2,000,000	3rd	$3,600,000	
B	$1,000,000	4th	$1,600,000	($3.2m × $1m/$2m)
	$7,000,000		$13,300,000	

The NPV of the optimum investment schedule for Delta Division is $13.3 million.

(c) Capital rationing can be divided into hard capital rationing, which is externally imposed, or soft capital rationing, which is internally imposed.

Soft capital rationing

Investment capital may be limited internally because a company does not want to take on a commitment to increased fixed interest payments; for example, if it expects future profitability to be poor. A company may wish to avoid diluting existing earnings per share or changing existing patterns of ownership and control by issuing new equity. A company may limit investment funds because it wishes to pursue controlled growth rather than rapid growth. Given the uncertainty associated with forecasting future cash flows, a company may limit investment funds in order to create an internal market where investment projects compete for finance, with only the best investment projects being granted approval.

Hard capital rationing

External reasons for capital rationing can be related to risk and to availability of finance. Providers of finance may see a company as too risky to invest in, perhaps because it is highly geared or because it has a poor record or poor prospects in terms of profitability or cash flow. Long-term finance for capital investment may have limited availability because of the poor economic state of the economy, or because there is a banking crisis.

(d) The risk of an investment project could be assessed by using probability analysis or by using the capital asset pricing model (CAPM).

Probability analysis

Project risk can be assessed or quantified by attaching probabilities to expected investment project outcomes. At an overall level, this could be as simple as attaching probabilities to two or more expected scenarios, for example, associated with different economic states. Key project variables might then take different values depending on the economic state.

At the level of individual project variables, probability distributions of values could be found through expert analysis, and the probability distributions and relationships between variables then built into a simulation model. This model could then be used to generate a probability distribution of expected project outcomes in terms of net present values. Project risk could then be measured by the standard deviation of the expected net present value.

CAPM

The systematic business risk of an investment project can be assessed by identifying a proxy company in a similar line of business. The equity beta of the proxy company can then be ungeared to give the asset beta of the company, which reflects systematic business risk alone as the effect of the systematic financial risk of the proxy company is removed by the ungearing process. The asset beta can then be regeared to reflect the systematic financial risk of the investing company, giving an equity beta which reflects the systematic risk of the investment project.

ACCA

FM

Financial Management

Mock Examination 4

(including ACCA Sep/Dec 2019 Section C exam questions)

Questions
Time allowed: 3 hours
ALL questions are compulsory and MUST be attempted

DO NOT OPEN THIS EXAM UNTIL YOU ARE READY TO START UNDER EXAMINATION CONDITIONS

Section A – ALL 15 questions are compulsory and MUST be attempted

Each question is worth 2 marks.

1 Which TWO of the following are roles of the money market?

☐ Allows investors to sell loan notes that they have purchased

☐ Allows companies to manage foreign currency risk

☐ Provides a less regulated market for small companies to trade their shares

☐ Enables companies to raise new short-term finance

2 Wallace Co manufactures and sells mid-range sports-wear in S-land. Wallace Co has high financial gearing, and all of its debt is paid at a fixed rate. Wallace Co is not currently planning to raise any new debt finance.

The government in S-land have adopted a contractionary monetary policy.

How would a contractionary monetary policy affect Wallace Co?

1 Lower demand for its products

2 Higher tax rates on profits

3 Increased interest rates on its debt finance

☐ 1 and 2

☐ 1 only

☐ 2 and 3

☐ 3 only

3 DD Co's P/E ratio is 12. Its competitor's earnings yield is 10%.

When comparing DD Co to its competitor, which of the following is correct?

	Earnings yield	P/E ratio
☐	DD's is higher	DD's is higher
☐	DD's is higher	DD's is lower
☐	DD's is lower	DD's is higher
☐	DD's is lower	DD's is lower

4 KEW Co is planning an investment of $10 million for a six-month period starting in three months' time.

KEW Co is worried about interest rates falling and hedges the risk using an appropriate forward rate agreement (FRA).

Details of the FRAs available to KEW Co are as follows:

6-9 FRA 2.80%-3.10%

3-9 FRA 3.00%- 3.20%

 BPP LEARNING MEDIA

Assume that in three-months' time, interest rates are 3.50%.

Which of the following shows the correct impact on cashflow for KEW to settle the FRA?

☐ KEW receives $50,000 from the bank

☐ KEW pays the bank $30,000

☐ KEW receives $40,000 from the bank

☐ KEW pays the bank $25,000

5 PXP Co is an ungeared company and has a weighted average cost of capital of 14%. The company is about to introduce long-term debt into its capital structure.

This is expected to increase PXP Co's cost of equity, but to increase the overall market value of the company.

This is consistent with which TWO theories?

☐ Modigliani & Miller's theory with tax

☐ Modigliani & Miller's theory without tax

☐ Pecking order theory

☐ Traditional theory of capital structure

6 Max Co is appraising a project with the following financial information:

	$m
Investment in depreciable non-current assets	10
Residual value of non-current assets at end of 5 years	2
Cash inflow in years 1-2	3
Cash inflow in years 3-5	4

What is the return on capital employed of the project based on average investment?

☐ 20.0%

☐ 33.3%

☐ 60.0%

☐ 36.0%

7 JC Co decides to offer an 4% early settlement discount that half of all customers take up. They pay in one month instead of the usual two. JC Co pays interest on its overdraft facility at 12% per year.

What impact will this have?

	Reduce	Increase
Cash operating cycle	☐	☐
Accounting profit	☐	☐

8 PP Co is a public listed provider of healthcare and operates a number of privately-run hospitals. NH Co is a state-controlled and -owned healthcare provider, it also operates a number of hospitals which are funded by the government.

Which TWO of the following are valid differences between the objectives of PP Co and NH Co?

☐ PP Co will aim to maximise shareholder wealth whereas NH Co won't.

☐ NH Co will not have financial objectives but PP Co will.

☐ NH Co will be most concerned about value for money whereas PP Co will prioritise the maximisation of shareholder wealth.

☐ NH Co will focus of satisfying a wide range of stakeholders whereas PP Co will only focus on satisfying shareholders.

9 Giblin Co has annual sales of $15 million. 30% of sales are for cash and the rest are on credit. Giblin Co finances its working capital with an overdraft at an annual interest rate of 10%.

Giblin Co's receivables are currently $1 million.

Assume a 360-day year.

What is the finance cost saving if receivables are reduced to 30 days?

☐ $13,699

☐ $12,500

☐ $87,500

☐ $62,500

10 A company has created an interest rate floor by purchasing an interest rate call option, in order to manage its interest rate exposure.

Which of the following statements concerning the company are true?

☐ It will receive a payment if the market rate exceeds the floor rate.

☐ It will receive a payment if the market rate is less than the floor rate.

☐ It will be required to make a payment if the market rate exceeds the floor rate.

☐ It will be required to make a payment if the market rate is less than the floor rate.

11 The following information is relevant to Connolly Co, a listed company:

At start of 20X1	$3.50
At end of 20X1	$4.00
Total dividend paid in 20X1	$0.20
EPS in 20X1	$0.50

BPP
LEARNING
MEDIA

What is the total shareholder return for 20X1?

☐ 17.5%

☐ 20.0%

☐ 28.6%

☐ 5.0%

12 Cham Co is planning to issue a loan note with a coupon rate of 5%.

At redemption each $100 nominal value loan note is either redeemable in five years' time or convertible into five ordinary shares.

The share price of Cham Co is expected to grow at a rate of 3% per year from its current level of $18.98.

Corporation tax is payable by the company at a rate of 20%.

Investors expect a yield of 6%.

What is the current market value of each loan note?

☐ $99.02

☐ $95.76

☐ $103.23

☐ $112.21

13 **Which TWO of the following are limitations of using the dividend valuation method to value an unlisted company?**

☐ The valuation fails to take account the premium required to obtain a controlling interest.

☐ The model cannot cope with periods of non-constant growth.

☐ It is based on profit not cash flow.

☐ It involves an unreliable estimate of the cost of equity.

14 The following information relates to the ordinary shares of G Co.

Share price $5.00

Dividend cover 2.5

Published dividend yield 4.8%

What is the earnings per share of G Co (to 2 decimal places)?

$ ☐

15 An issue of a 9% redeemable loan note in ATV Co is planned. This loan note is due to mature in five years' time at a premium of 15%, or convertible into 25 ordinary shares at that point. The current share price is $4, expected to grow at 10% per year. ATV pays corporation tax at a rate of 30%.

Which TWO of the following factors will cause the cost of this debt to increase?

☐ An increase in the rate of corporation tax

☐ An increase in the expected growth rate of the share price

☐ An increase in the market value of debt

☐ An increase in the conversion ratio

(Total = 30 marks)

Section B – ALL 15 questions are compulsory and MUST be attempted

Each question is worth 2 marks.

The following scenario relates to questions 16 to 20.

TGA Co's sales are exported to a European country and are invoiced in euros.

TGA Co expects to receive €500,000 from export sales at the end of three months. A forward rate of €1.680–€1.687 per $1 has been offered by the company's bank and the spot rate is €1.670–€1.675 per $1.

Other relevant financial information is as follows:

Short-term dollar borrowing rate	5% per year
Short-term dollar deposit rate	4% per year

TGA Co can borrow short term in the euro at 9% per year.

Assume there are 365 days in each year.

16 Which of the following are valid courses of action for TGA Co to reduce the risk of the euro value dropping relative to the dollar before the €500,000 is received?

 1 Deposit €500,000 immediately
 2 Enter into a forward contract to sell €500,000 in three months
 3 Enter into an interest rate swap for three months

 ☐ 1 or 2 only

 ☐ 2 only

 ☐ 3 only

 ☐ 1, 2 or 3

17 What is the dollar value of a forward market hedge (to the nearest whole number) in three months' time?

 $☐

18 What is the dollar value of a money market hedge in three months' time?

 $☐

19 TGA Co is considering futures contracts.

 Which of the following statements are true of futures contracts?

		True	False
1	Transactions costs are lower than other hedging methods.	☐	☐
2	They can be tailored to TGA Co's exact requirements.	☐	☐

20 The following statements refer to types of foreign currency risk.

1 The risk that TGA Co will make exchange losses when the accounting results of its foreign branches are expressed in the home currency

2 The risk that exchange rate movements will affect the international competitiveness of TGA Co

What types of risk do the statements refer to?

	Economic	Translation	Transaction
Statement 1	☐	☐	☐
Statement 2	☐	☐	☐

The following scenario relates to questions 21 to 25.

IML Co is an all-equity financed listed company. Nearly all its shares are held by financial institutions.

IML has recently appointed a new finance director who advocates using the capital asset pricing model as a means of evaluating risk and interpreting stock market reaction to the company.

The following initial information has been put forward by the finance director for a rival company operating in the same industry:

	Equity beta
AZT Co	0.7

The finance director notes that the risk-free rate is 5% each year and the expected rate of return on the market portfolio is 15% each year.

21 Calculate, using the capital asset pricing model, the required rate of return on equity of AZT Co (give your answer to the nearest whole number).

[]%

22 At the end of the year IML Co paid a dividend of 15c per share. At the year-end share price was $3.30 cum div. Share price was $2.50 at the start of the year.

What is the total shareholder return over the period (give your answer to the nearest whole number)?

[]%

23 Calculate the equity beta of IML Co, assuming its required annual rate of return on equity is 17% and the stock market uses the capital asset pricing model to calculate the equity beta (give your answer to one decimal place).

[]

24 Which TWO of the following statements are true?

- ☐ If IML Co's share price generally moved at three times the market rate, its equity beta factor would be 3.0
- ☐ The beta factor of IML Co indicates the level of unsystematic risk
- ☐ The higher the level of systematic risk, the lower the required rate of return by IML Co
- ☐ IML Co will expect the return on a project to exceed the risk-free rate

25 Are the following statements true or false?

		True	False
1	The CAPM model assumes that investors hold a fully diversified portfolio.	☐	☐
2	If IML Co has a low price/earnings ratio, it will have a low cost of equity.	☐	☐

The following scenario relates to questions 26 to 30.

Phobis Co is considering a bid for Danoca Co. Both companies are stock market listed and are in the same business sector. Financial information on Danoca Co, which is shortly to pay its annual dividend, is as follows:

Number of ordinary shares	5 million
Ordinary share price (ex div basis)	$3.30
Earnings per share	40.0c
Dividend payout ratio	60%
Dividend per share one year ago	23.3c
Dividend per share two years ago	22.0c
Average sector earnings yield	10%

26 Calculate the value of Danoca Co using the earnings yield method.

- ☐ $2m
- ☐ $5m
- ☐ $16.5m
- ☐ $20m

27 Are the following statements true or false?

		True	False
1	If the P/E ratio of Danoca Co is lower than the average sector P/E ratio then the market does not view the growth prospects of Danoca very favourably.	☐	☐
2	If the P/E ratio of Danoca Co is higher than the average sector ratio then an acquisition by Phobis Co could result in improved financial performance of Danoca Co	☐	☐

28 Using a cost of equity of 13% and a dividend growth rate of 4.5%, calculate the value
 of Danoca Co using the dividend growth model.

 ☐ $14.75m
 ☐ $5.00m
 ☐ $2.95m
 ☐ $16.50m

29 Calculate the market capitalisation of Danoca Co.

 ☐ $14.75m
 ☐ $16.50m
 ☐ $5.00m
 ☐ $20.00m

30 Which TWO of the following are true?

 ☐ Under weak form hypothesis of market efficiency, share prices reflect all available
 information about past changes in share price.

 ☐ If a stock market displays semi-strong efficiency then individuals can beat the
 market.

 ☐ Behavioural finance aims to explain the implications of psychological factors on
 investor decisions.

 ☐ Random walk theory is based on the idea that past share price patterns will be
 repeated.

 (Total = 30 marks)

Section C – BOTH questions are compulsory and MUST be attempted

31 Dusty Co wishes to improve its working capital management as part of an overall cost-cutting strategy to increase profitability. Two areas the company has been considering are working capital funding strategy and inventory management. Dusty Co currently follows a policy of financing working capital needs as much as possible from long-term sources of finance, such as equity. The company has been considering its inventory management and has been looking specifically at component K.

Current position

Dusty Co purchase 1,500,000 units of component K each year and consumes the component at a constant rate. The purchase price of component K is $14 per unit. The company places 12 orders each year. Inventory of component K in the financial statements of Dusty Co is equal to average inventory of component K.

The holding cost of component K, excluding finance costs, is $0.21 per unit per year. The ordering cost of component K is $252 per order.

Economic order quantity

Dusty Co wishes to investigate whether basing ordering of component K on the economic order quantity will reduce costs.

Bulk order discount

The supplier of component K has offered Dusty Co a discount of 0.5% on the purchase price of component K, providing the company orders 250,000 units per order.

Other information

Dusty Co has no cash but has access to short-term finance via an overdraft facility at an interest rate of 3% per year. This overdraft currently stands at $250,000.

Required

(a) (i) Calculate the annual holding and ordering costs of Dusty Co's current inventory management system. (1 mark)

 (ii) Calculate the financial effect of adopting the Economic Order Quantity as the basis for ordering inventory. (4 marks)

 (iii) Calculate the financial effect of accepting the bulk purchase discount. (4 marks)

 (iv) Recommend, with justification, which option should be selected. (1 mark)

(b) Discuss the key factors in determining working capital funding strategies. (10 marks)

(Total = 20 marks)

32 Dink Co is a small company that is finding it difficult to raise funds to acquire a new machine costing $750,000. Dink Co would ideally like a four-year loan for the full purchase price at a before interest tax rate of 8.6% per year.

The machine would have an expected life of four years. At the end of this period the machine would have a residual value of $50,000. Tax-allowable servicing costs for the machine would be $23,000 per year. Tax-allowable depreciation on the full purchase price would be available on a 25% reducing balance basis.

A leasing company has offered a contract whereby Dink Co could have use of the new machine for four years in exchange for an annual lease rental payment of $200,000 payable at the start of each year. The contract states that the leasing company would undertake maintenance of the machine at no additional cost to Dink Co. At the end of four years the leasing company would remove the machine from the manufacturing facility of Dink Co.

Dink Co pays corporation tax of 30% one year in arrears.

Required

(a) For the new machine:

 (i) Calculate the present value of the cost of borrowing to buy. **(6 marks)**

 (ii) Calculate the present value of the cost of leasing. **(3 marks)**

 (iii) Recommend which option is more attractive in financial terms to Dink Co.
 (1 mark)

(b) (i) Discuss general reasons why investment capital may be rationed. **(6 marks)**

 (ii) Discuss ways in which the external capital rationing experienced by Dink Co might be overcome. **(4 marks)**

 (Total = 20 marks)

Section A

1 The correct answers are:

Allows companies to manage foreign currency risk

Enables companies to raise new short-term finance

The money market is a section of the financial market where financial instruments with short-term maturities are traded. It is used as a way of borrowing and lending for the short term and for hedging risk (through the use of derivatives).

The Capital market enables companies to raise and sell new long term finance instruments such as loan notes. The Alternative Investment market (AIM) provides a less regulated market for small companies to trade their shares.

2 The correct answer is: **1 only**

A contractionary monetary policy involves increasing interest rates. Due to increased debt repayments, consumers have less disposable income resulting in decreased demand for products.

A contractionary **monetary** policy will increase interest rates on debt finance but this will not impact on Wallace Co's debt repayments, which are at a fixed rate.

3 The correct answer is: **DD's earnings yield is lower. DD's P/E ratio is higher.**

For DD Co, P/E = 12, Earnings yield (= 1/(P/E ratio) = 0.0833 = 8.3%.

For competitor, P/E (= 1/earnings yield) = 10, Earnings yield = 10%.

4 The correct answer is: **KEW pays the bank $25,000**

The FRA guarantees a net interest receipt of 3.0% (the lower end of the spread for an FRA starting in three months' time and ending six months later, ie a 3-9 FRA).

As the interest rate is above this (at 3.5%) , KEW Co will need to pay the bank
0.5% × $10 million × (6/12) = $25,000.

5 The correct answers are:

Modigliani & Miller's theory with tax

Traditional theory of capital structure.

Both M&M with tax and the traditional theory of gearing suggest that WACC will fall as the level of debt is initially increased (thereby increasing the market value of the company). Both accept that increased gearing will increase the financial risk of equity and will lead to an increase in the cost of equity.

M&M suggested that the WACC would continue to fall as the level of gearing is steadily increased but the traditional theory suggests that at an optimum point of gearing the WACC would start to rise again.

6 The correct answer is: **33.3%**

ROCE = Average annual accounting profit/average investment

Average investment = (10 + 2)/2 = 6

Total depreciation = 10 − 2= 8

Average annual accounting profit = (3 × 2) + (4 × 3) − 8 = 10/5 = 2.0

ROCE = 1.6/6 = 33.3%

Incorrectly using investment of 10 gives 2.0/10 = 20%

Incorrectly using CF (not deducting depreciation) and average investment = 3.6/6 = 60%

Incorrectly using CF (not deducting depreciation) and total investment = 3.6/10 = 36%

7 The correct answer is: **Both the cash operating cycle and accounting profit will reduce.**

Receivables paying sooner will reduce receivables days and hence reduce the length of the cash operating cycle. The cost of the discount (approximately 4% per month as they pay a month earlier than usual) outweighs the interest saved on the overdraft (at 12% per year this is 1% per month) hence the net effect will be reduced profit.

8 The correct answers are:

PP Co will aim to maximise shareholder wealth whereas NH Co won't.

NH Co will be most concerned about value for money whereas PP Co will prioritise the maximisation of shareholder wealth.

The key objective of a listed entity will be to maximise shareholder wealth whereas the key objective of a state owned entity will be value for money.

Notes on incorrect answers:

NH Co will not have financial objectives but PP Co will – while NH Co's objectives may not be profit focussed it will still have financial objectives.

NH Co will focus of satisfying a wide range of stakeholders whereas PP Co will only focus on satisfying shareholders. – PP's key objective will focus on shareholders but it will also need to meet the needs of a wide range of stakeholders.

9 The correct answer is: **$12,500**

$15m × 0.7 = $10.5m credit sales x 30/360 = $875,000 new receivables. Existing receivables are $1m therefore receivables reduce by $125,000 saving interest at 10% = $12,500.

Notes on incorrect answers:

$13,699 – incorrectly using 365 days

$87,500 – calculating interest saving on new receivables instead of the change in receivables.

$62,500 – using credit sales of $4.5m ($15m × 0.3)

10 The correct answer is: **It will receive a payment if the market rate is less than the floor rate**

An interest rate floor protects an investor from a fall in the market rate below the floor rate. The company will therefore receive a payment if the market rate is below the floor rate.

11 The correct answer is: **20%**

TSR = (dividend + capital gain)/SP at start of year

[$0.20 + ($4 - $3.50)]/$3.50 = 20%

Notes on incorrect answers:

[$0.20 + ($4 - $3.50)]/$4 (incorrectly using the end year price) = 17.5%

[$0.50 (incorrectly using EPS) + ($4 - $3.50)]/$3.50 = 28.6%

$0.2/$4 = 5%

12 The correct answer is: **$103.23**

In five years' time the share price is estimated as $18.98 × 1.03^5 = $22.

The bond would be converted as the MV of shares exceeds the nominal value on redemption 5 shares @ $22 = $110 conversion value

Time	CF $	DF@6%	PV
1-5	$5	4.212	21.06
5	$110	0.747	82.17
			103.23

Notes on incorrect answers:

$99.02 - incorrectly includes tax saving on interest

$95.76 - using par value for redemption

$112.21 - uses $6 as the interest and 5% as discount factor

13 The correct answers are:

The valuation fails to take account the premium required to obtain a controlling interest.

It involves an unreliable estimate of the cost of equity.

Explanation

No adjustment is made for achieving a controlling interest, it is mainly useful for valuing minority holdings.

An unlisted company's cost of equity is hard to estimate, basing it on an equivalent listed company is often used but this relies on finding an equivalent listed company which is unlikely.

Notes on incorrect answers:

Periods of non-constant growth can be adjusted for.

It is based on cash - as the dividend is cash.

14 The correct answer is: **$0.60**

Step 1 Calculate the dividend amount using dividend yield

Dividend yield = Dividend per share / share price

∴ 0.048 = dividend per share / $5

∴ $5 × 0.048 = Dividend per share = $0.24

Step 2 Calculate the EPS share using dividend cover

Dividend cover = Earnings per share / Dividend per share

∴ 2.5 = Earnings per share / 0.24

∴ 2.5 × $0.24 = Earnings per share = $0.60

15 The correct answers are:

An increase in the expected growth rate of the share price

An increase in the conversion ratio

Explanation

A higher share price and a higher conversion ratio (the number of shares per $100 of debt) will increase the cost of redeeming the debt.

Notes on incorrect answers

Higher corporation tax increases the tax shield on debt and therefore reduces the cost of debt.

A higher market value increases the finance raised for a given coupon interest repayment and redemption cost. This therefore reduces the cost of debt.

Section B

16 The correct answer is: **2 only**

TGA Co should enter into a forward contract to sell €500,000 in 3 months. Statement 1 is incorrect. TGA Co could use a money market hedge but €500,000 would have to be borrowed, then converted into dollars and then placed on deposit. Statement 3 is incorrect. An interest rate swap swaps one type of interest payment (such as fixed interest) for another (such as floating rate interest). Therefore it would not be suitable.

17 The correct answer is: **$296,384**

Forward market hedge

The higher rate should be used (the least favourable to TGA Co)

Receipt from forward contract = €500,000/1.687 = $296,384

18 The correct answer is: **$294,858**

Money market hedge

3-month euro borrowing rate = 9% × 3/12 = 2.25%

3-month dollar deposit rate = 4% × 3/12 = 1%

Borrow euros now 500,000/1.0225 = €488,998

Convert to $ now 488,998/1.675 = $291,939

Again the higher rate should be used (the least favourable to TGA Co)

$ after investing $291,939 × 1.01 = $294,858

19 The correct answer is: **Statement 1 is true and statement 2 is false.**

One of the advantages of futures contracts is that the transaction costs are lower than other hedging methods. One of the disadvantages is that they cannot be tailored to the user's requirements. So statement 1 is true and statement 2 is false.

20 The correct answer is: **Statement 1 refers to translation risk. Statement 2 relates to economic risk.**

21 The correct answer is: **12%**

The required rate of return on equity can be found using the capital asset pricing model:

$E(r_i) = R_f + \beta_i (E(r_m) - R_f)$

AZT Co

$E(r_i)$ = 5% + 0.7(15% − 5%)

 = 12%

22 The correct answer is: **32%**

Ex div share price = $3.30 - $0.15 = $3.15

Total shareholder return = $\dfrac{P_1 - P_0 + D}{P_0}$

$$= \frac{(315 - 250) + 15}{250}$$

 = 0.32 = 32%

23 The correct answer is: **1.2**

The equity beta for IML Co can be found using the same expression:

17% = 5% + β(15% − 5%)

$$\beta \;=\; \frac{(17\% - 5\%)}{(15\% - 5\%)}$$

The equity beta factor = 1.2

24 The correct answer is: **Statements 1 and 4 are true.**

The equity beta factor is a measure of the volatility of the return on a share relative to the stock market. If for example a share price moved at 3 times the market rate, its equity beta factor would be 3.0.

The beta factor indicates the level of systematic risk, which is the risk of making an investment that cannot be diversified away.

It is used in the capital asset pricing model to determine the level of return required by investors; the higher the level of systematic risk, the **higher** the required level of return.

It is true that companies want a return on a project to exceed the risk-free rate.

25 The correct answer is: **Statement 1 is true and statement 2 is false.**

Under the CAPM, the return required from a security is related to its systematic risk rather than its total risk. Only the risks that cannot be eliminated by diversification are relevant. The assumption is that investors will hold a fully diversified portfolio and therefore deal with the unsystematic risk themselves.

A low cost of equity would discount future earnings at a low rate – leading to a high market value and a high P/E ratio.

26 The correct answer is: **$20m**

Earnings yield = EPS/Price which is the same as 1 ÷ P/E ratio
So the P/E ratio = 10
Price/earnings ratio method of valuation
Market value = P/E ratio × EPS
EPS = 40.0c
Average sector P/E ratio = 10
Value of shares = 40.0 × 10 = $4.00 per share
(Alternatively 40.0 cents divided by earnings yield of 0.1)
Number of shares = 5 million
Value of Danoca Co = $20 million

27 The correct answer is: **Statement 1 is true and statement 2 is false.**

The current share price of Danoca Co is $3.30 which equates to a P/E ratio of 8.25 (3.30/0.4). This is lower than the average sector P/E ratio of 10 which suggests that the market does not view the growth prospects of Danoca Co as favourably as an average company in that business sector.

If Danoca Co has a **lower** P/E ratio, this would imply that an acquisition by Phobis could result in improved financial performance of Danoca Co.

28 The correct answer is: **$14.75m**

Dividend growth model method of valuation

$$P_o = \frac{D_o(1+g)}{K_e - g}.$$

Note. The formula sheet in this exam uses r_e instead of k_e.

D_0 can be found using the proposed payout ratio of 60%.

$D_0 = 60\% \times 40c = 24c$

$$\text{Value of shares} = \frac{0.24 \times (1 + 0.045)}{0.13 - 0.045}$$

$$= \$2.95$$

Value of Danoca Co = $2.95 × 5 million shares = $14.75 million

29 The correct answer is: **$16.5m**

Market capitalisation of Danoca Co is $3.30 × 5m = $16.5m.

30 The correct answers are:

Under weak form hypothesis of market efficiency, share prices reflect all available information about past changes in share price.

Behavioural finance aims to explain the implications of psychological factors on investor decisions.

'If a stock market displays semi-strong efficiency then individuals can beat the market' is not true. Individuals cannot beat the market because all information publicly available will already be reflected in the share price.

'Random walk theory is based on the idea that past share price patterns will be repeated' is not true. Chartists believe that past share price patterns will be repeated.

Section C

Question 31

Marking scheme

				Marks
(a)	(i)	Current holding cost	0.5	
		Current ordering cost	0.5	
				1
	(ii)	EOQ calculation	1	
		EOQ holding cost	0.5	
		EOQ ordering cost	0.5	
		Finance cost	1	
		EOQ saving	1	
				4
	(iii)	Bulk discount holding cost	0.5	
		Bulk discount ordering cost	0.5	
		Finance costs	1	
		Bulk order discount value	1	
		Bulk order discount saving overall	<u>1</u>	
				4
	(iv)	Advice		1
(b)		Current asset types	2	
		Finance cost/risk	2	
		Matching principle	2	
		Funding policies	2	
		Other points	2	<u>10</u>
				<u>20</u>

(a) (i) Annual holding and ordering costs of the current inventory management system
Each current order is 1,500,000/12 = 125,000 units per order
Average inventory = 125,000/2 = 62,500 units
Current holding cost = 62,500 × 0.21 = $13,125 per year
Current ordering cost = 12 × 252 = $3,024 per year
Current total inventory management cost = $13,125 + $3,024 = $16,149 per year

[Alternatively: financing costs can be expressed as $14 × 0.03 = $0.42 per unit and this can be added to the $0.21 so that total holding costs (including financing costs) = $0.63. If so, total holding costs = 62,500 × 0.63 = $39,375 per year and total inventory management cost = $39,375 + $3,024 = $42,399]

(ii) Financial effect of adopting EOQ model

EOQ = $(2 \times 252 \times 1{,}500{,}000/0.21)^{0.5}$ = 60,000 units/order
Number of orders = 1,500,000/60,000 = 25 orders per year
Average inventory = 60,000/2 = 30,000 units
Holding cost = 30,000 × 0.21 = $6,300 per year
Ordering cost = 25 × 252 = $6,300 per year
EOQ total inventory management cost = $6,300 + $6,300 = $12,600 per year

Reduction in total inventory management cost = $16,149 – $12,600 = $3,549 per year
Reduction in average inventory = (62,500 – 30,000) × 14 = $455,000
The overdraft will decrease by the same amount.
Finance cost saving = 455,000 x 0.03 = $13,650 per year
Overall saving = $3,549 + $13,650 = $17,199

[Alternatively: financing costs can be expressed as $14 × 0.03 = $0.42 per unit and this can be added to $0.21 so that total holding costs (including financing costs) = $0.63. If so total holding costs = 30,000 × 0.63 = $18,900 per year including financing costs and total EOQ inventory management cost = $18,900 + $6,300 = $25,200 which is a saving of $17,199 compared to the alternative solution to a(i) which showed a total inventory cost of $42,399.]

(iii) Financial effect of accepting the bulk order discount

Number of orders = 1,500,000/250,000 = 6 orders per year
Average inventory = 250,000/2 = 125,000 units
Holding cost = 125,000 x 0.21 = $26,250 per year
Ordering cost = 6 × 252 = $1,512 per year
Total inventory management cost = $26,250 + $1,512 = $27,762 per year
Increase in total inventory management cost = $27,762 – $16,149 = $11,613 per year
Increase in value of average inventory = (125,000 × 13.93) – (62,500 × 14) = $866,250
The overdraft will increase by the same amount.
Finance cost increase = 866,250 × 0.03 = $25,987.5 per year
Bulk order discount = 1,500,000 × 14 × 0·005 = $105,000 per year
Overall saving = $105,000 – $11,613 – $25,987.5 = $67,399.5

[Alternatively: financing costs after the discount can be expressed as $14 × 0.995 × 0.03 = $0.4179 / unit and this can be added to $0.21 so that total holding costs (including financing costs) = $0.6279. If so, total holding costs = 125,000 x 0·6279 = $78,487.5 per year including financing costs and total inventory management cost = $78,487.5 + $1,512 ordering cost $21,000,000 purchasing cost - $105,000 discount = $20,974,999.5.

Compared to current inventory costs of $42,399 from a(i) + $21,000,000 purchasing costs = $21,042,399, this is a saving of $67,399.5.]

(iv) The bulk order discount saves $67,399.5 compared to the current position, while the EOQ approach saves $17,199.

The bulk order discount is recommended as it leads to the greater cost saving.

(b) **Key factors in determining working capital funding strategies**

Permanent and fluctuating current assets

One key factor when discussing working capital funding strategies is to distinguish between permanent and fluctuating current assets. Permanent current assets represent the core level of current assets needed to support normal levels of business activity, for example, the level of trade receivables associated with the normal level of credit sales and existing terms of trade. Business activity will be subject to unexpected variations, however, such as some customers being late in settling their accounts, leading to unexpected variations in current assets. These can be termed fluctuating current assets.

Relative cost and risk of short-term and long-term finance

A second key factor is the relative cost of short-term and long-term finance. The normal yield curve suggests that long-term debt finance is more expensive than short-term debt finance, for example, because of investor liquidity preference or default risk. Provided the terms of loan agreements are adhered to and interest is paid when due, however, long-term debt finance is a secure form of finance and hence low risk.

While short-term debt finance is lower cost than long-term debt finance, it is higher risk. For example, an overdraft is technically repayable on demand, while a short-term loan is subject to the risk that it may be renewed on less favourable terms than those currently enjoyed.

Matching principle

A third key factor is the matching principle, which states that the maturity of assets should be reflected in the maturity of the finance used to support them. Short-term finance should be used for fluctuating current assets, while long-term finance should be used for permanent current assets and non-current assets.

Relative costs and benefits of different funding policies

A fourth key factor is the relative costs and benefits of different funding policies.

A matching funding policy would use long-term finance for permanent current assets and non-current assets, and short-term finance for fluctuating current assets. A conservative funding policy would use long-term finance for permanent current assets, non-current assets and some of the fluctuating current assets, with short-term finance being used for the remaining fluctuating current assets. An aggressive funding policy would use long-term finance for the non-current assets and part of the permanent current assets, and short-term finance for fluctuating current assets and the balance of the permanent current assets.

A conservative funding policy, using relatively more long-term finance, would be lower in risk but lower in profitability. An aggressive funding policy, using relatively more short-term finance, would be higher in risk but higher in profitability. A matching funding policy would balance risk and profitability, avoiding the extremes of a conservative or an aggressive funding policy.

Other key factors

Other key factors in working capital funding strategies include managerial attitudes to risk, previous funding decisions and organisation size. Managerial attitudes to risk can lead to a company preferring one working capital funding policy over another, for example, a risk-averse managerial team might prefer a conservative working capital funding policy. Previous funding decisions dictate the current short-term/long-term financing mix of a company. Organisational size can be an important factor in relation to, for example, access to different forms of finance in support of a favoured working capital funding policy.

Question 32

Workbook references. Analysis of leasing and capital rationing are covered in Chapter 8.

Top tips. Neat workings will be important to avoid careless errors in part (a), for example over the timing of the lease payments and the tax relief on the lease payments.

Easy marks. Discussion marks in part (b) should be straightforward as long as answers do not stray into irrelevant areas such as how to manage capital rationing issues using techniques such as the profitability index etc. Ideally discussion points would recognise that the company is an SME so points such as crowdfunding, grants, business angels would also be relevant as well as points such as delaying projects and joint ventures.

			Marks
(a)	(i)	Kd after tax	1
		TAD	1
		TAD benefits	1
		Service tax benefit	1
		Tax timing	1
		PV buying	1
			6
	(ii)	Lease tax benefits	1
		Lease timing	1
		PV leasing	1
			3
	(iii)	Recommendation	1
(b)	(i)	Hard rationing reasons	3
		Soft rationing reasons	3
			6
(b)	(ii)	Ways to overcome	4
			4
			20

(a) (i) After-tax cost of borrowing = 8.6 × (1 – 0.3) = 8.6 × 0.7 = 6%

Calculating PV of cost of borrowing to buy:

Year	0	1	2	3	4	5
	$	$	$	$	$	$
Purchase	(750,000)					
Residual value					50,000	
Service costs		(23,000)	(23,000)	(23,000)	(23,000)	
TAD benefit			56,250	42,188	31,641	79,922
Service cost tax benefits			6,900	6,900	6,900	6,900
Net cash flow	(750,000)	(23,000)	40,150	26,088	65,541	86,822
Discount at 6%	1.000	0.943	0.890	0.840	0.792	0.747
	(750,000)	(21,689)	35,734	21,914	51,908	64,856

PV of cost of borrowing to buy is $597,777.

Using the spreadsheet NPV function and spreadsheet-calculated discount factors, PV of cost of borrowing to buy is $597,268.

Working: TAD benefit

Year	0	1	2	3	4	5
	$	$	$	$	$	$
Purchase	750,000					
TAD		187,500	140,625	105,469	266,406*	
30% TAD benefit			56,250	42,188	31,641	79,922

*750,000 – 187,500 – 140,625 – 105,469 – 50,000 = $266,406

(ii) Calculating PV of cost of leasing:

Year	0	1	2	3	4	5
	$	$	$	$	$	$
Lease rentals	(200,000)	(200,000)	(200,000)	(200,000)		
Tax benefits			60,000	60,000	60,000	60,000
Net cash flow	(200,000)	(200,000)	(140,000)	(140,000)	60,000	60,000
Discount at 6%	1.000	0.943	0.890	0.840	0.792	0.747
	(200,000)	(188,600)	(124,600)	(117,600)	47,520	44,820

PV of cost of leasing is $538,460.

Using the spreadsheet NPV function and spreadsheet-calculated discount factors, PV of cost of leasing is $538,464.

(iii) Financial benefit of leasing = $597,277 − $538,460 = $58,817

Using the spreadsheet NPV function and spreadsheet-calculated discount factors, financial benefit of leasing = $597,268 − $538,464 = $58,804.

Leasing the new machine is recommended as the option which is more attractive in financial terms to Dink Co.

(b) (i) **Reasons why investment capital may be rationed**

Theoretically, the objective of maximising shareholder wealth can be achieved in a perfect capital market by investing in all projects with a positive NPV. In practice, companies experience capital rationing and are limited in the amount of investment finance available, so shareholder wealth is not maximised.

Hard capital rationing is due to external factors, while soft capital rationing is due to internal factors or management decisions.

General reasons for hard capital rationing affect many companies, for example, the availability of new finance may be limited because share prices are depressed on the stock market or because of government-imposed restrictions on bank lending.

If a company only requires a small amount of finance, issue costs may be so high that using external sources of finance is not practical.

Reasons for hard capital rationing may be company-specific, for example, a company may not be able to raise new debt finance if banks or investors see the company as being too risky to lend to. The company may have high gearing or low interest cover, or a poor track record, or if recently incorporated, no track record at all. Companies in the service sector may not be able to offer assets as security for new loans.

Reasons for soft capital rationing include managerial aversion to issuing new equity, for example, a company may want to avoid potential dilution of its EPS or avoid the possibility of becoming a takeover target. Managers might alternatively be averse to issuing new debt and taking on a commitment to increased fixed interest payments, for example, if the economic outlook for its markets is poor.

Soft capital rationing might also arise because managers wish to finance new investment from retained earnings, for example, as part of a policy of controlled organisational growth, rather than a sudden increase in size which might result from undertaking all investments with a positive net present value.

One reason for soft capital rationing may be that managers want investment projects to compete for funds, in the belief that this will result in the acceptance of stronger, more robust investment projects.

(ii) **Ways in which Dink Co's external capital rationing might be overcome**

Dink Co is a small company and the hard capital rationing it is experiencing is a common problem for SMEs, referred to as the funding gap. A first step towards overcoming its capital rationing could be for Dink Co to obtain information about available sources of finance, since SMEs may lack understanding in this area.

One way of overcoming the company's capital rationing might be business angel financing. This informal source of finance is from wealthy individuals or groups of investors who invest directly in the company and who are prepared to take higher risks in the hope of higher returns. Information requirements for this form of finance may be less demanding than those associated with more common sources of finance.

BPP
LEARNING
MEDIA

Dink Co could consider crowdfunding, whereby many investors provide finance for a business venture, for example, via an internet-based platform, although this form of finance is usually associated with entrepreneurial ventures.

Dink Co might be entitled to grant aid from a government, national or regional source which could be linked to a specific business area or to economic regeneration in a specified geographical area.

On a more general basis, Dink Co could consider a joint venture as a way of decreasing the need for additional finance, depending on the nature of its business and its business plans, and whether the directors of Dink Co are prepared to sacrifice some control to the joint venture partner.

Rather than conventional sources of finance, Dink Co could evaluate whether Islamic finance, for example, an ijara contract, might be available, again depending on the nature of its business and its business plans.

Mathematical tables and formulae

Formula Sheet

Economic order quantity

$$= \sqrt{\frac{2C_0 D}{C_h}}$$

Miller-Orr Model

$$\text{Return point} = \text{Lower limit} + \left(\frac{1}{3} \times \text{spread}\right)$$

$$\text{Spread} = 3 \left[\frac{\frac{3}{4} \times \text{transaction cost} \times \text{variance of cash flows}}{\text{interest rate}} \right]^{\frac{1}{3}}$$

The Capital Asset Pricing Model

$$E(r_i) = R_f + \beta_i (E(r_m) - R_f)$$

The asset beta formula

$$\beta_a = \left[\frac{V_e}{(V_e + V_d(1-T))} \beta_e \right] + \left[\frac{V_d(1-T)}{(V_e + V_d(1-T))} \beta_d \right]$$

The Growth Model

$$P_0 = \frac{D_0(1+g)}{(r_e - g)} \qquad\qquad r_e = \frac{D_0(1+g)}{P_0} + g$$

Gordon's growth approximation

$$g = b r_e$$

The weighted average cost of capital

$$\text{WACC} = \left[\frac{V_e}{V_e + V_d} \right] k_e + \left[\frac{V_d}{V_e + V_d} \right] k_d (1-T)$$

The Fisher formula

$$(1 + i) = (1 + r)(1 + h)$$

Purchasing power parity and interest rate parity

$$S_1 = S_0 \times \frac{(1 + h_c)}{(1 + h_b)}$$

$$F_0 = S_0 \times \frac{(1 + i_c)}{(1 + i_b)}$$

Present Value Table

Present value of 1 ie $(1 + r)^{-n}$

Where r = discount rate
 n = number of periods until payment

Discount rate (r)

Periods (n)	1%	2%	3%	4%	5%	6%	7%	8%	9%	10%	
1	0.990	0.980	0.971	0.962	0.952	0.943	0.935	0.926	0.917	0.909	1
2	0.980	0.961	0.943	0.925	0.907	0.890	0.873	0.857	0.842	0.826	2
3	0.971	0.942	0.915	0.889	0.864	0.840	0.816	0.794	0.772	0.751	3
4	0.961	0.924	0.888	0.855	0.823	0.792	0.763	0.735	0.708	0.683	4
5	0.951	0.906	0.863	0.822	0.784	0.747	0.713	0.681	0.650	0.621	5
6	0.942	0.888	0.837	0.790	0.746	0.705	0.666	0.630	0.596	0.564	6
7	0.933	0.871	0.813	0.760	0.711	0.665	0.623	0.583	0.547	0.513	7
8	0.923	0.853	0.789	0.731	0.677	0.627	0.582	0.540	0.502	0.467	8
9	0.914	0.837	0.766	0.703	0.645	0.592	0.544	0.500	0.460	0.424	9
10	0.905	0.820	0.744	0.676	0.614	0.558	0.508	0.463	0.422	0.386	10
11	0.896	0.804	0.722	0.650	0.585	0.527	0.475	0.429	0.388	0.350	11
12	0.887	0.788	0.701	0.625	0.557	0.497	0.444	0.397	0.356	0.319	12
13	0.879	0.773	0.681	0.601	0.530	0.469	0.415	0.368	0.326	0.290	13
14	0.870	0.758	0.661	0.577	0.505	0.442	0.388	0.340	0.299	0.263	14
15	0.861	0.743	0.642	0.555	0.481	0.417	0.362	0.315	0.275	0.239	15

(n)	11%	12%	13%	14%	15%	16%	17%	18%	19%	20%	
1	0.901	0.893	0.885	0.877	0.870	0.862	0.855	0.847	0.840	0.833	1
2	0.812	0.797	0.783	0.769	0.756	0.743	0.731	0.718	0.706	0.694	2
3	0.731	0.712	0.693	0.675	0.658	0.641	0.624	0.609	0.593	0.579	3
4	0.659	0.636	0.613	0.592	0.572	0.552	0.534	0.516	0.499	0.482	4
5	0.593	0.567	0.543	0.519	0.497	0.476	0.456	0.437	0.419	0.402	5
6	0.535	0.507	0.480	0.456	0.432	0.410	0.390	0.370	0.352	0.335	6
7	0.482	0.452	0.425	0.400	0.376	0.354	0.333	0.314	0.296	0.279	7
8	0.434	0.404	0.376	0.351	0.327	0.305	0.285	0.266	0.249	0.233	8
9	0.391	0.361	0.333	0.308	0.284	0.263	0.243	0.225	0.209	0.194	9
10	0.352	0.322	0.295	0.270	0.247	0.227	0.208	0.191	0.176	0.162	10
11	0.317	0.287	0.261	0.237	0.215	0.195	0.178	0.162	0.148	0.135	11
12	0.286	0.257	0.231	0.208	0.187	0.168	0.152	0.137	0.124	0.112	12
13	0.258	0.229	0.204	0.182	0.163	0.145	0.130	0.116	0.104	0.093	13
14	0.232	0.205	0.181	0.160	0.141	0.125	0.111	0.099	0.088	0.078	14
15	0.209	0.183	0.160	0.140	0.123	0.108	0.095	0.084	0.074	0.065	15

Annuity Table

Present value of an annuity of 1 ie $\dfrac{1-(1+r)^{-n}}{r}$

Where r = discount rate

 n = number of periods

Discount rate (r)

Periods (n)	1%	2%	3%	4%	5%	6%	7%	8%	9%	10%	
1	0.990	0.980	0.971	0.962	0.952	0.943	0.935	0.926	0.917	0.909	1
2	1.970	1.942	1.913	1.886	1.859	1.833	1.808	1.783	1.759	1.736	2
3	2.941	2.884	2.829	2.775	2.723	2.673	2.624	2.577	2.531	2.487	3
4	3.902	3.808	3.717	3.630	3.546	3.465	3.387	3.312	3.240	3.170	4
5	4.853	4.713	4.580	4.452	4.329	4.212	4.100	3.993	3.890	3.791	5
6	5.795	5.601	5.417	5.242	5.076	4.917	4.767	4.623	4.486	4.355	6
7	6.728	6.472	6.230	6.002	5.786	5.582	5.389	5.206	5.033	4.868	7
8	7.652	7.325	7.020	6.733	6.463	6.210	5.971	5.747	5.535	5.335	8
9	8.566	8.162	7.786	7.435	7.108	6.802	6.515	6.247	5.995	5.759	9
10	9.471	8.983	8.530	8.111	7.722	7.360	7.024	6.710	6.418	6.145	10
11	10.368	9.787	9.253	8.760	8.306	7.887	7.499	7.139	6.805	6.495	11
12	11.255	10.575	9.954	9.385	8.863	8.384	7.943	7.536	7.161	6.814	12
13	12.134	11.348	10.635	9.986	9.394	8.853	8.358	7.904	7.487	7.103	13
14	13.004	12.106	11.296	10.563	9.899	9.295	8.745	8.244	7.786	7.367	14
15	13.865	12.849	11.938	11.118	10.380	9.712	9.108	8.559	8.061	7.606	15

(n)	11%	12%	13%	14%	15%	16%	17%	18%	19%	20%	
1	0.901	0.893	0.885	0.877	0.870	0.862	0.855	0.847	0.840	0.833	1
2	1.713	1.690	1.668	1.647	1.626	1.605	1.585	1.566	1.547	1.528	2
3	2.444	2.402	2.361	2.322	2.283	2.246	2.210	2.174	2.140	2.106	3
4	3.102	3.037	2.974	2.914	2.855	2.798	2.743	2.690	2.639	2.589	4
5	3.696	3.605	3.517	3.433	3.352	3.274	3.199	3.127	3.058	2.991	5
6	4.231	4.111	3.998	3.889	3.784	3.685	3.589	3.498	3.410	3.326	6
7	4.712	4.564	4.423	4.288	4.160	4.039	3.922	3.812	3.706	3.605	7
8	5.146	4.968	4.799	4.639	4.487	4.344	4.207	4.078	3.954	3.837	8
9	5.537	5.328	5.132	4.946	4.772	4.607	4.451	4.303	4.163	4.031	9
10	5.889	5.650	5.426	5.216	5.019	4.833	4.659	4.494	4.339	4.192	10
11	6.207	5.938	5.687	5.453	5.234	5.029	4.836	4.656	4.486	4.327	11
12	6.492	6.194	5.918	5.660	5.421	5.197	4.988	4.793	4.611	4.439	12
13	6.750	6.424	6.122	5.842	5.583	5.342	5.118	4.910	4.715	4.533	13
14	6.982	6.628	6.302	6.002	5.724	5.468	5.229	5.008	4.802	4.611	14
15	7.191	6.811	6.462	6.142	5.847	5.575	5.324	5.092	4.876	4.675	15

Advanced Financial Management

Review Form – Financial Management (FM) (02/20)

Name: _____ Address: _____

How have you used this Kit?
(Tick one box only)

☐ On its own (book only)

☐ On a BPP in-centre course_____

☐ On a BPP online course

☐ On a course with another college

☐ Other _____

Why did you decide to purchase this Kit?
(Tick one box only)

☐ Have used the Workbook

☐ Have used other BPP products in the past

☐ Recommendation by friend/colleague

☐ Recommendation by a lecturer at college

☐ Saw advertising

☐ Other _____

During the past six months do you recall seeing/receiving any of the following?
(Tick as many boxes as are relevant)

☐ Our advertisement in *Student Accountant*

☐ Our advertisement in *Pass*

☐ Our advertisement in *PQ*

☐ Our brochure with a letter through the post

☐ Our website www.bpp.com

Which (if any) aspects of our advertising do you find useful?
(Tick as many boxes as are relevant)

☐ Prices and publication dates of new editions

☐ Information on product content

☐ Facility to order books

☐ None of the above

Which BPP products have you used?

Workbook ☐ *Other* ☐

Practice & Revision Kit ☑

Your ratings, comments and suggestions would be appreciated on the following areas.

	Very useful	Useful	Not useful
Passing FM			
Questions			
Top Tips etc in answers			
Content and structure of answers			
Mock exam answers			

Overall opinion of this Practice & Revision Kit Excellent ☐ Good ☐ Adequate ☐ Poor ☐

Do you intend to continue using BPP products? Yes ☐ No ☐

The BPP author of this edition can be emailed at: learningmedia@bpp.com

Review Form (continued)

TELL US WHAT YOU THINK

Please note any further comments and suggestions/errors below.